ART IN POLAND

1572-1764

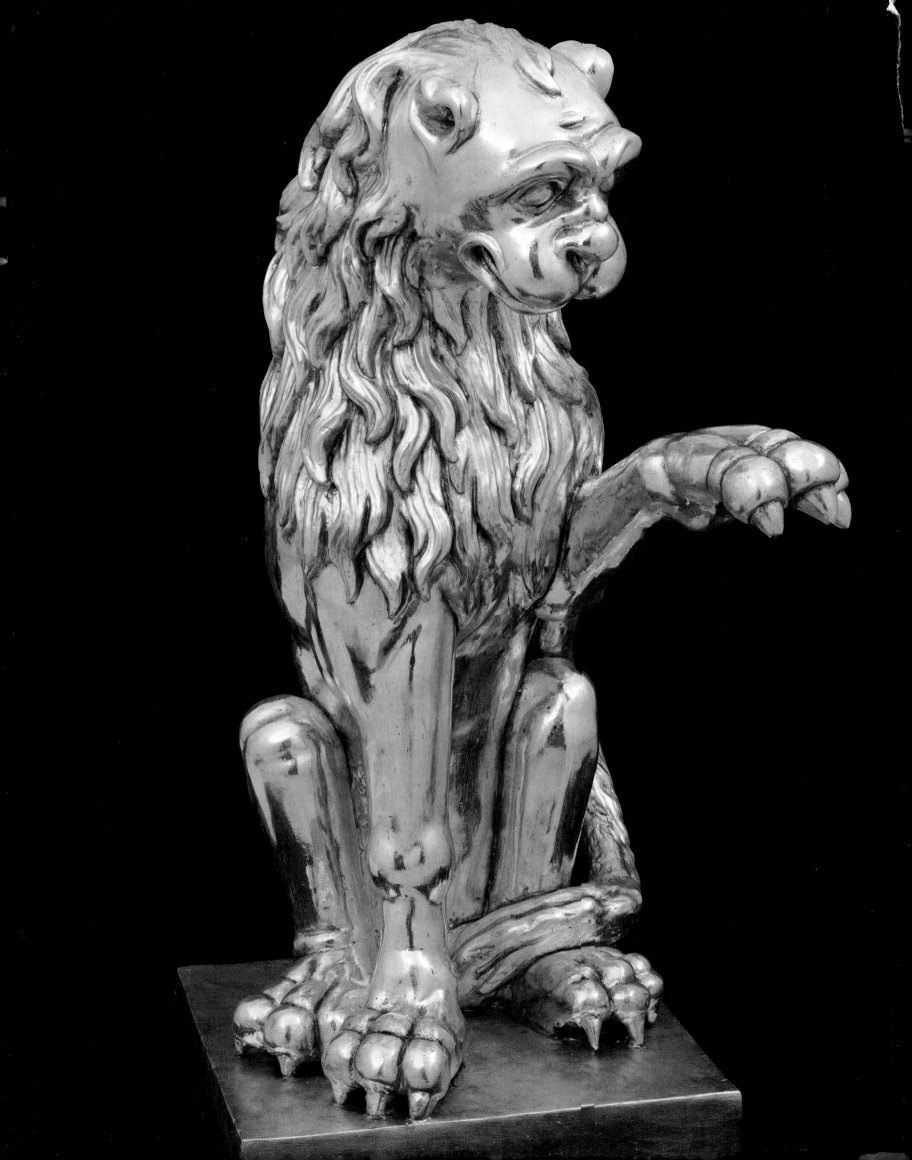

Land of the Winged Horsemen

Art in Poland

1572-1764

Jan K. Ostrowski

Thomas DaCosta Kaufmann

Piotr Krasny

Kazimierz Kuczman

Adam Zamoyski

Zdzisław Żygulski, Jr.

Art Services International

Alexandria, Virginia

In association with Yale University Press

1999

TRANSLATED BY Krystyna Malcharek

EDITED BY Jane Sweeney

DESIGNED BY Suzanne Stanton Chadwick, Chadwick Design Incorporated

CLOTHBOUND EDITION DISTRIBUTED BY
Yale University Press
ISBN 0-300-07815-4

TYPESET IN EuroSlavic Pala™
from Linguist's Software, Inc.
PRINTED ON 130 gsm Biberist Demi-Matte
BY Dai Nippon Printing, Inc.

PRINTED IN Hong Kong

COVER: *The King's Hussar Regiment* from *The Stockholm Roll* (detail, cat. 1b). Royal Castle, Warsaw

FRONTISPIECE: *Lion from the Castrum Doloris of Franciszek Salezy and Anna Potocki* (cat. 103a). Museum of the Province of the Bernardines, Leżajsk

LAND OF THE WINGED HORSEMEN: ART IN POLAND 1572–1764

This volume accompanies an exhibition organized and circulated by Art Services International, Alexandria, Virginia, in cooperation with The Walters Art Gallery, and supported by the Samuel H. Kress Foundation, The Kosciuszko Foundation, The Polish National Tourist Office in New York, and The Rosenstiel Foundation. **LOT** Polish Airlines is the official carrier of the exhibition.

LIBRARY OF CONGRESS CATALOGING-IN-PUBLICATION DATA

Land of the winged horsemen : art in Poland, 1572–1764 / Jan K. Ostrowski . . . [et al.; translated by Krystyna Malcharek].
 p. cm.
 Catalog of a traveling exhibition organized and circulated by Art Services International, Alexandria, Va. in cooperation with the Walters Art Gallery, Baltimore, Md.
 Includes bibliographical references and index.
 ISBN 0-88397-131-3 (pbk)
 1. Art, Polish—Exhibitions. 2. Art, Baroque—Poland—Exhibitions. I. Ostrowski, Jan K. II. Art Services International. III. Walters Art Gallery (Baltimore, Md.)
N7255.P6 L36 1999
709'.438'074—dc21 98–37979
 CIP
 r98

PHOTO CREDITS
ESSAYS: Kaufmann, *Definition and Self-Definition in Polish Culture and Art*: A. Bochnak, figs. 4, 5; Stanisław Michta, 1, 2; Muzeum Narodowe, Posnaniu, 1; Ryszard Petrajtis, 2; Wawel Royal Castle, Cracow, 2; Witalis Wolny, 3. Ostrowski, *Polish Art in Its Social and Religious Context*: Adam Bochnak, 14; N. Haczewski, 15; Institute of Art, Polish Academy of Sciences, Warsaw, 1, 4, 14–16; Ewa Kozłowska-Tomczyk, 4; Stanisław Michta, 5, 12, 13; J. Mierzecka, 7; National Museum, Warsaw, 6, 7; Henryk Poddębski, 1; Lukasz Schuster, 8; Stanisław Sobkowicz, 6; Jerzy Szandomierski, 11; Jan Świderski, 16; Edward Trzemeski, 2; Warsaw University Library, 3, 10; Wawel Royal Castle, Cracow, 5, 8. Ostrowski, *Mechanisms of Contact between Polish and European Baroque*: Zbigniew Hornung, 6; Stanisław Kolowca, 7, 9; Institute of Art, Polish Academy of Sciences, Warsaw, 5, 7, 9; Stanisław Michta, 4, 8; Ossoliński Library, Wrocław, 6; Jan K. Ostrowski, 3; Wawel Royal Castle, Cracow, 4, 8; N. Wojnarowicz, 5; Witalis Wolny, 1, 2. Żygulski, *The Impact of the Orient on the Culture of Old Poland*: Princes Czartoryski Museum, Cracow, 2–5, 9, 10; Rudolf Kozłowski, 1; Stanisław Michta, 7; Lukasz Schuster, 6; Wawel Royal Castle, Cracow, 1, 6, 7. Krasny, *Architecture in Poland, 1572–1764*: Stanisław Kolowca, 5; Monika Moraczewski, 1; Henryk Poddębski, 2, 12; Adam Rzepecki, 3; Witalis Wolny, 8. CATALOGUE: Agencja Foto-Studio Kołecki, cat. 22; Maciej Bronarski, 1, 3, 7, 9, 12, 14, 16a-c, 18, 27, 29, 31a-b, 51, 99, 127a-d, 129a, 130, 133, 137; Janusz Kozina and Grzegorz Zygier, 19, 36; M. Łanowiecki, 77; Stanisław Michta, 23, 52-55, 78-80, 86-96, 98, 100–102, 104–106, 115, 116; Muzeum Historyczne, Cracow, 112, 113; Muzeum Lubelskie, Lublin, 8; Muzeum Okręgowe, Zamość, 114; Ryszard Petrajtis 45, 46, 120; Łukasz Schuster 2, 5, 6, 13, 15, 17, 20, 24, 25, 30, 33, 35, 44, 47, 48, 51, 58–60, 62, 68-71, 73–76, 83, 84, 97, 117–119, 122, 123, 126b, 127e; Roman Stasiuk, 34; Andrzej Szandomirski, 4, 49; Adam Wierzba, 13, 15, 17, 21, 26, 32, 44, 61, 63, 64, 67, 71, 72, 81, 82, 85, 103, 121, 124, 125a-i, 126a; Tomasz Zaucha, 39–43, 65, 66, 108, 113, 131, 132, 134–136; Teresa Żółtowska-Huszcza, 28, 37; Żydowski Instytut Historyczny, Warsaw, 107.

Contents

Honorary Committee

His Excellency, The Honorable Bronisław Geremek
Minister of Foreign Affairs of Poland

Her Excellency, The Honorable Joanna Wnuk-Nazarowa
Minister of Culture and Arts of Poland

His Excellency, The Honorable Jerzy Koźminski
Polish Ambassador to the United States

The Honorable Daniel Fried
United States Ambassador to the Republic of Poland

The Honorable Henry A. Kissinger
Former Secretary of State of the United States

The Honorable Nicholas A. Rey
Former Ambassador of the United States to Poland

The Honorable Zbigniew Brzezinski
Center for Strategic and International Studies

Stan Musial
Member, Baseball Hall of Fame

Edward J. Piszek
Chairman, Copernicus Society of America

Lady Blanka A. Rosenstiel, O.S.J.
Founder and President, The American Institute of Polish Culture

Dr. Michael G. Sendzimir
Honorary Chairman and Trustee, The Kosciuszko Foundation

Message from the President of the Republic of Poland

With true joy and pride, I invite you to see the exhibition *Land of the Winged Horsemen: Art in Poland 1572-1764*. I am curious about your impressions of it. Poland's many friends in the United States are generally aware that our democratic and independent country, recently liberated from foreign domination by its own efforts, is taking bold steps to deal with the complex problems of contemporary life. They know that Poland is catching up in areas that used to be neglected, is on its way to joining the North Atlantic Treaty Organization (NATO), and is knocking on the European Union's door. Yet people sometimes find it hard to fully comprehend these transformations.

To those who wish to understand how the Poles are able to accomplish even the most difficult tasks with relative ease, I would like to say that our unwavering, strong will and the laboriousness with which we face every challenge are the decisive factors. I would refer all interested persons to Poland's past, which hides secrets that can often explain even the most puzzling present. Our past, more than a millennium old, remains, generally speaking, unknown and obscure. Thanks to the good will and interest of the American hosts and organizers of this exhibition, we are presented with an unusual opportunity to use the universal language of art to tell you some stories about Old Poland, to reveal some secrets about Poland's past.

The extent of this revelation is quite broad, spanning almost two centuries. The exhibition shows an era when Poland, just after uniting with the Grand Duchy of Lithuania, ranked as the second-largest country in Europe. Poland was a sovereign state, governed in accordance with an independently developed, unique system of democracy of the gentry, with a ruler–a king–who gained power through election. Poland was a multinational country, inhabited by people of all Christian faiths as well as Jews and Muslims. It was a powerful country, too. It was a country of significance on the international arena–a country whose civilization and culture radiated upon its neighbors.

Out of that gigantic melting pot of nations, cultures, religious beliefs, customs, and historical experiences emerged the Polish identity. Notable in our exhibition was the nobility's love of splendor, as illustrated in a painting (cat. 26) that shows how Polish diplomats could dazzle foreigners with the wealth of their cortèges. A sense of responsibility for other people constituted another component of the Polish identity. It was that moral imperative that directed the Polish "winged horsemen"–the hussars–to abandon the serene peace of their homesteads and follow King Jan III Sobieski in a race to Vienna to defend Christian Europe from the onslaught of Muslim invaders, as is evidenced by the Turkish tent (cat. 52), a trophy from that battle. The security of present-day Europe and North America, allied with NATO, is built on this type of foundation, which the Poles have cherished for centuries.

The Poles are proud of their past and even today draw heavily on their own historical experience. At the turn of a new century, enthusiastic about the present and a new, extraordinary destiny, the Poles agree with what the romantic poet Cyprian Kamil Notwid once said: "The past-it is today, but somewhat removed...."

I think that this exhibition will bring the picture of Poland and the Poles closer to our American friends. It will help the Poles become better understood in America.

Aleksander Kwaśniewski

Acknowledgments

The history of Poland in the baroque era is as exotic and dramatic as its art. This place and time of great contrasts is little known in the United States, and *Land of the Winged Horsemen: Art in Poland, 1572-1764* seeks to expand the understanding and appreciation of this era's magnificence. We are grateful to the Polish authorities for endorsing this project and to our friends in Poland and the United States for their cooperation in bringing this extraordinary idea to life in the form of an exhibition. We thank first Prof. Dr. Andrzej Rottermund, Director, Royal Castle, Warsaw, and Prof. Dr. Jan K. Ostrowski, Director, Wawel Royal Castle, Cracow, for initiating the venture in Poland, for overseeing the choice of the works of art, and for providing significant loans from their own institutions. We are equally grateful to Dr. Gary Vikan, Director, and Dr. Ellen D. Reeder, Curator of Ancient Art, The Walters Art Gallery, Baltimore, for recommending this vast project; for cooperating in its development from the outset; and, appropriately, for hosting the premiere venue. Such visionary colleagues are an asset we highly value.

We recognize the generosity of the members of the Honorary Committee for their devotion to Poland and for lending their distinguished names in support of the exhibition. The roster of the Honorary Committee is recorded at the opening of this volume. We commend the Polish Ministry of Culture and Arts for sponsoring the restoration of the works of art.

The collaboration of the museums participating in the exhibition has been crucial in bringing to the public these important works of art and the ideas they represent. We are pleased to acknowledge the cooperation of James N. Wood, Director and President, and Dr. Ian B. Wardropper, The Eloise W. Martin Curator of European Decorative Arts and Sculpture, and Ancient Art, The Art Institute of Chicago; Peter Baldaia, Chief Curator, Huntsville Museum of Art; Steven L. Brezzo, Director, and Steven Kern, Curator of European Art, The San Diego Museum of Art; and Marcia Y. Manhart, Executive Director, and Richard P. Townsend, Ruth G. Hardman Curator of European and American Art, The Philbrook Museum of Art, Tulsa.

This exhibition has brought together a broad group of organizations and individuals who recognize the importance of this endeavor and have provided their generous support. We are particularly grateful to Lady Blanka A. Rosenstiel, O.S.J., President, The American Institute of Polish Culture; Penny A. Hunt, Director, Medtronic Foundation; Roy Kaplan, Matching Gifts Administrator, Microsoft Corporation; Mr. and Mrs. Thaddeus S. Mirecki; Dr. Michael G. Sendzimir; and Colonel and Mrs. Casimir I. Lenard, all of whom provided valued support in the developmental stage of this project. Meaningful assistance to ensure the successful launch of the exhibition has been provided by Lisa Ackerman, Vice President, Samuel H. Kress Foundation; Joseph Gore, President and Executive Director, The Kosciuszko Foundation; Leszek Mokrzycki, Director, Polish National Tourist Office in New York; and Maurice C. Greenbaum, Trustee, The Rosenstiel Foundation. We are indebted to each for their involvement. And, with pleasure, we recognize LOT Polish Airlines as the official airline of the exhibition and send special thanks to Krzysztof Ziębiński for his commitment to the exhibition.

We are delighted to recognize two individuals who have been fundamental to the formation of this project. Count Andrew S. Ciechanowiecki has supported the exhibition from its earliest months, working to ensure balance and high quality throughout the

presentation. We are grateful that he has continued to trace the development of this project and provide his valued counsel as well as the Preface to this volume. Alina Magnuska, Cultural Counselor of the Polish Embassy, has assisted us throughout the development of the exhibition, and her tireless dedication deserves our special thanks. Her enthusiasm is infectious, and the exhibition could have no greater proponent.

We are also pleased to acknowledge Susan Drymalski Bowey, Robert H. McNulty, and John Somerville for their kind assistance at critical stages of this project.

It is the catalogue that will continue to reach new audiences after the works of art are returned to their different repositories throughout Poland. We enthusiastically commend the authors for their fine scholarship put forth in this volume and for their insightful and instructive commentary. Led by Prof. Dr. Ostrowski, Guest Curator of the exhibition in tandem with Prof. Dr. Rottermund, we are pleased to recognize Dr. Piotr Krasny, Dr. Kazimierz Kuczman, Adam Zamoyski, and Prof. Dr. Zdzisław Żygulski, Jr., in Poland and Dr. Thomas DaCosta Kaufmann in the United States. Production of the volume was in the imaginative and capable hands of Krystyna Malcharek, translator; Jane Sweeney, editor; Suzanne Stanton Chadwick, designer; and DNP America, Inc., printer. We thank them for their professionalism and for so eloquently presenting the art of Poland to a much expanded audience.

The staff of Art Services International has performed with proficiency in facilitating the exhibition and tour in America. We are proud to recognize the teamwork of Douglas Shawn, Donna Elliott, Sheryl Kreischer, Linda Vitello, Kerri Spitler, Catherine Bade, Sally Thomas, Marcia Brocklebank, and Kathryn Evans and congratulate them on their accomplishment.

LYNN K. ROGERSON
Director

JOSEPH W. SAUNDERS
Chief Executive Officer
ART SERVICES INTERNATIONAL

LENDERS TO THE EXHIBITION

CRACOW

Carmelite Church of the Visitation of the Blessed Virgin Mary "Na Piasku"

Cathedral of Saint Wenceslas and Saint Stanislas

Church of the Assumption of the Blessed Virgin Mary

Collegiate Church of Saint Florian

Corpus Christi Church of Canons Regular

Princes Czartoryski Museum

Jagiellonian University Museum (Muzeum Uniwersytetu Jagiellońskiego)

Jesuit Church of Saint Barbara

Museum of the History of Cracow (Muzeum Historyczne Miasta Krakowa)

National Museum (Muzeum Narodowe)

Wawel Royal Castle (Zamek Królewski na Wawelu)

GDAŃSK

National Museum (Muzeum Narodowe)

KIELCE

National Museum (Muzeum Narodowe)

LESZNO

Regional Museum (Muzeum Okręgowe)

LEŻAJSK

Museum of the Province of the Bernardines (Muzeum Prowincji Bernardynów)

LUBACZÓW

Museum at Lubaczów (Muzeum w Lubaczowie)

LUBLIN

Lublin Museum (Muzeum Lubelskie)

LVOV

Metropolitan Curia of the Latin Rite

MIECHÓW

Church of the Holy Sepulcher

NEW YORK

The Metropolitan Museum of Art

NIEBORÓW

Museum of Nieborów at Arkadia (Muzeum w Nieborowie i Arkadii-oddział Muzeum Narodowego w Warszawie)

OLKUSZ

Church of Saint Andrew

PRZEMYŚL

National Museum of the Przemyśl Region (Muzeum Narodowe Ziemi Przemyskiej)

TARNÓW

Treasury of the Cathedral of the Nativity of the Blessed Virgin Mary

ULANÓW

Church of Saint John the Baptist and Saint John the Evangelist

WARSAW

The Ciechanowiecki Family Foundation at the Royal Castle (Fundacja Zbiorów im Ciechanowieckich w Zamku Królewskim)

Jewish Historical Institute (Żydowski Instytut Historyczny)

Royal Łazienki Museum (Muzeum Łazienki Królewskie)

National Museum (Muzeum Narodowe)

Museum-Palace at Wilanów (Muzeum-Pałac w Wilanowie)

Royal Castle (Zamek Królewski)

WROCŁAW

Church of Corpus Christi

WSCHOWA

Museum of the Wschowa Region (Muzeum Ziemi Wschowskiej)

ZAMOŚĆ

Regional Museum (Muzeum Okręgowe)

Participating Museums

The Walters Art Gallery
Baltimore, Maryland

The Art Institute of Chicago
Chicago, Illinois

Huntsville Museum of Art
Huntsville, Alabama

The San Diego Museum of Art
San Diego, California

The Philbrook Museum of Art
Tulsa, Oklahoma

Royal Castle
Warsaw, Poland

PREFACE

Referred to by some as a "country on the moon," Poland was territorially the largest country in Europe from the fifteenth to the eighteenth centuries and was one of the most powerful in the sixteenth and seventeenth. Culturally it was a bridge between the East and the West. At Vienna in 1683 against the onslaught of the Turks, Poland saved Christendom by its winged horsemen, who so aptly give the title to this important exhibition.

This vast presentation was conceived to further the knowledge of Poland in the United States of America. The catalogue, brilliantly prepared by the staff of the Royal Castle in Cracow, and its accompanying essays explain the history and culture of Poland in words, while the carefully selected works in the exhibition reflect the art of the land and its real life. This magnificent exhibition's organizers, led by Lynn K. Rogerson and Joseph W. Saunders of Art Services International and Dr. Gary Vikan and Dr. Ellen D. Reeder at The Walters Art Gallery, have nurtured their splendid concept, which bears witness to Poland's past glory.

I hope it will enthrall the public visiting the exhibition in the United States, a country where many millions of citizens of Polish descent flourish and for whose independence many eminent Poles fought in the American Revolution.

COUNT ANDREW S. CIECHANOWIECKI
Knight of the Order of the White Eagle

INTRODUCTION

The legacy of European culture is richer and more complex than might be judged by the delineation created by popular textbooks and great exhibitions concentrating on the tried and true "Giotto-to-Picasso" formula or displays of Russian icons and Fabergé's opulent bibelots. This image of the past of western civilization ignores numerous important sectors. How faintly present in our consciousness is the tradition of classical antiquity or the magnificent heritage of the Middle Ages. How rare are the occasions for seeing the documents concerning such phenomena as the culture of the Vikings or of the Crusaders and their successors, the orders of knights. The culture of Poland between the sixteenth and eighteenth centuries, developed from unique political, national, and religious conditions, falls into this neglected category. This period of the Polish-Lithuanian Commonwealth was an ethical-aesthetic universe that has been almost destroyed by events of the last two hundred years. The present exhibition reveals to the American public an entirely unknown world, though for numerous Americans of Polish extraction this is the world from which they descend.

It is never a simple matter to assign precise dates for the beginning and end of an epoch. In the present case the year 1572 has been conventionally accepted as a starting point. The death of King Sigismund Augustus in that year, tantamount to the end of the Jagiellonan dynasty, opened the door to the free election of the monarch, one of the principles of Old Poland's political system. The year 1764, the date of the election of the last king, Stanislas Augustus Poniatowski, constitutes just as conventional a closure. After that date Poland declined toward her inevitable fall, which came with the last partition of the Commonwealth in 1795. His reign also saw dramatic efforts aiming at improving the turbulent situation in the country and the first struggles in defense of the independence of its people, which were to become the leitmotiv of Polish history in the nineteenth century. In the field of art the reign of Stanislas Augustus brought neoclassicism. Hence the period 1572–1764 encompasses a classical phase in Old-Polish culture but at the same time covers the epoch understood as baroque.

Illustrating the culture of an age that lasted nearly two hundred years was far from easy. When selecting the objects to be exhibited, their significance as historical documents and their aesthetic qualities were taken into account. The heavy losses suffered by the Polish legacy should be remembered as well. World War II, usually blamed for most of the ravages, was here neither the first nor the last factor. Suffice it to mention that after 1944, in the first years of communist rule, interiors were destroyed in the country houses that for centuries had stored tens of thousands of works of art and mementos. Scarcity of historical material was particularly grievous with regard to the culture of national and religious minorities. It turned out to be extremely difficult to obtain works of art that would represent Jewish culture and that of the Orthodox and Uniate Churches. A great many desirable objects could not be used in the exhibition because of the difficulty of their transportation or the fragility of their condition; we have designed several catalogue essays to illuminate facets of Old Polish life that these monuments would illustrate.

JAN K. OSTROWSKI ANDRZEJ ROTTERMUND
Director Director
WAWEL ROYAL CASTLE, CRACOW ROYAL CASTLE, WARSAW

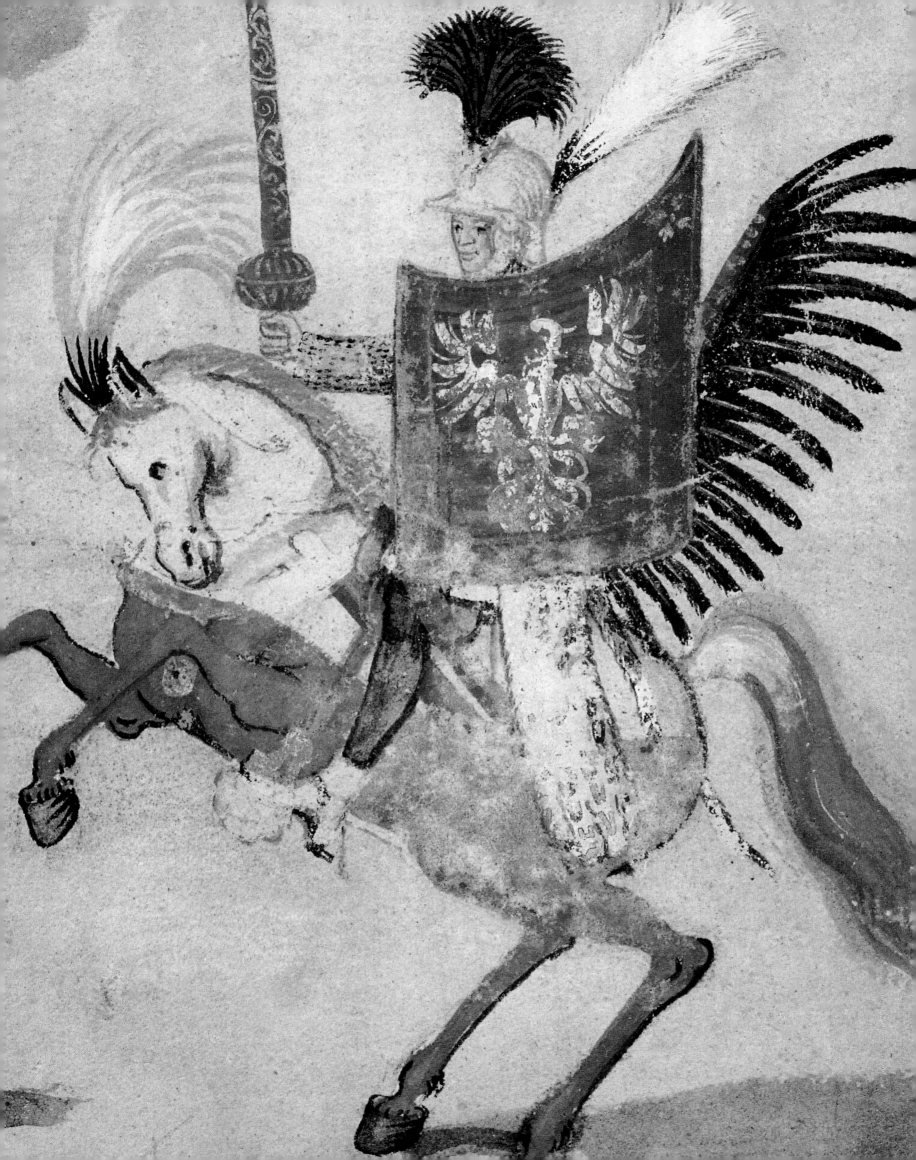

The winged horseman provides a strikingly appropriate emblem for the present exhibition. Like an exotic creature from folklore or myth, the Polish warrior emerges from a land on the edge of the unknown. An image dissimilar to any other European cultural symbol of the sixteenth to eighteenth century that American museum visitors might have previously encountered, it thus seems fitting for the first display of Polish art and culture of the Old Regime to be shown in the United States. All the more so, since, as subsequent essays indicate, the winged horseman also epitomizes a Polish ideal of the time, the Sarmatian. With its combination of familiar and unfamiliar, of western and eastern features, it embodies the cultural mixture incorporated in the huge Polish-Lithuanian Commonwealth during the period 1572–1764. And this figure derives from lived experience, a personification of the Polish self-image as a military bulwark, not a product of the imagination, of fine art.

The winged horseman also introduces some central issues that may engage visitors and readers much as they have occupied scholars. How are foreigners, especially North Americans, even of Polish descent, to interpret the culture and art of Old Poland? To what extent does the image of the Polish horseman further serve to define the land with which it is associated? Does this fanciful form of expression confirm preconceived notions? Or does it correspond to a modern distinction that nevertheless articulates the self-definition of Poles of the past?

For four and a half decades after World War II Poland disappeared behind the Iron Curtain that descended along the Elbe River. It belonged to the regions of Europe condemned to the map of forgetting.[1] If its history was remembered by most Americans, it was as a site of atrocities during the war whose end in 1945 confirmed Poland's fate until 1989. If Poland and Polish culture presented any other than a negative image, from 1945 they evoked a vision of Eastern Europe as a folkloric domain, especially of song and dance.[2] Only during the past decade has Poland along with its neighbors started to be reintegrated into the community of European nations. But now, just as Poland joins NATO, a strange warrior, not an image of art, appears from the East to announce the advent of a display of Polish culture in the United States.

The appearance of a horseman, not an artist, who stands for Poland might seem to echo a preconception that Poland is located at the limits of the West, lacking much in common with advanced forms of western European culture. Poland has been regarded as a realm at the edge of Asia, with whose hordes it at times fought. Poland may have been perceived as a colorful place, but it has accordingly been granted little credit for possessing much more than its own kind of folk culture, populated by creatures like the horseman. Only vaguely familiar as a European land, its denizens, if known at all through foreigners' reports, refugees, and emigrés, have been thought at best to indulge in the opulence of the East, whose flamboyance the horseman suggests.

The prejudice that Poles lack art and possess little culture was already established at the time represented by the objects in the exhibition. An article by the chevalier Louis de Jaucourt in the great *Encyclopédie* of the eighteenth century, the grand project of the French Enlightenment, perpetuated such assumptions when, getting even population figures substantially wrong, it said that "This state, larger than France, counts only five million inhabitants. . . . It has no school of painting, no theatre; Architecture is in its infancy; history is treated there without taste; Mathematics little cultivated;

DEFINITION AND SELF-DEFINITION IN POLISH CULTURE AND ART 1572–1764

THOMAS DaCOSTA KAUFMANN

sound Philosophy almost unknown."[3] Similarly the great English political philosopher Edmund Burke, making what was intended as a sympathetic comment on the Polish revolution of the 1790s (in contrast with what he had to say about the French Revolution), could call the Poles "a people without arts, industry, commerce, or liberty."[4]

This is an idea that has had consequences. For instance, German nationalist propaganda of the nineteenth and earlier twentieth centuries portrayed Germans as those who carried culture to the less fortunate lands to the East. When the Nazi armies invaded and occupied Poland in 1939, however, they wreaked destruction on people, monuments, and resources, including books and works of art. Thus they nearly created a wasteland like that which their antagonistic propaganda falsely presupposed had existed before Germans came.[5] But even in a country like the United States, where a substantial population of Polish descent resides, the culture and history of Poland have remained all too little known. Heretofore Poland has been effectively ignored by most American museums, universities, and publications. Dismissal or ignorance of Polish history and culture have had a broad effect on political discussions in the United States, if one with results not so destructive as those stemming from attitudes held earlier in Germany. Dismissal or ignorance of Poland has even entered the realm of opinion of foreign policy experts, as could be heard recently in the voices of those policy makers and pundits who have been opposed to the admission into NATO of Poland and its neighbors in East Central Europe.[6]

Yet the rich assemblage of objects, the essays in the present volume, and the illustrations herein surely give the lie to the image of Poland as a land without art or culture. Instead, not only colorful costumes, but the splendid gold pieces and furniture, richly worked tapestries, exquisite sculpture, and fine paintings may be seen here to offer a picture of a land abundant in a wealth of cultural expression. The culture of the Polish-Lithuanian Commonwealth was as rich and as varied as were the peoples who inhabited the largest realm west of Russia in seventeenth- and eighteenth-century Europe. That was so at least until, suffering a fate in geopolitics like that which it was later to endure almost in reality during the Second World War and in western cultural memory thereafter, it was erased from the map by its neighbors.

But is the image of Poland as a quasi-exotic land distinct from the rest of Europe, then, one that has simply been imposed by the West, or does it have its sources in Poland itself? And what is the relation of this cultural definition to Polish art anyway? Such questions seem inescapable when a show employs a title and image such as this. An exhibition dealing with the same time period, encompassing the seventeenth century, in the Netherlands or Belgium might be called the "Age of Rembrandt" or the "Age of Rubens," or one devoted to Austria or the other Habsburg lands of Central Europe in the eighteenth century might be entitled the "Age of Mozart." Yet even though similar problems of definition might exist for other lands, not artists but a winged horseman has been chosen to represent Poland.

This symbol is explained in the informative essays written by Polish scholars for this volume, and it may be regarded as a form of exhibition rhetoric. Nevertheless, it also echoes the self-definition of past as well as of present Poles. Hence western "orientalism," cultural prejudice, has not been the only factor that has set Poland as

something apart, to be regarded at best as a bridge to the East.[7] Poles have also long seen themselves as occupying a mediating role and have accordingly assumed an identity that has not simply been imposed on them, but has also been constructed by Poles for themselves. For instance, the organizers of the Polish contribution to a series of exhibitions to celebrate the international year of the baroque in Central Europe, several of whom have also been involved in the present venture, adopted the telling title "Where East Meets West" for a show in which the issue of representation and self-representation was central, namely portraits of personages of the Polish-Lithuanian Commonwealth.[8] The idea of Poland as a land that possesses western traits and yet approximates and assimilates oriental elements is also a theme in this catalogue and exhibition. It is therefore not merely a matter of geography that has placed Poland in the center of Europe, nor the whim or ignorance of western scholarly traditions that has situated Poland where it is located on the map of European cultures.

In fact, the winged horseman represents one expression of Polish ideology that was current in the period 1572–1764. Although a recent critique has argued that the identification of eastern Europeans with the ancient peoples of the steppes, such as the Sarmatians, is a deprecatory expression of what may be regarded as a kind of western orientalism, Sarmatianism or Sarmatism was an identification that Poles assumed for themselves in the sixteenth to eighteenth centuries.[9] Several essays in this catalogue reiterate that Sarmatism was manifested in the appearance of some cultural forms, such as the horseman, and more generally in an openness to oriental influences, especially in costume and coiffure. To be specific, it appears in the adaptation of Turkic and Armenian fashions, the promotion of certain distinct forms of portraiture, especially of subjects attired in this sort of costume, and in the development of a new portrait, the coffin effigy sometimes subsequently used for epitaphs.

While forms such as the coffin portrait might at first seem to be idiosyncratic—although their sources are pointed out in essays here—the Sarmatian movement was unique neither in its location nor in its motivations. Other Central European peoples, notably Hungarians, could also identify their nations with Sarmatians.[10] Furthermore, Sarmatianism was but one indication of the sort of Renaissance "self-fashioning" in which many European nations indulged. Indeed nation, in the sense of birth or birthplace, is a key word here, for many Europeans sought for their origins in the peoples of the past, ransacking classical authors for their putative ancestors.[11] Polish aristocrats such as the Krasiński were thus no different from many an Italian family when they sought their ancestry in an ancient Roman *gens*, in their instance the (Valerius) Corvinus clan, putting the story of Corvinus on the pediment that the great sculptor Andreas Schlüter carved on their palace in Warsaw, now the National Library.[12]

Sarmatism was one expression of this common search for identity through assumption of ancestors, but it went further than a search through Roman history. The Sarmatians had been mentioned by older Greek authors, such as Herodotus. The Sarmatians were thought to have been inhabitants of some lands situated vaguely in East Central Europe that were occupied by the Polish Commonwealth (even its specifically Polish part) in the sixteenth to eighteenth centuries. The Sarmatians, then, were for the Poles and more specifically for the Polish gentry, called *szlachta*, to and for whom this ideology

was restricted, what Homer's Trojans were for many other peoples, British, French, or Roman. The impulse at identification ties Polish aspirations to efforts elsewhere at self-definition related to humanism, in the sense of the study of the classical past, while the geographical or ethnic source discovered is different.

This self-defintion, though seemingly comparable to a western, humanist notion in oriental garb, was moreover but one of several identities assumed by Poles. Just as Sarmatism was not restricted to Poles, it was only one way in which they portrayed themselves, or had themselves portrayed. As noted, and as seen in this show (cat. 14) and in similar possible assemblages of contemporaneous portraits of Poles, they could also dress up as Romans. As the image by Rubens (cat. 2) suggests, they could also adopt the latest contemporary western European fashions.[13]

The winged horseman therefore appears as one among many symbols, meant, along with the larger Sarmatian complex, to suggest something distinctively Polish and fitting for the period of the sixteenth to eighteenth centuries. But the question, even if rhetorical, remains, why this emblem? Would not some specifically Polish art or artist serve equally well? One answer is that, except for what could be called distinctively iconographic motifs, namely the appearance of Poles as Sarmatians, and coffin portraits, Sarmatism actually received little expression in art. Yet, as this exhibition points out, there is no lack of Polish art, and it might be asked if something else might not have served equally well. This leads to another question: what might be specifically Polish about Polish art, particularly during the time period of this exhibition, 1572–1764?

As discussed in an essay by Jan Ostrowski below, this period corresponds to the epoch that is usually called the "baroque" in western Europe. However, the period for which distinctive Polish forms have most often been found is not that of the baroque, but the preceding one, namely that of the Renaissance. The golden age of the Polish commonwealth is thought to have occurred during the lengthy era of the reign of the Jagiellonan dynasty (1386–1572) whose high point in the sixteenth century, the time period corresponding to the Renaissance, is also thought to be that in which Poland-Lithuania expressed itself most directly in a distinctive form of art. Ostrowski cites an essay on the baroque by the distinguished Polish scholar Jan Białostocki,[14] but other writings by Białostocki on the relation of the Polish to the European Renaissance not only came to terms with earlier treatments of the issue, but offered an important approach to the definition of specifically Polish Renaissance artistic phenomena.[15]

In contrast with earlier, emotionally charged, and often nationalistic treatments of the question of the Polishness of Polish art, Białostocki followed another avenue into the geography of art, ultimately one suggested in part by George Kubler.[16] Kubler had noted the existence of certain prime forms in art, which were then broadly replicated. Treating the Renaissance as a system of forms related to the Italianate style rather than as a period, ideology, or complex of thought, Białostocki found such elements in Poland, too. He observed that the Renaissance came first to Hungary and Poland of all European countries outside Italy. It was also brought there directly by Italians, from Florence and elsewhere. Because of wars in other lands, the Renaissance survived longer in Poland than in Hungary; in Poland certain forms the Italians brought, namely the centrally planned chapel and sculpture showing a recumbent effigy of the deceased, became particularly widespread during the sixteenth century. In addition,

Białostocki regarded as indigenous to Poland another architectural form, the Polish *attica*, a culminating upper story that resembles a parapet. This feature is visible on the facade of many buildings in Poland, as for example on houses on the Old Town Square in Warsaw or the Cloth Hall in Cracow.

The appearance of these forms is also pertinent to the question of what kind of art might especially characterize Poland during the period represented by the present exhibition. Białostocki argued that many of the distinctively Renaissance forms in Poland persist into, indeed signficantly shape, artistic expression in the succeeding period, that of this exhibition. Indeed the proof that certain forms became thoroughly assimilated and characteristic for Polish art is found by Białostocki in such examples as the replication of the Sigismund chapel of the first half of the sixteenth century in the seventeenth-century Vasa chapel adjacent to it in the Wawel Cathedral of Cracow. A similar story can be told of the recumbent tomb figure. And several of the examples of Polish parapets to which Białostocki alludes are in fact found on seventeenth-century buildings. More could be mentioned, such as the parapet on the still-existing synagogue of the third quarter of the seventeenth century in Żółkiew, now in Ukraine.

The problem is that the parapet is no more indigenously Polish than are other such phenomena that supposedly represent national styles, such as the combination of *sgraffito* ornament with a special form of attica adduced by Białostocki as indigenously Czech.[17] All these forms, no less than recumbent tomb figures or centrally planned chapels, originated elsewhere. They are not native to Central Europe, but were only imported to Poland or to Bohemia. Their place of origin was Italy. Białostocki himself pointed to the central Italian origins of the tomb sculpture and chapel, but the parapet, *sgraffito* ornament, and a further variety of gable forms also appear first in the north of the Italian peninsula, and then in Alpine regions, and in Germany, Austria, and Hungary, simultaneously if not before they appear in Poland.

Rather than representing something indigenously Polish, even those forms that have been repeatedly described as particularly Polish therefore represent part of a continuing response to the Italianate instead. The reaction to Italy was, as evinced by paintings by Dolabella, works by Czechowicz, and other items in this exhibition (cats. 25, 75), a persistent phenomenon. This development is demonstrated by buildings in Poland designed in the seventeenth and eighteenth centuries by Italians such as Constantino Tencalla and Giovanni Gisleni and by paintings in Poland of the same period (and often in the same sorts of buildings) by Italians such as Michelangelo Palloni, which are mentioned in the subsequent essays in this volume. Mariusz Karpowicz could thus argue that not the Renaissance represented by the sixteenth century, but the *seicento,* the seventeenth century, was the epoch of absolute affirmation of the Italian-izing current in Polish art.[18]

The presence of much that was created by Italians, like much work by other foreign-born artists in Poland, of course once again demonstrates that Poland was hardly a land without art and culture during the seventeenth and eighteenth centuries, even if monuments were often made or decorated by foreign-born artists. The relation of the extensive net of monuments made in seventeenth- and eighteenth-century Poland to the art of the baroque elsewhere in Europe is discussed by Ostrowski in an essay below. But if there is no specifically indigenous form of art in Poland, and much was created by foreigners, how else are Polish art and culture to be defined? This catalogue establishes that Poland does possess art and architecture produced by others, but is the

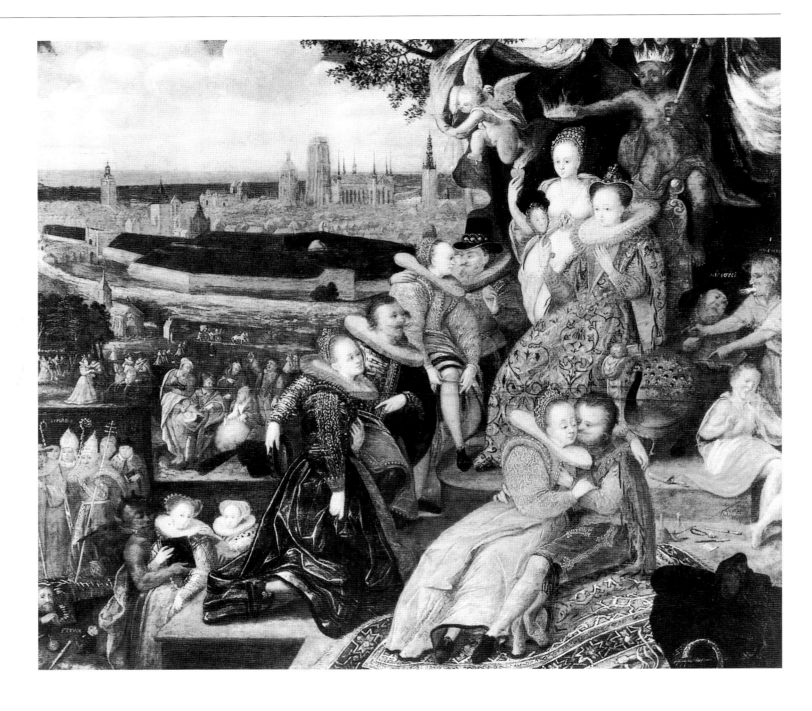

1. Anton Möller, *The Allegory of Pride*, early 17th century. National Museum, Poznań

choice of the winged horseman then a solution for a symbol that has been reached out of necessity, in the absence of a distinctive Polish form of art? Regardless of the evidence for an abundance of art found in Poland, was Jaucourt then right when he said Poland had "no school of painting," no school of art?

Attention could however be drawn to an area not so well represented in the exhibition or in the catalogue, art in the northern port city of Gdańsk (Danzig).[19] Although Gdańsk could count many speakers of German as well as many who spoke other languages among its inhabitants, in 1466 the city fell under Polish suzerainty and remained there all during this period until it was taken by Prussia in 1793. Important imagery in contemporaneous Gdańsk art refers to the city as the *porta aurea*, the golden gateway to the Commonwealth.[20] And certainly another rich tradition, that of art, is to be associated with Gdańsk. Painting flourished there from the late sixteenth to at least the late seventeenth century. Among the painters active in Gdańsk were artists of Flemish and German origin, other figures who came from Silesia and Prussia, and Polonized painters

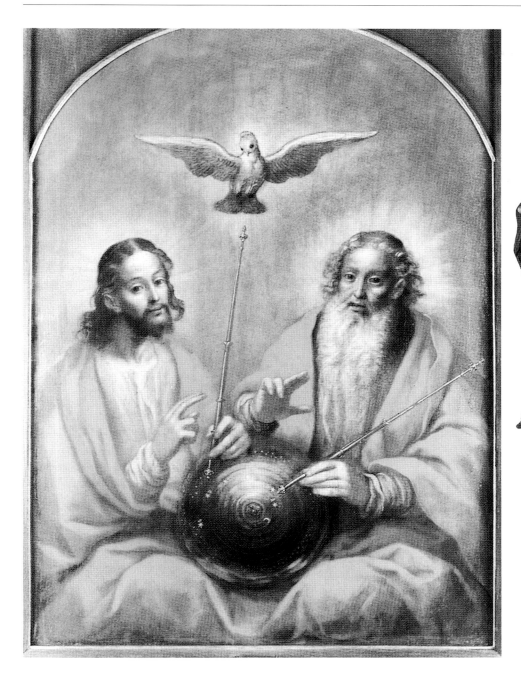

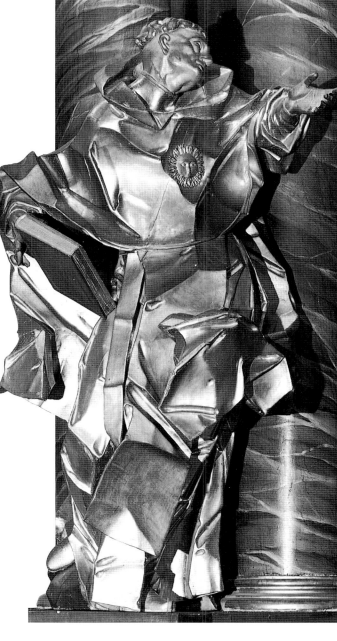

whose ancestors had come from elsewhere. The names of such important painters as Hans and Paul Vredemann de Vries, Anton Möller (fig. 1), Isaac van den Blocke, Hermann Han (fig. 2), Hans Krieg, Bartholomaeus Strobel, and later Daniel Schultz and Andrzej Stech may be noted; some of their works are exhibited here.

The existence of other groups, or traditions, or "schools" of art can be found in other media. Although its particulars and artists remain to be completely researched, a tradition of sculpture may be associated with Gdańsk from Willem (Wilhelm) van den Blocke in the sixteenth century to Andreas Schlüter in the late seventeenth.[21] Stuccoists and masons originating in Italy, but working with or inspiring other nationals, have also been associated with the town and region of Lublin in the early seventeenth century.[22] And, as represented by at least one object in the present exhibition (cat. 77), sculpture flourished in the eighteenth century, especially in Lvov (fig. 3), where it obtains a standard of aesthetic quality notable for its emotional expressiveness and imaginative solutions that may equal that of contemporaneous work elsewhere in Europe.[23]

2. Hermann Han, *The Holy Trinity with the Ptolemaic Model of the Globe*, 1610. National Museum, Gdańsk

3. Antoni Osiński, *Saint Thomas Aquinas*, 1757, sculpture. Church of the Blessed Virgin Mary, Leżajsk

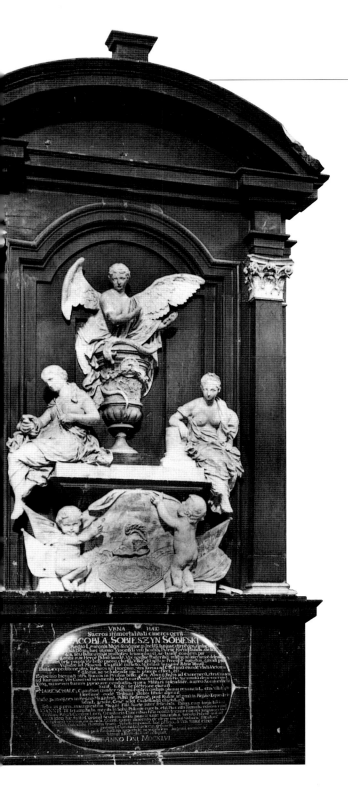

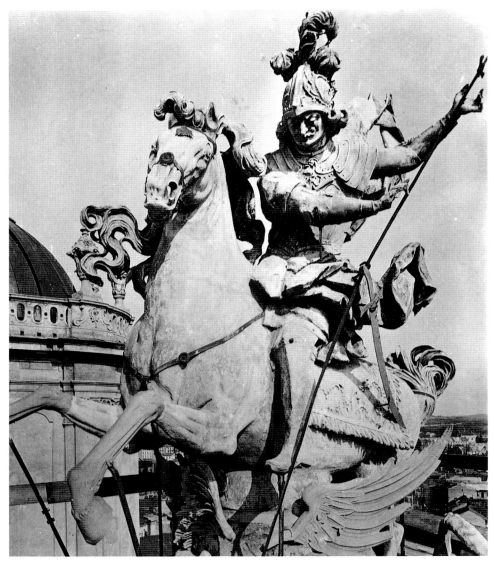

4. Andreas Schlüter, *Sepulchral Monument of Jakub Sobieski (d. 1646)*, 1692–93. Collegiate Church of Saint Lawrence the Martyr, Żółkiew

5. Johann Georg Pinsel, *Saint George*, 1759–60, sculpture. Saint George's Cathedral, Lvov

The fact that artists of the importance of the De Vries, of the stature of Schlüter (fig. 4), or of the verve of Master Johan Georg Pinsel of Lvov (fig. 5), not to mention outstanding architects such as Bernard Meretyn and Tylman van Gameren among many others, could thrive in Poland demonstrates that Poland in the "baroque" possessed its masterworks. It says something even more, too. While one way of looking at art in Poland during this period is no doubt, as suggested in an essay below, via a model of center and periphery in which Poland is designated the peripheral recipient, Poland was not merely a place in which influences were passively received.

Even if many artists came to Poland from elsewhere, they often created local centers that had a lasting impact. This condition is not different from what marks other "schools" of art, such as that of Fontainebleau or Prague, and it therefore seems legitimate to speak of "schools" of art in Poland such as that of painting in Gdańsk.[24] The existence of such schools provides moreover one way of accounting for the multiple regional differences evident in Polish art and architecture.[25] For Poland is a land of

many diverse forms of art. What might distinguish Polish centers from those elsewhere is the question of the broader impact that they might have had outside a limited region and the reciprocal influence they might have had on other European regions. Nevertheless, some individuals to be sure, certainly a figure such as Andreas Schlüter, gained a place or reputation as great as that obtained by any other sculptor-architect among his European contemporaries.[26]

Furthermore, given the establishment of a variety of local centers in Poland, models other than that of simple cultural or artistic influence must be adduced. Other paradigms need to be sought to account for those moments of genuine creativity and originality that can be found in Polish art. Hence other notions, such as acculturation or cultural transfer, may be proposed as ways to discuss Polish art and culture. These views may suggest that the process of reception of outside influences was a more active one, in which forms were adopted or transformed in a creative manner. In this way a more positive role can be assigned to Poles.[27] A model in which Polish reception is regarded as an active factor in the multiethnic Polish Commonwealth helps to explain how there could be so many, multifarious manifestations of art there.

While it is true that Poland provided a home for a broad variety of foreign artists and influences, it should also be realized that much of European culture was equally mixed or hybrid. Not just Poland, but the other regions of Central Europe were crossroads for cultural influences. Netherlandish, Italianate, and French elements can all be found combined or coexisting in seventeenth- and eighteenth-century art and architecture in Austria, Hungary, Bohemia, the German states, and Switzerland, too.

Moreover, it is also true, if little acknowledged, that far from being ethnically pure, many of the sites that are regarded as the main centers for the arts at the time, in Italy, the Netherlands, or France, were also cosmopolitan conglomerations. The leading architects in Rome, Borromini and Bernini, came from elsewhere in the peninsula, the former from the region of the Lombard lakes, whence many of his predecessors had gone to Central Europe, the latter from Naples, but *seicento* Rome was enriched by many foreigners as well. The Fleming François Duquesnoy worked opposite Bernini in Saint Peter's; Nicolas Poussin and Claude Gelée (Le Lorrain), natives of Normandy and Lorraine, were major painters; and Dutch, German, and French artists were major presences. Art in Naples was inspired and fed by Italians from elsewhere and by many foreigners, the best known of whom is the Spaniard Jusepe de Ribera from Valencia. Conversely Spanish golden-age art was nourished by influences from Italy and from the low countries, and by the end of the century the leading artists were Italians, to be replaced in the eighteenth century by the French. In Portugal the eighteenth-century reign of João V saw works by Roman painters and sculptors and the major architect João Frederico Ludovici, a Swabian who had worked in Rome. Arguably the most important painters active in England until well into the eighteenth century came from the Continent, men such as Rubens, Antony Van Dyck, Peter Lely, Godfrey Kneller, and many others. Artistic culture in France gained from the presence of foreigners: music at Versailles was led by the Italian Lully, and the sculptor Martin Desjardins was actually a Netherlander, Van den Bogaert. It has been increasingly recognized that even the Dutch golden age was not strictly an indigenous exercise, because the first impulses came from artists south of the Scheldt River; Huguenot and German-born artists (Govaert Flinck, Johann Lingelbach, and others) constantly enriched production in Holland.[28]

In this light the borrowings of Polish patrons do not seem such a provincial or peripheral phenomenon. Before the partitions, before dynastic rapacity destroyed the Commonwealth, and before nationalist antagonism downplayed Polish accomplishments, Poland offers but an extreme example of what was, despite distances and borders, an exceedingly cosmopolitan world.

If it is so distinctive, what then can the emblem of the winged horseman suggest about Polish art and culture? To recast an answer, the image that he suggests may stand for the original solutions reached in Poland in what remained a commonly shared European culture. It is to be hoped that at the very least that will be what the attentive reader or viewer may learn from the present enterprise.

NOTES

1. This term, first coined by Czesław Miłosz, is discussed in relation to the postwar treatment of the earlier history of Central Europe (including Poland) in Kaufmann 1995a, 16.

2. See Wolff 1994, 331.

3. As quoted in translation in Wolff 1994, 189.

4. Quoted in Wolff 1994, 280.

5. See Michael Burleigh, *Germany Turns Eastwards: A Study of Ostforschung in the Third Reich* (Cambridge, 1988), for the twentieth-century side of the story in scholarship. Lynn H. Nicholas, *The Rape of Europa: The Fate of Europe's Treasures in the Third Reich and the Second World War* (New York, 1995, first ed. 1994), 57ff, offers an accessible account of what happened to art in Poland, but her information needs to be corrected by, for example, Jerzy Lileyko, *Le château de Varsovie* (Warsaw, 1981), and Stanisław Lorenz, *Walka o Zamek 1939–80* (Warsaw, 1980). These statements are by no means meant to overlook or downplay the destruction wrought by the Soviet invaders and occupiers, especially in the east of Poland, but also in places like Gdańsk, whose story as a place of battle is however admittedly complicated.

6. I have responded to this sort of misinformation in a number of recent published letters that should lead also to the opposition mentioned: "West Mustn't Bow to Russia's NATO Fears," Letter to the Editor, *The New York Times*, 24 January 1997, p. A30; "Expanding NATO," Letter to the Editor, *The New York Review of Books*, July 17, 1997, p. 62; "Lessons of History," Letter to the Editor, *The New York Times*, May 4, 1998, p. A18.

7. Used in this sense "*orientalism*" is to be sure a term coined in a critique in Said 1978, but the idea has already been expanded and adopted for a critique of the eastern regions of Europe in Maria Todorova, *Imagining the Balkans* (New York and Oxford, 1997). Such a critique in reference to the treatment of Poland by westerners is already implicit in Wolff 1994.

8. See Warsaw 1993.

9. Here as in the previous paragraph this essay is in part responding to the arguments of Wolff 1994. For the subject of Sarmatism or Sarmatianism, in addition to the following essays, the reader may consult Kaufmann 1995a, 288–89, with references on 523–24.

10. For the question of Hungarian or Slovak Sarmatism see *Portrait* 1985.

11. The broader international and cross-temporal aspects of this sort of phenomenon are discussed in essays in *The Invention of Tradition*, ed. Eric Hobsbawm and Terence Ranger (Cambridge, 1983), 183.

12. See Mossakowski 1994, 283ff.

13. I have also further discussed this issue in relation to the question of "Ethnic versus Dynastic Identity" in a chapter in Kaufmann Forthcoming.

14. Białostocki 1981, 106ff.

15. See for example Białostocki 1976 and Białostocki 1979, 21–58.

16. See Kubler 1962.

17. For details of this critique see Kaufmann 1978; Kaufmann 1995b, also in Polish as "Rzeźba i rzeźbiarze włoscy poza Italia: Problemy interpretacji i możliwosci recepcji," *Biuletyn Historii Sztuki* 57, no.1–2 (1995), 19–34; and Kaufmann 1995a.

18. Karpowicz 1977, 101.

19. For the period of painting in Gdańsk until 1620, with further references to earlier literature, see Teresa Grzybkowska, *Złoty wiek malarstwa gdańskiego na tle kultury artystycznej miasta 1520–1620* (Warsaw, 1990). The catalogue of an exhibition of art in Gdańsk held in 1997 at the Muzeum Narodowe there, *Porta Aurea Rzeczepospolitej. Sztuka Gdańska od polowy XV do końca XVIII wieku*, was not available to me at time of writing.

20. See for example Halina Sikorska, "Apoteoza Łącznosci Gdańska z Polską," *Biuletyn Historii Sztuki* 30, no. 2 (1968), 228–30; Eugeniusz Iwanayko, *Apoteoza Gdańska. Program ideowy malowideł stropu Wielkiej Sali Rady w gdańskim ratusza Głównegu Miasta* (Gdańsk, 1976), and *idem, Sala Czerwona ratusza gdańskiego* (Wrocław etc., 1986).

21. In Kaufmann 1993, I alluded to Schlüter's connection with the tradition of sculpture in Gdańsk and called for its study. A thorough investigation of sculpture in Gdańsk still remains a desideratum for scholarship.

22. See Jerzy Kowalczyk, "Kościól pobernardyński w Lublinie i jego stanowisko w renesansowej architekturze Lubelszczyzny," *Kwartalnik Architektury i Urbanistyki* 2 (1957), 127–44; *idem*, "Turobińsko-zamojski murator Jan Wolff oraz jego dzieła na Lubelszczyźnie," *Biuletyn Historii Sztuki* 24 (1962), 123–27. Kowalczyk, "Architektura sakralna między Wisłą a Bugiem w okresie późnego łaroku," *Dzieje Lubelszczyzny*, vol. 6, *Między Wschodem a Zachodem*, pt. 3, *Kultura artystyczna*, ed. T. Chrzanowski (Lublin, 1992), 37–118, describes regional characteristics in the same region.

23. The most accessible introduction to sculpture in Lvov is found in the second part of *Teatr I Mistyka. Rzeźba barokowa pomiędzy Zachodem a Wschodem/ Theater and Mysticism. Baroque Sculpture Between West and East*, ed. Konstanty Kalinowski, exh. cat. Muzeum Narodowe (Poznań, 1993).

24. For a discussion of the meaning of "schools" of painting in this regard, see my *L'école de Prague. La peinture à la cour de Rodolphe II* (Paris, 1985), and further the revised edition, *The School of Prague. Painting at the Court of Rudolf II* (Chicago and London, 1988). For Fontainebleau see most recently the authoritative comments of Sylvie Béguin, "L'école de Fontainebleau," in Jean Delumeau and Ronald Lightbown, *La Renaissance* (Paris, 1996), 364–73, and Henri Zerner, *L'art de la Renaissance en France. L'invention du classicisme* (Paris, 1996), 57ff.

25. See further for this point Kaufmann 1995a, 230.

26. For the international aspect of Schlüter's career and reputation see Kaufmann 1993, with further references.

27. For an explication of this interpretive strategy, see Kaufmann 1995b.

28. For the problem of the "Dutchness of Dutch Art" see my "An Independent Dutch Art? A View from Central Europe," *De Zeventiende Eeuw* 13 (1997), 359–69.

The Polish kingdom became part of Christendom in the year 966 with its conversion to the Church of Rome. Over the next centuries it was, like its neighbor to the south, the Czech kingdom of Bohemia, a fairly typical Christian feudal state on the fringes of Europe. But in 1349 King Casimir the Great (1333–70) annexed the two Ruthene principalities of Halicz and Vladimir in what is now Ukraine, thereby extending Poland to the east. This move was rich in implications and consequences.

The implications were that Poland must take an increased interest in what was going on beyond her eastern frontier. The consequences were that she extended her sway over the Danubian principality of Moldavia and, in 1386, joined her fate to the Grand Duchy of Lithuania. Jagiello, grand duke of Lithuania, took over the throne of Poland, thus founding a dynasty that reigned until 1572. He brought into the common state not only the ethnic territory of Lithuania but also enormous possessions in the present Belarus and Ukraine. The Lithuanian nation, pagan until then, was Christianized and largely adopted Polish language, culture, and law. This initially loose confederation of two nations was formalized by the Union of Lublin of 1569. The state, called the Polish Commonwealth, comprised two equal parts, the Crown (Poland) and the Grand Duchy (Lithuania), and encompassed most of the territory between the Baltic and the Black Seas and from Silesia to the very gates of Moscow.

At that time the Polish Commonwealth was the largest state in Europe, if one excludes the vast underpopulated expanses of Muscovy. It covered an area of some 815,000 square kilometers (315,000 square miles), stretching over mountain, plain, forest, and bog and including some of the poorest sandy soil as well as the most fertile black earth in Europe. The population of the Commonwealth was nearly ten million, equal to that of Italy and of the Iberian Peninsula, twice that of England, and two-thirds that of France. Only about forty percent were Poles, and they were concentrated in about twenty percent of the area. The settled peasantry was made up of three principal ethnic groups, Polish, Lithuanian, and Ruthene, and its lifestyle varied considerably across the country. The free land-owning peasantry of Greater Poland (Wielkopolska) had little in common with the primitive serfs of Lithuania or Byelorussia in either standard of living or outlook.

The cities, too, were far from uniform. Gdańsk, a great Hanseatic emporium on the Baltic coast, was preponderantly German-speaking. Nearby lay the smaller but equally busy port of Elbing, which had a large colony of English and Scots. In Cracow, the capital of the country, it was not until the first half of the sixteenth century that the Polish community outnumbered the German speakers who had prevailed there in the Middle Ages. The city also had an important Italian minority. Lvov, a city with a highly individual outlook, which had three Christian archbishoprics (Catholic, Orthodox, later Uniate, and Armenian), was made up of Poles, Ruthenes, Germans, Italians, and Armenians.

Almost every town had its Jewish community. In the north, where certain cities had exemptions under medieval charters granted by the Order of Teutonic Knights, Jews were confined to a specific quarter and banished from the city center. In the rest of the Commonwealth, they settled where they would. From six-tenths of one percent of the population at the beginning of the sixteenth century, the Jewish segment of the population increased to five percent by 1650. In the cities they constituted about thirty percent of the population, and there were many small towns, mostly in the south and east, that were almost exclusively populated by Jews. The Jewish community communicated largely in Hebrew or Yiddish. A charter of 1551 set up what was in effect a Jewish state

ADAM ZAMOYSKI

within a state, with elected bodies that passed laws and collected taxes and founded and regulated its own legal system and institutions. On the fringe of the Jewish community lived the Karaites, an ethnic group speaking a Turkish dialect and professing a specific version of Judaism.

At the center of Polish life stood the *szlachta*. Though the words "nobility" or "gentry" are commonly used for this group and one cannot quite avoid this identification, in fact the *szlachta* had little in common with those classes in other European countries in origin, composition, or outlook. Its origins remain obscure. Polish coats of arms are unlike those of European chivalry and were held in common by whole clans. It is not known whether these originated as tribal or family groupings, but their existence has suggested similarities with the clans of Scotland. The *szlachta* or gentry was not limited by, nor did it depend for its status on, either wealth, land, or royal writ. It was defined by its function, that of a warrior caste. Clannish and arrogant, the *szlachta* underpinned its position with mutual solidarity and fierce rivalry with other groups. To be a member of the *szlachta* was like being a Roman citizen in the days of the empire. The *szlachta* thought of itself as the nation, while the remaining ninety-odd percent of the population were the plebs, who did not count.

But while they were inherently apart from the rest of the population, the members of the *szlachta* were in some ways curiously representative of it, if only in their variety. By the mid-sixteenth century it included Lithuanian and Ruthene boyars, Prussian and Baltic gentry of German extraction, as well as Tatars (descendants of warriors who had settled in Lithuania in the fourteenth and fifteenth centuries). A foreigner could be granted the status of a Polish noble, mostly for military merit. The right to accord this privilege belonged to the king and later to the parliament. Jews who converted to Catholicism were automatically admitted to the ranks of the noble order. As there was no college of arms, cases of abuse of the gentry's rights were quite common.

The *szlachta*'s lifestyle also varied dramatically. The wealthiest could compare with any grandees in Europe, the poorest were the menial servants of the rich. In between they might be wealthy landowners or humble homesteaders plowing and harvesting with their hands, barefoot and in rags, poorer than many a peasant. Their level of education was just as variable, their religious affiliation was multifarious. The gentry nevertheless developed an exceptionally homogeneous culture and outlook. And not only was this culture representative of the various groups within the country, it was also imitated by the lower orders.

The *szlachta* had evolved its view of itself and of its place in the order of things largely through the struggle with the Crown that it had carried on over the past two centuries. It began with a quite understandable reluctance to pay taxes, moved on to assert the principle of no taxation without representation, and flourished in the evolution of a fully fledged parliamentary system. The *szlachta*, which in some areas made up as much as seven to ten percent of the whole population, was more numerous than the clergy and more articulate than the town-dwellers. And, what was more important, its members made up the backbone of the armed forces. This gave it greater power and a stronger influence in shaping the future than any other group.

As well as the ruler's need for money and troops, the *szlachta* exploited his other inherent weakness after the extinction of the Piast dynasty. At Košice in 1374, King Louis of Anjou, who ruled in Poland and Hungary, had to bribe the *szlachta* to accept

the succession of his daughter to the Polish throne by reducing the tax on agricultural land belonging to them and promising that in the future no tax would be imposed without their consent. Henceforth no royal son or daughter could succeed to the throne without their assent.

From 1468 onward the assemblies of the *szlachta* of various provinces met annually as one parliament, known as the Sejm. In 1493 the Sejm had defined itself as three estates: the king, the senate, consisting of bishops and dignitaries, and the lower house or Sejm proper, consisting of deputies of the *szlachta* from every province with a small representation of the largest cities. In 1505 the Sejm set the seal on its power by passing the act *Nihil novi*, which stipulated that the king could take no action whatsoever without its prior assent. Beginning in 1507, legislation passed by the Sejm was published at the end of each session under the title *Constitutions*, originally in Latin but from 1545 in Polish. This formal establishment of the Sejm as the supreme legislative power in the land coincided with the arrival of the Renaissance in Poland, and over the next decades much theory would be written to elaborate the new system of government. But it also coincided with the religious reformation.

Religion was important to the Poles from the moment when conversion to Christianity earned the country a place in Christendom. But the subsequent expansion of Poland's frontiers meant that its population was by no means homogeneous from the religious point of view. The Ruthenes predominant in the eastern part of the country originally adhered to the Orthodox rite, although from the Brześć (Brest-Litovsk) Synod in 1596 the Uniate or Greek-Catholic confession was gaining more and more followers among them. There were numbers of Armenians who practiced their own liturgy independent of either Rome or Constantinople (they adhered to the union with Rome in 1630). On top of this, there were large numbers of non-Christians, namely Jews and Tatars, the latter who had been admitted to the ranks of the *szlachta* but clung to the Islamic faith. (In the mid-sixteenth century there were about forty mosques in the Polish Commonwealth.)

And even that minority of Roman Christians was not as steadfast as the pope might wish. Many Lithuanians had converted in word only, and in the fifteenth century some Polish Christians had followed the lead of the Czech heretic Jan Hus. Yet the established Church was immensely rich, owning a huge proportion of the land, more than the crown. It wielded political power through its bishops who sat in the senate. It impinged on the everyday lives of every person through its tribunals, which exercised power over laymen living on the land it owned or who were otherwise involved with it. And it continued to grow in financial power through compulsory tithes.

Thus Martin Luther's challenge to the Church of Rome failed to shock the Poles on the one hand and met with their sympathy on the other. The predominantly German inhabitants of the northern cities embraced Lutheranism, while the *szlachta* opted mainly for Calvinism. By the 1550s an important proportion of the deputies to the Sejm were Protestants as were most of the greatest noblemen in the land. Anabaptists seeking refuge from persecution in Germany established themselves in Poland, as did some Mennonites from Holland. A group of "Czech Brethren," spiritual descendants of the Hussites, also moved to Poland in 1548 after their expulsion from Bohemia. They found plenty of kindred spirits in Poland and quickly multiplied under the alternative names of Arians, Polish Brethren, Anti-Trinitarians, and Socinians. These latter took

the ideas of the Reformation the furthest. They were pacifists, opposed to the tenure of any civic office, to all forms of serfdom, to the possession of wealth, and to the use of money.

The Polish church hierarchy restrained its urge to punish and damn. In 1564 it brought the Jesuits to Poland to reconquer the hearts and more specifically the minds of the Poles. This was done through the political argument that the vast and disparate Polish Commonwealth needed something to unite it. Over the next century the *szlachta* drifted back to Catholicism with some minor exceptions. More than that, the Church had managed to equate Catholicism with Polish reasons of state and the *szlachta*'s own interests.

The Reformation in Poland had not been fundamentally a spiritual movement. It was a sally by the articulate classes who made use of the liberating challenge of Luther to further a process of intellectual and political emancipation that had started long before. The *szlachta*, which had done everything to curtail the power of the Crown, had seized eagerly on the possibilities offered by the movement for reform in order to break the power of the Church. Ecclesiastical courts were abolished in 1562, and the Church lost its exemption from taxation, but no limits were set to its spiritual activities. Straightforward anticlericalism was easily confused with a desire to return to Christian principles.

Apart from cutting down the power and influence of the Church, the Reformation had established one fundamental principle in the Polish Commonwealth, the absolute primacy of personal freedom. "It is not a question of religion, it is a question of liberty," as Hetman Jan Tarnowski put it. Members of the *szlachta* who committed acts of sacrilege against the Catholic faith found themselves being delivered from jail by posses of Catholic *szlachta* who cared less that a host had been defiled than that one of their number had been imprisoned. No institution, be it the Crown or the Church, took precedence over the sacred right of the *szlachta* to personal liberty.

The impending extinction of the Jagiellon dynasty gave them the opportunity to make sure that the future shape and constitution of the Polish polity was made to their measure. As it became clear in the 1550s that King Sigismund Augustus would not produce an heir, the *szlachta* assumed the role of guardians of the state. When he died, in 1572, it was they who decided the shape of things to come. They created, in effect, a republic (in the contemporary political terminology *respublica mixta*), ruled by a parliament, the Sejm, made up of three "estates": the deputies of the *szlachta* and the major towns, the senate, and the king. The senators were ex-officio, the deputies were elected by the *szlachta* in their constituencies, and the king, elected by the entire *szlachta* of the country, was in fact something like a lifelong president.

At this crucial juncture, the outlook of the *szlachta* was affected by two influences that might be thought mutually exclusive. The first was the rediscovery of ancient Rome. Like every other people affected by the new learning of the Renaissance, the Poles had been fascinated by the cultural and political legacy of ancient Rome. The apparent similarities between some of their own institutions and those of the ancient republics tickled the national vanity. Ignoring the difference of scale with the Greek city states and without looking too closely at the pitfalls that led to the demise of the Roman Republic, the Senatus Populusque Polonus drew further on this model. The Polish political vocabulary bristled with terms such as "citizen," "senate," and "tribune." Styles of behavior and fashion were also affected; Latin was largely in use not only in

religious and legal circumstances but also in everyday language, in the form of omnipresent macaronisms. At the psychological level, this analogy gave the Poles a sense of belonging to a European family, based not on the Church of Rome or the empire but on the idea of Roman civilization whose legacy they now arrogated to themselves.

The second influence was more nebulous but far more pervasive. It stemmed from a theory elaborated by various writers at the beginning of the sixteenth century to the effect that the Polish *szlachta* were not of the same Slav stock as the peasantry, but descendants of the Sarmatians, a warrior people from the Black Sea steppe who had swept through southeastern Europe in the sixth century. This theory drew a neat pseudo-ethnic distinction between the political nation and the rest of the population. It was accepted with enthusiasm by the multiracial *szlachta* in spite of its illogicality. How far they really believed in it is not clear, but it was useful to this motley collection who were far more at home with the "noble warrior" Sarmatian myth than with the image of Christian chivalry with all that this entailed in terms of fealty, homage, service, humility, and vassalage.

In time the Sarmatian ethic, or simply Sarmatism as it has become known, grew into an all-embracing ideology, but in the sixteenth century its influence was visible principally in manners and taste. As a result of contacts with Hungary and Ottoman Turkey various accoutrements of eastern (Turkish and Persian) origin were gradually incorporated into everyday wear and use.

A big portion of the *szlachta* did not own land. As a result, they invested only in movable riches, which meant clothing, jewelry, and arms. The Poles were close to their horses, which were symbols of their warrior status, and looked after them with loving care. The horses were dressed in fine trappings, covered in rich cloths, adorned with plumes and even wings, and, on high days and holidays, dyed. The dye was applied to the coat everywhere except for the back under the saddle, and sometimes the mane and tail would be dyed a different color for contrast. The most popular color was cochineal, but at funerals, for instance, black and purple or green were favorite combinations.

Another area in which supposedly eastern atavisms were encouraged by Sarmatism was the love of ceremony. Hospitality was a way of showing respect and friendship and was rarely confined to providing adequate quantities of food and drink. Highly spiced with aromatic roots and herbs, the fare was not unlike Persian or northern Indian cooking. Banquets were extended to give them importance, often lasting half the day. A great deal of drinking accompanied this banqueting. Vodka and other spirits were never served at the table or in the home; the Poles drank wine, imported for the most part from Hungary and Moldavia, but also from France, Italy and Germany, and even the Canary Islands.

Fortunes were spent on extravagance and display. There was no lack of money between 1550 and 1600. The price at which Poles sold their agricultural produce went up by more than three hundred percent during the sixteenth century. The actual buying power of what the *szlachta* had to sell went up against staple imports by nearly one hundred percent. During the same period the quantity exported more than doubled. Landed Poles became a great deal richer in terms of cash to spend than their counterparts elsewhere in Europe.

Increasing numbers of the Polish gentry traveled abroad. They did so primarily in order to study at universities such as Wittenberg, Basel, Louvain, Bologna, and above all Padua. Often they mixed tourism with study, and by the end of the sixteenth century noblemen young and old regularly set off on the grand tour to broaden their minds. They returned loaded with ideas, books, and art.

This gave rise to an explosion of building and embellishing in the Renaissance style, to the enrichment of intellectual life, and to a flowering of music and the arts. It also gave impetus to a "Silver Age" of Polish literature. Polish men of letters published their books not only in Poland, but also in France, Italy, the Netherlands, Spain, and England. They corresponded with foreign writers whose works were translated and published in Poland. It was these Polish editions of the classics and of European literature that provided the Muscovites, who had never had the resource of Latin, with an introduction to western culture.

As Poland seemed to be taking its place firmly within the life of Europe, it was being drawn eastward with ever greater compulsion. Persian and Ottoman culture began to exert a strong fascination for Polish society. In 1600 the son of the chancellor of Poland was learning four languages: Latin, Greek, Turkish, and Polish. By the time he had completed his studies, he was fluent not only in Turkish but also in Tatar and Arabic. This was just as well, for it was problems in the east that would absorb Poland's energies over the next centuries.

Great shifts in power had been taking place since the first quarter of the sixteenth century, when the Jagiellon king of Poland and his brother, king of Bohemia and Hungary, ruled over most of east-central Europe. The Habsburgs of Austria acquired Bohemia and Hungary definitively, taking with them Silesia, which had once been part of the Polish kingdom. Brandenburg began to consolidate its position in Pomerania. Sweden entered her brief phase as an international power. Muscovy, which had been little more than a small city-state, absorbed all the other Russian states and grew into a major player. And the Ottoman Porte embarked on its protracted struggle to achieve dominion in Central Europe. From the 1570s Poland was heavily engaged in wars with Muscovy, during which time Polish troops temporarily occupied Moscow, ending in 1667 with the loss of a large portion of the border territory with Kiev and Smolensk. Sweden also featured in some of these wars, and Poland crossed swords with the Swedes several times during the first decades of the seventeenth century. Most of this fighting was not in the national interest of Poland but in that of the princes of the Swedish Vasa dynasty who had been elected kings of Poland. The invasion of Muscovy had been inspired by one of those kings' dream of mounting the throne of the tsars and converting Russia to the Church of Rome.

The southeastern borderland was continually threatened by the Tatars, and from the beginning of the seventeenth century a much more dangerous Turkish invasion was even more probable. The Poles increasingly came to see themselves as defenders of Christendom against the pagan hordes. The bucolic themes that had dominated Polish poetry of the 1500s were ousted in the next century by epics dramatizing the heroic crusade. The Polish *szlachta* were portrayed as valorous knights holding the infidel at bay, and the biblical images often called up to render the epic quality increasingly suggested the concept that they were the chosen people of God.

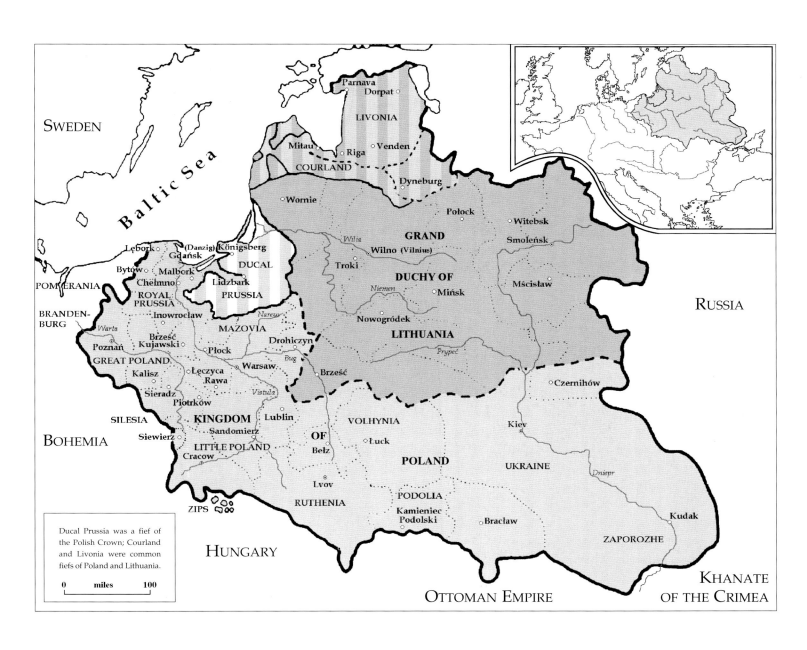

SWEDEN

Baltic Sea

Parnava
Dorpat

LIVONIA

Mitau
Riga Venden
COURLAND
Dyneburg

Wornie
Połock
Witebsk
Smoleńsk

GRAND

Lębork (Danzig) Königsberg
Gdańsk
DUCAL
Bytów
Malbork
Chełmno
Lidzbark
Chełmno
PRUSSIA
ROYAL
PRUSSIA

Wilia
Wilno (Vilnius)
Troki

DUCHY OF

Niemen
Mińsk
Mścisław

RUSSIA

Inowrocław
Nareur
MAZOVIA

Nowogródek

BRANDEN-
BURG
Warta
Brześć
Kujawski
Poznań
Płock
Drohiczyn
LITHUANIA
Prypeć
GREAT POLAND
Kalisz
Łęczyca
Rawa
Warsaw
Bug
Brześć
Sieradz
Vistula
Piotrków

Czernihów

SILESIA
KINGDOM
Lublin
VOLHYNIA
Kiev
BOHEMIA
Siewierz
Sandomierz
OF
Łuck
LITTLE POLAND
Bełz
POLAND
UKRAINE
Cracow
Dniepr
ZIPS
Lvov
PODOLIA
Kudak
HUNGARY
RUTHENIA
Kamieniec
Podolski
Bracław
ZAPOROZHE

KHANATE
OF THE CRIMEA

OTTOMAN EMPIRE

Ducal Prussia was a fief of
the Polish Crown; Courland
and Livonia were common
fiefs of Poland and Lithuania.

0 miles 100

Polish-Lithuanian Commonwealth c. 1600–1650

The core of the Commonwealth's armed forces was made up of volunteers drawn from the *szlachta*. They fought in cavalry units based on the old chivalric pattern of a rich knight followed by one or more retainers who made up the second and third ranks. Although the infantry, made up of peasants, and the foreign mercenaries, usually German, played a crucial role in any major battle, it was the cavalry, and therefore the *szlachta*, who delivered the decisive blows and represented Poland's military might. The *szlachta* deluded itself with heroic imagery and an ever more fervent faith in God's protection. The few who noticed the inherent weakness of the state could not make themselves heard until it was too late.

In 1648 the Cossacks mutinied and whipped up a general revolt in the Ukraine. They then marched into the heart of the kingdom under their leader Bohdan Chmielnicki. The Commonwealth was taken unaware, the first army it sent out was cut to pieces, and the second, a mass conscription of the *szlachta*, fled in disarray. In spite of acquiring the support of the Tatars, Chmielnicki was defeated in 1651, but that was not the end of the matter. In 1654 he accepted the overlordship of the tsar of Muscovy, who invaded Poland to support him. At this point Sweden decided to invade Poland from the other side, and the whole country was soon overrun. Between 1648 and 1668, when peace was finally signed, the Commonwealth was ravaged by the armies of Muscovy, Sweden, Brandenburg, Transylvania, the Cossacks, and the Tatars. All were eventually beaten back, but the cost was immense.

The wars decimated the population, devastated the towns, and destroyed a large proportion of the movable wealth. This was all the more serious as the country had been drifting into unfavorable economic cycles during the first decades of the seventeenth century, merely selling agricultural produce and raw materials and not investing in any kind of industry of its own. The result was that the country could not recover economically.

More important was the damage sustained by the structure of the state. The crisis of 1648–68 had revealed that, whereas the human fabric of the Commonwealth was resilient and difficult to tear apart, the structural element of the state was desperately flimsy. In place of the institutions and procedures that constitute the beams and girders of most political edifices, the Commonwealth had only moral concepts and hazy traditions. Neither the Crown, nor the Sejm, nor the army had proved capable of withstanding the storm.

In effect, the perceived community of interest of the *szlachta* had become largely fictitious. The gap between the richest and the poorest had grown immense, destroying the cooperative ethic that had founded the Commonwealth. The decline in standards of education and the loss of the humanist vision of the sixteenth century aggravated this. The *szlachta* was more and more concentrated on local interests and not on those of the country as a whole, and from 1652 onward single deputies to the Sejm began to use the veto to strike down legislation that did not suit their constituency or their local magnate. Crowds of poor *szlachta*, who lived on the generosity of the magnates but enjoyed full political rights, were easy to manipulate. The political education of the Populus Polonus was simply not up to the governance of the country.

A siege mentality was born among the *szlachta*, despising the towns and the alleged vice they represented, condemning progress and "foreign ways," trusting in the purity of the simple life and a God who was necessarily on the side of his chosen people. It bred a kind of fatalistic optimism that allowed for endless disruptive behavior. Elections

and Sejm sessions became rowdier, people became less prepared to pay taxes or fight for their country. The occasional hero such as Jan Sobieski, who was elected king in 1674, could still save the country from Turkish invasion and revive its reputation by military feats. But he was powerless to reverse the general decline.

After his death, in 1696, the decline became terminal. The election of his successors, the cornerstone of the Polish constitution, was turned into farce. A French Bourbon prince was elected, but before he could get to Poland the unsuccessful candidate, Friedrich Augustus (Augustus II as king of Poland), elector of Saxony, simply seized the throne by force of arms. Another rightfully elected king, Stanislas Leszczyński, would also be seen off, in 1734, by Augustus' son, with military help from Russia. In 1718 Russia had made herself the "protector" of Polish freedom and integrity, which in effect abolished Poland's sovereignty as a state. Central government ceased to function, and it was local assemblies of the *szlachta* that governed on a regional basis, raising local taxes, policing their localities, and electing judges. This minimalist government functioned surprisingly well, and it was very cheap since there were no national taxes to speak of.

The most confusing aspects of the century of rapid decline that began in 1648 are that the huge rickety state lasted so long without falling apart altogether and that it was accompanied by a rich cultural life and a spectacular outburst of spending on buildings, painting, sculpture, and every sphere of the decorative arts. What is just as extraordinary is that the resulting artistic heritage should be of such high quality.

The dichotomy that characterized the *szlachta*'s outlook in the sixteenth century, between the "Roman" and the "Sarmatian," had by no means resolved itself. If anything, it had grown more complex. The "Roman" point of view had altered its consistency and turned itself into a panegyric mythology that exalted the *szlachta* in much the same way as the Sarmatian myth did. Great families such as the Radziwiłł and the Lubomirski claimed descent from Hector of Troy and assorted ancient Romans. The intelligent or western element in the original "Roman" outlook had mutated into a sophisticated, largely French-inspired trend among a section of the aristocracy. It gave rise to some interesting though derivative literature and it expressed itself in courtliness, cosmopolitanism, and a taste for the modern. It nevertheless had to coexist with Sarmatism, which had grown from a style and a way of looking at things into a way of life.

By the early 1600s the Polish cavalry had adopted most of the weaponry used by the Turks as well as many of their tactics. The hetmans used the *bulava*, the baton of command, and horse tails, which denoted the highest rank among the Turks, were borne aloft behind them, too. The Poles also dressed more and more like their foe, and even the Tatar habit of shaving the head was widely practiced on campaign. So much so that on the eve of the Battle of Vienna in 1683 the king had to order Polish troops to wear straw cockades so that their European allies should not take them for Turks. With Sobieski's accession to the throne, military fashion invaded the court. The Sarmatian costume had the advantage of being neither French nor German and was thus not associable with foreign intrigue. It thus became a symbol of healthy, straightforward patriotic Polishness.

The Poles also had a feeling for the beauty of Islamic art, which was not appreciated in western Europe. They prized the design and craftsmanship of the weaponry and the horse trappings and relished the art and the luxury of Ottoman textiles. Eastern

hangings replaced Flemish tapestries, and richly set arms joined pictures on the walls of castle and manor house. At the Battle of Chocim, John Sobieski captured a silk embroidery studded with "two thousand emeralds and rubies" from Hussein Pasha that he thought so beautiful that he caparisoned his horse with it for his own coronation. A few years later he gave it as the richest gift he could think of to the grand duke of Tuscany, who put it away and wrote it down in his inventory as "una cosa del barbaro lusso" (a thing of barbaric magnificence).

Oddly enough, oriental clothes suited baroque architecture, and servants were dressed up accordingly. Wealthy *szlachta* and magnates, the most wealthy and powerful members of this class, often kept captive Tatars or janissaries (elite Turkish troops) at their courts, but they also dressed up their Polish pages as Arabs and their bodyguards as Circassian warriors. This taste was carried so far that religious music in the chapel of the Radziwiłł palace at Nieśwież was provided by a Jewish band in the garb of janissaries.

The luxury of Ottoman taste suited the Sarmatian love of extravagance and ritual in everyday life. Money still had no investment role in the minds of most Poles, and all surplus went into movable property of the most opulent kind. In this respect, inventories made on the death of members of the *szlachta* are illuminating. A poor man would be found to possess a horse or two, fine caparisons and horse cloths, saddles, arms and armor, a small amount of rich clothing, jewelry, perhaps some personal table silver, a few furs, and hardly anything in the way of money. Inventories of castles and country houses reveal the same pattern. Jewelry, clothes, silver, saddlery, arms and armor, cannon, uniforms for the castle guard, furs, lengths of cloth, Turkish, Persian, and Chinese hangings, banners, tents, horse cloths, rugs and kilims, Flemish tapestries, and pictures are listed. Furniture hardly figures except where it is made of silver. The chattels of a Polish gentleman therefore differed in quite specific ways from those of his equivalent in England or France, where clothes, jewels, paintings, or tapestries tended to be only the tip of the iceberg of wealth. The Polish magnate's only remotely productive investment was land. The rest of his wealth was invested in belongings. A rich man's coat was a tradeable item, so stiff was it with gold thread. Every button was a jewel, the clasp at his throat and the aigrette on his fur cap were works of art.

Another expression of a man's wealth and power was the hordes of people he surrounded himself with. Poor relatives and landless friends, the sons of less wealthy henchmen and allies of one sort or another, would form a court around a magnate. On top of this he would employ teachers for his children, musicians, whole *corps de ballet*, astronomers, jesters and dwarfs, a quantity of chaplains, secretaries, managers, and other officers. Such a court needed organizing, and there was always a marshal of the court. After that came the servants, stable staff, kitchen staff, falconers, huntsmen, organists, castrati, trumpeters, units of cavalry, infantry, and artillery. The fashion for showy attendants meant that there were dozens of *hajduks* wearing Hungarian dress, *pajuks* in Turkish janissary costume, and *laufers*, all in ostrich-feathers. These attendants had no purpose beyond standing about or running in front of the master when he rode out. The numbers were impressive. When Rafał Leszczyński's wife died in 1635 he had to provide mourning dress for just over two thousand servants (not including cooks and kitchen staff, who were not seen). Karol Radziwiłł's private army in the 1750s numbered six thousand regular troops.

The heads of such families took themselves seriously, and much of this splendor was indulged out of a feeling of self-importance and dignity. Every major event in the life of a family was treated with gravity, and ceremonies were constructed around it. When a child was born the artillery fired salutes and special operas were staged. When the master returned from the wars triumphal arches were erected and fireworks set off. More than mere show, it was a style of behavior that introduced ritual into every action and translated its significance into visible form.

A fine understanding of this had allowed the Catholic Church to entrench itself at the center of Polish life during the seventeenth century. Through the juxtaposition of life and ritual it had made the practice of religion into an integral part of people's regular activities. Outward signs of faith were encouraged in every way. The cult of the Virgin and the saints was revived. Pictures of the Virgin before which miracles were alleged to have taken place were "crowned" and declared to be miraculous. The solemn coronation of the Black Madonna of Częstochowa took place on 8 September 1717 before a crowd of a hundred and fifty thousand people. By 1772 there were a staggering four hundred officially designated "miraculous" pictures of the Virgin within the Commonwealth, each one a center of pilgrimage and a recipient of votive offerings of jewelry, money, tablets, and symbolic limbs.

Physical expressions of religious intent were encouraged, including processions and penances. Just as in artistic expression, the accent was on translating feeling and purpose into ritual action. Nowhere was this more pronounced than where public life and religion came together, as, for instance, at funerals. A magnate would have a huge architectural folly built as a canopy for his coffin, decked out with symbols of his office, his portrait, and his coat of arms. The ritual included the old Polish custom of breaking up the dead man's symbols of office, and if he were the last of his family, shattering his coat of arms. Neighbors, friends, family, servants, and soldiers would pay their last respects in more or less theatrical ways, while congregations of monks and nuns sang dirges and recited litanies. Bells tolled and cannon boomed the while, and the whole process could last a good couple of weeks.

The baroque style lent itself ideally to accommodating this bizarre way of life, itself a unique growth produced by cross-pollination between the Catholic high baroque and Ottoman culture at its zenith. It could only flourish in the ethnically diverse soil of the Commonwealth. It was a natural East-West synthesis, perfectly suited to the Poles' need for expression. Everything about it was theatrical and declamatory. It was radically inimical to the bourgeois ethic of thrift, investment, self-improvement, and discipline that was beginning to dominate the behavior of western Europe, and as a result it was often condemned as ridiculous and primitive, even by the Poles of later centuries. At its worst, Sarmatism was absurd and destructive, encouraging as it did outrageous behavior and an attitude that bred delusion. But its exuberance and its appeal, which went far beyond the frontiers of the Commonwealth, testify to its success in producing, in this hybrid form, a distinctive culture that flourished in this part of Europe.

LITERATURE

Davies 1982; Zamoyski 1990.

POLISH
BAROQUE
ART
IN ITS SOCIAL AND
RELIGIOUS CONTEXT

JAN K. OSTROWSKI

Two events that took place as far back as the fourteenth century underlay the specific social and cultural phenomena in Poland between the sixteenth and eighteenth centuries. The first was the extinction of the royal line of the Piast dynasty with the death of King Casimir the Great in 1370. Casimir's successors no longer had the position of hereditary monarchs, so in order to strengthen their rule they were compelled to solicit support from the *szlachta*, a group encompassing the notions of western nobility and gentry. This political process, inaugurated in 1374 by King Louis of Anjou, resulted in a series of legislative acts of 1496–1505 that ensured the gentry full political power and unprecedented economic and fiscal privileges. The process of formation of a commonwealth of the gentry was solidified by the introduction of the principle of the free election of a king, after the Jagiellon dynasty became extinct in 1572. Thenceforth every member of the Polish gentry had the right not only to choose his king but also to offer himself as a candidate for the crown.

The second event of crucial importance was the marriage of Hedvige of Anjou, successor to the Polish crown, to Jagiello, grand duke of Lithuania, in 1386, thereby concluding a political union of the two states. The hitherto pagan Lithuania, a true eastern European power, a warlike neighbor continually attacking the Polish frontiers, was thus to be incorporated with Poland and Christianized. The union with Lithuania switched the country's life to another track and determined its entirely new political, economic, and cultural prospects.

Until the mid-fourteenth century Poland had been a state of medium size, nationally homogeneous, oriented westward in its culture and economy. The eastern frontier of the state also marked the limits of the Latin Christian world, beyond which lay Orthodox Russia and pagan Lithuania. The intensity of the changes is best illustrated on the map. In 1300 Poland, still divided into provincial principalities, occupied around 200,000 square kilometers (77,000 square miles), but by 1400 the territory of the Polish-Lithuanian state had increased more than three times.

The union with Lithuania was tantamount to turning a homogeneous nation into a multinational state and to changing Poland's orientation from West to East. Until as late as the end of the eighteenth century the direction of the country's development was determined by the immensity of its territory with a population of mixed national, religious, and cultural character and by the gradually increasing domination of the gentry. In the seventeenth and eighteenth centuries the citizens of the Commonwealth who enjoyed full rights were convinced that its political system was ideal and permanent. The government was in the hands of the gentry embodying all virtues, representing a uniform cultural model based on the Jesuit educational system and deeply pervaded with baroque expression in language, literature, and art. Catholicism with its different rites was a dominant religion. Those professing other religions were tolerated, but Protestants were suspected of sympathizing with hostile Sweden, while some of the Orthodox groups were more and more clearly exponents of the political interests of Russia. The governmental system, advantageous to relatively numerous classes of the population, worked as long as Poland succeeded in maintaining more or less peaceful relations with her neighbors and enjoyed economic prosperity. However, around the middle of the seventeenth century it proved vulnerable to internal crises and invasions, and the end of the eighteenth century saw its final breakdown and the loss of independence.

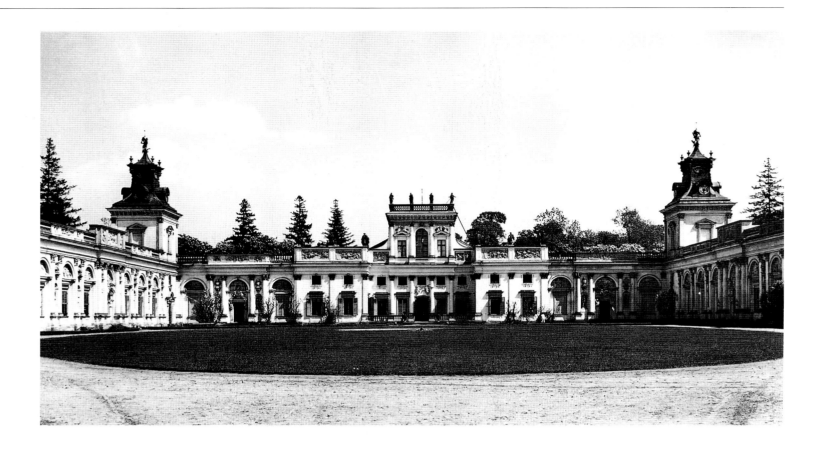

1. Augustyn Locci, *Wilanów Palace*, 1677–96, extended by Giovanni Spazio and Johann Sigmund Deybel, 1722–33

This suburban residence of King John III Sobieski was gradually developed from a modest manor house to a baroque palace.

In the light of its historical experience, a severe judgment is generally passed on the legacy of the Polish Commonwealth. Nevertheless, this does not alter the fact that the social and religious specificity of Poland from the sixteenth to eighteenth centuries left its strong stamp on the country's culture and art. It is mainly this specificity, and not the originality of stylistic solutions, that determines the individual character of its culture and art.

Art of the sixteenth through eighteenth centuries in Poland, as in fact of almost everywhere in Europe at that time, constituted a decorative setting in various spheres of life, a means of social communication, and a determinant of prestige on a par with sumptuous costume or the number of servants. He who commissioned a work of art had the upper hand over the artist, who in most cases contented himself with the humble position of an artisan. The output of this time is best treated as a unique historical record, revealing long-forgotten meanings and human attitudes. The gentry, a social class with numerous and affluent members, conscious of its distinct character, created an elaborate system of customs. This system embraced all spheres of life, regulating family, social, and political relations as well as economic activity and the way of waging war and, finally, a man's attitude toward transcendence, the manner of practicing religion, and forms of devotion. Some of these phenomena are best documented by contemporaneous works of art.

A member of the Polish gentry of this time, irrespective of his affluence or status in social hierarchy, spent most of his time in the countryside. The declining towns were an alien milieu for him, and the court of elected kings did not hold as much attraction for him as had the great courts of absolute monarchs. If he left his estate or the immediate neighborhood, it had to be for a clearly defined reason such as a military campaign, participation in the local assemblies of nobility, the Sejm, or a session of the Tribunal, the election of the new king, sale of grain in Gdańsk, a pilgrimage to a holy place, or a family celebration. His attachment to his home and his own country was not necessarily

tantamount to backwardness or isolation, as the above-mentioned occasions afforded a good many contacts with the world, and a large proportion of the sons of the gentry were educated in various schools at home and abroad.

The setting for a gentleman's life was his country residence. Its size and form were a direct function of his wealth and importance, but it was always the center of his land that constituted his basis of living. Until the turn of the sixteenth and seventeenth centuries the residences of the magnate elite, the richest and most powerful members of the gentry, usually had a form derived from medieval castles, these being several-winged layouts with inner courtyards in a Renaissance or mannerist mantle. With the development of artillery the castle walls lost their function of the main line of defense. Therefore the seventeenth century saw the predominance of a new type of residence, a palace forming a compact block surrounded by bastion fortifications. Finally, in the eighteenth century open layouts on a horseshoe plan prevailed (fig. 1). Apart from some local differences, most magnates' residences represented the types well known in other central European countries, frequently of clear Italian or French provenance.

Such a residence was a microcosm accommodating several hundred people, and with court troops, sometimes several thousand. The degree of its magnificence depended on the owner's affluence. Every castle or palace was filled with richly decorated weapons, precious vessels, and textiles brought from western Europe (Flemish and Dutch tapestries enjoying great popularity) and from the Islamic East. In the interiors decorative art usually took precedence over painting, although numerous inventories of palace picture galleries document several hundred paintings said to include works by great masters. The best-known example of this kind is the eighteenth-century gallery of the Rzewuski family at Podhorce, consisting of more than five hundred pictures (fig. 2). Close examination reveals that the early attributions to the masters were generally optimistic, since the paintings mentioned in the archives as works by Leonardo, Raphael, and Rembrandt are in most cases copies. A fully conscious practice of collecting pictures came with the Enlightenment in the second half of the eighteenth century.

2. Podhorce Palace, *Golden Room*, c. 1640, redecorated c. 1750

The famous Koniecpolski later Rzewuski and Sanguszko palace in Podhorce had been the best preserved Polish baroque residence until World War I. This 1880 photograph shows one of the state rooms.

3. Tylman van Gameren, *Plan of a Wooden Manor House*, c. 1670–80. University Library, Warsaw

During the seventeenth century a geometrical ground plan of Palladian villas was adapted to Polish residential architecture and fully incorporated into the Polish national tradition.

Palaces of the magnates formed only a small proportion of the innumerable Polish country houses, while the particularities of a gentleman's life, relating to economy and customs, were much more markedly reflected on lower rungs of the social ladder. The home of a gentleman, whether a wealthy owner of villages or a *szarak* working his field with his hands, was called a manor house. Initially this term referred not only to a dwelling proper but also to the entire homestead that functioned as the center of administration of the landed estate. It is hard to trace the early genealogy of the Polish country residence. Some masonry manor houses that continue the medieval type of dwelling tower date from the sixteenth century. They are usually two-storied and represent a simple spatial arrangement of no more than two or three rooms at each level. As a rule they functioned exclusively as the dwellings of the proprietors' families and, in the event of the threat of attack, as the last bulwark of defense. The accommodation for the servants as well as the kitchens, baths, and storerooms were located in separate, usually wooden buildings, the whole built-up area being enclosed by simple fortifications consisting of a palisade and possibly an earthen rampart and a moat.

By the beginning of the seventeenth century the process of integrating the hitherto scattered parts of a manor house within a single building had commenced. This was connected with the patriarchal lifestyle of the landed proprietor's family, a desire for comfort, and relinquishment of defenses that at least in the central regions of the country were markedly less needed. Those spacious manor houses of the new type seemed to exhibit a technological setback in comparison with a several-story masonry Renaissance manor. They were for the most part built of timber, the upper story usually being unused except for less important rooms in the attic. The reasons for these preferences, ensuing from the economic and social realities of the life of the landed gentry, may be found in contemporary writings. The models of spatial solutions were borrowed from Renaissance architectural treatises, above all from Serlio and Palladio. The layout that won the greatest popularity comprised an entrance hall on an axis with symmetrically arranged rooms on either side, ensuring the possibility of three to a dozen-odd rooms within a compact rectangular block, frequently enriched by angle alcoves (fig. 3). In this way the typical plan of a northern Italian, Palladian villa was implemented in countless structures all over the Commonwealth (fig. 4). Gradually adopted by ever-wider social groups, in the first half of the twentieth century this plan was still encountered in peasant houses in numerous regions of the country.

Particular parts of a manor house differed from one another in character, each fulfilling its specific function. The interior was divided into the men's section, which was open, assigned to receiving guests, and the women's rooms, more intimate, intended for housework and bringing up children. The furnishings of the residence were modest, this frequently contrasting with sumptuous clothes and military equipment. Not until the eighteenth century does literature record a quick evolution toward comfort or luxury. The hall was usually hung with weapons and trophies of the chase. The largest and most stately chamber was the dining room, where meals were eaten and meetings held. It was almost obligatorily decorated with family portraits. The plain wooden walls encouraged their being covered with textiles such as tapestries, carpets, or other hangings, this being still generally practiced in Polish homes today. The exterior of manor houses gradually acquired baroque features borrowed from monumental architecture. In the neoclassical period its obligatory element was a columned portico, which became a truly emblematic mark of a manor house. Even after the Second World

War, in some regions such porticoes were still used to distinguish the houses of the minor gentry, treasuring its ancestry, from those of its peasant neighbors.

A manor house, inhabited by several generations of a family and by numerous servants, constituted a veritable microcosm of the country life of the gentry. Its advantages and attractions were praised at length in baroque literature, and in the nineteenth and twentieth centuries it was at the center of the myth of the golden age of the gentry. Until the Second World War the Polish intelligentsia, in a marked proportion descended from the impoverished gentry, did not stop dreaming about the return from the town to the country, from a small flat to a spacious manor house in which everyone and everything was in the right, time-honored place. Financial success achieved by an industrialist, lawyer, writer, or artist was as a rule followed by the purchase of a country house in which the traditions of the landed gentry were consciously cultivated. Before the First World War and in the inter-war period this nostalgia found expression in a widespread vogue for urban or suburban villas stylized as baroque or neoclassical manor houses. This in fact was not only a manifestation of a sentimental longing but also of a search for a "national" style in art, demanded by the national consciousness developed by romanticism. Quite unexpectedly this phenomenon has revived in the last few years, albeit devoid of the theoretical foundation that was so characteristic of the early twentieth century. Polish post-modernism again readily refers to the Old Polish manor house, seeing in it one of the sources of overcoming the vulgarity and monotony of architecture determined by modern technology alone.

One of the most frequent occasions for a gentleman in the baroque period to come into contact with the visual arts was to commission a portrait of himself, of members of his family, or of his ancestors. However, the urge to create such pictures, except to some extent for graphic works, had nothing in common with the need for perpetuating a fleeting moment. In the baroque era a portrait was conceived as a monumental work

5. *Princes Sapieha Gallery of Family Portraits*, formerly in the church at Kodeń, after a 19th-century lithograph

This arrangement of true and fantastic family portraits was painted in a short period c. 1720 and occupied a wall in the family chapel.

expected to last forever as a document not only of the model's appearance but, in much greater measure, of his or her status and merit. It is probably not mere chance that in Polish writings of that epoch there are no descriptions of anyone sitting for a portrait, while they are so numerous in western European sources; on the other hand, there are references to the painting of portraits of the deceased both from nature, which was connected with the requirements of the funerary ceremonial, and on the basis of the earlier likenesses supplied to the artist as well as the relatives' instructions. This of course does not mean that no importance was attached to facial resemblance. On the contrary, one of the primary qualities of Old Polish portraiture is its realism, at times even physiognomical verism, so remote from the idealizing manner adopted by most western artists. As important as the model's features was the social code, encompassing

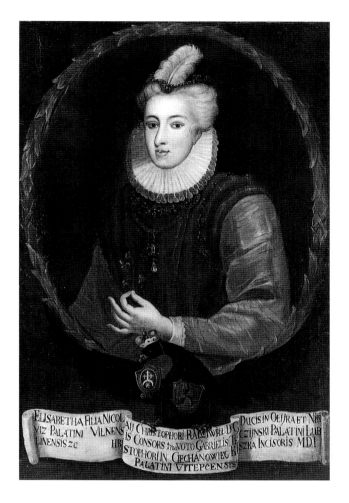

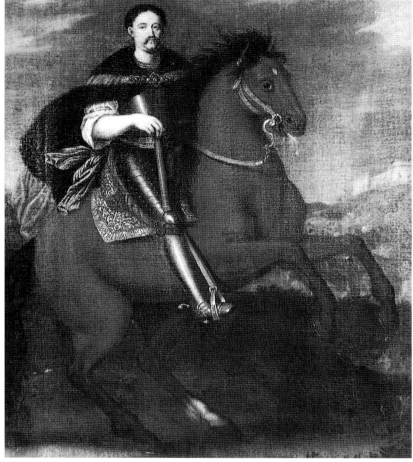

the format of a canvas, the pose, as well as surroundings, costume, and attributes. Baroque portraits very often bear coats of arms and inscriptions (or at least the initials of the model's surname and office), facilitating identification and dating of the works of art. Following these conventions sufficed for portraying someone long dead whose features were not known to anyone. Numerous galleries of ancestors abound in "portraits" of this kind, mass-produced to adorn the hall of a magnate's palace or the dining room of a manor house. Such painted genealogies, in which reliable documentation mixed with fantasy and fiction, could number from a few paintings up to scores of them. Sometimes they were executed within a short period by order of one person, this being exemplified by the Sapieha gallery in the family chapel at Kodeń (fig. 5). The opposite tendency is represented by the gallery of the princes Radziwiłł (fig. 6), which was built up from the seventeenth through the twentieth centuries according to a consistently applied scheme of composition and ideas.

Portraiture, treated as an important means of communication within a close-knit social group, generated a rich symbolic language that is largely forgotten today. Without referring to contemporary sources, one would not understand that the bare arm of Hetman (commander-in-chief) John Sobieski (not yet a king) in his equestrian portrait denotes his rank of officer (fig. 7), or that the atypical "Caucasian manner" of girding

6. *Elżbieta Kiszka, born Princess Radziwiłł*, 1700–1750. Art Museum, Minsk

This portrait, with oval laurel frame, heraldic eagle, and inscriptions, belongs to the Princes Radziwiłł gallery, which was built after a uniform pattern from the 17th to the 20th centuries.

7. *Hetman Jan Sobieski (the Future King John III)*, c. 1670. Palace Museum, Wilanów

A bare arm was a traditional distinction of an officer. This portrait is a rare document of this almost forgotten custom.

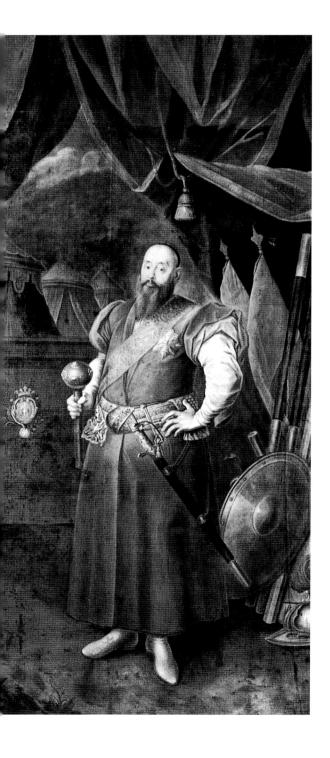

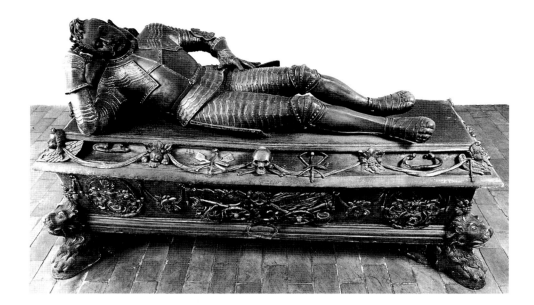

on Hetman Wacław Rzewuski's saber (fig. 8) alludes to his participation in the Confederation of Radom in 1767, which caused his deportation to Russia and, in consequence, became his claim to glory as a patriotic martyr.

Portraits in the classical sense of the word, that is created exclusively for a commemorative-decorative purpose, are probably not the most numerous and surely not the most original ones among the extant Old Polish likenesses. The vast majority of sixteenth-century images of Poles are not paintings but tomb sculptures. The sepulchral monument to King Sigismund the Old in his funerary chapel at Cracow Cathedral, executed between 1529 and 1531, inaugurated the type of tomb that was to be imitated in hundreds of memorials until as late as the mid-seventeenth century. In them the deceased are as a rule represented reclining as if in slumber, clad in full-plate armor. In the reign of Sigismund the Old this kind of armor was still in use, but undoubtedly such costly and, with time, less useful gear was not worn by all of those knights sleeping on the tombs in Polish churches (fig. 9). That it functioned as an attribute of a knight identified with a *Miles Christianus*, and an attribute closely connected with a tomb at that, is best illustrated by the fact that at the same time painted portraits produced for the same clientele followed entirely different conventions.

A characteristic type of Old Polish portrait evolved in the second half of the sixteenth century, of later origin than the type of memorial with an armored effigy but in the period when the latter was still very popular. Although most painted portraits were also strongly conventionalized, for about a hundred years armor appeared in them only sporadically, mainly in royal likenesses and in archaized ones of long-dead ancestors. It does not mean that in those portraits members of the gentry relinquished heroization or emphasis on their knighthood. This role was played by the saber, an inseparable accessory, by signs of military rank such as different kinds of war maces, and by a national costume treated as a kind of military uniform. Especially great importance was attached to this last association. The national garb was obligatory for hetmans, the power of its military-patriotic connotations being evidenced by an episode from the Cossack war of 1649. During the battle of Zborów, King John Casimir, who usually followed a foreign fashion, dressed up in Polish costume, trying with this gesture of solidarity to stop the panic that spread in the army.

The situation did not change until the last quarter of the seventeenth century. In that period armor appeared in tomb sculpture only occasionally, whereas it materialized

with an increasing frequency in portraiture, attaining its apogee in the eighteenth century. Considering the fact that in the majority of cases the models wore western European plate armor, which had gone out of use about a hundred years before at the least, one can appraise the power of convention and the scale of demand for a fiction confirming the knightly status of the gentry, the more so as in that period Poland was a country almost completely demilitarized.

In addition to recumbent figures, sepulchral art created a good many other types of portraits of the deceased, painted and sculptured. Most have their counterparts in other countries, but two types are specific to Poland. One is the coffin portrait, which was fixed to a shorter side of the coffin itself and therefore well seen by all participants in the funeral (fig. 10 and cats. 99, 100, 102). After the ceremony these portraits were hung in churches, occasionally being set in stone or wooden epitaph tablets. The function of such a portrait determined its form. It was usually painted on a hexagonal or octagonal metal plate. The rendering was reduced to a bust or head, great emphasis being laid on the poignant realism of the physiognomy, which produced the effect of the physical presence of the person during the obsequies. At the same time the defunct represented by a portrait was the addressee of panegyric rhetoric, an obligatory element of the ceremony. Researchers see the origins of coffin portraiture in the 1586 likeness of Stephen Batory, painted on a metal plate which, however, was not yet of the characteristic shape.

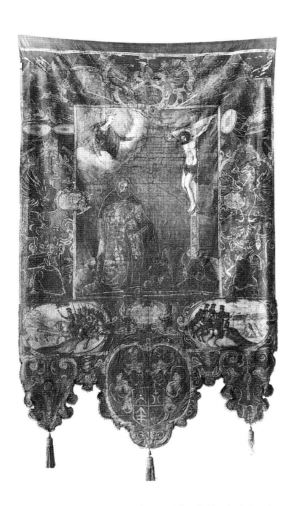

11. *Tomb Banner of Jan Działyński (d. 1643)*. Parish Church, Nowe Miasto Lubawskie

This huge banner is a kind of funeral monument, considered as particularly suitable for a soldier and in the 17th century very popular in Poland.

A coffin portrait attained its classical form in the seventeenth century, its latest reliably dated example being from 1814. The functional and formal origins of coffin portraiture have not been fully elucidated. This type of portrait is known exclusively from the territory of the Polish Commonwealth, where it was used in all Christian rites. It is worth noting the readiness with which this typical Polish custom was adopted by immigrants, as is evidenced by numerous coffin portraits of people bearing foreign names.

Similar customs and traditions lay at the origin of tomb banners (fig. 11). Their main element was the painted likeness of a deceased person, usually represented in the pose of an orant, in principle not unlike portraits in epitaphs or votive pictures of other types. Additionally, such banners carried devotional representations, knightly attributes, armorial bearings, and inscriptions. Most banners were made of purple damask, emblematic of the blood shed for the faith and mother country. It was chiefly soldiers who were entitled to banners of this kind, although there are also examples of their being made for clergymen, women, or even children. They were perhaps used during funeral ceremonies but were primarily intended as specific knightly epitaphs to be hung in a church. At times they replaced tombs of durable material or were suspended next to stone monuments. In some cases they were accompanied by suits of armor and other elements of military equipment belonging to the deceased. The first dependable references to tomb banners date from the early sixteenth century, and the last example from the heartland of Poland is dedicated to a gentleman who died in 1681. The abandonment of this original custom may have been connected with the unfavorable attitude of the Counter-Reformation Church toward the presence of secular elements inside sacred buildings.

It is evident from various sources that in the sixteenth and seventeenth centuries hundreds or perhaps even thousands of tomb banners hung in Polish churches. Owing to their fragility only a dozen-odd objects have survived, for the most part in a poor state of preservation. In this case, too, there is every indication that the idea of a specific knightly monument in the form of a banner was conceived in Poland. From there it probably found its way to some neighboring territories, as such banners are known from Spisz (Zips) and Orava, in those days both belonging to Hungary, as well as from Silesia and above all from East Prussia. The Prussian nobility, descendants of the Teutonic Knights, maintaining close relations with Poland, generally adopted the custom of making tomb banners and seem to have practiced it for another fifty years or so after it had died out in Poland. However, the pragmatic Germans replaced silk with the incomparably more durable copper plate.

The seventeenth and eighteenth centuries were the period of triumphant Catholicism in the Polish Commonwealth. Baroque piety, usually more ostentatious than spiritually or intellectually profound, gave rise to a multitude of splendid religious foundations, on the one hand treated as a means of meriting eternal life and on the other as a determinant of worldly prestige (fig. 12). While every place except for the largest towns had one parish church, the number of monasteries was as a rule unlimited. Hence the two centuries witnessed innumerable foundings of monasteries. Some magnate families were patrons of particular orders, endowing a dozen or more of these institutions. Surprisingly, monumental structures were also established by persons of high social and financial standing but far below the narrow elite. These facts give some idea of the scale of the accumulation of wealth in the hands of a relatively small group, at the same time clearly attesting to that group's preferences in managing their financial surpluses.

A desire to commemorate the founders of churches led to various initiatives of symbolic character, in some of which an ostentatious Christian humility was accompanied by risky baroque concepts and unbridled pride. Michał Kazimierz Pac, who died in 1682, ordered that his body be buried under the threshold of the Church of Saints Peter and Paul, founded by him in Vilnius (Wilno), but on the facade had almost blasphemous words placed, joining the family name with the titles of the Virgin Mary ("*Regina pacis funda nos in pace*"). The founders' coats of arms on the facades, portals, and vaults were practically a rule, but the Potocki family went so far as to give the form of their armorial sign to the crosses crowning churches. Similarly, Bishop Andrzej Stanisław Załuski placed a lamb, his family's heraldic figure, at the top of his chapel in Cracow Cathedral (fig. 13). There is even a church built on a plan resembling an arrow, the chief motif of the arms of the Kalinowski family.

In the seventeenth and eighteenth centuries Polish church architecture was typologically and stylistically connected with the art of Italy and the countries of the Holy Roman Empire. A clearly local custom was reflected in the extremely popular type of central, domed chapel-mausoleum derived from the Renaissance Sigismund Chapel at the Cracow Cathedral.

The victory of the Counter-Reformation bore fruit in the form of the development of the cult of the Virgin Mary and the appearance in the seventeenth and eighteenth centuries of dozens of miraculous images of the Mother of God. The veneration of those

12. Circle of Santi Gucci, *The Myszkowski Family Burial Chapel*, 1603-14. Dominican Church, Cracow

King Sigismund's chapel at Cracow Cathedral, built by Bartolomeo Berrecci in 1517–33, was imitated by noble families and prominent clergymen for more than a century. The Myszkowski Chapel is a fine interpretation of Berrecci's model in the mannerist stylistic language.

13. *Top of the Dome, Chapel of Bishop Andrzej Stanisław Załuski*, Cathedral, Cracow, after 1758

This unusual motif has a double meaning. The lamb alludes to the Eucharist and the Apocalypse but is also the figure of the bishop's coat of arms.

pictures and of other holy images found particular expression in their being adorned with crowns and in their total or partial covering with sheet silver, frequently gilded, lavishly decorated with relief and engraved designs, and sometimes also with jewels. The coronation of a picture, sanctioning its special cult, required permission from the highest Church authorities and was a great religious ceremony attended by hundreds of clergymen and thousands of the faithful. Such coronations took the form of a baroque spectacle of several-days' duration, with a splendid plastic and musical setting, military escort, gun salutes, and display of fireworks. In many cases the crown added to a picture was simply an attribute of the Virgin, to which she had been entitled in iconography since the Middle Ages. The remaining silver appliqué elements on the pictures were a kind of votive offering from the faithful in thanksgiving for divine favors. Numerous Polish cult images won popularity in the form resembling metal reliefs, owing to their silver covers, while their painted layer remained practically unknown. This concerns, among others, the miraculous image of Our Lady of Częstochowa (see cat. 73), whose original Byzantine-Gothic form has been widely popularized only in the last few decades. The origins of the practice of decorating pictures with metal covers are rather obscure. Surely the inspiration provided by the Orthodox Church was not without some bearing here, as its icons were adorned in a similar manner. Nevertheless, this was not a simple adoption of the eastern custom. The covers and appliqué adornments on the Polish pictures usually consist of numerous elements that were added to a painting at a later date. In contrast, the metal covers of Orthodox icons were wrought of one piece of metal and were frequently more important than the painting itself, which merely filled the openings left in them with the faces and hands of the holy persons.

New kinds of church services gave rise to artistic solutions hitherto unknown. In various places throughout the country there sprang monumental complexes of Calvary chapels used during the mysteries of the Holy Week and during some Marian feasts. A specific type of altar is connected with the Forty Hours Devotion. To the widespread custom of holding solemn processions should be ascribed the development of the feretory, a special kind of two-sided picture in a sumptuous frame adapted to being carried by the faithful (cat. 76). The custom of carrying effigies in processions is known in all Catholic countries, and feretories with pictures were an exclusive Polish specialty.

Funerals of members of the social elite were another example of liturgy accompanied by a spectacle with a magnificent artistic setting. Sometimes prepared for several months, they gave rise to unique types of works of art, some of which have already been mentioned, and frequently accounted for new overall arrangements of church interiors. Intended in principle as ephemeral decorations, many a time they lasted for several decades. These extant elements of the baroque *pompa funebris* (cat. 103) are a great rarity and a priceless document of the custom of a bygone era.

Among the most interesting artistic phenomena in Old Poland, excellently illustrating the national and religious relations that prevailed in it, should be ranked a specific convergence of the architectural forms and decoration of churches of different Christian denominations that took place during the baroque period, especially in the eighteenth century. The art of Protestant churches participated in this process to a relatively small degree, because as far back as the sixteenth century it had evolved its own iconographic-functional canon and was impervious to influences of the Catholic counteroffensive. Nonetheless, it is worth noting here the occurrence in Protestant art of typical "Sarmatian" phenomena, such as coffin portraits and tomb banners. The eastern Church was quite a

different case. Already in the fifteenth and early sixteenth centuries there existed a kind of osmosis between Byzantine-Ruthenian and western art. This is exemplified on the one hand by late-Gothic Orthodox churches in Lithuania (Synkowicze, Małomożejków, Nowogródek, Supraśl) and on the other by the paintings of Ruthenian artists, preserved to this day in Roman Catholic churches in Cracow, Lublin, Wiślica, and Sandomierz. Orthodox icons frequently found their way to Catholic churches. These phenomena well reflect the mutual relations of the two religious and cultural formations. The Orthodox Church was ready to avail itself of western achievements in the domain of architecture, whereas it adhered strictly to its rigid canons in painting and the iconographic and functional structure of a church interior. The Catholics accepted without greater objections Orthodox painting, whose iconography did not contain any elements alien to them, while the form was seen as an expression of centuries-old tradition and spiritual quality. It was only as late as the second half of the sixteenth century that, on a wave of Counter-Reformation zeal, attempts, in fact futile, were made to ban the presence in churches of pictures painted by non-Catholics.

Certain closer contacts inevitably resulted from the many years' coexistence of various religious communities that availed themselves of the services of the same artists. For instance, at the turn of the sixteenth and seventeenth centuries, an Italian architect, Paolo Dominici called the Roman, built in Lvov a Bernardine church and the Orthodox church of the Dormition of the Blessed Virgin, the latter also known as the Walachian church. In stylistic aspect the architecture of the two structures is similar, but their spatial arrangements are different, and the Orthodox character of the Walachian church is clearly indicated by its three domes. At the same time there began a process of loosening the canons of Orthodox painting and of its closer and closer resemblance to western art (see cat. 104). A vital role was played here by western European graphic patterns used by icon painters and by an increasing number of commissions that they accepted for secular paintings, above all for portraits, which required the ability to render individual facial features of a sitter and familiarity with the rules of rendering three-dimensional space.

Although the 1596 union of the Churches warranted the preservation of the separate tradition of the eastern rite, with time it brought about profound changes in the art of the Greek Catholic Church. Its almost immediate consequence was that the Uniates were granted full civil rights in the towns governed by the Magdeburg Law. For artists this meant access to guilds and to a wider range of commissions, which accelerated the process of occidentalization of their art. However, no essential changes took place until the eighteenth century, the synod of the Greek Catholic Church held at Zamość in 1720 being considered an important moment in this respect. It was then that far-reaching decisions were taken with the purpose of making the Uniate liturgy resemble the Latin rite, these being soon reflected in art. At the same time the integration of the two rites went so far as to secure for the Uniate Church a great number of generous founders among Roman Catholic magnates, while in the previous century it could count on them only sporadically. For an eighteenth-century owner of vast estates a choice between the foundation of a Latin or a Greek Catholic church was an exclusively pragmatic decision connected with the pastoral needs of the local population. Thus prominent eighteenth-century Greek Catholic churches, such as Saint George's Cathedral in Lvov and the Basilian churches at Berezwecz (fig. 14) and Poczajów, rank among the outstanding achievements of the late baroque and rococo period in the Polish Commonwealth. In

14. *Basilian Church*, Berezwecz, after 1753

The architecture of this church, destroyed by the Soviet authorities after World War II, is one of the highest achievements of the rococo. It closely resembles Bavarian examples and is a prominent illustration of the Latinization of Greek-Catholic religious art in Poland.

15. *High Altar, Greek-Catholic Pokrova Church*, c. 1765, Buczacz

This example illustrates a perfect unification of the oriental iconostasis with the western altar.

their graceful forms, sinuous elevations, and moldings that could easily be mistaken for the works of the Austrian or Bavarian baroque one can hardly discern any links with the tradition of eastern Christianity.

Very important changes took place in the arrangement of the interiors of Greek Catholic churches. The iconostasis was reduced and modified to resemble a Roman Catholic retable (fig. 15). There appeared side altars, pulpits, and figural sculptures until then almost unknown in Orthodox churches. It is worth noting almost concurrent, seemingly similar phenomena in Russian architecture, this being connected with the occidentalization of all spheres of the country's life decreed by Peter the Great. However, the Orthodox churches in Russia took on a baroque mantle only, whereas the traditional spatial structure of the edifices and of all elements of the interior that were related with the cult remained unaltered. Incidentally, during the Orthodox "reconquest" in the nineteenth and twentieth centuries that affected the eastern Polish territories captured by Russia and next by the Soviet Union, the specific elements of Greek Catholic art fell victim to an exceptionally brutal and systematic purge.

The Armenian Church in Poland went even further in its integration with Roman Catholicism than did the Greek Catholic Church. The Armenians formed large communities in the eastern regions of the Commonwealth as early as the fourteenth century. The credo of their Monophysite Church profoundly differs from both the Catholic and the Orthodox faiths; hence initially they kept their clearly distinct character, cultivating the artistic traditions of their far-off mother country. However, in 1630 the Armenian bishop of Lvov joined the union with the Roman Church. Although the Armenian ritual and liturgical language were retained, with time the union brought about a total assimilation of the Armenian minority, whose numerous representatives joined the ranks of the Polish gentry. The price that the Armenians paid for the union and their social rise was a gradual decline of their language and of their cultural individuality. Among a dozen-odd extant Armenian churches in the southeastern regions of the Polish Commonwealth, only the medieval Lvov Cathedral reveals features that are not found in Catholic church architecture.

Non-Christian communities held a vital position in the ethnic and cultural panorama of Old Poland. The most numerous among them were the Jews who had lived in the country since the early Middle Ages and who, with the passage of time, increased their proportional share in its population. Owing to doctrinal differences, it was impossible for Jewish and Christian religious art to come closer to each other. All the same, numerous, often splendid synagogues built in the Commonwealth followed the generally prevailing stylistic canons and frequently included elements typical of Polish architecture, such as, for instance, decorative parapets. On the other hand, in a country constantly short of qualified specialists, religious or national prejudices yielded to practical solutions, Jewish goldsmiths or casters being entrusted with the execution not only of articles of daily use but also of liturgical objects. Moreover, in the eighteenth century there appeared a Jewish engraver who accepted commissions for works in the field of Catholic iconography and painters of Jewish descent who covered church interiors with late baroque frescoes.

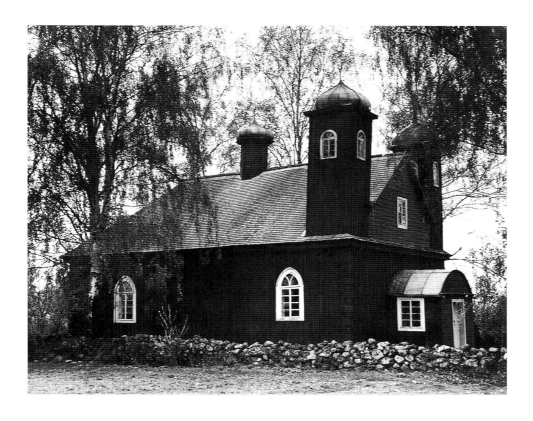

16. *Mosque, Kruszyniany*, late 18th century

Modest wooden mosques of the Polish Tatar Islamic community are astonishingly close to the churches from the neighboring villages. This example contains all external features of a church, including a turret on the roof, corresponding to an ave-bell turret.

The Muslim population, living in the Tatar military colonies, was far less numerous and also culturally weaker than the Jews. Therefore, while a synagogue cannot be mistaken for a church in Poland, the scarce and very modest mosques of the Polish Muslims hardly differ from wooden churches in the neighboring Christian villages (fig. 16).

This essay presents only a brief overview of the social and religious context of art in Old Poland. It is offered as a sociological key that might help to interpret Polish art and facilitate the proper perception of the exhibition. The artistic heritage of Europe consists not solely of masterpieces and great names, but also of a multitude of works affording priceless testimony to history and customs. In a panorama of baroque art, works by Bernini, Rubens, and Rembrandt stand beside coffin portraits and banner epitaphs. Without recognition of the full complement of Polish artistic production, the picture of European late baroque architecture and sculpture would disregard the original phenomena of the cultural borderland of the Polish Commonwealth's eastern regions and would therefore be incomplete.

LITERATURE

J. A. Chrościcki, *Pompa funebris* (Warsaw, 1974); H. Kozakiewiczowa, *Rzeźba XVI wieku w Polsce* (Warsaw, 1984); I. Kozina, J. K. Ostrowski, "Grabfahnen mit Porträtdarstellungen in Polen und Ostpreußen," *Zeistschrift für Kunstgeschichte* 61, 225–55; J. Z. Łoziński, *Grobowe kaplice kopułowe w Polsce* 1520–1620 (Warsaw, 1973); W. Łoziński, *Polnisches Leben in vergangenen Zeiten*, [1907], übersetzt von A.v. Guttry (Munich [1917]); T. Mańkowski, *Genealogia sarmatyzmu* (Warsaw, 1946); W. Tomkiewicz, "Organizacja twórczości i odbiorczości w kulturze artystycznej polskiego Odrodzenia," in *Odrodzenie w Polsce*, vol. 5 (Warsaw, 1958),. 329-70; S. Wiliński, U *źródeł portretu staropolskiego* (Warsaw, 1958).

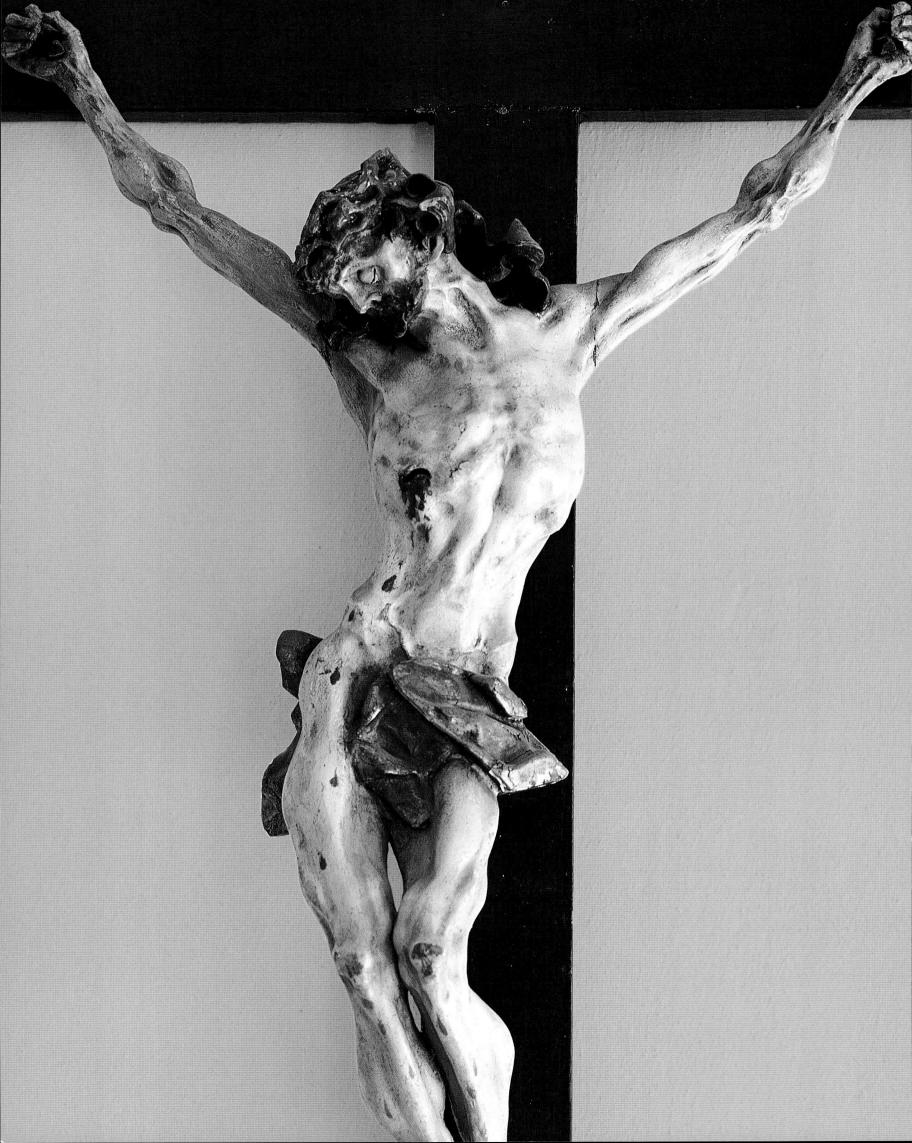

MECHANISMS OF CONTACT BETWEEN POLISH AND EUROPEAN BAROQUE

JAN K. OSTROWSKI

The Baroque: Style, Epoch, Attitude." Of the three basic denotations of this concept, analyzed forty years ago in Jan Białostocki's excellent study, the most essential in the present essay will be the understanding of the baroque as a great cultural epoch. It permits western European art of around 1600–1780 to be regarded as a certain whole without overlooking its immense diversity in the chronological and the territorial sense. The character of the problems discussed here exempts the present study from being obliged to justify precisely the adopted limits of time and from the necessity of defining the baroque character of all the examples given.

In this epoch, just as in any other, there were some artistic centers that took the lead and set the main lines of development for the whole of Europe, the relationship between these centers and more or less peripheral territories usually being expressed in terms of influences. This term, one of the most essential notions in the history of art as a study of the history of the social process of artistic creative work, has not been defined in a satisfactory manner, despite numerous efforts. More than that, its inaccurate application or even misuse is responsible for its being frequently associated with a superficial, unscholarly approach that, unfortunately, revives again and again as a threat to this discipline of learning. The present attempt to analyze the mechanisms of the transmission of artistic patterns does not aspire to a general solution of the problem but may be useful for the understanding of the position of Poland within baroque Europe.

The ontological character of a work of visual art as a material, in-principle unique object, frequently unmovable, causes the mechanism of the propagation of influences to be more complicated in this sphere of human activity than in the domains in which the ideal existence of intellectual concepts and literary works permits their circulation in the form of easily reproducible records. The statement of the influence of work of art A on work of art B must encompass the possibility of at least indirect contact of the author of B with A. If A and B were created in different milieus (X and Y respectively), it is indispensable for the occurrence of any influence that at least one of the following conditions be satisfied: the importation of a work (or works) of art from center X to center Y, which thus becomes accessible to local artists; the bringing from center X to center Y of an artist who implants in a new territory the forms transferred from his native milieu; the journey of an artist from Y to X (frequently tantamount to studies there), where he becomes acquainted with local patterns and often assimilates the procedures of that center; the accessibility in Y of reference material concerning the art of X, which in the epoch discussed here usually took the form of pattern books, illustrated treatises, and graphic reproductions of works of art.

It is easy to see these mechanisms favor one direction of inspiration, from a cultural center toward the periphery. Even the highest values when created in a minor milieu have a slender chance of making way against the current of this general tendency. The development of European baroque art followed the directions set in three main centers: Italy, France, and the Netherlands. This domination, independent of the fluctuation of forces in particular phases of the epoch and particular branches of art, left no room for broader expansion of other milieus. Numerous original works of superior quality created in Spain, England, or German-speaking countries remained achievements on a local scale. Examples of a wider influence exerted by Velázquez on Italian painting or by Fischer von Erlach on French architecture are unknown.

What determined the importance of a particular town or country on the cultural map of Europe was not solely the value of its achievements but also a convergence of political, social, and economic phenomena conditioning the wide popularization of these attainments.

In the present discussion only the most important of these conditions can be enumerated. Their exhaustive presentation would require extensive studies, and the problem of the connections between artistic activity and its social background is exceptionally obscure. Such difficulty also arises in the case of the material discussed here. After all, the leading milieus of the baroque period developed in such different conditions as, on the one hand, the feudal theocracy of the Papal State and, on the other, the burghers' democracy of Protestant Holland laying the foundations of modern capitalism. Therefore, while seeking an answer to the question of the origins of the poles of artistic domination, such aspects as the tradition of the metropolitan status of certain cities, their role as the seats of great centers of power, and their convenient geographical location are factors to be considered.

It seems that certain situations on the border between socioeconomic phenomena and the structural basis of artistic life are a decisive factor. It was indispensable that a particular society should be economically capable of devoting large sums of money to cultural purposes. This capability could be attained either by the concentration of immense resources in the hands of the central authority or through the wealth and economic initiative of wide circles of the population.

The thus-created demand for diverse works of art would have had to be matched by the possibility of satisfying it through a suitable organization of artistic activity, encompassing various problems connected with the acquisition and practicing of an artist's profession. In this connection, too, there was a variety of possible solutions. On the one hand there was the guild and on the other the academic system of education. There was the artist-craftsman but at the same time the independent member of the town community, or the artist-courtier working for a powerful patron to whom he owed his social and economic position.

The phenomenon observed in all leading milieus was the emergence of specialized forms of dealing in works of art, facilitating their sale and contributing to the popularization of artists' achievements. Among particularly significant factors, though at the same time hard to perceive, was the existence of an integrated milieu serving as a forum of discussion, exchange of experience, and formation of the hierarchy of values. Such a milieu could assume the traditional forms of a guild, an academy of humanities, or even an informal Bohemian brotherhood, but it was always an indispensable factor of a stimulating atmosphere within and an influence outside the milieu. Of course, the creation of an academy remarkably raised the standing of a particular center. It contributed to improvement in the level of professional training and theoretical knowledge of artists and ensured them the earlier-unknown prestige of the intellectual practicing a learned profession. The renown of the great academies attracted students from various parts of Europe and led to dissemination of the ideas obtaining in them.

Notwithstanding the imperfections of the present description, it can easily be used as a basis for the construction of a model of the steadily increasing power of a milieu

once it has succeeded in laying its foundations. A cultural position is usually very stable, changes in it occurring more slowly than in politics or the economy. The prestige of the center facilitates the wide dispersal of its products, at the same time attracting and assimilating outstanding individuals from the periphery who contribute to the augmentation of its potential.

The role of peripheral centers is for the most part reduced to following the successive fashions coming from the main one. Some of them may afford excellent and original achievements. It is on the periphery that ultimate conclusions may be drawn from certain processes whose development in the major centers is interrupted by the continual emergence of new concepts. Yet even achievements of superb value but created on the periphery have difficulty in finding their way toward the main center where they might play a universal role. Their significance is brought out in the panorama of the attainments of a given epoch, while it is much harder to find a place for them in outlines of the principal lines of development.

Poland remained on the remote periphery of Latin Europe, no matter whether viewed from Rome, Paris, Amsterdam, or Antwerp. Likewise, within the range of central European culture, whose center of gravity lay in the Habsburg and southern German lands, Poland was usually a weaker element, taking over rather than creating cultural patterns. This is hardly surprising. Poland joined the western community rather late and for a long time constituted its easternmost outpost beyond which there extended the domain of the Orthodox Church and paganism. From the end of the fourteenth century, as a result of the union with Lithuania and incorporation of vast Ruthenian territories, the cultural border between the Latin and the Byzantine world ran right through the Polish-Lithuanian state.

All this, together with geographical remoteness, was bound to affect the ways of keeping in touch with the cultural centers of the West and modes of reception of the patterns coming therefrom. There was an additional obstacle in the form of the system of democracy of the landed gentry established in the early sixteenth century, with its growing xenophobia and contempt for townspeople's occupations and mode of life, while the latter constituted a basis for the modern culture of the West. Nevertheless, in the Renaissance epoch and in that of the baroque of immediate interest here, Poland maintained regular and intensive relations with western centers, with results sometimes amazing in their topicality and artistic qualities. More than this, the territories of central Poland came to play the role of a bridge for the transmission of the achievements of Latin culture farther to the East. It was in the baroque epoch that the latinization of the eastern borderland, assuming the form of polonization and catholicization, came to be reckoned as the chief problem of the country, with tremendous cultural, social, and political consequences.

It is high time to pass on to the subject proper of the present paper, an attempt to outline the mechanisms of contacts of Polish art with the centers of European baroque through illustration by examples of the forms of carrying these contacts into effect. The description will take into account territorial and historical variables and the specificity of particular kinds of art; there will also be an effort to indicate the main social forces constituting the motive power of the analyzed processes.

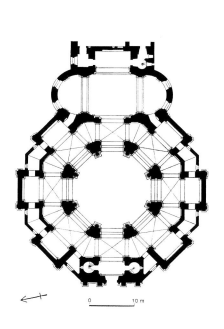

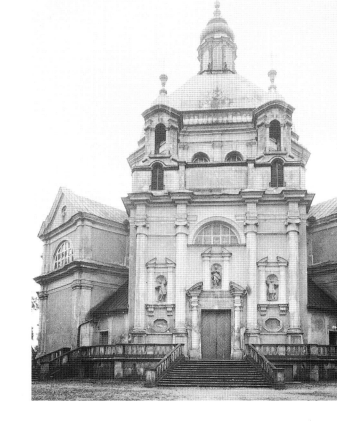

1 *Ground Plan* and *General View*, *Church of the Order of Saint Philip*, Gostyń, 1679–98

IMPORTATION OF WORKS OF ART

It was as far back as the late Middle Ages that Poland permanently entered the European trading system, and representatives of the great Italian and German merchant houses settled in its principal towns. It seems, however, that this exchange did not on a large scale include works of art. Importation from abroad of paintings or sculpture required special endeavors and was generally connected with the travels of potential patrons and collectors and the activities of diplomatic agents. All the same, foreign art objects reached Poland regularly in considerable amounts; they represented all branches of art, including architecture in the form of designs.

Around 1612, at the very beginning of the period under discussion, Vincenzo Scamozzi made a design for the family residence of the princes Zbaraski and published it in his treatise. However, Scamozzi's elegant villa with merely token defenses was transformed in the course of construction in the years 1627–31 into a stout fortress of simplified early baroque forms.

The collegiate church at Klimontów, founded by the *voivode* Krzysztof Ossoliński and raised in the years 1645–50 by the master builder Lorenzo Senes, was clearly modeled on the much earlier design of the Roman architect Ottaviano Mascherino, never carried out in Italy itself.

The church of the Order of Saint Philip at Gostyń (fig. 1) in Great Poland faithfully repeats the plan of the church of Santa Maria della Salute in Venice. It was probably erected according to a design obtained from Baldassare Longhena himself by the founder of the church Zofia Konarzewska, née Opalińska, during her visit to Venice in 1676.

An important route of the influx of architectural models was provided by monastic orders, which varied in their procedures. The Discalced Carmelites and the Capuchins followed detailed instructions concerning the permitted dimensions of buildings, their spatial composition, and their kind of decoration. Nonetheless there was a tendency to unify actual formal solutions only within particular provinces. The Jesuits were at the same time more flexible and more centralized. While on the one hand

consent was given to a considerable variety of churches of the order, on the other each design had to be approved by Rome, and not infrequently plans made there were sent to various places for realization. The design of the church of Saints Peter and Paul in Cracow is considered by some scholars to be a product of this kind, attributed to the chief architect of the Jesuit order, Giovanni de Rosis. With certain alterations it was used for the construction of the church of Saint Casimir in Vilnius (Wilno).

While in the seventeenth century Italian links in architecture were the rule, the eighteenth century brought essential new phenomena. The two successive Saxon electors on the Polish throne relied in their architectural undertakings on a state building office with a branch in Warsaw. Intended for Poland, the designs by outstanding architects such as Mathäus Daniel and Karl Friedrich Pöppelmann, Joachim Daniel Jauch, Johann Christoph Neumann, Zacharias Longuelune, or Gaetano Chiaveri could have been made in Dresden or in Warsaw. In both cases they introduced to Poland architectural forms in the specific, Saxon, dry, and linear version of the baroque with strong French influences.

The 1730s also saw examples of importation directly from Paris of complete interiors. The furnishings of the drawing rooms in the Warsaw palace of Marshal Bieliński and the palace of the Czartoryski princes at Puławy were designed by Juste-Aurèle Meissonier and executed in France, from wall decoration to furniture. These works, today unfortunately known only from iconographic records, were among the earliest and most sumptuous examples of the new rococo fashion.

The importation of paintings and sculptures in the baroque epoch must have been appreciable; nevertheless, it is extremely difficult to reconstruct it with precision. There are very few examples of European baroque art for whose presence in Poland documentary evidence has been supplied since the time near that of their creation. As a rule there is a gap between the archival sources concerning objects that disappeared long ago and those relating to present collections of monuments of art whose pedigree rarely reaches back further than the nineteenth century.

Purchases of paintings and sculpture for the royal collections are documented the best. The successive kings of the Vasa dynasty employed for this purpose their diplomatic representatives, Polish church dignitaries staying in Italy, and also special agents additionally charged with the task of engaging musicians and actors. In this way the Polish court participated, for instance, in the sale of Rubens' collection. The grand tour through Europe made by the Prince Royal Ladislas Sigismund in the years 1624–25 brought a rich harvest in the form of purchases and gifts; Ladislas visited the studios of Rubens, Guido Reni, and Guercino as well as great court art collections in the Netherlands and Italy. The magnate galleries were of similar provenance, their surviving inventories frequently numbering several hundred items.

Pictures were bought both with the intention of embellishing residences and for churches remaining under the special care of particular persons. In the latter case, the emotional attitude toward a religious work of art took precedence over its artistic value. Mikołaj Sapieha simply stole from the Vatican a copy of the *Virgin Mary of Guadalupe*, which to this day has enjoyed a great cult in the church at Kodeń. From time to time, however, Poland imported some outstanding works of art, such as the *Deposition* by Rubens (fig. 2), brought by Piotr Żeroński for the church of Kalisz about 1620, or a whole series of paintings by Giovanni Battista Pittoni, which can be found in Saint

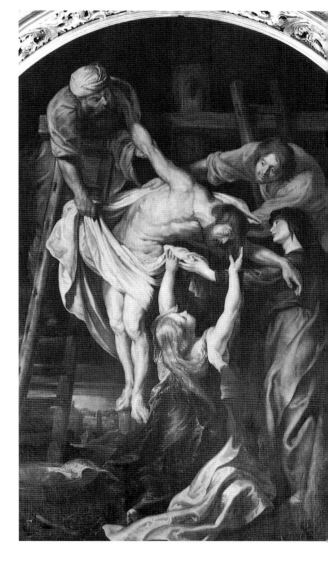

2. Peter Paul Rubens and Workshop, *Deposition*. Formerly Saint Nicholas Church, Kalisz

The painting is an example of a direct commission given to a prominent foreign artist by a Polish patron.

Mary's church in Cracow, a series that was most probably commissioned by canon Jacek Łopacki in around 1750.

Both archival data and the surviving objects prove that works by Italian, Flemish, and Dutch painters enjoyed the greatest popularity. In the eighteenth century there was also demand for paintings by French masters as well as those representing other nationalities and those linked with the Dresden court, which mainly followed French patterns. The inventories of the royal and magnate collections frequently contain references, today impossible to verify, to works of great masters. In addition to originals by eminent artists or pictures passing for such works, purchasers did not hesitate to acquire copies of famous paintings. The paintings of the Rzewuski family from the castle at Podhorce, the only one among Old Polish collections in which, despite dispersal, its original character can still be read, are an amazing conglomeration of remarkable works, more or less successful copies, and third-rate local products. A likewise unequal value must have been present in other magnate or even royal art collections. Unfortunately, the Saxon kings of Poland did not contribute to the creation in Warsaw of a counterpart of the Dresden gallery.

The question of imports in decorative art appears different from the situation in other branches of art. First of all, it seems that the common mechanisms of international trade worked here in greater measure. There are some cases of giving large commissions abroad, excellently exemplified by the silver decorations of the altar in the chapel of Our Lady of Częstochowa executed by Augsburg artists to King Sigismund III's order. Here the main sources of importation differed from those predominating in painting. The gold- and silverware came for the most part from South German centers such as Nuremberg and Augsburg, while a considerable quantity of metalwork and textiles was imported from the Orient, mainly Turkey and Persia.

SUMMONING FOREIGN ARTISTS

In the face of the absence in Poland of any opportunities for the education of artists in accordance with modern European standards, frequently the only way of carrying out ambitious artistic plans was to bring an artist from abroad. As far as can be inferred from incomplete source material, foreign artists appeared in Poland in consequence of one of three possibilities. In most cases an artist was summoned on the initiative of a powerful patron in order to accomplish a specific task. Such a quest was not always successful, particularly in periods of great demand for highly qualified specialists in their native centers. Many of the thus-summoned foreigners remained in Poland for good as members of the court of the king or a magnate. Architects were frequently granted the rank of officer in the army. The second way of commissioning artists from abroad was through the international connections of religious orders. Here the principal role was played by the Jesuits whose churches were built and decorated in large measure by members of the order themselves, who were trained in various skills. When needed these specialists were moved from one country to another; there also operated the mechanism of recruiting foreign craftsmen to the Jesuit Order in Poland. The third possibility was the migration of craftsmen in search of work, this tradition going back to the Middle Ages.

Foreign artists active in Poland came from various countries. In the domain of architecture and architectural decoration the Italians predominated, the majority

3. Giovanni Battista Gisleni(?), *Facade*, Church of the Carmelite Nuns, Lvov, 1683–96

The purely Roman form of the facade was probably designed by Gisleni, one of a long series of Italian architects working in Poland in the Renaissance and baroque periods.

4. Giovanni Battista Gisleni, architect, and Francesco Rossi, sculptor, *Monument to Bishop Piotr Gembicki*, 1657. Cathedral, Cracow

Two Roman artists produced this excellent piece in Cracow, but after the most advanced Italian fashion.

5. Baldassare Fontana, *Holy Cross Altar*, late 17th century. Saint Anne's Church, Cracow

Fontana, a North Italian stucco master trained in Rome, brought to Cracow an art directly connected with the circle of Bernini.

coming from the north of the country, but generally, at least as regards more eminent ones, trained in Rome. In the seventeenth century Italian domination was absolute. Masters such as Giovanni Battista Trevano, Giovanni Battista Gisleni (fig. 3), Costante Tencalla, or Giuseppe Bellotti found but few rivals representing other nationalities of whom the Dutch architect (trained, however, in Venice) Tylman van Gameren was to the fore. In the eighteenth century, alongside the still-numerous Italians (Pompeo Ferrari, Giuseppe and Paolo Fontana, Francesco Placidi) an important role was played by the architects from the circle of the Saxon Bauamt. At that time also the presence of architects from the Habsburg countries became significant. In both periods the French appeared sporadically, often combining the profession of architect with that of military engineer (Guillaume de Beauplan, Pierre Ricaud de Tirregaille).

Italians are noted for outstanding achievements in seventeenth-century figural sculpture (Francesco Rossi [fig. 4], Pietro Perti, Baldassare Fontana [fig. 5]); beside them an important role was played by Germans, most of whom came from the regions bordering Poland (Hanus Pfister of Wrocław, Andreas Schlüter from Gdańsk, the city with a German-speaking population but belonging to Poland). The eighteenth century in turn saw an influx of eminent artists bearing German names; scanty documents and

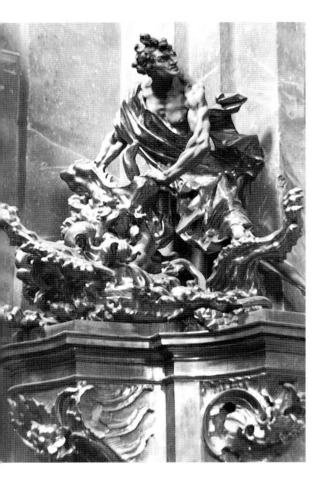

6. Johann Georg Pinsel, *Samson and the Lion*, c. 1758. Picture Gallery, Lvov

The eighteenth century saw a massive immigration to Poland of artists from southern Germany and the Habsburg countries. Pinsel's sculptures rank among the highest achievements of late baroque art in Central Europe.

7. Kacper Bażanka, *Church of the Lazarists Missionaries*, Cracow, 1719–32

Bażanka, a former student at the Accademia di San Luca in Rome, combined in this church the ideas of two prominent Roman architects. The facade is inspired by San Andrea al Quirinale by Gianlorenzo Bernini, and the interior, Borromini's chapel of the Collegio di Propaganda Fide.

the character of these masters' oeuvre indicate that they came from the Habsburg and South German lands (David Heel, Johann Georg Plersch, Sebastian Zeisel, Thomas Hutter, Sebastian and Fabian Fesinger, Johann Georg Pinsel [fig. 6]).

Among the foreign painters of the seventeenth century a certain equilibrium was maintained between those who came from Italy (Tommaso Dolabella of Venice, Michelangelo Palloni of Florence), the Netherlands (Pieter Danckers), and France (Claude Callot, Henri Gascar, François Desportes). A particular role was played by Gdańsk artists, Polish subjects and at the same time representatives of truly western European art who were closely linked with the Netherlandish and North German centers (principally Daniel Schultz). What characterized the eighteenth century was the appearance of a whole group of fresco painters from the Habsburg countries, especially from Bohemia and Moravia (Franz Eckstein, Joseph Mayer).

As to decorative art, the ways of influx of foreign artists were analogous to the channels of importation of the works of art themselves. The Polish eastern borderland, Lvov in particular, was a place of settlement for numerous Armenian weavers and gold- and silversmiths whose products had the pure oriental forms of Persian and Turkish provenance. This production, enjoying great popularity in Poland (among its enthusiasts was King John III Sobieski), added a strong oriental accent to the panorama of Polish baroque art.

POLISH ARTISTS ABROAD

A trip abroad made as an apprentice was in late medieval Poland an obligatory element of the education of a craftsman, thus also of a painter or a sculptor. Unfortunately, the crisis of urban civilization, which started in the early sixteenth century, in large measure discouraged this practice. Such peregrinations did not take the form of modern artistic journeys to Italy, to which western European art owed so much. In Poland, native artistic production kept within the bounds of provincialism. The traditional methods of guild training were less and less adequate to meet the academic standards indispensable for the competent practicing of modern art. Attempts to form artists in a royal school of painting in the time of John III Sobieski could not significantly improve the situation.

In the seventeenth century some efforts were made by Polish artists to restore direct contacts with European art. In the privilege granted the painter Jan Tretko by John III can be read that he studied in Gdańsk but also with Jordaens and Poussin. In the years 1649–56 a great artistic tour of Europe was made by the learned Jesuit Bartłomiej Wąsowski, who recorded his observations in the form of sketches and notes. He subsequently used this material for writing a Latin treatise on art and for his own somewhat amateurish architectural activity.

John III, in addition to taking steps toward the training of artists within the country, enabled Jerzy Szymonowicz and Jan Reisner to study abroad, mainly at the Accademia di San Luca in Rome. Consequently Szymonowicz, though not very original, attained a level of technical expertise until then unknown among Polish artists. Moreover, his prestige as an academic painter facilitated his exceptional rise in society from Lvov burgher to gentleman and landowner.

The eighteenth century did not bring any dramatic changes in this respect. A few artists, such as the architect Kacper Bażanka (fig. 7) or the painters Szymon Czechowicz (fig. 8), Sylwester Mirys, and Tadeusz Kuntze (Konicz), succeeded in completing their studies in Rome, mostly with the help of their powerful protectors. It was not until the time of King Stanislas Augustus Poniatowski in the second half of the century that a large-scale campaign of this kind was undertaken. The artists educated abroad surpassed the others in professional skill and in knowledge of the current trends in European art.

CIRCULATION OF GRAPHIC PATTERNS

With the invention of the woodcut and then copper engraving, the circulation of works of graphic art became one of the most important channels of dissemination and exchange of artistic ideas. The sixteenth century saw the emergence of a wide range of publications of different kinds suited to the needs of particular branches of art. Thus even artists living in the provinces received invaluable help enabling them to bridge some gaps in their own inventiveness and acquainting them with the current situation of art in its large centers. Illustrated publications and separate engravings became an indispensable part of an artist's studio, used for teaching and for his daily work. Centers of graphic production gained the possibility of a much wider influence than the status of the art created there would suggest.

8. Szymon Czechowicz, *The Communion of Saint Stanislas Kostka*, c. 1750. Picture Gallery, Lvov

Czechowicz studied at the Accademia di San Luca in Rome. His art reflects the early eighteenth-century Roman style and is particularly close to that of Carlo Maratti. Stanislas Kostka, a young Polish Jesuit, was one of the most popular saints of the Counter-Reformation.

9. Franciszek Lekszycki, *The Crucifixion*, c. 1659–64. Bernardine Church, Cracow

A modest Franciscan painter was able to produce this monumental canvas thanks to an etching after a Van Dyck composition.

Foreign graphic patterns played a significant role in the development of Polish late Gothic painting and sculpture, and their importance did not decrease in the centuries to come. In the baroque period Flemish, German, and French pattern books were responsible for the shaping of successive vogues in ornamentation.

In architecture, the principal role was played by Italian treatises on architecture by Andrea Palladio, Sebastiano Serlio, Pietro Cattaneo, Giacomo Vignola, and Vincenzo Scamozzi. From these publications, ground plans of buildings were borrowed as well as designs of particular motifs such as fireplaces and door and window surrounds. Owing to its practical approach, Serlio's famous study enjoyed the widest influence, being of use to both outstanding architects and modest master builders. Andrea Pozzo's treatise on perspective had a tremendous impact on two kinds of eighteenth-century art, altar architecture and fresco painting. French treatises and pattern books by Jacques Perret, Pierre Le Muet, Jean and Jean-François Blondel, Jean Le Pautre, and Jean Marot were known in Poland. Netherlandish and German pattern books provided prototypes for details and ornamentation used in architecture and decorative art. As regards the latter sphere of artistic production, the regency and rococo periods saw the predominance of patterns of at least indirect French provenance.

Inspiration in painting came from slightly different directions, the widest influence being exerted not so much by the greatest artists as by those who specialized in mass production of engravings or compositional designs for printmakers. Among the Italians one should mention above all Antonio Tempesta, active in Florence in the second half of the sixteenth century, whose compositions were repeated throughout the next century. However, the most important role was played by the immense graphic output of Antwerp that ensured popularity to the compositions of Marten de Vos and later Rubens. In the eighteenth century the *quadraturisti* consulted not only the treatise by Pozzo but also Jacob Schübler's and Francesco Galli Bibiena's publications of similar kind.

In decorative art, the greatest importance was attached to pattern books of ornamental motifs, the fashions imposed by them being so rigidly followed that today these constitute a valuable aid in the dating of works of woodcarving or metalwork. Engravings serving artists as prototypes obviously enhanced the influence of the artistic centers in which they were created. Nevertheless, it seems that in the baroque epoch the provenance of those works was not clearly distinguished, nor did particular artists attach importance to the stylistic conformity of their source of inspiration with the tradition of their own heritage. The Venetian Tommaso Dolabella readily availed himself of compositions by Marten de Vos. The Dutchman Tylman van Gameren referred to Italian as well as French patterns. The fresco painters from Bohemia, Moravia, and Silesia were the main propagators of Pozzo's ideas.

Access to graphic models enabled even artists with little inventiveness or those with gaps in their education to undertake relatively complicated tasks. For many of them recourse to engravings was the basic method of work, this being well illustrated by the Bernardine painter Franciszek Lekszycki, author of huge reproductions of Rubens and Van Dyck compositions (fig. 9). Graphic patterns were undoubtedly a valuable bridge linking Polish art with Europe. All the same, their influence, though important, was obviously limited. Prints provided sufficient information on the composition and modeling of a painting but could say nothing about the colors of the original.

In conclusion, summoning artists from abroad was undoubtedly the most important among the four main channels of contact of Polish with European art. This concerns the quantity as well as the quality of the thus-created works. However, the close connection of the major achievements of Polish baroque art with leading European models does not exclude the originality of some local phenomena and processes. Foreign artists working in Poland had to take into account local conditions, to adapt their creations to the "Polish sky and custom." Consequently, in Polish art foreign inspiration invariably coexists with quite particular phenomena and a certain degree of provincialism, with originality resulting from the local component of the equation.

The factor of second importance is the use of foreign graphic patterns, one of the methods widely employed by representatives of all branches of art. Importation of original paintings or sculptures was not of such consequence because of its limited scope and the concentration of the majority of imported works in the hands of only a few private owners. On the other hand, there are examples of copies of foreign paintings being made in Poland.

Unfortunately, the funding of studies abroad of Polish artists came almost to nothing. The creation of a strong local milieu would have required a campaign on a much larger scale and the ensurance of proper conditions in Poland for acquiring and practicing artistic professions. Such functions should have been fulfilled by an academy of art which, however, despite certain projects in the time of Stanislas Augustus Poniatowski, was not established until the end of the Polish kingdom.

The selection of sources of inspiration as a rule corresponded with the importance of particular centers in Europe. In addition to the traditional predominance of Italy, Polish baroque art reflected the flowering of Flemish and Dutch painting and the increasing appreciation of French art. It is also worth emphasizing the growth of the independence of the central European region from the early eighteenth century onward and the essential role at that time of the patterns coming from the Habsburg and South German territories. The role of particular foreign centers was fairly varied, depending on which center in Poland and which branch of art there was concerned. Thus until the end of the baroque epoch Cracow favored Roman prototypes. In Greater Poland an important role was played by its neighborly relations with Silesia. In the seventeenth century Lvov maintained close relations with the German-speaking centers of Silesia and Prussia and in the eighteenth with the territories of the Habsburg monarchy. The Saxon element was most pronounced in eighteenth-century Warsaw. In Vilnius and in the whole of Lithuania the eighteenth century brought the development of an architectural school that manifested striking analogies to the rococo architecture of Bavaria. A separate place is occupied by Gdańsk, lying on the frontier of Poland and an active cultural center fully western-European in character, linked by means of a network of ties with the entire northern cultural region along the coasts of the North and Baltic Seas.

Architecture, which in the seventeenth century followed mainly Italian models, in the next century extended its range of inspiration to French and central European ones.

Sculpture, predominately Italian in the seventeenth century, in the eighteenth veered dramatically and fruitfully toward Central European traditions. Painting was characterized by a certain balance of Italian and northern inspirations. In decorative art, strong German and oriental influences can be seen.

While viewing the problem of the relations of Polish baroque art with Europe in terms of their social background, the conclusion is inescapable that the main role was played by the patronage of the magnates, which fully corresponds with the oligarchic system ruling in Polish policy and social life. In view of the limited financial resources of the elected kings, royal patronage not only had no chance of outclassing the sum of magnates' initiatives, but many a time also yielded precedence to the foundations of individual persons. The magnates had the necessary economic means at their disposal and were genuinely interested in maintaining contacts with the West. Artistic patronage raised the prestige of that class not solely because of its scale and intrinsic value. The adoption of the style of living of the western European aristocracy together with its artistic setting was an expression of the magnates' anxiety to distinguish themselves from the Sarmatian masses of the gentry and to sanction their own supremacy.

The Church, apart from the role of the religious orders, participated in these processes in a relatively small degree. Of course, Polish art reflected the phenomena characteristic of the Church as a whole, such as the realization of the decisions of the Council of Trent and the introduction of the cult of new saints and new kinds of divine service. However, as an institution the Church was interested above all in the ideological aspect of these problems, as a rule not interfering in the details of their artistic manifestation. The patronage of bishops and other representatives of high-ranking clergy did not essentially differ from such activities undertaken by lay magnates.

It follows that Polish baroque art drew on European prototypes. On the other hand Poland was the easternmost region to have organically assimilated baroque culture, a variety of sources of inspiration and the specificity of local conditions combining to form a picture full of color and richness. Poland did not contribute any solutions that would steer the universal development of European baroque art. Nevertheless, in addition to numerous works of high artistic quality it did contribute original phenomena, if only to mention a very early introduction to baroque culture of oriental elements or specific types of portrait painting connected with Sarmatian funeral customs. In the panorama of European baroque such achievements may not be disregarded.

LITERATURE

E. Bassi, J. Kowalczyk, "Longhena in Polonia. La chiesa dei Filippini di Gostyń," *Arte Veneta* 26, (1972), 1–13; Białostocki 1962; J. Białostocki, "The Descent from the Cross in Works by Peter Paul Rubens and his Studio," *Art Bulletin* 46 (1964),. 511–24; J. Kowalczyk, "Andrea Pozzo e il tardo barocco in Polonia," in *Barocco fra Italia e Polonia*, ed. J. Ślaski (Warsaw, 1977),. 111–29; S. Lorentz, "Projets pour la Pologne de J. A. Meissonier," *Biuletyn Historii Sztuki* 20 (1958), 186–98; See also the Literature of P. Krasny's essay in this volume.

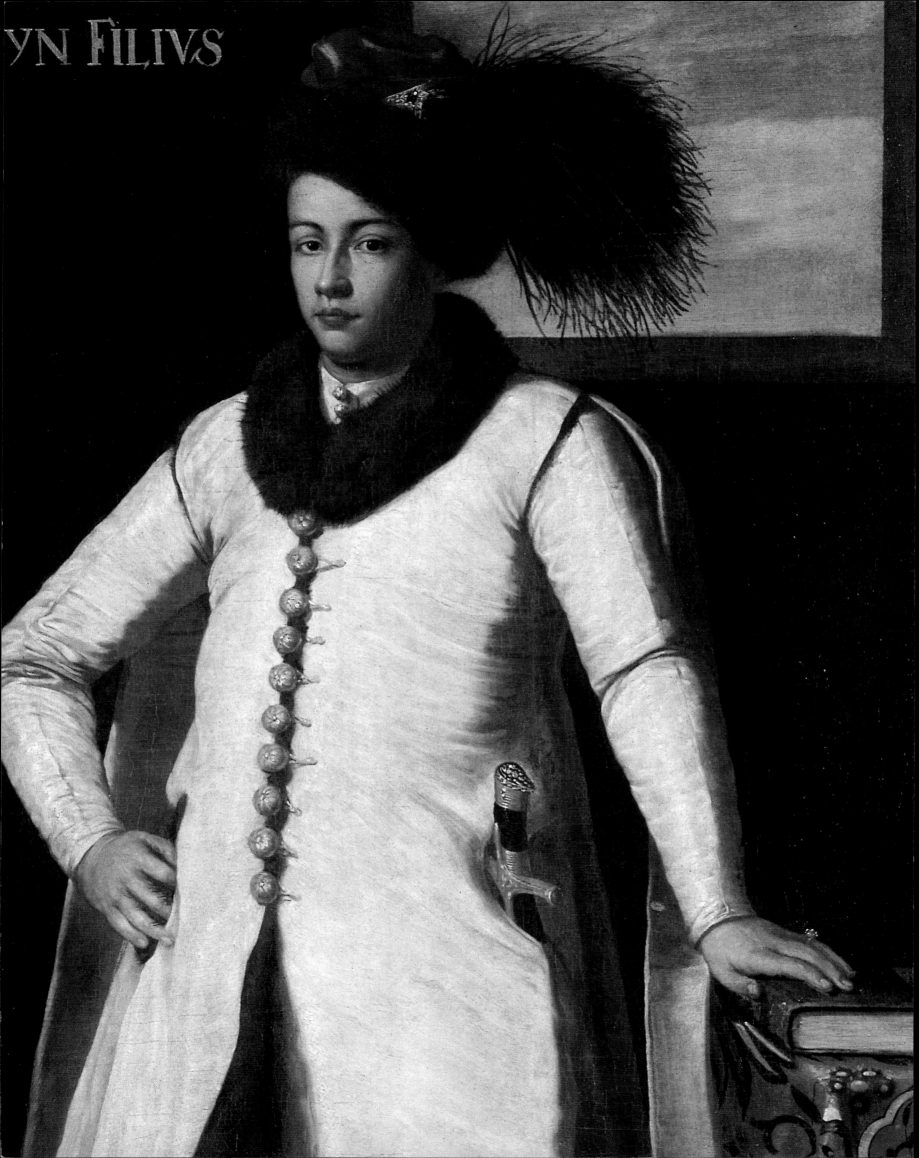

...YN FILIVS

Poland, a country situated in the middle of Europe, was from the beginning of her history subject to influences from West and East. She succeeded in using these inspirations to create her own original culture, which in effect became the main factor of her development and power and in the time of political decline the bulwark of survival. The term West denotes a civilization rooted in the tradition of classical antiquity, based on Roman law and Christian ethos and having its capital in Rome. The word East in turn denotes a civilization of various nations adhering to Orthodox Christianity with its original capital in Constantinople and of those professing Islam, including Arabs, Persians, and Turks, inhabiting the Near East. Jews, Armenians, and Karaites, among others, also represent oriental culture.

By adopting the Christian faith from Rome in 966, Poland joined the sphere of western culture and has remained faithful to it for more than a millennium. On the other hand, beginning from the time of the rulers of the first, Piast, dynasty, Poland also maintained intense political, commercial, and cultural relations with eastern nations. In the eleventh century the kings Boleslas the Brave and Boleslas the Bold undertook expeditions against Kiev; there were frequent marriages between the Polish Piast and the Ruthenian Rurikid dynasties. In the thirteenth century Poland checked the devastating incursions of the Mongols known as Tatars.

The situation of Poland and her "Eastern policy" changed radically after she had concluded a personal union with Lithuania toward the close of the fourteenth century. Jagiello, grand duke of Lithuania, was converted, together with his subjects, to the Roman Catholic rite, married Queen Hedvige (related to the last king of the Piast dynasty, Casimir the Great), and became king of Poland. With time the immense Polish-Lithuanian state was formed under the scepter of the Jagiellons, being formally established in the so-called Union of Lublin in 1569. Along with the Poles and Lithuanians, the Commonwealth was inhabited by Ruthenians and Byelorussians, Jews, Germans, Italians, Greeks, and Scottish people as well as Tatars, Armenians, Karaites, and Walachians, each of these contributing to the creation of a rich, multifaceted civilization. Under the Jagiellons there was a change in the style of dress and of arms and armor in Poland, which until then had been almost exclusively western European. The style of costume and weapon is an important distinctive mark of culture. From numerous extant written and iconographic sources it is clear that sixteenth-century Poland was in a specific situation in this respect; a mixture of various kinds of fashion could be observed here. This was because of strong local tradition and climatic conditions. The infinite eastern expanses had a harsh continental climate with severe and long winters and with hard circumstances of living and transport. The light and short garments made in Italy, Spain, France, and even Germany were unsuitable for eastern Europe. (The ignorance of these climatic differences was to bring a military catastrophe to the French army in 1812 and to the Germans in the years 1941–44.) In the East, long woolen attire had been obligatory for ages, as well as skins and fur coats, quilted caftans and felt boots, a saber instead of a sword, bow instead of crossbow, javelin instead of lance, a small shaggy horse, nimble and hardy, and a light saddle and a seat with bent knees. Wide areas of forest, steppe, or desert were covered on horseback or in sleighs, and hunting was not so much a pastime as a necessity.

If the Poles wanted to rule this huge country, they had to adapt to those conditions also in dress and custom. They did not do it mechanically. They invented a myth ideologically justifying their standpoint: the myth of Sarmatism.

ZDZISŁAW ŻYGULSKI, JR.

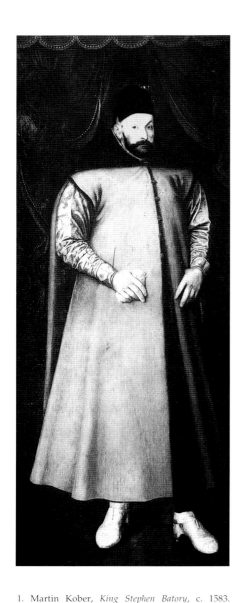

1. Martin Kober, *King Stephen Batory*, c. 1583. Monastery of the Lazarists (Missionaries), Cracow

This portrait is one of the the earliest manifestations of the oriental fashion introduced into the country through Hungary. Not only clothing, but also the handkerchief in the king's hand—an attribute of Byzantine emperors and Turkish sultans—is a document of close relations with the East. Kober's picture set a model of the Polish state portrait for almost two centuries.

Sarmatism was rooted in the erroneous conviction that the Poles were descended from the ancient Sarmatians, a nomadic Iranian people closely related to the Scythians, who until the third century B.C. had inhabited the territories between the Don and Volga Rivers. The Sarmatians were valiant fighting horsemen, armed with bows and swords, usually wearing scale armor, the scales having been cut from horse hoofs. In the course of their migrations westward they reached the Danube and waged wars on the borders of the Roman Empire. In the first centuries A.D., under the pressure of the Goths, Huns, and Slavs, some Sarmatian tribes settled in the Danubian provinces, recognizing the supremacy of Rome. Greek and Roman geographers extended the name Sarmatia to cover territories north of the Black Sea and the Caucasus. Referring to their authority, sixteenth-century Polish chroniclers advanced the thesis that the Sarmatians had also taken over the lands between the Dnieper and Vistula, turning the local population into slaves. The Sarmatians were the alleged ancestors of the Polish knighthood and of the gentry descended from it. This fantastic theory assured the gentry a privileged position and justified its dominance in state government. It was members of the gentry alone who enjoyed unlimited personal freedom, the "golden freedom"; furthermore, the myth gave rise to their self-adulation, xenophobia, and megalomania along with a belief in their historic mission, and, what is of immediate interest, orientalization of their customs and aesthetic tastes. Convinced that Poland had the best sociopolitical system under the sun, the gentry regarded with contempt and horror both the tyrants of the East—Turkish Sultan, Tatar Khan, and Tsar of Muscovy—and the absolute rulers of the West. Contradictions were to be found in everything, since while drawing inspiration from Islamic peoples who allegedly resembled the mythical Sarmatians, the Poles doggedly fought those pagans, turning Poland into the "bulwark of Christendom." The Church made good use of the Sarmatian myth to fuel religious zeal and even fanaticism.

In the field of art, especially in architecture, western European forms, from the Gothic to neoclassicism, were adopted, the baroque style in particular being richly developed with numerous foreign masters engaged to work in Poland. The royal palaces and magnate residences, located in the countryside and in towns, were centers of western culture. The Sarmatian taste was manifested above all in painting and decorative arts and in innumerable articles of daily use.

The portrait in Poland was a remarkable phenomenon of this culture. Commonly though not quite correctly called Sarmatian, it was consistently developed from the end of the sixteenth century. The painter was expected to represent the sitter with physiognomical verism, to render accurately his costume and attributes, armorial bearings, and inscriptions relating to his position and offices, but it was not taken amiss if the artist rendered the model's features with what we see today as exaggeration to the point of caricature. The coffin portrait (cats. 99, 100, 102) was a specifically Polish custom; it was usually hexagonal, painted on a metal plate, and fixed to the coffin during the funeral ceremony. A similar function was performed by the funeral banner bearing a painted likeness of the deceased. Objects of beauty surrounded the "Sarmatian" from birth to death, this being particularly noticeable in garments, interior furnishings, ornaments of the banqueting table, and also in travels, hunts, and wars. Thus emerged a uniform and original culture, fascinating to its representatives and to foreigners alike, though the latter viewed it with some amazement. This was a perfect mixture of western and oriental motifs imaginable only in a country in which West met East. When King Sigismund II Augustus, the last monarch of the Jagiellon dynasty, died in 1572, the Poles offered the throne to Henry of

Valois, son of King Henri II of France and Catherine de Médicis. After the election Polish envoys set out to bring the new monarch from Paris. They entered the capital of France in a magnificent procession, exciting admiration not only with the splendor but also with the cut of their costumes, so unlike that of western attire. The envoys, wearing Polish caps and long *delias*, were later portrayed in the tapestries commissioned by the queen mother to commemorate this event and preserved to this day at the Uffizi in Florence. At the same time, though, some Poles followed the French fashion. King Henry stayed in Poland for no more than a few months; as soon as he was notified of the death of his brother King Charles IX, he secretly fled Poland to assume the vacant French throne, to the disappointment of the Poles. In the successive election the Habsburg archduke Maximilian was favored to win. But the gentry instead turned to a Hungarian, Stephen Batory, palatine of Transylvania. Batory was to some extent a vassal to the Ottoman emperor and was therefore supported by Turkey, albeit he tried hard to free his country from this subjection.

Under the new monarch a wave of oriental influences swept over Poland. By that time the process of orientalization in Hungary had already been far advanced. Unlike the Polish "Sarmatians" the Hungarians were indeed descended from Asiatic nomads. Centuries before, they had lived in the steppes of central Asia next to the Mongol and Turkish tribes and resembled them in tradition and custom. Toward the end of the ninth century the Hungarian tribes, migrating westward under the lead of Arpad, began to take over the former Roman province Pannonia, thereby coming into contact with western civilization. In heavy fighting against Great Moravia and the German Empire the Hungarians consolidated their control of the territory and underwent westernization, accepting Christianity from Rome and in the year 1001 crowning their ruler Stephen of the Arpad dynasty. From the end of the fourteenth century Hungary defended its independence against the pressure of the Ottoman Turks, who aimed at the conquest of southern Europe. It also became the arena of fierce dynastic rivalry between the Habsburgs and the Jagiellons. For some time the Jagiellons were the kings of Hungary, and the son of Jagiello, Ladislas, was killed during the campaign against the Turks at Varna in 1444. The Ottoman Empire eventually gained the upper hand, and in the sixteenth century Hungary was split into three parts. The central territory together with the capital city of Buda was annexed to the Turkish state, the western part was subjected to Habsburg rule, while Transylvania in the east was governed by Hungarian palatines dependent on the sultan. Stephen Batory was one of those palatines; an excellent commander and wise politician, in 1576 he acceded to the throne of Poland, carried out military reforms, and won a number of spectacular victories in the wars with Muscovy. Batory intended to mount a great campaign against Turkey with a view to liberating Hungary, but his premature death thwarted his plans.

This time a passion for things oriental spread throughout Poland thanks to King Stephen himself. His personal style has been preserved in numerous royal portraits. Around 1580 an official full-length royal portrait was painted by the court artist Martin Kober (fig. 1), to become the prototype of a great many Sarmatian portraits. The king is wearing a *magierka* (cap) of black felt adorned with heron plumes, a *żupan* and *delia*, tight-fitting trousers, and yellow shoes; a saber hangs at his side and a handkerchief with which sultans used to be portrayed is in his right hand. It should be added that in those days elements of the Hungarian fashion were mixed with those of the Turkish one. Not only were the Hungarians fascinated with the gorgeous eastern style, but the Turks also adopted various Hungarian ideas relating to costume and armor. Of course the turban, not used in Christian countries, was a sign of Islam, while the Hungarians wore the felt cap (fig. 2).

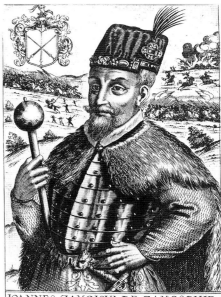

2. Giacomo Franco, *Jan Zamoyski*, etching, c. 1596. Princes Czartoryski Museum, Cracow

The effigy of this chancellor and hetman, one of the most prominent figures in Polish history, illustrates an early version of hussar armor, with a breastplate constructed of movable elements and a Hungarian hat instead of a helmet.

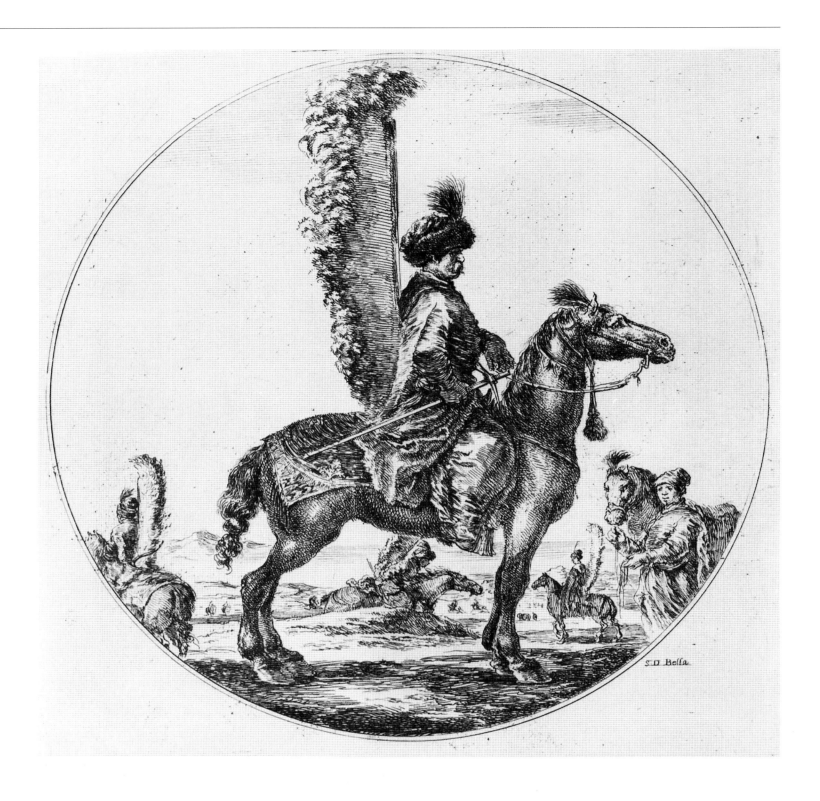

3. Stefano Della Bella, *A Hussar Officer on Horseback (Col. Szczodrowski)*, etching, 1651. Princes Czartoryski Museum, Cracow

Della Bella's drawings and etchings are among the best documents illustrating Polish fashion and customs in the seventeenth century. The represented officer does not wear armor, but has a wing as an attribute of his status.

Batory's time saw the development of the *husaria* (hussar cavalry), the most characteristic and famous Polish military formation. Its eastern origin is beyond dispute. As early as the fifteenth century, during the reign of King Matthias Corvinus, oriental-style light cavalry regiments were organized in Hungary. Their members were usually Serbians famed for their valor, in Poland called Ratse. Their attire consisted of a cap with a brim or a hat similar to a top hat, after the Flemish fashion, a caftan called *dolman*, with loops, a short cloak (*mente*), tight-fitting trousers, and shoes with spurs. They did not wear any armor, their sole protection being a wooden asymmetrical shield, usually bearing the sign of a black eagle's wing. They used offensive weapons in the form of long lances and sabers of Hungarian type. It was they who were labeled hussars and who won fame for their prowess. Matthias Corvinus' excellent army scattered after his

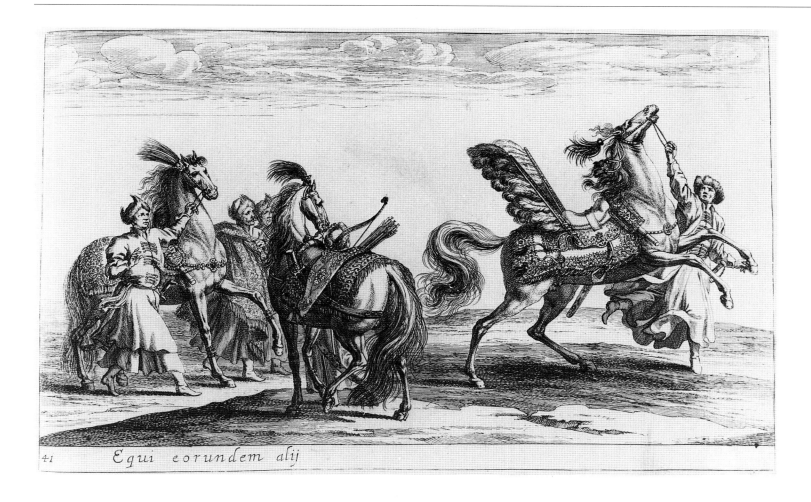

Equi eorundem alij

death. The hussars willingly entered the service of the emperor or joined the army in Poland. First references to mercenary Ratse hussars in Poland date from before 1500. This early *husaria* has been rendered accurately in *The Battle of Orsza*, a painting at the National Museum in Warsaw. The battle of 1514 ended in the victory of the united Polish-Lithuanian forces over the Muscovite army; the picture was painted soon after that date by an unknown German artist from the circle of Lucas Cranach the Elder. The artist must have been an observer of the battle, as the realism of the rendition does not allow any doubt.

Hussars, who replaced heavily armed medieval spearmen, were soon generally accepted in Poland and Lithuania, their ranks being joined by citizens of the two countries. With time the Polish hussar cavalry abandoned Hungarian wooden shields, adopting light laminated armor with an open *zischägge* helmet, wings in the Tatar-Turkish style, and a decoration in the form of a skin of a beast of prey: tiger, leopard, or wolf. They still mainly fought with the long lance reaching a length of five meters (almost fifteen feet), hollow inside for lightness, with a short iron head and a long pennon. At full gallop a hussar easily transfixed his opponent with such a lance which, however, would snap on impact. Therefore, when fighting at close quarters, he used a saber, *estoc*, war hammer, and pistols. The hussar's feathered wings had no particular function except for their psychological role of making him a superhuman creature (fig. 3, see also cat. 1b). As far back as the sixteenth century dyed ostrich feathers were used, and later as a rule those of birds of prey, eagles or hawks; but in view of the scarcity of these even dyed goose or swan feathers were sometimes employed. The wings were fixed in tubular holders of the cantle (fig. 4) or less frequently fastened to the backplate of the armor (see cat. 53). Generally a single, not very tall wing with black feathers was used in combat and a pair of more splendid wings on parade. Occasionally hussars put the wings aside before a battle.

4. Georg Christoph Eimmart, *Certamen equestre* (detail showing Hussar horses), etching, c. 1672. Princes Czartoryski Museum, Cracow

The etching shows the details of Polish horse trappings, including the way of attaching hussar wings to the saddle. The grooms are dressed after the Polish-Hungarian military fashion.

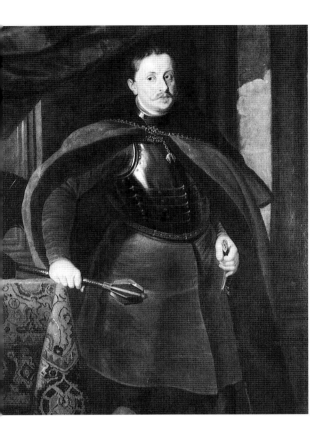

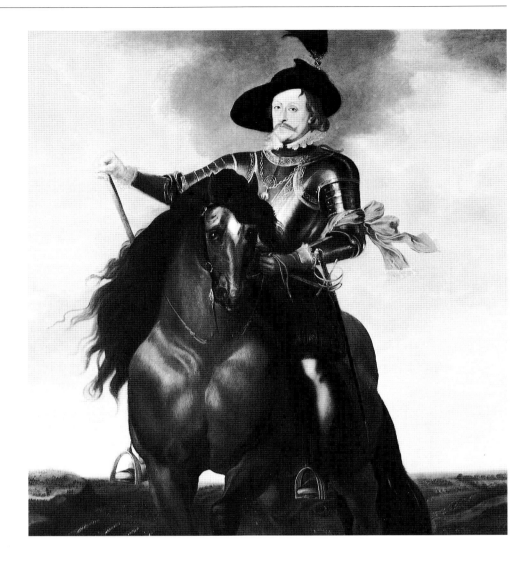

5. *Ladislas Sigismund Vasa, the Future King Ladislas IV*, c. 1621. Princes Czartoryski Museum, Cracow

The young prince royal wears light hussar attire. He is armed with a *buzdygan* war mace and a Polish-Hungarian saber. These national attributes are rare in Ladislas' iconography, as the western fashion predominated at the court of the Polish Vasa. The royal portraits of this king introduced into Polish portrait painting the custom of armored representations, which did not become widespread, however, until the latter half of the seventeenth century.

6. *Ladislas Sigismund Vasa, the Future King Ladislas IV*, after 1624. Wawel Royal Castle, Cracow

This fully western portrait is connected with Ladislas' European grand tour of 1624–25, although the battle in the background is the heroic defense against the Turks at Chocim in 1621.

Hussar armor, sabers, and saddles together with additional arms and equipment, all of very high quality, were produced by local craftsmen. The Polish *husaria* of the sixteenth and seventeenth centuries, a felicitous combination of the military experience of East and West, was one of the best and most universal cavalry formations in Europe, deciding numerous victories such as those over the Swedes at Kircholm in 1605, over Muscovy at Kłuszyn in 1610, and over the Turks at Vienna in 1683.

In addition to the new type of hussar cavalry, King Stephen Batory introduced into Poland a Hungarian infantry formation called *hajduks*. The infantry, recruited mainly from the peasantry, wore uniform caps of *magierka* type, blue *delias* and *żupans*, and were armed with harquebuses, sabers, and war axes. Patterned in some measure after the famous Turkish janissary infantry, it became a model for Polish infantry.

After Batory's death the Polish throne was assumed by Sigismund III, son of John Vasa, king of Sweden, and Catherine Jagiellon, daughter of Sigismund the Old. He was in turn succeeded by his two sons Ladislas IV (figs. 5, 6) and John Casimir (fig. 7), and next by Michael Wiśniowiecki and John III Sobieski. Their reigns covered almost the whole of the seventeenth century, the period of devastating wars in Europe and in Poland. Poland then waged defensive wars on all her frontiers and also internally, particularly tragic being the civil war, a Ukrainian rebellion under the leadership of Bohdan Chmielnicki, and a disastrous Swedish invasion known in the Polish tradition as the "Deluge." Heavy fighting continued in the eastern borderland against Muscovy, Tatars, and Turkey. The relations with the East acquired a dynamic character, conflicts alternating with diplomatic missions and intense commercial exchange being carried on. Victorious expeditions were accompanied by the capture of booty, and "Turkish

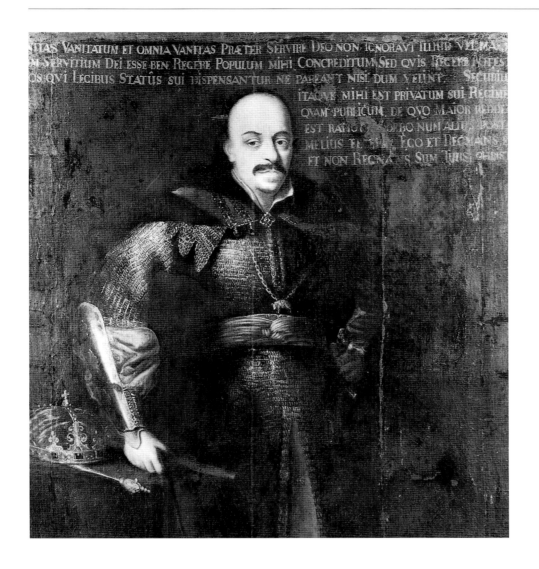

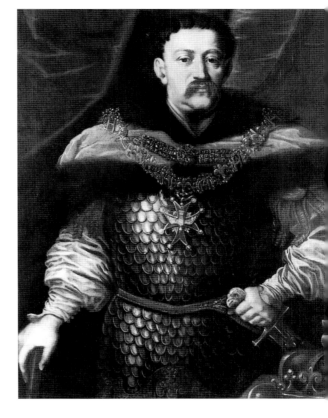

goods" came to be an important incentive to going to war. However, the Poles, too, suffered pillage, and thousands of Polish people were taken prisoner during the Tatar incursions. Numerous Polish and Ukrainian girls and women were sold to Turkish harems where they bore children and accepted the local customs, thereby contributing to specific Polish-Turkish relations.

The Polish art of war was adapted to the conditions for campaigning in the East. There was a characteristic dualism of formations; one part of the army was armed and trained after the western fashion and was called the foreign, while the other, remaining under a strong oriental influence, was called the national contingent. The hussars were a formation of mixed character. In addition, regiments of half-heavy cavalry were formed. They were called *pancerni* and resembled heavily armed mounted Turkish *spahis* wearing mail shirts and mail caps, carrying *kalkans* (circular shields woven of fig wands and silk) and fighting with short lances and with sabers but at the same time armed with bows and light firearms. There were also light horse regiments akin to Walachian mounted troops, without armor or shields but carrying sabers, lances, and bows. It was from this cavalry that later the famous Polish *uhlans* (lancers) and light horse formations developed.

In the first half of the seventeenth century, Polish encounters with Ottoman Turkey were defensive, marked by the defeat at Cecora in 1620 and the victorious defense of Chocim in 1621. In the second half of that century, in the reigns of Kings Michael Wiśniowiecki and John III Sobieski, Poland first suffered a terrible defeat, losing her most important fortress of Kamieniec Podolski and surrendering Podolia to Turkish occupation, but then, thanks to Sobieski (fig. 8), scored brilliant victories: again at

7. *King John Casimir in Mail Armor*, c. 1650. Wawel Royal Castle, Cracow

King John Casimir used western clothes all his life with the exception of the 1649–50 Cossack campaign. In this painting, the Polish national dress (*żupan, delia*) completed with eastern-type armor was a manifestation of the king's solidarity with his army.

8. *John III Sobieski*, after 1676. National Museum, Warsaw

John III epitomized the character and virtues of a Polish nobleman, defender of his country and of the Christian faith. The scale armor, alluding both to the classical and oriental traditions, was a product of Sarmatian ideology. The king wears the French Order of the Holy Spirit. The eagle head of the hilt of his saber is an element of the royal coat of arms.

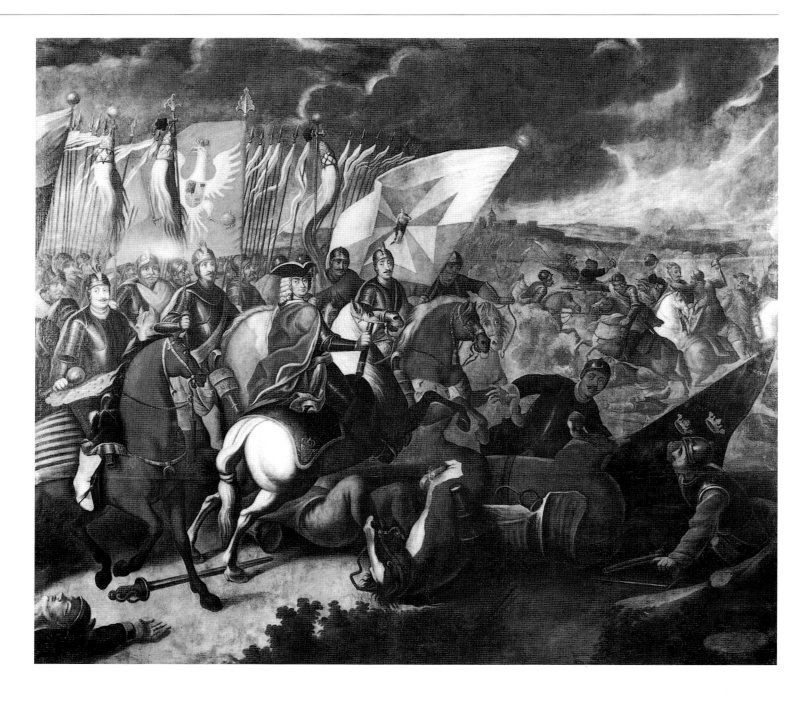

9. *Battle of Kalisz*, 1700–50. Princes Czartoryski
Museum, Cracow

The battle fought during the Northern War in 1706
was a minor one, but it was the last successful mili-
tary exploit of the Polish hussar cavalry. The picture
perfectly illustrates the contrast between the western
armor of King Augustus II and the traditional Polish
armament of his soldiers. Two hetmans participating
in the event are identified by war maces in their
hands and *buntschuks* with small wings.

Chocim in 1673 and at Vienna in 1683, which contributed to the repulsion of the Turkish
danger and the conclusion of the peace of Karlovitz in 1699. However, prior to this date
the Turks had occupied a substantial part of Poland's southeastern lands for twenty-
seven years, converting the Kamieniec Cathedral into a mosque.

Hostile as well as peaceful relations with the East contributed to the orientalization
of Polish taste and lifestyle. King Sigismund III, brought up in western culture and
maintaining friendly relations with the Holy Roman Emperor, the monarch at whose
court western artists predominated, was at the same time a great lover of oriental products,
sometimes even dressing up as a hussar. In 1601 he dispatched the Armenian merchant
Sefer Muratowicz to Persia, instructing him to buy various precious objects, among
them gold-threaded silk carpets and tents and damascened sabers. The carpets
brought by Muratowicz had been woven in the tapestry technique in Kashan and were
decorated with the king's armorial bearings. Some of them have been preserved in the
collections of the Munich Residenz as part of the dowry of King Sigismund's daughter
who married Philip Wilhelm, the future palatine of the Rhineland.

Persian and Turkish rugs played a great role in contemporary Polish culture. They were imported in immense quantities from the sixteenth century or perhaps even earlier, a major market center for them being Lvov. This city along with other towns in the south-eastern border territories—Żółkiew, Brody, Kamieniec Podolski—developed a large-scale production of articles in oriental style, partly from imported raw materials and semi-manufactured products. These were above all goldsmith's works and also weapons and military equipment: sabers, maces, *bulavas*, *kalkans*, bows and archer's tackle, saddles, horse trappings, and tents (see cats. 52, 61–67, 70–72). The guild master craftsmen enjoyed the patronage of John III, the greatest connoisseur of the Orient and lover of oriental art among Polish monarchs. He took under his special protection the Armenians living in large colonies in Lvov and Kamieniec Podolski. The Armenians, who settled in Poland as early as the fourteenth century, were soon polonized, but they continued to use at home their own language and preserved their own religion, building Christian churches of their own rite. They were excellent merchants and disseminators of oriental art.

The eighteenth century witnessed a radical change in Poland's attitude toward Islamic states. Following the Peace of Karlovitz (1699), Turkey reduced its imperialistic aspirations and soon found itself in a serious political, military, and economic crisis. Russia, after victory over the Swedes, grew into a powerful monarchy dangerous to its neighbors, especially the Polish Commonwealth and Turkey. This naturally led to a Polish-Turkish alliance aimed at defense against Russian expansion. The Crimean Tatars gave up their centuries-old incursions into Poland and assumed a defensive position; however, before long they were forced to surrender to Russia.

An exceptionally long period of peace for Poland under King Augustus III (1735-63) was conducive to stability and economic improvement. Poland continued her traditional trading with the East and still abounded in her favorite oriental goods: textiles, rugs, superb leather, precious stones, spices, and fruits. Appropriate raw materials were still used for production of oriental-style objects in Poland. This primarily concerned gentleman's attire. Although the French fashion—dress coats, wigs, smallswords—had its followers, the Sarmatian style still prevailed and came to be generally regarded as a sign of Polishness. The national costume consisted of a *żupan* and a *kontusz* worn over it, with a sumptuous sash tied around the waist and a *karabela* (see cats. 37–44, 64). The head was covered by a Polish cap that, toward the close of the period, assumed a square shape borrowed from far-eastern headdresses. The four-cornered cap eventually became a symbol of a Pole and has remained as such ever since. The *kontusz* sash was of eastern origin; belts of this kind were at first imported from Turkey or Persia and next, in view of a growing demand, produced at home in various workshops, the most celebrated being a manufactory of lamé silk sashes at Słuck set up by the Polish Armenians. The production of sashes worn with the national costume survived into the early nineteenth century. These belts are a true pride of Polish craftsmanship. Originating from analogous Turkish, Persian, and Indian belts, they nevertheless constitute a separate class, their patterns including, apart from oriental motifs, quite a proportion of native ones; they are distinguished besides by technical excellence.

For a considerable part of the eighteenth century the Polish army retained its traditional form, this being one of the causes of the loss of Poland's independence (fig. 9). While her aggressive neighbors Russia, Prussia, and Austria had modern armies several hundred thousand strong, the Commonwealth, encompassing the immense

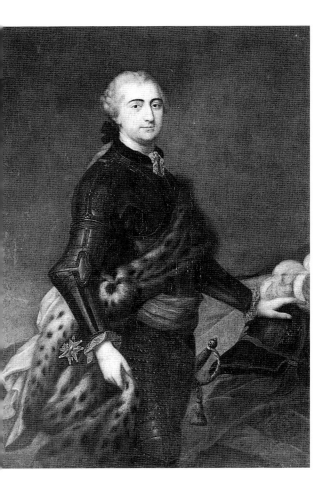

10. *King Stanislas Augustus Poniatowski*, c. 1765. Princes Czartoryski Museum, Cracow

The king's western-type full armor is a heroic attribute, fully anachronistic in the eighteenth century.

territories of Poland, Lithuania, and Ruthenia, had fewer than twenty thousand soldiers at its disposal. Foreign troops moved freely about the country, extorted cantonment and food, by threat and violence forcing political decisions. The Polish army still consisted of the national and foreign contingents, and the hussar cavalry was regarded the queen of arms. Its apparel was increasingly sumptuous, adorned with leopard skins and wings, but it was no longer of any military importance in view of the development of infantry and artillery formations. As the hussars frequently took part in the funerals of dignitaries, they were contemptuously called "funeral soldiers." According to the tradition going back to the previous century, janissary troops in characteristic caps, caftans, and loose galligaskins were maintained for gala occasions. Apart from the style of costume and arms, this formation had little in common with the Ottoman infantry of old, famous for its numerous victories; these eighteenth-century Polish janissaries were a manifestation of "playing the Orient" so characteristic of that epoch. As a matter of fact, influences of specific orientalism were now reaching Poland from the West, mainly from France and Saxony. An interest in the art of the Near and Far East became fashionable in the West as an expression of a longing for exoticism, reflected for the most part in ephemeral park architecture and in figural decorations using Turkish and Chinese motifs, the "turqueries" and "chinoiseries." The leading role in this fashion was played by France, which had for long maintained friendly relations with Turkey and also showed sympathy toward China. The artistic domination of France in Europe, dating back to the time of King Louis XIV, was largely responsible for the dissemination of this fashion, especially in the German states and in Poland. Thus at Polish magnate residences one could find Chinese bowers and bridges and Turkish minarets and baths. The eastern influence met with scientific, that is cognitive orientalism, promoted by the European Enlightenment.

King Stanislas Augustus Poniatowski (fig. 10), the last monarch on the Polish throne, inherited his orientalist passion from his father Stanisław, castellan of Cracow. Stanisław, in the ups and downs of his political career, maintained close relations with Turkey; as counsellor and friend of the king of Sweden, Charles XII, after Sweden's defeat at Poltava in the war with Russia, Stanisław took refuge, together with Charles, in the Ottoman Empire. King Stanislas Augustus had primarily political matters in view. During his journey to the eastern provinces of his state in 1787 he visited Kamieniec Podolski, at that time again in Polish hands. Earlier still, in 1766, setting store by the training of the Polish diplomatic staff, he established in Istanbul a school of oriental languages for Poles.

One of the first scientific orientalists in Poland was the polyglot and bibliophile Prince Adam Kazimierz Czartoryski, who was interested in oriental languages, including Sanskrit, and maintained learned correspondence with the eminent English scholar William Jones and with the Austrian orientalist of Hungarian descent Karl Emmerich Reviczky. Princess Isabella Czartoryska, Adam's wife, accumulated exquisite oriental works of art, including part of the Turkish booty from the Battle of Vienna in 1683, in the first Polish historical-artistic museum, the Temple of Sibyl at Puławy, which opened in 1801. These are high-quality items: saddles, horse trappings, elements of armor, weapons, and *tughs* preserved to this day in the Princes Czartoryski Museum in Cracow. A great many Turkish trophies and other examples of oriental art have survived

in the Wawel collections and at Jasna Góra monastery in Częstochowa, some of them being votive offerings from King John III Sobieski.

With the loss of Poland's independence in 1795, the Poles had a new situation to face. The struggle to regain the country's autonomy, inaugurated by Tadeusz Kościuszko's insurrection in 1794, became the guiding motive for the nation. Successive armed uprisings, relying on revolutionary France and on the illusory power of Napoleon, in November 1830, in the spring of 1848, and in January 1863, ended in defeat. The insurgents had to emigrate, and those captured by the Russians were deported and dispatched to hard labor, usually in Siberia or the Caucasus. The East frequently became a new fatherland for the exiles, who worked there and who also discovered the secrets of those lands. The chief political force of the Polish émigrés was focused toward France, as it was on that country that the Poles set their greatest hopes for regaining independence; however, amicable Turkey also was an important focus. Thanks to Prince Adam Jerzy Czartoryski's efforts an agency for Polish affairs was set up in Istanbul that was particularly active during the Crimean War. Numerous Polish officers, heroes of the insurrections, joined the sultan's army. Outstanding among them was Józef Bem, participant in the November Rising and subsequently leader of the Hungarian insurrection against Russia in 1848. Władysław Kościelski was, under the name of Sefer Pasha, master of ceremonies at the court of Sultan Abdul Aziz. He built an impressive collection of works of oriental art, mainly Turkish and Persian arms and armor, which after his death was made over to the National Museum in Cracow, established in 1879.

Toward the end of the nineteenth century a valuable collection of far eastern art from Japan, China, and Korea was accumulated by Feliks "Manggha" Jasieński, a celebrated connoisseur and art critic. His collection, too, passed into the Cracow Museum and eventually stimulated the erection in Cracow in 1994 of a Center of Japanese Art and Technique.

The relations between Poland, which regained her independence in 1918, and eastern countries have continued and developed in the present century, chiefly in political, economic, and cultural spheres. At the Polish universities, especially in Cracow and Warsaw, departments of Arabic and Persian studies as well as of Sinology and Japanese studies have been set up. Polish scholars have significantly contributed to the development of oriental studies, winning international recognition.

The Enlightenment and subsequently the dramatic experience of the period of partitions have made the Poles reject the Sarmatian myth and swing back toward the West. Nevertheless, echoes of Sarmatism have remained in their national consciousness, nourished with works of old art and literature and with current theatrical performances and films, along with numerous objects of historical and artistic value that have been accumulated in Polish museums. The present exhibition offers clear evidence of these traditions and sentiments.

LITERATURE

T. Chrzanowski, "Orient i orientalizm w kulturze staropolskiej," in *Orient i orientalizm w sztuce* (Warsaw, 1986), s. 43–69; T. Mańkowski, *Orient w polskiej kulturze artystycznej* (Wrocław, 1959); Sulimirski 1979; Żygulski 1973; Z. Żygulski, Jr., *Broń w dawnej Polsce na tle uzbrojenia Europy i Bliskiego Wschodu* (Warsaw, 1975); Żygulsk 1987; Żygulski 1990.

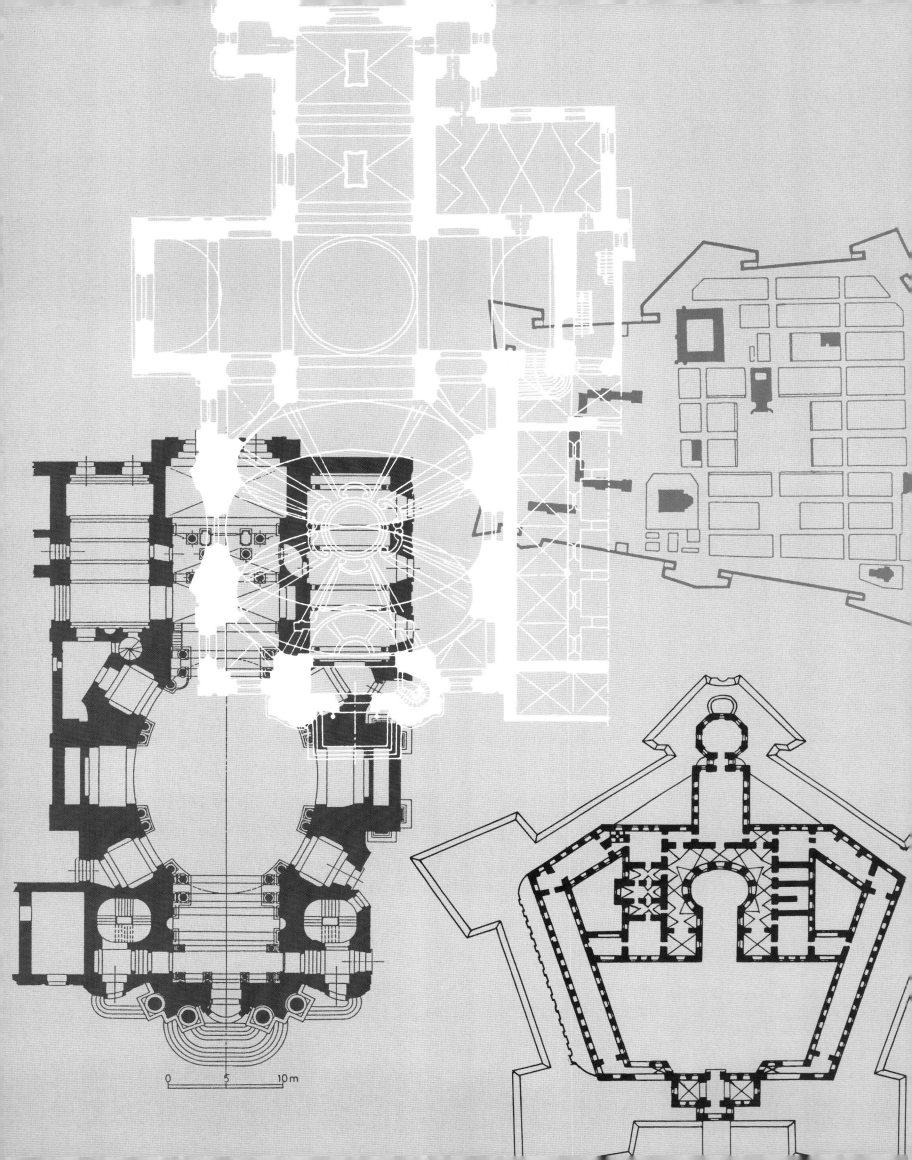

0 5 10m

The years 1572–1764 were of particular importance to the shaping of the Polish architectural landscape. Several times more structures were erected then than in medieval Poland. The intensity of building activity around 1600 was the result of the excellent economic situation of the Polish-Lithuanian Commonwealth at that time. Nevertheless, even during a deep crisis, which affected the Polish economy after a series of devastating wars in the middle of the seventeenth century, means were found for new architectural foundations. The years 1740–70 saw the next building boom in Poland, caused by lasting peace and economic growth. Architectural activity in the Commonwealth in the seventeenth and eighteenth centuries would not have developed to such an extent had the initiative and scale of building been motivated solely by utilitarian reasons. Edifices sprang up in those days beyond actual need. For example, medieval churches preserved in good state were demolished to be replaced by more impressive ones. Palaces were almost incessantly expanded by new wings and rooms not so much for greater comfort to their residents as for enhancing the stately character of those structures. All of these enterprises were an expression of the high status assigned to architectural foundations in the hierarchy of human activities.

The Aristotelian thesis that the erection of magnificent buildings is a deed particularly worthy of great men found ready followers in Poland. Splendid churches, public edifices, and residences constituted specific memorials to their founders. Founders were commemorated on buildings by inscribed tablets, armorial bearings, or even choices of subjects for sculptural decoration. The stateliness of a building was perceived relatively. Only a large church or a pompous residence would be regarded as a fitting monument to a magnate. An owner of no more than one village would be admired for founding a small wooden church. A very important role in the development of Catholic and Orthodox Church architecture was played by the so-called theology of merit. In the light of this doctrine, the erection of a church to the greater glory of God was deemed a good work of exceptional rank that could decide the founder's salvation. Although this kind of thinking was in manifest contradiction to Protestant theology, it also frequently influenced decisions to build new Protestant churches.

Vigorous building activity in the Polish territories brought about the need for a great many architects who would carry out numerous commissions and who were expected to meet various requirements, depending on the affluence, education, and artistic consciousness of their clients. The most powerful of these patrons, representing the elite of state authority or higher clergy, could usually boast fairly extensive knowledge in the field of architecture, acquired for the most part by reading architectural treatises and by journeys to the main art centers in Europe. Their tastes would not be satisfied by the professional abilities of the builders trained in the Polish guilds that had not managed to adjust their educational system to the development of modern art. Despite his efforts King John III Sobieski did not succeed in establishing an academy of art in Poland. It remained only to bring architects from abroad or to send young Poles for training to the leading centers of European art. Such expensive and complex measures were taken by very few investors; the majority of magnates sought to casually employ foreign architects.

Among the architects invited from abroad, the Italians predominated. These were above all Luganese and Ticinians (Giovanni Trevano, Matteo Trappola, Giuseppe Simone Belotti, Paolo Antonio Fontana), many of whom boasted training in

ARCHITECTURE
IN POLAND
1572–1764

PIOTR KRASNY

the Roman circle (Matteo Castelli, Constante Tencalla, Carlo Antonio Bay), and also native Romans (Giovanni Battista Gisleni, Pompeo Ferrari, Francesco Placidi). A great many architects working in the Commonwealth in the eighteenth century came from the German states, chiefly from Saxony (Carl Friedrich Pöppelmann, Johann Sigmund Deybel, Johann Friedrich Knöbel, Johann Heinrich Klemm) and from the Bohemian-Austrian circle (Karl Martin Franz, Bernard Meretyn, Johann Christoph Glaubitz, Joseph Horsch). In that century also a small number of French masters reached Poland (Pierre Ricaud de Tirregaille). Tylman van Gameren, a prominent architect active in the Polish territories in the second half of the seventeenth century, was a Dutchman trained both at home and in Italy. Talented young Poles were sent for architectural studies above all to the Accademia di San Luca in Rome, which enabled Kacper Bażanka, among others, to develop his great talent. Numerous Poles studying at western European knights' academies became acquainted with the principles of building fortifications and studied the general rudiments of architecture.

Architects trained in guilds could but sporadically secure prestigious commissions. Those artists sometimes worked for powerful customers who did not attach great importance to the artistic quality of a building. They were mainly engaged by a less affluent clientele: minor gentry, burghers, and religious minorities. Their relatively low fees were made up for by the great number of their commissions. For example, in the first half of the seventeenth century architects from the Lublin guild erected in the town's environs scores of churches and more than a dozen synagogues of highly standardized forms.

A dynamic development of building activities in the Commonwealth in the baroque period required the legal and institutional establishment of architects' working conditions. State authorities, however, had laid down no up-to-date building regulations, while those of the medieval Magdeburg Law were quite unsuitable for the new conditions. Therefore, a considerable role in the shaping of the Polish building market was played by a system of precedents that permitted the evasion of the obsolete rules.

The Magdeburg Law prescribed that all architects should belong to builders' guilds. In the modern era guild architects were relegated to the background of Polish artistic life; nevertheless, in the seventeenth and eighteenth centuries guilds were active in all large towns of the Commonwealth and also in dozens of smaller centers. One of a guild's obligations was to ensure a uniform distribution of commissions among its members. The most gifted and resourceful architects considered the guild system a serious restriction on their creative opportunities, so they endeavored to evade the necessity of guild membership. Municipal authorities enforced this obligation effectively only in the seventeenth century and exclusively in certain centers, such as Gdańsk, Toruń, Lublin, and Lvov.

It was extremely advantageous for an architect to obtain the so-called servitorate, a permanent employment at the court of the king, a magnate, or a bishop. Such a job ensured an artist regular wages and also a kind of advertisement when he was seeking additional commissions on his own. The title of royal servitor was of particular importance to an architect, as it protected its bearer from any claims on the part of guild authorities throughout the country. Hence numerous architects who were not actually connected with the Court solicited to obtain a formal royal servitorate. In the seventeenth century such a privilege could be granted for one's services to the Com-

monwealth, for instance for participation in a campaign as an engineer-constructor of fortifications. In the following century royal servitorates were granted in recognition of architects' professional skills. Having obtained such a title, an architect was permitted to establish a building firm that accepted independent commissions. This kind of activity was as a rule undertaken by the most ambitious and talented masters (P. Ferrari, K. A. Bay, Bernard Meretyn, J. C. Glaubitz) who consequently, around the middle of the eighteenth century, gained control of the building market in numerous centers, securing the most prestigious commissions.

Poland was the arena of activity of relatively numerous architects who were members of monastic orders and congregations, working primarily for their own communities but from time to time accepting commissions from other clients as well. In the first half of the seventeenth century this group included mainly architects from Italy (Giovanni Maria Bernardoni, Giuseppe Bricio, Giacomo Briano) and from the Habsburg lands. However, Polish congregations soon began to send their own talented novices to study architecture in Rome, Prague, and other art centers, enabling them to have quite a large group of highly trained Polish architects (Bartłomiej Wąsowski, Paweł Giżycki, Tomasz Żebrowski) at their disposal. In addition, notable designs in civil architecture were made by some military engineers serving in the Polish army (Jan de Witte).

The architects representing these categories worked for different groups of clientele, which considerably limited the mutual influence of their creative work. Those trained outside the Commonwealth used the forms obtaining in their respective centers of education without modifying them substantially. Local guild masters were for the most part unable to understand let alone assimilate in full the imported solutions. It is no wonder that Polish architecture of the baroque period exhibited a wide spectrum of concurrently used forms. Hence its history cannot be presented as a simple sequence of successive stylistic trends. One should rather point out and describe the most important phenomena occurring in town planning and in urban building as well as in sacred and residential architecture.

The network of large towns in the Commonwealth developed in full during the Middle Ages. Despite economic prosperity, around 1600 no center had been created that would deserve to be called a metropolis. It was mainly the large cities of Royal Prussia (eastern Pomerania), Toruń and Gdańsk, that benefited from the favorable circumstances; there are hence numerous houses in those two centers whose effective forms recalled Netherlandish mannerist architecture. In addition, the propitious economic situation influenced the transformation of numerous small towns including Łowicz, Kazimierz Dolny, Jarosław, Wschowa, Nowy Sącz, and Krosno, in which wooden houses were supplanted by several-story brick structures.

A slump in the Polish economy, deepening after the middle of the seventeenth century, affected mainly the middle class. Impoverished burghers were unable to maintain their real property. Magnates and gentry as well as the Roman Catholic Church were interested in purchasing those grounds, the Church counting on fruitful pastoral work in churches situated amid multitudes of the faithful. The Gdańsk and Toruń authorities, using their special municipal rights, effectively hindered the process of acquiring urban lots by such purchasers. They realized that this would lead to a decrease in economic activity and tax revenue in their cities. However, the remaining

large cities of the Commonwealth failed to control the purchase of their grounds by magnates, gentry, and the Church. Old medieval structures were supplanted in them by ecclesiastical and residential architecture. Toward the end of the eighteenth century there were sixty-four churches in Cracow, and one third of the town's area belonged to various institutions of the Roman Catholic Church. During the baroque period the Old Town in Lublin was surrounded by a ring of numerous churches and monasteries spreading almost uninterruptedly along the city walls. Some houses in the market squares of Lvov and Cracow were compelled to give way to the palaces of magnates and higher clergy. Those transformations were not accompanied by any attempts to regulate urban layouts. Significantly, during the rebuilding of Vilnius (Wilno) after a disastrous 1737 fire the chaotic and nonfunctional medieval plan of the city was retained.

The plan of Warsaw in the modern era evolved in a very special way. It was decided in 1569 that all parliamentary meetings would be held in this city. Thenceforth Warsaw was the chief center of political life in Poland and with time also the residence of the royal court. This contributed to the rapid expansion of the city, in which magnate palaces were put up along with churches and monasteries of the orders and congregations that strove to settle in the new capital. The area of the medieval Old Town, enclosed by a tight ring of walls, was filled up with burgher houses and religious buildings. New edifices were erected along the Krakowskie Przedmieście, the thoroughfare leading to Cracow, and along Wierzbowa and Miodowa Streets, the roads leading out of the city and running westward. In addition, around the nucleus of the capital there sprang numerous *jurydyki* (private settlements) that were not subject to the municipal authorities. When building outside the walls of medieval Warsaw, the investor was not restricted by municipal building regulations relating to the size of the lot and structures erected on it. Consequently, in the seventeenth and eighteenth centuries, palaces of the capital were for the most part extensive country residences with large courtyards and gardens. The spatial layout of Warsaw acquired thereby the character of a chaotic accumulation of haphazard elements. The first attempts to regulate it were made by Kings Ladislas IV and John Casimir, who converted the Krakowskie Przedmieście into a specific "forum," a monument to the Vasa dynasty and an urban setting for state ceremonies. The exceptional character of the street was accentuated by dominant spatial elements: splendid edifices and memorials, the most remarkable of the latter being the Sigismund III Column, set up at its northern edge. The regulation of Warsaw on a much wider scale was undertaken by Kings Augustus II and Augustus III, who to this end established the Bauamt (court building office). Nevertheless, the results of these activities proved to be rather modest except for the ambitious 1715 urban layout called the Saxon Axis. The core of it was formed by three streets in the innovatory radial arrangement, centered on the new royal palace. In practice the Saxon Axis was separated from the generally accessible urban area, becoming principally a ground for military reviews and court festivities. It may therefore be said that until the close of the eighteenth century the entire Warsaw conurbation, except for the Old Town area, represented the type of residential city characteristic of Central European capitals. Ceremonial arteries flanked by monumental edifices contrasted with disorderly, loose building in the remaining urban areas similarly as in Dresden, Munich, or Mala Strana in Prague.

1. *Aerial Photograph* and *City Plan of Zamość*, founded in 1580

This large town was built in a dozen or so years, following the pattern of Italian Renaissance "ideal cities," as the center of the largest magnate estate in the Polish-Lithuanian Commonwealth.

The period 1572–1764 saw the establishment of at least 250 new towns, but they were with very few exceptions no more than settlements of local importance, frequently lacking a proper economic base. Most of them were founded as private towns, functioning as small administrative centers for landed property. A marked proportion of those foundations were not decided by economic reasons alone; the rise of a new town was a considerable enterprise in terms of money and organization, thereby bearing eloquent testimony to the founder's power. A new town could make an exceptionally impressive monument dignifying the founder and his family. The monumental function of a town found expression in its name, referring to the founder's surname (Zamość, Żółkiew Sieniawa, Potok Złoty), to his armorial bearing (Pilawa), or to important events in the history of his family. The names of monument towns were especially frequently derived from first names, with the adoption of possessive forms characteristic of the Polish language (Tomaszów, Stanisławów) or the invention of structures borrowed from Greek (Annopol, Teofilpol).

When designing monument towns, ceremonial considerations were given priority over a functional urban layout. Thus the Renaissance conception of an ideal city, enclosed within a regular figure with a regular, rectilinear gridiron of streets, enjoyed great popularity in Poland. In the seventeenth century as a rule endeavors were made to fill this attractive layout with sumptuous edifices (Zamość [fig. 1], Żółkiew, Stanisławów). The following century still witnessed the foundation of splendid ideal towns (Sieniawa), but there also occurred some situations demonstrating the absurdity of this concept. For instance, single-story wooden cottages and barns were built into the regular network of streets in Frampol, and the accurately measured lots were never built upon at Krzeszów on the River San.

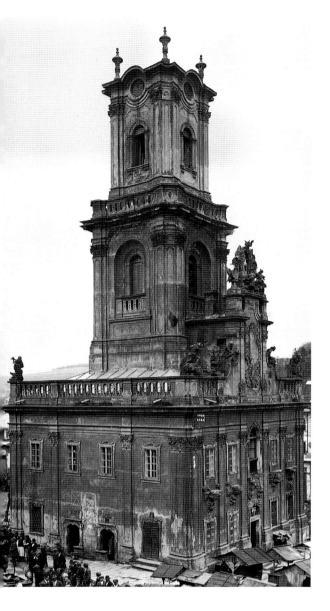

2. Bernard Meretyn, *Town Hall, Buczacz*, c. 1750

This stately rococo building repeats the forms used in Polish town halls from the sixteenth century, the compact block of the edifice being surmounted by a lofty tower. The rich sculpted decoration by Johann Georg Pinsel expresses ideas quite alien to burgher art, glorifying the Potocki family, the owners of the town of Buczacz.

The spatial composition of monument towns was sometimes also based on the system of dominant points. In the skyline of a settlement it was sought to bring to prominence the owner's residence and its symbolic pendant, the church constituting the tomb, "the house of eternal residence" for the family owning the town. To this end, tall towers were sometimes added to a residence and a church as at Rzeszów. In most towns these two structures were distinguished against modest burgher architecture by their impressive brick construction. The road linking the dwelling with the church was usually one of main streets in the town, occasionally taking the form of a regular, clear-cut urban axis.

The end of the seventeenth and beginning of the eighteenth centuries saw the creation of small private country towns in the western border regions of the Commonwealth (Rakoniewice, Nowa Częstochowa) in which large groups of craftsmen of one specialty were settled. These small towns were built on a very regular checkerboard plan filled with typified artisan houses whose gable walls, with arcades in front of them, faced the street.

In consequence of the economic decline of the Polish towns, which began in the second half of the seventeenth century, only very few splendid public edifices were erected in them. Among more prominent examples of Polish architecture from the seventeenth and eighteenth centuries one can indicate no more than a few town halls. In 1701 Tylman van Gameren merely, though considerably, remodeled the town hall in Warsaw, enclosing it with a regular rectangle of brick market stalls. Around the middle of the century similar stall complexes were built in the markets of smaller towns in the eastern regions of the Polish republic including Brzeżany, Husiatyn, and Włodawa.

A stately town hall did not fit in with the concept of a private monument town, which was expected to attest to its owner's power and not to the idea of municipal government. Splendid towered town halls were erected in only a few private towns at the centers of large estates (Zamość, Leszno, Stanisławów) to accomodate the admistrative staff of those latifundia, functioning like the government of independent principalities. Such a specific function was performed by the town hall at Buczacz (fig. 2), which in addition to its grand architectural form was remarkable for its elaborate sculptural decoration. This decoration extolled in an allegorical manner the Potocki family, the owners of Buczacz, by which the edifice largely lost its municipal character, becoming instead a pompous monument to a magnate family.

Toward the close of the sixteenth century the inhabitants of the multinational Commonwealth professed various religious beliefs. The Poles and Lithuanians were Roman Catholic or adhered to the Protestant Reformation in its several variants (Lutheranism, Calvinism, Unitarianism), the Ruthenians were Orthodox, while the Armenians had their national Church following the Monophysite doctrine. The Jews professed Judaism, the Tatars Islam, and a very small Karaite community their own national religion based on the Old Testament but in a different interpretation from that given by the Jewish tradition. This pluralistic image underwent considerable modification in the subsequent century. The Counter-Reformation measures taken by the Roman Catholic Church reduced the domain of Protestantism to a few centers in the country. Beginning with 1596, Orthodox believers gradually accepted the union with the Holy See, establishing on the Polish territories the Greek Catholic (Uniate) Church.

In 1630 the Polish Armenians also submitted to the pope but retained their own liturgy.

Therefore the ecclesiastical architecture in Polish lands was characterized by a wide variety of church types adjusted to the liturgy and traditions of particular religions. The dominating position of the Roman Catholic Church was manifested in thousands of churches built all over the country. Synagogues also were erected in the towns of almost the whole of the Commonwealth. In the eastern part of the state Uniate and Orthodox churches predominated; besides, a dozen-odd Armenian churches were built there. A small number of Lutheran churches appeared in Great Poland and Royal Prussia (eastern Pomerania), while Calvinist ones were put up in the north of Lithuania. In Lithuania, too, modest mosques were erected for the Tatars and *kenessahs* for the Karaites.

Around 1600, Roman Catholic sacred architecture in the Polish republic was still dominated by solutions clearly dependent on the medieval tradition. In Podolia there even appeared churches that were Gothic in form but whose decorative detail combined medieval and modern motifs exemplified by the parish churches at Dunajów, Brzeżany, and Podajce. Throughout the Commonwealth, churches were put up that in their spatial disposition referred to medieval canons but in their stylistic attire were consistently modern. The bodies of the most splendid churches were given the form of a basilica as in Bernardo Morando's collegiate church in Zamość, 1578–1600, or a hall. A spatial arrangement of this kind persisted for a particularly long time in churches of the religious orders of medieval origin, such as the Dominicans and Franciscans. More modest parish churches as a rule had no aisles. Their vaults were decorated with a characteristic stucco network pattern (evolved in the circle of Lublin guild architects), and their gables with massed volutes and obelisk-shaped finials.

Side by side with churches of traditional form there appeared in Roman Catholic sacred architecture some solutions inspired by Italian mannerist and early baroque structures. One such example is the collegiate church at Klimontów perhaps by Lorenzo Senes (1643–50), built on an effective oval plan closely resembling that in one of Ottaviano Mascherino's draft designs.

New spatial arrangements and facade compositions in churches, as a rule referring to Roman architecture of about 1600, were introduced above all by the religious congregations established during the Counter-Reformation. An exceptional role here fell to the Jesuits. The spatial disposition and facades of some of their churches, such as G. M. Bernardoni's Corpus Christi Church at Nieśwież, 1586–99, or the church of Saints Peter and Paul in Cracow, 1596–1633 (fig. 3), and Jan Frankiewicz's church of Saint Casimir in Vilnius, 1604–16, were patterned upon the Jesuit mother church, the Gesù, in Rome. Its modified plan was also used in the architecture of the Discalced Carmelites, frequently in a most individual and sophisticated manner, as is evidenced, for instance, by the church of Saint Theresa in Vilnius by C. Tencalla, 1635–50, or by that of Christ the Savior at Wiśnicz Nowy by Matteo Trappola, 1631–35. The oldest churches of the Jesuits and Discalced Carmelites were founded by the king and prominent magnates who employed for their construction outstanding architects fresh from Italy. Thanks to them the facades of the church of Saints Peter and Paul in Cracow, 1619–30, and of the Carmelite church of Our Lady of Loreto in Lvov by G. B. Gisleni, after 1650, received impressive solutions modeled on Carlo Maderna's works: plastic,

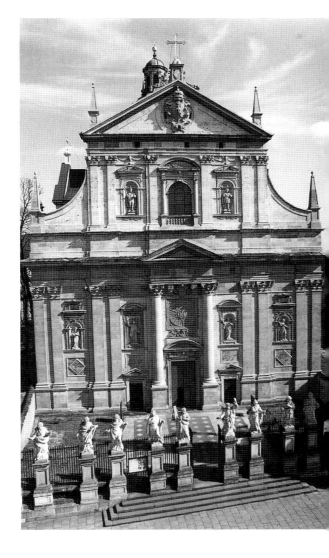

3. *Church of Saints Peter and Paul, Cracow*, 1596–1633

The fence of the parvis in front of the church, built in the years 1715-22 by the architect Kacper Bażanka and embellished with figures sculpted by David Heel, is an excellent example of the use of scenic corrections in high baroque architecture.

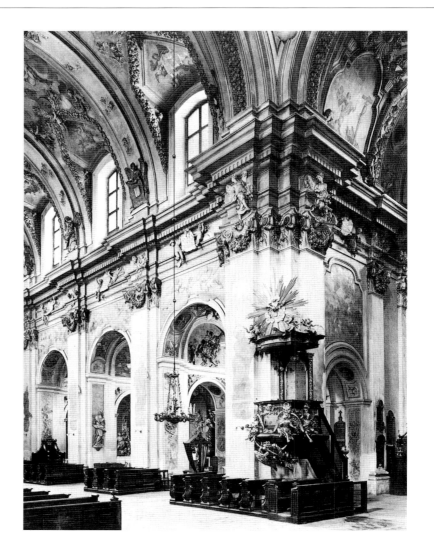

4. Tylman van Gameren, architect, Baldassare Fontana, interior, *Saint Anne's Church,* Cracow, 1689–1703

Altars of complex architectural structure, hundreds of stucco sculptures, and exuberant ornamental decoration are in perfect harmony with the elaborate architecture of the church in the Berninesque spirit.

chiaroscuro articulation, fleshy stone detail, and massive sculptural volutes. In the decoration of the interiors of those churches a particular role was played by stucco, Giovanni Battista Falconi's work in the Jesuit church in Cracow and in that of the Discalced Carmelites at Wiśnicz Nowy being distinguished by a wealth of fanciful ornamental motifs. It is worth noting that in the 1630s and 1640s this artist decorated another dozen-odd churches in Little Poland and Red Ruthenia, thereby frequently modifying the simple interiors of small churches and chapels in a radical manner. In monastic and parish churches more traditional forms characteristic of the architecture in the Habsburg countries were adopted; their bodies were given the functional form of a basilica with a gallery as at G. Briano's Jesuit church in Lvov, 1610–36, the Dominican church at Żółkiew, 1653–55, and the Jesuit church at Święta Lipka, 1688–93.

In the last quarter of the seventeenth century a central plan by Tylman van Gameren was becoming popular in Roman Catholic sacred architecture. Tylman applied the Greek-cross plan to build effective churches surmounted by monumental domes, seen in the church of the Sisters of the Blessed Sacrament in Warsaw, 1689–95, and the Bernardine church at Czerniaków, 1690–92. Flat but distinct articulation following the classical orders imparted a strong classicizing character to these structures. When designing the church of Saint Anne in Cracow, 1689–1703 (fig. 4), Tylman modernized the traditional longitudinal church scheme as well. He varied here the mode of shaping and lighting particular bays, at the same time modulating the system of interior articulation by means of ingenious adjustments. His outstanding implementations inaugurated a classicizing current in Roman Catholic Church architecture in

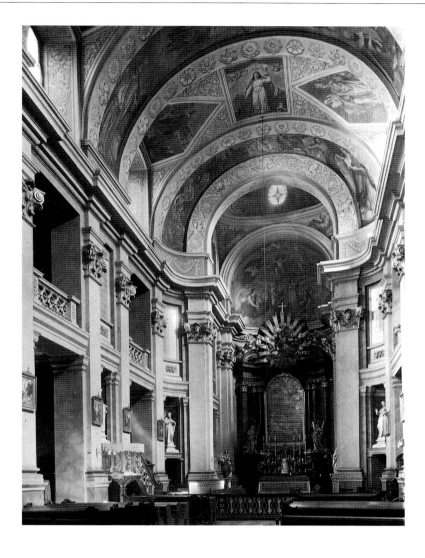

Poland. Tylman's followers in the eighteenth century continued his characteristic
forms, supplementing them with new solutions such as the facade scheme following
the colossal order derived from Andrea Palladio's work, which was very popular in
Poland until as late as the close of the century.

The influence of the Roman and northern Italian high baroque in Polish church
architecture appeared in several stages. Toward the end of the seventeenth century
church interiors began to exhibit combined architectural, sculptured, and painted
motifs similar to Gianlorenzo Bernini's works. The practice of composite interior
decoration was introduced into Poland by prominent Italian architect/decorators such
as Baldassare Fontana in the arrangement of the interior of the church of Saint Anne in
Cracow, 1693–1703, and Pietro Perti in the interior of the church of Saints Peter and
Paul in Vilnius, completed in 1686. In order to impart dynamic qualities to the space
of church interiors, the artist introduced to them free-standing columns, for example B.
Wąsowski's Jesuit church in Poznań, 1677–1701, forming coulisse-like, scenographic
compositions that recalled structures by Baldassare Longhena, Andrea Pozzo, and the
Bibienas. An exceptionally high artistic quality was achieved in the composite arrange-
ments of church interiors created by Kacper Bażanka on the basis of models drawn
from Bernini, Borromini, and Pozzo, such as the church of the Premonstratensian Nuns
at Imbramowice, after 1711–20, and the Lazarist church in Cracow, 1719–28 (fig. 5). An
important role in bringing out the qualities of these arrangements was played by light
directed through an intricate system of openings and mirrors.

6. Pompeo Ferrari, *Interior* and *Plan*, *Cistercian Church*, Ląd, 1728–35

The nave, with a complex ground plan covered by an unusual, lofty dome, is distinguished by its carefully considered spatial composition, including effective "open structures" characteristic of late baroque architecture developed under the influence of the work of Francesco Borromini and Guarino Guarini.

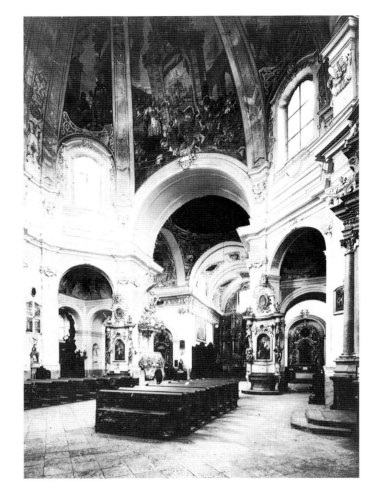

7. Jan de Witte, *Interior* and *Plan*, *Dominican Church*, Lvov, 1745–59

The interior of the spacious oval nave has acquired a highly plastic character thanks to pairs of columns carrying the entablature strongly forward and backward. Above the columns stand effective wooden figures optically "supporting" the smaller columns inside the drum, in this original manner realizing the baroque concept of the unity of visual arts.

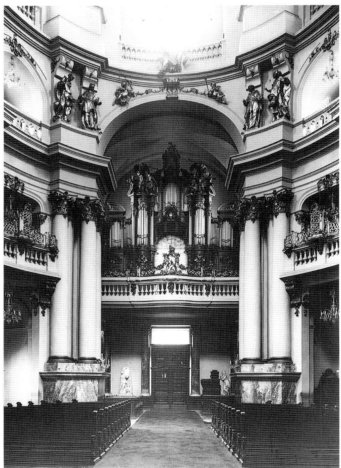

From the early eighteenth century some Polish churches were built on a curvilinear plan based on a sequence of ovals modeled upon the structures of Borromini and Guarino Guarini. This solution, especially popular in Great Poland and in the eastern regions of the Commonwealth, was transferred directly from the source by the Italian architects active in Poland, including P. Ferrari in the body of the Cistercian church at Ląd, 1728–35 (fig. 6), Paolo Antonio Fontana in the church of the Benedictine nuns at Drohiczyn, 1734–38, and Francesco Placidi. It also reached Poland via Bohemia, appearing in the work of the architects who came from the Habsburg countries such as K. M. Franz in the parish church at Rydzyna, 1746–50, J. Horsch in the parish church at Puchaczów, 1778–86, and B. Meretyn.

The impact of the Italian high baroque was also discernible in the forms of church facades. The Borrominesque idea of a concave-convex-concave facade was implemented in the 1720s in the structures of P. Ferrari, P. A. Fontana, and C. A. Bay. The last-mentioned architect, active in Mazovia and Podlasie, enhanced the sculptural character of undulating facades by a profusion of columns set against the wall in the Piarist church at Łowicz, 1720–47. Numerous such facades were erected until as late as the 1750s, their forms exhibiting with time attempts to make them lighter and more decorative; see for example P. Giżycki's Jesuit church at Krzemieniec, 1731–46, and F. Placidi's Trinitarian church in Cracow, 1752–58.

The solutions characteristic of the Roman high baroque appeared also in monumental, spatial colonnaded altars constructed by prominent architects working in the Commonwealth. An extraordinary configuration was adopted in Vilnius churches in which several or a dozen-odd sumptuous altars were linked together into a singular decorative network covering the entire interior of the church as in J. C. Glaubitz' arrangement of the interior of the church of Saint John, 1744–45, and Franz Hoffer's design of the interior of the church of the Holy Spirit, 1753–60.

The turn of the 1730s and 1740s saw the appearance in Polish sacred architecture, along with Italian inspirations, of strong Austrian and Bohemian influences. The plan of the church of Saint Charles Borromeo in Vienna, based on an oval surrounded by a ring of chapels, was repeated in the churches put up by P. A. Fontana in Lublin environs including the Paulite church at Włodawa, 1741–80, and the Piarist church at Chełm, 1753–63. The most striking adaptation of this scheme was the Dominican church in Lvov designed by J. De Witte and built in 1745–59 (fig. 7). De Witte introduced here such unusual solutions as a facade in the form of a magnified Dientzenhofer motif (an aedicule with columns and a broken segmental pediment) and wooden figures set into the articulation system of the nave interior.

In the years around the middle of the eighteenth century, characteristic high baroque solutions, especially the complex spatial disposition of the interior and the sculptural treatment of a church block, began to disappear from Roman Catholic churches. Churches were given the simple form of halls as in the Jesuit church at Chojnice, 1733–34, by Johann Zelner or of basilicas as in B. Meretyn's Transfiguration Church at Tarnogród, 1751–71, with their interiors strongly integrated by means of slender, delicate pillars and uniform intense lighting. Under the influence of French regency architecture and the Austro-Bohemian "decorative style," the articulation of the outer walls of churches was reduced to linear, sparsely spaced pilasters or pilaster strips. Their extensive surfaces formed a background for a display of lavish, mostly rococo

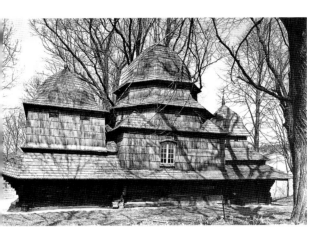

8. *Greek-Catholic Church*, Równia, 1700–1750

This small church is representative of the forms used for hundreds of wooden Uniate churches erected in the eastern provinces of Poland. The builders made use of the traditional division of an Orthodox church into three parts, giving each of them a fanciful domed covering, which was responsible for the effective "jagged" silhouette of the modest structure.

decoration. Outstanding examples of such solutions are provided by the architecture of Red Ruthenia, especially by B. Meretyn's churches of slender form decorated with characteristic openwork vases, as in the parish church at Hodowica, 1751–58. A predilection for openwork and vertical forms also found expression in the structure of the Vilnius churches erected or remodeled by J. C. Glaubitz, for example the church of the Benedictine nuns, 1742–46, or the Lazarist missionary church, 1750–57. This architect enriched church blocks by tall towers pierced with large openings and by many-storied gables of complex undulating outline.

In the seventeenth and eighteenth centuries a great many Roman Catholic churches in the Polish territories were built of timber. It was sometimes attempted to adapt to their forms the complex layouts of spaces used in the contemporary brick structures by giving them a form resembling a basilica such as the parish church at Tomaszów Lubelski, c. 1727, or the parish church at Szalowa, 1739–56, or by building them on the central plan seen in the church of Saint Margaret in Cracow, 1680–90. In the church at Mnichów (1765–70) there is even an attempt to imitate the complex forms of the Cracow church of Saint Anne, including its monumental dome.

The architecture of the Orthodox and Greek Catholic churches in the sixteenth and seventeenth centuries continued the spatial dispositions evolved in the Byzantine-Slavonic ecclesiastical structures of the Middle Ages. The most magnificent Orthodox churches used the Greek cross plan, for example the Orthodox church of Saints Peter and Paul in Kamieniec Podolski, c. 1580, the Orthodox church of Saint Onoufrius at Husiatyn, c. 1600, or the longitudinal plan of a structure consisting of three members, each for the most part surmounted by a dome. Those traditional edifices usually received a modern-style mantle based on clear-cut divisions following the classical order and on effective late mannerist masonry decoration as in Paolo Dominici's Walachian church, 1591–1629, and the Chapel of Three Saints in Lvov, after 1671. The scheme of a tripartite church was adapted to timber Orthodox architecture (fig. 8). In the seventeenth and eighteenth centuries it was repeated in hundreds of Orthodox churches whose domes were at times transmuted into fanciful slender tops of elaborate outline.

Around 1700 the last Orthodox dioceses in the Commonwealth accepted the union with the Holy See. The synod of the Greek Catholic Church convened in 1720 at Zamość decreed that the Uniate liturgy should be modified to resemble the Roman Catholic rite. This was followed by the occidentalization of the forms of Uniate churches, which began to look like Roman Catholic churches. The largest of them were built on a plan recalling that of the Gesù or were given a basilican layout, their facades receiving a pair of tall towers as at the cathedral at Chełm, 1735–56. Inside, similarly as in Roman Catholic churches, monumental altars decorated with sculpture were set up. The Greek Catholic cathedral in Lvov by B. Meretyn, 1743–72 (fig. 9), was distinguished by the rococo elegance of its slender body and by the exceptionally felicitous sculptured decoration of its facade. The Uniate churches designed by J. C. Glaubitz, including the cathedral at Połock, 1738–65, and the Basilian church at Berezwecz, 1750–67, amaze by the lightness of their openwork towers and slender gables, as do this architect's churches in Vilnius. In the eighteenth century baroque forms became evident in Armenian churches as well, which is evidenced by the effective interior of the church at Stanisławów (1742–62), filled with freestanding columns reminiscent of the Roman Santa Maria in Campitelli built by Carlo Rainaldi.

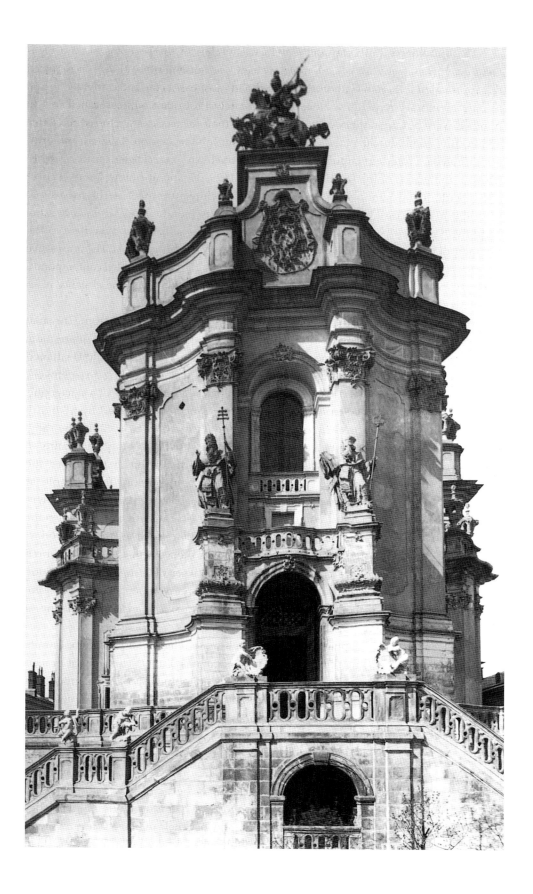

9. Bernard Meretyn, *Cathedral of Saint George*, Lvov, 1743–72

The rococo body of the cathedral, especially its undulating facade, is an excellent example of adaptation to Orthodox Church building of the solutions characteristic of western European baroque architecture. Contrary to the Orthodox tradition, the Greek Catholics in Poland even decorated their churches with sculpture such as these superb statutes by Johann Georg Pinsel in the facade of this cathedral.

10. *Synagogue*, Żółkiew, c. 1650

The compact block of the synagogue, corresponding with the character of its interior adapted to the needs of the traditional Judaic liturgy, is entirely different from Renaissance and early baroque Christian churches built in Poland in the sixteenth and seventeenth centuries. Nonetheless, on the elevations of the structure there appear motifs generally employed in the Polish architecture of that period such as the high parapet crowned with picturesque cresting.

The building of Lutheran and Calvinist churches in the seventeenth and eighteenth centuries met with considerable obstacles, as, among other things, it required the approval of a Roman Catholic bishop who in most cases consented to the erection of only temporary structures. Nevertheless, stately Protestant edifices, albeit few in number, were put up in the seventeenth century; their forms clearly referred to Gothic architecture as in Marcin Woyda's church of Saint John at Leszno, 1652–54. In northern Lithuania, Protestant churches usually took the form of an aisleless structure with a tower on the axis of the facade as at Deltuva, 1629–38, and at Kelme, 1660–70, provided with ogival windows. Protestant sacred architecture owes its high baroque solutions to P. Ferrari, who in 1685 designed the church of the Holy Cross at Leszno. Here the nave, on the plan of two interpenetrating ovals, has been inscribed in the rectangle of the main walls to ensure enough room for spacious galleries. The impressive church of the Holy Spirit in Toruń by Efraim Schroeger, 1753–56, resembled contemporary Roman Catholic churches in its clear-cut hall, spatial disposition, and the elegance of its slender body with a fanciful gable.

Synagogues, adapted to the needs of Judaic rites, totally differed from Christian churches. A synagogue consisted of the men's hall, as a rule built on a square plan, with adjacent annexes, the women's gallery, and a *cheder*. The *bimah* (pulpit) situated in the center of the men's hall in the sixteenth century was marked by an openwork iron grating. From about 1620 a massive pillar was placed in the middle of a synagogue, hollowed out to contain a *bimah* opening with four arches and vaulted by a kind of blind dome as at Łuck, 1626–28, or at Słonim and Tykocin, both 1642. In the same period synagogues began to be surmounted by parapets (fig. 10) and to acquire an early baroque mantle, their elevations receiving the articulation that followed the classical orders and their vaults stucco network ornamentation, for example at Szczebrzeszyn, c. 1620, Zamość, before 1630, and Łęczna, before 1648. The form of synagogues did not in principle alter until the middle of the eighteenth century, when the *bimah* began to be surrounded by four very slender pillars such as at Tarnogród, c. 1760. This permitted spatial integration of the interior, thenceforth resembling church interiors of that time, filled with intense light passing between delicate supports. Besides, in the eastern regions of the Polish Commonwealth, large wooden synagogues were built with sometimes elaborate structural solutions employed, an example being at Grodno, second half of the eighteenth century.

On account of some similarity between the Karaite religion and Judaism, Karaite *kenessahs* assumed forms resembling those of synagogues. Built exclusively of timber, these were modest structures on the square plan with a pulpit placed in the middle of the prayer hall. Tatar sacred architecture was just as modest. Wooden mosques were erected on the central plan, crowned by domes, and provided with adjacent tower-minarets as at Słonim, Łukiszki near Vilnius, and Kruszyniany.

Medieval residences built in the Polish lands had the form of a castle, that is a fortified structure composed of a number of wings enclosing a courtyard. The castles were reinforced by mighty gate towers, angle towers, and battlements surmounting the walls. In the sixteenth century castles of this kind began to lose their military value, owing to the development of artillery. Around 1600 only the huge castles built in the southeastern borderland of the Polish Commonwealth retained their defensive function, since

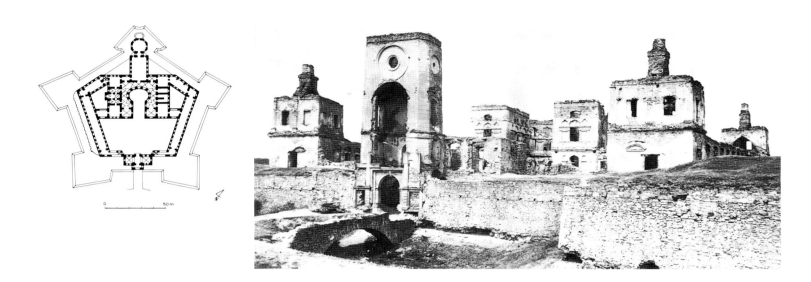

they were intended as a refuge for the local people in case of a plundering raid by the Tatars, who did not use firearms.

In the remaining provinces of Poland, taking up residence in a castle was a symbolic gesture. Great families with pride in their knightly tradition did not want to abandon the castles, their "family nests." Furthermore, the new members of the gentry were eager to buy the castles of the ancient families that had died out, thereby seeking the legitimization of their social position. The forms of medieval castles were thoroughly modernized, their courtyards being surrounded by arcaded galleries and late mannerist stonework details as in M. Trappola's remodeling of the castle at Wiśnicz Nowy, c. 1615–21. It also happened that in the central provinces of the Polish state new castles were erected from foundations as symbols of their owners' knightly traditions and virtues. Structures of this kind ostentatiously exhibited pseudo-defensive solutions such as gate towers, angle towers, rows of loopholes, or portals stylized to resemble fortified gateways. A residence of the *palazzo in fortezza* type, a kind of castle adapted to the new fashion, was very popular in the Commonwealth. The dwelling houses thus laid out were protected by a ring of bastions. The most impressive residence of this type was Krzyżtopór Castle, 1631–44, remarkable for its immensity and the mannerist arrangement of courtyard space (fig. 11).

The first quarter of the seventeenth century saw important changes in the spatial arrangement of residential buildings. Medieval castles were sporadically imitated, but toward the end of the sixteenth century there appeared palaces of villa type, an example being Santi Gucci's palace at Książ Wielki, 1585–95. Around 1630, Polish residential architecture displayed remarkably grander spatial solutions, popularized chiefly by C. Tencalla and other Italian architects connected with the royal court. Between 1635 and 1645 they raised numerous palaces for the kings and prominent magnates of the Commonwealth. In those palaces the double-pile arrangement was employed, following the patterns drawn from the treatises of Palladio and Serlio. The elevations of these buildings were enriched by elegant stonework decoration and sparingly applied articulation following the classical orders. Locating towers at the corners of palaces was to make them look like castles and thereby acquire the symbolic character of seats of defenders of the mother country.

11. *Ground Plan* and *Ruins of Krzyżtopór Castle*, Ujazd, 1631–44

This gigantic castle with an intricate mannerist spatial arrangement was encircled by bastion fortifications, the entrance being guarded by a mighty gate tower. These defenses symbolized in a specific way the chivalrous virtues of the owners of the castle, the Ossoliński family. However, in the middle of the seventeenth century they were unable to withstand the challenge of contemporary military technology, as the castle was reduced to ruins during a brief siege by the Swedish army.

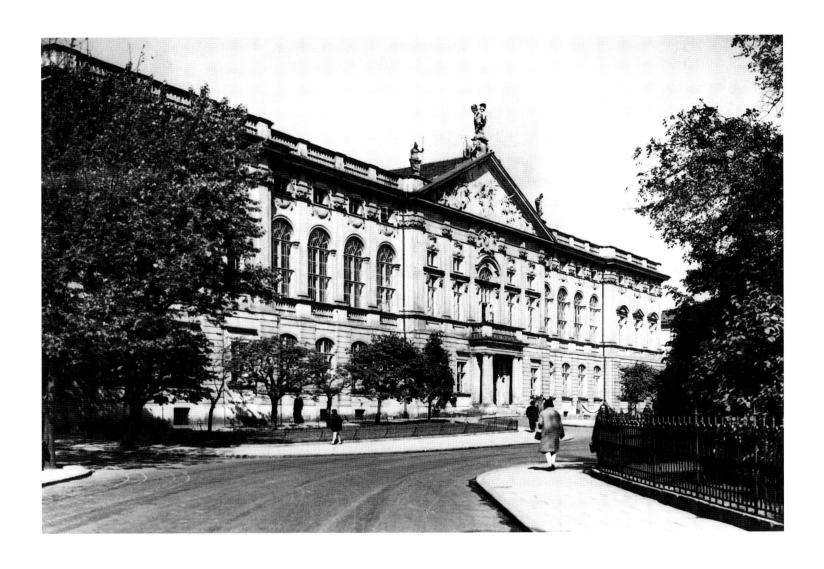

12. Tylman van Gameren, *Krasiński Palace*, Warsaw, 1689–95

This structure is typical of this designer's palaces, which gave rise to a new tendency in Polish residential architecture. Tylman, under the influence of Palladian concepts and seventeenth-century classicizing Dutch architecture, worked out the characteristic form of palaces, whose compact structure was enriched with a flat pilaster portico on the axis of the building.

Palace architecture of the second half of the seventeenth century was almost completely dominated by the classicizing works of Tylman van Gameren. This architect adapted his designs to local custom, adding towers to the corners of palaces. He introduced novel solutions borrowed from his native Dutch architecture such as the flat pilastered portico on the axis of a palace facade in the Krasiński Palace in Warsaw, 1689–95 (fig. 12). He also drew on French patterns, introducing the motif of an oval drawing room partly projecting from the outer wall of a palace as at the palace at Puławy, 1671–79. He was the first architect in the Polish kingdom to consistently locate palaces *entre cour et jardin*, accentuating the difference between the stately front and the more freely treated garden elevation. Moreover, he referred to the Polish architectural tradition by emphasizing the corners of buildings with towers.

King John III Sobieski, fascinated with the personality of Louis XIV, commissioned Augustyn Locci to refashion his favorite residence at Wilanów in 1679–92 on the model of the French monarch's celebrated residence at Versailles. The eighteenth century saw the appearance in Polish lands of numerous grand magnate residences that also imitated the palace of Versailles: J. S. Deybel and J. H. Klemm's Białystok, 1728–71, Jakub

Fontana's Radzyń Podlaski, 1752–66, and P. Ricaud de Tirregaille's Krystynopol, 1756–61. Likewise, the architecture of more modest palaces was dominated by solutions of French provenance, introduced above all in the second quarter of that century by Saxon architects from the Bauamt in Warsaw. They readily employed the motif of an oval drawing room projecting from the outer wall of a building. They frequently segmented the block of a palace into several parts, each covered with its own mansard roof, in imitation of French regency residential architecture. The designers of these palaces practically relinquished elaborate elevations lest the viewer's attention be distracted from the effective overall impression created by the building, a good example being J. S. Deybel's Przebendowski Palace in Warsaw, before 1729. Sometimes an entirely different procedure was adopted, whereby palaces formed simple cubic blocks enlivened by rich ornamental and figural decoration in imitation of residences in the Habsburg countries and in southern Germany. Examples include Karl Heinrich Wiedemann's summer palace in Rzeszów, 1737–46, and the Branicki Palace in Warsaw, remodeled around 1740.

When planning residential complexes, models were also sought in sixteenth-century treatises. Among others, Palladio's ideas were used, quadrantal galleries being added to the sides of palaces such as Łabunie, after 1744. F. Placidi built a palace at Grabki (c. 1742) on a bizarre plan of a windmill borrowed from Serlio's treatise.

The simplest but most widespread kind of residence in Poland was the manor house, a relatively small, single-story building erected mainly by the less affluent gentry. In their form manor houses imitated, as far as modest means allowed, the solutions used in the contemporary palace architecture, such as the Palladian double-pile disposition of rooms or a drawing room partly projecting from the outer wall of a building. Manor-house blocks were often enriched by alcoves, a specific reduced version of towers, and by the so-called broken roof, a simplified kind of mansard roof as seen in a manor house at Ożarów, 1756.

LITERATURE

Dmochowski 1956; Karpowicz 1983; Karpowicz 1987; Karpowicz 1990; J. Kowalczyk, "Główne problemy badań nad architekturą późnobarokową w Koronie i na Litwie," *Kwartalnik Architektury i Urbanistyki* 40 (1995),. 175–213; A. Miłobędzki, *Architektura polska XVII wieku* (Warsaw, 1980); Miłobędzki 1994; Mossakowski 1994.

CATALOGUE

NOTE TO THE READER

Dimensions, height before width before depth, are given in centimeters followed by inches in parentheses.

AUTHORS OF CATALOGUE ENTRIES

Artur Badach (AB)
Czesława Betlejewska (CB)
Ryszard Bobrow (RB)
Iwona K. Brzewska (IKB)
Stanisława Bulanda-Lenczowska (SB-L)
Barbara Czajkowska (BC)
Krzysztof J. Czyżewski (KJC)
Władysław Czyżyk (WC)
Jan J. Dreścik (JJD)
Jacek Gajewski (JG)
Irena Grabowska (IG)
Barbara Grątkowska-Ratyńska (BG-R)
Maria Hennel-Bernasikowa (MH-B)
Marcin Kaleciński (MK)
Piotr Kondraciuk (PK)
Józefa Kostek (JK)
Kazimierz Kuczman (KK)
Anna Kuśmidrowicz-Król (AK-K)
Anna Kwaśnik-Gliwińska (AK-G)
Grażyna Lichończak-Nurek (GL-N)
Hanna Małachowicz (HM)
Ewa Martyna (EM)

Grażyna Michalak (GM)
Przemysław Mrozowski (PM)
Dariusz Nowacki (DN)
Monika Ochnio (MO)
Stanisława Odrzywolska (SO)
Ewa Orlińska (EO-M)
Jan K. Ostrowski (JKO)
Anna Petrus (APe)
Jerzy T. Petrus (JTP)
Anna Piskorz (AP)
Magdalena Piwocka (MP)
Danuta Radwan (DR)
Joanna Renner (JR)
Andrzej Szczepaniak (ASz)
Anna Szkurłat (AS)
Dorota Szmyt (DS)
Irena Voisé (IV)
Maria Taszycka (MT)
Barbara Tuchołka-Włodarska (BT-W)
Wanda Załęska (WZ)
Zdzisław Żygulski, Jr. (ZŻ)

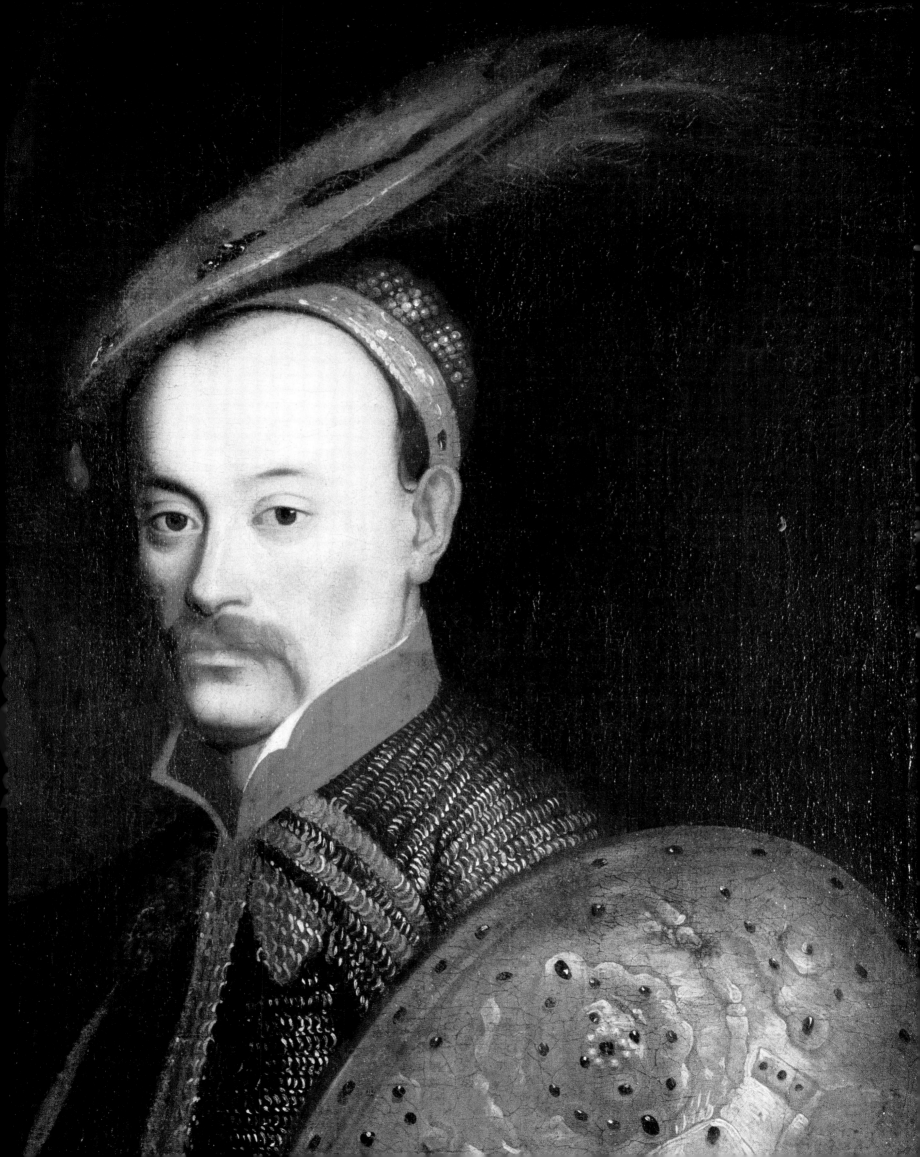

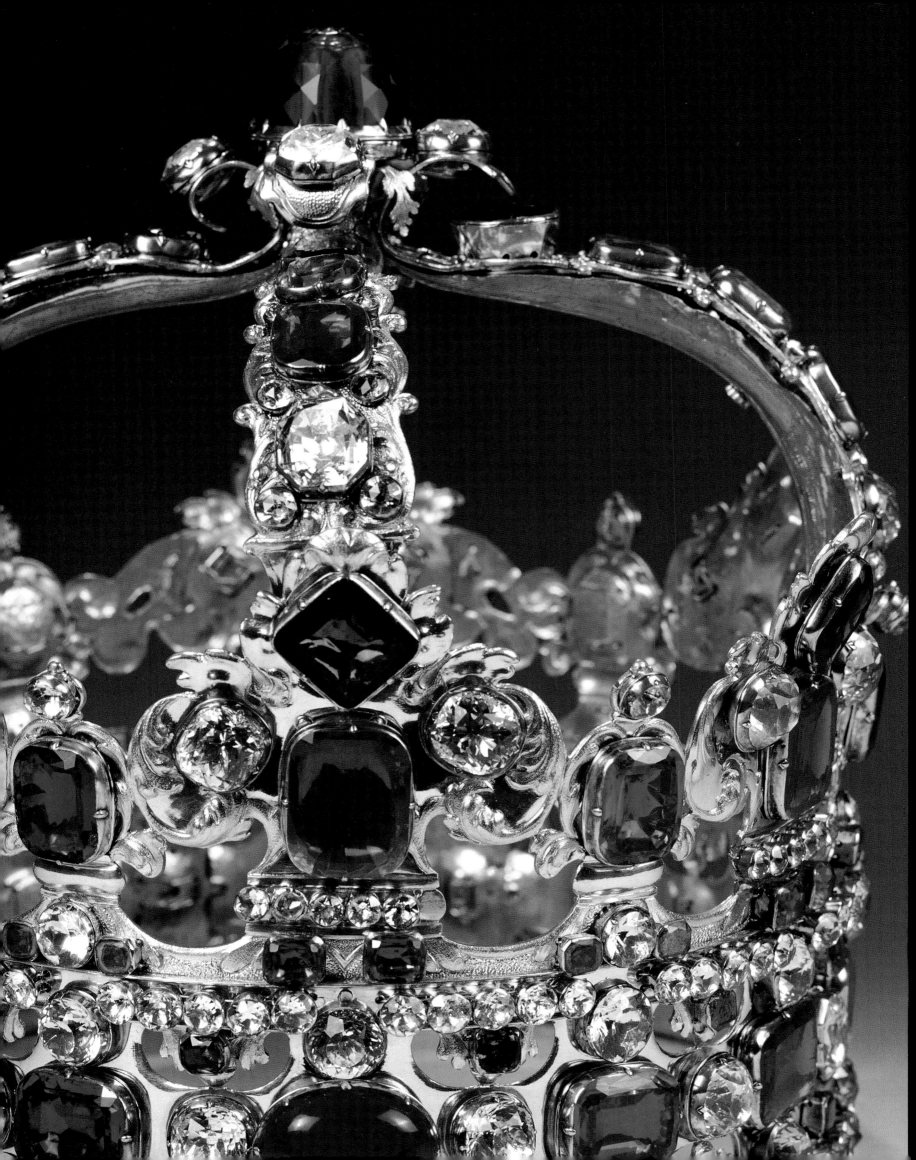

The Monarchy

The extinction of the Piast dynasty in 1370 undermined the principle of succession to the throne in Poland. By 1573 the kings, while retaining outward royal splendor, in fact had become lifelong presidents of the state. Every king-elect was compelled to swear that he would observe articles that drastically limited his powers. The real sovereign was the parliament of the gentry, called the Seym.

In theory, the freedom of electing a king and the very early introduction of the rule of a constitutional monarchy should have contributed to the consolidation and flourishing of the country. However, the reverse happened. The principles followed during elections, usually invented for the benefit of the current political situation, were not in the least conducive to an optimum choice. Worse still, an increasing role in the elections was played by foreign influences, at first in the form of discreet intrigue and bribery and in the eighteenth century based on overt military intervention. Under these circumstances it was extremely difficult to achieve lasting improvement in the situation of the country. The kings, outstanding warriors such as Stephen Batory and John III Sobieski, were capable of winning great victories on the battlefield but unable to make political capital out of them. Even nature seems to have conspired against the strengthening and stabilization of royal power: the chronic shortage of successors to the throne automatically impeded endeavors to introduce the principle of succession.

In addition to disastrous political consequences, the elective character of the Polish monarchy had a negative effect on the sphere of culture and art. A king with no prospects of dynastic continuation set short-term goals rather than those for the distant future. As a result Poland never developed cultural and educational establishments such as an academy of fine arts until the nineteenth century. Having only limited private wealth at his disposal, the monarch could not undertake art patronage on a truly regal scale. What is worse, the dissolution of the royal court after the death of each king was usually accompanied with the scattering of the art collection that he had amassed. It is no wonder that Kings Augustus II and Augustus III, also electors of Saxony, housed their magnificent gallery in Dresden where, albeit not wearing the royal crown, they enjoyed all royal rights, rather than in Warsaw where they were subjected to such restrictions.

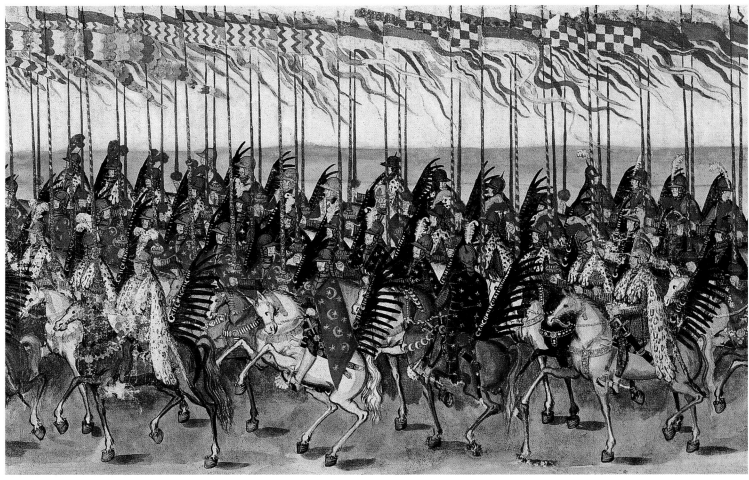

This painting in the form of a frieze represents the ceremonial entry into Cracow of the wedding procession of King Sigismund III and Constance, archduchess of Austria, on 4 December 1605. The composition was probably based on notes made by the master of ceremonies for arraying the procession and also on sketches executed during the ceremony. The scroll has not survived in its original length. The original scroll form posed serious problems to conservators whenever the object was to be exhibited; therefore, during conservation treatment the component sheets of paper in the roll were separated.

The authorship of the roll remains unknown. It used to be ascribed to Balthasar Gebhard, court painter to Archduke Ferdinand, whose participation in the procession is confirmed by source references. However, there are no known works by Gebhard that would permit comparative analysis. Some researchers hold that the authorship should be sought among several local artists, which seems to be evidenced by different handling of particular parts of the painting.

The extraordinary iconographic value of the frieze lies in the accurate and realistic rendering of the character and details of the costumes and military equipment and in an attempt at portraying major personages. Nevertheless, the artist or artists combined the fidelity of depicting realities with a specific stylization aimed at giving the whole as stately a character as possible. The end result reflects not only the magnificence of the ceremony itself but also the splendor surrounding the royal court and family.

Although it is not known for certain how the work reached Sweden, it is believed that it found its way to Stockholm as booty in the years 1655–56. In 1902 it was transferred from the Royal Archives in Stockholm to the Royal Armory. In 1974, on the initiative of the prime minister of Sweden, Olof Palme, it was presented to the Royal Castle in Warsaw.

The composition and the rendering of the figures in perspective, slightly from above, make the whole resemble a filmstrip. The head of the procession is formed by a group of unmounted horses led by batmen. It is followed by two private detachments, hussars and infantry, of Hieronim Gostomski, palatine of Poznań. Then, preceded by the equerry, come the king's horses whose caparisons bear the arms of Sigismund III. The next distinguished formation is the king's hussar regiment led by Sebastian Sobieski, standard bearer of the Crown (cat. 1a).Following the royal hussars (cat. 1b) are military commanders of high rank and behind them Polish and Austrian dignitaries as well as representatives of foreign countries. The Persian and Turkish envoys are distinguished by their oriental attire. They are followed by eight riders, one of whom is undoubtedly Jacob von Breiner, marshal of the Austrian court, representing the emperor. One scene depicts men from the crowd of onlookers who fight for the coins or coin-medallions thrown to the crowd, a custom that accompanied processions of exceptional importance in Poland. Next to this scene can be seen the embassy from Moscow. At the side of the Muscovite envoy, Athanasius Ivanovitch Vlasyev, one can identify Jerzy Mniszech, the father of Maryna who had married Czar Dmitri (False Dmitri) a few days before. They are followed by the papal nuncio Claudio Rangoni in the company of Cardinal Bernard Maciejowski and by the marshals of the Polish Commonwealth. Following them, two files of the royal halberdiers escort the most important participants in the ceremony.

1

ENTRY OF THE WEDDING PROCESSION OF CONSTANCE OF AUSTRIA AND SIGISMUND III INTO CRACOW ("STOCKHOLM ROLL"), AFTER 1605

ANONYMOUS PAINTER, CRACOW

WATERCOLOR, GOUACHE, GOLD PAINT, RIBBED PAPER

FIVE PANELS, PARTS OF A SCROLL ORIGINALLY 28 × 1,528 CM (11 × 601 1/2 IN.)

A, SEBASTIAN SOBIESKI, STANDARD BEARER OF THE CROWN 27.7 × 42.5 (10 7/8 × 16 3/4)

B, THE KING'S HUSSAR REGIMENT 27.8 × 42.7 (10 7/8 × 16 7/8)

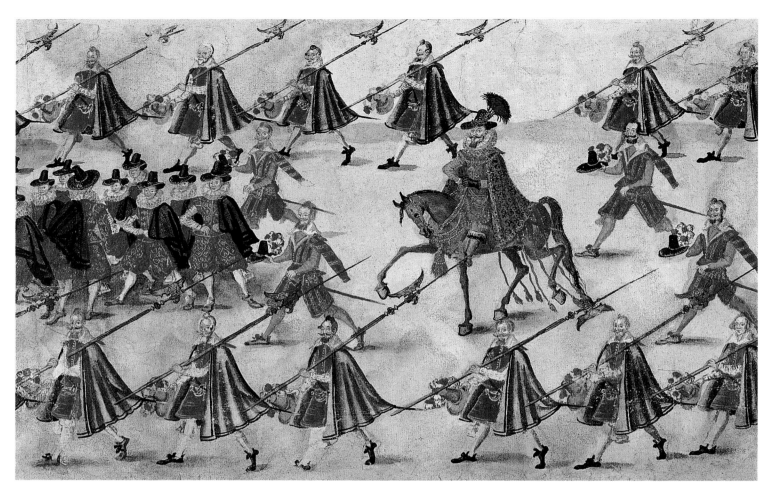

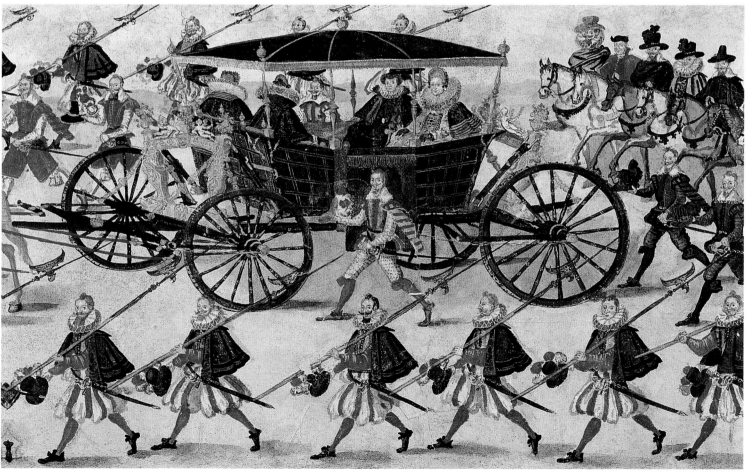

Next, preceded by a group of pages, King Sigismund III rides a chestnut horse (cat. 1c). He wears a red costume embroidered with gold, pearls, and jewels. He is followed by Archduke Maximilian Ernest, the bride's elder brother, and, mounted on a white horse, ten-year-old Prince Royal Ladislas, son of Sigismund III and his first wife, Anne of Austria. Behind them an ornate black coach drawn by eight horses is carrying the bride, Archduchess Constance, her mother, Archduchess Marie, her sister Marie Christine Batory, and the king's sister, the Swedish Princess Anne Vasa (cat. 1d). Seventeen-year-old Constance is distinguished by her pale dress embroidered with jewels and adorned with a large ruff. Finally come carriages with ladies-in-waiting and trunks containing the bride's trousseau (cat. 1e). The lonely rider between the carriages is probably the master of ceremonies. Detachments of the city militia bring up the rear of the procession. The first three units in Polish costume are the burghers of Kazimierz, the fourth represents those of Stradom, and at the end follow detachments of the militia of Cracow in sumptuous dress of western European cut.

AK-K

C, KING SIGISMUND III
27.3 × 41.8 (10 3/4 × 16 1/2)

D, COACH OF THE BRIDE,
ARCHDUCHESS CONSTANCE
27.5 × 42.2 (10 7/8 × 16 5/8)

E, CARRIAGES OF LADIES-IN-WAITING
27.5 × 42.2 (10 7/8 × 16 5/8)

ROYAL CASTLE, WARSAW,
INV. ZKW/1528, GIFT OF THE
ROYAL ARMORY IN STOCKHOLM, 1974

LITERATURE
Steneberg 1943, 13–14; *Sztuka dworu Wazów* 1976, cat. 25; Bocheński 1988, 39–74; Żygulski 1988, 5–38; *Orzeł Biały* 1995, cat. III 24; Petrus 1996; *Narodziny Stolicy* 1996, cat. XI 6.

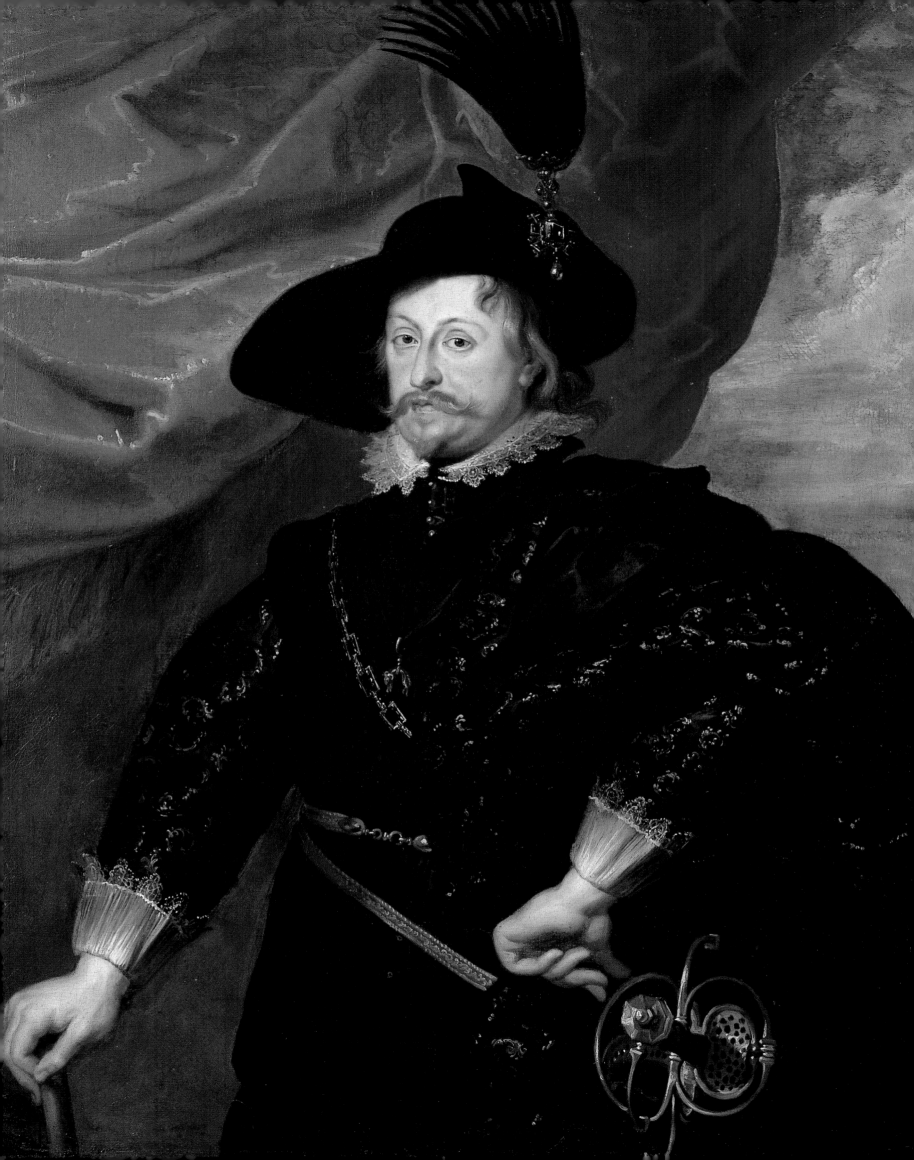

Prince Royal Ladislas Sigismund (1595–1648), son of the king of Poland Sigismund III Vasa and Anne of Austria, gained the throne in 1632 as Ladislas IV. He fought the Swedes, Turks, Muscovites, and Cossacks. He was a patron of artists and an art collector who in 1624–25 went on a tour of western Europe. During his stay in the Netherlands, at the request of the Governess Isabella Clara Eugenia, he sat for Rubens, who portrayed him in the present painting. The best of the extant likenesses of Ladislas IV, it clearly reveals some traits of Rubens' artistry; however, the quality of the execution of details does not permit it to be attributed exclusively to the master, whose contribution was surely limited to capturing a likeness and sketching the composition. The portrait of Ladislas most akin to the painting described here is at the Galleria Durazzo-Pallavicini in Genoa. Graphic copies of the portrait were made by, among others, Paulus Pontius and Jan van der Hayden.

KK

2

LADISLAS SIGISMUND VASA, C. 1624

PETER PAUL RUBENS (1577–1640) AND STUDIO

OIL ON CANVAS

125 × 100.9 CM (49 1/4 × 39 3/4 IN.)

THE METROPOLITAN MUSEUM OF ART, NEW YORK, INV. 29.100.12, GIFT OF H. O. HAVERMEYER, 1929, SINCE 1976 ON LOAN TO THE WAWEL ROYAL CASTLE, CRACOW

LITERATURE
Przezdziecki 1937, 206; Larsen 1952, cat. 64; Puyvelde 1952, 146; Ruszczycówna 1969, 253–56; *Sztuka dworu Wazów* 1976, cat. 135; Chrościcki 1981, 160–66; *Gdzie Wschód spotyka Zachód* 1993, cat. 35.

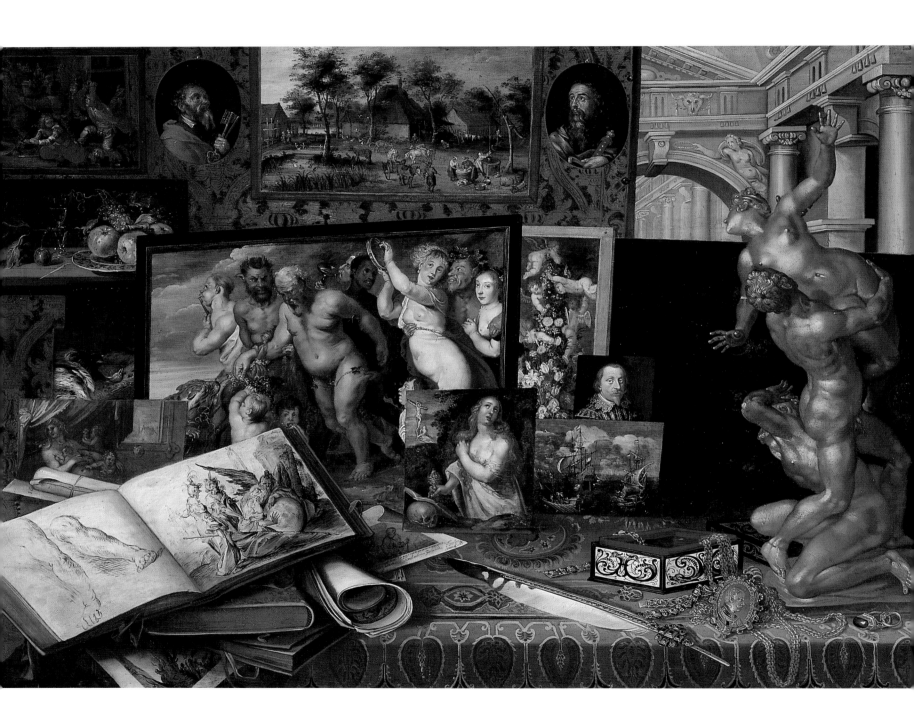

In the years 1624–25 Prince Ladislas Sigismund visited Vienna, the Germanic lands, the Netherlands, France, and Italy. The purpose of his tour was to be presented at the European courts as the Polish heir to the throne who was famous for his victories in the wars with Turkey. In addition, Ladislas Sigismund tried to win support for the plans of his father, King Sigismund III, to recover the Swedish throne for the Vasas. Apart from political goals, the journey was aimed at the prince's artistic education, and it afforded him the opportunity to purchase works of art.

The picture documenting these acquisitions was painted in Warsaw in 1626, soon after Prince Ladislas' return to Poland. Nothing is known about its later fate until 1947 when it was in Victor Spark's collection in New York. Certainty that the painting depicts part of Ladislas Sigismund's collection is evidenced by the medal in the foreground, lying on a table on the right, representing a portrait of the prince and his titles. Ladislas commissioned the medal in 1624 in Vienna, where he stopped at the beginning of his tour. It was wrought by the Viennese goldsmith Alessandro Abondio.

Among the paintings presented here, those by Flemish and Dutch artists predominate. The center is occupied by one of several versions of *Drunken Silenus* by Rubens (until World War II in the Kaiser Friedrich Museum, Berlin); above it hangs a landscape in the style of Jan Brueghel the Elder. Prince Ladislas visited the studios of the two artists during his stay in Antwerp. It is also possible to identify in the upper left-hand corner David Vinckboons' *Scuffle in Front of a Tavern* (today at the Rijksmuseum, Amsterdam) and an engraving by Hendrick Goudt after Adam Elsheimer's *Tobias*. To the right stands Giambologna's sculpture *The Rape of the Sabines*.

In Spark's collection the painting passed for Jan Brueghel the Elder's work finished by his son, Jan the Younger. Juliusz Chrościcki, interpreting the signature, attributed it to Etienne da La Hyre, father of Laurent. This attribution was contested by Pierre Rosenberg, who pointed out that the last-mentioned artist had stayed in Poland toward the end of the sixteenth century, and there is no source evidence for supposing that he went there again more than twenty-five years later. Besides, it is known that around 1625 he gave up painting, instead conducting business in Paris. In Jan Białostocki's oral opinion, reported by Chrościcki, the author of the picture may have come from the artistic Heere family of Ghent.

The painting is unquestionably the work of a Flemish artist, perhaps from Antwerp, who was well acquainted with the oeuvre of Frans Francken II and Jan Brueghel the Elder, the prominent painters of the *cabinet d'art* type in the first quarter of the seventeenth century. The composition, based on principles identical with those followed in the works of Frans II (of the so-called *Preciosenwand* kind, examples in Vienna, Frankfurt, Syon House, Groussay, and Hampton Court), and the physiognomical type, resembling the "Franckenesque" manner, suggest that its author should be sought in the circle of the Francken family or of their imitators. The question of the signature remains to be elucidated.

HM

3

THE ART ROOM OF PRINCE ROYAL LADISLAS SIGISMUND VASA, 1626

ANTWERP PAINTER ACTIVE IN WARSAW

OIL ON BOARD

72.8 × 105.6 CM (28 5/8 × 41 1/2 IN.)

SIGNED AND DATED: *HERE. FECIT/ VARSAVA 1626*

ROYAL CASTLE, WARSAW, INV. ZKW 2123

LITERATURE
Pictures within Pictures 1949, no. 9; Ważbiński 1977, 62; Rosenberg, Thuillier 1988, 61; Chrościcki 1988, 3–7.

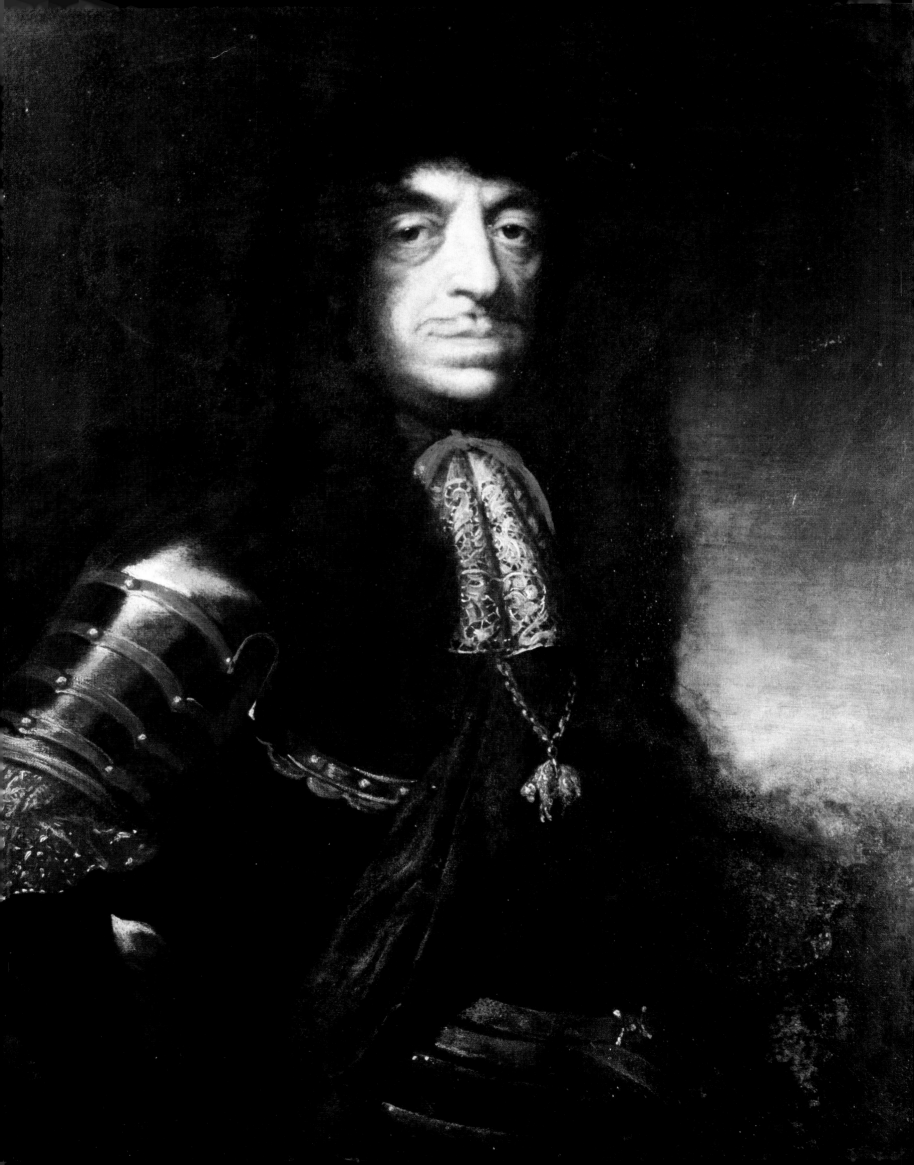

John Casimir Vasa (1609–72) was the son of Sigismund III, king of Poland, and Archduchess Constance Habsburg. In 1648 John Casimir was elected king of Poland.

The portrait was painted before May 1659 in Warsaw (probably between 1657 and 1659). John Casimir gave the painting, together with one of his queen, Louise Marie de Gonzague, not preserved, to the Warsaw Camaldolites during the visit of the royal court on 17(?) May 1659 to the Bielany hermitage near Warsaw. Until the early 1920s the portrait was stored in the sacristy of the former Camaldolite church, in the gallery of the founders and benefactors of the Warsaw hermitage, whence it was transferred to the former so-called Władysławowski hermitage, and from 1986 the portrait was in the house of the Provincial Board of the Marists in Warsaw. In 1992 the work was acquired for the Royal Łazienki and placed in the Palace on the Island. Conservation was undertaken in around 1924 and again in 1993 at the National Museum in Warsaw; at the latter time it was relined with new canvas. During conservation fragments of the painting were exposed and losses filled in the bottom part of the picture. The portrait was shown at the exhibition of Flemish and Dutch paintings in 1924 in the Baryczka House in Warsaw.

The intimate character of the moving vision of the monarch's sad face emerging from the depth of darkness, the face of a man depressed by years of war and by his inner worries, encourages the supposition that this austere psychological study of John Casimir, painted from life, was not designed for official display and popularization. The expressive power of the likeness is enhanced by the model's eye contact, which engages the viewer and by the gloomy mood of the picture emphasized by restrained coloring in dark tones and the background suggesting a disquieting, stormy landscape, calling forth the memories of incessant war throughout John Casimir's reign.

The painting belongs to the group of portraits showing the model as a hero in wartime, in western European armor with a sash (sometimes replaced by a chain) across the breastplate, the Order of the Golden Fleece, and a leonine wig. This group of portraits of John Casimir showing him as a commander, at that time popular all over Europe, is an iconographic pendant to concurrent wartime portraits of the monarch in Polish costume created by Schultz for propaganda-political reasons.

The outstanding artistic qualities of the portrait of John Casimir gave rise to associations with Rembrandt's circle (information by Prof. Juliusz Starzyński, 1973, concerning the presence of the portrait in the exhibition in the Baryczka House in 1924). The present portrait was a model for the likeness of John Casimir in the royal commemorative picture in the chancel of the Camaldolite church in Bielany, Warsaw.

JG

4

KING JOHN CASIMIR,
BEFORE MAY 1659

DANIEL SCHULTZ THE YOUNGER
(C. 1615–83)

OIL ON CANVAS

90 × 71.4 CM (35 1/2 × 28 IN.)

ROYAL ŁAZIENKI MUSEUM, WARSAW,
INV.Ł.KR. 776, PURCHASED 1992

LITERATURE
Gajewski 1977, 47–61; Raport 1993, 17 (J. Gajewski); *Gdzie Wschód spotyka Zachód* 1993 (J. Gajewski, "Portret w drugiej połowie XVII wieku"), 26, 27, cat. 107, 344; *Narodziny Stolicy* 1996, cat. 13, 374 (J. Gajewski); *Aurea Porta* 1997, cat. VIII 28, 309–11 (J. Gajewski).

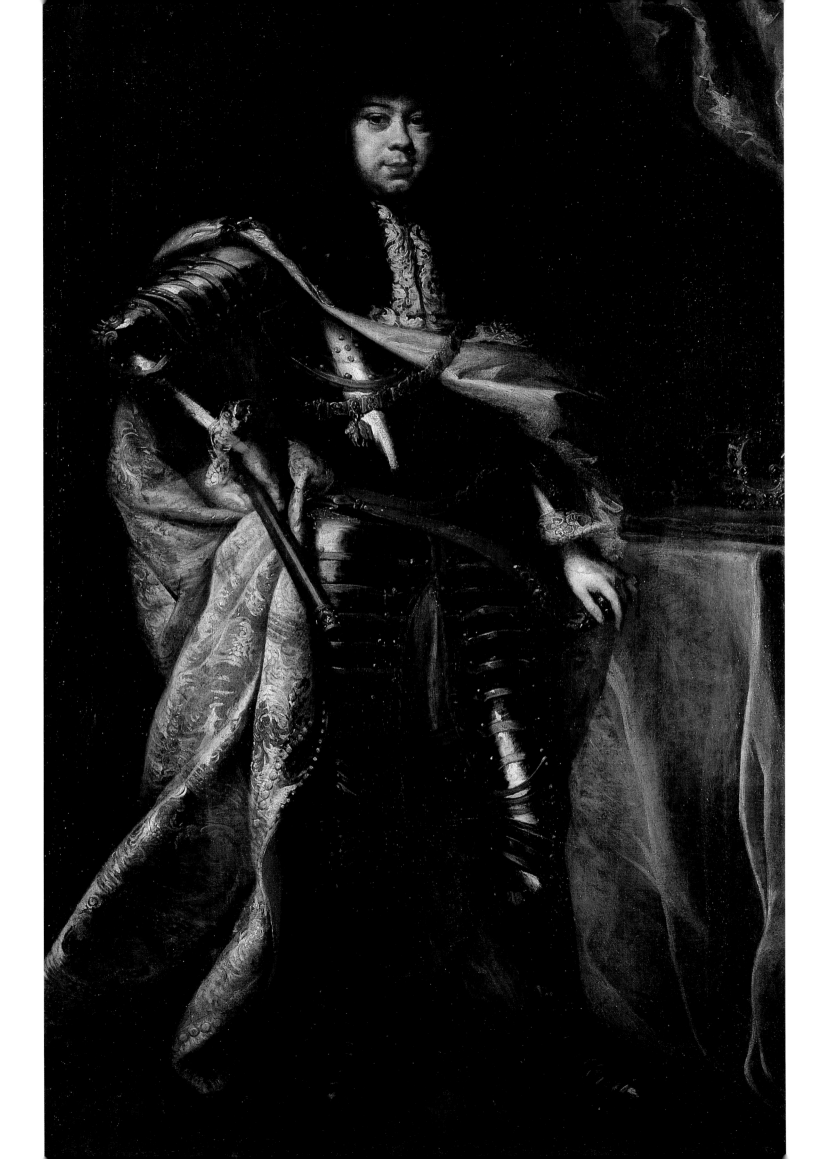

Michael Wiśniowiecki (1640–73), bearer of the Korybut coat of arms, was the son of Jeremi, palatine of Ruthenia, and Gryzelda née Zamoyska. From 1669 Michael was king of Poland.

The portrait was probably taken by Daniel Schultz to the imperial court in Vienna in connection with the king's intended marriage in 1670 to Eleanor Marie, daughter of Leopold I. Before World War II it was bought in Austria for Wawel by the Polish Academy of Science and Letters from the funds of Dawid and Antonina Abrahamowicz. Conservation in 1949 by Rudolf Kozłowski included adding the missing parts of the canvas (at the bottom and on the left side).

This is a full-length state coronation portrait, showing the king in a suit of armor, coronation mantle, and with a commander's baton in his hand, the royal insignia being displayed on the table. The expressive rendering of the king, who in reality was neither handsome nor remarkable for the qualities of his character, as well as a subtle color scheme and gradation of values, attest to the painter's wide range of artistic abilities, clearly inspired by Flemish and Dutch portraiture. The present painting counts among the best works of the Gdańsk artist, a servitor to the king.

Replicas and copies of the portrait survive, full-length or reduced to busts; engraved copies were made by, among others, Johann Bensheimer, Wolfgang Filip Kilian, and Cornelius Meyssens.

KK

5

KING MICHAEL KORYBUT WIŚNIOWIECKI, 1669

DANIEL SCHULTZ THE YOUNGER
(C. 1615–83)

OIL ON CANVAS

195.4 × 120.5 CM (76 7/8 × 47 1/2 IN.)

WAWEL ROYAL CASTLE, CRACOW, INV. 1423, GIFT OF THE POLISH ACADEMY OF SCIENCE AND LETTERS, 1936

LITERATURE
Mycielski 1911–12, 4: pl. III; Mańkowski 1949, 116–22; Mańkowski 1950, 259ff.; *Malarstwo polskie* 1971, 360–361, cats. 119, 120; *Zbiory Zamku* 1990, cat. 33; *Gdzie Wschód spotyka Zachód* 1993, cat. 110.

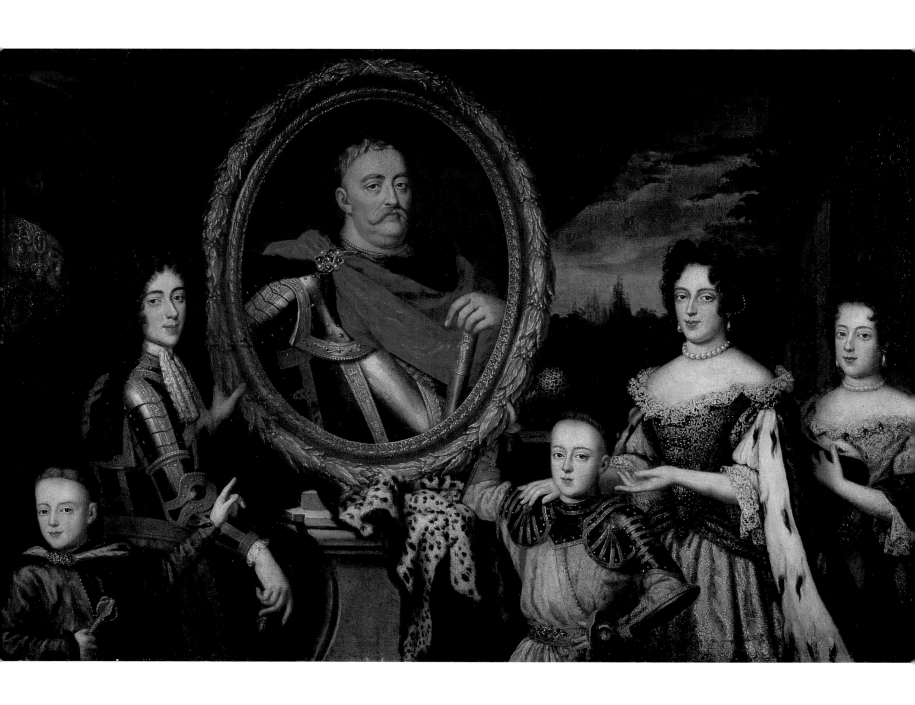

John III Sobieski (1629–96), bearer of the Janina coat of arms, was the son of Jakub, palatine of Ruthenia, and Zofia Teofila née Daniłowicz. John was grand hetman of the Crown from 1668 and as king from 1674 is one of the most popular Polish monarchs. As the victor in numerous battles during the wars fought by Poland against Turkey, especially as commander in chief of the allied forces that defeated the Turkish army besieging Vienna in 1683, he won fame in the whole of Europe. In 1665 he married Marie Casimire née d'Arquien, widow of Jan Zamoyski, and loved her dearly all his life, this being evidenced by the extant body of letters written to her, which are a literary masterpiece. They had five children: Jakub Ludwik (1667–1737), Teresa Kunegunda (1676–1730), Aleksander Benedykt (1677–1713), Konstanty Władysław (1680–1726), and Jan (1682–85). In 1695 Teresa Kunegunda married the elector of Bavaria, Maximilian II Emanuel.

The oval likeness of John III, propped against a socle, is supported by his sons: left Jakub, right Aleksander, and standing beside Jakub, Konstanty. To the right are Marie Casimire and Teresa Kunegunda. The king is clad in armor decorated with the initials IR surmounted by a crown and with the Janina arms, wearing the Order of the Holy Ghost. Jakub also wears a suit of armor adorned with the family arms and trophy. The remaining sons are dressed in Polish costume, with insignia of military power in their hands. The queen and her daughter wear court gowns with lace edging their bodices. In the background are a curtain and a landscape beyond the window.

The picture is now slightly cut at the bottom and on the sides. On the relined reverse is a copied(?) inscription: *Joannes tercius Rex Poloniae. | Maria Casimira Regina. | Jacobus Princeps Maior natus. | Aleksander Princeps minor natus. | Constantinus Princeps minimus. | Maria Theresia Cunegunda. | Filia Regis | H. Gascar pinxit Vandio A[nn]o 1691*. The authorship of Gascar, a French portrait painter, has never been contested. Nor has the date of the painting, consistent with the age of the portrayed children. The picture was probably executed in Rome, where Gascar stayed for some time, on the basis of the iconographic material supplied to him. This seems to be confirmed by a graphic copy of the portrait, made in Rome in 1693 by Benoit Farjat. The composition recalls the French grand dauphin's family portrait painted in 1687 by Pierre Mignard.

Around the middle of the nineteenth century the portrait was in Wincenty Sarnecki's collection in Warsaw, where in 1854 it was renovated by Ksawery Kaniewski, and subsequently in the Broel-Plater collection in Vilnius. After World War II it was taken over by the Polish state.

KK

6

KING JOHN III SOBIESKI
AND HIS FAMILY, 1691

HENRI GASCAR (1634/35–1701), ROME(?)

OIL ON CANVAS

151 × 231 CM (59 1/2 × 91 IN.)

WAWEL ROYAL CASTLE, CRACOW,
INV. 3222, MADE OVER BY THE MINISTRY
OF CULTURE AND ART IN 1946

LITERATURE
Jenike 1862, 33 f.; Chwalewik 1927, 502; Mańkowski 1950, 255; Tomkiewicz 1958, 181; Ryszkiewicz 1961, 32; *Zbiory Zamku* 1990, cats. 36–37.

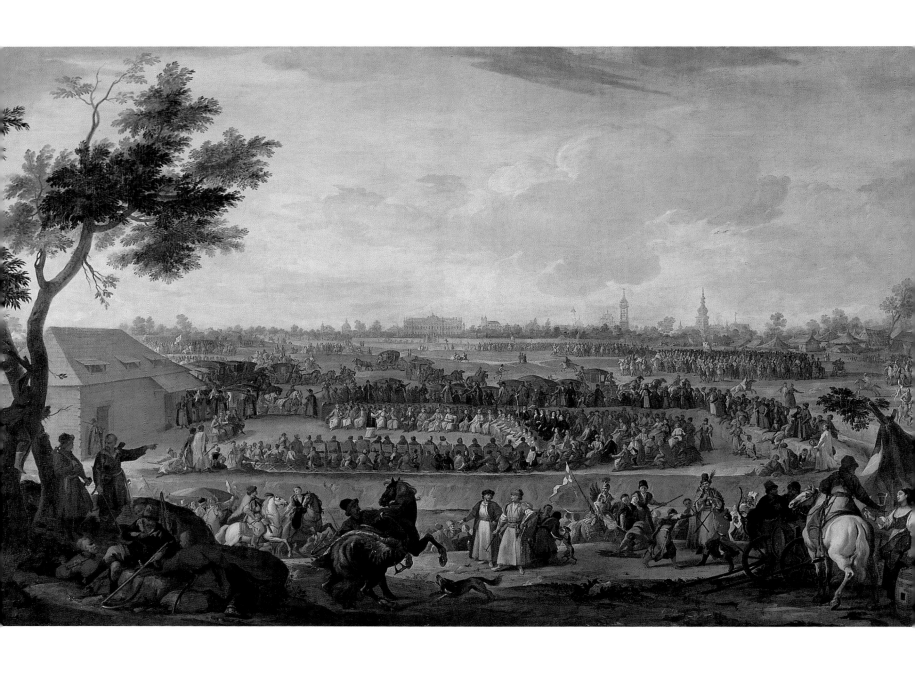

After the death of John III Sobieski, the significant candidates for the Polish throne were François Louis, prince de Conti, cousin of Louis XIV, and Friedrich August I, elector of Saxony. The Electoral Seym debated in Warsaw from 15 May to 28 June 1697, choosing the new king on 27 June. The painting depicts the debate of the Seym in the fields of the village of Wola on the outskirts of Warsaw (today one of its districts). On the left is a wooden structure called a *szopa*, which was erected for the duration of the debates. In the field encircled by a trench and an earth bank are senators, seated in armchairs, and provincial deputies on chairs. The most important seat in the row opposite the *szopa* is taken by the primate, acting as the interrex. In the middle stands an envoy presenting a candidate to the Polish throne. Judging by his clerical garb, this is Count Lamberg, bishop of Passau, an envoy from the emperor, who is recommending the candidacy of the elector of Saxony. In the distance can be discerned crowds of noblemen rallied under the banners of particular palatinates. The genre scenes in the foreground show representatives of various estates. On the horizon spreads a panorama of Warsaw with its state buildings brought into prominence; for instance, on the left the tower of the royal castle and, on the axis of the picture, the facade of the Krasiński Palace, one of the most beautiful and largest baroque palaces in Warsaw. In the bottom left-hand corner is a trace of an illegible signature.

A. Rottermund has attributed the picture to Marco Allessandrini (Allessandri), a painter working in Rome and Bergamo, whose compositions frequently represented multifigural historical and battle scenes. As a canon of the cathedral in Bergamo the artist may have been one of the clergymen accompanying the papal nuncio present at the election of Augustus II in Warsaw.

HM

7

THE ELECTORAL SEYM IN 1697, C. 1697

PAINTER ACTIVE IN POLAND
AT THE TURN OF THE 18TH C.

OIL ON CANVAS

199 × 316 CM (78 3/4 × 124 3/8 IN.)

ROYAL CASTLE, WARSAW,
INV. ZKW 1533, PURCHASED IN 1979
BY THE NATIONAL MUSEUM WITH THE
INTENTION OF TRANSFERRING IT TO A
MUSEUM BEING ORGANIZED IN THE
ROYAL CASTLE IN WARSAW, IN 1982
MADE OVER TO THE CASTLE

LITERATURE
Rottermund 1978, 28, 49; *Pod jedną koroną* 1997, cat. I 7.

Augustus II (1670–1733), called the Strong, was the son of the elector of Saxony, Johann Georg III, and Anne Sophie, princess of Denmark. He was elector of Saxony as Friedrich August II after 1694 and king of Poland 1697–1704 and again 1709–33.

Augustus is portrayed down to his knees, turned slightly rightward, in a wig with a cadogan queue, the left hand resting on the hip and the right on a staff of command. He wears a tight-fitting red velvet coat, trimmed with gold embroidery, over a waistcoat of a slightly lighter hue. Under them are a cuirass and a white shirt with lace cuffs, clasped at the neck with a ruby-inlaid brooch. On his breast on a red ribbon hangs the Order of the Golden Fleece, and at his side on a blue sash with the Order of the White Eagle. In front of the king lies a mantle of dark blue velvet lined with ermine and on it a fragment of armor and a star of the Order of the White Eagle. The background features a landscape with overcast sky, to the right of which is a tree and on the left a group of artillerymen; behind them, amid clouds of smoke, can be seen a bombarded town.

This is one of several workshop replicas of the portrait of Augustus II, the original of which is untraced and probably did not survive. Other versions are kept in the Dresden Gallery. Until the Second World War an analogous portrait was in the collections of the palace at Wilanów. Among other versions of the portrait are those in the castle of Gołuchów and in the Wawel Royal Castle.

BC

8

KING AUGUSTUS II, C. 1728(?)

WORKSHOP OF LOUIS DE SILVESTRE
(1675–1760)

OIL ON CANVAS

159 × 106 CM (62 5/8 × 41 3/4 IN.)

LUBLIN MUSEUM, LUBLIN,
INV. S/M/960/ML, PURCHASED 1972 FROM
ANDRZEJ MOSCZYŃSKI OF KOMARÓW

LITERATURE
Gdzie Wschód spotyka Zachód 1993, cat. 203.

Augustus III (1696–1763), son of Augustus II and Christine Eberhardine, descended from the house of Wettin. He was elector of Saxony and became king of Poland in 1733. He is portrayed here in a palace interior in Polish costume with the high-shaved head, wearing a *żupan* and *kontusz* with a Polish sash tied around the waist, and the ermine-lined mantle beside him. His decorations include the Order of the Golden Fleece and a cross and star of the Order of the White Eagle. He carries a *karabela* at his side and holds a *kolpak* in the left hand. The back of the armchair is decorated with the royal monogram.

As one of the workshop versions of the Dresden portrait of Augustus III painted by Silvestre in 1737, the portrait forms a pendant to that of his wife Marie Josephine, in Polish dress. The portrait was very popular in Poland, hence its numerous replicas and copies, including those in the Kórnik Library of the Polish Academy of Sciences, National Museum in Cracow, Wawel Royal Castle, palace at Rogalin, National Museum in Warsaw, and museum at Pszczyna. This type of portrait of Augustus III was also popularized by the engravings of C. Drevet, J. Daullé, Beauvarlet, and J. Zucchi.

IV

9

KING AUGUSTUS III,
1737 OR LATER

LOUIS DE SILVESTRE (1675–1760)

OIL ON CANVAS

247.5 × 168 CM (97 1/2 × 66 1/8 IN.)

MUSEUM PALACE AT WILANÓW, WARSAW
INV. WIL.1153, FROM STANISŁAW KOSTKA
POTOCKI'S COLLECTION, RECORDED IN THE
WILANÓW INVENTORIES SINCE 1821

LITERATURE
Voisé, Głowacka-Pocheć 1975, cat. 123;
Gdzie Wschód spotyka Zachód 1993, cat. 20.

10

PRINCE JOSEPH AUGUSTUS WILLIAM, 1727

LOUIS DE SILVESTRE (1675–1760)

OIL ON CANVAS

143 × 91 CM (56 1/4 × 35 7/8 IN.)

THE CIECHANOWIECKI FAMILY FOUNDA-
TION AT THE ROYAL CASTLE, WARSAW,
INV. FC-ZKW 1133

LITERATURE
Wybór dzieł 1989, cat. 43; *Pod jedną koroną*, 1997,
cat. V 43.

This is a portrait of the second son of King Augustus III and Marie Josephine, one of the infant portraits of the royal couple's numerous children that were painted by the artist of the Dresden court, Louis de Silvestre the Younger. Of the fourteen children three died in infancy. One of the three was Prince Joseph Augustus (1721–28), portrayed when he was about six. This is perhaps his last likeness before he died in March 1728, not yet seven years of age.

HM

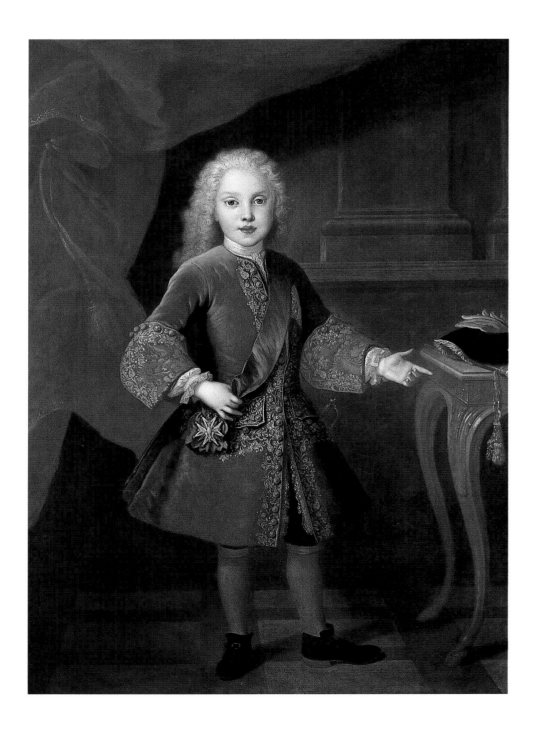

Frederick Christian (1722–63), son of King Augustus III, was intended to be the heir to the throne. Between 1738 and 1740 he went on a journey to Italy. His younger sister, Marie Amalie, married Charles de Bourbon, king of the Two Sicilies, in 1738. Frederick Christian, who accompanied her there, was awarded then the newly founded Order of Saint Januarius. One of the objectives of his tour was the island of Ischia, where the prince was to undergo treatment for lameness in the famous baths. On his way back in 1739 he stopped in Rome, where he commissioned a portrait from one of the most esteemed portraitists of that time, Pierre Subleyras. The artist perpetuated in it Frederick Christian's stay in Naples, by bringing into prominence the Order of Saint Januarius (on a crimson sash), and his visit to Rome, by placing in the background the silhouettes of the Castel Sant'Angelo and Saint Peter's Basilica. The painting is signed in the bottom left-hand corner beneath the surbase of the pedestal: *SVBLEYRAS*.

The Gemäldegalerie Alter Meister collection in Dresden holds another version of this portrait (inv. 3841), with a landscape in the background.

HM

11

CROWN PRINCE
FREDERICK CHRISTIAN, 1739

PIERRE SUBLEYRAS (1699–1749), ROME

OIL ON CANVAS

107 × 87 CM (42 1/8 × 34 1/4 IN.)

THE CIECHANOWIECKI FAMILY
FOUNDATION AT THE ROYAL CASTLE,
WARSAW, INV. FC-ZKW 1135

LITERATURE
Subleyras 1987, 241; *Wybór dzieł* 1989, cat. 47;
Pod jedną koroną 1997, cat. XII 9.

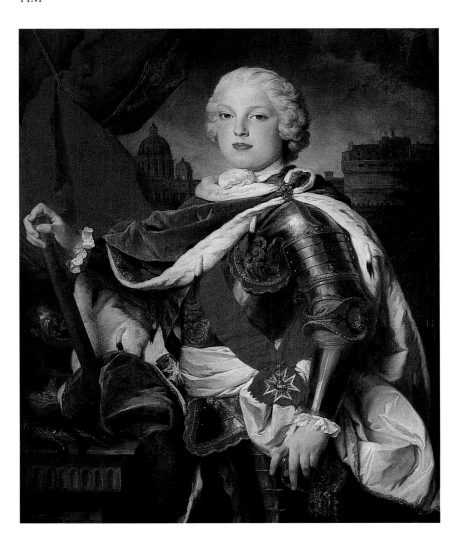

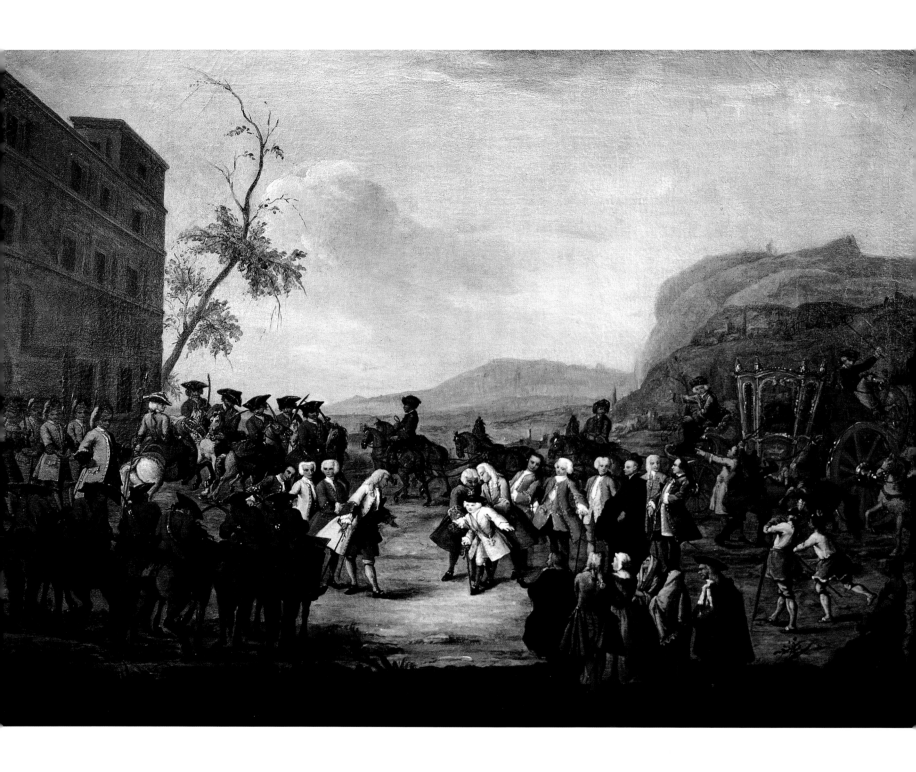

The Republic of Venice was one of the stages of the Italian journey made by Frederick Christian, son of King Augustus III, from 1738 to 1740. He followed the route of his father's youthful travels, when as an adolescent Augustus III had twice visited Venice. Those visits bore fruit in the form of Augustus' fascination with Venetian art, which he widely promulgated in Dresden, inviting to his court eminent painters as well as musicians from Venice. During his stay in that city Frederick Christian used the contacts that his father had made more than twenty years earlier and also made other acquaintances, one of them being the composer Antonio Vivaldi.

The painting depicts the moment of greeting of the prince at the frontier. The artist has rendered the scene with a reporter's realism, not omitting the fact that Frederick Christian, afflicted with paresis of the legs (probably caused by poliomyelitis, which he had suffered in childhood), had difficulty in walking unaided (see detail below).

HM

12

THE GREETING OF PRINCE FREDERICK CHRISTIAN AT THE FRONTIER OF THE REPUBLIC OF VENICE IN 1739, 1739

PIETRO LONGHI (1702–85)

OIL ON CANVAS

79 × 106 CM (31 1/8 × 41 3/4 IN.)

THE CIECHANOWIECKI FAMILY FOUNDATION AT THE ROYAL CASTLE, WARSAW, INV. FC-ZKW 1130

LITERATURE
Wybór dzieł 1989, cat. 27; *Pod jedną koroną* 1997, cat. XII 10.

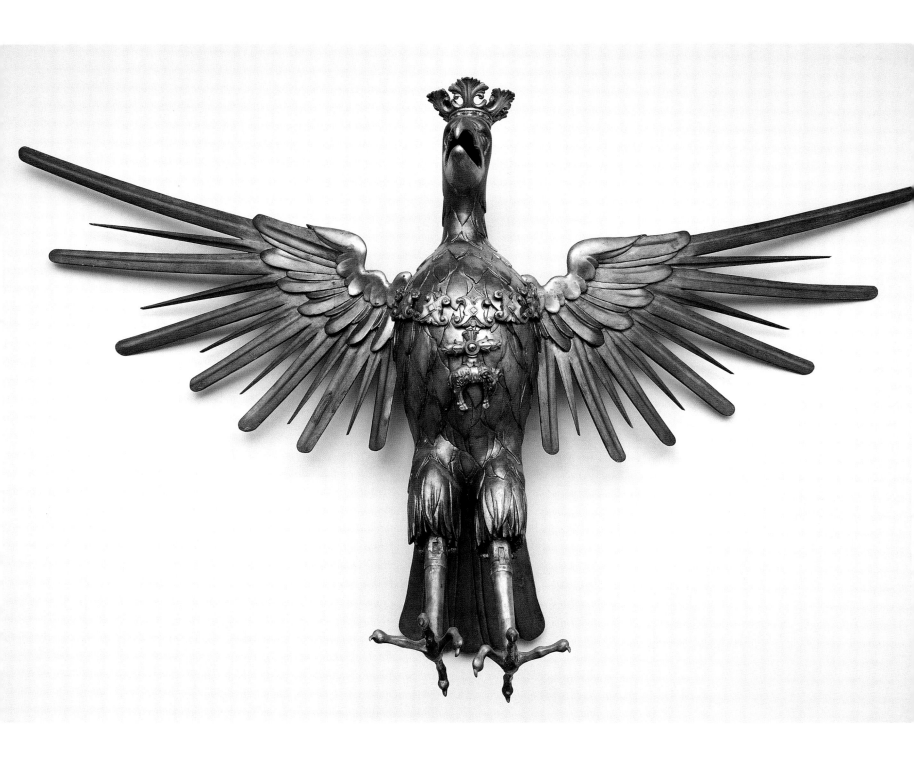

This eagle was part of the cresting of the case of the organ constructed between 1638 and 1641 by the organ maker Jerzy Nitrowski, who continued the work begun in 1618–24 by Hans Humel. After the dismantling of the case in 1819, the eagle was hung over the new organ and later over the chapel of Our Lady of Loreto. Conservation was undertaken in 1932 by Leon Wiadrowski and in 1998 at Wawel Castle by Adam Kruk.

The bird has a slender body, its head facing the viewer, with an open beak and wide-spread wings whose feathers—broad alternating with narrow—are arranged radially. On the head is an open crown, and on its breast is suspended a chain of the Order of the Golden Fleece. The body is silvered, while parts of the wings as well as the legs, order, and crown are gilded, and the inside of the beak is painted red. The hinged legs are movable, as are the wings hinged to the body. At the back is a compartment closed with a door containing documents relating to the history of the eagle.

The figure of an eagle decorated with the Order of the Golden Fleece, set up at the top of the grand organ, called the royal organ, probably referred to King Ladislas IV, who, as had his predecessors on the Polish throne, had the right of patronage of Saint Mary's Church, the main parish church of the capital of Poland. According to a description of 1819, during a mass the eagle, thanks to a special mechanism, bowed before Christ present in the Blessed Sacrament. Movable eagles, bowing to the king entering the capital, are known from descriptions of the triumphal arches erected on the occasion of ceremonial entries of monarchs; hence the erroneous suggestion advanced by some researchers that the figure from Saint Mary's Church is a fragment of one such temporary structure.

The sculpture is a representative example of Cracow woodcarving, which flourished in the first half of the seventeenth century. Particularly characteristic here is great expressiveness in rendering the bird's figure. An attempt by E. Smulikowska to attribute it to the workshop of Andrzej Hertel and Krzysztof Kolmitz must remain in the sphere of conjecture for lack of corroboration in source material.

KJC

13

EAGLE FROM AN ORGAN CASE, 1638–41

CRACOW

WOOD, IRON; CARVED, SILVERED, GILDED

157 × 265 × 62 CM (61 3/4 × 104 3/8 × 24 3/8 IN.)

CHURCH OF THE ASSUMPTION OF THE BLESSED VIRGIN MARY, CRACOW

LITERATURE
Rożek 1976, 19, fig. 4, n. 162; *Katalog Zabytków* 1971, 22, fig. 903; Smulikowska 1989, 74, 176, 235, fig. 94; Sudacka 1994, 58–62.

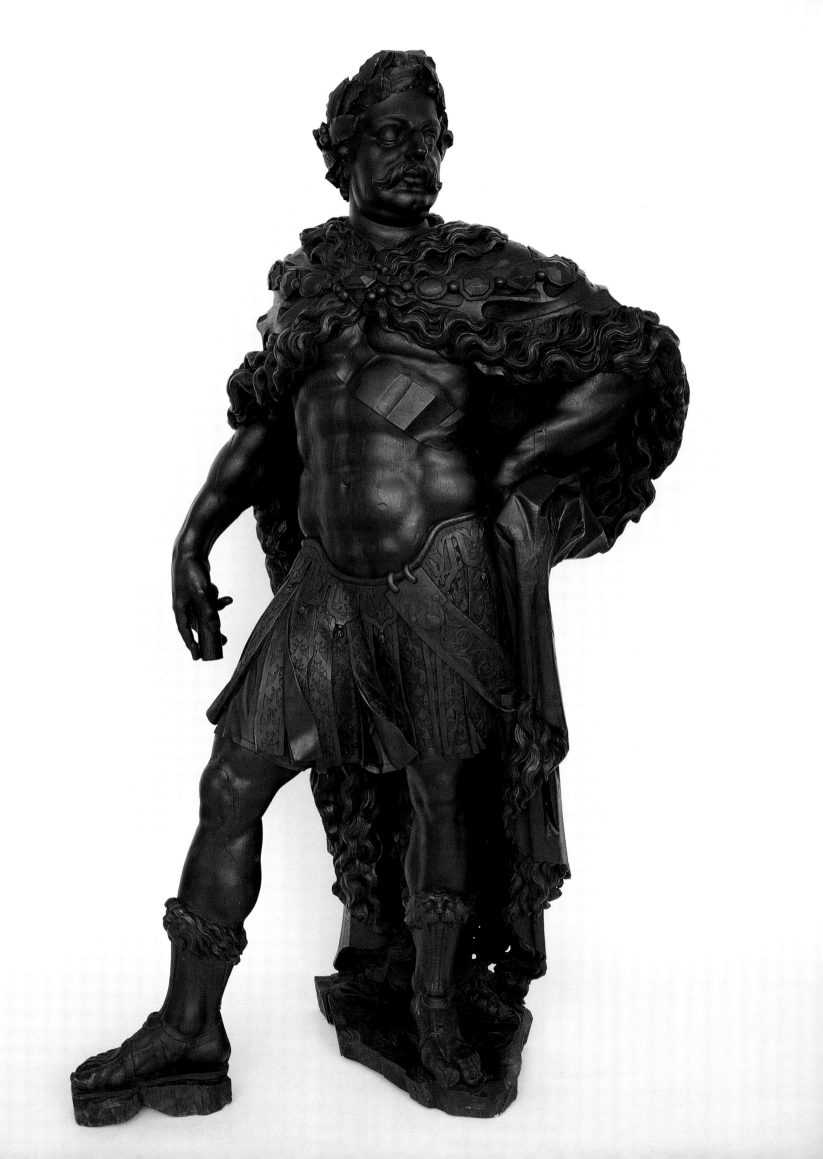

John III Sobieski (1624–96), from 1674 king of Poland, was one of the outstanding rulers of the Polish kingdom in the modern era. A wise politician and excellent military commander, he waged wars against the Tatars, Cossacks, Russia, and Turkey. In 1683 he crushed the Turkish army, which was threatening Europe, at Vienna (see also cats. 6, 51).

The exhibited effigy is a fragment of a monument intended for the cathedral at Le Puys in France, one of ten that were to be raised in honor of John III in the churches of the diocese of Puys. The sculpture was executed on the initiative of Bishop Armand de Béthune, whose brother, François Gaston, brother-in-law of the queen of Poland, Marie Casimire, was an ambassador in the Polish kingdom. In addition to the statue of the king, the monument at Le Puys was to include four figures of fettered slaves and eight reliefs featuring the battle, entry of the army into Vienna, and allegorical representations. Pierre Vaneau probably did not manage to finish the work before his death. Some reliefs, initially bought by John III's family, in 1866 found their way to Ksawery Branicki's collection in his castle at Montrésor, Indre-et-Loire. Three reliefs owned by the Louvre, allegories of the defeat of the Turkish troops, are now deposited at the Musée Crozatier at Le Puys. Until 1962 the figures of the king and slaves formed part of the castle collection at Brassac (Puy-de-Dôme), from where the statue of John III was acquired by Andrzej Ciechanowiecki.

The monarch is shown full-length, standing in contrapposto, with a laurel wreath on his head. He wears Roman-type armor—a muscled breastplate and an apron of short pendant strips—and a fur-lined mantle, and the sandals on his feet are decorated with lion's masks. On his breast can be seen the sash of the Order of the Holy Ghost. In the right hand he holds a commander's baton. The figures for the monument to John III are among the first and also the best works by Vaneau. They attest to his technical mastery, excellent knowledge of human anatomy, and ease in handling ornamental decoration. Particular elements of the monument reflect certain patterns to which Vaneau remained faithful to the end of his creative activity. The figures of the slaves resemble Michelangelo's sculptures from the tomb of Pope Julius II, and the allegories in the reliefs recall Roman baroque works including those by Gianlorenzo Bernini. The effigy of John III in the costume of an antique hero may have been inspired by the statue of Louis XIV, executed by M. Desjardins, set up at Versailles in 1683.

AB

14

KING JOHN III SOBIESKI, 1683–87

PIERRE VANEAU (1653–94)

STAINED MAHOGANY

186 × 85 × 65 CM (73 1/4 × 33 1/2 × 25 5/8 IN.)

ROYAL CASTLE, WARSAW, INV. ZKW 2091, GIFT OF ANDRZEJ CIECHANOWIECKI IN 1986

LITERATURE
Vitry 1938, 5–71; Bénézit 1976; *Pierre Vaneau* 1980; *Wybór dzieł* 1989, cat. 235; Ryszkiewicz 1992, 86; Badach 1994, 85–86.

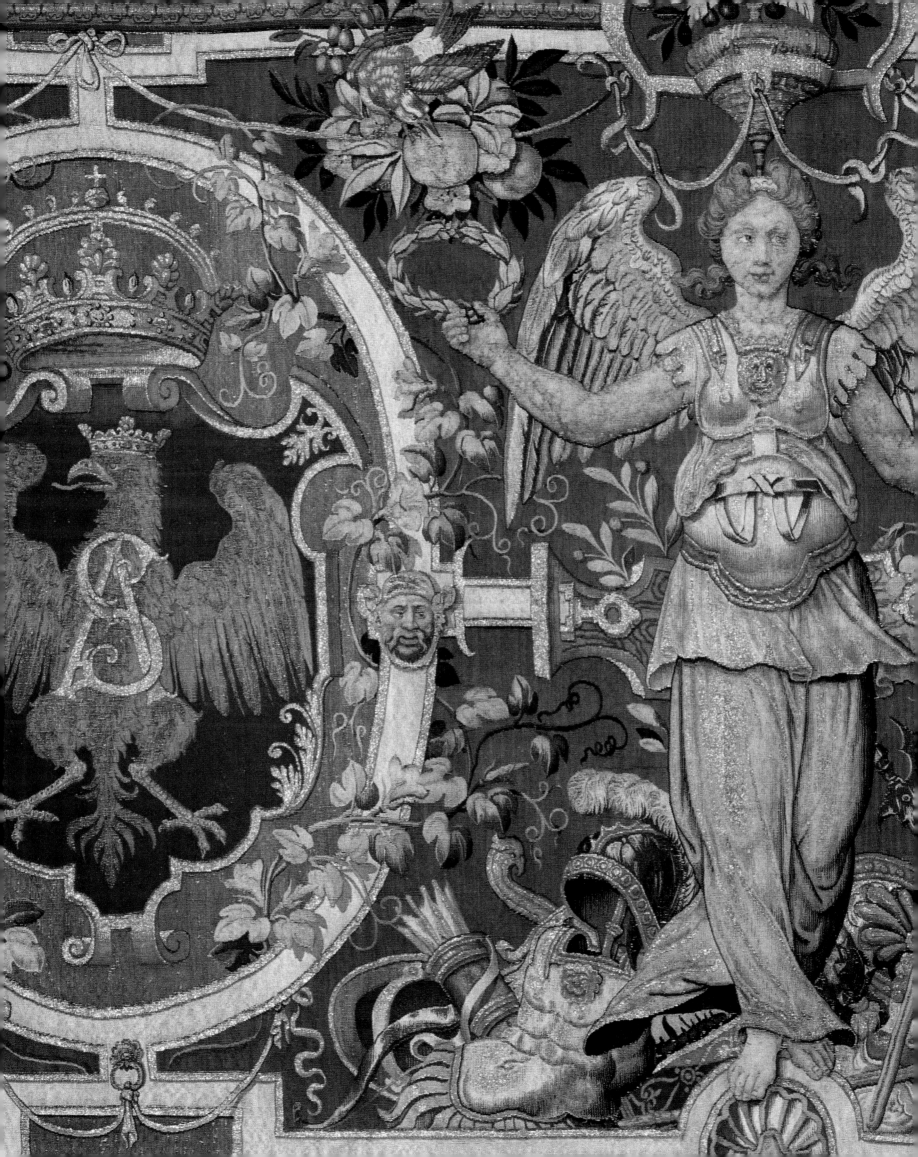

The tapestry illustrates Sigismund Augustus' aspiration for the legal settlement of the union of the Polish and Lithuanian nations. Within ornamental borders are cartouches with the coats of arms of Poland, the Order of the White Eagle bearing the interlaced letters *SA* (Sigismundus Augustus) on its breast, surmounted by a royal crown; and of Lithuania, the Pursuit (a knight on horseback) and a ducal coronet above him. The armorial bearings flank the winged goddess Victory, who is holding a laurel wreath, a trophy of glory, and a broken spear. At her feet are discarded weapons: armor, helmets, axes, shield, and quiver with arrows. The symbolic meaning of the representation is that the unification of the kingdom will ensure peace and triumph. The composition is supplemented by bunches of ripe fruit, flowers, leaves suspended on ribbons, and birds.

The tapestry bears the mark of the weaver Jan van Tieghem. The cartoon by which it was woven was executed by an artist from the circle of Cornelis Floris (1514–75) and Cornelis Bos (1506 or 1510–64). The woolen, silver, gold, and silver threads are woven at eight threads of warp per centimeter. It belongs to the group of heraldic pieces that forms part of the collection of Sigismund Augustus' tapestries. Today the collection numbers 136 items, comprising textiles of superb artistic and technical qualities whose subject matter are biblical scenes, landscapes with animals, armorial bearings, and monograms. Purchased and brought in by the king from Brussels in the 1550s, in the course of centuries the collection experienced extremely dramatic vicissitudes. Pillaged by the czarist authorities, in the nineteenth century it was held in Russia, and during the Second World War it was evacuated to Canada, thereby being saved from the Germans, to return in 1961. The collection is regarded as the Polish national treasure.

MH-B

15

TAPESTRY WITH THE ARMS OF POLAND AND LITHUANIA, c. 1555

BRUSSELS

WOOL, SILK, GOLD, AND SILVER

155 × 289 CM (61 × 113 3/4 IN.)

WAWEL ROYAL CASTLE, CRACOW, INV. 85, FROM THE TAPESTRY COLLECTION OF KING SIGISMUND AUGUSTUS

LITERATURE
Gębarowicz, Mańkowski 1937; Piwocka 1972; Hennel-Bernasikowa 1998.

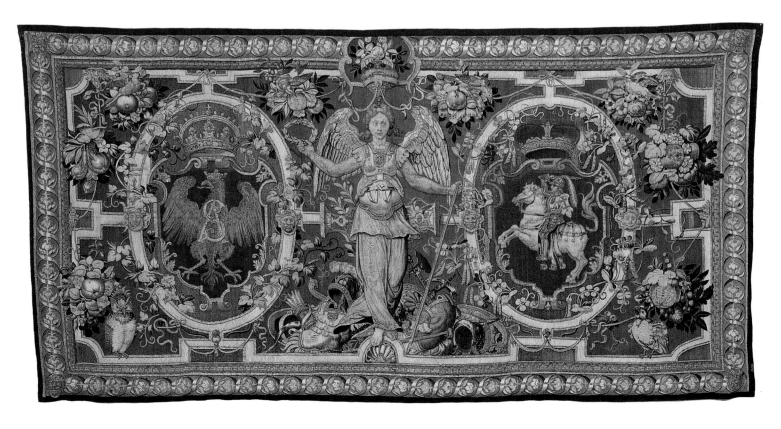

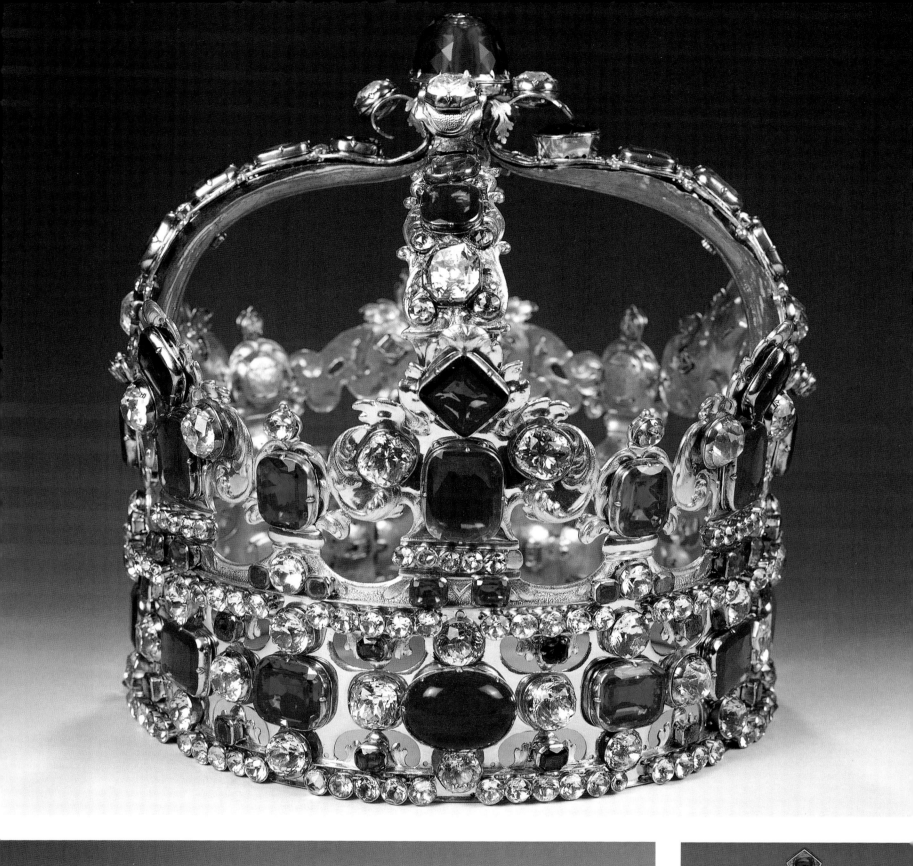
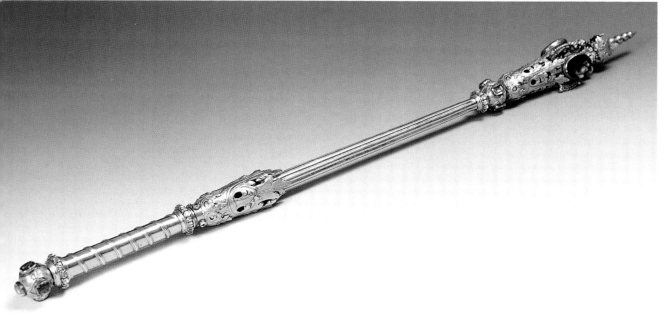
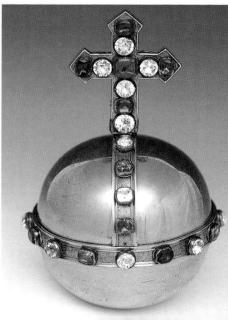

After the death of King Augustus II the Strong, the Electoral Seym chose Stanislas Leszczyński as his successor, whereas the supporters of the Saxon dynasty acclaimed Augustus Frederick (1696–1763), the late king's son; the latter candidate also won the support of Russia, which manifested it by sending its troops to Poland. Leszczyński, on the other hand, did not receive the help promised him by France. Nonetheless, the grand treasurer of the Crown, an antagonist to the Saxon king-elect, removed the historical Polish regalia from the Wawel Crown Treasury and hid them in one of the tombs of the Holy Cross Church in Warsaw. Therefore, Augustus ordered his jeweler, Köhler, to make new insignia for him and his spouse. In addition to the extant crowns, scepters, and orbs, the artist wrought a clasp for the mantle as well as a star and order of the White Eagle, which can be seen in the 1737 copperplate by C. P. Lindemann. They were originally studded with the gems removed for this occasion from the Dresden sets of orders. The coronation of Augustus III took place in Cracow Cathedral on 14 January 1734. Afterward, the precious stones were replaced by imitation gems. Until 1737 the regalia were stored in Warsaw, and later in Dresden. In 1924 the Saxon authorities made them over to the last king, from whom in the following year, through a Viennese antiques shop, they were bought by the National Museum in Warsaw. During the Second World War they were looted by the Germans and brought to Dresden, whence the Red Army carried them to the Soviet Union. They were returned to the museum in 1960.

The closed crown resembles to some extent the one made in 1697 for Augustus II (Rüstkammer Dresden), whose crossed arches are surmounted by a characteristic large cabochon; in the Polish crown, at the juncture of the arches was a gold orb surmounted by a cross.

According to U. Arnold's findings, after the termination of the Polish-Saxon union, the insignia were lent to members of the Saxon dynasty for requiem masses. It was surely then, though at a moment hard to define, that the crown was enlarged by the insertion of an additional segment, thereby losing its original form visible in the Lindemann copperplate. It was represented in a slightly simplified form, together with the scepter and orb, by Louis de Silvestre in his portraits of the king in Polish costume (Museum at Wilanów; Gemäldegalerie Alte Meister Dresden).

RB

16

INSIGNIA OF THE CORONATION OF AUGUSTUS III, 1733

JOHANN HEINRICH KÖHLER (D. 1736), DRESDEN

SILVER-GILT, IMITATION GEMS

A, CROWN
24.3 × 24.5 × 24 CM (9 1/2 × 9 1/2 × 9 1/2 IN.)

SIGNATURE ON ONE OF THE FLEURS-DE-LIS: *JK*

B, SCEPTER
65.5 × 4.5 (25 3/4 × 1 3/4)

C, ORB
20 × 13.5 × 4.5 (7 7/8 × 5 3/8 × 1 3/4)

NATIONAL MUSEUM, WARSAW,
INVS. SZM 7035, SZM 7037, SZM 7039

LITERATURE
Rożek 1973, 104–6; Lileyko 1987, 105–7; Arnold 1996, 70; *Pod jedną koroną* 1997, cat. II/36.

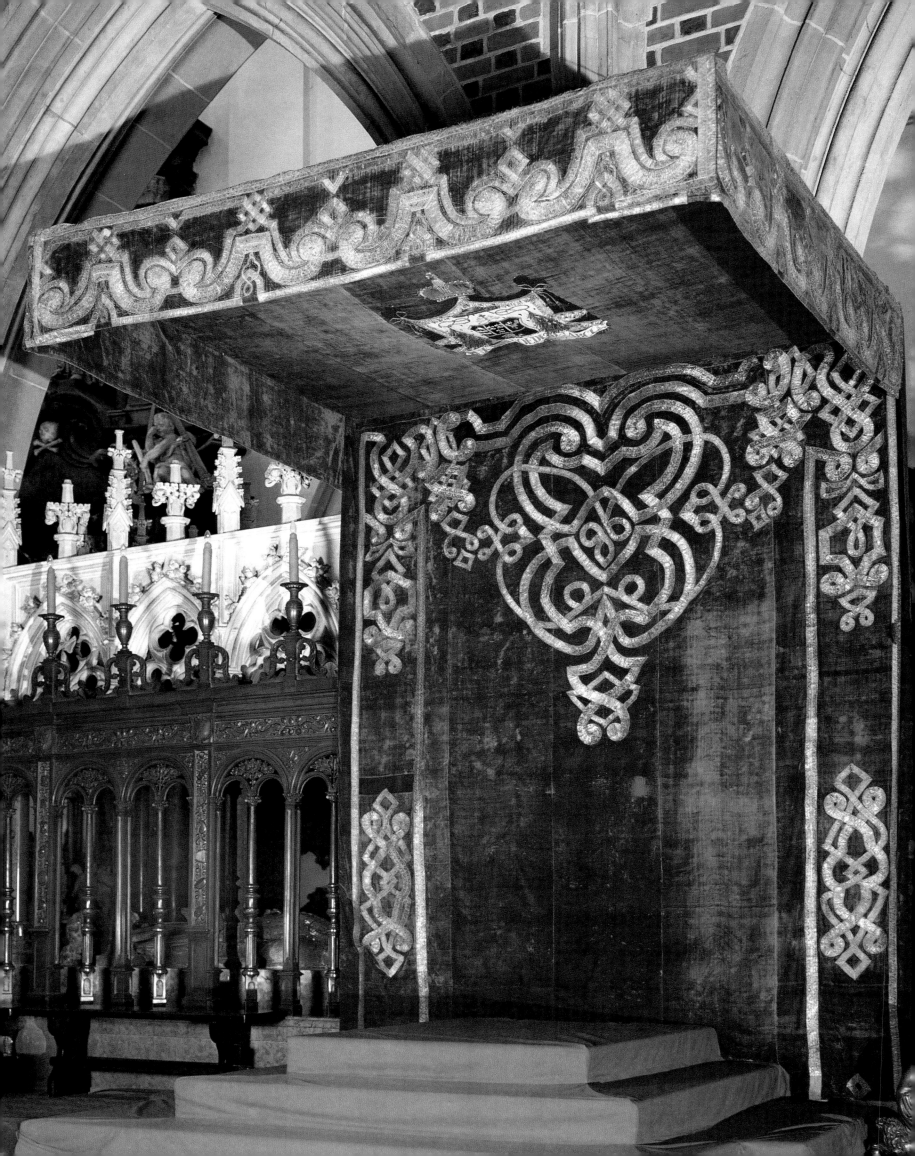

This baldachin was used during the coronation of Augustus III of Saxony and his wife, Marie Josephine, in Cracow Cathedral on 17 January 1734. After the ceremony it was left at the cathedral with a set of wall coverings of red velvet. Since then it has been fixed over the bishop's throne in the chancel of the Cathedral.

For centuries a baldachin played an important role in both the secular and the church ceremonial. Placed over the monarch, it singled him out among his subjects, glorifying him. Under the baldachin stood the royal throne: during the coronation, in the audience chamber, during the ceremony of receiving homage, or during ceremonial banquets. To this day a baldachin has been used to mark the bishop's seat in the cathedral.

The exhibited object consists of a back and a ceiling with a lambrequin of dark red velvet trimmed with ornamented gold braid (the gilding is now badly worn) of varying width. The upper part of the back, the borders running along its vertical sides, and the ceiling are decorated with symmetrically composed geometrical patterns of interlacing ribbons. The lambrequin bears a similar continuous ribbon ornament.

The baldachin was an element of the occasional adornment of the chancel of Wawel Cathedral, in which from 1320 to 1734 the coronations of Polish monarchs took place (except for Stanislas Leszczyński, who was crowned in 1705 in Warsaw). The last coronation ceremony in Cracow Cathedral, of Augustus III of Saxony in 1734, had a splendid artistic setting, known by contemporary descriptions and iconographic sources. The cathedral chancel was then embellished with hangings of red velvet, and the royal throne was set up under a richly decorated baldachin. The ornament on the lambrequin of the cathedral object is almost identical with that discernible on the canopy fixed over the throne of Augustus II the Strong in the audience chamber of the Royal Castle in Warsaw, fortunately preserved in a drawing by Joachim Daniel Jauch depicting the audience given by the king of Poland to a Turkish envoy in 1731. The drawing does not show the back, so it is impossible to establish whether its decoration also resembled the analogous ornamentation of the Cracow baldachin. Arrangements in the cathedral for the coronation were made in a rather short time, hence it cannot be ruled out that earlier-made elements were used, including perhaps a canopy brought from Warsaw (not necessarily the one from the audience chamber). It is likewise possible that the coronation baldachin was executed in imitation of the Warsaw canopy or from the same design.

KJC

17

BALDACHIN FOR THE CORONATION OF
AUGUSTUS III OF SAXONY, 1733/34(?)

POLAND

VELVET, GALLOONS; STITCHING, APPLIQUÉ

BACK 400 × 300 CM (157 1/2 × 118 1/8 IN.);
CEILING 300 × 200 (113 1/8 × 78 3/4);
W. OF LAMBREQUIN 50 (19 5/8)

CATHEDRAL OF SAINT WENCESLAS AND
SAINT STANISLAS, CRACOW

LITERATURE
Rożek 1973, 107.

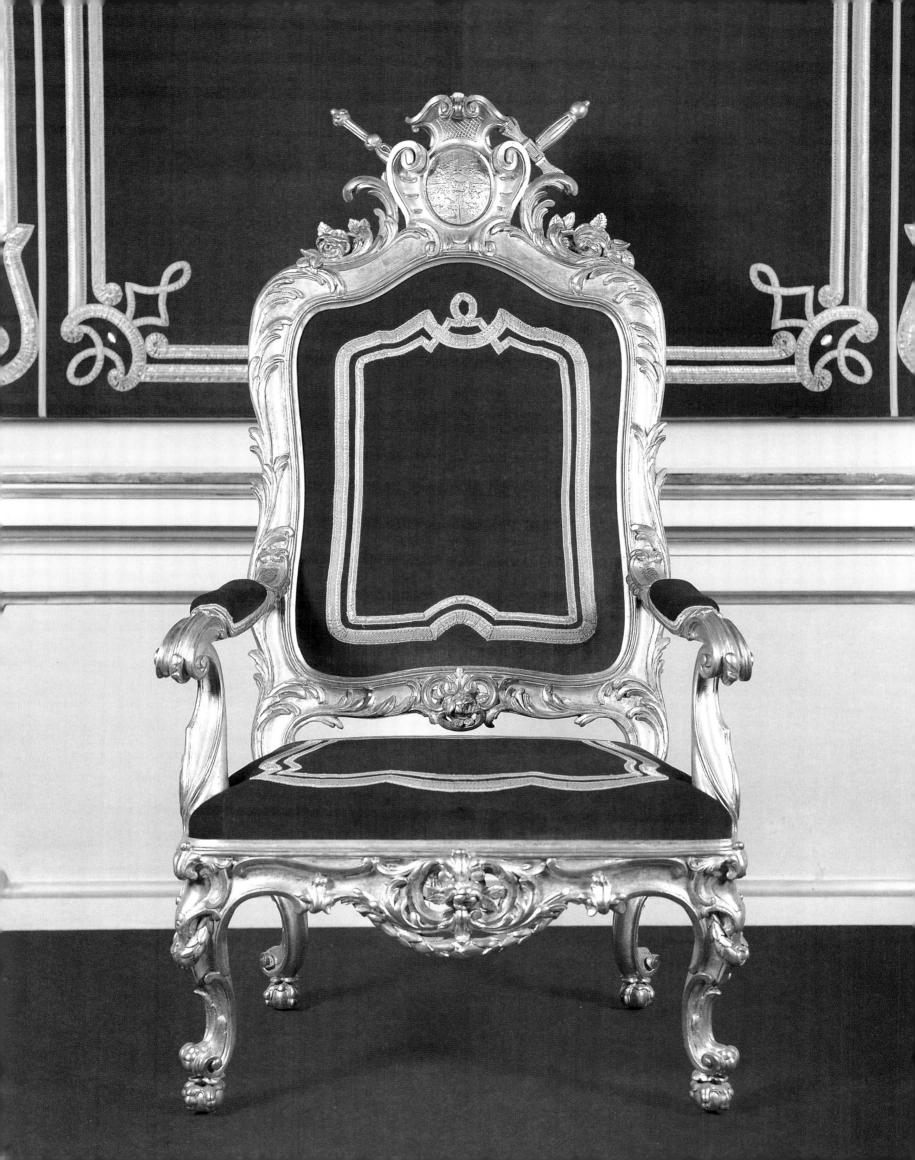

In the cresting, a cartouche with a scepter and sword bear the arms of the Polish Commonwealth and the Ciołek arms of King Stanislas Augustus. This is one of three thrones made in 1764 on the occasion of the election and coronation of Stanislas Augustus Poniatowski as king of Poland. The extant object belonged to the furnishing of the senate chamber or the audience chamber of the Royal Castle in Warsaw. The throne, with upholstered seat and back in a rococo frame decorated with an acanthus vine, flowers, and volutes, was designed under the influence of the Saxon rococo and made by a Warsaw craftsman who must earlier have worked for the court of Augustus III of Saxony. The upholstery, of loose velvet cushions on a wooden frame, and galloons, is new.

BG-R

18

THRONE, 1764

WARSAW

PINE, BIRCH, LIMEWOOD, GILDING

157 × 85 × 66 CM (61 5/8 × 33 1/2 × 26 IN.)

ROYAL CASTLE, WARSAW, INV. ZKW 3385

LITERATURE
Maszkowska 1956, 24; Lorenz 1971, 33–34;
Chyb 1978, 10–23.

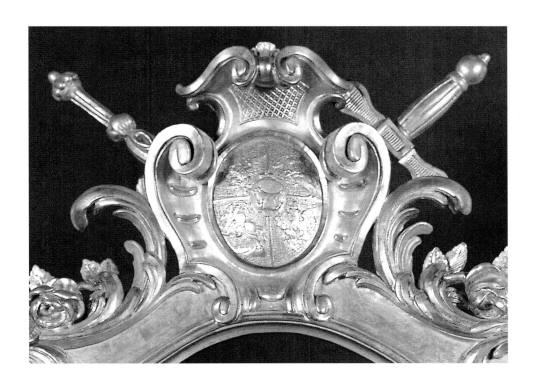

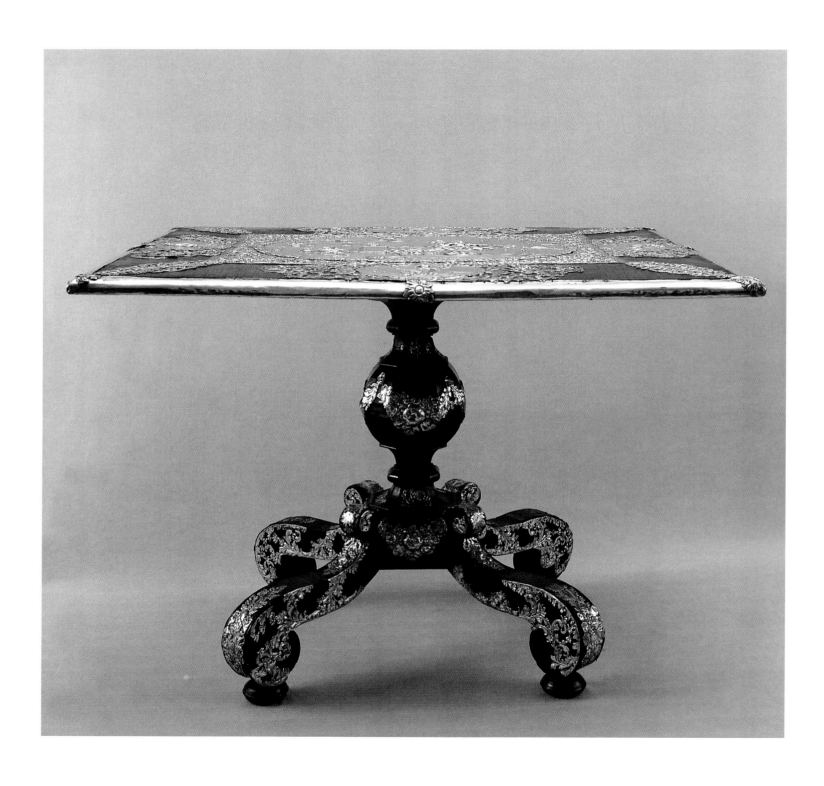

This table, traditionally believed to have belonged to King John III Sobieski, has been kept in the Cracow collections since the early nineteenth century, this being attested by the hallmarks stamped on the silver between 1806 and 1807. It came to the university collections in 1898 as a bequest from Maria Potulicka. It represents the type of Augsburg high baroque palace furniture made for audience chambers and antechambers. In Poland, references to silver-covered furniture can be found in inventories of such residences as that of the Sobieski family at Żółkiew or of the Radziwiłłs at Nieśwież; in Cracow, an analogous piece of furniture was owned by the Lubomirski family. Augustus II brought from Dresden to Cracow some Augsburg furniture decorated with silver for his coronation in 1697.

The present table belonged to a set with a mirror and two gueridons. The table is light in weight with a movable top easily unscrewed, to be transported from one residence to another. The rectangular top rests on a leg in the form of a molded octagonal baluster supported by four S-shaped volutes terminating in flattened spheres. It is embellished with applied silver plaques and silver ornaments. It bears the master's mark SS in an oval; mark of Augsburg with a stone-pine cone, used from 1695 to 1700; mark of the Cracow assay office in the form of a crescent and the letter E, used in the years 1806–07; and the hallmark used in the Austrian Empire from 1810–25, with the initials TT in a circle. The center of the top is decorated with two large plates, one inserted in the other: an oval plaque with a figural scene and a rectangular one with compositions of acanthus leaves and flowers. Around them are disposed four smaller oval plaques carrying allegories of the seasons in openwork frames of acanthus motifs. The diagonal joins of the top are concealed under rhomboidal plaques with foliate motifs. The edges of the top are fitted with molded strips on which are applied four flower-shaped elements and another four on the corners in shell form. The leg is decorated also with silver elements. On the baluster are fruit-and-flower festoons and single flowers; the backs of the supports bear a leaf-and-festoon motif, and their sides an openwork flower-acanthus vine. The central plate of the top features Mars and Venus in a triumphal carriage pulled by two *amorini*, while a third one is holding a shield. Above, Cupid aims his bow at the riding couple. In the background are garden architecture, the front of a palace, and fragments of a ruined temple. The subject, borrowed from depictions of Roman triumphal processions, in the baroque period was frequently used in the work of painters and goldsmiths and also for court decorations on the occasion of the nuptials of monarchs. A reference to some details of this scene is provided by the *Entry of Venus* in a plaque at the Rijksmuseum in Amsterdam (Hoos 1981, no. 11).

Among Augsburg tables, three are akin to the Cracow piece in general proportions and structure. However they all differ from it in that their wooden elements have been treated merely as a framework, hidden under silver plates. In its artistic expression the Cracow object is more akin to small cabinetmakers' works such as clock cases, box reliquaries, or cases in which silver decoration was harmoniously combined with the dark wood of the background.

AP

19

TABLE OF KING JOHN III SOBIESKI, 1695–97

SAMUEL SCHNEEWEISS (D. 1697), AUGSBURG

OAK, OAK AND ROSEWOOD VENEER, STAINED BIRCH, WROUGHT IRON; BEATEN SILVER, REPOUSSÉ, OPENWORK, TEXTURED

75 × 100 × 83 CM (29 1/2 × 39 3/8 × 32 5/8 IN.)

JAGIELLONIAN UNIVERSITY MUSEUM, CRACOW, INV. 7500

LITERATURE
Rosenberg 1923; Estreicher 1973; Seeling 1980; Hoos 1981; *Odsiecz wiedeńska* 1990; Gradowski 1994.

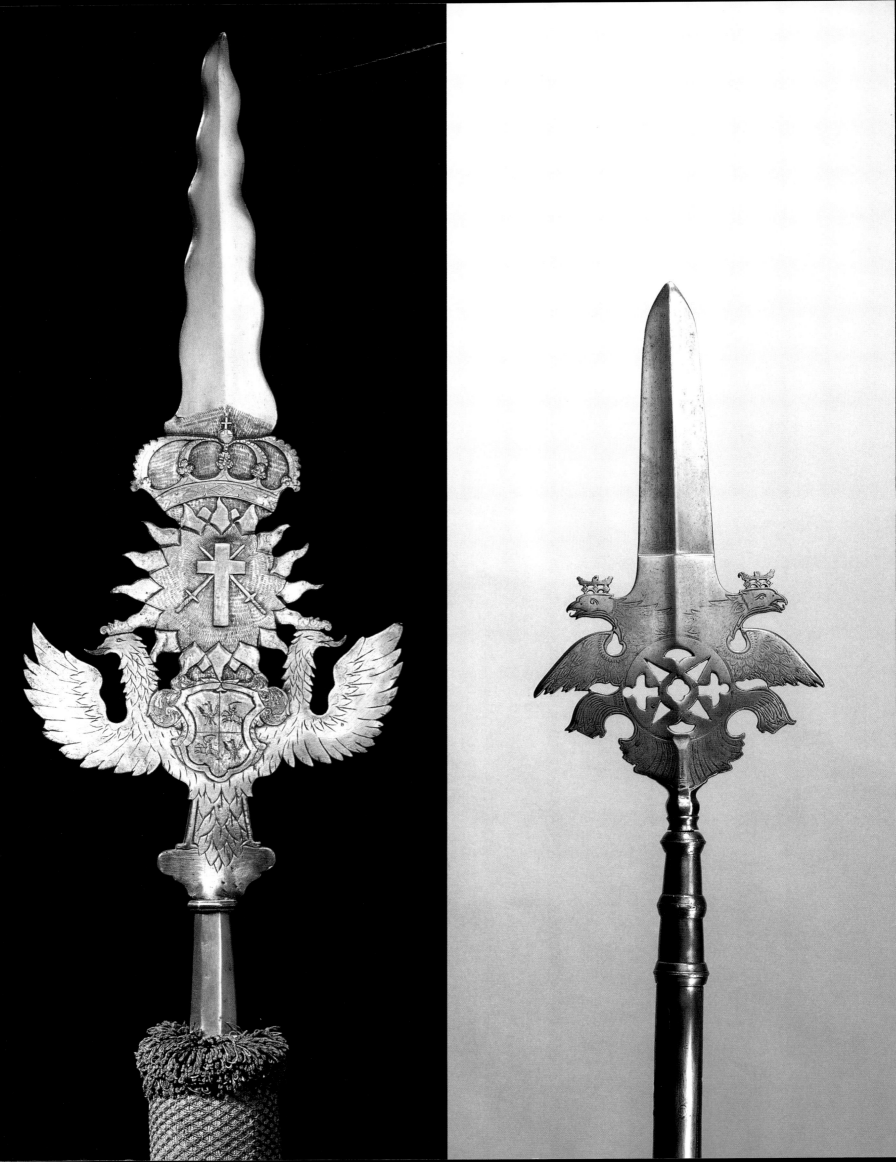

Until 1880 this ceremonial weapon (opposite left) was in the Russian imperial collection at at Tsarskoe Selo, then in the Hermitage, Saint Petersburg, whence in 1924 it was recovered by the Polish Republic together with other treasures of Polish culture plundered by Russia during the partitions of Poland.

The Polish bodyguard of noblemen (*chevalier-garde*) was created in 1703 by King Augustus II. In 1719, on the occasion of the nuptials of his son, Prince Frederick Augustus, it was equipped with new partisans. It mounted guard during court and state ceremonies such as the coronation of Augustus III of Saxony in Cracow in 1734.

The head is flat, with prongs in the form of crowned half eagles, and with the quartered shield bearing the arms of the Polish Kingdom and the Grand Duchy of Lithuania, each repeated in diagonally opposite corners. The upper part of the head is in the shape of a broad flamboyant spike with a median rib, set at the top of the crown surmounting the cross with two electoral swords surrounded by a glory of flamelike rays. A polygonal socket holds a blue and gold tassel. The shaft is of later date. Numerous analogous examples have been preserved in Polish and foreign collections.

KJC

20

PARTISAN OF THE POLISH BODYGUARD OF NOBLEMEN OF AUGUSTUS II THE STRONG, 1719

SAXONY

STEEL, WOOD, SILK AND METAL THREADS; WROUGHT, ETCHED, GILDED

OVERALL LENGTH 285 CM (112 1/4 IN.)

WAWEL ROYAL CASTLE, CRACOW, INV. 209

LITERATURE
Wystawa rewindykacyjna 1929, 53, cat. 105; Petrus 1980, n.p.; Petrus 1989, 27, fig. 10; *Zbiory Zamku* 1990, 249, cat. 128a.

Like the previous weapon, this partisan (opposite, right) was in the Russian imperial collections at Tsarskoe Selo until 1880 and later in the Hermitage, Saint Petersburg, whence in 1924 it was recovered by the Polish Republic together with other Polish treasures seized by Russia during the partitions of Poland.

The Swiss Guard, created in 1656 in Dresden by the Elector Johann Georg III, was restored in 1699 by Augustus II, king of Poland and elector of Saxony. This formation existed until 1813.

The head of the partisan is set on a tapering socket with three rings; a rib runs along its entire length. The spike is broad and straight and the prongs take the form of crowned half eagles. In the center is a circular medallion with an openwork rosette. The shaft is of a later date. Similar objects have survived in collections in Poland and elsewhere.

KJC

21

PARTISAN OF THE SWISS GUARD OF AUGUSTUS III OF SAXONY, 1740–45

SAXONY

STEEL, WOOD; WROUGHT, ETCHED

OVERALL LENGTH 267 CM (105 1/8 IN.)

WAWEL ROYAL CASTLE, CRACOW, INV. 206

LITERATURE
Wystawa rewindykacyjna 1929, 52, cat. 102; Petrus 1980, n.p.; Petrus 1989, 27.

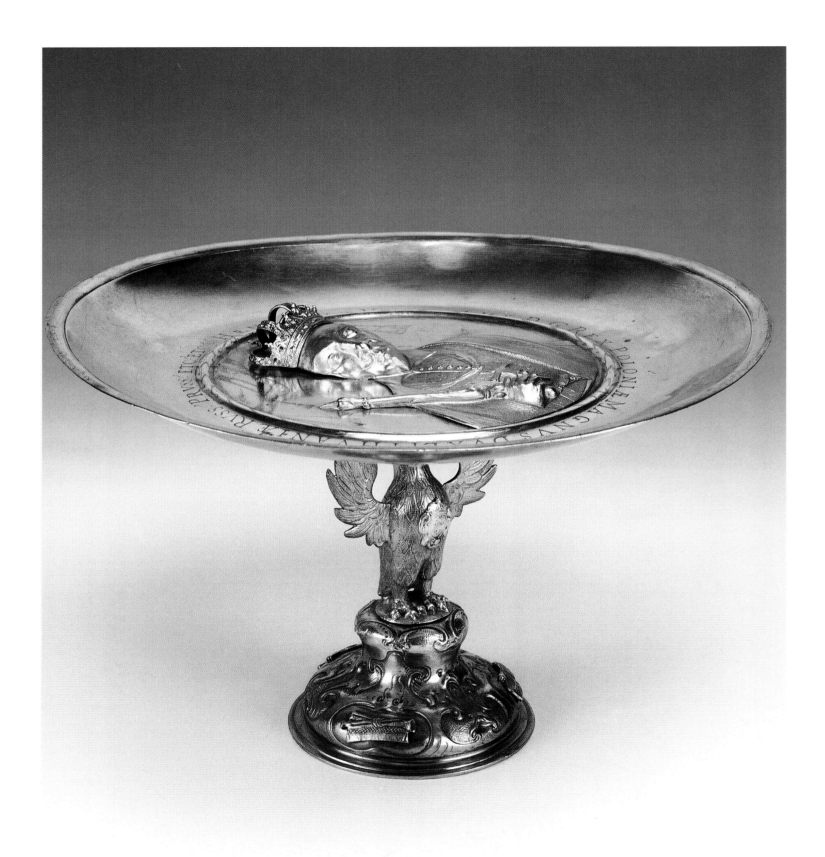

142

This footed dish bears a medallion with a portrait of Henry of Valois. Around the bust of the king is the incised majuscule inscription: *HENRICVS VALESIVS. D.G. REX POLONIAE MAGNVS DVX LITHVANIAE RVSS.PRVSS*. [ETC.] The vessel belonged to a set of twelve tazzas bearing portraits of the kings of Poland, from Ladislas Jagiello to John Casimir, each carrying a cartouche with the arms of the portrayed monarch. The tazzas were probably a gift from the city of Gdańsk to John Casimir soon after his accession to the Polish throne in 1648. They were wrought in the Gdańsk workshop of Andreas Mackensen I, court goldsmith to King Ladislas IV. In 1666 the king presented them to Jan Kazimierz Krasiński, grand treasurer of the crown, on the occasion of the wedding of the latter's son, Jan Bonawentura, with Teresa Chod-kiewicz, daughter of the castellan of Vilnius. Thenceforth they were kept in the family collection, and from the early twentieth century in the library of the Krasiński Entailed Estate in Warsaw. After the suppression of the Warsaw Rising in 1944 the Germans set fire to the library building together with its collection; after the war the badly damaged fragments of the tazzas were found in the debris and made over to the National Museum in Warsaw. As a result of conservation treatment four tazzas and one plate without its stem, as well as a medallion bearing a portrait of a king, have been recovered.

The exhibited tazza rests on a domed foot decorated with a repoussé auricular ornament. The stem in the form of a fully molded Polish eagle, with the heraldic stylization of its wings, bears an armorial cartouche on its breast, containing the family arms of Henry of Valois: three fleurs-de-lis of the Valois dynasty. The stem supports a circular plate with a broad plain rim, while at the bottom is an applied repoussé plaque with a bust of Henry of Valois in French attire, wearing a crown and holding a scepter in his right hand.

EM

22

TAZZA, C. 1650

ANDREAS MACKENSEN I (1596–1677), GDAŃSK

BEATEN SILVER; REPOUSSÉ, CAST, PARTLY GILDED

19 × 28 CM (7 1/2 × 11 IN.)

SIGNED WITH THE MARK OF GDAŃSK FROM THE MID-17TH C. AND WITH THE MONOGRAM OF THE GOLDSMITH *AM*

NATIONAL MUSEUM, WARSAW, INV. SZN 820

LITERATURE
Mille ans 1969, cat. 152; *Kunst des Barock* 1974, cats. 71, 72; *Sztuka dworu Wazów* 1976, cats. 251, 252; Lileyko 1983, 56, fig. 35; *Orzeł Biały* 1995, cat. IV.30.

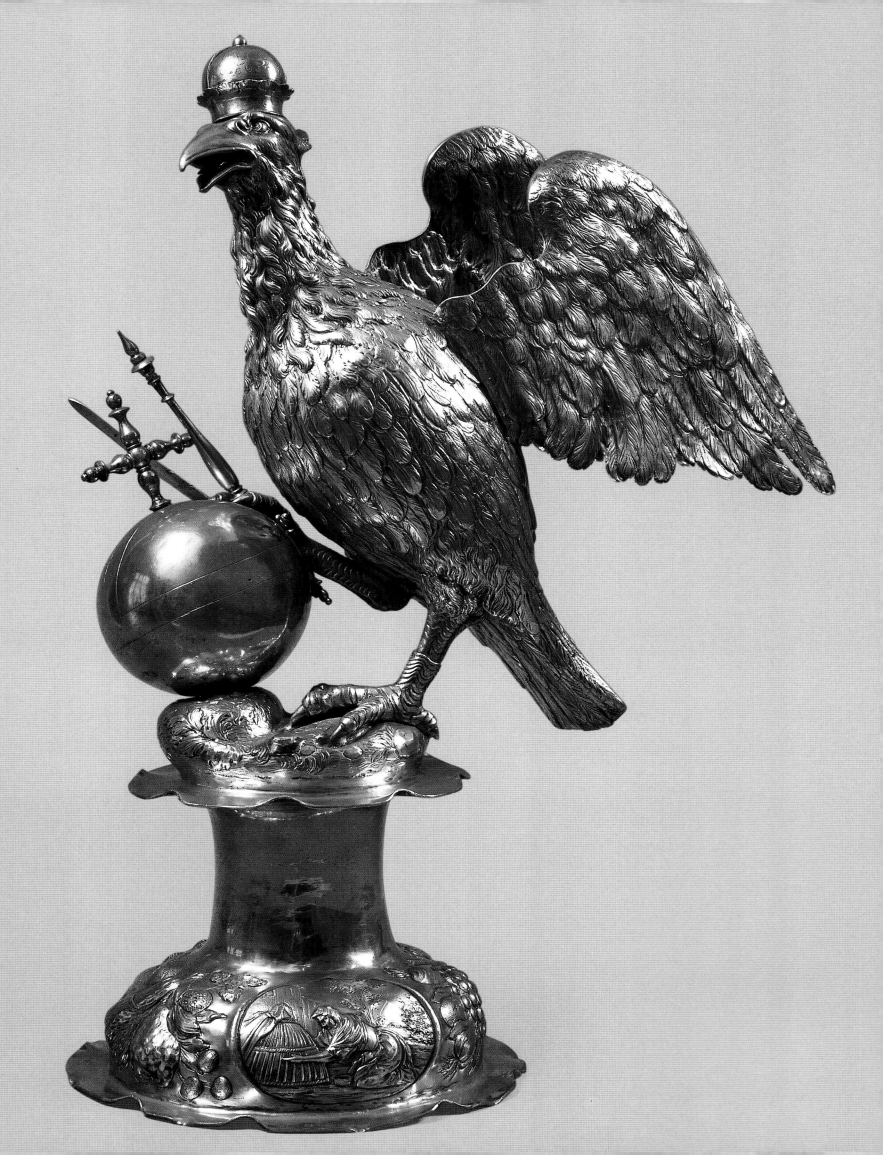

The silver table set, one of the symbols of the prestige of the Polish royal court, is known today almost exclusively from archival material. The chance surviving single pieces date from as late as the seventeenth and eighteenth centuries, these being for the most part the vessels made in Augsburg, a leading European center of the gold-smith's art in the modern era. Among them, an important position is held by a parade service wrought for John Casimir Vasa and in December 1671 presented in Moscow to Czar Alexis Mikhailovich by the envoy of the king of Poland, Michael Korybut Wiśniowiecki. Its centerpiece is a monumental eagle (Moscow, Kremlin, MZ 191) made in Augsburg by Abraham I Drentwett, and after his death in 1666 finished by Heinrich Mannlich. It is accompanied by figures of smaller sizes—heraldic symbols composed in free, baroque arrangements—among which it has been possible to identify the exhibited eagle, the Gotland Lion (Kremlin, Moscow, OP 1927), and, hypothetically, the Pursuit, a horseman on a rearing horse (Kremlin, Moscow, OP 1912), all having been executed by Mannlich. That the Wawel eagle was kept in Russia is confirmed by the nineteenth-century Russian marks of weight: *6 f[untów] 93 Z[ołotniki]* incised on the underside of the foot. In 1930 the eagle was recorded on the antiquary market.

The vessel in the form of the Polish eagle has an inlet stopped by a crown and an outlet through its open beak. The tall two-part oval base consists of a domed foot and a plain stem surmounted by the base proper for the figure. On the foot are bunches of fruit and unidentified emblematic representations: a wayfarer in front of a pyramid and a woman kneeling before a cage. The body of the vessel has the form of a fully wrought bird taking flight with spread wings, its right foot gripping the regalia comprising an orb, scepter, and sword. The other foot rests on a relief patch of ground with rocks, grass, and leaves. On the edge of the foot are the mark of Augsburg, a stone-pine cone, and of the goldsmith's workshop *HM* in an oval.

DN

VESSEL IN THE FORM OF THE
POLISH EAGLE, C. 1666(?)

HEINRICH MANNLICH (ACTIVE 1658–98),
AUGSBURG

SILVER, PARCEL GILT; BEATEN, CHASED,
CAST, REPOUSSÉ, ENGRAVED

48 CM (18 7/8 IN.); BASE 20.8 × 18.5 (8 1/4 × 7 1/4)

WAWEL ROYAL CASTLE, CRACOW,
INV. 6022, PURCHASED IN 1974 FROM
ANDRZEJ CIECHANOWIECKI

LITERATURE
Seling 1980, 3:210, cat. 1613c; Fischinger 1990,
85–90; *Orzeł Biały* 1995, cat. IV 31, fig. 87;
Nowacki 1995, 146–49, fig. 3a; *Narodziny Stolicy*
1996, cat. XII 32, fig. 75.

The book was dedicated to John III Sobieski, king of Poland, by Jan Hermanni in Rome on 2 January 1675 ("Sermoni detti da Gian Paolo Oliva e da Antonio Vieira della Compagnia de Giesj nella solennitB del B. Stanislao. In Roma, per il Lazzari Varese 1675"); in the introduction, the author discusses the merit of Saint Stanislaus Kostka, whose intercession was believed to have contributed to John III's victories over the Turks. According to the annotations and marks of ownership on the first leaves, the copy presented by Hermanni to the king was entered in the royal library; it was next in the libraries of Bishop Andrzej Załuski in Warsaw, of Roman Sanguszko at Sławuta, and of the Szydłowski family. The book was purchased for the Wawel Castle collections in 1957.

The baroque binding of red morocco on cardboard has lavish gold-tooled fan-shaped (*éventail*) decoration identical on the front and back covers. The panel is ornamented with an interlace border and a fan motif in the corner and bears the super ex libris of John III Sobieski in the center: a five-field shield surmounted by a closed crown repeated with the arms of Poland and Lithuania diagonally in opposite corners of the shield and the Janina coat of arms in the central field. The armorial cartouche is ornamented with scrolls and a pair of cherubs pointing at the crown.

A super ex libris, the mark of the owner of a book, tooled in the center of the front cover and representing the ornamental armorial bearing of the owner or his monogram, had been known in European countries since the fifteenth century, attaining the apogee of popularity in the sixteenth. With time it was replaced by a much more modest ex libris bearing the name of the owner of a library.

APe

24

BOOK WITH THE SUPER EX LIBRIS OF JOHN III SOBIESKI

OCTAVO, THREE UNNUMBERED LEAVES, PAGES 99 AND 79

BINDING: ROME 1675, RED LEATHER ON CARDBOARD, GOLD-TOOLED

17.2 × 11.5 CM (6 3/4 × 4 1/2 IN.)

WAWEL ROYAL CASTLE LIBRARY, CRACOW, SIGN. CIM. 5

LITERATURE
Odsiecz wiedeńska 1990, 1: cat. 165;
Tron Pamiątek 1996, cat. 184.

From the sixteenth to the eighteenth centuries Poland knew an idea of aristocracy that was different from the concept familiar in western Europe. Throughout the Middle Ages the whole country was ruled by members of the house of Piast. No other family had any traditional right to the title of duke or count or baron. With the formation of the legal system of the Polish-Lithuanian Commonwealth of the gentry in the sixteenth century the status quo was raised to an important principle of political structure. In theory, all members of the nobility enjoyed equal rights, the only formally recognized hereditary titles being those of dukes of the local Lithuanian and Ruthenian dynasties that had joined the Polish nobility. Of course, some Polish families acquired the title of prince or count from foreign monarchs, above all from the Holy Roman emperors. These titles had no legal validity, but the weak and inconsistent authorities were unable to enforce the interdiction against using them.

The absence of hereditary titles did not mean that there was a lack of differentiation within the numerous gentry. Achieving distinction was tied to two factors, political accomplishment and wealth. The history of Poland affords numerous examples of careers made by outstanding individuals who succeeded in raising their hitherto modest families to the top of the social ladder. In such cases a political career and the rapid making of a fortune as a rule helped each other. Inclusion among the magnates, the most wealthy and powerful of the gentry, occurred at the moment of attaining a custom-determined level in the two spheres but was not sanctioned by law, nor did it ensure any formal privileges. An ambitious careerist who began as a petty nobleman could become an influential and rich senator or minister, and his son could even reach for the royal crown, as in the case of Stanislas Augustus Poniatowski.

In Old Poland wealth was tantamount to power. The court of a powerful magnate was a political center not only deciding the local situation but frequently influencing that of the whole country and sometimes even conducting its own foreign policy. This was especially evident in the Lithuanian and Ruthenian territories, where many magnates' estates comprised several hundred villages and hundreds of thousands of serfs. Individual magnates often had fortunes larger than the royal property, and their private armies, when put together, exceeded in force the army of the Commonwealth.

An important role in creating the magnates' splendor was played by their artistic aspirations. They found it indispensable to have suitably grand residences, and the requirements of comfort and prestige necessitated their proper furnishing. Furthermore, the magnate's position obliged him to undertake religious foundations on a proper scale. Despite the politically destructive role of the magnates, it is to them that we owe the richest part of the heritage of Old Poland.

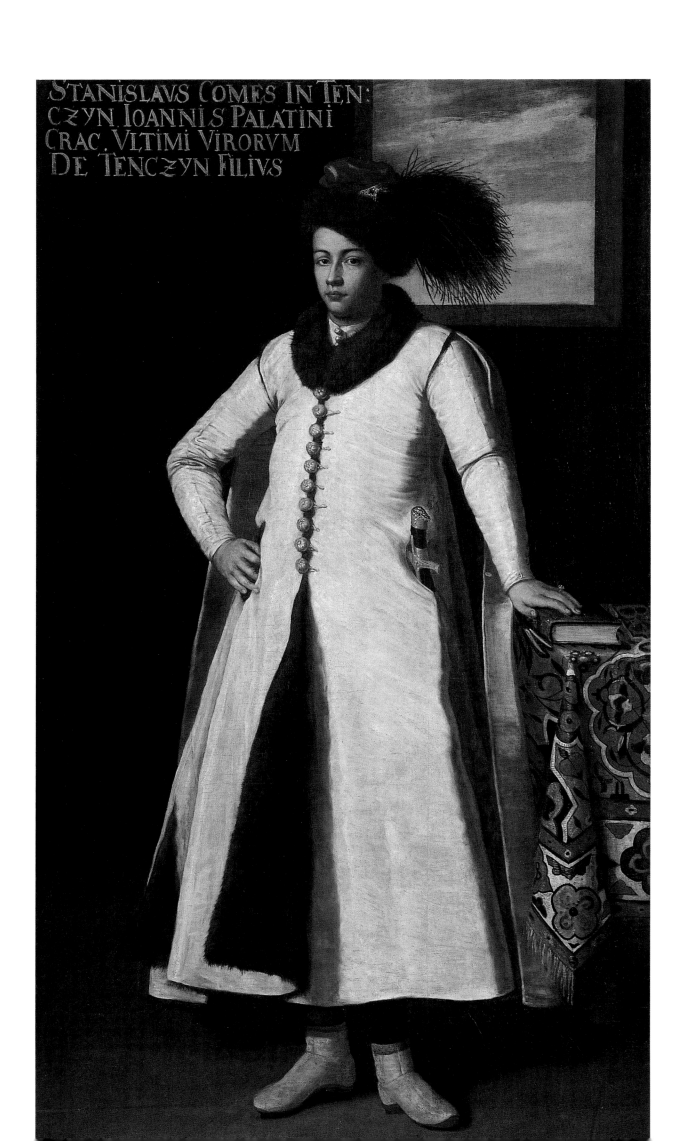

STANISLAVS COMES IN TEN:
CZYN IOANNIS PALATINI
CRAC. VLTIMI VIRORVM
DE TENCZYN FILIVS

Count Stanisław Tęczyński (1611–34) was the youngest of the three sons of Jan, palatine of Cracow, and also the last descendant in the male line in the family. Tradition has it that he died from wounds sustained during a boar hunt in Kamieniec Podolski, where he had stayed at the time of the Polish-Turkish military conflicts.

The evocative manner of portraying the model encourages the assumption that the portrait was painted in Stanisław's lifetime; the inscription, referring to his father as the last (living) male descendant of the family, was added after Stanisław's death. Originally the painting was in Tenczyn Castle near Cracow, the family residence of the Tęczyńskis; from the second half of the eighteenth century it was in turn in the hands of the Czartoryski, Lubomirski, and Potocki families; from the first quarter of the nineteenth century until World War II it was alternately in the Potocki palaces in Krzeszowice and Cracow. In 1945 the portrait was taken over by the state.

Stanisław is portrayed standing, his left hand resting on a book that lies on a table covered with a Persian rug. He is dressed in a typical Polish nobleman's costume: a white *żupan*, discernible below the neck, and a fur-lined *delia* in a similar color; on his feet are yellow boots, on the head a red *kolpak* (cap) with a dark plume; at his side, from under the *delia*, protrudes the hilt of a *karabela* saber. The dark background is enlivened by the blue sky outside the window. In the upper left-hand corner is the Latin inscription *STANISLAVS COMES IN TEN. / CZYN IOANNIS PALATINI CRACOVIENSIS VLTIMI VIRORUM DE TENCZYN FILIVS.*

The Persian rug on the table, a product of Kashan, has its close analogy in a carpet owned by a private collector in Kuwait. The likeness of Tęczyński is one of the two known portraits that depict carpets from Kashan (the other is *Portrait of a Senator* by Leandro Bassano, Ashmolean Museum, Oxford).

The exhibited portrait, combining the formal qualities of western European painting with the colorful *realia* of "Sarmatian" culture, ranks among the most beautiful and, since the romantic period, best-known portraits of Polish noblemen of the seventeenth–eighteenth centuries. Researchers have linked it with the northern Italian artistic milieu, in particular with the Venetian school and its chief exponent in Poland, Tommaso Dolabella, or sometimes with the painting of the Netherlands. The composition with a carpet-covered table and a window in the background, the restrained ease and natural pose of the model, the type of slightly idealized face with delicate features and a gentle look, and finally, artistic merit, a harmony of somewhat subdued reds and browns with blues as well as a soft gradation of chiaroscuro effects, are qualities found in the portraiture of Paolo Veronese, Jacopo Tintoretto, and the Bassanos. The attribution linking the portrait of Tęczyński with Dolabella, a follower of late sixteenth-century Venetian painting who was brought to Cracow by King Sigismund III, is in accordance with oral tradition recorded first in scholarly literature in the middle of the nineteenth century.

KK

25

Stanisław Tęczyński,
c. 1630

Attributed to Tommaso Dolabella
(c. 1570–1650), Cracow

Oil on canvas

195 × 108 cm (76 3/4 × 42 1/2 in.)

Wawel Royal Castle, Cracow,
inv. 3223, made over by the
Ministry of Culture and Art in 1946

Literature
Rastawiecki 1857, 188; Kopera 1926, 193;
Dobrowolski 1948, 98; *Malarstwo polskie* 1971,
cat. 95; Kuczman 1972, 149–50; *Portret polski* 1977,
cat. 4; *Zbiory Zamku* 1990, cat. 43; Thijssen 1992,
83; Klose 1993, 30–32; *Gdzie Wschód spotyka
Zachód* 1993, cat. 64.

26

THE ENTRY OF JERZY OSSOLIŃSKI INTO
ROME, AFTER 1643

UNIDENTIFIED ITALIAN PAINTER; ROME(?)

OIL ON CANVAS

116 × 386 CM (45 5/8 × 152 IN.)

WAWEL ROYAL CASTLE, CRACOW,
INV. 4050, MADE OVER BY THE MINISTRY
OF CULTURE AND ART IN 1956

LITERATURE
Polonia 1975, cat. 172; *Zbiory Zamku* 1990,
cat. 44; *Narodziny Stolicy* 1996, cat. VIII 22.

Jerzy Ossoliński (1595–1650) was grand chancellor of the Crown and one of the most able diplomats under the kings of the Vasa dynasty. Appointed envoy with the mission of notifying Pope Urban VIII of the election of Ladislas Sigismund to the throne of Poland and of winning support for the king's policy, he demonstrated in Rome the truly oriental wealth of his retinue, numbering three hundred persons. Before entering Rome, the Polish dignitaries and courtiers in colorful noblemen's costumes as well as small detachments of various military formations were joined by cardinals and prelates representing the pope and by envoys from several European monarchs. The richly caparisoned horses (said to have cast their gold shoes) along with mules and camels lent color to this extraordinary pageant. The entry of Ossoliński into Rome on 27 November 1633 was, in the opinion of the inhabitants of the eternal city, one of the most splendid ceremonies of this kind and was also engraved on the Poles' historical consciousness for many years to come. The envoy returned home with the title of prince, *princeps Ossoliński dux in Ossolin*, conferred on him by the pope.

The inscription in the picture defines Ossoliński as grand chancellor of the Crown, the dignity he received in 1643, a terminus post quem for the dating of the painting. Prior to World War II the picture was in the Zamoyski collection in the Blue Palace in Warsaw, and after the war was taken over by the state.

The composition, of a panoramic character, shows a winding, colorful pageant against a background of Rome with the dome of Saint Peter's. Each group of participants in the entry is marked with a letter of the alphabet; in the bottom left-hand corner a stone pedestal bears the papal arms of the Barberini and an explanatory inscription in Italian: *ENTRATA IN ROMA DELLE CC[LARISSI]MO / AMB[ASCIATO]RE DI POLONIA L'ANNO 1633* (The Entry into Rome of His Excellency the Ambassador of Poland in the year 1633), subsequently describing particular segments of the pageant: *A*, Jerzy Ossoliński's cavalrymen; *B*, the cardinals' mules; *C*, camels; *D*, trumpeters of the Holy Church; *E*, archers; *F̄*, pages in Persian costumes; *G*, pages of the Holy Church; *H*, parade horses; *I*, Master of the Horse of the Holy Church; *L*, camels of the Holy Church; *M*, cardinals; *N*, Polish dignitaries and Roman princes; *P*, Jerzy Ossoliński in attire of cloth of gold, on a horse with trappings set with gold; *Q*, prelates of the Holy Church; *R*, carriage of the Holy Church.

The unidentified painter, surely from the Roman milieu, relied for his composition in part on works by the well-known copperplate engraver Stefano della Bella, an eyewitness to the ceremony. The ease with which the artist unfolds his pictorial narration and the accuracy of rendering the colors of the Polish costumes encourage the supposition that the author of the picture also knew the spectacle from direct observation.

KK

Sewer Jan Andrzej Morsztyn was from 1647 *stolnik* of Sandomierz, from 1658 grand referendary of the Crown, and from 1668 to 1683 grand treasurer of the Crown. In 1683 he was accused of high treason and, having resigned his office, left Poland and settled in France, where he acquired an estate and the title of count of Châteauvillain. Morsztyn was one of the foremost poets of the Polish baroque period.

The inscription on the reverse of relined painting was transferred from the original: *Effigies Illüstris Andreae de Raciborsko Morsztyn Supremi Polo: / niae Regni Thesaurarii picta Lutetatie Parisiorum / Anno Domini. 1690 a Pictore Rygou.* The portrait was probably painted in Paris in 1690 in the studio of Hyacinthe Rigaud, a leading portraitist at the court of King Louis XIV. The work was originally oval and smaller (95 × 88 cm); when the canvas was enlarged, some elements of staffage were added (lengthening of the sash, the helmet, and the hilt of the smallsword). The painting has been kept in the Morstin family collection, before 1939 at Pławowice and then in Cracow and Warsaw.

The standing figure is rendered to his waist, posed at a three-quarter angle with his head turned toward the viewer, his left hand resting on the head of a cane. He wears a wig and armor with a lace jabot tied at the neck; at his left side is an amply draped sash, below is the richly ornamented hilt of a smallsword. On the left on the table lies a helmet. In the perceptively rendered face, with sharp features picked out with strong chiaroscuro, the viewer's attention is focused on the eyes; their suggestive expression as well as an indulgent smile aptly characterize the intellectual and psychological traits of the personality of an aristocrat and poet. The background is neutral brown. The tone of the painting is rather dark, with chiaroscuro reflections in fine impasto touches applied to the face, the armor covering the arm, the hand, and the sash at the side.

Although the portrait of Morsztyn is not mentioned in the painter's book of accounts published by J. Roman (see Ryszkiewicz 1967, 12), its style and high artistic quality raise no doubt as to its authorship. In Rigaud's output the portrait of Morsztyn should be counted among his intimate unofficial works: devoid of elements of sumptuous staffage, it accentuates the portrayed man's social status more discreetly, by his gestures and facial expression. At the same time it is one of the artistically most mature likenesses of Polish celebrities of the late seventeenth century. A smaller, reduced replica of the portrait is kept in the collections of the museum at Wilanów (inv. Wil. 1199).

PM

27

JAN ANDRZEJ MORSZTYN, 1690

HYACINTHE RIGAUD (1659–1743), PARIS

OIL ON CANVAS

116 × 88 CM (45 5/8 × 34 5/8 IN.)

ROYAL CASTLE, WARSAW, INV. ZKW 385, BEQUEST OF LUDWIK HIERONIM MORSTIN; GIVEN TO THE NATIONAL MUSEUM IN WARSAW IN 1967 BUT INTENDED FOR THE ROYAL CASTLE, TO WHICH IT WAS TRANSFERRED IN 1982

LITERATURE
Mycielski 1911, pl. VI; Ryszkiewicz 1967, 12–13; *Portrety* 1967, cat. 138a; *Gdzie Wschód spotyka Zachód* 1993, cat. 160.

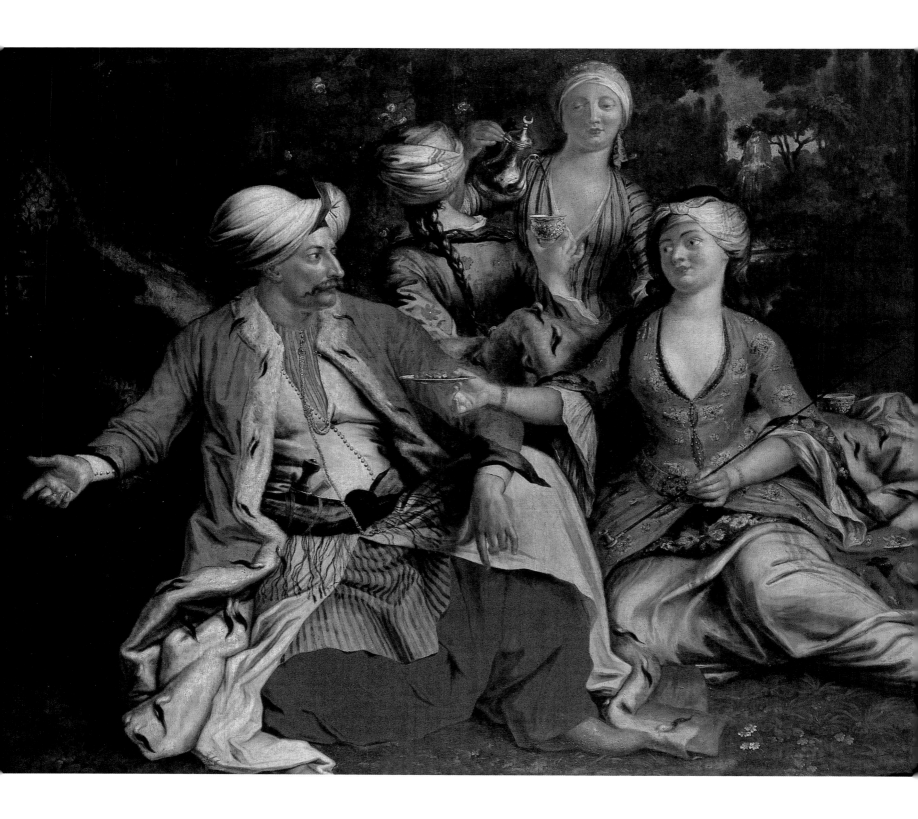

This is one of a series of four pictures representing genre scenes from life at the court of King Augustus II. Its pendant is entitled *A Coquettish Negress* (National Museum, Warsaw, at present deposited in the Royal Castle in Warsaw, inv. ZKW 230 Dep.), and the remaining paintings of the series are titled *A Game of Dice* and *A Courting Negro*. The series was painted for the king to decorate the Saxon palace in Warsaw, the residence of the monarch himself and of his son and successor Augustus III. The pictures are entered in the 1739 inventory of the palace, entitled *Inventarium über die Sämtlich Königl. Meubles zu Warschau* (Staatsarchiv Dresden, 3603), as nos. 462–65. Nothing is known about their fate after Augustus III's death in 1763; they were not included in the collection of his successor, King Stanislas Augustus. In the present century they were kept in private collections in Warsaw including that of Prince Janusz Radziwiłł before the Second World War.

Coffee Table Scene is one of the rather early paintings showing the custom of drinking the beverage, which appeared in Europe in the seventeenth century through contacts with the Ottoman Empire. Tradition has it that after the repulsion of the Turkish army, which in 1683 besieged Vienna, an immense supply of coffee fell into the victors' hands. Jerzy Franciszek Kulczycki, an interpreter of the Turkish language, was rewarded by the emperor, for his services during the siege, with the privilege of running a coffee house. Following Vienna's example, the custom of making and drinking coffee was adopted by the Wettin court first in Dresden and slightly later in Warsaw. The first coffee house in Warsaw was opened in 1724.

A reference in the above-mentioned inventory tells that the Mock picture represents the king's Turk, Nicolas, in the company of three Turkish women ("Der Königl. Türcke Nicolas mit 3 Türckinnen Caffée trinckend"). The women are waiting on the man, preparing his drink and offering him a pipe and sweetmeats. The costumes and the atmosphere of the scene are a good illustration of the way of viewing oriental culture typical of that period.

HM

28

COFFEE TABLE SCENE, EARLY 1730s

JOHANN SAMUEL MOCK (1687–1737)

OIL ON CANVAS

175 × 200.5 CM (68 7/8 × 70 IN.)

NATIONAL MUSEUM, WARSAW, INV. 129886, PURCHASED 1948, DEPOSITED IN THE ROYAL CASTLE IN 1983, INV. ZKW 230 DEP.

LITERATURE
Malarstwo austriackie 1964, cats. 153, 154.

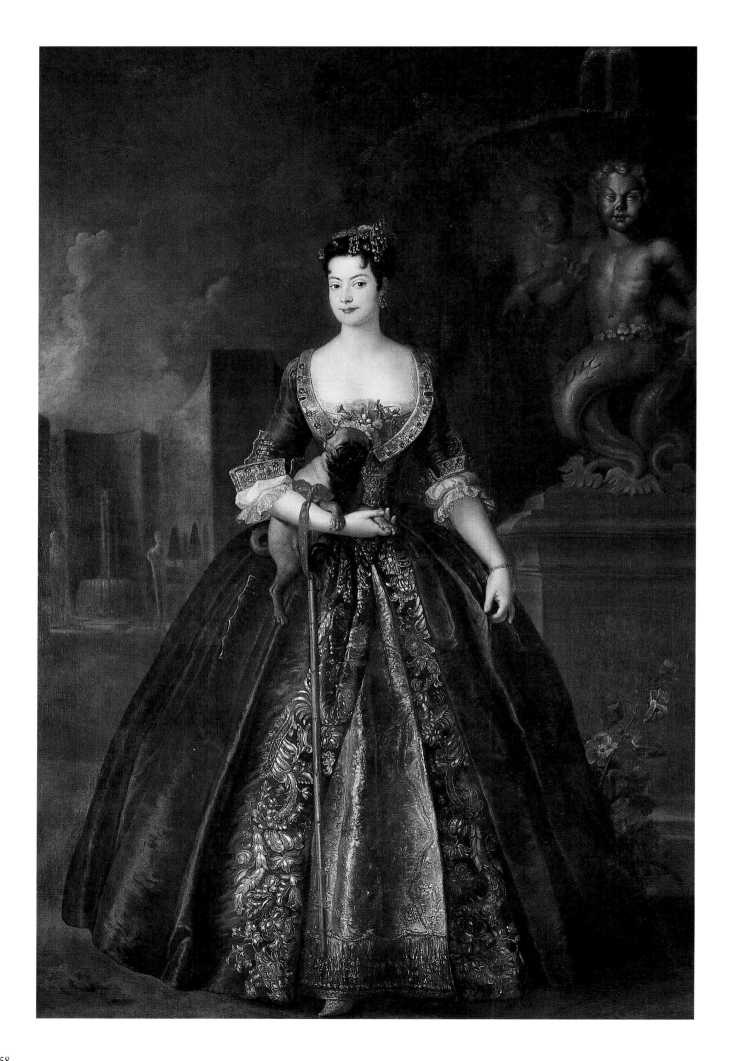

Anna Orzelska (1702 or 1707–69) was the natural daughter of King Augustus II and Henrietta Rénard-Duval, daughter of the owner of a wine-vault in Warsaw. Forgotten by her father, Anna was brought up in unknown conditions. Around 1724 she was found by her half-brother Fryderyk August Rutkowski, commander of Augustus II's household cavalry regiment. The king officially recognized her as his daughter, granted her the title of countess and the surname Orzelska, accorded her a regular stipend, and slightly later presented her with the Blue Palace in Warsaw. In 1730 she was married to Prince Ludwig Karl Holstein-Beck, with whom she had a son, Karl Friedrich. Divorced in 1733, she continued to lead a free life, spending most of her time in Italy and France. She probably died in Avignon or Rome.

The portrait was painted in the studio of Antoine Pesne around 1728, probably to the order of King Augustus II the Strong. It may have originally been intended for the interior of the Blue Palace in Warsaw. In all likelihood it found its way to Nieborów before 1736, when the palace was owned by the Lubomirski family. It may have been brought there by Karolina Fryderyka von Vitzthum-Eckstadt, wife of Aleksander Jakub Lubomirski. In 1774 it became the property, together with the palace, of Michał Hieronim Radziwiłł, remaining in the Radziwiłł picture collection at Nieborów until the end of the Second World War.

Orzelska is standing, her head slightly turned to her right. Her attractive face is adorned with dark hair dressed high and topped by a cone of jewels and flowers. She is wearing a blue gown of the "pannier" type, with a lace-edged low neckline and lace cuffs and with silvery embroidery lavishly decorating the front and sleeves. With her right arm she holds a pug and a long garden cane reaching almost to the ground, and with the left one is delicately lifting a fold of her gown. In the background is a view of a park with the Triton fountain and tall clipped hedges.

The portrait passed for the work of Louis de Silvestre. Its authorship was conclusively settled by Andrzej Ryszkiewicz, who ascribed it to the studio of Antoine Pesne.

Particularly noteworthy in the portrait are the fascinating face and the natural, lively rendering of the model's figure, these features distinguishing it favorably among many portraits painted in that period at the courts of Berlin, Dresden, and Warsaw.

ASz

29

ANNA ORZELSKA, C. 1728

STUDIO OF ANTOINE PESNE (1683–1757)

OIL ON CANVAS

233 × 157 CM (91 3/4 × 61 3/4 IN.)

MUSEUM AT NIEBORÓW AND ARKADIA, NIEBORÓW, INV. NB 485 MNW, MADE OVER IN 1945

LITERATURE
Jabłoński, Piwkowski 1988, 30, 135, fig. 105; Ryszkiewicz 1957, 163–67, fig. 9; Ryszkiewicz 1964, 80; *Malarstwo europejskie* 1967, 37, cat. 964; Rottermund 1970, 11–16, fig. 6; Piwkowski, Żółtowska-Huszcza 1993, 5, fig. 26.

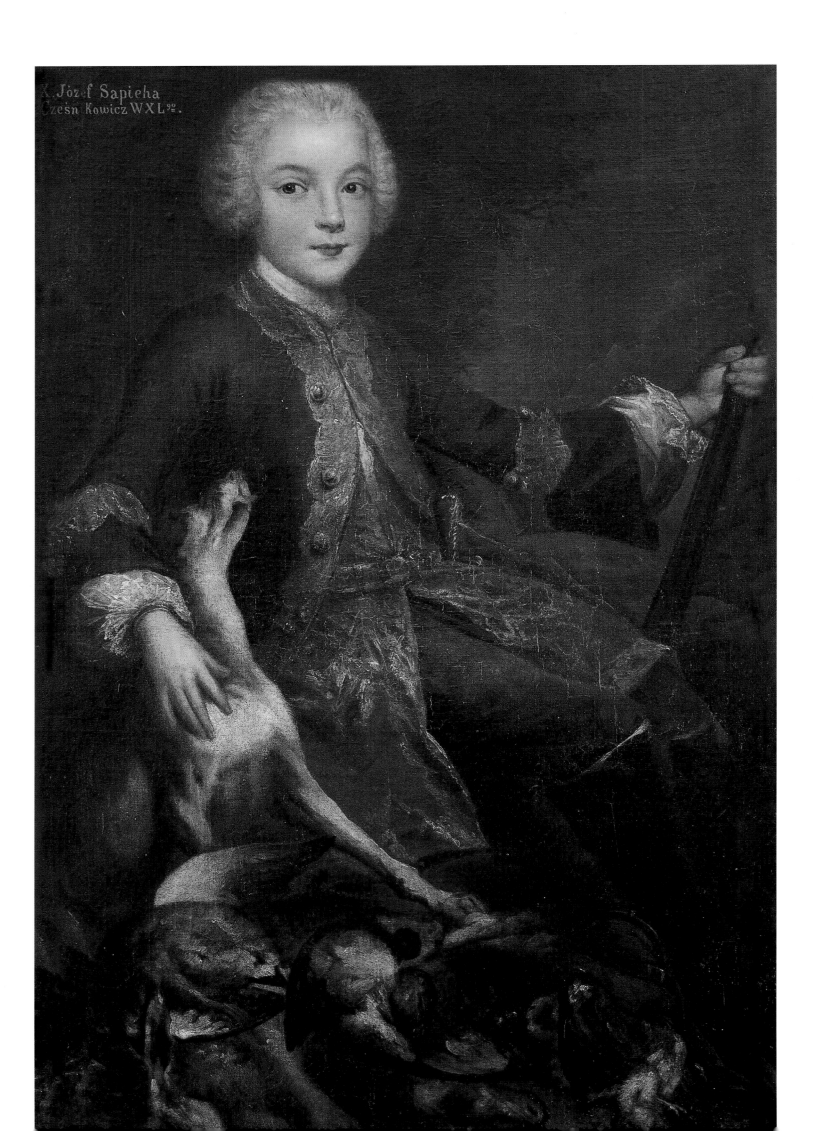

X. Józef Sapieha
Cześn Kowicz WXL[?].

Józef Sapieha (1737–92), son of Ignacy, cup bearer of the Grand Duchy of Lithuania and palatine of Mścisław, and Anna Cetner née Krasicka, became colonel of the Lithuanian army, 1766–84, esquire carver of the Grand Duchy of Lithuania, and confederate of Bar (during the Confederation of Bar, marshal of the district of Wołkowysk and deputy hetman of Lithuania). He was married in 1761 to Teofila Jabłonowska, daughter of the palatine of Nowogródek.

The portrait was initially suggested as the work of François Desportes (1661–1743); its authorship was convincingly changed to Augustyn Mirys (1700–90) by Andrzej Ryszkiewicz (*Malarstwo polskie* 1971). The place and circumstances of the portrait's execution have been determined only hypothetically. Ryszkiewicz identified it as Mirys' work from a reference in the 1792 inventory of the palace at Wielicko (translated as "Portrait of Prince Józef Sapieha, Sewer of Lithuania, as a boy of seven years of age, landscape, a hunt. The portrait itself copied from the earlier original. In the said inventory the painter is called Mirys Augustyn"). Józef Sapieha was seven in 1744, hence the portrait may be dated to that time. Ryszkiewicz indicated a document from which it follows that Mirys had portrayed Józef and Jan, both sons of Ignacy Sapieha, his stepson Ignacy, and Eleonora née Cetner at Nadwórna, the Sapieha manor in eastern Galicia (Ryszkiewicz 1961). It was transferred to the National Museum by the Ministry of Culture and Art.

The portrait represents a boy in a small powdered wig, wearing a green coat (*kaftan*) and red waistcoat, both sumptuously embroidered in gold, a white shirt, dark green breeches, and dark leather high boots. He sits on a rock, turned three-quarters to his right, looking straight at the viewer; with his right hand he is patting a dog at his side and with the left grasping a rifle leaning against the rock. At his left side can be seen the straight hilt of a hunting knife suspended from a belt. Heaped at his feet are dead small game, a hare and three black and white birds. In the background, on the left, is a dark green, almost black slanting wall overgrown along its edge with small plants; on the right are dark gray clouds outlined against a deep blue sky. The delicate face has been painted in glazes, and the effective details of the costume, including the embroideries gleaming with gold, are rendered almost texturally with impasto. The saturated coloring is today darkened.

The young Józef Sapieha was portrayed as a hunter, the painting being composed as a mirror image of the *Self-Portrait of F. Desportes*, 1699 (Musée du Louvre, Paris), where the painter-animalist depicted himself surrounded by hounds and with hunting trophies. Mirys must have used an engraved copy of this portrait as a model.

MO

30

JÓZEF SAPIEHA, C. 1744

AUGUSTYN MIRYS (1700–90)

OIL ON CANVAS

110 × 76 CM (43 1/4 × 29 7/8 IN.)

INSCRIPTION IN CREAMY WHITE OIL PAINT:
X. JÓZEF SAPIEHA CZEŚN KOWICZ WXL 9º

NATIONAL MUSEUM, WARSAW, INV. 211646, DEPOSITED IN THE MUSEUM-PALACE AT WILANÓW, MADE OVER IN 1945

LITERATURE
Ryszkiewicz 1961, 53; *Malarstwo polskie* 1971, 409; *Gdzie Wschód spotyka Zachód* 1993, cat. 257.

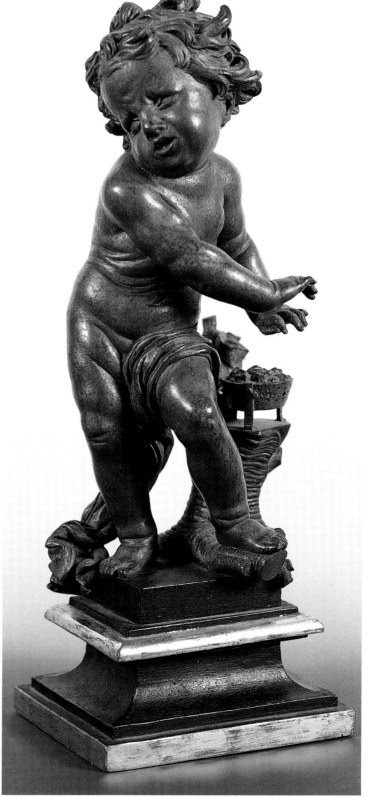

utumn is personified as a child in a wreath of grapevine leaning against a tree trunk, with a bunch of grapes and a festoon of vine in his hands, whereas Winter is a child with his hair streaming in the wind and a grimace of pain on his face, warming himself by a brazier. Four figures personifying the seasons (*Spring*, *Summer*, *Autumn*, and *Winter*) were carved for Elzbieta Sieniawska, commissioned 1728/29 from Hoffmann to his own designs. They were intended for the palace at Wilanów, which was at that time undergoing modernization. The palace, which had formerly belonged to King John III Sobieski, was purchased by Sieniawska in 1720. The sculptures formed part of the furnishings of the palace when it was given over to Augustus II for life (from 1730) by Maria Zofia née Sieniawska, widow of Stanisław Denhoff, palatine of Połock. In the late 1770s the figures were placed in the apartment of Izabela Lubomirska in the palace at Wilanów.

The four discriminating studies of a child's body and facial expressions were created with the keen observation of nature so characteristic of Hoffmann's art. They were composed to be set in pairs of contrasting seasons: *Spring* and *Autumn*, *Summer* and *Winter*, each bearing its specific attribute. Personifications of the seasons were among favorite themes particularly in the late baroque period. Associated with symbols of the passage of time, they were frequently linked with ideas relating to love; the *Four Seasons* cycle carved by Hoffmann was to be displayed in the palace at Wilanów in reference to the latter theme.

JG

31

PERSONIFICATIONS OF THE SEASONS, 1729/30

JOHANN ELIAS (JAN ELIASZ) HOFFMANN (C. 1691–1751)

LIMEWOOD; PAINTED WITH POWDERED COPPER, VARNISHED, GILDED

A, AUTUMN
44.5 CM (17 1/2 IN.)

B, WINTER
42.5 (16 3/4)

MUSEUM-PALACE AT WILANÓW, WARSAW, INVS. WIL. 2871, M2872

LITERATURE
Bohdziewicz 1964, 73–74; Fijałkowski 1969, 262; *Kunst des Barock* 1974, 25–26, cats. 32–35; *Polonia* 1975, 90, cats. 67–70; Gajewski 1992, 227; *Pod jedną koroną* 1997, 442, cat. XIV 50.

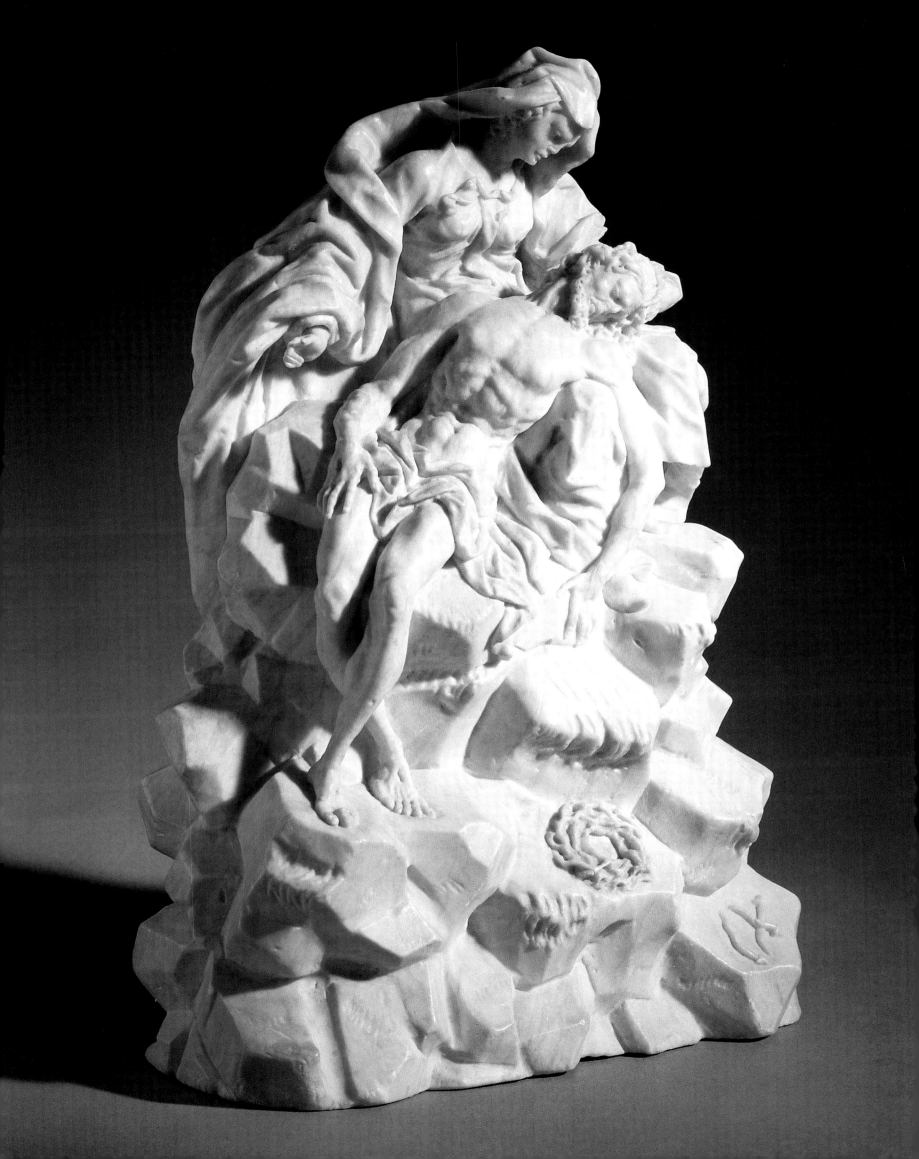

Mary is seated on a high rock, her son's head resting on her lap as his body slips down. This composition in the round is mystical in mood and at the same time dynamic. The arrangement of the slender bodies of Mary and Christ is refined, the robes expressively folded. Mary's subtle features have a lyrical expression. This small sculpture is intended for private devotion, recalling ivories, similar in type, carved in Bohemia and southern Germany, but is an exception in the oeuvre of Lehnert, an artist from Opava, who was mainly responsible for the sculptural decoration of church interiors. It may be supposed that the *Pietà* was carved in Cracow, where between 1744 and 1747 Lehnert worked for the Paulite church On Skałka. The subtlety of the rendering suggests a young artist, so it cannot be ruled out that the sculpture was executed earlier, in Opava. The work is signed *J. G. Lehner / fecit*.

In 1997 Mary's right hand was reconstructed by Jan Kostecki.

KK

32

PIETÀ, 2ND QUARTER 18TH C.

JOHANN GEORG LEHNERT
(ALSO LEHNER, MENTIONED FROM
1718, D. 1771), CRACOW OR OPAVA

ALABASTER

33.2 × 22 × 10 CM (13 × 8 5/8 × 4 IN.)

WAWEL ROYAL CASTLE, CRACOW,
INV. 7723, PURCHASED IN 1992 FROM
ANTONI POTOCKI OF CRACOW

LITERATURE
Nabytki 1993.

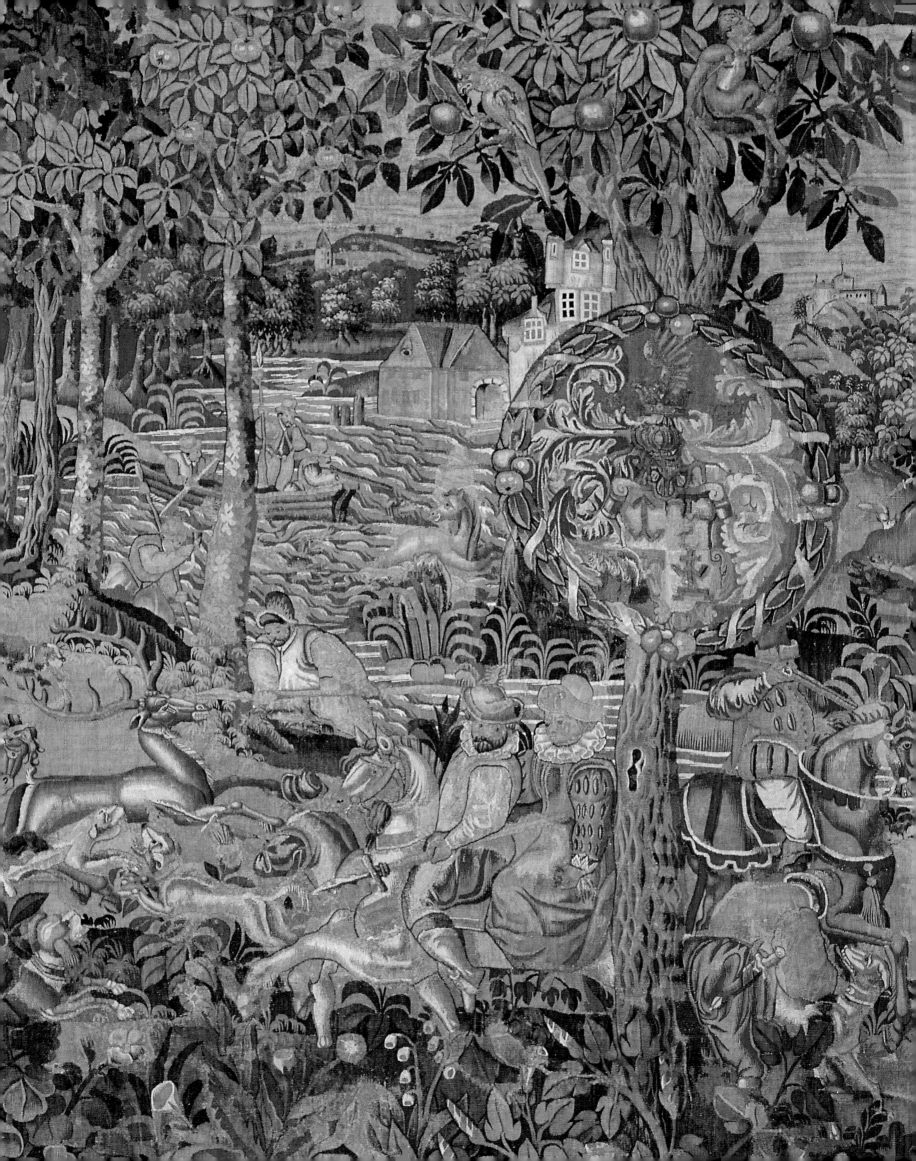

Depicted in woodland scenery, with a castle on the lake in the background, are two hunting scenes, a stag hunt on the left and a boar hunt on the right. In the center is a laurel wreath attached to a tree trunk, and inside the wreath, beneath the crest with mantling, is a cartouche containing the arms of the Chalecki family: Kroje and Lichtarz. Above the cartouche are the initials *D.Ch.* The arms and initials refer to Dymitr Chalecki, grand treasurer of Lithuania (c. 1550–c. 1598). In the border is a roll-work ornament enriched by bunches of ripe fruit, and in the corners are symbols of the four elements: earth, air, fire, and water.

The custom of decorating castle and palace interiors with tapestries, ushered in by the kings of Poland in the early sixteenth century, gained popularity with time. It was adopted by powerful dignitaries, bishops, and high officials. Particularly treasured today are those few extant tapestries that were woven specifically to Polish order, as is evidenced by the armorial bearings on them. They were made either in well-known European centers of tapestry weaving or, especially in the later period (eighteenth century), locally in court workshops whose production was designed exclusively for their owners' use.

The Chalecki tapestry represents the first group. It is woven with five to six threads of warp to the centimeter. The National Museum in Warsaw has another piece depicting a lion hunt from the same set.

MH-B

33

TAPESTRY OF DYMITR CHALECKI,
4TH QUARTER 16TH C.

FLANDERS, PROVINCIAL WORKSHOP

WOOL, SILK, SILVER

400 × 432 CM (157 1/2 × 170 IN.)

WAWEL ROYAL CASTLE, CRACOW,
INV. 4694, GIVEN IN 1962 BY
JULIAN GODLEWSKI OF ZURICH

LITERATURE
Szablowski 1963, 36; *Gobeliny* 1971, cat. 23,
fig. 18; *Zbiory Zamku* 1990, cat. 18; *Sigismund III*
1990, cat. 13; Hennel-Bernasikowa 1998.

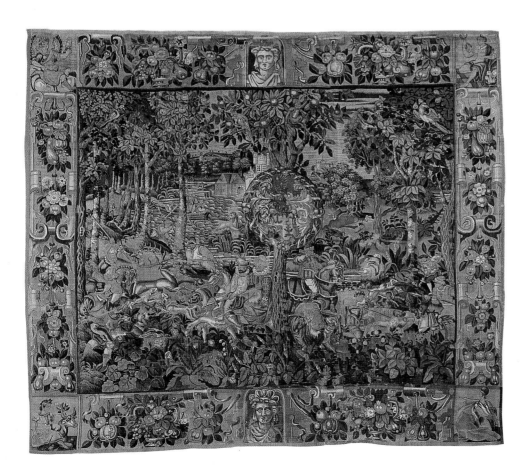

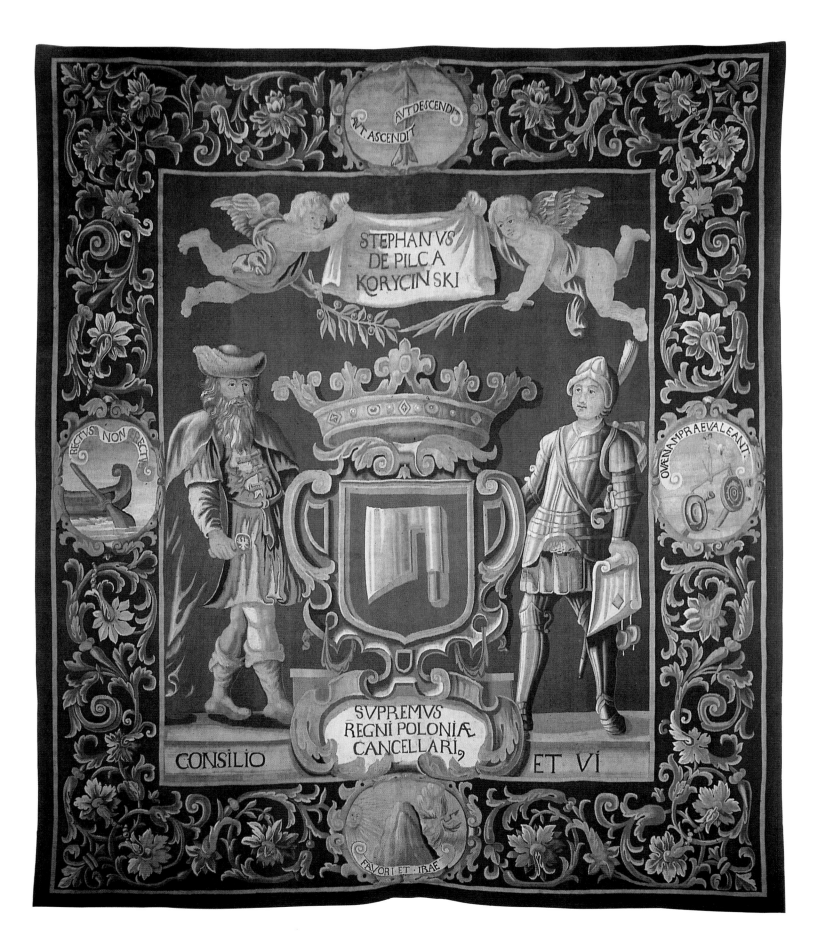

The tapestry was made at the order of Stefan Koryciński (1617–58), *starosta* of Ojców, grand chancellor of the Crown 1653–58. He distinguished himself by his courage in battles with the Cossacks at Beresteczko and Żwaniec and accompanied King John Casimir in his escape to Opole Silesia during the Swedish invasion. The tapestry was part of a series of several pieces, of which three have survived. They were commissioned by Koryciński to decorate his family residence at Ojców when he held the office of chancellor. The ideative draft design must have been presented to the chancellor by someone from his court and was reproduced in an undetermined Dutch or northern German workshop. In the nineteenth century it was owned by Sallab, a lieutenant in the Austrian army, until 1912 by Maurice Scheps, editor of *Tageblatt*, a periodical in Vienna, and subsequently passed into the hands of Baron Götz-Okocimski. Conservation on the tapestry was undertaken in 1994–96.

The warp is of linen and measures six to nine threads to the centimeter. The weft is of wool, twenty to thirty-six threads to the centimeter; silk, eighteen to thirty-eight threads to the centimeter; and linen, twenty-two to thirty-four threads to the centimeter. On the dark green ground of the central panel is a cartouche with the Topór arms surmounted by a coronet, resting against an inscribed horizontal cartouche supported by two figures. One is an old man holding a seal with an eagle in his hand, dressed in a braided knee-length costume with a silk sash tied around the waist and a long red cloak; the other is a young man clad in armor, holding a scroll with seals. An inscribed cloth above is supported by two putti with a palm and an olive branch in their hands. The dark green border is filled with interlaced light green acanthus stems and leaves, large stylized flowers, and four emblematic representations disposed axially: a boat and oar, an arrow pointing upward, a pair of scales with suspended weapons, and a rock sunlit on one side and struck by lightning on the other.

This is one of the very few baroque heraldic textiles woven in western Europe for Polish patrons that have been preserved in Polish collections. It is an example of a heraldic textile glorifying the family and virtues of the person who commissioned it. It shows the patron's coat of arms, Topór, and clearly gives his surname and political functions in inscriptions in the central field: *STEPHANUS / DE PILICA / KORYCIŃSKI, SVPREMVS REGNI POLONIAE* [?] *CANCELLARI [US]*, and *CONSILIO* and *ET VI*; in the border, in the cartouche placed in the center of each band: left, *RECTVS NON ERECTVS*, right, *QVAE NAM PRAEVALEANT*; top, *AVT ASCENDIT AVT DESCENDIT*; bottom, *FAVORI ET IRAE*. His virtues are referred to by the allegorical figures Wisdom (the old man) and Valor (the young man). His services are also emphasized by the content of the emblematic representations in the border, supplemented with cautions, so typical of that epoch, as to the fickleness of fortune and the necessity of survival in the ups and downs of life.

AK-G

TAPESTRY OF STEFAN KORYCIŃSKI, 1653–58

HOLLAND OR NORTHERN GERMANY(?)

292 × 252 CM (115 × 99 1/4 IN.)

NATIONAL MUSEUM, KIELCE, INV. MNKI/R/890, PURCHASED IN 1956 BY THE NATIONAL MUSEUM IN WARSAW, IN 1972 MADE OVER TO KIELCE

LITERATURE
Pagaczewski 1929, 25–33, fig. 3; Göbel 1934, 249; Mańkowski 1954, 44, fig. 55; Barelli 1963, 96; Kwaśnik-Gliwińska 1984, 165–70, fig. 1; Kwaśnik-Gliwińska 1991, 44–48, cat. 11.

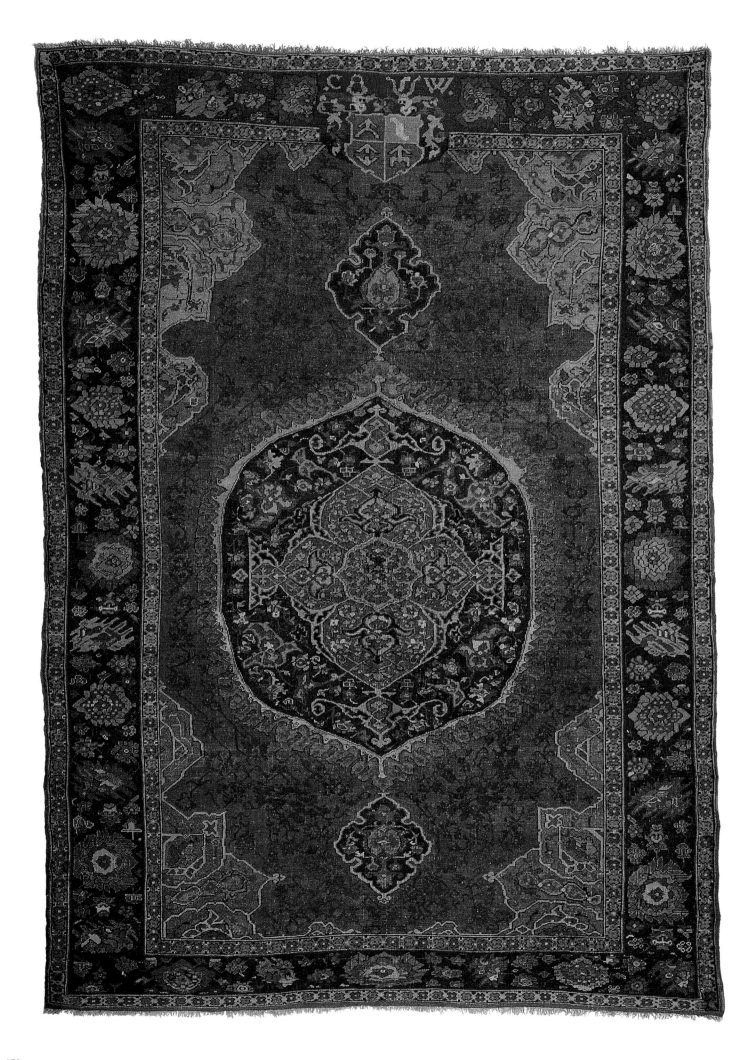

The taste for Near Eastern textiles, especially carpets, was responsible for their early importation to Poland from the best centers in Turkey and Persia. Following in the wake of the expensive imports, as early as the first half of the seventeenth century orders were placed in Kashan (Iran) or Ushak (Anatolia) for carpets with Polish armorial bearings and the monograms of the persons who commissioned them. A carpet with the arms of Jan Andrzej Próchnicki (1553–1633), archbishop of Lvov, today kept in a private collection in Sweden, is one of the products of those manufactories. Alongside the inflow of "originals," local manufactories began to produce successful imitations for the home market. The present carpet is believed to be one such product. It was commissioned by Krzysztof Wiesiołowski, bearer of the Ogończyk coat of arms, steward (1600), sewer (1620), court marshal and standard keeper of Grodno (1623), and grand marshal of Lithuania (1635), who died on 19 April 1637.

In the central field of subdued red is a large oval medallion with a quatrefoil bar medallion inscribed in it. Two small cartouches are placed on its axis. In the corners and at the longer sides are segments of medallions with a light green ground covered with vegetal arabesque. The upper border contains a quarterly escutcheon bearing the Ogończyk, Szreniawa, Bogoria, and Odrowąż coats of arms and the initials *CW*. The borders consist of three bands, the middle one being filled with palmettes and dentate leaves. The absence of the signs of the dignity of marshal in Wiesiołowski's armorial bearing suggests the dating of the carpet to the years before 1635.

The place of its production has been disputed by scholars for more than fifty years. The testament of his widow, Aleksandra Marianna Wiesiołowska (d. 1645), lists twenty-four "home-made" rugs bequeathed to the convent of the Brigittines founded by her in Grodno and several more to the executors of her will: five pieces to Kazimierz Leon Sapieha and twelve pieces to Michał Gedeon Tryzna (copy in the Glinka Files, Center of the Documentation of Historical Monuments, ODZ, Warsaw). On this basis attempts have been made to define the heraldic carpet as a product of the court workshop of the Wiesiołowski family. The quality and twist of wool and the regularity of knotting (754–936 knots per square decimeter), along with the precision of the reproduction of the design, do not differ from those in Anatolian specimens; consequently, they do not permit a conclusive determination of its eastern or local execution. Even the questioned coloring (green and yellow) has its analogies in an Ushak rug at the Museum of Islamic Art in Cairo (inv. 15766). In a twin specimen preserved at the Staatliche Museen in Berlin (inv. J 4928) the letters of the monogram are inverted, which might testify to the weaver's foreign descent.

The exhibited rug was originally on the Wiesiołowski estate in Lithuania or Polesie and was recovered from the Soviet Union in 1925. Since then it has been kept at Wawel.

MP

35

MEDALLION USHAK-TYPE CARPET OF
KRZYSZTOF WIESIOŁOWSKI, BEFORE 1635

TURKEY (ANATOLIA) OR POLAND

WOOL

348 × 227 CM (137 × 89 3/8 IN.)

WAWEL ROYAL CASTLE, CRACOW, INV. 240

LITERATURE
Mańkowski 1954, 70–73, fig. 76, pl. IX; Mań-
kowski 1959, 186–89; *Zarys dziejów* 1966, 215,
433–35, fig. 162; *Mille ans* 1969, cat. 144; *1000
Years* 1970, cat. 195; *Zbiory Zamku* 1990, 251,
cat. 139.

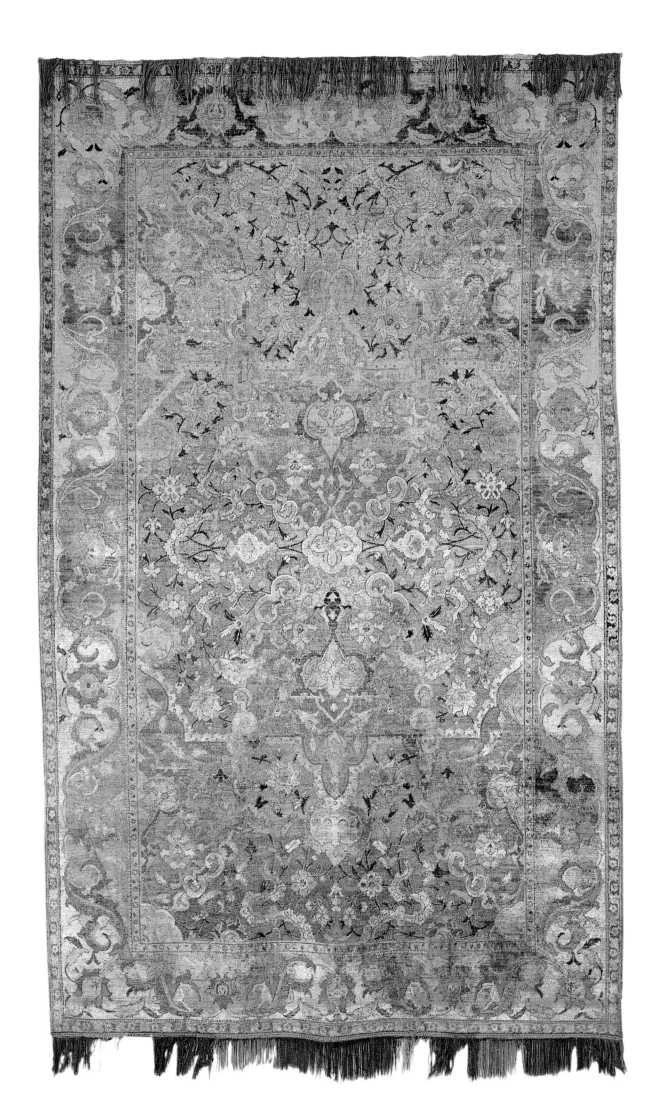

The carpet, probably captured in the Battle of Vienna in 1683, was given by King John III Sobieski to the treasury of Saint Mary's Church in Cracow. In 1895 the Jagiellonian University bought it from the church for its collection. The object belongs to a series of luxury products of the court carpet-weaving manufactory in Isfahan. In Poland, such textiles found their way to the royal and magnate courts during the seventeenth century through Armenian merchants or as war booty after the battles of Chocim and Vienna. Their name "Polish" was not coined until the late nineteenth century, in the period of European collectors' increased interest in Polish collections, which had retained most of these rugs.

On a cotton warp, the silk weft is tied with Persian knots at around 4,900 knots per square decimeter; the brocading is with silver thread on a white silk core and gilded thread on a yellow silk core. The decoration of the shorn parts of the design are harmoniously combined with the flat, brocaded areas. On the silver-gold ground of the central panel are motifs of scrolled tendrils, leaves, several kinds of palmettes and rosettes, and a "feathered snake" in beige, pink, yellow, gray, blue, willow green, turquoise, emerald green, and navy blue; in their distribution the principle of mirror and translation symmetry has been followed. The central field of a three-striped border bears a band of palmettes and silver-gold and partly multicolored leaves on creamy white and light green grounds. An analogy to the composition of the present carpet can be found in the wall painting of the Abaduaziz-Han madrasa of 1652 in Bukhara (Biedrońska-Słotowa 1987, 110).

AP

36

So-called Polish Carpet, 1st half 17th c.

Isfahan, Persia

Cotton, silk; knotted, partly brocaded with gold and silver

258 × 150 cm (101 1/2 × 59 in.)

Jagiellonian University Museum, Cracow, inv. 828

Literature
Mańkowski 1959; Spuhler 1968; Biedrońska-Słotowa 1987.

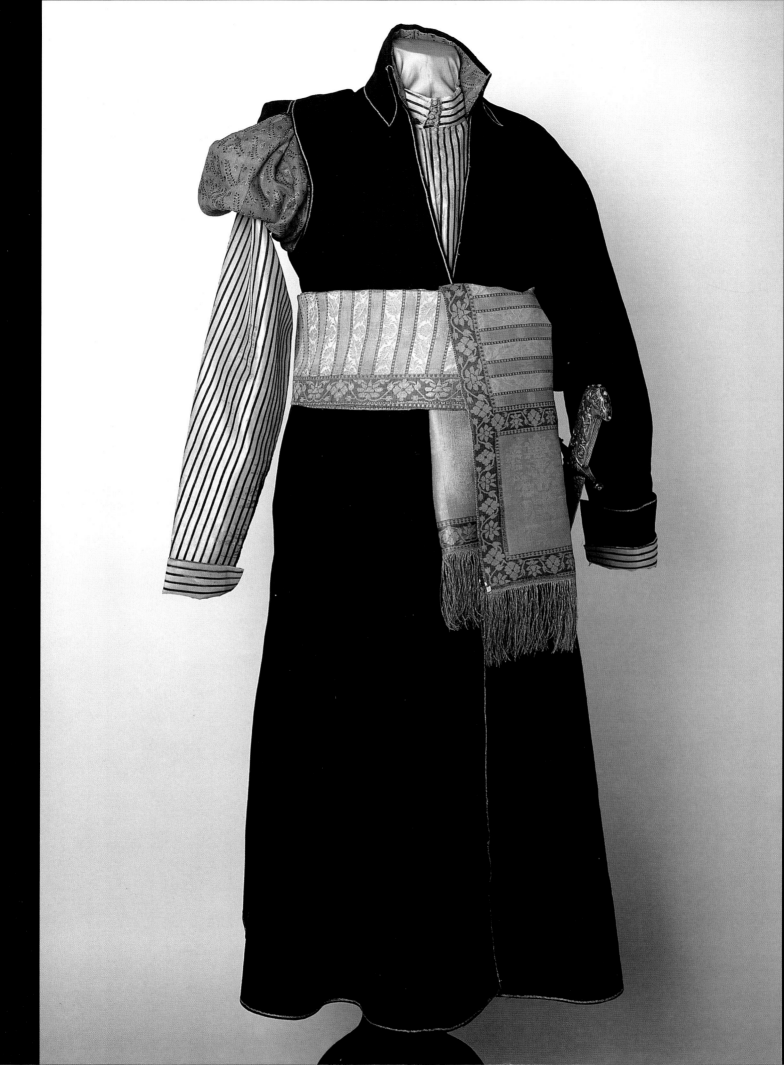

A *żupan*, worn under a *kontusz*, was usually made of costly, highly decorative silk fabric, which was used also for lining the sleeves and the skirts of the *kontusz*. The back of the *żupan*, hidden under the outer garment, was made of linen or cotton for economy. The *kontusz* and *żupan* formed traditional Polish attire from the end of the seventeenth to the early nineteenth century and even later, in the twentieth, when it still served as a ceremonial and occasional costume. In the second half of the eighteenth century a silk *kontusz* sash—highly decorative, fastened and tied in a special manner—became an indispensable element of this costume. A *kontusz* was usually made of thicker cloth than the *żupan*, revealing it underneath in its more decorative fabric, its color contrasting with that of the *kontusz*. The back of the long ample garment was styled to ensure free movement when walking or riding a horse.

The present *żupan* is of black-striped pinkish crimson silk. Close-fitting to the waist, the skirts of the lower part overlap slightly. It fastens to the neck with small passementerie buttons partly concealed, four of which are visible at the collar. A rather low stand-up collar adjusts at the back. The linen back is laced. Long fitted sleeves with turned-back cuffs fasten by hooks and eyes. There are pockets in the side seams. The garment is lined with fustian down to the waist.

The exhibited *kontusz* is of dark navy blue wool cloth with sleeves—thrown over the shoulders—of pinkish-crimson fabric in a pattern of scattered flowers and branches; it fits closely to the waist, and in the lower part the skirts overlap. Eight concealed passementerie buttons are sewn down the front. Above is a *V* neck with a high, stand-fall collar. The cut of the back is classic for the *kontusz*, with a central panel and pleats on either side. In the pleats are pockets braided, similarly as on all the edges of the garment, with gold purl. The long fitted sleeves are slit from the armpits down to the elbows, and the cuffs are turned back.

EO-M

37–38

ŻUPAN AND KONTUSZ, LATE 18TH C.

POLAND

37, ŻUPAN

SILK
120 CM (47 3/4 IN.); WIDTH OF
LOWER PART 282 (110)

NATIONAL MUSEUM, WARSAW,
INV. SZT 2815, PURCHASED FROM
GUSTAW BISIER, 1928

38, KONTUSZ

WOOL, BROCADED SILK
130 (51 1/8); WIDTH OF LOWER
PART 318 (125 1/4)

NATIONAL MUSEUM, WARSAW,
INV. SZT 2813, FROM WOJCIECH
KOLASIŃSKI'S COLLECTION,
PURCHASED AT AUCTION AT
RUDOLF LEPKE'S IN BERLIN, 1917

LITERATURE
Gembarzewski 1926, 11, cat. 46;
Tkanina i ubiór 1976, cat. 20.

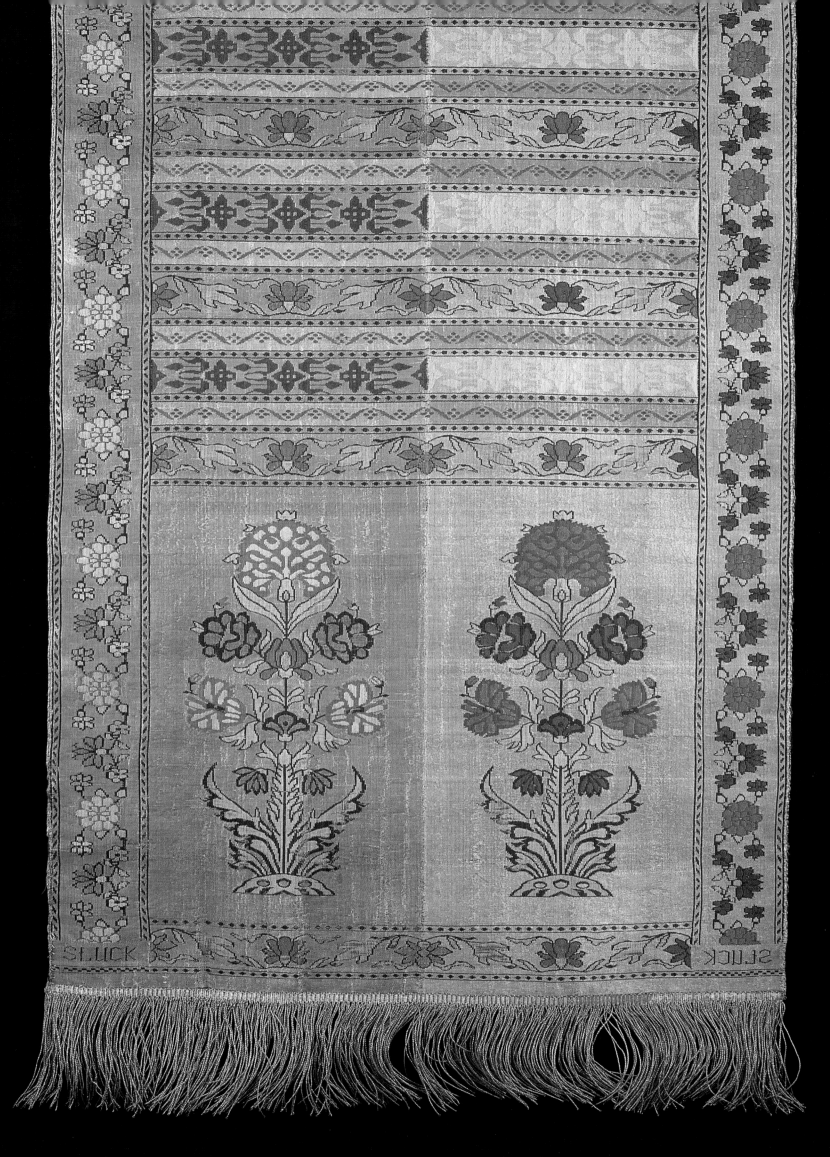

Such a sash was an accessory of the *kontusz* costume of a Polish nobleman and a symbol of his social status. This is one of the so-called four-sided sashes, that is divided along the obverse and reverse, by means of interlocking, into two halves of different colors. Appropriately folded before tying, with either one or the other side turned out, these sashes could be worn with different kinds of attire and were suitable for different occasions.

In the exhibited sash, silk, gold, and silver threads are woven in weft-faced compound tabby with brocading and interlocking. In the end panels are two symmetrical flowering shrubs; the central stalk is surmounted with a large carnation, and at the base is a small mound of earth. In the vertical borders is a continuous vegetal ornament with rosette-shaped flowers; in the horizontal borders the design is a vine with axial motifs of flowers shown in profile, rhythmically inverted, linked by elongated leaves. The stripes alternate, the first motif containing a simplified silhouetted vegetal ornament with axial quatrefoils and the second the same as the horizontal borders. Between the stripes are narrower bands carrying a simplified ornament of a regular undulating vine. The ground is half gold, half silver, and on the reverse is brown. On the gold ground the decoration is in cinnabar, blue, and pale celadon; on the silver, it is in cinnabar, dark green, and pale celadon. The ornament of the alternating stripes is crimson and straw yellow respectively.

The motif of carnations, borrowed from eastern (Persian and Turkish) belts, in a simplified and thicker stylization and in a different color scheme, was frequently used to decorate the end panels of Słuck sashes in the 1780s. Słuck, part of Poland in the eighteenth century, is now in the Republic of Belarus.

MT

39

GOLD LAMÉ SILK SASH, C. 1780

KAROL RADZIWIŁŁ'S MANUFACTORY
LEASED TO LEON MADŁARSKI AT SŁUCK

SILK, GOLD, SILVER

447 × 35 CM (176 × 13 3/4 IN.)

SIGNED *SŁUCK*

NATIONAL MUSEUM, CRACOW,
INV. MNK.XIX-2289,
GIFT OF FELIKS JASIEŃSKI, 1929

LITERATURE
Ceintures et costumes polonais 1972, 10, cat. 6;
Taszycka 1985, 83–84, cat. 7, fig. 9; *Orient* 1992,
76, cat. II/32, fig. 76.

In the end panels, on the axis, is a single motif of a low embossed vase with an asymmetrical bouquet of flowers of various kinds. At the top are two butterflies in flight and a birdcage suspended from a ribbon, shifted slightly to the right. In the borders are small, slightly asymmetrical sprays of roses, rhythmically inverted. The stripes alternate, the first motif being plain, the second being rows of scattered, slightly asymmetrical flower sprigs. The ground is salmon pink, the ornament in the end panels is red, pink, blue, shades of green, and gold in the vase and cage. The pattern of the borders and stripes is gold and golden yellow. The decoration of the sash, especially of its end panels, reveals the influence of the designs of French textiles, characteristic of the products of the royal silk manufactory in Grodno. The designer, undoubtedly one of the French artists employed there, referred in the motif at the sash ends to the style of decorative fabrics designed by the Lyons draftsman Philippe de Lasalle (1723–1803).

Grodno was part of Poland in the eighteenth century and is now in the Republic of Belarus.

MT

40

SILK SASH, 1768–80

ROYAL SILK MANUFACTORY, GRODNO

SILK AND GOLD THREADS; SATIN, LISÉRÉ, BROCADED

308.5 × 25 CM (121 1/2 × 9 7/8 IN.)

NATIONAL MUSEUM, CRACOW, INV. MNK.XIX-2466, GIFT OF FELIKS JASIEŃSKI, 1929

LITERATURE
Ceintures et costumes polonais 1972, 10, cat. 10, fig. 7; Taszycka 1985, 86–87, cat. 9, fig. 11.

In the end panels a medallion is repeated three times. Its form is a flattened oval radially overgrown with alternating short rose and carnation stems. In the vertical borders are rows of palmettes filled with axial floral stems (carnation, irises, and others). The horizontal borders contain rhythmically inverted palmettes as do the vertical ones. The first set of stripes, a continuous decoration of flattened multi-foliate motifs filled with stylized vegetal ornament, alternate with stripes as in the horizontal borders. Between the stripes are narrower bands containing a simplified vine with axial flowers. The background of the sash is golden except for the predominant stripes, whose ground is salmon-pink. The ornament is pink, blue, green, white, and silver outlined in brown and red.

The sash, signed *S.FILSJEAN / W KOBYŁCE*, was executed by a French weaver who probably came from Lyons. It is more akin to oriental prototypes than other *kontusz* sashes produced in Poland. It is broader than a typical Polish sash, and its end panels contain three instead of two motifs, the latter number being a rule in the decoration of Polish specimens. The motif of an oval medallion with radially arranged flower sprays, which decorates the end panels, is a clear borrowing from Persian sashes. Owing to the above-described features, it had passed for an oriental product until E. Swieykowski discovered the signature hidden in the hem of the sash.

The sash was the property of Jan Podhorski, captain of national cavalry, and was given to the National Museum in Cracow by his descendant, Edmund Podhorski, in 1889.

MT

41

GOLD LAMÉ SILK SASH, 1787–91

SZCZEPAN/ETIENNE FILSJEAN'S MANUFACTORY AT KOBYŁKA

SILK, GOLD, AND SILVER; WEFT-FACED COMPOUND TABBY, BROCADING, INTERLOCKING

408 × 39 CM (160 5/8 × 15 3/8 IN.)

NATIONAL MUSEUM, CRACOW, INV. MNK.XIX-2584, GIFT OF EDMUND PODHORSKI, 1889

LITERATURE
Swieykowski 1906, 269, cat. 392, fig. XXII;
Ceintures et costumes polonais 1972, 11, cat. 13;
Taszycka 1985, 88–89, cat. 12, fig. 14;
Orient 1992, 76–77, cat. II/33.

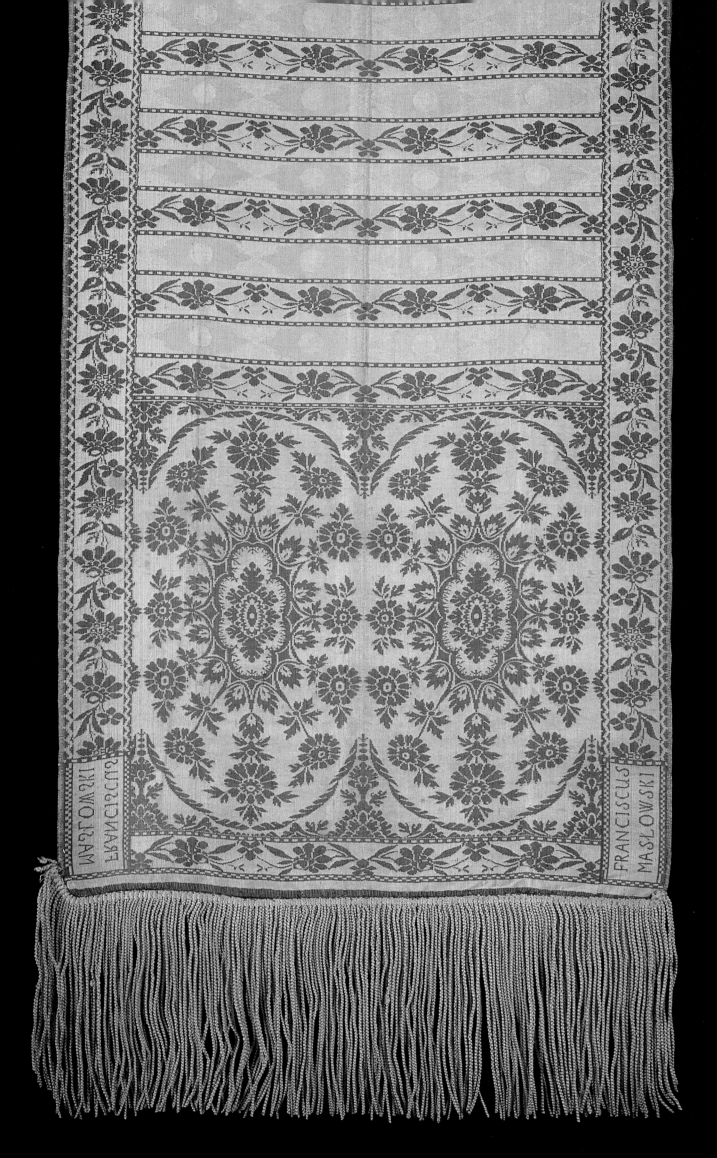

The end panels contain two joined oval medallions formed by narrow leaves. In the center of each medallion is a small six-leaf form overgrown with short floral sprigs in a radial arrangement. In the vertical borders are palmette motifs filled with single axial floral sprays (carnations, irises) turned edgeways. In the horizontal borders the motifs are as in the vertical ones, rhythmically inverted and dovetailed. Stripes form a continuous decoration of flattened elongated hexagons, with "pennies" inside, alternating with stripes that repeat the horizontal borders. The background is golden yellow. The vegetal ornament is brown, the geometrical ornament is half pink and half blue. The sash is signed *FRANCISCUS MASŁOWSKI.*

Masłowski's workshop relied on repeating designs borrowed from the repertory of decorative motifs of well-known Polish manufactories. In the exhibited sash this motif is of Persian provenance, an oval medallion with the radial arrangement of flowering sprays, that appears in sashes manufactured at Słuck, Kobyłka (in the S. Filsjean period, see cat. 41), and Korzec. In addition, oval medallions occur in sashes from the workshop of Antoni Puciłowski, also from Cracow, in the late eighteenth century.

MT

42

SILK SASH, LATE 18TH C.

FRANCISZEK MASŁOWSKI'S WORKSHOP, CRACOW

SILK THREAD; WEFT-FACED COMPOUND TABBY, INTERLOCKING

354.5 × 28.8 CM (139 5/8 × 11 3/8 IN.)

NATIONAL MUSEUM, CRACOW, INV. MNK.XIX-2485, FROM THE COLLECTIONS OF THE FORMER INDUSTRIAL MUSEUM IN CRACOW, WHICH PURCHASED IT IN 1897

LITERATURE
Ceintures et costumes polonais 1972, 13, cat. 22, fig. 12; Taszycka 1985, 94–95, cat. 20; *Orient* 1992, 77, cat. II/34, fig. 77.

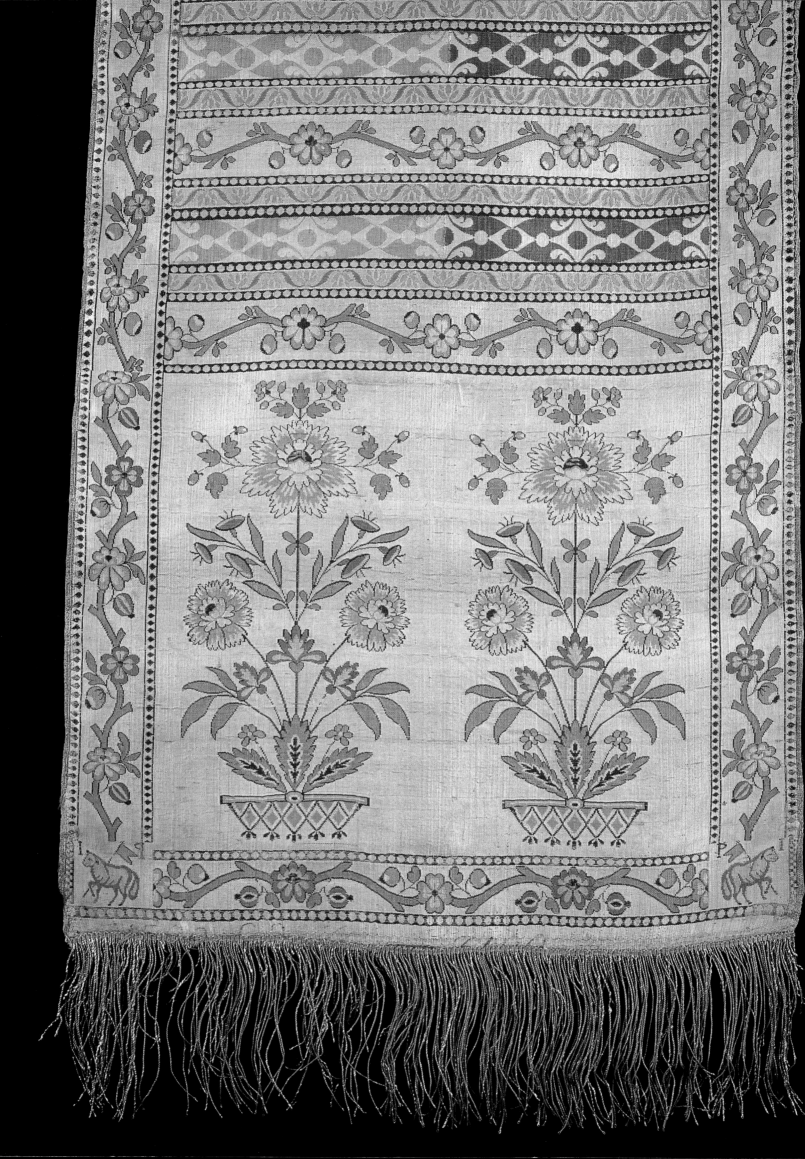

In the end panels a twice-repeated symmetrical axial motif of a flowering shrub grows out of a low trapezium-shaped vase. The vertical borders contain a thick leafless vine with two kinds of flowers and side shoots cut short. In the horizontal borders the ornament is as in the vertical ones, with the axial arrangement of floral motifs. Stripes filled with a geometrized foliate ornament arranged in oval forms alternate with stripes like the horizontal borders. Between the stripes are narrower bands with a simplified ornament of a regular wavy vine. The background is straw yellow. The floral ornament is in pink, blue, light green, and yellow with brown contours. The geometrical ornament is half dark pink, half grayish purple. The signature is a paschal lamb and the letters *PI*.

This woven sash is an example of the technically and artistically more modest products of the manufactory at Lipków, Poland. It is woven exclusively of silk threads, without gold or silver wefts. The flowering shrub motifs in the end panels of the present specimen are unlike the designs characteristic of most sashes signed with a lamb, which are luxuriant, full-blown, or even slightly heavy in form.

MT

43

SILK SASH, 1791–94

MANUFACTORY OF PASCHALIS JAKUBOWICZ AT LIPKÓW

SILK, WEFT-FACED COMPOUND TABBY, BROCADING, INTERLOCKING

345 × 36 CM (135 7/8 × 14 1/8 IN.)

NATIONAL MUSEUM, CRACOW, INV. MNK.XIX-2491, FROM THE COLLECTIONS OF THE FORMER INDUSTRIAL MUSEUM IN CRACOW

LITERATURE
Ceintures et costumes polonais 1972, 12, cat. 17.

This baroque table with a drawleaf top is supported on four turned legs, each with a massive ball in the middle. The legs, joined by plain batten stretchers, additionally rest on flattened spheres. At the front of the broad frame are two drawers whose panels are decorated with acanthus vine and lions' heads. The same motif is repeated on the remaining sides. At the bottom of each side of the frame is a carved openwork apron. The center of the top bears an inlaid star motif.

Gdańsk cabinetmaking of the late sixteenth and first half of the seventeenth centuries developed under the predominant Netherlandish influence; in the course of years, however, it acquired its own character. The furniture made toward the close of the seventeenth century was distinguished by its individual stylistic features: massive construction with pronounced molded cornices and panels on the one hand and lavish carved decoration on the other. Its forms, with small modifications persisting until as late as the eighteenth century, were readily repeated in the nineteenth and even twentieth centuries. Here belong large hall cupboards with characteristic sharply beveled convex door panels and with carved decoration in the form of repeated vegetal-flower motifs, acanthus, personifications of the seasons, putti, lions, and the coat of arms of Gdańsk; chairs with high backs, in wickerwork or covered with ornamental leather; linen presses and tables with characteristic spirally turned or baluster supports, heavy tops with extending leaves, and with frames covered with carved ornamentation.

The table from the Wawel collection is a rather early example of this kind of furniture. Albeit displaying a full range of decorative motifs encountered in Gdańsk cabinetmaking, such as lions' heads functioning as handles, acanthus, flowers, heads of moustached men, or an inlaid star on the top, it still retains the plain rectangular frame of stretchers, a relic of the earlier Dutch influences, and baluster legs, after 1700 superseded by strongly twisted columnar supports.

SB-L

44

TABLE, C. 1700

GDAŃSK

OAK, INTARSIA OF SYCAMORE AND STAINED PLUM WOOD; TURNED, CARVED

71 × 149 × 94 CM (28 × 58 5/8 × 37 IN.)

WAWEL ROYAL CASTLE, CRACOW, INV. 555, PURCHASED AT THE DOM SZTUKI ANTIQUES SHOP IN WARSAW BEFORE 1939

LITERATURE
Gostwicka 1965, 34, fig. 61.

45

CHAIR, C. 1680

GDAŃSK

OAK, CORDOVAN

88 × 45 × 40.5 CM (34 5/8 × 16 IN.)

NATIONAL MUSEUM, GDAŃSK,
INV. MNG/SD, SINCE 1945

LITERATURE
Bieniecki 1960, 12, fig. 11; Drost 1957, 216,
figs. 192, 196, 201.

The exhibited chair was made in a Gdańsk workshop, surely commissioned by Zachariasz Zappio and, together with the library that he amassed during his life, bequeathed to the church of Saint John in Gdańsk. Zappio (1613/20–1680), a Gdańsk merchant, was a curator and, from 1660, head of a council at the church. Zappio's library, called "Johannitana," was opened in 1690. Today his book collection is incorporated in the Gdańsk Library of the Polish Academy of Sciences.

The form of the chair is typical of Gdańsk baroque furniture; its back set perpendicularly to the seat reveals the influence of Flemish prototypes. The oak is stained dark and french-polished, with legs and stretchers spiral-turned. The frames of the seat and back are straight and at right angles to each other; the spiral legs and stretchers are joined by cubes. The feet rest on balls. The seat and the upper part of the back are covered in cordovan. The cordovan is from goatskin, tooled, silvered, polychromed, and glazed. On the dark green ground of the leather are scattered full-blown roses and tulips as well as grapes and vine leaves. The floral-fruit decoration is in a golden brown tone, full of realism and succulent vitality. The decoration of the Gdańsk cordovan is patterned on a series of engravings by Jeremiasz Falck (1610/15–1677, Gdańsk), devoted to flowers, from the *Verscheyde Nieuwe Tulpen en andere Bloemen* cycle, after 1657.

CB

Owing to its wealth of decorative elements, this object was probably assigned to a ceremonial room in a burgher's house.

Stained dark and french-polished, the chair is carved in bas-relief and in the round. Two pairs of *S*-shaped legs cross below the seat. Their upper parts form pairs of lion heads on strongly arched necks, with baluster armrests in their mouths, and at the bottom the legs end in lion paws. The whole is covered with acanthus and scroll ornaments. At the crossing of the legs is an acanthus rosette with a boss in the center. Plain leather covering the rectangular seat is fixed with rosette-headed nails. The decoration displays the influence of Italian cabinetmaking. The variety and sumptuousness of motifs—lion heads in the round, legs in the form of lion paws, acanthus ornament, and acanthus-shaped rosettes—emphasize the ceremonial function of the chair.

DS

46

FOLDING CHAIR WITH LION HEADS,
C. 1700

GDAŃSK

OAK, LEATHER

97 × 99.5 × 54 CM (38 1/4 × 39 1/8 × 21 1/4 IN.)

NATIONAL MUSEUM, GDAŃSK,
INV. MNG/SD/162/MB

LITERATURE
Rehorowski 1960, 7, pl. V, fig. 2; Gostwicka 1965, 36, fig. 65.

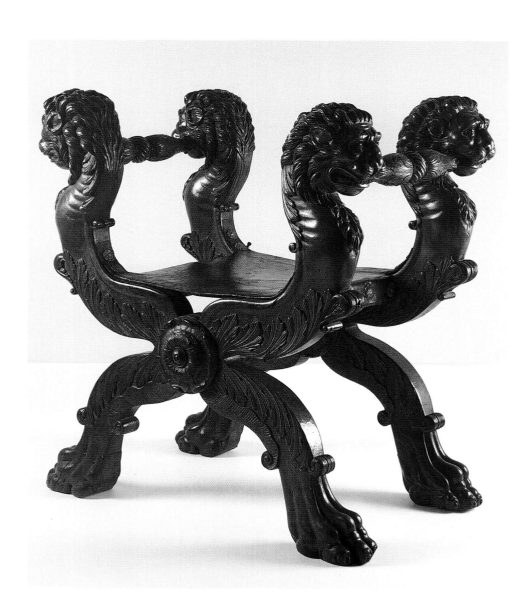

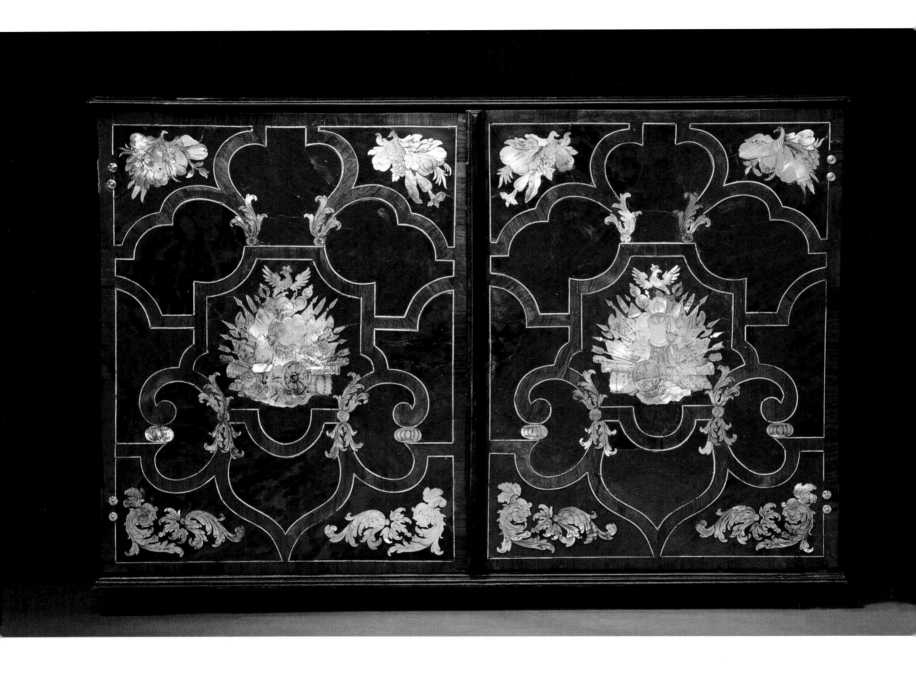

The cabinet has the form of an angular box closed by a pair of doors. Inside are eight small drawers in two tiers, four drawers in each, and one long drawer at the bottom. It is veneered with tortoiseshell divided into irregular panels by rosewood bands bordered with ivory; the panels contain mother-of-pearl decoration in the form of swags of fruits, trophies with eagles, birds catching insects, as well as flowers, hunting horns, and an acanthus turning into helmeted knights' heads. On the sides are brass handles in the form of intertwined snakes. The original crowning gallery is missing.

Trophies surmounted by crowned eagles that decorate the front panels of the doors recall the Greek symbol of triumph. They are a frequent motif in seventeenth-century emblems and panegyrical illustrations extolling rulers and their deeds. Probably this is why the cabinet was displayed in 1883 in the Cracow jubilee exhibition devoted to King John III Sobieski, being associated with his victory at Vienna and the glorification of the monarch.

In the seventeenth century cabinets made of exotic materials were rather rare in Poland. Small caskets or cabinets faced with tortoiseshell and inlaid with mother-of-pearl are mentioned only in reference to the royal or magnate courts.

The modest form of the present object, the lack of architectural divisions, and structural defects resulting from the difficulties posed by handling uncommon material suggest its production in Poland. It is more akin to the local coffers for transporting valuables than to elaborate pieces embellishing *Wunderkammern* so fashionable in other parts of Europe at that time. The ornamentation of the cabinet—in tortoiseshell inlaid with motifs in mother-of-pearl and rosewood strips bordered with ivory—is based on Netherlandish pattern books undoubtedly known to the cabinetmaker. These books were frequently used for the decoration of cabinets produced in the Antwerp workshops of the second half of the seventeenth century.

SB-L

47

CABINET, END 17TH C.

POLAND

OAK, BRAZILIAN ROSEWOOD (PALISANDER), TORTOISESHELL, MOTHER-OF-PEARL, GILT BRASS

52 × 74 × 45 CM (20 1/2 × 29 1/8 × 17 3/4 IN.)

WAWEL ROYAL CASTLE, CRACOW, INV. 1794, GIFT OF ADAM BYSZEWSKI OF BEJSCE, 1929

LITERATURE
Katalog wystawy 1883, 19, pl. XXXV; Zabytki 1884.

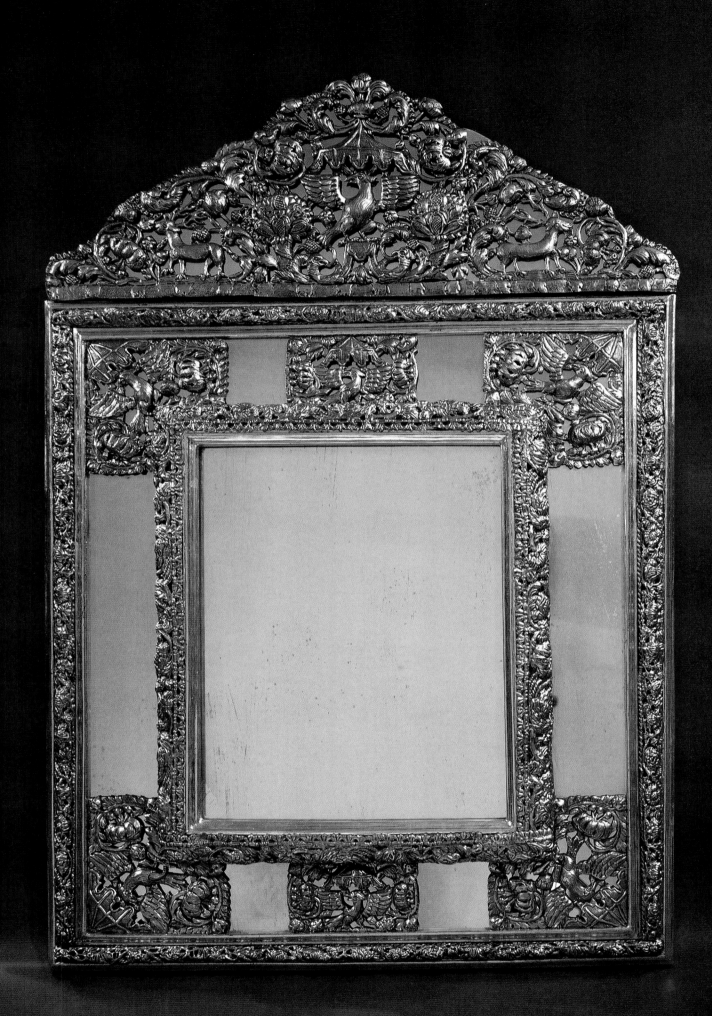

The central rectangular mirror panel is fitted into a convex decorative frame placed in a wide border composed of mirror strips with applied ornamental elements and of small molded frames and a roll molding. There is a decorative triangular cresting with wavy edges and with plate glass showing through an openwork pattern. For the ornamentation of the frame, in stamped, openworked, embossed, and silvered sheet copper, diverse vegetal motifs have been used (acanthus, oak leaves and fruit, grapevine, flowers, among them tulips and lilies, and stylized cornucopias with pomegranates and figs) in combination with figures of animals (eagles under a lambrequin baldachin) and stags. An additional effect is produced by the use of a varied foundation under the openwork decoration: plate glass in the crest and under the appliqués of the border and cobalt-painted wood in the roll moldings of the frame.

The compositional scheme of the mirror, with a wide border carrying ornamental appliqués and a top pediment, was used as early as the second half of the sixteenth century. Among other mirrors large and small it appears in a woodcut by Jost Amman symbolizing the mirror maker's craft. It was widespread in Flanders in the seventeenth century. In Poland, descriptions of palaces and seventeenth-century inventories contain references to articles of this kind, similar in form, though rare and expensive at that time. For instance, the inventory of the palace at Wilanów, made after John III's death in 1696, lists "a large square mirror in cut-glass frames with an ornament of flowing curves."

Particularly noteworthy is the original decoration of the mirror, a kind of appliqué made of silvered openworked sheet copper resembling the so-called *sukienki* (robes), metal covers placed on paintings or, as in the case of Toruń goldsmiths' products, even on sculptures. Akin to the goldsmithery of the late seventeenth and early eighteenth centuries in northen Poland, mainly in the Toruń region, are also the motifs occurring in the ornamentation, especially a predominance of flowers over an acanthus. One may also see in them some affinity with the embroideries executed in the convents at Żarnowiec and Żukowo, undoubtedly on the basis of Dutch botanical pattern books.

Nonetheless, mirrors were not in common use in Poland until the eighteenth century, owing their increasing popularity in large measure to the production of the glass and mirror manufactory at Urzecze established in 1737. Its products included rectangular mirrors with crowns or voluted crests, with cut-glass frames. Thus in respect of form the exhibited mirror was not a rarity in Poland. Particularly noteworthy, however, is its original decoration made of silvered openwork sheet copper. Its motifs on the one hand are akin to the ornamentation employed in goldsmithery and embroideries of the late seventeenth and early eighteenth centuries in northern Poland (predominance of flowers over acanthus) but on the other betray a conformity to the symbolic images widespread in objects of Jewish art (an eagle under a baldachin, stags, pomegranates, and cornucopias). This might suggest the reuse of the decorative elements for assembling the frame of the mirror.

SB-L

48

MIRROR, 1ST QUARTER 18TH C.

POLAND

LARCH, POLYCHROMED AND SILVERED, MIRROR PANELS, SHEET COPPER

104 × 72 × 11 CM (41 × 28 3/8 × 4 3/8 IN.)

WAWEL ROYAL CASTLE, CRACOW, INV. 5986, PURCHASED FROM THE CONGREGATION OF LAZARIST MISSIONARIES IN CRACOW, 1973

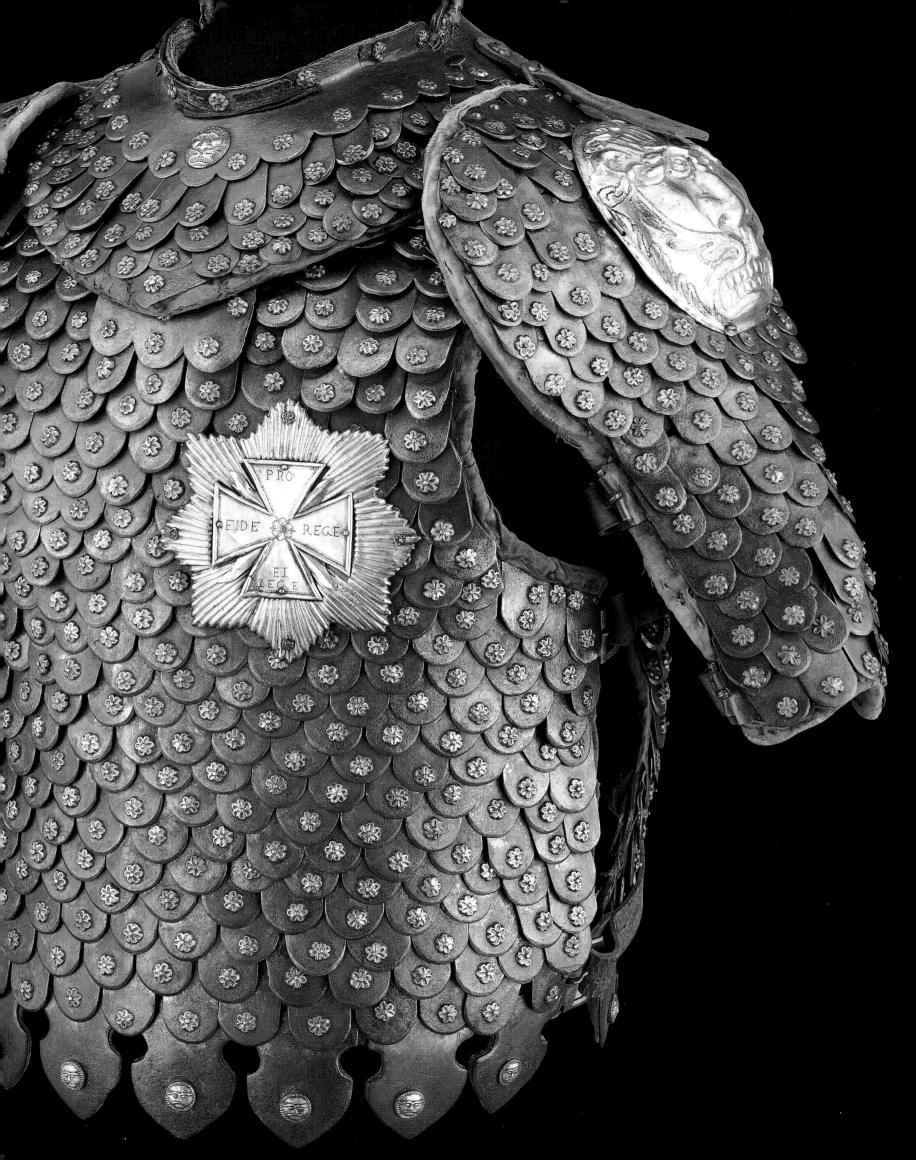

I n past centuries soldierly virtues and the ability to command were among the most desired assets of the ruler and representatives of the social elite. Gallantry on the battlefield was the most generally accepted prerequisite for making a career. These medieval values survived in the Commonwealth until the end of the eighteenth century, though Poland had relinquished offensive wars much earlier.

Every Polish gentleman considered himself a soldier and a defender of the faith and the fatherland, deriving from this axiom his rights and privileges. He regularly carried a saber, a claim denied to plebeians, and identified a military uniform as a national costume . He also went out of his way to obtain at least a titular officer's function in the army. When summoned, gentlemen had the obligation to present themselves, armed, in camp, where their skills and weapons were assessed. Between the sixteenth and eighteenth centuries these activities acquired a more and more symbolic character, and the *levée en masse* of the gentry was no longer of any importance on the battlefield. The descendants of the medieval knighthood had in fact turned into the landed gentry.

This of course does not mean that a gentleman found skill with weapons useless. A career in the army was one of the main opportunities for a son of a modest gentleman. Even in the period of formal peace the southeastern provinces were incessantly threatened by Tatar invasions and Cossack rebellions. The weakness of executive power invited conflicts between neighbors and even private wars. Hence, a gentleman who wanted to be safe from his belligerent neighbor or to exact a favorable verdict from the tribunal had to be skilled in using a weapon and to keep a few armed men. The magnates had under their command private armies at times several thousand strong.

From the sixteenth century the center of gravity of the Commonwealth's military force shifted to professional soldiers. It was understood that they alone could effectively defend the country against increasing dangers, and yet their number and equipment were never adequate. One reason for this was that the gentry as members of the Seym had a conflict of interest: they were reluctant to vote for and pay taxes to support such an army. Another was the fear that a numerous and strong army in the king's hands might threaten the gentry's freedom.

From 1633 the Polish army consisted of two contingents, called Polish (or national) and foreign. The Polish contingent comprised traditional cavalry formations with hussars at the head. These detachments were organized in a traditional system in which a companion (a knight) was assisted by one or two rank-and-file. The rank of companion in a detachment of the national contingent brought prestige. The traditionally organized and armed cavalry was effective in combat at the eastern frontier, in brilliant victories over the Swedes, and in its charge upon the Turks at Vienna in 1683. Soon afterward the development of firearms and military engineering deprived it of its former importance. Detachments of the foreign contingent were organized and armed after the Western fashion, with commands given in German and with numerous foreigners serving in it, although the core of the army was formed by the inhabitants of the Commonwealth.

Military garb, equipment, and weapons were ranked by the gentry among determinants of prestige. Hence their frequently elaborate decoration, even at the expense of their practical value. They are among the most beautiful and decorative products of Old Polish culture.

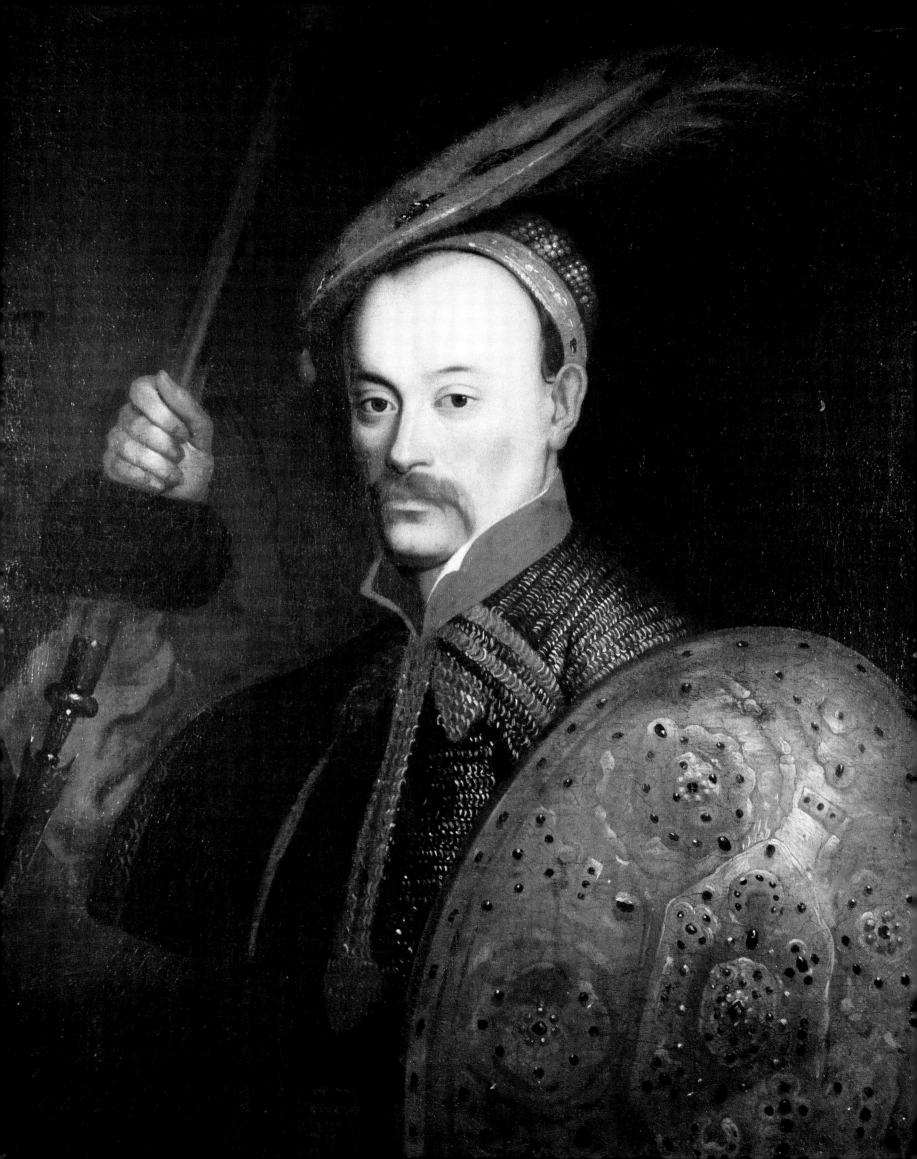

Wincenty Aleksander Gosiewski (Gąsiewski) (before 1620–62) was the son of Aleksander, palatine of Smolensk, and Ewa née Pac. He supplemented his education at the academy at Vilnius by his studies at European universities, visiting, among other places, Vienna, Rome, and Padua. He had an illustrious military and diplomatic career and was also a poet. In 1646 he became sewer of Lithuania; in 1651 general of Lithuanian artillery; in 1652 grand treasurer of Lithuania and grand clerk of Lithuania; and in 1654 field hetman of Lithuania. He participated in the sessions of the Seym in 1650 and 1652 as marshal of the chamber of deputies. He distinguished himself in the campaigns against the Cossacks of 1648–49 and 1651, was one of the commanders in the field during the war with Russia in 1654–55, and was a protagonist during the Swedish invasion of Poland. In 1658–62 he became a Russian captive. After his release he headed the royal commission for the pacification of the confederated Lithuanian army. Accused of treason by the confederates, he was executed in 1662.

The depiction of Gosiewski as he looked on the battlefield (in a mail shirt with a *kalkan* shield on his arm and a short spear for hand-to-hand fighting on horseback) and the lack of symbols of higher military power point to the execution of the painting prior to his appointment as general of the Lithuanian artillery in 1651. It may be supposed that the portrait was painted during Gosiewski's longer stay in Warsaw at the session of the Seym. It found its way to Stanislas Augustus' collection probably from the Czartoryski, who owned it in consequence of the marriage of Gosiewski's widow to Jan Karol Czartoryski. Before 1776 the painting was placed at the Royal Łazienki palace in the vestibule of the Bath, the Palace on the Island, over of the doorway to the dining room. In 1776 the portrait was entered in an inventory drawing by Jan Chrystian Kamsetzer, and in 1783 listed for the first time in the inventory of the royal collection in Łazienki. During World War II it was carried away by the Germans and later recovered, and in 1962 transferred from the National Museum in Warsaw to the Royal Łazienki and set in its former place, in the vestibule of the Palace on the Island. Conservation was undertaken in 1993.

The portrait of Gosiewski hung opposite the imaginary portrait of the French knight Pierre du Terrail de Bayard (a seventeenth-century copy of a picture by Pietro Muttoni called della Vecchia) at the king's palace. This placement was connected with the idea, entertained in the circle of Stanislas Augustus, of referring in the education of young knights in Poland to the universal values of the chivalric ethos and to the traditions of Polish knighthood and was also associated with the principles of training at the knights' school, whose honorary commander was the king himself. The introduction around 1772–76 into the program of the royal residence of the portrait of Bayard as an embodiment of the ethos of European knighthood, facing that of Gosiewski personifying the ethos of the Polish knights, was additionally related with the then-recent event (1768) that had shaken the Commonwealth, the attempt of the Bar oppositionists on the life of King Stanislas Augustus. The two heroes, Bayard and Gosiewski, called forth by their kings as paragons of knightly virtues, had won fame by sacrificing their lives in the loyal service of their monarchs.

JG

WINCENTY ALEKSANDER GOSIEWSKI, 1650–51

DANIEL SCHULTZ THE YOUNGER (C. 1615–83)

OIL ON CANVAS

92 × 67 CM (36 1/4 × 26 3/8 IN.)

ROYAL ŁAZIENKI MUSEUM, WARSAW, INV. Ł.KR. 136

LITERATURE
Iskierski 1931, 47, cat. 181; Mańkowski 1932, 442, cat. 2227; *1000 Years* 1970, 69, 74, cat. 106; *Malarstwo polskie* 1971, 37; *Malarstwo polskie* 1975, 453, cat. 1199; Petrus 1978, 30; *Polaków portret własny* 1986, 56; Kwiatkowski 1991, 22; *Gdzie Wschód spotyka Zachód* 1993 (J. Gajewski, "Portret w drugiej połowie XVII wieku"), 26–27, 357–58, cat. 165.

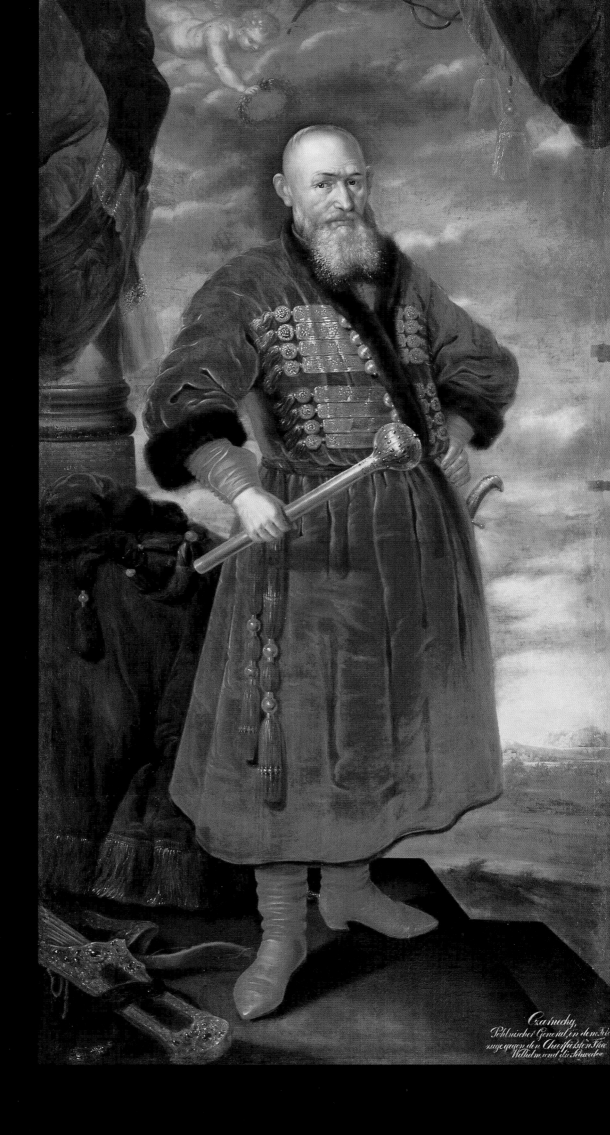

Stefan Czarniecki (1599–1665), one of the outstanding military commanders in the history of Poland, fought in the wars against the Cossacks, the Tatars, Sweden, and Moscow. In 1652 he became camp commander, in 1665 castellan of Kiev, in 1656 deputy hetman, in 1657 palatine of Ruthenia, in 1664 palatine of Kiev, and in 1665 field hetman of the Crown. During the Swedish invasion of 1655–60 he was an adherent of King John Casimir.

Brodero Matthisen, court painter to Friedrich Wilhelm, elector of Brandenburg, signed and dated the portrait in 1659. In that year Czarniecki went to Denmark, where as the commander of the Polish division he fought under the elector against the Swedes, thereby supporting the king of Denmark, an ally of Poland. The participation of Polish troops in this campaign, and especially the daring seizure of the island of Als and conquest of the Koldynghus fortress, brought glory to Czarniecki and became the occasion for his portrait as a victorious commander, surely to the elector's commission.

Czarniecki is portrayed with his left hand resting on his side and in the right one a *buława* (see cat. 61). His severe facial features are set off by his gray beard and shaved head with a wisp of hair above the brow. He wears a fur-lined velvet *ferezja* with wide loops densely sewn on the front and a silk sash around his waist and morocco boots. On the left is a table covered with a gold-fringed heavy textile on which lies a fur and velvet cap. At his feet are a bow and a quiver with arrows. In the background stands a column wrapped in drapery, the end of which hangs on the right side, caught up by a gold-tasseled cord. Above his head, a *putto* emerges from the clouds. The figure stands against an overcast sky and sweeping landscape with silhouettes of riders at a gallop, outlines of rocky mountains, and massive buildings on the horizon. Inscriptions on the portrait include, on the base the column, a Latin inscription enumerating the sitter's dignities and merits: *Stephanus [de] Cz[arn]cza Czarniecki / Terrarum Russiae Palatinus [...]/[...]/[...]/[...] / Aetatis Suae 55 / Anno 1659* (actually Czarniecki was 59 then), and in the bottom right-hand corner a nineteenth-century German inscription: *zarnecki / Pohlnischer General, in dem Feld / zuge gegen [sic] den Churfürsten Fried / Wilhelm und die Schweden.*

The portrait, painted with ease and subtlety, exhibits a vivid palette in which the deep red of Czarniecki's attire predominates. The uniformly distributed light and shade bring out the textural qualities of the velvet costume and the draperies. Fine impasto touches pick out gold-trimmed decorations of the clothing and accessories. It occupies a special place in Matthisen's output as one of the very few extant paintings by this artist, most of which were destroyed in 1859 in the fire in Frederiksborg Castle near Copenhagen. The painting attests to the artist's skill in its clarity of rendition and deep sense of realism in representing facial features, costume, and accessories.

In the nineteenth century the picture was in the royal collections in Berlin; in 1926 it was acquired for the state art collection in Poland, the Royal Castle in Warsaw. After 1945 it entered the holdings of the National Museum in Warsaw; in 1982 it was transferred as a deposit to the Royal Castle in Warsaw, to become its property in 1993.

PM

50

STEFAN CZARNIECKI, 1659

BRODERO MATTHISEN (D. 1666)

OIL ON CANVAS

228 × 119 CM (89 3/4 × 46 7/8 IN.)

ROYAL CASTLE, WARSAW,
INV. ZKW 3411, MADE OVER IN 1993 BY
THE NATIONAL MUSEUM IN WARSAW

LITERATURE
Drecka 1953, 67-74; *Malarstwo europejskie* 1967, cat. 764; *Gdzie Wschód spotyka Zachód* 1993, cat. 174.

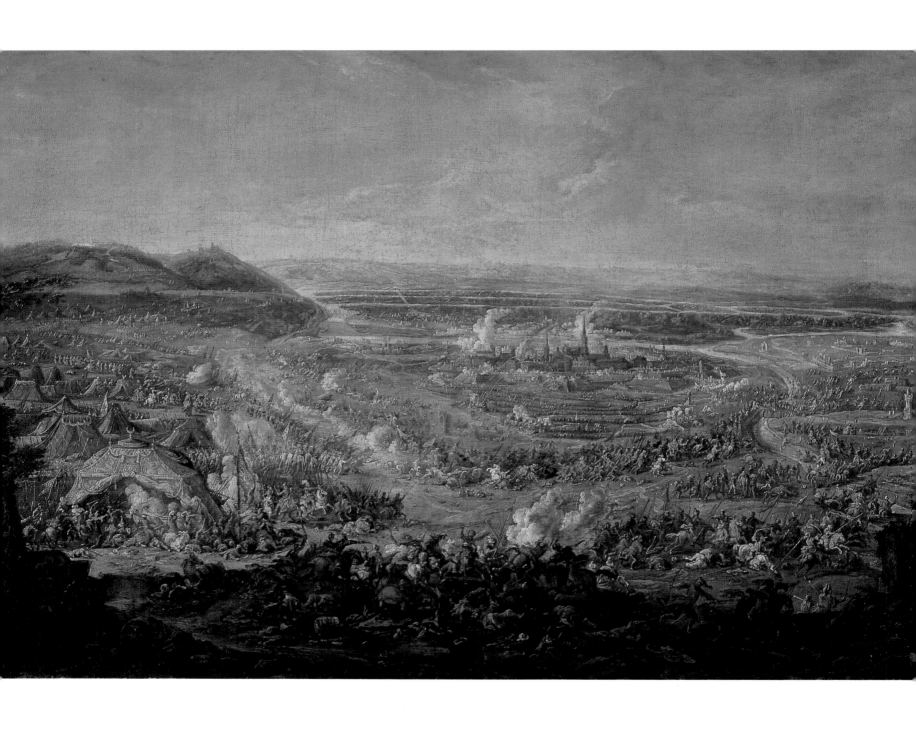

The Battle of Vienna, one of the most important in the history of post-medieval Europe, was the last great military success in the history of pre-partition Poland. After three months of siege by the Turkish army under the command of the Grand Vizier Kara Mustapha, on 12 September 1683 the allied forces consisting of troops from Poland, Austria, and the Germanic lands, under the command of the king of Poland, John III Sobieski, crushed the Turkish besiegers and liberated Vienna, the capital of the Habsburg Empire.

In the foreground in the Turkish camp over which flutters the green banner of the Prophet, the Polish army, with a red banner bearing the White Eagle, charges the Turks. Among the cavalrymen is John III Sobieski, riding a white horse, and his son Jakub (see detail below). Farther back Turkish artillery is bombarding the city, on the left the allied troops are descending the hills of the Vienna Woods, and to the right can be seen the retreating Turkish detachments with a richly decorated carriage, perhaps Kara Mustapha's private treasury.

The Battle of Vienna has an ample, especially graphic iconography. The picture presented here is the best rendition of this subject in art. Fidelity to the facts and objective narration encourage the supposition that the painter relied on several records comprising reports of the participants in the battle and iconographic material. Up to now it has been impossible to establish the identity the creator of the painting. The affinities of the composition with engravings by the Dutch artist Romeyn de Hoogh (1645–1708), representing the later battles with the Turks, do not yet settle his authorship, though they direct the researcher's attention toward his artistic circle.

KK

51

THE BATTLE OF VIENNA,
4TH QUARTER 17TH C.

DUTCH PAINTER(?)

OIL ON CANVAS

97 × 142 CM (38 1/4 × 55 7/8 IN.)

ACADEMY OF FINE ARTS, CRACOW,
DEPOSITED 1955 IN THE WAWEL ROYAL
CASTLE, INV. DEP. 344

LITERATURE
Świerz-Zaleski 1933, cat. 309;
Katalog wystawy 1933, cat. 66; Odsiecz 1990,
cat. 365; *Zbiory Zamku* 1990, cat. 46.

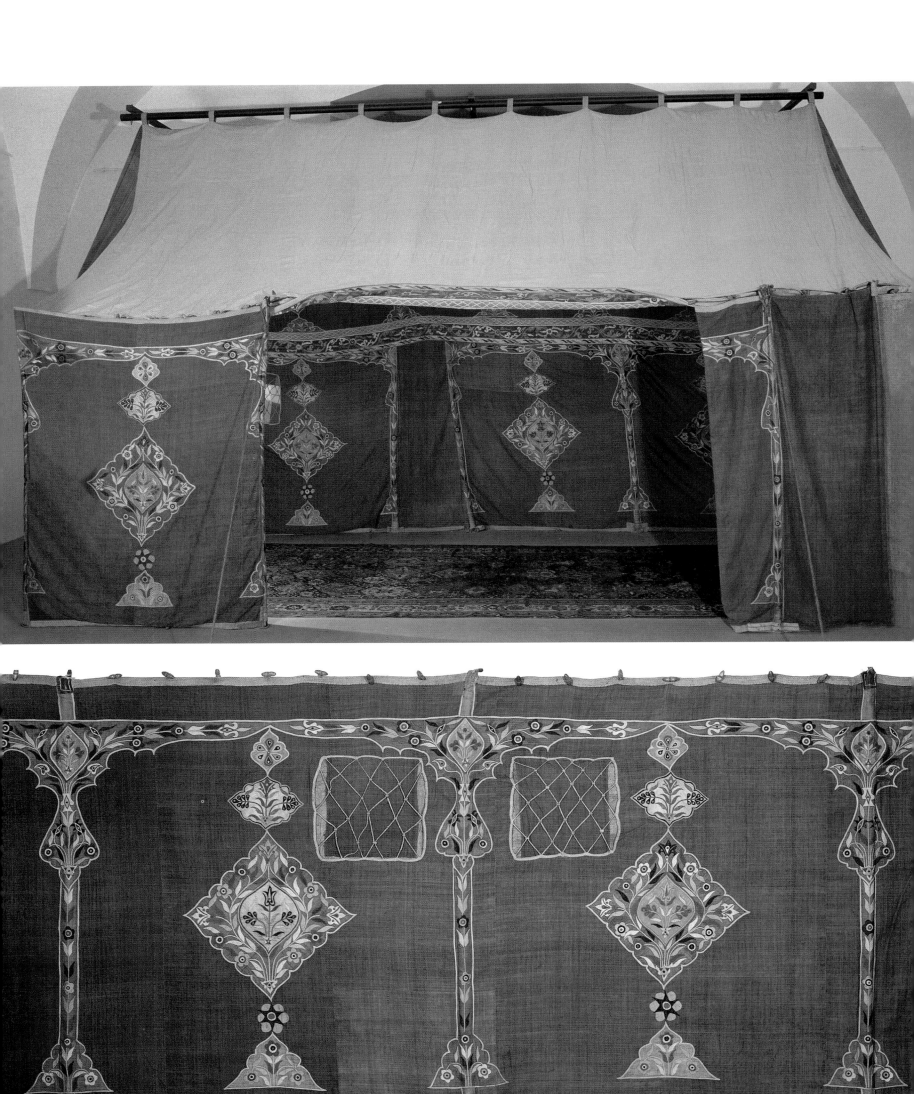

The fact that the southeastern territories of the Polish Commonwealth bordered on those conquered by the followers of Islam, as well as frequent conflicts alternating with peaceful relations with the Turks and Tatars, brought about the penetration into Poland of works of decorative art from Asia Minor, the Crimea, and far-off Iran. The natural process of the "orientalization of taste" in the seventeenth century, the period of wars waged by the Polish army against the Turks, developed into an extraordinary fascination. As a result, objects of Near Eastern art—carpets, wall hangings, tents along with arms and armor—became permanent elements of the Sarmatians' everyday and ceremonial lives. Particularly valued as spoils of war and indispensable as military equipment were tents of diverse shapes and functions, in peacetime frequently used during journeys, during sessions of the Seym, or on the occasion of garden feasts. The Wawel Museum boasts the largest collection of them in Europe, consisting for the most part of memorabilia of the Relief of Vienna (1683) but also of peacetime gifts. The oval tent described here comes from the last-mentioned group. Made in Turkey in the late seventeenth century, it probably was part of the tent collection assembled by Augustus II the Strong in Dresden in the first half of the eighteenth century. Two walls and a saddle-back roof are all covered with architectural decoration. Flattened Moorish arches divide each wall into five arcades on the inside, two of which are provided with windows with rope netting and flaps (opposite, below). The arcades contain four medallions varying in size and form. The ornamentation of the roof is composed of fields corresponding with the wall divisions and analogously decorated. Stellate rosettes form a broad band running along either side of the ridge; below is a frieze of oblong panels with alternating blue and yellow grounds filled with vases of flowers. Around the lower edge runs a valance bearing the motif of a sinuous vine.

The ground of the inner surfaces of the tent is red while the outside is covered with thick grayish-green linen. The absence of openings for poles indicates that the tent was pitched by means of stays. Vertical poles have been sewn in the walls along the border-line between the arcades. The pegs and rope loops for joining the edges and walls are original. The closest analogies in the divisions and the ornamentation along the ridge can be seen in an object kept at the National Museum in Cracow, traditionally believed to have been captured by Jan Drohojowski at Vienna (inv. XIX-6808, ill. 126, pl. XV; Zurich 1974, 103, no. 66).

Until 1939 a similar tent was held in the historical collection in the castle of Podhorce near Lvov.

MP

52

TENT, END 17TH C.

TURKEY

LINEN, SATIN, LEATHER; APPLIQUÉ

310 × 565 × 280 CM (122 × 222 1/2 × 110 1/4 IN.)

WAWEL ROYAL CASTLE, CRACOW,
INV. 2537, GIFT OF SZYMON SZWARC, 1933

LITERATURE
Die Türken vor Wien 1983, 109, cat. 12/1; *Türkische Kunst* 1985, 2:232, 353, cat. II/1; *Im Lichte des Halbmonds* 1995, 196, cat. 194.

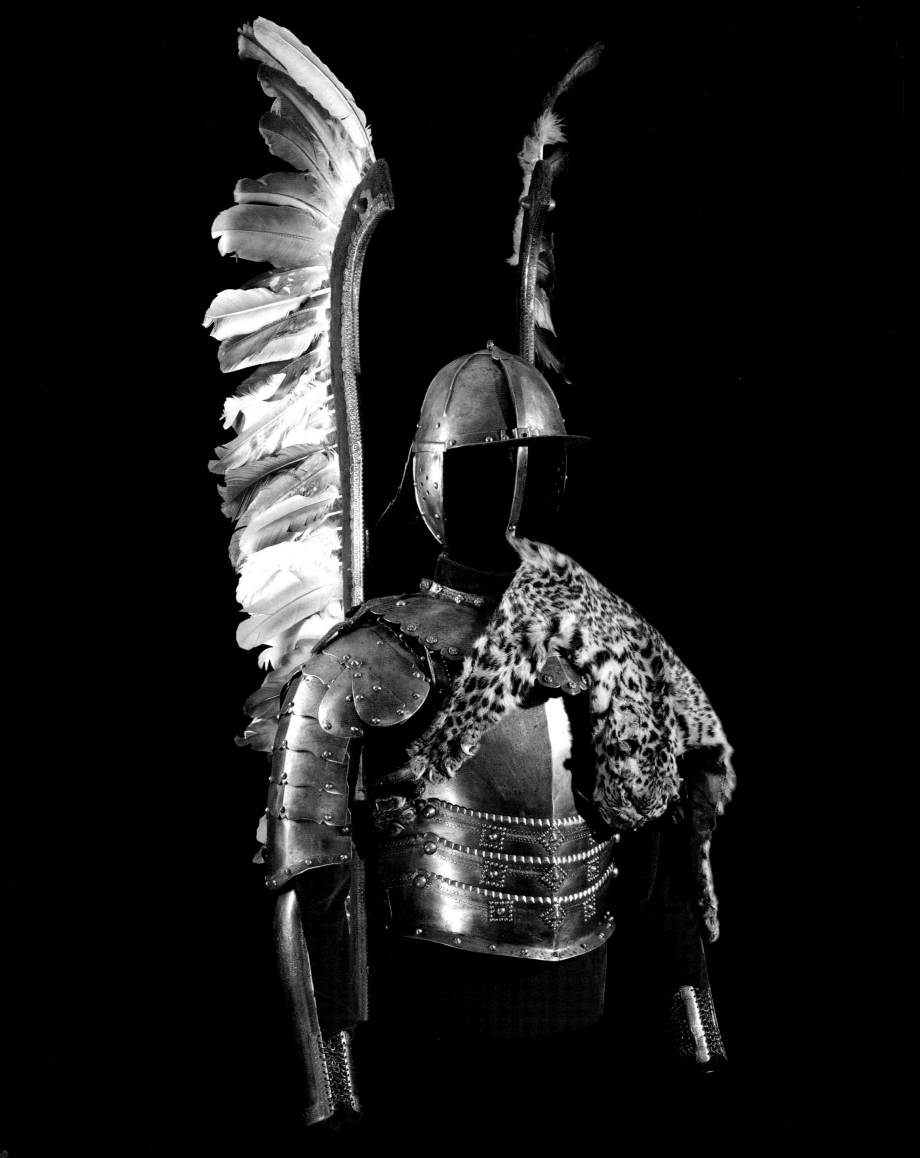

Armor of this kind was used by the Polish hussars in the second half of the seventeenth century. The *husaria* (heavy cavalry) formed the main shock forces in battle. It became customary for the hussars to use wings fastened either to the cantle of the saddle or to the backplate and to wear a tiger or leopard skin or a small kilim rug hung over the shoulder. This hussar armor specific to Poland, not used in any other European military formation, made the *husaria* in the eyes of foreigners the most characteristic unit of the Polish army.

The exhibited suit of armor is made from hammered steel and brass. It consists of a *zischägge* (helmet), breastplate, gorget, and pairs of pauldrons (shoulder coverings) and *karvashes* (oriental-type vambraces covering the arm from the elbow to the wrist). The *zischägge* is of western European type, surmounted by a stalk, with a peak and nasal bar, cheekpieces, and a neck guard of several lames (sliding pieces). The breastplate, with a median ridge and three lames, is decorated with brass applications. The gorget consists of two parts and bears a knight's cross of brass. The pauldrons have six lames. Three-part *karvashes* with mail joins are ornamented with an engraved design. The wooden wings covered in velvet with eagle feathers and a leopard skin are modern additions.

ZŻ

53

WINGED HUSSAR ARMOR WITH A LEOPARD SKIN, 2ND HALF 17TH C.

POLAND

STEEL, BRASS, LEATHER, WOOD, VELVET, LEOPARD SKIN

255 × 100 CM (100 3./8 × 39 3/8 IN.)

A, ZISCHÄGGE, 15.5 × 22 CM (6 1/8 × 8 5/8 IN.)

B, BREASTPLATE, 37.5 × 37 (14 3/4 × 37)

C, GORGET, 16.5 × 37.5 (6 1/2 × 14 3/4)

D, PAULDRONS, 36 AND 39.5 (14 1/8 AND 15 1/2)

E, KARVASHES, 31.5 (12 3/8)

F, WINGS, 150 (59)

G, LEOPARD SKIN

PRINCES CZARTORYSKI MUSEUM, CRACOW, INVS. XIV-245; XIV-298; XIV-289; XIV-268/1, 2; XIV-319/1, 2; MU/3, 4; MU/6

LITERATURE
Żygulski 1975; *Kurfürst Max Emanuel* 1976; *Die Türken* 1983; *Im Lichte des Halbmonds* 1995, 198–99, cat. 204 a–g.

54

BREASTPLATE, 2ND HALF 17TH C.

POLAND

STEEL, BRASS, LEATHER; HAMMERED,
PUNCHED, BURNISHED

54 × 35 CM (21 1/4 × 13 3/4 IN.)

WAWEL ROYAL CASTLE, CRACOW,
INV. 893, PURCHASED FROM
FRANCISZEK STUDZIŃSKI, WARSAW, 1933

This breastplate has a median ridge. The lower part consists of four movable lames joined by rivets. The edges around the neck and armholes as well as the bottom are flanged and decorated with brass borders with studs concealing rivet heads. In the upper part of the breastplate, a knight's cross is inscribed in a rectangle; in the lower part, on the lames, are brass quatrefoil rosettes. All brass applications bear a simple ornament of punched circles. On the shoulders and the sides of the bottom lames are rectangular apertures for passing straps through them; the present straps are newer.

KJC

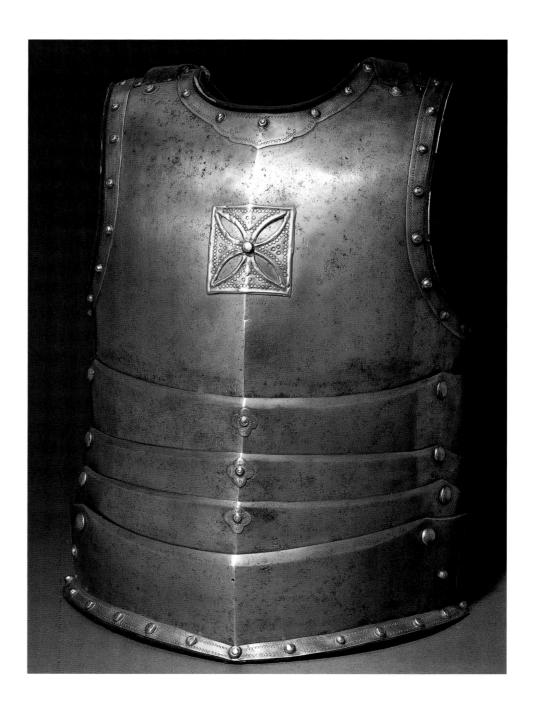

Breastplates, used by the hussars from the late sixteenth to the third quarter of the eighteenth century, differed from those worn in western Europe in the introduction of movable lames in the lower part and in sumptuous, albeit simply achieved brass decoration (borders, ornamental heads of rivets, appliquéd knight's crosses and medallions, usually bearing an image of the Virgin Mary of the Immaculate Conception).

A ridge runs along the middle of the exhibited breastplate, which is provided with three movable lames. Ornamental brass rivet heads in the form of rosettes lie along the edges and, as lion's heads, on the lames. The joining points of the lames are marked with plain domical studs. On the left is an applied brass knight's cross with shafts of rays between its arms; in the center of the cross is a circular medallion with a cut-out triangle (symbol of the Holy Trinity). The arms of the cross bear the letters *IA [.]V*. In the upper part of the breastplate are the brass-inlaid initials *W* and *R*. Slightly above the cross is a bullet mark. The straps for fastening the breastplate are of later date.

KJC

55

BREASTPLATE, 1ST HALF 18TH C.

POLAND

STEEL, BRASS, LEATHER; BEATEN, CAST, STAMPED, RIVETED, INLAID, BURNISHED

48.5 × 38 CM (19 1/8 × 15 IN.)

WAWEL ROYAL CASTLE, CRACOW, INV. 1276, PURCHASED FROM TADEUSZ WIERZEJSKI IN LVOV, 1935

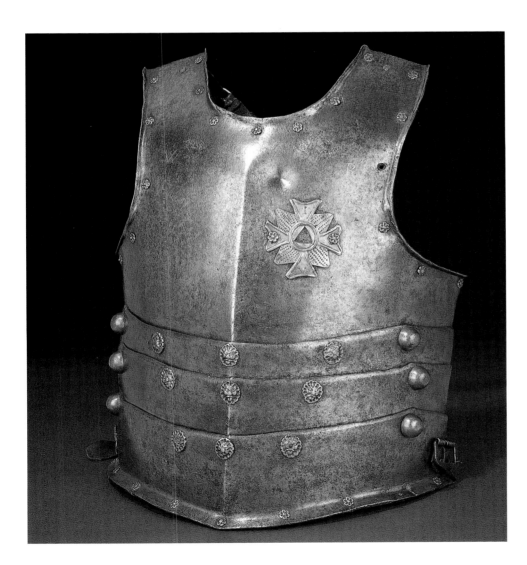

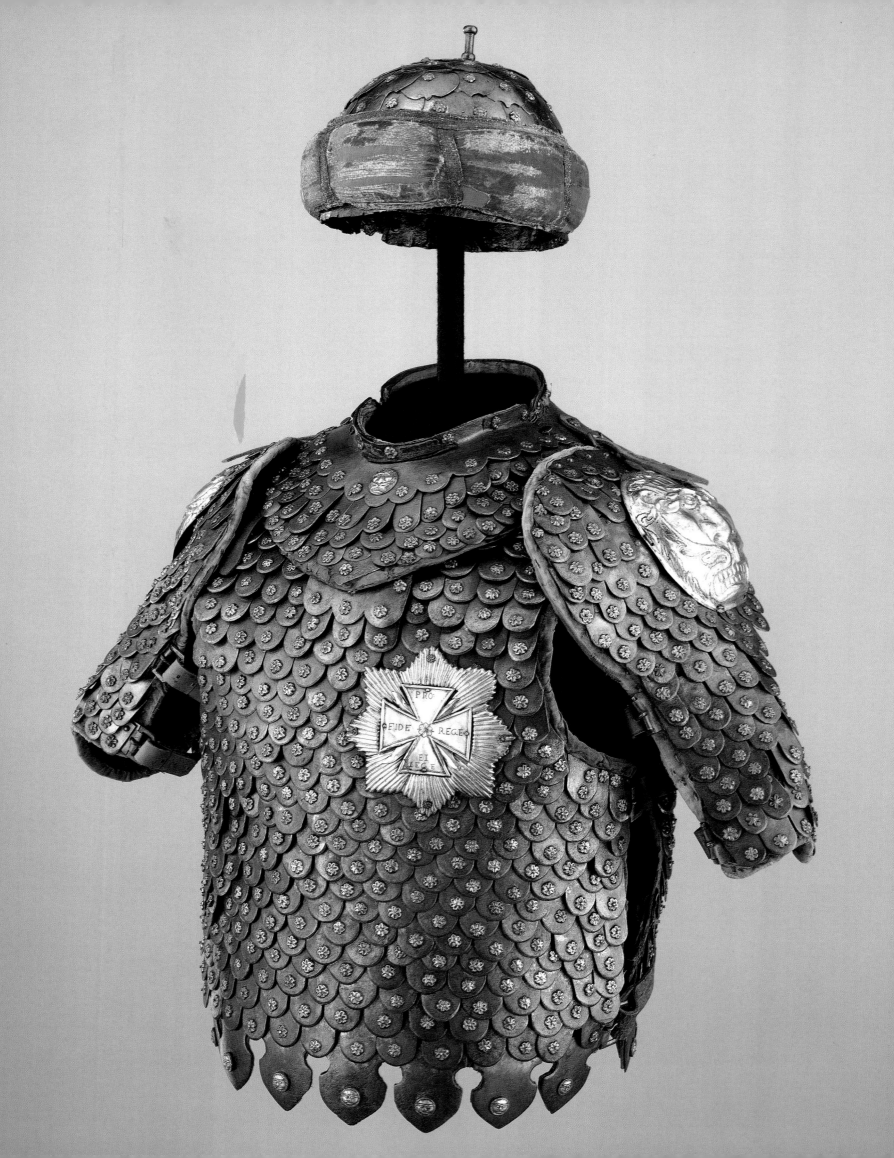

Karacena armor (of iron scales riveted to a leather support) was one of the most original types of defensive arms invented. It was used in Poland in the last quarter of the seventeenth century and well into the middle of the eighteenth. It did not surpass ordinary plate armor in its defensive qualities and was much heavier than the latter type; thus the causes of its creation were not so much of practical as of ideological nature. It referred to ancient Sarmatian, Dacian, and Scythian armor, known from reliefs on the columns of Trajan and Marcus Aurelius, and also to late ancient Roman defensive arms. As *karacenas* were very expensive, they were usually worn by kings, hetmans, and superior officers in the hussar and *pancerni* (light cavalry) troops.

The exhibited armor consists of a breastplate, backplate, gorget, and pair of pauldrons. All parts are made of imbricated blackened steel scales of semicircular form, riveted to a new leather support. Each scale is ornamented with a brass rosette. At the bottom of the breastplate and backplate a row of single large scales is decorated with brass mascarons (masks). Fragments of velvet and gold fringe and of a silk lining remain. On the breastplate is a gilded brass star with a silvered knight's cross on which in the center is an engraved and blackened rosette (perhaps the Poraj arms) and on its arms the inscription *PRO FIDE KEGE ET LEGE* (device of the Order of the White Eagle). On the two-part gorget is a small brass lion's mask, and on the pauldrons are gilded circular, highly stylized mascarons with bared teeth and leaflike mustaches. According to tradition, the armor belonged to Atanazy Miączyński (1639–1723), palatine of Volhynia and colonel of the Polish army, who took part in the battles of Podhajce and Żurawno and in the Vienna campaign of 1683. Until 1934 at the Miączyński-Dzieduszycki Museum in Lvov, it was taken over for the state treasury for arrears in taxes and subsequently made over to the Wawel collections, and in 1977 deposited at the Metropolitan Museum of Art.

KJC

There were two types of *zischägges* (helmets) made of scales, worn with *karacena* armor: the first repeated the shape of a hussar *zischägge*, while the second acquired an oriental look, owing to its hemispherical skull decorated with a turban of colorful fabric, although it was an original Polish creation having no equivalents among Turkish or Persian helmets.

The exhibited *zischägge* is of the latter type. The hemispherical skull is made of imbricated circular scales toothed at the bottom, fixed to a leather support by means of rivets with rosette-shaped brass heads. At the top the helmet bears a multifoil medallion from one piece of metal sheet, surmounted by a tall stalk. The rim, of several strips of sheet metal, is embellished with a turban of raspberry-red silk, badly worn, edged with gold galloon. The whole helmet was originally blackened.

KJC

56

KARACENA (SCALE) ARMOR, 17TH/18TH C.

POLAND

STEEL, BRASS, LEATHER, VELVET; HAMMERED, RIVETED, CAST, REPOUSSÉ, ENGRAVED, BLACKENED, GILDED, AND SILVERED

BREASTPLATE 57.8 × 55 CM (22 3/4 × 21 5/8 IN.)
BACKPLATE 54 × 56 (21 1/4 × 22)
GORGET 11.9 × 27 × 33 (4 5/8 × 10 5/8 × 13)
PAULDRONS: 40 × 31.6 (15 3/4 × 12 1/2), RIGHT; 39 × 30.7 (15 3/8 × 12 1/8), LEFT

WAWEL ROYAL CASTLE, CRACOW, INV. 956, ON LOAN TO THE METROPOLITAN MUSEUM OF ART, NEW YORK

LITERATURE
Bocheński 1939, 4–6, fig. 2; *Zbiory Zamku* 1969, cat. 180; *Odsiecz wiedeńska* 1990, 197.

57

KARACENA (SCALE) ZISCHÄGGE, 2ND HALF 17TH C.

POLAND

STEEL, BRASS, LEATHER, SILK, GALLOON; HAMMERED, CAST, RIVETED, BLACKENED, STITCHED, 19.5 × 21 CM (7 5/8 × 8 1/4 IN.)

WAWEL ROYAL CASTLE, CRACOW, INV. 1274, PURCHASED FROM TADEUSZ WIERZEJSKI IN LVOV IN 1935, ON LOAN TO THE METROPOLITAN MUSEUM OF ART, NEW YORK, SINCE 1977

LITERATURE
Petrus 1981, cat. 3.

58

HUSSAR ZISCHÄGGE, LATE 17TH C.

POLAND

STEEL, BRASS; HAMMERED, BURNISHED

25 × 40 × 20.5 CM (9 7/8 × 15 3/4 × 8 1/8 IN.)

WAWEL ROYAL CASTLE, CRACOW,
INV. 490, PURCHASED BY
MARIAN MORELOWSKI IN RUSSIA
IN 1928

A hussar *zischägge* is a type of helmet generally used in detachments of Polish hussar cavalry similar to western-European Pappenheimer helmets (see cat. 59). It is decorated for the most part like hussar armor, with borders and appliqués of brass punched in geometrical designs. They were produced in some variety, with a stalk at the top, with a tall comb, or with fan-shaped wings on the skull (this last type was popular in the first half of the eighteenth century).

The exhibited object has a hemispherical fluted skull with twelve ribs departing radially from a rosette with a ring placed at the top. The neck guard consists of four lames joined by rivets and leather straps underneath. The pointed peak with a movable nasal bar ending in a leaf form is fixed in a holder with a screw. The cheekpieces are in the form of rounded triangles, with ventilation holes arranged concentrically. The rivets have brass heads; underneath are partly preserved leather borders.

KJC

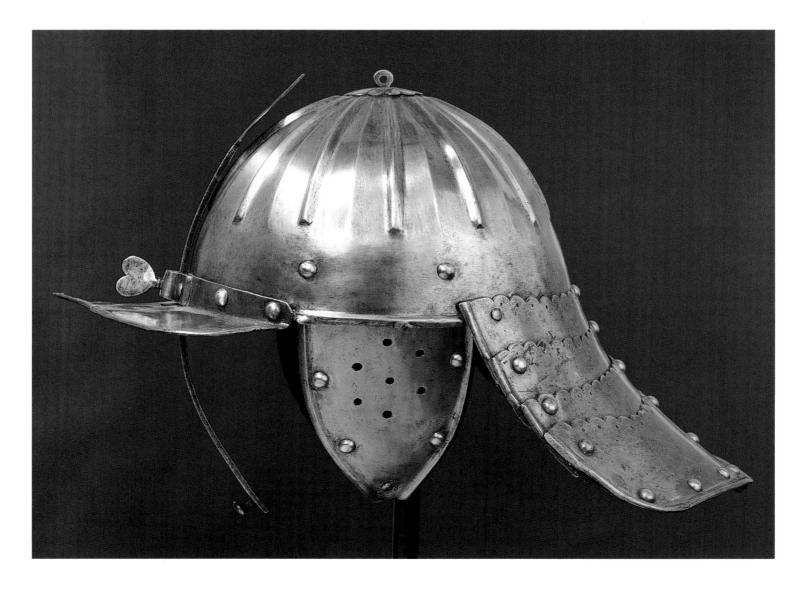

This helmet has a hemispherical skull with six ribs departing radially from a circular plate and a ring placed at the top. The neck guard consists of four lames riveted together. Below the pointed peak is a nasal bar ending in a leaf form, fixed in a holder with a screw. The cheekpieces are in the form of rounded triangles with concentrically arranged ventilation holes. The peak and nasal are stamped with the armorer's marks.

Pappenheimer helmets, in their structure resembling hussar *zischägges*, were sometimes used in their place, similarly as adapted western European cuirasses were sometimes worn with hussar armor.

KJC

59

PAPPENHEIMER HELMET, C. MID-17TH C.

GERMANY

STEEL, LEATHER; HAMMERED, BURNISHED

27 × 41 × 19.5 CM (10 5/8 × 16 1/8 × 7 5/8 IN.)

WAWEL ROYAL CASTLE, CRACOW,
INV. 1728, DEPOSITED IN 1928 BY
ANTONI SAPIECHA OF WARSAW

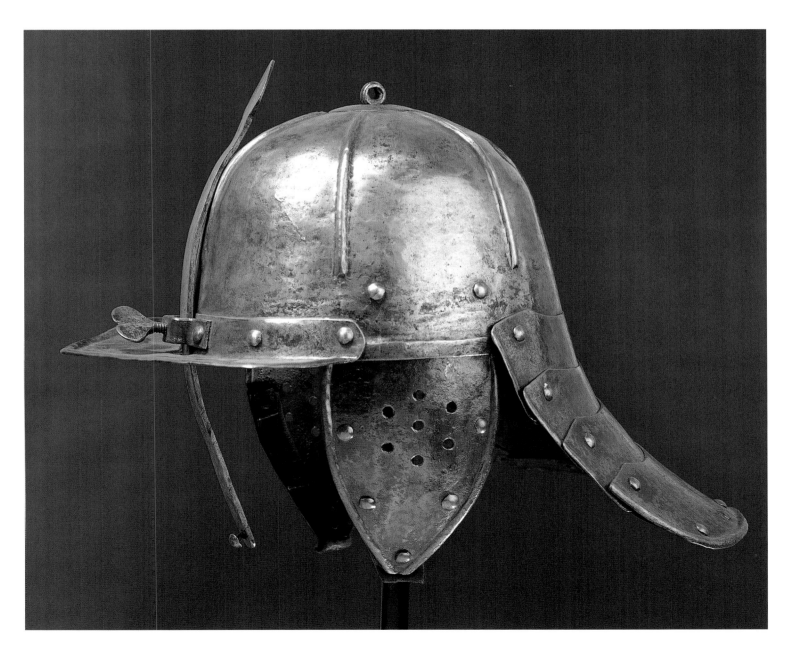

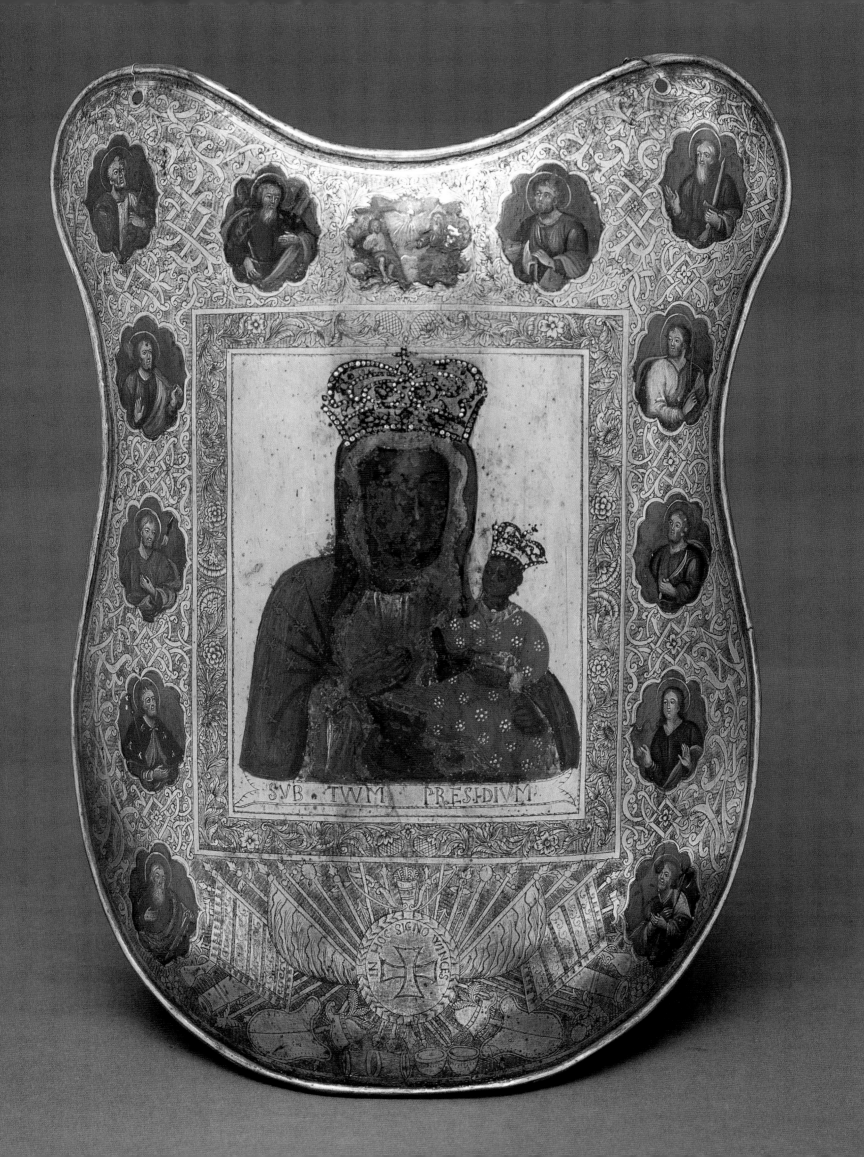

SVB TWM PRESIDIVM

A pectoral plate, originating from the gorget of a knight's armor, was used in Poland in the eighteenth century, especially by the Bar confederates in the period 1768–72. Bearing images of the Virgin Mary and saints and religious scenes, it functioned symbolically as a "spiritual buckler."

The exhibited pectoral plate has the form of a convex shield with a rounded wavy outline. The gilded obverse carries lavish engraved and painted decoration. In the center in a rectangular frame is a painted image of Our Lady of Częstochowa, and beneath the inscription *SVB. TVVM PRESIDIVM*. On the sides and at the top is a dense ribbon-vegetal ornament with painted oval medallions (wavy in outline) containing a representation of the Holy Trinity and busts of the twelve apostles. Below the image of Our Lady of Częstochowa is a panoply with a knight's cross in the middle and the inscription: *IN HOC SIGNO WINCES [sic]*. On the reverse (below) is a painted image of Christ bearing the cross.

KJC

60

PECTORAL PLATE, MID-18TH C.

POLAND

COPPER; HAMMERED, GILDED, ENGRAVED, PAINTED IN OILS

39 × 27.5 CM (15 3/8 × 10 7/8 IN.)

WAWEL ROYAL CASTLE, CRACOW, INV. 1298, GIFT OF OLGA MOCHNACKA OF LVOV, 1935

LITERATURE
Fischinger 1988, 38.

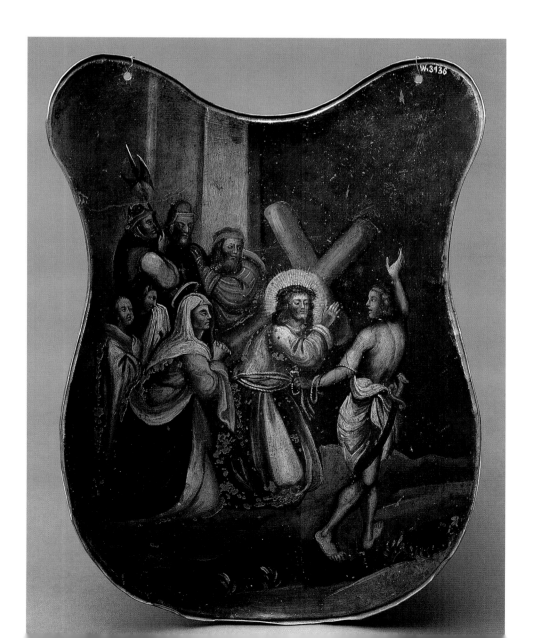

61

BUŁAWA, 2ND HALF 17TH C.

POLAND

STEEL, GOLD, SEMIPRECIOUS STONES;
WROUGHT, INLAID, SET WITH PRECIOUS
STONES

64 CM (25 1/4 IN.)

WAWEL ROYAL CASTLE, CRACOW,
INV. 4520

LITERATURE
Świerz-Zaleski 1933, cat. 74; Żygulski 1964,
2:282-83; Żygulski 1982, 293, fig. 352; Żygulski
1984, 67, cat. 56; *Zbiory Zamku* 1990, 253, cat. 148.

The *buława* (a weapon of percussion consisting of a shaft and a spherical or pear-shaped solid head) was in Poland in the seventeenth and eighteenth centuries a sign of the highest military rank, that of hetman. The lavishly decorated examples of this weapon that have been preserved in Polish collections, both those imported from the East or Hungary and those locally made, are frequently linked, on the basis of more or less reliable tradition, with concrete historical personages. Today crossed *buławas* denote in the Polish army the rank of marshal.

The exhibited piece has a spherical head segmented by ribbing into eight fields, surmounted by a rosette. It is decorated with gold horizontal zigzag bands (forming lozenges at half the height of the head) containing delicate foliate vines and numerous turquoises and almandines set in rosettes. The shaft, round in section with three plain rings (one at the end, another marking off the lower segment, and the third at the base of the neck connecting the shaft with the head), is divided in the middle segment into eight parts by ribbing, covered with gold leafy vine and studded with turquoises and almandines. Concealed inside the shaft is a gold-inlaid dart with a blade triangular in section.

According to unconfirmed tradition, the exhibited *buława* belonged to one of the hetmans from the Rzewuski family. From 1914 it was in Bruno Konczakowski's collection in Cieszyn, and in 1961 it was purchased together with his collection of arms for the Wawel Royal Castle. Another *buława* of similar form and decoration, dated around 1700, has survived at the Czartoryski Museum in Cracow.

KJC

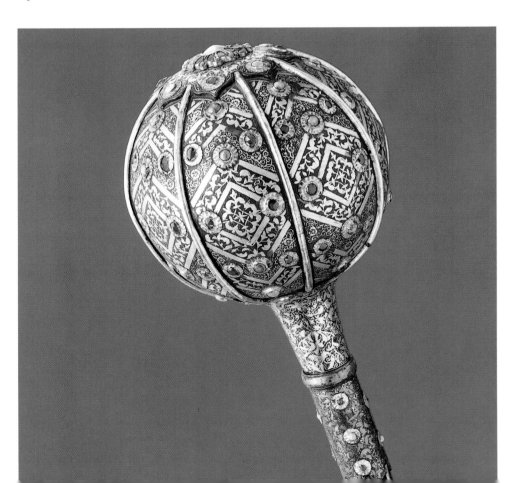

A *buzdygan*, a weapon of percussion consisting of a shaft and a head of vertical flanges, was generally used in the Polish army in the seventeenth and eighteenth centuries as a sign of military rank, that of captain of horse and colonel. The *buzdygans* used in Poland were not only made locally but also came from Turkey and Persia as purchases or spoils of war. Moreover, they functioned as insignia of the elders in craft guilds, in which character they have been used to this day.

The head of the exhibited *buzdygan* consists of six triangular flanges and a cone-shaped finial. The shaft, round in section, is divided with vertical rope moldings and decorated with two ruby-set rings (one at the base of the head and the other separating the lower segment of the shaft), and it terminates in a molded ring and a ball. Inside the shaft there is a screwed-in dart whose blade is triangular in section. The whole object is covered with sheet silver-gilt bearing oriental-style chased and nielloed vegetal decoration (interlaced vine with small leaves and carnations as well as cypresses), except for the lower part of the shaft whose ornamentation consists of western-European scrolls. The lower ring studded with rubies, the finial on the head, and the ball at the end of the shaft were reconstructed in 1996 in Cracow by Wojciech Bochnak.

The *buzdygan* in the Wawel collection strongly resembles two such objects traditionally linked with Hetman Stanisław Jabłonowski, which are kept at the National Museum in Cracow and at the Polish Army Museum in Warsaw.

KJC

62

BUZDYGAN, END 17TH C.

POLAND

STEEL, SILVER, BRASS, RUBIES; WROUGHT, CAST, CHASED, ENGRAVED, NIELLOED, GILDED, SET WITH PRECIOUS STONES

63 CM (24 3/4 IN.)

WAWEL ROYAL CASTLE, CRACOW, INV. 8298, PURCHASED IN 1995 FROM ALICJA SZCZEPANIAK-KUNIK OF WARTA BOLESŁAWSKA

LITERATURE
Nabytki 1996, 217, cat. 15.

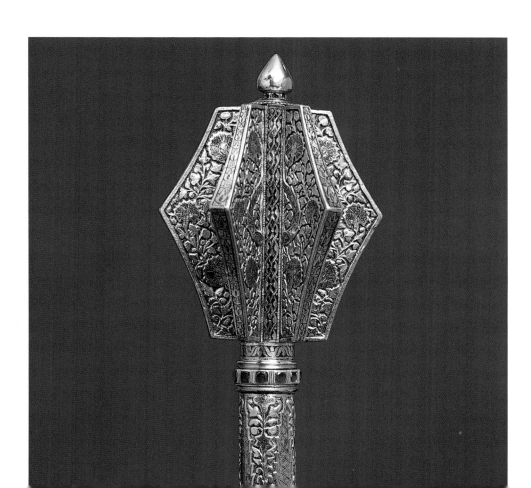

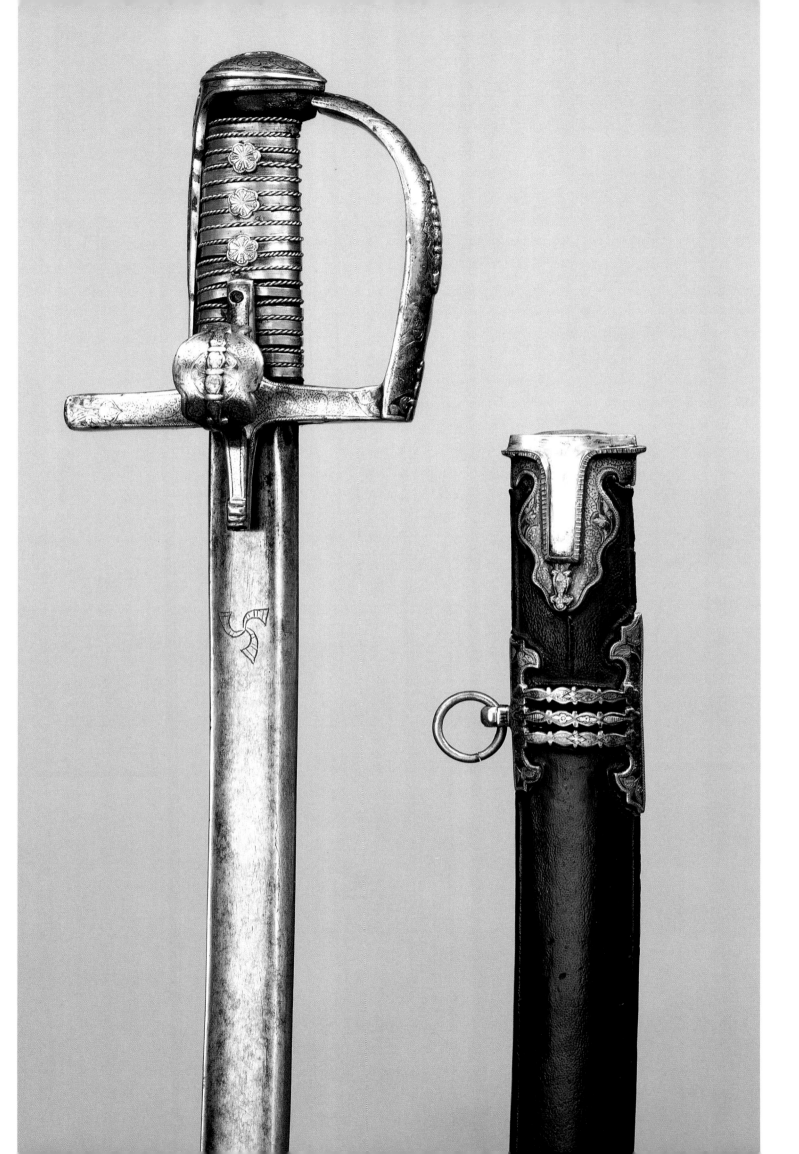

The hussar saber (so called on account of its general use in regiments of the national heavy cavalry) originated in about the middle of the seventeenth century. This is a specifically Polish weapon, rightly acknowledged as the finest achievement in the field of edged weapons in Poland. It is distinguished by its perfect functionality and beautiful form. It combines in an original and harmonious manner the features of oriental and western European weapons. The hilt is provided with quillons forming the cross bar and a thumb guard for a stronger grip. The quillons are linked with the almond-shaped pommel by means of a slightly deflected knuckle-bow, which, however, is not connected with the pommel structurally. Such a solution enhanced the springiness of the knuckle-bow that guarded the hand. A wz.76 ceremonial officer's saber, used in the Polish army today, refers directly to a hussar saber.

The curved blade with hollowed sides bears the Trąby arms engraved on the forte. The hilt with crossbar quillons and a knuckle bow linked with the almond-shaped pommel of the grip is covered with black leather, with silver strip and wire wound around it and additionally decorated with rosettes that hide the heads of the rivets. The quillons and the knuckle bow are faced with sheet silver, while the cap of the pommel and the strip extending from the cap to the base of the grip are of silver. The wooden scabbard is covered with black leather and fitted with silver mounts: neck, ferrule, and two bands with rings. The silver elements of the saber and scabbard are decorated with engraved and nielloed vegetal ornament.

KJC

63

HUSSAR SABER AND SCABBARD, 17TH C.

POLAND

97.8 CM (38 1/2 IN.)

WAWEL ROYAL CASTLE, CRACOW, INV. 7450, FROM TADEUSZ JAKUBOWSKI'S COLLECTION, PURCHASED 1987 FROM HELENA JAKUBOWSKA

LITERATURE
Żygulski 1975, fig. 233.

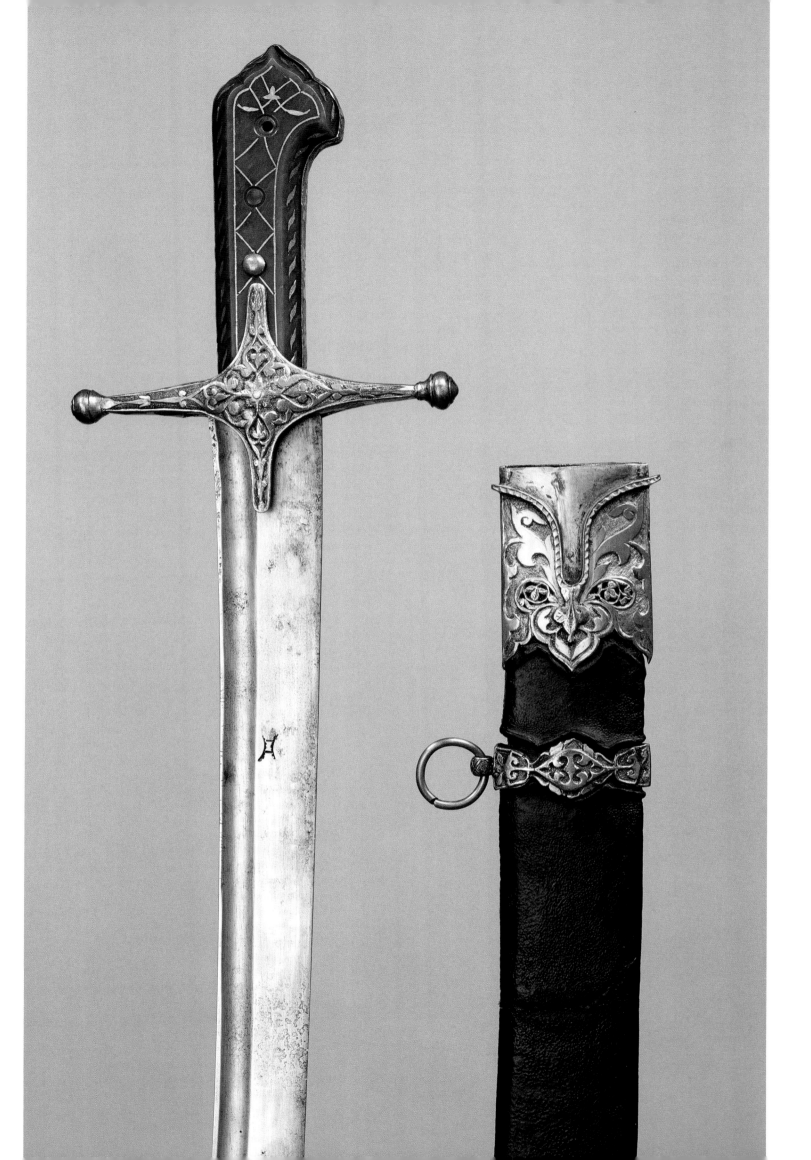

Despite its eastern origin a *karabela* is considered the kind of saber most characteristic of the culture of the Polish gentry in the seventeenth and eighteenth centuries. It is distinguished by an open hilt with a pommel resembling a bird's head in profile. In addition to simple fighting *karabelas*, parade varieties were also made, the latter, very costly, lavishly decorated with silver, gold, and precious and semiprecious stones and carried with a ceremonial Polish costume. In Poland during the partition this kind of saber was accepted as a symbol of the nation's glorious past; ornamental specimens were produced, frequently decorated with patriotic motifs, and were carried with a *kontusz* during national celebrations and manifestations.

The exhibited *karabela* saber has a curved blade, both sides grooved along the back edge, and on the obverse the gold-inlaid inscription *STEPHANUS. D.G. Rex. POL. D. PRVS.* The hilt is flat with rounded edges, slightly widening toward the pommel, made of chalcedony plates inlaid with a gold geometrical design and fixed to the tang with rivets. The fillet placed along the line of junction of the plates bears an engraved vegetal motif. The cruciform quillons are of silver-gilt, decorated with stylized foliage, with the crossbars ending in balls. The scabbard is covered in black shagreen leather, whose silver-gilt mounts bear a foliate ornament.

This is a typical example of a Polish parade *karabela*; at a later date (probably in the nineteenth century), its blade was inscribed with the name of one of the greatest kings of Poland, Stephen Batory (r. 1576–86), an excellent military commander and a victor in the war against Czar Ivan IV the Terrible.

KJC

64

KARABELA SABER AND SCABBARD, 1ST HALF 18TH C.

POLAND

STEEL, SILVER, CHALCEDONY, GOLD, WOOD, LEATHER; WROUGHT, CAST, CHASED, ENGRAVED, GILDED, INLAID

92 CM (36 1/4 IN.)

WAWEL ROYAL CASTLE, CRACOW, INV. 7528, PURCHASED FROM MIECZYSŁAW MORKA IN WARSAW IN 1988

65

SABER AND SCABBARD, 2ND HALF 18TH C.

POLAND

STEEL; PARTLY GILDED, STUDDED WITH
GOLD, DIAMCNDS

82.5 CM (32 1/2 IN.)

NATIONAL MUSEUM, CRACOW,
INV. V 1307, PURCHASED IN 1960
FROM THE MOSZYŃSKI COLLECTION

The blade of the saber is decorated with French regency ornaments and the gold-studded monogram *JFK*. The quillon, curved toward the pommel, forms a knuckle guard. The grip is in black shagreen. The scabbard is in black shagreen with the neck, band, and ferrule of sheet iron.

IG

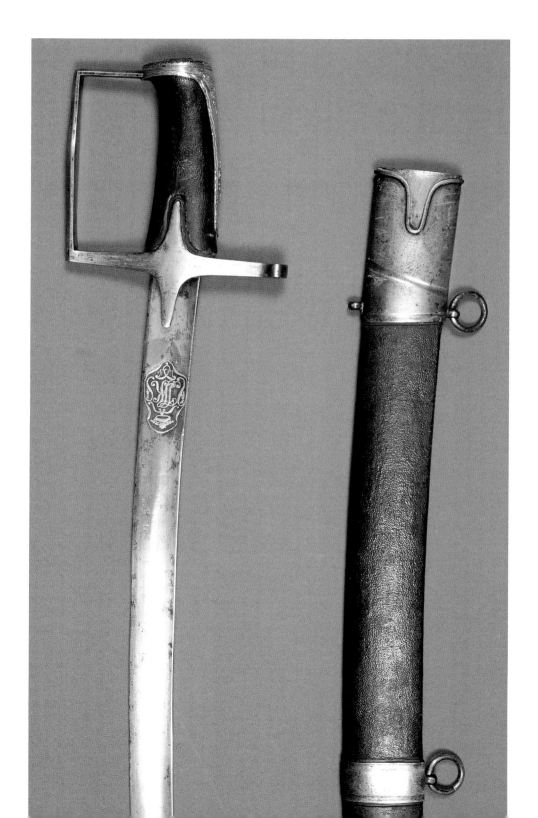

On the forte of the blade of the saber is an etched double-headed eagle. The saber has brass crossbar quillons and facing of horn with relief cartouches and figural motifs. The scabbard is of sheet metal lacquered black with brass neck and ferrule with engraved radiate lines, rosettes, and acanthus leaves.

IG

66

SABER AND SCABBARD, END 18TH C.

POLAND

STEEL, BRASS, HORN; ENGRAVED, ETCHED, AND LACQUERED BLACK

104 CM (41 IN.)

NATIONAL MUSEUM, CRACOW, INV. V 1224/2, GIFT OF WITOLD MIESZKOWSKI, 1935

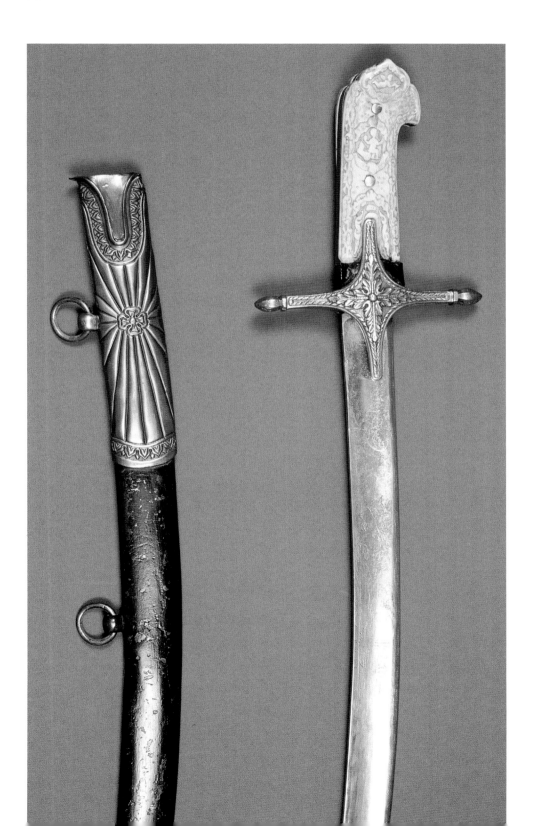

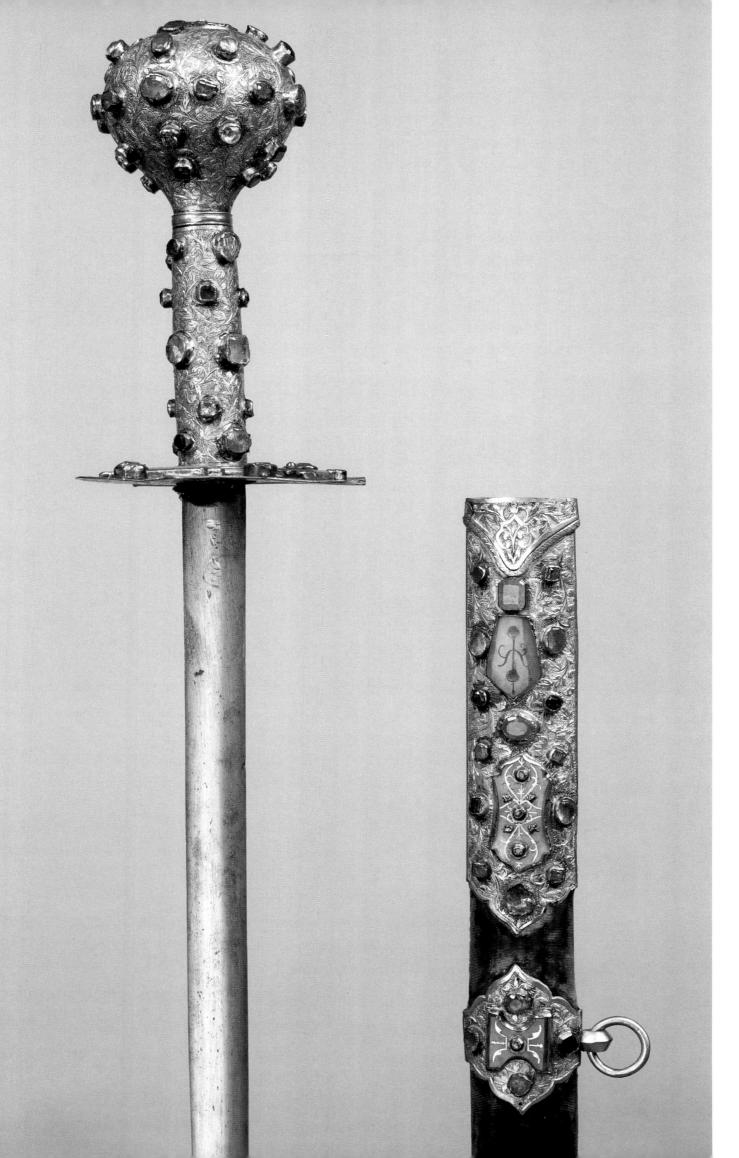

An *estoc*, an edged weapon with a long, narrow blade adapted to piercing, was used in Poland as an element of the equipment of the hussar and *pancerni* (light) cavalry.

On the basis of trustworthy tradition, the exhibited *estoc* is considered to have been the property of King John III Sobieski. Originally in the Żółkiew collection, in 1740 it found its way to Michał Kazimierz Radziwiłł's treasury at Nieśwież. In 1813 it was plundered by the Russians, included in the imperial collection at Tsarskoe Selo and in 1880 in the Hermitage collections, recovered in 1924, and made over to the Wawel Royal Castle.

The *estoc* has a smooth blade, lenticular in section. The silver-gilt hilt with a large spherical pommel and a flat quillon in the form of a pentagon, its two corners rounded, are entirely covered with intertwined fine foliate vine on a grained background and additionally decorated with stones (emeralds and green, red, yellow, and white imitation gems) set in high mounts and with gold-inlaid jasper plaques studded with almandines. The reverse of the quillon bears the motif of crossing ribbons. The scabbard is covered in green velvet with silver-gilt mounts: "neck," ferrule terminating in an embossed ball, and two bands. The decoration of the obverses of the mounts is analogous to that on the hilt, while on the reverses it is the same as on the reverse of the quillon. This is an excellent example of orientalization in Polish military equipment both in terms of composition (a large pommel, disc-shaped quillon) and decoration (fine vegetal ornament, lavish setting with precious and semiprecious stones, jasper plaques inlaid with gold and almandines).

KJC0

67

ESTOC AND SCABBARD, LAST QUARTER 17TH C.

POLAND

STEEL, SILVER, WOOD, VELVET, PRECIOUS AND SEMIPRECIOUS STONES; WROUGHT, ENGRAVED, CHASED, GILDED, BURNISHED, STONE-STUDDED

123 CM (48 3/4 IN.)

WAWEL ROYAL CASTLE, CRACOW, INV. 172

LITERATURE
Wystawa rewindykacyjna 1929, 44, cat. 22; Świerz-Zaleski 1933, 18, cat. 77; *Zbiory Zamku* 1969, cat. 247; Fischinger 1982, 44; Żygulski 1982, fig. 221; *Odsiecz wiedeńska* 1990, 1:149–50, cat. 133; 2:106.

68

CARTRIDGE BOX, 1ST HALF 18TH C.

POLAND

WOOD, LEATHER, METAL THREAD,
SILVER; EMBROIDERED, ENGRAVED,
GILDED, NIELLOED

6.2 × 21 × 3.5 CM (2 1/2 × 8 1/4 × 1 3/8 IN.)

WAWEL ROYAL CASTLE, CRACOW,
INV. 7680, FROM FELIKS ŚCIBAŁŁO'S
COLLECTION, CRACOW, PURCHASED 1991
FROM JADWIGA ŚCIBAŁŁO

LITERATURE
Zbiory wawelskie 1992, 24, cat. 24, fig. 30.

Lavishly decorated cartridge boxes were generally used in the seventeenth and eighteenth centuries by Polish noblemen who served in the army. They were frequently emblazoned with the owner's arms, knight's crosses, or images of patron saints or the Virgin Mary. The companions of noble stock carried them on the right side, and the rank and file on the left side.

The exhibited object has the form of a flat, rectangular, slightly arched box with apertures for ten cartridges. It is covered in black leather, its ridge being embroidered in gold lozenges and branches. The flap is of sheet silver-gilt (lined with yellow leather) with engraved and nielloed decoration: three medallions of concave-and-convex outline filled with floral sprigs and a border with a foliate-scroll ornament.

KJC

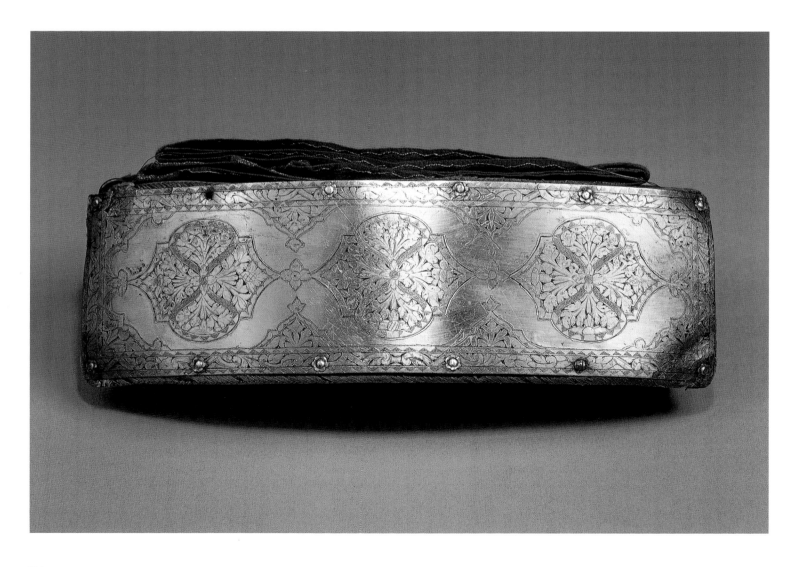

The cartridge container has the form of a flat, rectangular, slightly arched box with apertures for ten cartridges. It is covered in black leather, its ridge embroidered in gold lozenges. The silver-gilt flap (lined with red leather) is decorated with chased and nielloed dense interlaced foliate-floral vine and three oval medallions of gold-inlaid carnelians bearing ornamental motifs and a figure of Saint John Nepomuk. The decoration of a gold lamé band with mounts and a buckle of silver-gilt resembles that on the flap. In one of the carnelian medallions there is an image of Divine Providence.

KJC

69

CARTRIDGE BOX, 2ND QUARTER 18TH C.

POLAND

WOOD, LEATHER, METAL THREAD, SILVER, CARNELIAN; EMBROIDERED, CHASED, GILDED, NIELLOED, SET WITH PRECIOUS STONES, INLAID

6.7 × 20.5 × 3.3 CM (2 5/8 × 8 1/8 × 1 1/4 IN.)

WAWEL ROYAL CASTLE, CRACOW, INV. 7678, FROM FELIKS ŚCIBAŁŁO'S COLLECTION IN CRACOW, PURCHASED 1991 FROM JADWIGA ŚCIBAŁŁO

LITERATURE
Zbiory wawelskie 1992, 23–24, cat. 23, fig. 29; *Pod jedną koroną* 1997, 416–17, cat. XIII 8.

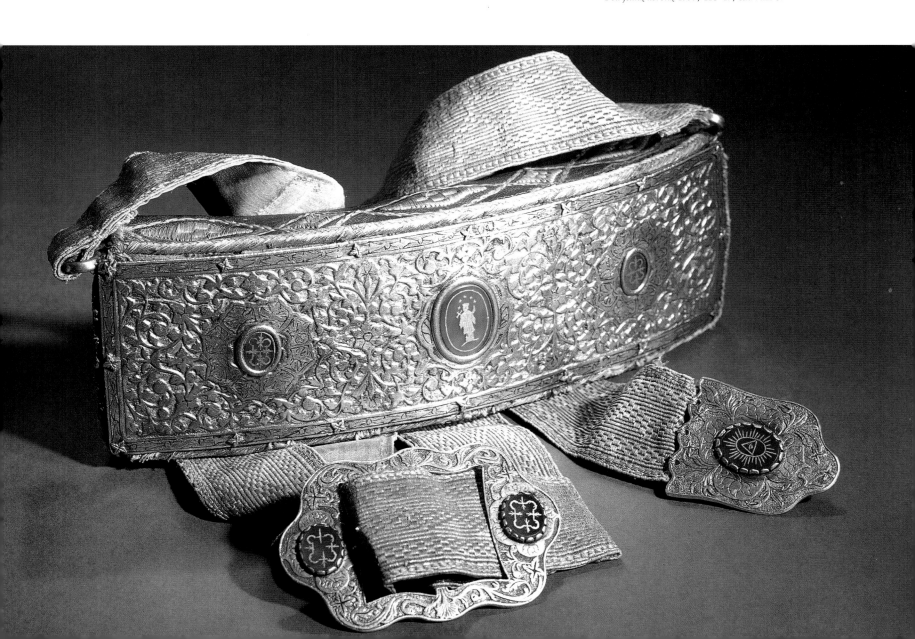

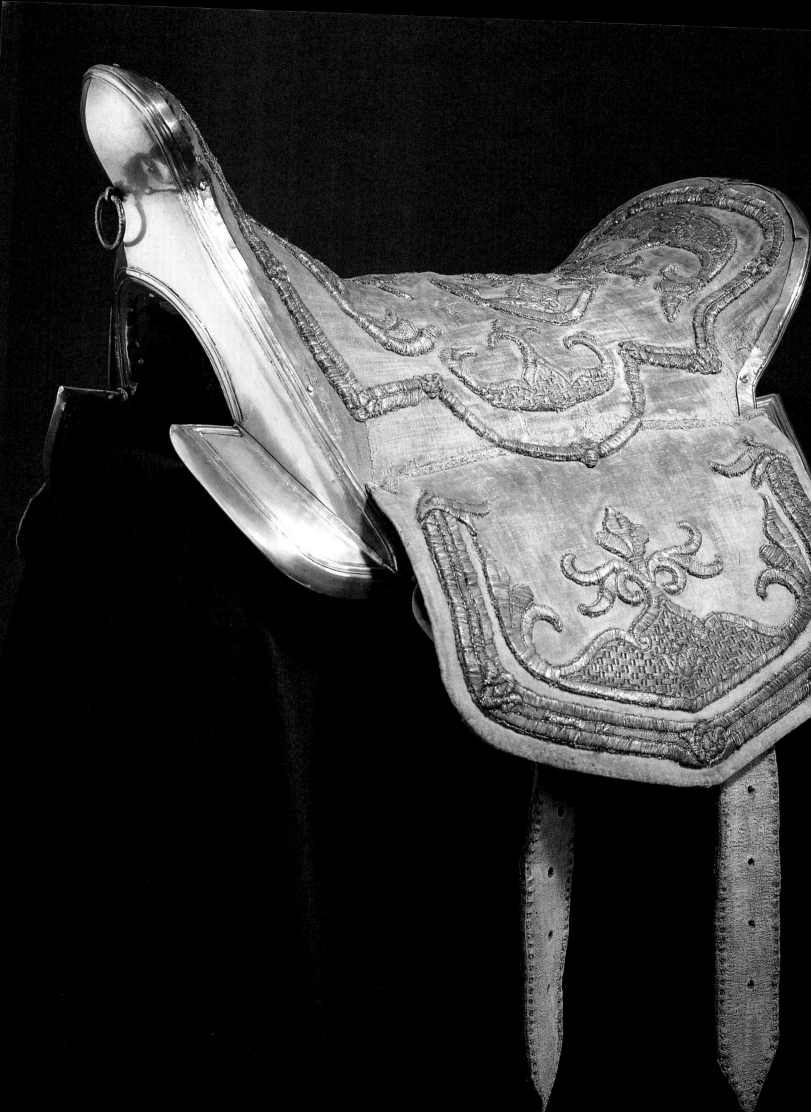

The saddle belonged to the collection of the Rzewuski family. It was confiscated in 1833 by the czarist authorities as a reprisal after the suppression of the November Uprising (1830/31) and recovered (together with trappings) under the terms of the Treaty of Riga (1921) from the Hermitage collections in Saint Petersburg. In 1997 thorough restoration, including reconstruction of the destroyed parts of the embroidery, was undertaken in the conservation studios of the Wawel Royal Castle.

Polish saddles of the seventeenth and eighteenth centuries followed oriental patterns in their construction. They consisted of benches (laths running parallel to the horse's back) connected by the bow in front and the cantle at the rear. Oriental and Polish saddles were light and shallow, facilitating a horseman's movement. The orientalization of the Polish saddle was manifest not only in its construction but also in its decoration, which was frequently extremely lavish, imitating Turkish and Persian ornamentation. Gala specimens were fitted with silver-gilt nielloed mounts set with precious stones and inlaid. The finest saddles were even coated with sheet gold.

The bench ends as well as the front bow, pommel, and the lower arched cantle of the exhibited saddle are coated with plain silver plates. The seat, with side flaps lined with brown leather, is covered in blue velvet (today faded to green) embroidered with silver threads in a symmetrical ornament of highly stylized vegetal motifs of tendrils, foliage, and palmettes in relief. Around the seat and side flaps runs a single or double border. The benches are lined with blue linen, the girths are of straps tanned white.

KJC

70

SADDLE, 1ST HALF 18TH C.

POLAND

WOOD, LEATHER, LINEN, VELVET, METAL THREADS, SILVER; BEATEN, RAISED LAID EMBROIDERY

28.5 × 54 × 28.7 CM (11 1/4 × 21 1/4 × 11 1/4 IN.)

WAWEL ROYAL CASTLE, CRACOW, INV. 202

LITERATURE
Lenz 1908, 77, cat. M.139.

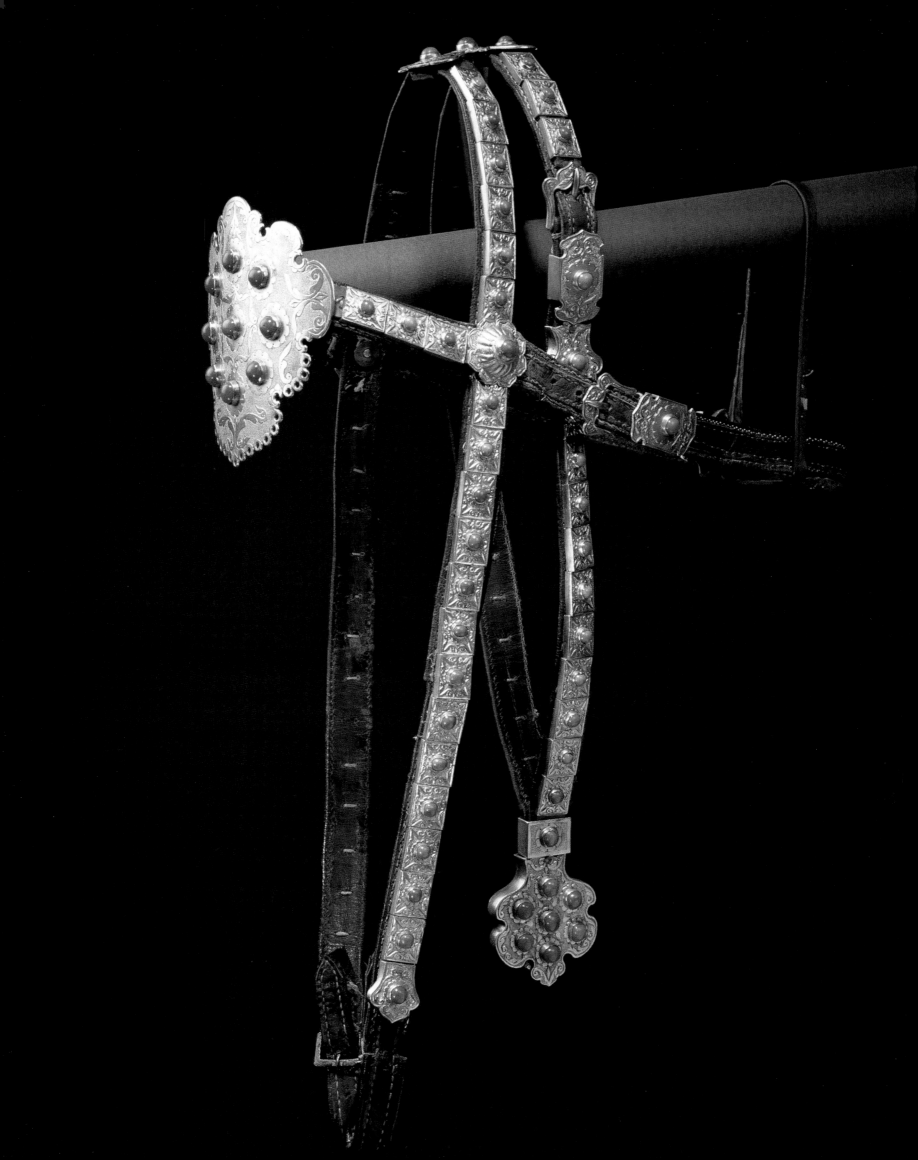

The Polish gala horse trappings of the seventeenth and eighteenth centuries were for the most part decorated with mounts of silver-gilt (exceptionally even of gold) bearing chased and nielloed ornaments whose forms were sometimes borrowed from oriental art or betrayed its influence. They were lavishly studded with turquoises, garnets, rubies, and plates of chalcedony. As in Turkish horse equipment, throatbands in Polish trappings were occasionally provided with *tugh* (horse tail)-shaped decoration.

The exhibited ensemble consists of headgear, noseband, breast strap, and crupper. All parts except the noseband are of brown leather straps stitched along the edges with gold thread and covered with rectangular ornamental plates at almost their entire length. The straps terminate in mounts, clasps, and buckles of wavy outline. The brow-band is in the form of an arched medallion whose edges, of fanciful outline, are partly openwork. The noseband (below), similar in form, is adorned with flat-braided double chains and green bands gold-striped along the edges. The throat band ends in a flat pendant resembling a leaf in shape. The breast strap and the crupper are joined by medallions in the form of octofoil rosettes with pronounced domical studs embossed in a swirling pattern. All silver elements are gilded, filled with a stylized foliate design on a textured ground, and set with round coral cabochons in rosette-shaped mounts.

The horse trapping formed a set with a similarly decorated saddle of which only the mounts of the benches and of the front bow and cantle survive. It may be regarded as a representative example of Polish gala horse equipment. Worth noting here are its restrained ornamentation and the elegant juxtaposition of gold with the delicate red of the corals.

In 1996 this harness was thoroughly restored, including reconstruction of the missing metal elements and supplementation of corals, under the direction of Wojciech Bochnak (metal parts) and Anita Bogdanowicz (leather) in Cracow.

KJC

HORSE TRAPPING, 1ST HALF 18TH C.

POLAND

LEATHER, METAL THREAD, SILVER, CORAL; STITCHED, CAST, CHASED, GILDED, SET WITH PRECIOUS STONES

A, HEADGEAR, 63 CM (24 3/4 IN.)

B, NOSEBAND MEDALLION, 12.2 × 14 (4 3/4 × 5 1/2)

C, BREAST STRAP, 109.5 (43 1/8); CRUPPER, 91 (35 7/8)

WAWEL ROYAL CASTLE, CRACOW, INV. 5248, PURCHASED WITH SADDLE MOUNTS IN 1966 FROM MARIA JAROSZYŃSKA OF CRACOW

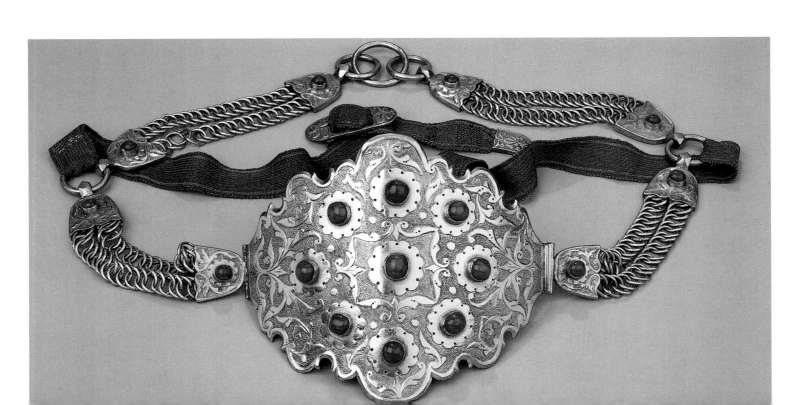

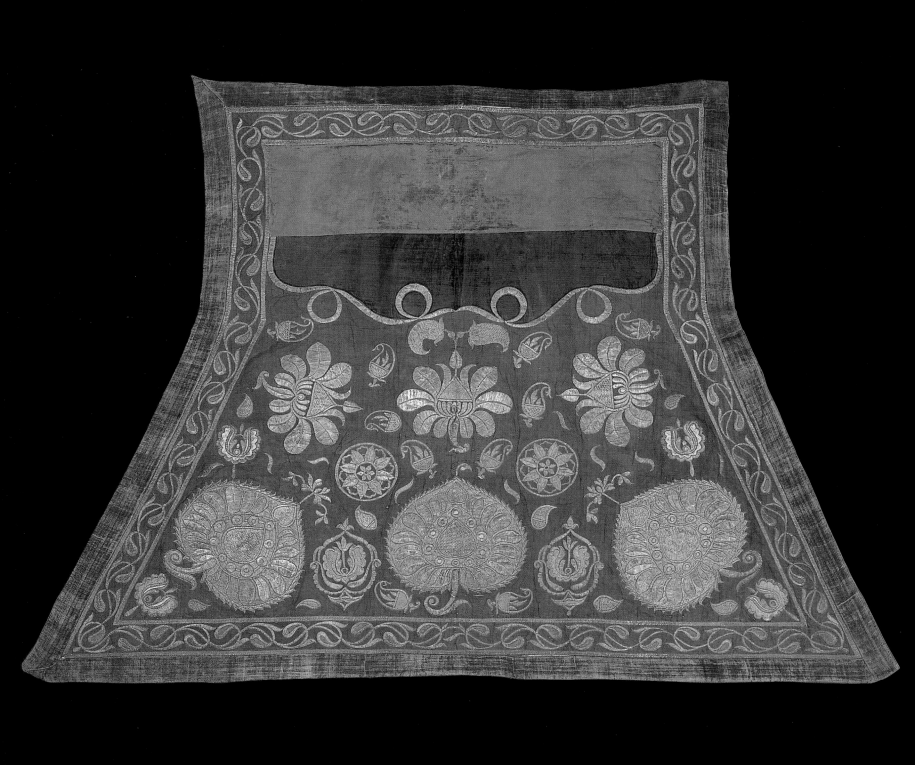

In the seventeenth and eighteenth centuries, especially in the period of the Polish-Turkish wars, Turkish and Persian weapons and horse equipment were much in use in Poland. They included *shabracks* (caparisons), exceptionally impressive because of their lush, dense, and highly stylized vegetal ornamentation embroidered in gold and silver. Not infrequently, captured *shabracks* were reused as altar frontals or made over into liturgical vestments (see cat. 78).

The exhibited object is made of olive-green rep and velvet (badly worn), rectangular, in the hind part widening to form a trapezium, decorated with silver and gold embroidery with colorful red and blue accents. The border running along the edges, trimmed with crimson velvet, is filled with a sinuous leafy vine. The hind part bears vegetal motifs, among which are three prominent large heart-shaped palmettes with asymmetrical stalks and three flower calyxes; between them are two circular rosettes, flowers, and small leaves. Inserted in the unornamented front part are pieces of velvet in a different color tone.

KJC

72

CAPARISON, 1ST HALF 18TH C.

TURKEY(?)

COTTON AND SILK REP, VELVET, METAL THREAD; STITCHED, LAID EMBROIDERY (FLAT AND RAISED)

127.5 × 182 CM (50 1/4 × 71 5/8 IN.)

WAWEL ROYAL CASTLE, CRACOW, INV. 4846, GIFT OF RYSZARD JAN DRESZER, 1964

LITERATURE
Petrus, Piątkiewicz-Dereniowa, Piwocka 1988, 14, 52.

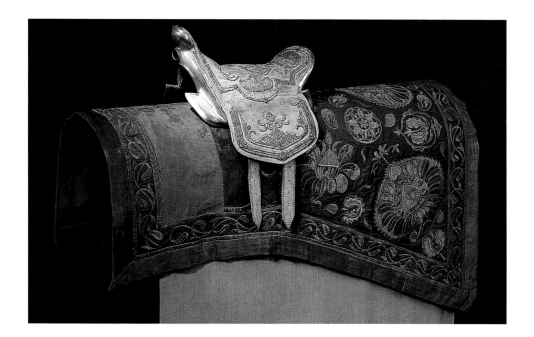

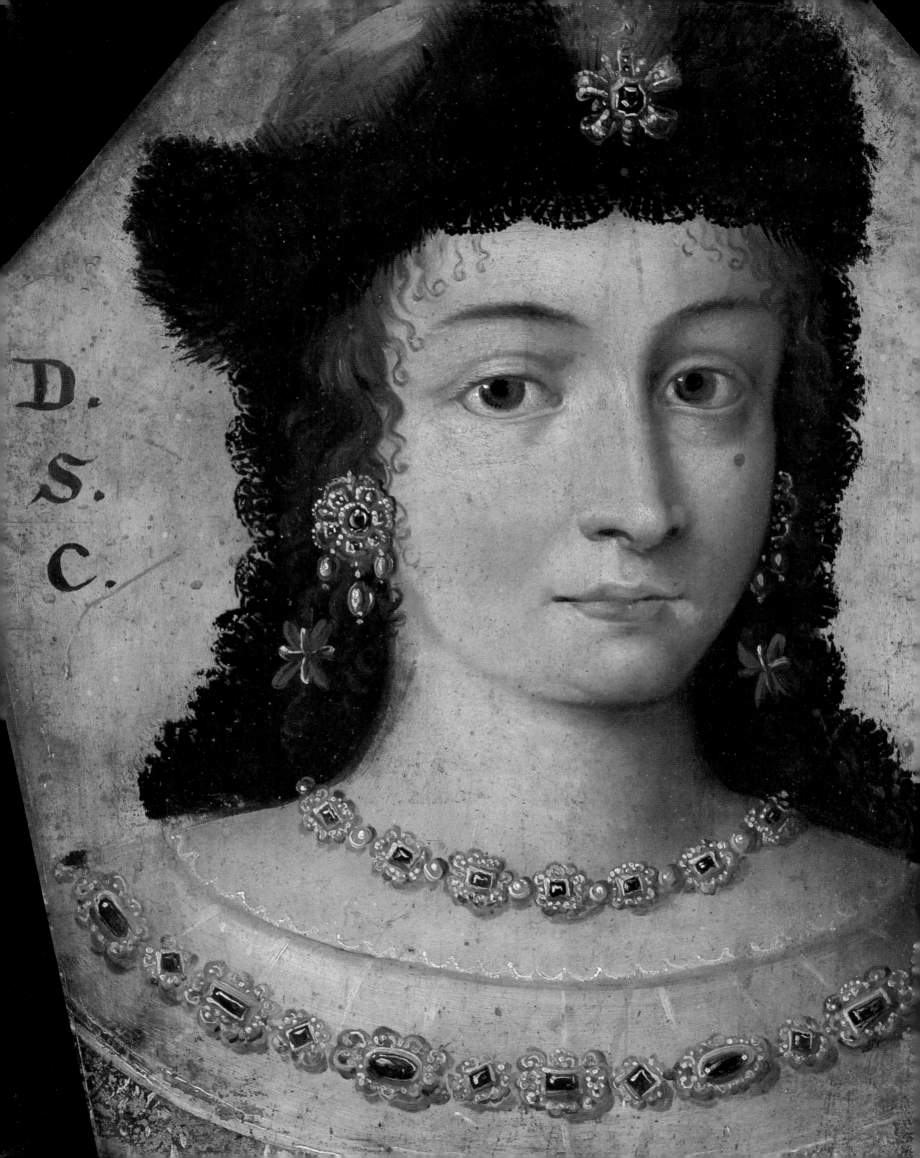

RELIGION

The adoption in 966 of the Christian faith in the Latin rite determined the direction of Poland's cultural development. Christianization of the country took generations, but toward the close of the fourteenth century Poland was almost uniformly Catholic, the only minority being Jews who had begun to settle in Poland at the turn of the twelfth century. The creation of the Polish-Lithuanian Commonwealth diversified the religious makeup of the country. Ethnic Lithuanians accepted Christianity in the Roman rite, but their state also embraced a huge Orthodox population. In addition, the decline of the Middle Ages saw the rise of the military colonies of the Muslim Tatars and of the Karaites, a variety of Judaism. Armenians who appeared in the towns of the southeastern territories of the Polish Kingdom followed a form of Christianity different from both the Roman and the Orthodox rites.

The Reformation brought Protestantism to Poland. Calvinism won a considerable following among the gentry, and Lutheranism in the urban middle class; one radical Protestant sect adopted the name Polish Brethren. Consequently, in the middle of the sixteenth century, the country represented a veritable religious mosaic, and Roman Catholicism, while remaining the established religion of Poland, lost its majority. Nonetheless, this never led to large-scale religious conflicts, and freedom of religion was one of the articles that every king-elect promised to observe.

Toward the end of the sixteenth century the Catholic Church undertook a successful campaign to recover its dominance. The years 1595–96 witnessed a union with the Orthodox Church in the Commonwealth, which recognized the supremacy of the pope and basic Catholic dogma while retaining its own hierarchy, liturgy, and customs. In 1630 the Polish Armenians joined the union on similar terms. The Orthodox Ruthenian elite continued to be converted to Roman Catholicism, and most of the families who in the sixteenth century had become Protestant returned to their former faith. Jews enjoyed full freedom of religion, the only incentive to their conversion being the facilities offered for obtaining noble privileges.

Despite the differences that separated Christians from Jews and Muslims, or Protestants from Armenians, many cultural phenomena surmounted religious divisions. The knightly ethos of the gentry, encompassing a hierarchy of values, ways of behavior, and costume, was common to Christians of all rites and also to many Tatar nobles. The same miraculous pictures of the Virgin Mary were venerated by Roman Catholics, Uniates, and Orthodox. Specific Polish types of art, such as coffin portraits or banner epitaphs, occur among Catholics, Protestants, and the believers of the eastern Churches.

It is worth noting the relatively high state of preservation of the religious cultural heritage. Many churches and monasteries are still veritable museums of ancient art that, unlike the collections of secular institutions or private owners, escaped destruction or dispersal in the political troubles that have enveloped Poland since their time. Church treasuries suffered heavy losses as a result of the dissolution of monasteries by the Austrian authorities toward the end of the eighteenth century, war contributions between 1806 and 1810, the abolition of the Church Union and the dissolution of Roman Catholic monasteries in the Russian partition zone in the nineteenth century, and the devastation of nearly all churches in the Polish territories incorporated into the Soviet Union. The state of preservation of historical objects connected with other beliefs is worse, the heritage of the Polish Jews having been annihilated during the Nazi occupation.

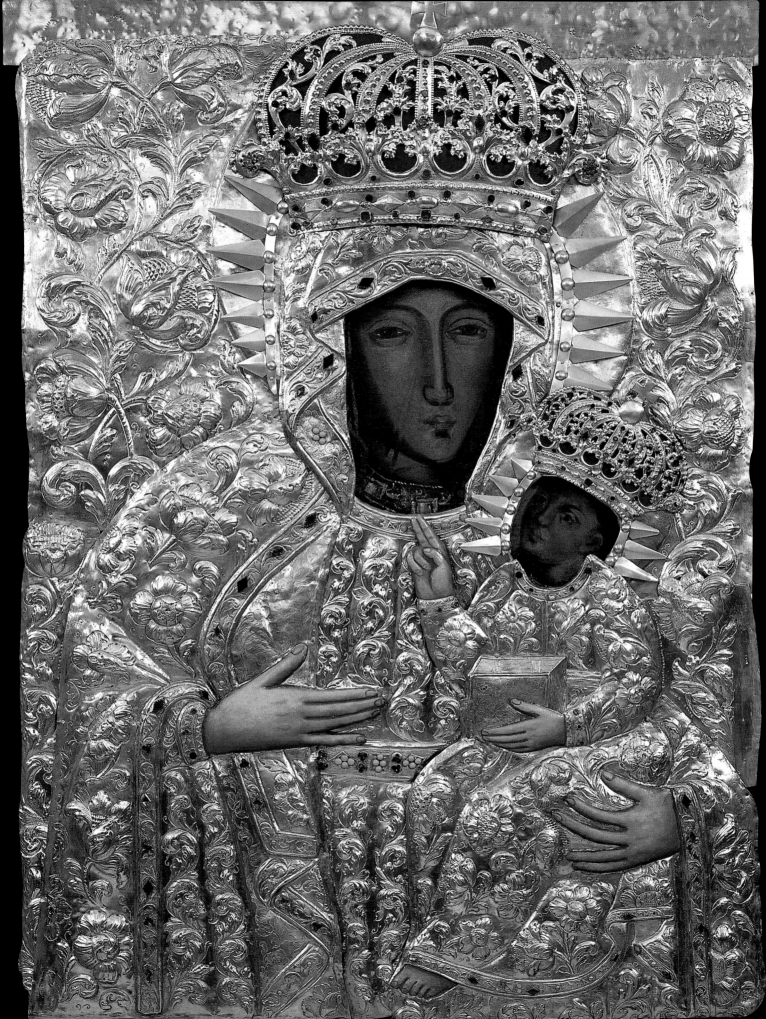

The painting comes from the Calced Carmelite church of Saint Michael the Archangel in Lvov, whence it was brought to Cracow in 1945. According to reliable monastic tradition, the Carmelite painting was originally owned by Lvov burghers named Pełka, residents of Halickie, a suburb, who sold it to the local painter Szydłowski. In turn the image of the Virgin was supposedly bought for four ducats by Father Eligiusz Niwiński, a Carmelite from Sąsiadowice, who in 1616 was to set it up in the newly erected church of the Visitation of the Virgin Mary in Lvov, in Halicki Square. The picture, held in great veneration by the inhabitants of Lvov, won renown as a miraculous image. In 1786 the occupying Austrian authorities took the church away from the Calced Carmelites, giving them instead another one confiscated earlier from the Discalced Carmelites. Consequently, in 1789, the painting was placed in the high altar in Saint Michael's. It has been repeatedly renovated: at the turn of the eighteenth century, in 1887, conserved and set in a feretory in around 1950, and in 1997 at Wawel Castle by Anna Kostecka (painting) and Jan Kostecki (cover).

The exhibited work represents Our Lady, in half-figure, holding the infant Jesus on her left arm. They are dressed in robes with vegetal-floral patterns and gems. Except for the faces the picture is covered completely with a "robe" of silver, partly gilt, repoussé in acanthus scrolls and flowers (garments) and lush floral vines (background). On their heads the Virgin and Jesus wear crowns set with semiprecious stones and their imitations; their hands are embossed in sheet silver and polychromed in flesh tones.

The picture is a copy of the image of Our Lady of the *Hodegetria* type, which has for more than six centuries been held in great veneration. Kept in the Paulite sanctuary at Jasna Góra in Częstochowa, the model has played an exceptional role in the history and religious life of the Poles. The here-exhibited painting is an accurate copy of the miraculous image at Jasna Góra as it looked in the early seventeenth century, with such characteristic elements as two slashed scars on Mary's right cheek (trace of a profanation in 1430) and the suspended draperies painted on both sides of the figures, edged with broad lace, the real ones serving to veil the original picture. The "robe" on the picture, made from precious metal, symbolizes divine light but at the same time is an expression of the veneration of Mary by the faithful. The exhibited object has close analogies in the pictures of Our Lady of Częstochowa in the parish church at Wielkie Oczy near Lubaczów and in the former Paulite church at Stara Wieś, both painted in 1613 by the Cracow artist Jan Śniadecki.

This is one of the rather early copies of the Jasna Góra picture on the territory of the archdiocese of Lvov. Along with it are the paintings at Kołomyja and Nadwórna, which testify to the development of the Marian cult in the southeastern provinces of the Commonwealth.

JTP

73

OUR LADY OF CZĘSTOCHOWA, EARLY 17TH C.

LVOV OR CRACOW

COVER ("ROBE"), 17TH/18TH C.

LVOV

OIL ON CANVAS, SILVER

134 × 94 CM (52 3/4 × 37 IN.)

CARMELITE CHURCH OF THE VISITATION OF THE BLESSED BIRGIN MARY, CRACOW

LITERATURE
Barącz 1891, 161; Wacław z Sulgostowa 1902, 400–2; Fridrich 1904, 248–50; Urban 1984, 117.

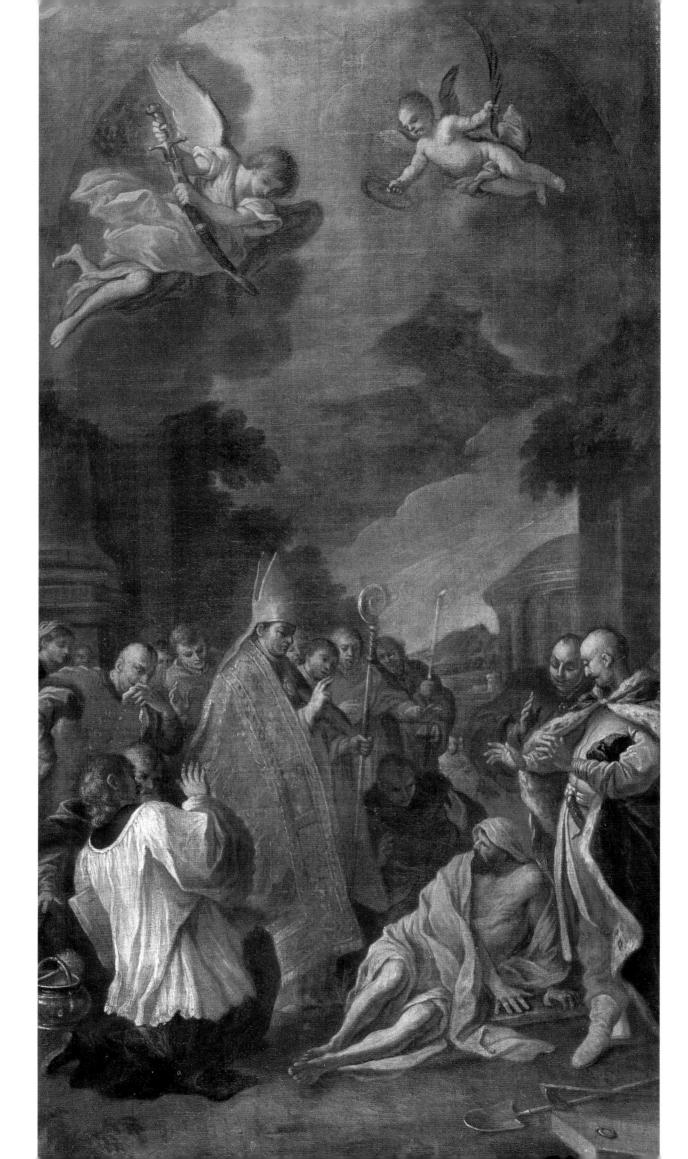

The painting depicts an episode in the life of Saint Stanislaus, bishop of Cracow (d. 1079). Szymon Czechowicz took up this subject several times, beginning with his youthful design for an engraving made during his stay in Rome, probably around 1725. The picture in the collection of the Wawel Royal Castle is undoubtedly a *modello* for an altarpiece. Using this composition, Czechowicz executed at least two large paintings: one in the former Jesuit church in Poznań, dated c. 1756, and the other in the parish church at Olesko, lost during World War II. Furthermore, there existed two almost identical *modelli*, one at the presbytery of the Corpus Christi Church in Poznań (lost during World War II) and the other in the palace gallery at Podhorce (lost during World War I). Besides, pencil sketches of individual figures are known that were once in the Przezdziecki Library in Warsaw and in the Wróblewski Library in Vilnius.

The painting is one of the iconographically and artistically most developed examples of the depiction of Saint Stanislaus. In terms of composition and style it grows out of the tradition of classicizing Roman painting. Czechowicz became familiar with it during his long stay in Rome, employing its solutions to the end of his long life. The general composition is based on Domenichino's *Communion of Saint Jerome*, while the kneeling priest in the foreground has been borrowed from Lazzaro Baldi (Orańska 1948). The painter sought an interesting mode of rendering the remoteness of the depicted event. The lay participants in the scene were stylized to look like "Sarmatians," this reference to the eleventh century being an obvious anachronism. Nevertheless, their costumes and hair were evidently archaized in relation to eighteenth-century fashion. A similar allusion to the loosely treated historical tradition is played by fragments of classical architecture, especially by the Roman temple of Vesta in the middle distance.

The loss of most of the paintings from Czechowicz's series, of which the present picture once formed a part, precludes any closer analysis of the function of this painting or a precise hypothesis about its dating. It is not clear why Czechowicz painted several virtually identical *modelli* for one composition. It is, however, worth indicating that the palace at Podhorce housed a set numbering scores of such sketches forming a specific gallery in the so-called Green Room of the residence (Ostrowski 1998). The historical context of the creation of the set (the artist's stay in Poznań in 1756 and at Podhorce from around 1762 to 1767) would point to a rather late date of execution of the Cracow *modello*, in the 1750s or 1760s.

JKO

74

SAINT STANISLAUS RAISES THE KNIGHT PIOTR FROM THE DEAD

SZYMON CZECHOWICZ (1689–1775)

OIL ON CANVAS

90.5 × 46.2 CM (35 5/8 × 18 1/8 IN.)

WAWEL ROYAL CASTLE, CRACOW, INV. 665, FROM THE BEQUEST OF COUNT JERZY MYCIELSKI, 1929

LITERATURE
Orańska 1948, 77–79, 145; *Malarstwo polskie* 1971, 414–15; Ostrowski 1998, 343–51.

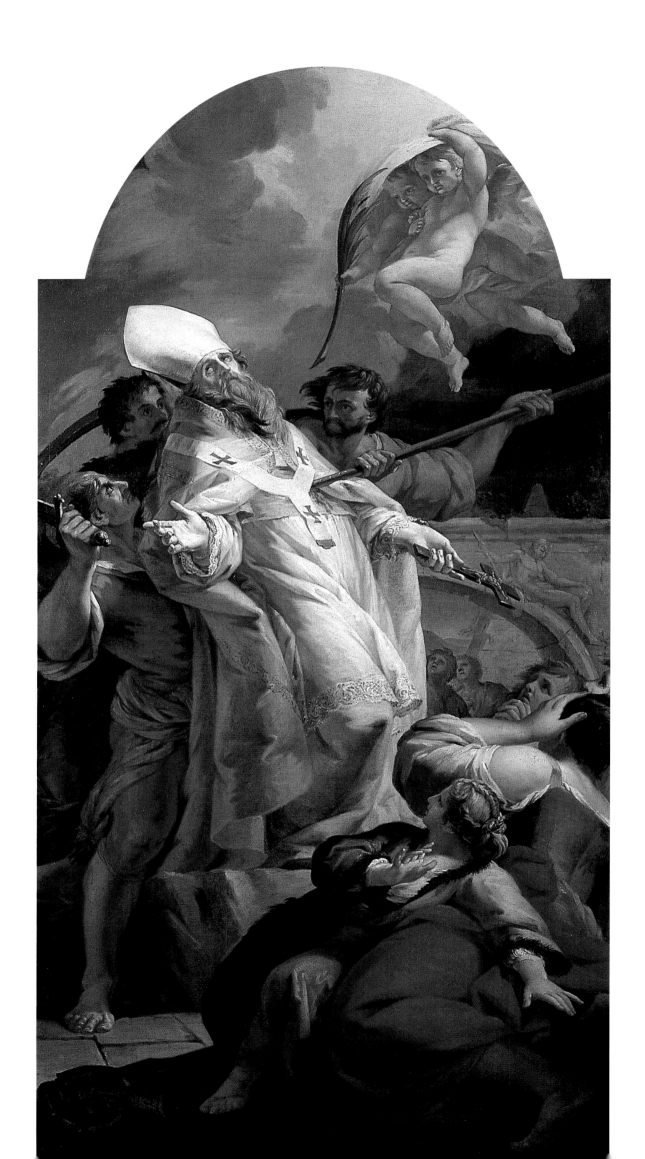

Saint Adalbert (Wojciech), the first Slavonic martyr and patron saint of Poland, was the bishop of Prague who came to Poland to christianize pagan Prussia. He died a martyr in the year 997, at the beginning of his missionary activity, pierced by pagan arrows. Boleslas the Brave brought out the martyr's body and buried it in the cathedral in Gniezno. Canonized soon afterward, Adalbert became the patron saint of the newly established ecclesiastical metropolis.

It follows from Kuntze's signature *Kunze fecit Romae 1754* that he painted *The Martyrdom of Saint Adalbert* in Rome in that year. It was one of several canvases commissioned by Bishop Andrzej Załuski for Cracow Cathedral. Originally it was set in a baroque altar dated 1752–56 in the nave of the cathedral. In 1900 the altar was removed and the painting transferred to the sacristy (the former chapel of Saint Margaret), where it remains to this day.

The painting ranks among Kuntze's best early works. The artist skillfully applied compositional solutions developed in the Roman milieu, known earlier from paintings by Domenichino and works by Pietro da Cortona and Carlo Maratti. Pathos befitting scenes of martyrdom has been achieved here by the luminous and chromatic contrasting of the groups of figures composed along the diagonal. The women in the foreground remain in half shadow, unlike the figure of the bishop-martyr, depicted farther back, which is illuminated by a heavenly light. Other elements characteristic of Roman baroque painting add to the mystical and dramatic dimension of the scene: theatricality of gestures and facial expression, contrasting juxtaposition of colors of different values, a fantastic, visionary background with an ancient-style bridge, and flying cherubs bringing Saint Adalbert the palm of martyrdom. In this work Kuntze reveals great mastery in handling a varied palette, especially remarkable in the martyr's attire, which shines with subtly juxtaposed shades of pale lilac, blue, and whitened celadon.

The Martyrdom of Saint Adalbert attests to the artistic maturity of Kuntze, whose style, when viewed against Roman painting of the mid-eighteenth century, is representative of the current high rococo, free from sentimentality and the "porcelain-like" softness of form so characteristic of the oeuvre of Francesco Trevisani or Sebastiano Conca, while it is enriched with the virtuosic drawing, delicacy of color, and textural effects inspired by the works of Neapolitan masters, especially Francesco Solimena and Corrado Gianquinto.

MK

75

THE MARTYRDOM OF SAINT ADALBERT, 1754

TADEUSZ KUNTZE (1727–93)

OIL ON CANVAS

179 × 93.5 cm (70 1/2 × 36 3/4 in.)

CATHEDRAL OF SAINT WENCESLAS AND SAINT STANISLAS, CRACOW

LITERATURE
Katalog Zabytków 1965, 95.

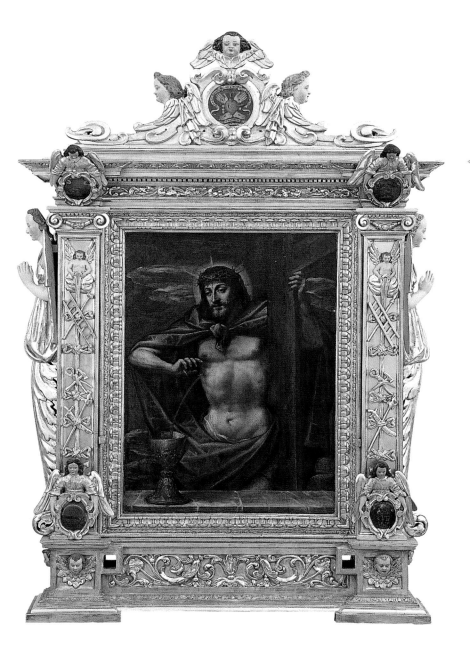
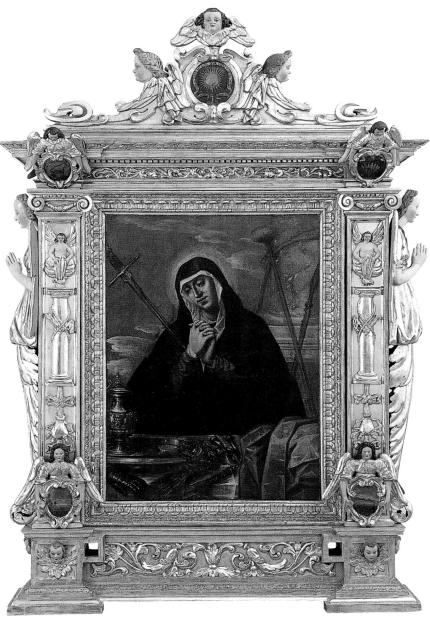

A feretory is a religious picture or figure in a sumptuous frame on a pedestal or provided with a pair of bars for carrying it, like a banner, during solemn processions. Feretories usually belonged to religious confraternities active at particular churches.

Architectural in form and two-sided, the exhibited work consists of a pedestal, a rectangular picture flanked by Ionic pilasters, and the entablature bending forward and backward with sculptured cresting. The pedestal and the frieze of the entablature are decorated with acanthus; the shafts of the pilasters bear the instruments of Christ's Passion suspended on cloths held by angels rendered in half-figure; the frame is covered with a foliate design. On the protruding ends of the pedestal are cherubs' heads, and at the foot of the pilasters and over their capitals, against the entablature, are half figures of angels holding rollwork cartouches with painted emblematic representations and lemmas on banderoles, referring to the Eucharist. The sides are accentuated by herms in their lower part covered with foliage and with their hands joined in prayer. The triangular cresting consists of a rollwork cartouche containing a painted emblem with a lemma (on the obverse [opposite, left] the five wounds of Christ, and on the reverse [opposite, right] a monstrance) and surmounted by a cherub head flanked by volutes and angel heads in profile. The woodcarving is gilded, while the faces, forearms, and hands of the herms and angels are painted in flesh tones. Square apertures in the pedestal serve to pass bars through them. This is one of the oldest feretories in Poland, remarkable for the high quality of both the carved wooden frame and the paintings.

The pictures have hitherto been linked with the workshop of Tommaso Dolabella, who settled in Cracow; however, they should rather be connected with the studio of Łukasz Porębski, author of numerous paintings that decorate the Corpus Christi Church to this day. The obverse depicts the half-length figure of Christ as the Man of Sorrows wearing the crown of thorns on his head. His left hand embraces the cross, and the right points at a wound in his right side, from which a stream of blood flows into a gold chalice, studded with precious stones, which stands in the foreground. The reverse represents the sorrowful Mother of God dressed in a blue garment and a darker blue cloak and veil. Mary is turned slightly to the right, wringing her hands in a gesture of sorrow. Her head is surrounded by a yellowish orange glow. The point of the sword of sorrow is directed to her heart. In the foreground is the top of the table, covered with a cloth, on which are laid the instruments of Christ's Passion (a scarlet cloak, scourges, a reed, a gauntlet, crown of thorns, three nails, and a silver basin with an ornamental, partly gilded ewer). On her left is a plinth on which stands a marble column with a rope around it; against the column leans a reed with a vinegar-soaked sponge crossed with a lance. The subjects of the pictures and emblematic representations are linked with the cult of Christ's Wounds, thus of the Passion (connected with the veneration of the sorrowful Mother of God, suffering together with her son, thereby being the co-redemptress of man and the world) and also with the cult of the Eucharist, intensively developed at the church in Kazimierz.

KJC

76

FERETORY, C. 1634/35

ŁUKASZ PORĘBSKI(?), CRACOW

LIMEWOOD CARVED, POLYCHROMED, AND GILDED; OIL PAINTING ON CANVAS PASTED ON BOARD

FERETORY, 215 × 145 CM (84 5/8 × 57 1/8 IN.); PAINTINGS 103 × 74 (40 1/2 × 29 1/8)

CORPUS CHRISTI CHURCH OF CANONS REGULAR, CRACOW

LITERATURE
Kopeć 1977, 117–18; *Katalog Zabytków* 1987, 61, figs. 230, 320, 321.

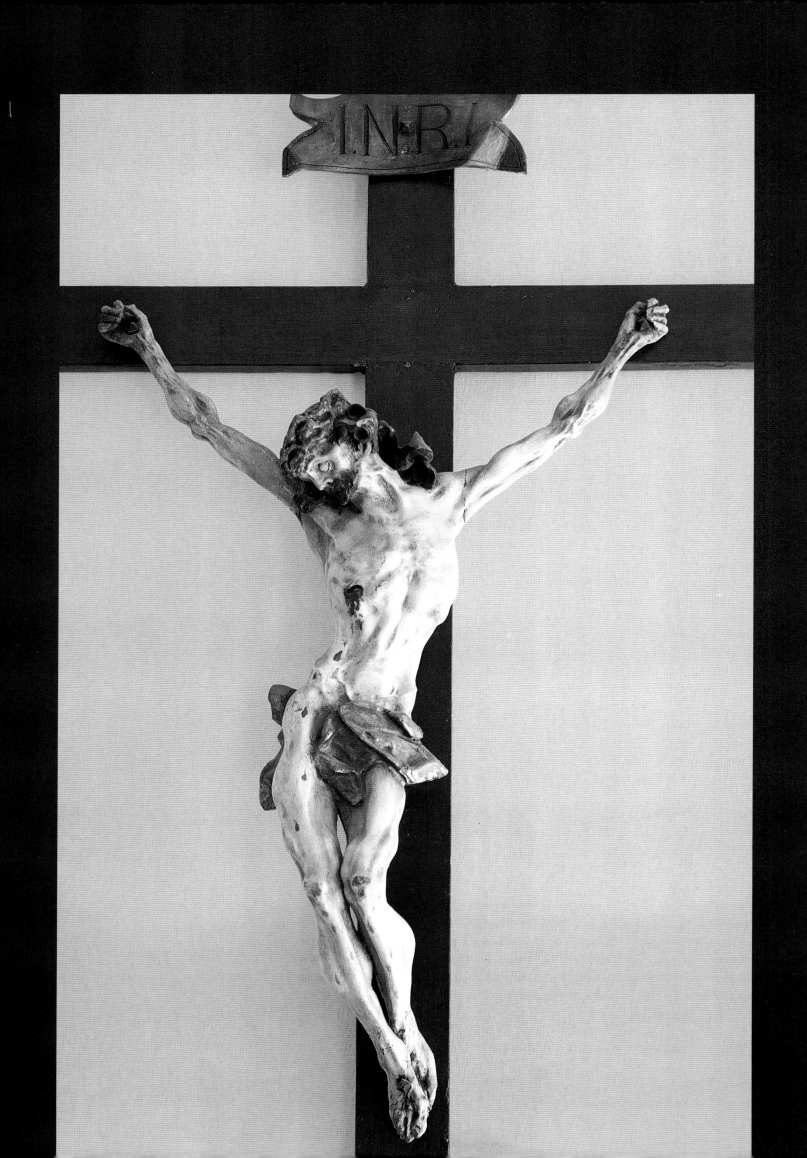

The sculptured decoration of the parish church at Hodowica, whence the exhibited object originates, was carved about 1758, undoubtedly according to a general design by Bernard Meretyn, an outstanding exponent of rococo architecture in the Lvov milieu. All scholars credit Johann Georg Pinsel (and his workshop, including Maciej Polejowski, later the most notable representative of the younger generation of sculptors in the Lvov school) with the authorship of the sculptures, except for Hornung, who attributed most of the Hodowica sculptures to Antoni Osiński.

The elaborate composition of the high altar consisted of a set of single figures and sculptured groups fixed against a background of illusionist architectural painting. Today only its sculpted elements exist, while the church, Meretyn's excellent work, is in a dilapidated state.

The small *Christ on the Cross* was certainly carved at the same time as the remaining elements of the church decoration and was used as a processional cross. In 1946, during the deportation of the Polish population from the territories annexed by the Soviet Union, the cross was taken from Hodowica and for more than forty years was believed to be lost. It was not until 1990 that the crucifix was identified in the Corpus Christi Church on the occasion of the Wrocław exhibition of Pinsel's sculptures from the Lvov collections.

Among Pinsel's well-known works are three other figures of the Crucified Christ: from the church at Horodenka, from the high altar at Hodowica, and from the church of Saint Martin in Lvov. Each of them was composed individually, the third being distinguished by its expressive qualities. The small sculpture from Hodowica (perhaps the *modello* of a larger composition) is the most original achievement in the whole series. It combines virtuoso command of technique with the deeply moving dramatic expression and flamboyant stylization of the arrangement of Christ's body, bringing to mind a comparison with a rocaille ornament.

JKO

77

CHRIST ON THE CROSS, C. 1758

JOHANN GEORG PINSEL (D. 1761 OR 1762)

POLYCHROMED WOOD

40 CM (15 3/4 IN.)

CHURCH OF CORPUS CHRISTI, WROCŁAW

LITERATURE
Bochnak 1931, 54, 85, fig. 52; Hornung 1937; Mańkowski 1937, 102, figs. 78–79; Hornung 1976; Woznicki 1990; *Teatr i mistyka* 1993, II.62–64; Ostrowski 1993, 31, 34, fig. 113.

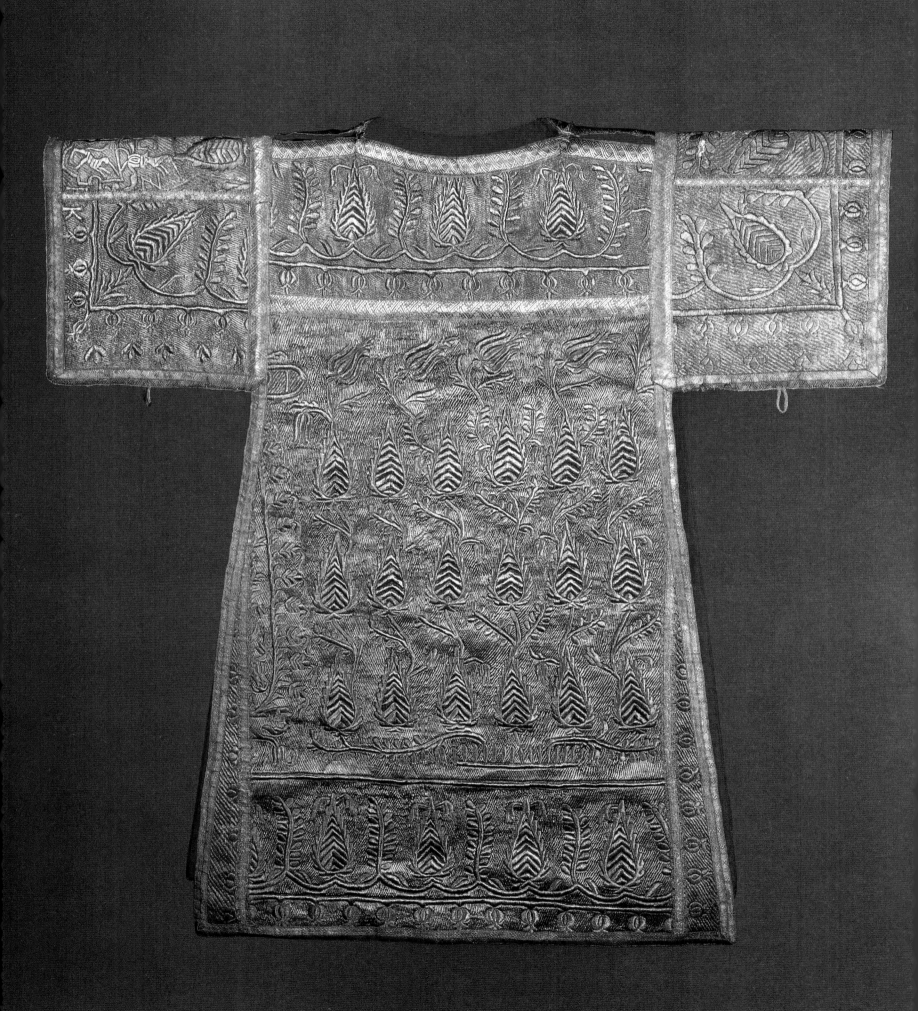

A dalmatic is used in the Roman Catholic Church as the liturgical vestment of a deacon. It usually belongs to a set consisting of a chasuble, two dalmatics, and a cope.

The entire surface of the exhibited dalmatic is decorated with a gold vegetal pattern (tulips, leaves, palmettes, and the like) on a laid gold ground. Particular motifs are arranged in rows, linked with one another by stalks or branches, some of them being placed in the borders separated by fillets. It is edged with gold braid. On the arm are the embroidered Jednorożec coat of arms and the letters *GZRKFK*.

The arrangement of the ornament (some motifs are cut off, the lack of full symmetry, the coat of arms on the arm) indicates that the vestment was made from reused fragments of fabric embroidered for a different purpose. These were probably pieces of a caparison supplemented with new embroidery, which can be distinguished by slightly different threads and manner of execution. The remaking of secular textiles into liturgical vestments was frequent in the seventeenth and eighteenth centuries. This practice is excellently exemplified by the altar frontals made from Turkish *shabracks* (caparisons) and the chasubles with sewn-on fragments of Turkish embroidery that are kept in the church at Krasne.

KJC

78

DALMATIC, 2ND HALF 17TH C.

POLAND

LINEN, METAL THREAD;
LAID (FLAT AND RAISED) EMBROIDERY

103.4 × 104 CM (40 3/4 × 41 IN.)

CHURCH OF THE ASSUMPTION OF THE
BLESSED VIRGIN MARY, CRACOW

LITERATURE
Katalog Zabytków 1971, 42.

CHASUBLE, 2ND HALF 17TH C.

CRACOW(?)

LINEN, METAL THREAD;
EMBROIDERY (FLAT AND RAISED)
LAID WITH METAL THREAD

116.5 × 78 CM (45 7/8 × 30 3/4 IN.)

CHURCH OF THE ASSUMPTION OF THE
BLESSED VIRGIN MARY, CRACOW

LITERATURE
Katalog Zabytków 1971, 42, fig. 936.

The chasuble is covered all over with raised embroidery in gold vegetal ornament on a silver ground. The vertical bands are separated by embroidered strips imitating galloons filled with axial decoration of massive, succulent flowers and leaves. The sides bear a sinuous leafy vine with large flowers filling its bends. Around the neck are flowers and foliage. All plant motifs are highly stylized and couched with stitches forming geometrical patterns.

This is a typical example of sumptuous Polish baroque embroidery in which the massive geometrical stylization of plant ornament (with tulips, so fashionable in the second half of the seventeenth century) is combined with the most expensive and effective materials, gold and silver.

KJC

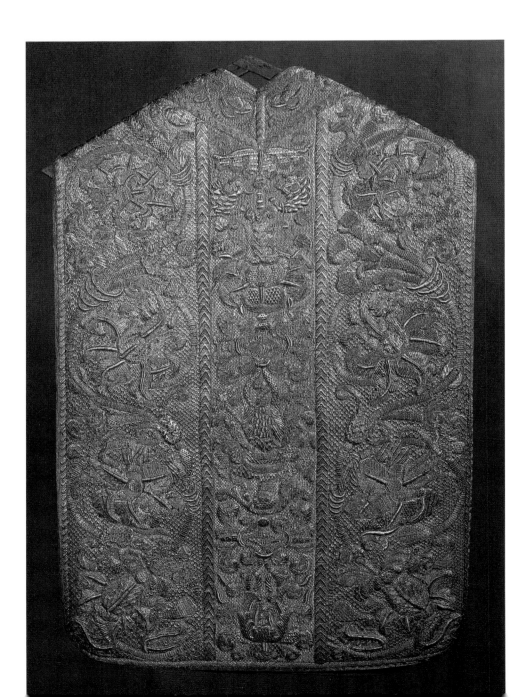

In the Roman Catholic Church a cope is a liturgical vestment worn by a priest during various kinds of divine service, processions, benedictions, and the like.

The exhibited cope is covered entirely with reticular ornament embroidered in gold on a silver ground, consisting of quatrefoils filled with rosettes and pomegranates enclosed by lanceolate leaves. On the ornamental border is a silver ornament on a gold ground: quatrefoil medallions with two-handled vases in which branches with fruit and leaves are symmetrically arranged. On the hood, against a gold background, is the silver hierogram of Christ (*IHS*) in foliate stylization, a cross, three nails, and rosettes; along the edges is a foliate border, and in the upper part is the donor's inscription *ANNA BAIEROWA/ 1644* in gold letters decorated in black enamel and set with rubies.

This is one of the most sumptuous examples of seventeenth-century Polish embroidery. The use of silver and gold threads and relief forms of highly stylized vegetal motifs, revealing oriental influences covered with geometrical patterns, produces the effect of exceptional wealth and splendor. It is unique that the hood is inscribed with the full name and surname of the donor, a Cracow townswoman, and with the date of donation; usually only a coat of arms bearing initials was placed on it.

KJC

80

COPE, 1644

CRACOW(?)

LINEN, METAL THREAD, GOLD, RUBIES; FLAT AND RAISED EMBROIDERY, CAST, ENAMEL, SETTING WITH PRECIOUS STONES

134.5 × 274 CM (53 × 107 7/8 IN.)

CHURCH OF THE ASSUMPTION OF THE BLESSED VIRGIN MARY, CRACOW

LITERATURE
Katalog Zabytków 1971, 43, fig. 964; Rożek 1977, 59–60, 312; Samek 1984, 180, 184; *Corpus Inscriptionum* 1990, 51, 135–36, cat. 79; Samek 1990, 257, fig. 198.

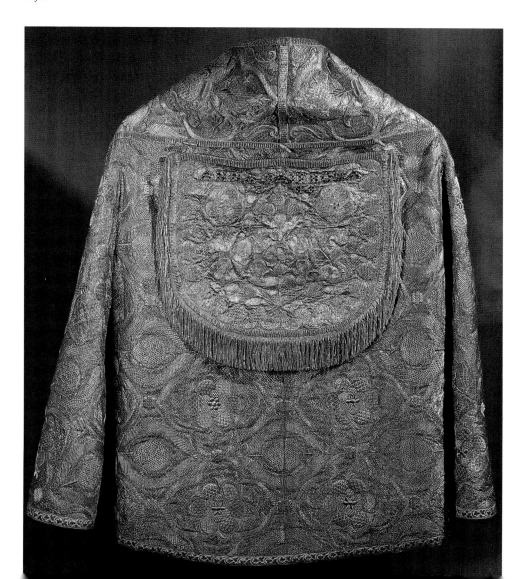

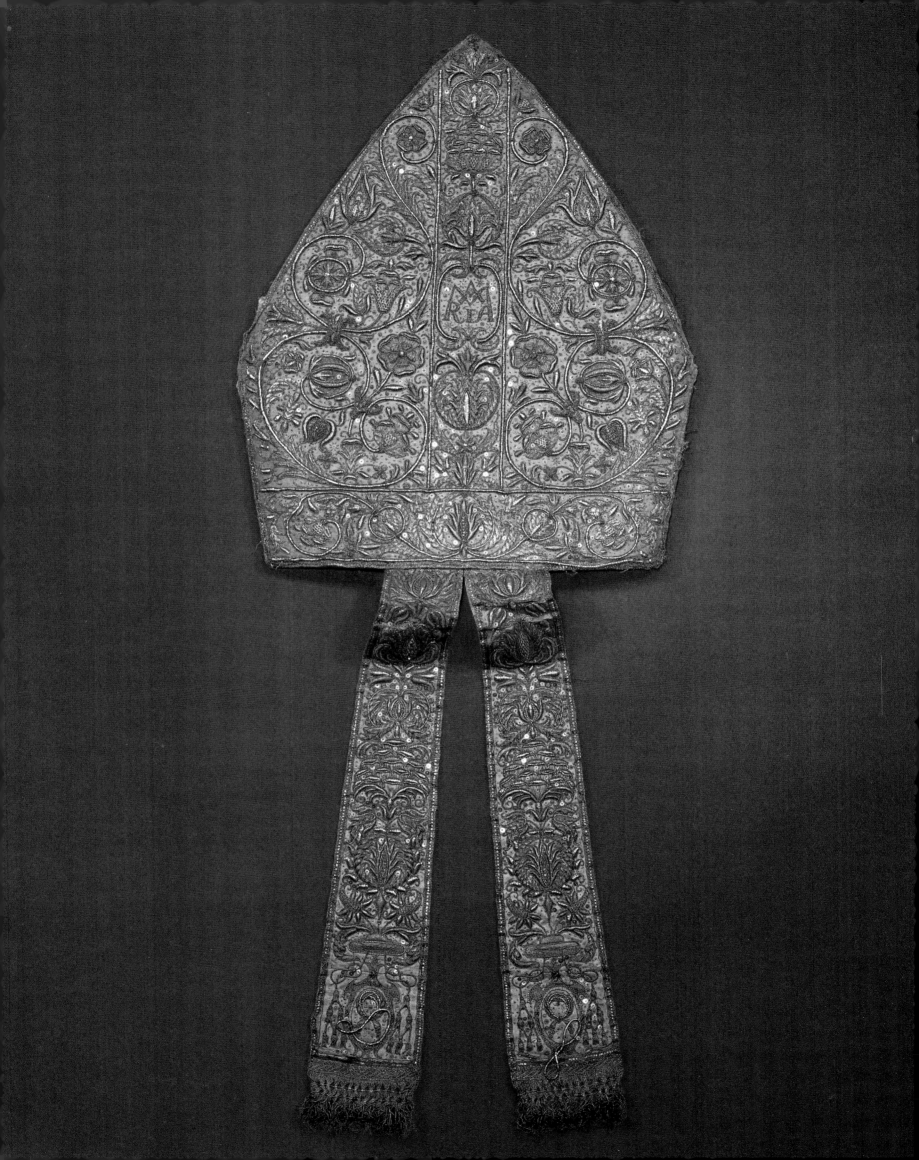

On the basis of the Nałęcz coat of arms on the lappets it may be supposed that the present object (along with two other miters) found its way to the treasury of the church of the Holy Sepulcher as a legacy from Piotr Gembicki, bishop of Przemyśl and then of Cracow and commendatory abbot of the convent at Miechów (1635–42). In the text of his testament the following description refers to them: "Also three miters, which were stolen, later recovered but damaged. These were made over with addition of passementerie ornaments." However, it cannot be ruled out that the miter was given by the successive abbot of Miechów, Jan Gembicki, bearer of the same coat of arms. The miter underwent conservation in 1998 under the direction of Jerzy Holc.

In the Roman Catholic Church a miter is the liturgical headdress of a bishop and of other clergymen entitled to wear pontificals (such as some abbots, protonotaries apostolic). Depending on the period of the liturgical year and on other circumstances, three kinds of miter are used: the first (so-called *mitra pretiosa*), lavishly embroidered with gold and pearls and additionally adorned with jewels of gold, silver, enamels, and precious stones; the second (so-called *mitra auriphrygiata*), embroidered with gold and silver; and the third (so-called *mitra simplex*), white, plain or from ornamented damask. The first kind of miter occurs rarely and can only be found in the richest church treasuries.

The exhibited miter is an example of the *mitra pretiosa*. It is of white satin, covered on both sides with decoration of identical composition, embroidered with various kinds of silver thread (plain, scalloped, bullion, strip) and spangles. The lappets are decorated in a similar way. The front and back are divided into a *circulus* (circlet), *titulus* (the median vertical band), and *campi* (fields on each side). All parts, including the lappets, bear a stylized delicate vine ornament with fairly lush leaves and flowers densely covering the ground, composed symmetrically about the central axis. In the middle of the *titulus* is an oval medallion bearing the hierogram of Christ and three nails (on the front) and of Mary (on the back). At the ends of the lappets oval cartouches contain the Nałęcz arms, surmounted by episcopal hats. The background is uniformly covered with spangles and fine dots of spirally coiled wires. The edges are bordered with narrow silver braid, and the lappets end in silver fringe. The lining of white silk is of a later date.

The Miechów treasury holds another miter, of red fabric, with identical decoration except for additional pearls. Both objects are good examples of Polish embroidery of the mid-seventeenth century, using plant motifs derived from Renaissance ornamentation but with prominent flowers and foliage and a dense composition.

KJC

81

MITER, C. 1633–66

POLAND

CARDBOARD, LINEN, SATIN, METAL THREAD, SPANGLES; LAID EMBROIDERY (FLAT AND RAISED ON THREAD FOUNDATION)

43.2 × 36 CM (17 × 14 1/8 IN.); LAPPETS (WITHOUT FRINGE) 43.4 (17 1/8)

CHURCH OF THE HOLY SEPULCHER, MIECHÓW

LITERATURE
Wiśniewski 1916, 127; *Katalog Zabytków* 1953, 234; Chrzanowski, Kornecki 1982, fig. 187.

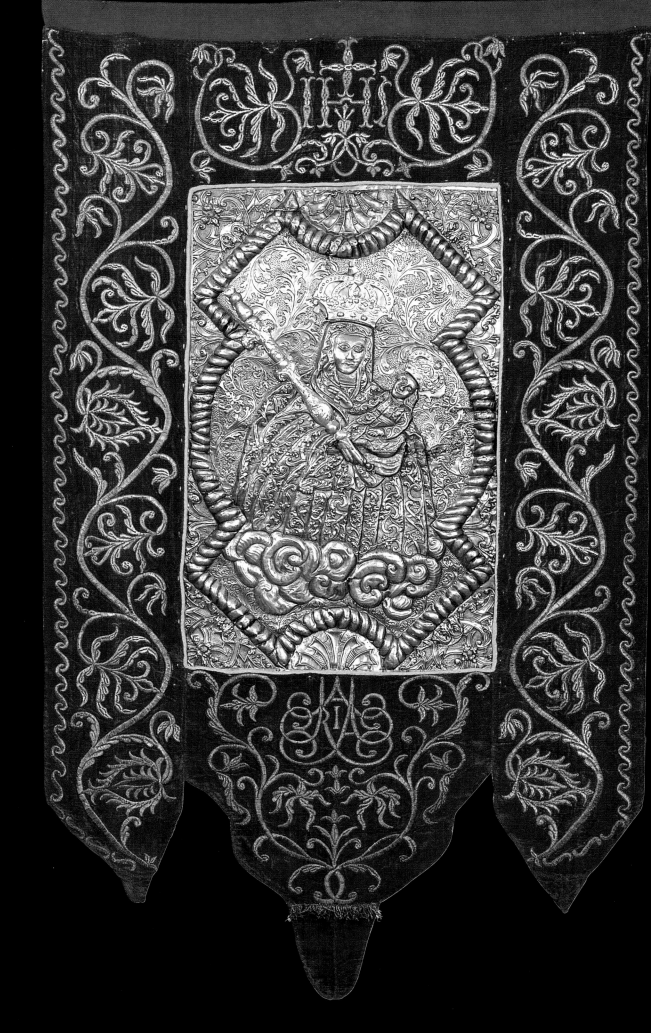

Church banners with painted or embroidered religious representations were for the most part the property of various church confraternities, sodalities, and also the guilds that had their own altars in particular churches. Members of those organizations carried them during solemn processions.

The exhibited banner is rectangular, with three teeth cut out at the bottom. The obverse is framed in red velvet embroidered with gold thread in a sinuous acanthus vine enriched with flowers; in the upper part is a foliate interlace ornament with the hierogram of Christ (*IHS*) and three nails; at the bottom, on the middle tooth, is the hierogram of Mary in a similar ornamental frame; wavy bands run along the side edges. The reverse frame is of plain new fabric. In the center of the banner is a rectangular, two-sided picture made from silvered sheet brass. On the obverse is the half figure of the Virgin Mary and Child with stylized clouds at the bottom. Mary and Jesus are dressed in robes decorated with withered acanthus leaves and fine stippled vegetal vine. They wear gilded crowns on their heads, and Mary holds a scepter. On the reverse (right) is a standing figure of Saint Casimir in a long, richly ornamented robe (ribbon in pincer-like arrangement, flowers, withered acanthus), with a ducal coronet on his head, a lily in his right hand, and a crucifix in his left; at his feet are placed a crown and scepter (on the right) and an asymmetrical cartouche bearing the arms of Hungary (on the left). Both representations are in embossed frames of concave-convex form, with intertwined withered acanthus, ribbons in pincer-like arrangement, and rosettes and shells in the background.

The object is mentioned in the 1764 description of the church, together with another analogous banner with images of the Virgin and Child with Saint Anne and Saint Barbara ("Archives of the Metropolitan Curia in Cracow," ms. 51, p. 164). Originally embellished with silk cords and with gold and silver tassels, it was attached to a shaft surmounted by a cross covered with silvered sheet brass. The two banners probably belonged to the Confraternity of Saint Barbara, which came into being in 1730 as an association of raftsmen, of whom large numbers lived at Ulanów. These are the only examples known in Poland of processional banners in which the picture is embossed on metal and not, as was common practice, embroidered or painted. The themes of the pictures on the banner are characteristic: the Virgin Mary, who was accorded great veneration in Poland, and Saint Casimir (d. 1484), son of Casimir Jagiellon and Elizabeth Habsburg and a member of the Jagiellonan dynasty. Saint Casimir, pretender to the Hungarian throne (hence the arms of Hungary at his feet), is venerated not only in Poland and Lithuania (his tomb is in the cathedral at Vilnius), but also in other countries, including Italy.

The banner was thoroughly restored in 1997 under the direction of Jerzy Holc and Wojciech Bochnak.

KJC

82

PROCESSIONAL BANNER, 2ND QUARTER 18TH C.

POLAND

BRASS, VELVET, METAL THREADS; BEATEN, REPOUSSÉ, STAMPED, SILVERED, GILDED, RAISED EMBROIDERY

155 × 95.5 CM (61 × 37 5/8 IN.)

CHURCH OF SAINT JOHN THE EVANGELIST AND SAINT JOHN THE BAPTIST, ULANÓW

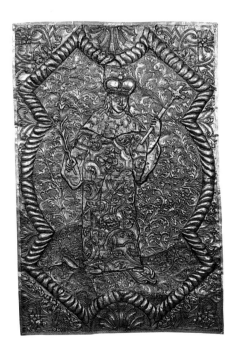

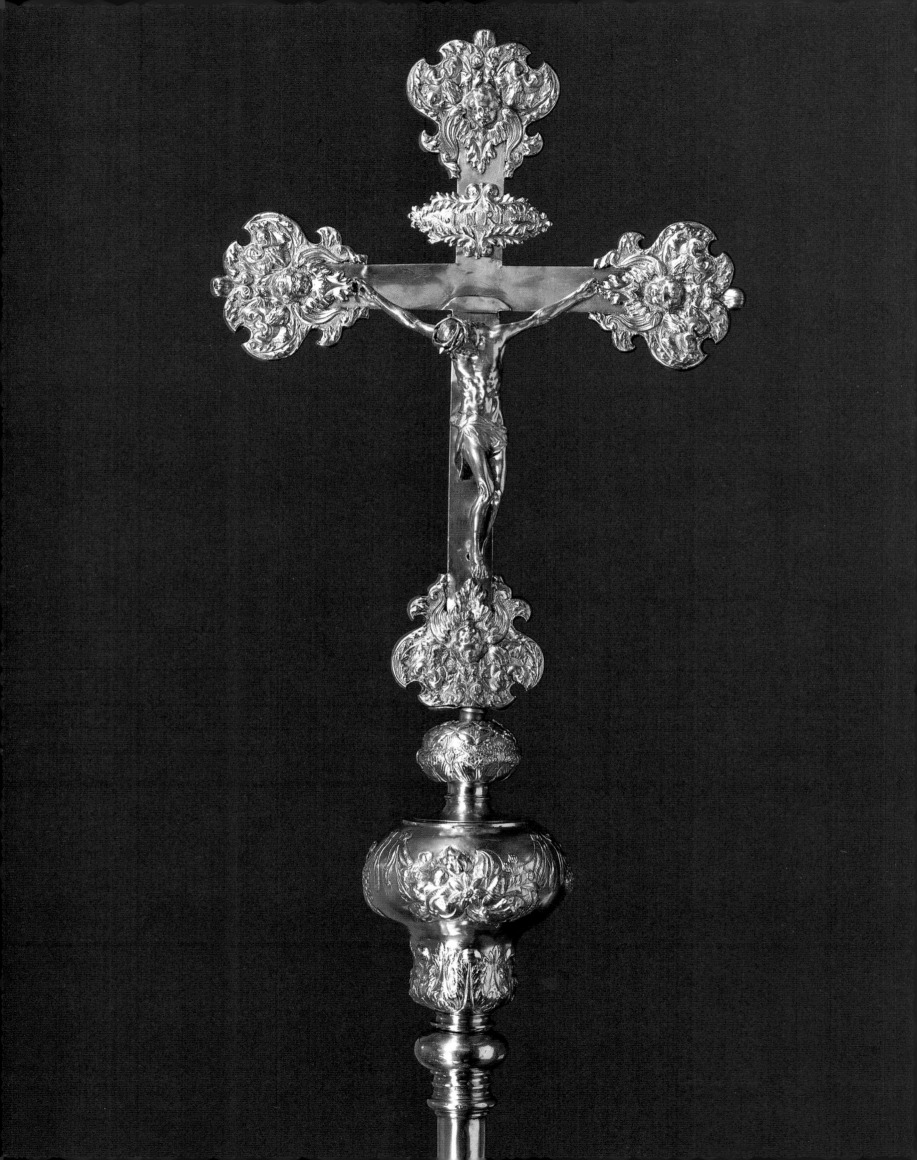

The cross was commissioned in 1691 by Father Jerzy Januszowicz, archpriest of the Church of the Assumption of the Virgin Mary, popularly known as Saint Mary's Church. In the lower part of the knob are the Kłośnik arms in a cartouche bearing a miter and crosier as well as the date 1691. The cross bears the Austrian contribution mark for 1806/07, stamped at the Cracow Assay Office, and was restored in 1997 by Wojciech Bochnak in Cracow (including reconstruction of the destroyed part of the end of the lower arm of the cross).

In the Roman Catholic liturgy a processional cross is carried by a cross-bearer at the head of a procession during a solemn mass (Processions of the Entrance and Exit), during various ceremonies of the liturgical year (including Corpus Christi and its octave, Rogation Days), as well as on special occasions such as the introduction of relics, and, in the case of this church, the greeting of the king-elect or the king entering the capital or the ingress of the archpriest. The cross-bearer is usually attended by two acolytes carrying candles in processional candlesticks, often made to form a set with the cross.

The stem of the exhibited cross is plain, divided by rings. The pear-shaped knob bears acanthus leaves and bunches of fruit and foliage suspended on festoons. Above the knob is a slightly compressed ball covered with foliage, which forms the base for the cross with elaborate, ornamental ends of the arms bearing cherub's heads and an acanthus motif. The title placed over the fully-wrought figure of Christ is decorated with an acanthus. On the reverse are the engraved instruments of Christ's Passion.

A. Ciechanowiecki has linked the cross with the goldsmith Jan Ceypler.

KJC

83

PROCESSIONAL CROSS, 1691

CRACOW

SILVER; BEATEN, REPOUSSÉ, CAST, ENGRAVED, CHASED, GILDED

OVERALL HEIGHT 286.5 CM (112 1/4 IN.); CROSS 48 × 37 (18 7/8 × 14 5/8)

CHURCH OF THE ASSUMPTION OF THE BLESSED VIRGIN MARY, CRACOW

LITERATURE
Katalog Zabytków 1971, 40, fig. 844; Ciechanowiecki 1974, 28; Rożek 1977, 59, 316.

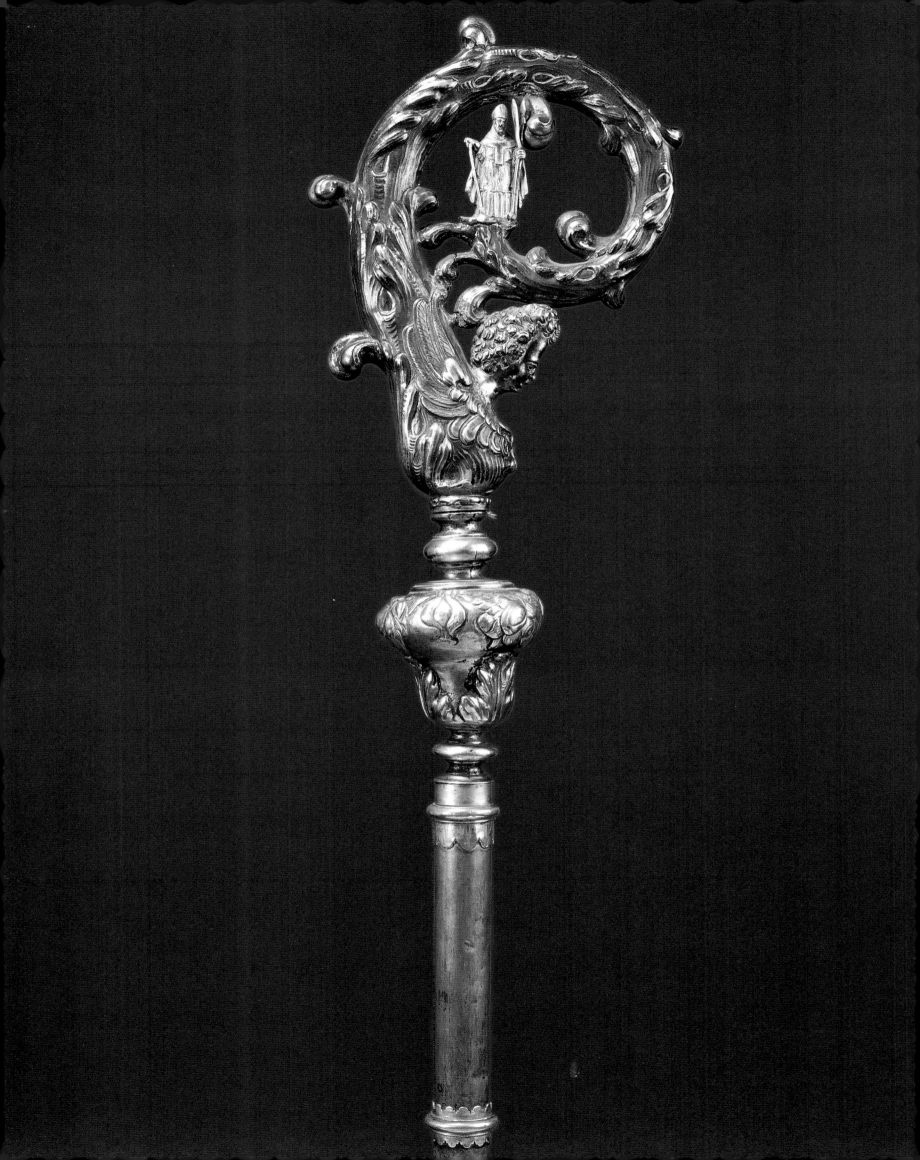

This work was probably commissioned by Wojciech Koryciński, abbot of Miechów from 1655, bishop of Kamieniec Podolski, and subsequently archbishop of Lvov from 1669 to 1677. The lower segment of the staff bears the engraved inscription: *C. S. EC. P. G. M. renovari fecit 1713*. The lower, ornamental end of the staff dates from the time of the renovation; the piece was conserved in 1998 by Wojciech Bochnak.

A crosier, in its form recalling a shepherd's staff, is used in the Roman Catholic Church by bishops and some abbots as well as by other clergymen entitled to wear pontificals. The abbot of the Keepers of the Holy Sepulchre at Miechów, from 1374 superior of the order in Central Europe, was granted this right in 1411 on the strength of the antipope John XXIII's bull.

The crosier is composed of a plain shaft divided into three segments by rings, a pear-shaped knob, and a scrolled crook. The knob is decorated with fruit-and-flower festoons and foliage. The surface of the crook is covered with acanthus leaves whose tips have been shaped as fully molded shoots. At the base of the crook is a cherub's head and at its end a gilded figurine of Saint Adalbert. The piece bears the Austrian contribution mark stamped at the Cracow Assay Office in 1806/07.

The Miechów crosier reveals numerous similarities with other seventeenth-century Polish crosiers: that of Bishop Piotr Gembicki in Wawel Cathedral, of the prioress of the Benedictine nuns at Staniątki, a specimen in the treasury of Gniezno Cathedral, and another appearing in the portrait of Bishop Andrzej Trzebicki in the Franciscan monastery in Cracow.

KJC

84

CROSIER, 1655–77

POLAND

SILVER; CAST, REPOUSSÉ, CHASED, GILDED

OVERALL HEIGHT 186 CM (73 1/4 IN.),
CROOK 24 × 16 (9 1/2 × 6 1/4)

CHURCH OF THE HOLY SEPULCHER,
MIECHÓW

LITERATURE
Wiśniewski 1917, 127; Kornecki,
Krasnowolski 1972, 271–73.

85

MISSAL BINDING, 2ND QUARTER 18TH C.

CRACOW(?)

SILVER; WROUGHT, REPOUSSÉ,
CHASED, CAST, ENGRAVED

36.6 × 23.6 × 7.8 CM (14 3/8 × 9 1/4 × 3 1/8 IN.)

CHURCH OF THE ASSUMPTION OF THE
BLESSED VIRGIN MARY, CRACOW

LITERATURE
Srebrne oprawy 1996, 47, cat. 38.

The missal was ordered for Saint Mary's Church in Cracow; in 1894 the binding was used for the new printed text *Missale Romanum* (Tournai, 1894). The binding bears the Austrian contribution marks for the years 1806/07 stamped at the Cracow assay office.

The binding consists of two almost identical covers joined by a spine and a pair of clasps. The covers are rectangular, bordered by bands of French regency decoration with vegetal elements and shells in the corners; the central panels bear plates with analogous decoration surrounding the hierograms of Mary on the front cover and Christ with a cross and three stars on the back cover. The spine is divided by molded bands into five fields approximating squares, decorated with the motif of ribbons and vegetal scroll; in three middle fields are centrally placed rosettes. The clasps bear the campanula motif (one was reconstructed in 1996). Among the very few extant examples of Polish silver book bindings, the present specimen is one of the most sumptuous.

DN

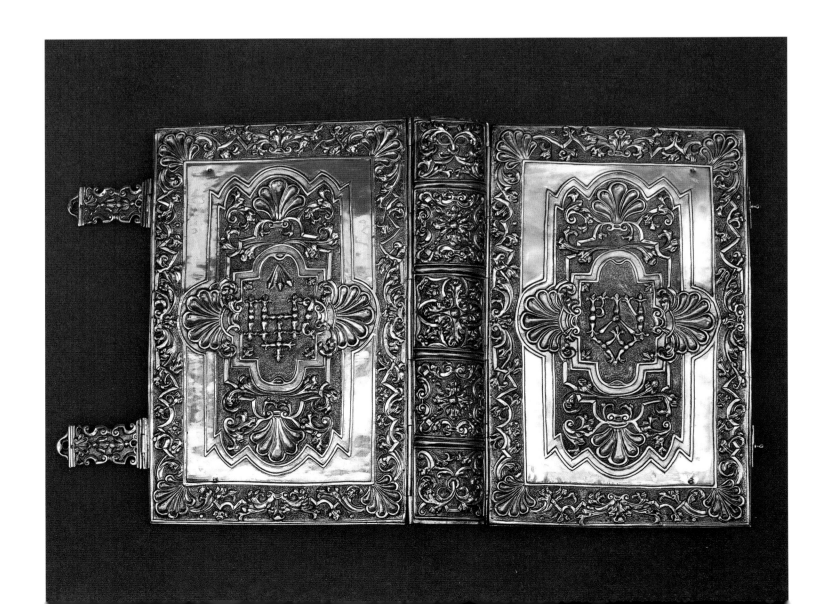

The lectern was commissioned by Father Jan Karol Konopacki, commendatory abbot of the Cistercians at Wąchock and of the Benedictines at Tyniec. After his death in 1643 it was bought in 1645 by the convent at Tyniec. The hallmarks are the Austrian contribution mark stamped at the Cracow Assay Office in 1806/07 and that for the years 1809/10. Following the dissolution of the abbey in 1816, the lectern was transferred to the cathedral in Tarnów.

The base of the lectern rests on four supports, and the book rest is joined to it by hinges; the book rest consists of a rectangular frame filled with crossing openwork strips formed by volute motifs. The bracket of the book rest is cut out as a column with a baluster shaft and Tuscan capital. The openwork strip for supporting the missal is decorated with an engraved auricular ornament and the founder's family coat of arms.

This is a unique example of liturgical furniture in that it is wrought of precious metal. Wooden lecterns were in common use, only the richest cathedral and monastic treasuries being able to afford silver ones.

KJC

86

Lectern for a Missal, 1635–43

Poland(?)

Silver; cast, engraved

9.2 × 27.2 × 38.9 cm (3 5/8 × 10 3/4 × 15 1/4 in.)

Treasury of the Cathedral of the Nativity of the Blessed Virgin Mary, Tarnów, inv. 57

Literature
Tyniec 1994, 90–91, cat. V/49.

The cult of the Eucharist, developing splendidly in the Counter-Reformation period in such ceremonies as processions, adorations, and forty-hour services, called for a suitable artistic setting. The solemn exposition of the Blessed Sacrament in the monstrance (see cats. 88, 89) required a base (throne of exposition) either integrally joined to the tabernacle or portable and set up as needed on the mensa.

The exhibited throne for the Eucharist served as a base for the monstrance. It is in the form of an octagonal pedestal with concave sides tapering upward, with a two-step plinth and a prominent roll molding at the top. The plinth and the crowning molding are decorated with cherubs' heads and bunches of fruit (including grapes), leaves, and ears of grain suspended on festoons. The sides bear three large fully molded angel heads and relief figures of two advancing cherubs supporting a bunch of fruit and foliage hung on a cloth. One of the cherubs holds a bundle of grain in his right hand. In the background can be seen the growing grain, grapevine, and a sheaf.

Eight holes in the edge of the base are perhaps traces of feet, not preserved, though it cannot be ruled out that they served to fix the throne to the tabernacle. The throne bears the Austrian contribution mark stamped at the Cracow Assay Office in 1806/07. It has been dated by A. Ciechanowiecki to the years 1688–89 and attributed to Jan Ceypler, one of the outstanding Cracow goldsmiths of the second half of the seventeenth century, who made a gold monstrance set with sapphires (melted down in 1794) for Saint Mary's Church. The exhibited object is one of the masterpieces of Cracow baroque goldsmithery.

KJC

87

THRONE FOR THE EUCHARIST, 1660–90

CRACOW

SILVER; REPOUSSÉ, CAST, CHASED, GILDED

26 × 45 × 41.9 CM (10 1/4 × 17 3/4 × 16 1/2 IN.)

CHURCH OF THE ASSUMPTION OF THE BLESSED VIRGIN MARY, CRACOW

LITERATURE
Katalog Zabytków 1971, 36, fig. 880; Ciechanowiecki 1974, 28.

The monstrance (ostensory) is used in the Roman Catholic Church for exposing the eucharistic host during various divine services and eucharistic processions. A special host designed for exposition is kept in a container (*custodia*) in the tabernacle except when it is placed in the monstrance in its glazed receptacle (*reservaculum*) in a crescent mount called *lunula* or *melchizedek*. Monstrances were first made in the late Middle Ages in connection with the development of the cult of the Eucharist. Gothic monstrances were architectural in form, while in the baroque period the widespread types of ostensories were provided with radiate glories surrounding the receptacle.

The exhibited monstrance is of the latter type. It has a hexagonal lobed foot with a collet and a domed base, and the slender upper part is decorated with an auricular ornament (elongated medallions on the base) and fully molded cherub heads alternating in the panels on the foot surface with rollwork and shell motifs. The pear-shaped knob (a truncate square in section), markedly elongated and with a delicate frame-like decoration, is set on a molded octagonal ring and crowned by a compressed ball with cabochons and shells. The upper part of the stem is in the form of a figurine of Our Lady of the Immaculate Conception, standing on a crescent moon and a terrestrial globe around which is coiled a serpent with an apple in its mouth. The crown on the Virgin's head is set with three rubies. The hexagonal receptacle is decorated with rose-cut imitation topazes and with cherubs' heads and encircled by a glory of straight and flame-like rays. The glory is crowned by a small cross.

This is one of the earliest (if not the earliest) of the extant Cracow radiate-type monstrances. Particularly noteworthy here is the fine artistic quality of the figurine of Our Lady of the Immaculate Conception. Unfortunately, the stones that now surround the receptacle and also the cross are of a later date (twentieth century?), and the knob is deprived of its cast appliqués (probably bunches of flowers and fruit).

A. Ciechanowiecki has dated it as 1630 and linked it with the Jesuit goldsmith Maciej Krajecki (Krajecensis), who wrought many objects for the Church of Saint Barbara. The monstrance bears the Austrian contribution mark stamped at the Cracow Assay Office in 1806/07.

KJC

88

MONSTRANCE, MID-17TH C.

CRACOW

SILVER, PRECIOUS STONES AND THEIR IMITATIONS; CAST, REPOUSSÉ, CHASED, GILDED, SET WITH PRECIOUS STONES

65.2 CM (25 5/8 IN.)

JESUIT CHURCH OF SAINT BARBARA, CRACOW

LITERATURE
Katalog Zabytków 1971, 105, figs. 730, 736; Ciechanowiecki 1974, 72.

This monstrance was commissioned in 1679 by the convent of the Benedictines at Tyniec for the monastic church of Saints Peter and Paul. It was made of the silver obtained from melted-down old liturgical vessels. After the dissolution of Tyniec Abbey in 1816 it was transferred to Bochnia and in 1826 to the cathedral in Tarnów. The edge of the foot is inscribed: *A.D. 1679: 20 : May.* Hallmarks comprise the Austrian contribution marks stamped at the Cracow Assay Office in 1806/07 and 1809/10.

The piece has an elongated lobed foot with a separate base decorated with lush flowers with stems and leaves and four cherub heads. The stem, octagonal in section, consists of molded rings and a slender baluster covered with acanthus leaves. Foliage and four cherub heads in the round decorate the pear-shaped knob. Above the knob are attached two *S*-bent arms supporting statuettes of Saints Benedict and Scholastica. The glazed octagonal receptacle is framed by a multicolored foliate vine in filigree enamel, with stones (sapphires, amethysts, rubies, and paste) set in high mounts. Around the receptacle is a glory of straight and flame-like rays surrounded by a wreath of intertwined grapevine branches; over the receptacle is a relief image of the Sorrowful Mother of God. The monstrance is surmounted by a splendid crown decorated with an enameled vine, gems, with a crucifix and figurines of the Virgin Mary and Saint John at the top. The whole is gilded except for the wreath around the glory and the foot, on which only the cherubs' heads are gilded.

This is a typical, splendid example of a Cracow monstrance from the second half of the seventeenth century, characterized by its slender proportions, radiating glory surmounted by a crown, and arms supporting figurines of saints (in other monstrances sometimes angels).

KJC

89

MONSTRANCE, 1679

CRACOW

SILVER, PRECIOUS AND SEMIPRECIOUS STONES AND THEIR IMITATIONS; CAST, REPOUSSÉ, CHASED, ENGRAVED, GILDED, FILIGREE ENAMEL, SET WITH PRECIOUS STONES

99 CM (39 IN.)

TREASURY OF THE CATHEDRAL OF THE NATIVITY OF THE BLESSED VIRGIN MARY, TARNÓW, INV. 56

LITERATURE
Tyniec 1994, 80–81, cat. V/36.

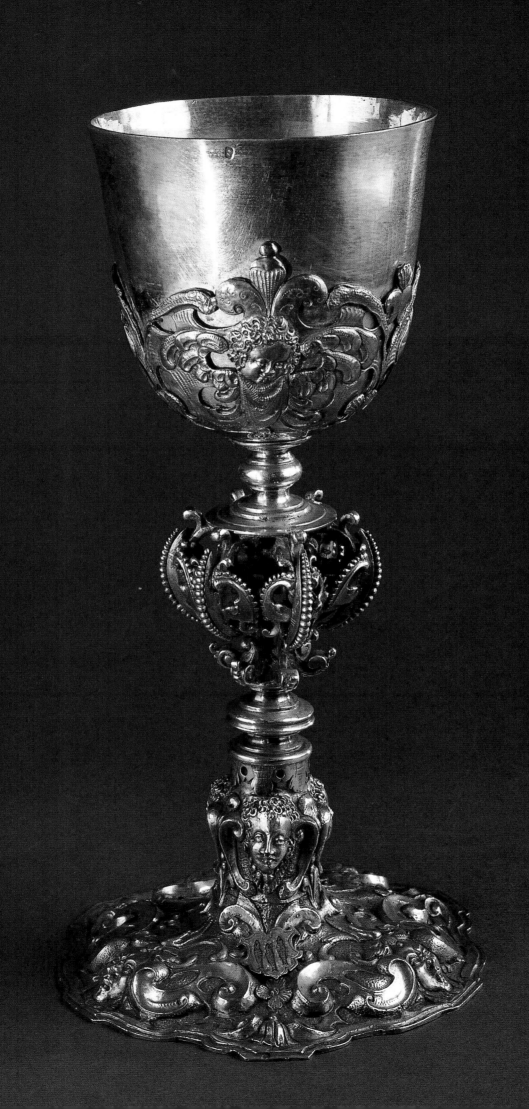

A chalice with its paten is the most important liturgical vessel in the Roman Catholic Church. Considering that it is in a chalice that the Transubstantiation of the wine into the blood of the Savior takes place, the vessel is made of costly material such as gold and silver and frequently decorated with motifs referring to the Eucharist.

The foot with a wavy outline, approximating a circle, is covered with lush auricular-cartilaginous and strapwork motifs and human masks, its upper part being decorated with masks whose ears have been enlarged in a grotesque manner. The prominent openwork pear-shaped knob on a molded stem is composed of six fully molded auricular-cartilaginous elements. The slightly flared bowl rests in an openwork calyx consisting of an auricular ornament and winged cherub heads.

This chalice was commissioned in 1627 for Saint Mary's Church in Cracow by the elders of the herring sellers' stalls. On the foot is a cartouche bearing an emblem of three herrings. The underside of the foot is inscribed: *KIELICH SPRAWIONI PRZES STARSZE ZE SLEDZIOWICH IATEK NALEZACZE DO CZECHU ROKV PANSKIEGO 1627 NA CESZ NA CHWALE PANV BOGV*. This is an outstanding mannerist example of Cracow goldsmith's art. Worth noting is the early use of the auricular-cartilaginous ornament, which in the Cracow circle became widespread in the 1630s.

KJC

90

CHALICE, C. 1627

CRACOW

SILVER; BEATEN, CAST, REPOUSSÉ, CHASED, ENGRAVED, GILDED

26.2 CM (10 3/8 IN.)

CHURCH OF THE ASSUMPTION OF THE BLESSED VIRGIN MARY, CRACOW

LITERATURE
Katalog Zabytków 1971, cat. 1, p. 37, figs. 758, 784; Rożek 1977, 57, 310; Samek 1984, 70, fig. 36; *Corpus Inscriptionum* 1987, 50, 128–29; Samek 1988, 144, fig. 109; Samek 1990, 255, fig. 166; Samek 1993, 28, 64, fig. 92; *Między Hanzą a Lewantem* 1995, 80, cat. IV/34.

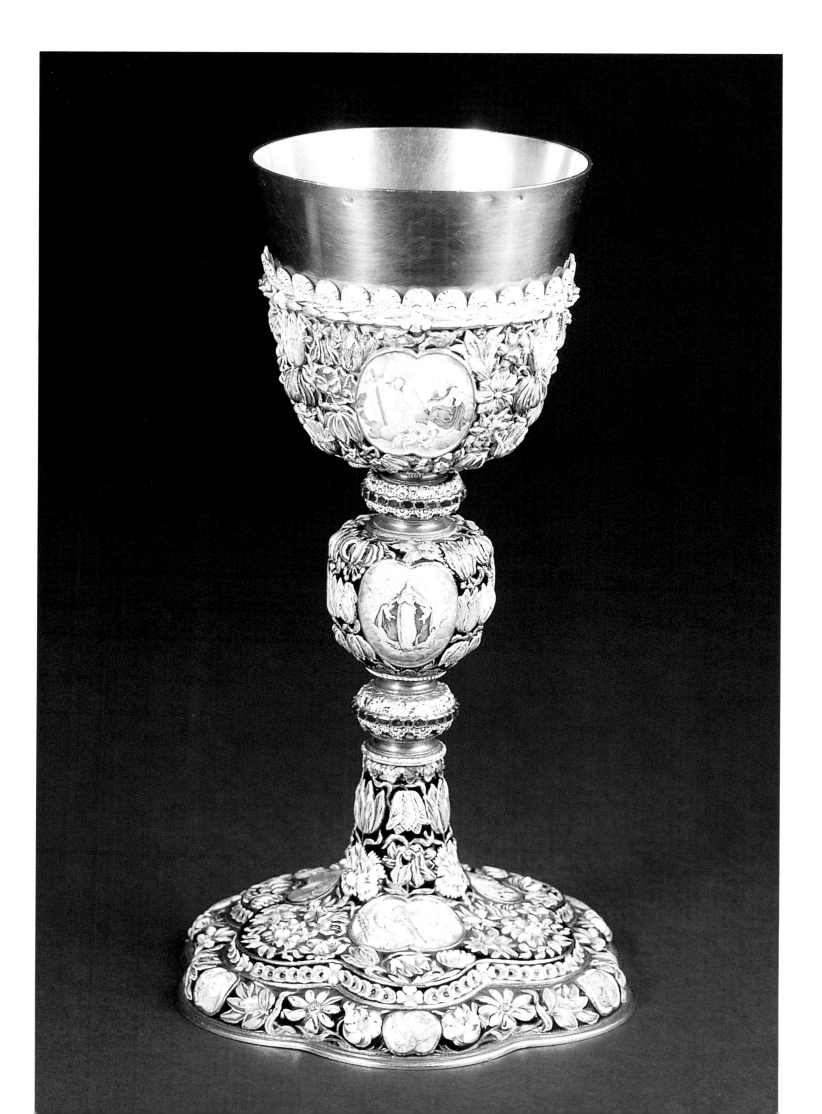

This chalice has a hexagonal lobed foot, an ovoid knob with a flattened ball at top and bottom, and a slightly flared bowl resting on a calyx. Except for the bowl, it is covered with multicolored, realistically rendered flowers in painted enamels. On the base and the surface of the foot are medallions with figural representations of Saints Casimir, Stanislaus Kostka, Hyacinth, Francis of Assisi, Benedict and Scholastica, Ignatius of Loyola and Francis Xavier, and Peter and Paul, along with the Poraj coat of arms and the arms of Tyniec Abbey. The knob and the calyx bear scenes of the Annunciation, Nativity, Holy Trinity, Last Supper, and Saint Anne and the Virgin Mary. Hallmarks comprise the Austrian contribution mark for silverware stamped at the Cracow Assay Office in 1806/07; the Austrian contribution mark for small silver products stamped at the Cracow Assay Office in 1806/07; and the Austrian contribution mark for gold products stamped at the Lvov Assay Office in 1806/07. The chalice was commissioned by Father Stanisław Pstrokoński, commendatory abbot of the Benedictine Abbey at Tyniec near Cracow; after the dissolution of the abbey in 1816 it was transferred to Bochnia and in 1826 to Tarnów Cathedral. It was thoroughly restored in 1889 by Józef Hakowski, including partial reconstruction of damaged medallions.

The Pstrokoński chalice undoubtedly ranks among the most splendid seventeenth-century Polish chalices because of the material, the lavish painted enameling, and the wealth of figural representations so rare in Polish goldsmith's art. The close relationship between the founder of the chalice and the royal court in Warsaw suggests the possibility of its being wrought by one of the goldsmiths working for the monarch and his court.

KJC

91

CHALICE, 1646–55

POLAND(?)

GOLD, PAINTED ENAMEL, RUBIES;
CAST, BEATEN, SET WITH PRECIOUS STONES

26.1 CM (10 1/4 IN.)

TREASURY OF THE CATHEDRAL OF THE
NATIVITY OF THE BLESSED VIRGIN MARY,
TARNÓW, INV. 51

LITERATURE
Tyniec 1994, 73–74, cat. V/23; Czyżewski,
Nowacki, Piwocka 1995, 174.

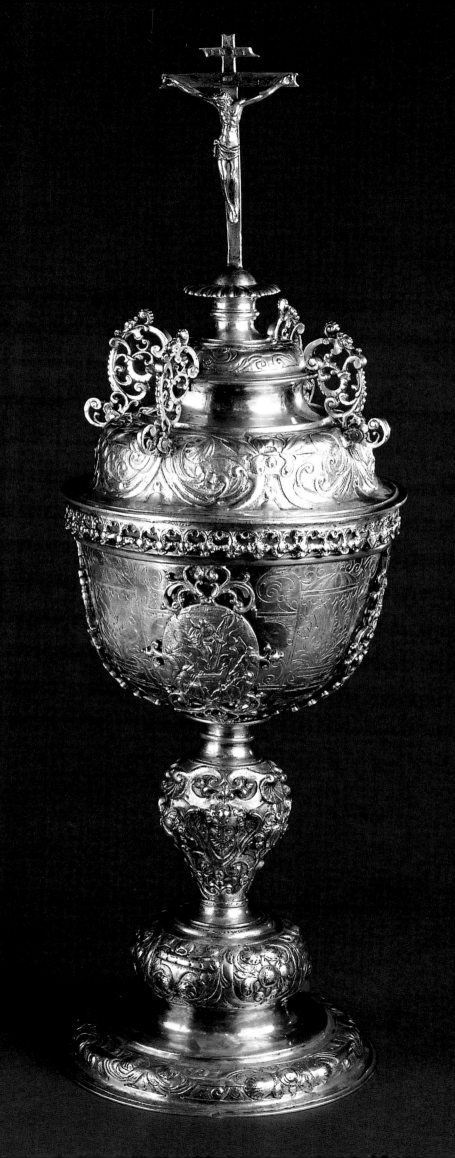

In the Roman Catholic Church a pyx is used for reserving the Blessed Sacrament in the tabernacle. Made of sumptuous materials, it is frequently covered with a veil of costly, sometimes embroidered, fabric.

The round foot with a bulbous surface rests on a prominent base decorated with rollwork and bunches of fruit. The molded stem is provided with a large pear-shaped knob bearing rollwork ornamentation with cherub heads, bunches of fruit, and shells. The bowl is enfolded by four openwork strips composed of scroll motifs, two of them additionally decorated with oval medallions containing scenes of the Transfiguration and Resurrection. The spaces between the strips are engraved in fanciful decorative motifs consisting of strapwork ornament and vases of flowers, resting on feet and surmounted by baldachins with lambrequins. The molded, three-tiered cover bears an ornament similar to that on the foot; it is crowned with a tall crucifix and enriched with four openwork S-shaped ears with human masks and cartilaginous motifs; at the bottom is an openwork frieze of foliage in Gothic stylization.

The hallmark is the Austrian contribution mark stamped at the Cracow Assay Office in 1806/07. On the inner surface of the cover is a plaque bearing the Leliwa arms and the initials *IS* and date *AD 1610*.

KJC

92

PYX, 1610

CRACOW

SILVER; BEATEN, CAST, REPOUSSÉ, CHASED, ENGRAVED, GILDED

43 CM (16 7/8 IN.)

CHURCH OF THE ASSUMPTION OF THE BLESSED VIRGIN MARY, CRACOW

LITERATURE
Katalog Zabytków 1971, 38, fig. 788; Samek 1984, 70; *Corpus Inscriptionum* 1987, 52; Samek 1988, 114, fig. 108; Samek 1990, 225, fig. 164; Samek 1993, 64, fig. 90.

93

CRUETS AND SALVER,
3RD QUARTER 17TH C.

CRACOW

SILVER; REPOUSSÉ, CAST, CHASED,
ENGRAVED, GILDED

CRUETS, 12.4 CM (4 7/8 IN.);
SALVER, 25.2 × 33 (9 7/8 × 13)

CHURCH OF THE ASSUMPTION OF THE
BLESSED VIRGIN MARY, CRACOW

LITERATURE
Katalog Zabytków 1971, 41, figs. 861, 873.

In the Roman Catholic liturgy cruets are used during Mass. The wine and the water in them, after being mixed in the chalice, become the blood of Christ as the priest says the prayer of Consecration. Cruets frequently form a set with a salver, which functions as a basin during the ritual washing of the hands by the priest prior to the Consecration.

The feet of the cruets are circular; their bulbous molded bases are decorated with shell and scroll-foliate motifs, and the top of the upper part of the feet carries an embossed flange. The molded stems bear embossed pear-shaped knobs. The bodies are ornamented with pairs of auricular-cartilaginous cartouches containing engraved personifications of Charity and Justice on the cruet for water and of Faith and Justice on the cruet for wine; along the edges run borders with a stippled leafy vine; the lips are in the form of cherub herms. The *S*-shaped scroll handles are decorated with cherub herms. The molded lids, bearing a pattern analogous to that on the bases, are surmounted by stylized cones and provided with knobs in the form of figurines of cherubs holding letters that denote the contents of the cruets: *A* [*aqua*, water] and *V* [*vinum*, wine] respectively. The whole is gilded except for the plaques in the cartouches.

The oval salver has a marked rim bearing auricular-cartilaginous motifs, bunches of fruit and foliage, and four oval medallions on which are engraved the scenes of the Annunciation, Nativity, Adoration of the Magi, and Christ's Circumcision. The plain bottom has two circular sockets for the cruets, engraved plaques bearing the hierograms of Christ (with a heart, three nails, and a cross) and of Mary (with a heart and cross) encircled by laurel wreaths; between the sockets are two palmettes. The whole is gilded except for the plaques on the rim and in the sockets. The set bears the Austrian contribution mark stamped at the Cracow Assay Office in 1806/07.

KJC

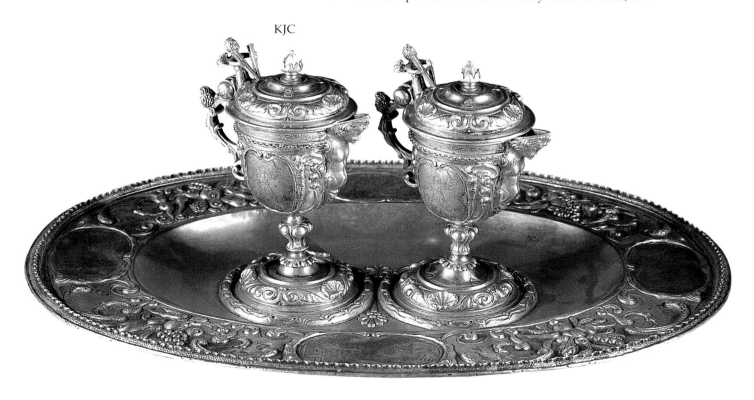

The squat body of this censer rests on a circular foot; the body is decorated with an auricular-cartilaginous ornament, cherub heads, fruit-and-leaf bunches, and foliage. Three *S*-shaped hooks for attaching chains are decorated with a cartilaginous motif. The pierced cover, in the form of a slightly tapering cylinder with a pronounced molded base and a domed top, bears three strapwork cartouches with the Dołęga coat of arms, scroll-and-leaf motifs, and an interlace ornament. The thurible is suspended on three chains joined by an embossed handle; the fourth chain, for lifting the cover, terminates in a ring. The piece bears the Austrian contribution mark stamped at the Cracow Assay Office in 1806/07; on the cover are the Dołęga arms. At the top of the cover are the donor's initials and the date: *P S S S T D P D ANNO DNI 1642.*

KJC

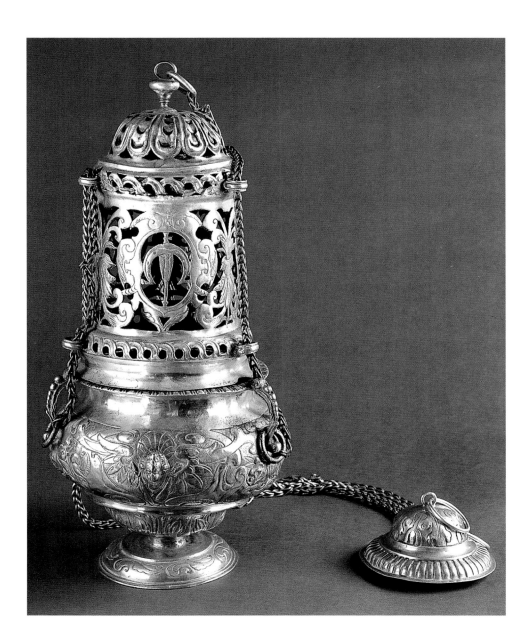

94

THURIBLE, 1642

CRACOW

SILVER; REPOUSSÉ, CAST, OPENWORK, CHASED, ENGRAVED

33 × 17 CM (13 × 6 5/8 IN.)

CHURCH OF THE ASSUMPTION OF THE BLESSED VIRGIN MARY, CRACOW

LITERATURE
Katalog Zabytków 1971, 46, fig. 876; *Corpus Inscriptionum* 1987, 52; Samek 1990, 255, fig. 168.

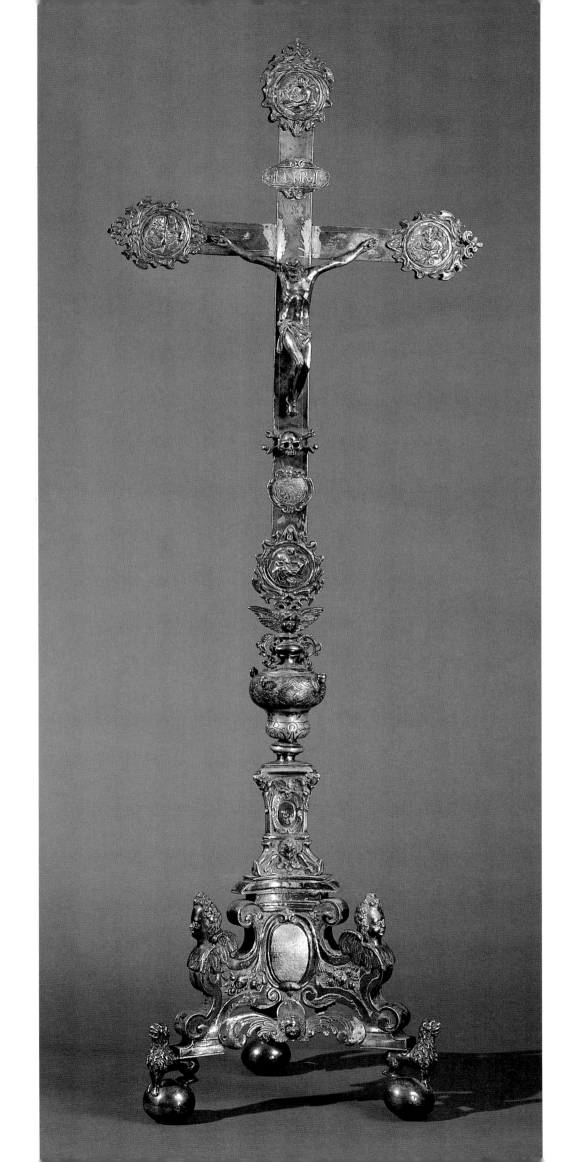

In the Roman Catholic liturgy an altar cross is placed on the mensa at which a priest celebrates Mass, a bloodless reenactment of Christ's redemptive sacrifice on the cross. Together with candlesticks and an altar cloth, it is an indispensable element of the altar furnishings.

The exhibited cross was commissioned in 1634 by Father Wojciech Borowski, *custos* (keeper) of the collegiate church of Saint Florian, from the funds left by the deceased *custodes* Father Sebastian Nagrodzki and Father Jan Zaborowski. It was remodeled in 1675 to the order of Father Wojciech Papenkowicz, provost of the church of Saint Florian.

The three-cornered two-tiered base of this cross is supported by figurines of lions resting on spheres, the corners of fanciful outline being accentuated by angels' heads in the round. The decoration on the sides is composed of bunches of fruit, scrolls, angels' heads, and oval cartouches, one of them containing the dedicatory inscription *ALBERT. | BOROVIUS: | S.T.D.S. FLOR. | CVSTOS. COMPA | RAVIT. PARTIM. EX. |RELICT.RDI.OLIM. | SEBAST.NAGROD. | SIERADZ:PARTIM | EX: RELICT. RDI.?OLIM:IOANNIS | ZABOROVIUS FLO | CUSTODIS A.D | 1.6.3.4.* Above the base are a compressed sphere with openwork ears and a pear-shaped knob with angels' heads. The plain cross bears a fully molded figure of Christ and auricular-cartilaginous medallions at the ends of the arms. The medallions contain figures of the Evangelists on the obverse and Christ at the Pillar, wearing a crown of thorns, with scourges and a reed and bearing the cross on the reverse. There is a title over the figure of the Lord, and beneath his feet are the death's head and an auricular-cartilaginous cartouche with an engraved pelican feeding her young and the inscription *M.ALBERTVS PAPENCOVIVS VSTIEN: S.T.H. DOCTOR PROT 1675 APLIC PRE. P:S . FLO.* There is also the Austrian contribution mark stamped at the Cracow Assay Office in 1806/07.

The upper part of the cross, including the knob, was probably wrought in 1675 to replace the destroyed or damaged part of the original cross dating from 1634. Its base is an interesting example of borrowing from the forms that appeared in Augsburg goldsmithery. Plaques with identically composed Passion scenes are encountered fairly frequently in Polish goldsmiths' products of about the middle and the third quarter of the seventeenth century.

KJC

95

ALTAR CROSS, 1634 AND 1675

CRACOW

SILVER; REPOUSSÉ, CAST, CHASED, ENGRAVED

108.7 × 37 CM (42 3/4 × 14 1/2 IN.)

COLLEGIATE CHURCH OF SAINT FLORIAN, CRACOW

LITERATURE
Sidorowicz 1959, 422.

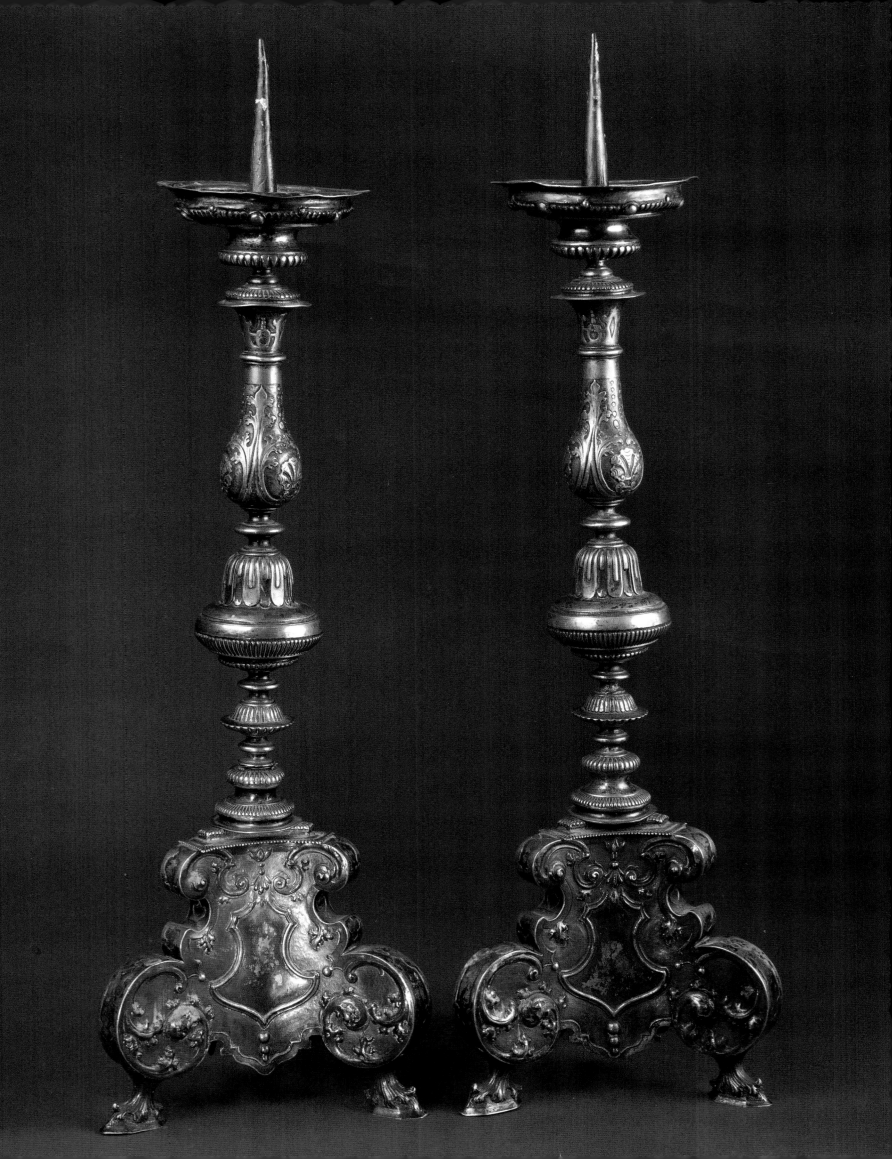

In the Roman Catholic liturgy, altar candlesticks are placed on the mensa beside the cross. Two, four, or six are used (sometimes one pair differs from another in height), not infrequently forming a set with a cross. The light of the candles symbolizes the presence of God.

The exhibited candlesticks have triangular bases resting on feet, with panels sinuous in outline, withered acanthus leaves, and volutes. The lower part of each stem is richly molded and decorated with fine embossing; above is an embossed pear-shaped knob, and the upper part of the stem is in the form of a baluster bearing the motifs of withered acanthus and shells. The grease pan is molded and embossed.

The candlesticks bear the Austrian contribution mark stamped at the Cracow Assay Office in 1806/07.

KJC

PAIR OF ALTAR CANDLESTICKS, 1ST QUARTER 18TH C.

CRACOW

SILVER; REPOUSSÉ, CAST, CHASED, ENGRAVED

68 CM (26 3/4 IN.)

COLLEGIATE CHURCH OF SAINT FLORIAN, CRACOW

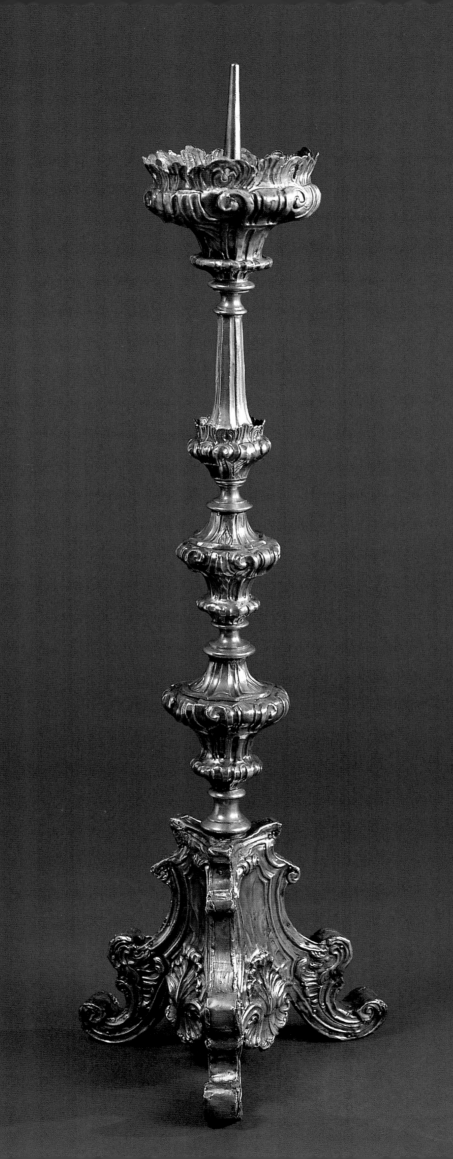

Six altar candlesticks were placed on the mensa, as, according to liturgical prescriptions, at least two candles must burn during Mass, four during a holiday Mass, and six during a high Mass. The set was an important element of the baroque setting for the altar.

Each of these candlesticks has a three-cornered base with corners cut out in the form of scrolls, on which is fixed a three-part molded stem terminating in a pricket for a candle, placed in a deep cup-shaped grease pan. The surface of each candlestick is covered with a relief design consisting of angular frames, flattened scrolls, comb-like rocailles, and stylized acanthus leaves. The particular parts, wrought of thin sheet metal on wooden cores, are threaded on an iron tang. Originally the brass was silvered.

This type of candlestick is characteristic of gold, silver, and pewter ware produced between 1650 and 1750, popular in the Polish territories and influenced by the art of Gdańsk, Pomerania, and Silesia. Similar silver candlesticks were confiscated under the terms of contribution in the period of the Partition of Poland and destroyed on a mass scale.

The exhibited set underwent conservation at 1996 at Wawel Royal Castle.

APe

SIX ALTAR CANDLESTICKS, 1730–60

POLAND

BRASS CUT OUT, REPOUSSÉ, CAST; WOOD, IRON

93 × 30 CM (36 5/8 × 11 3/4 IN.)

WAWEL ROYAL CASTLE, CRACOW, INVS. 2711–16, MADE OVER BY THE MINISTRY OF CULTURE AND ART IN 1946

LITERATURE
Hołubiec 1990, 47–48.

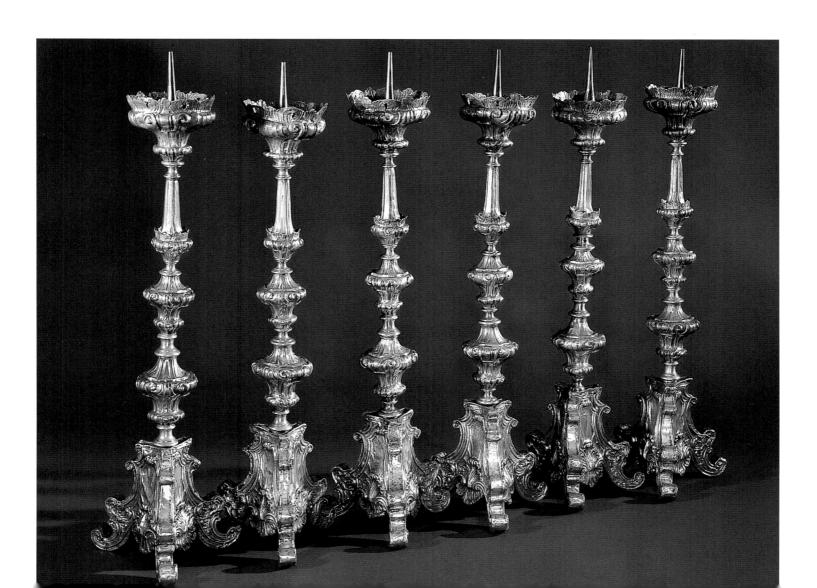

Baltazar Horlemes (1622–77 or –82) was probably the grandson of Hieronim, a Cracow merchant and councillor who dealt with mining at Olkusz. His family was descended from the German nobility. He fought with the Swedes in 1655. The portrait of this well-educated man, intended for his coffin, was after the funeral set at the top of the marble epitaph commissioned by his widow, Krystyna, and placed in the church at Olkusz. The long Latin inscription in the epitaph lauds the virtues and deeds of the dead man. It is likely that Adrian Horlemes (d. 1675), whose coffin portrait has been preserved in the Church of Saint John in Toruń, was Baltazar's brother.

The coffin portrait—a likeness painted on a metal plate and attached to the coffin—was typical of Polish baroque culture. It was created for the elaborate funeral ceremony and afterward usually removed from the coffin and placed in a church, in a stone epitaph with a coat of arms and inscription. The Olkusz portrait shows an elderly man with a shaved head after the Polish fashion and a long gray beard. In comparison with other coffin portraits by anonymous artists it is distinguished by the clear-cut rendering of facial features, serene psychic expression, and careful workmanship.

KK

98

COFFIN PORTRAIT OF
BALTAZAR HORLEMES, 1677 OR 1682

BETWEEN SILESIA AND LITTLE POLAND

OIL ON HEXAGONAL TIN PLATE

53 × 47.5 CM (13 3/4 × 12 3/4 IN.)

CHURCH OF SAINT ANDREW, OLKUSZ

LITERATURE
Vanitas 1996, cat. 60.

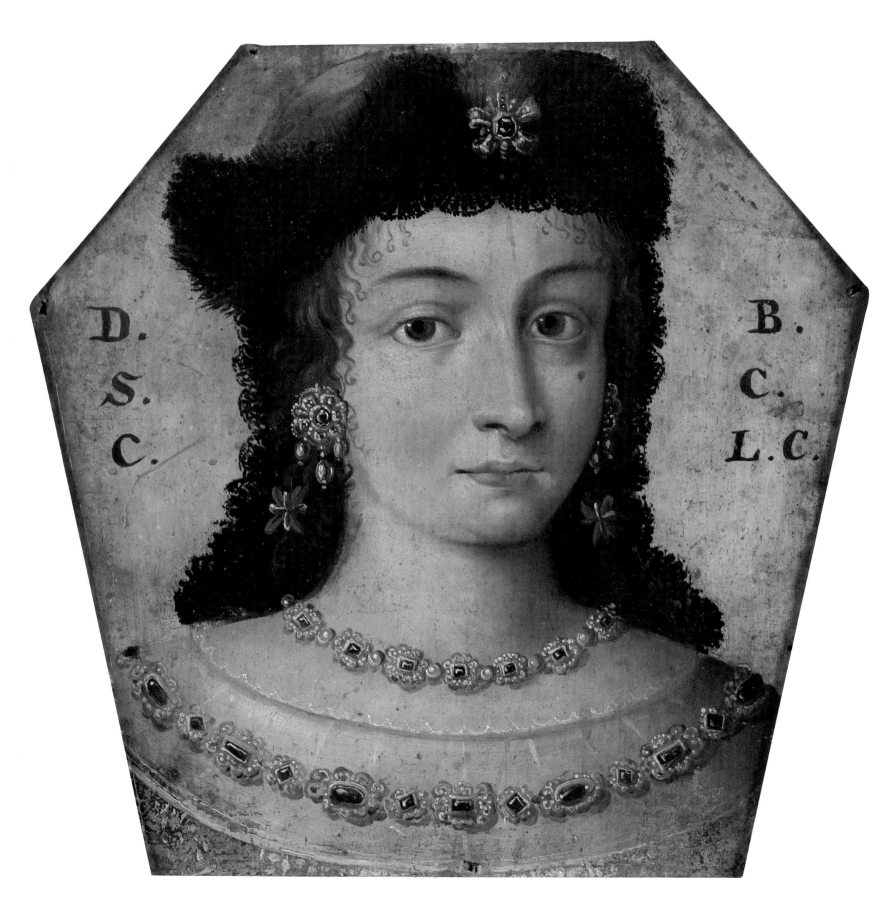

On the basis of the remains of an inscription in pencil on the back of the plate: *[. . .] Barb[. . .] Lub[. . .]* and the initials on the front of the picture in black oil paint: *D.*[omicella] *B.*[arbara] *S.*[zczawińska] *C.*[omitis] *C.*[onstantini] *L.*[ubomirski] *C.*[onsors], Jadwiga Ruszczyc identified the portrayed person as Barbara Domicella, daughter of Jan Szymon Szczawiński, palatine of Brzeg-Kuyavia, and Regina of Bogusławice, née Sierakowska. In 1648 Barbara married Konstanty Jacek Lubomirski (d. 1663), starosta of Sącz and Grybów, later starosta of Golub and Crown cup-bearer. In 1667 she was married again, this time to Mikołaj Wiktoryn Grudziński, starosta of Golub and Grybów. She probably died in 1676.

Domicella Barbara died as Grudzińska, therefore the initials on her coffin portrait should indicate this surname. However, they refer to Konstanty Lubomirski, her first husband, which may point to her being buried beside him. It is then likely that her coffin portrait was originally at Jarosław, Konstanty Lubomirski's burial place. There exists another coffin portrait of Barbara Domicella (without initials) in the parish church at Ozorków. Both of them seem to have been painted at the same time, around 1676, this being evidenced by the details of costume such as the cut of the fur cap, the style of the broad edging of the neckline of the gown, and the shape of cabochons in the jewels. The copying of coffin portraits was not at all unusual.

In the present portrait the young woman is depicted bust-length; she wears a cap trimmed with dark fur, her hair being covered with black lace and adorned with two buttefly-shaped clasps, and also a decolleté white gown and rich jewelry: cabochon earrings and two similar necklaces as well as a decorative clasp on the front of the cap.

MO

99

COFFIN PORTRAIT OF
BARBARA DOMICELLA GRUDZIŃSKA, C. 1676

MAZOVIA

OIL ON HEXAGONAL LEAD PLATE

35 × 32.5 CM (13 3/4 × 12 3/4 IN.)

NATIONAL MUSEUM, WARSAW,
INV. MP 4298, IN THE MUSEUM'S
COLLECTIONS SINCE 1945

LITERATURE
Portrety 1967, cat. 108; *Gdzie Wschód spotyka Zachód* 1993, cat. 379.

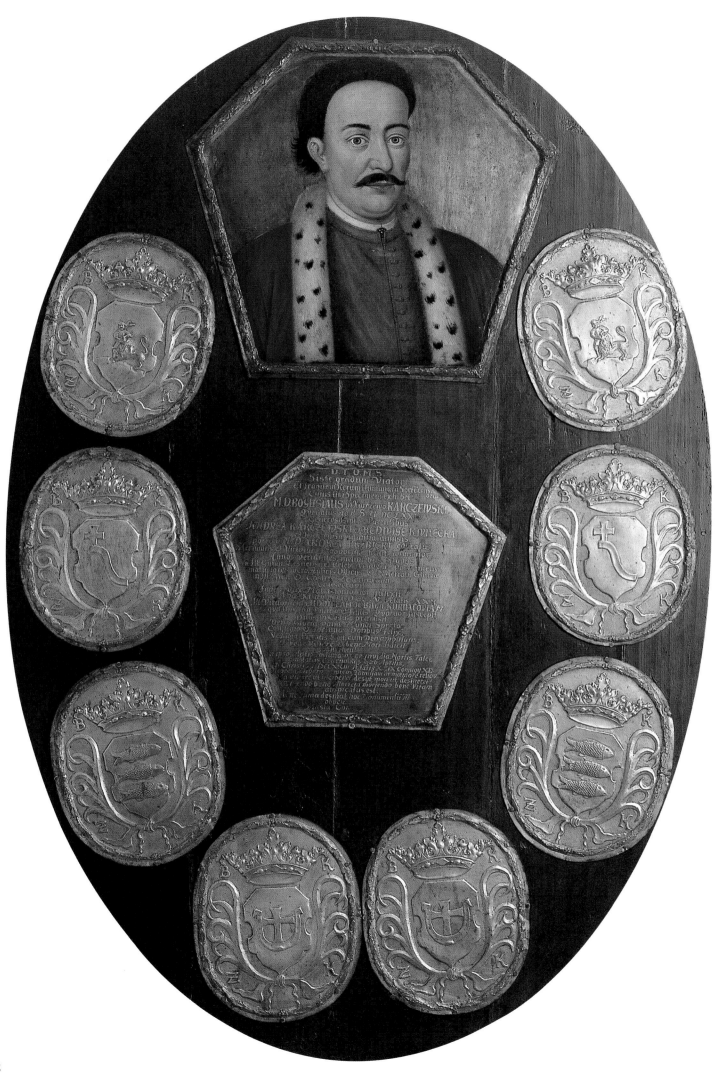

Bogusław Karczewski (1674–1723), born into a moderately wealthy noble family in Great Poland, was a member of a small Protestant community of the Bohemian Brethren, who had established communities in the Wschowa Region. He was an active participant in the camp of dissenters who struggled for freedom for non-Catholic religions in the Commonwealth. The portrait of Karczewski is distinguished among other Old Polish coffin portraits by its large size. The deceased is rendered in a three-quarter view, wearing a blue *żupan* and a red *delia*. The painting is framed with an acanthus-leaf border. The portrait and a pentagonal plaque with a thirty-two-line Latin inscription in minuscule letters were placed on an oval wooden panel and surrounded by eight plates featuring the coat of arms of the deceased, Samson, and the armorial bearings of his ancestors: Szreniawa, Korzbok, and Jastrzębiec. Such plates were usually nailed to the coffin and frequently laid with it in the grave. Sometimes, however, they remained in a church as a substitute for or supplement to the tomb of the deceased. In the southwestern territory of Great Poland they were put together to form a compositional whole with the portrait of the expired person, forming a specific epitaph. This ensemble originally was hung on the organ gallery in the Church of Saint John in Leszno, and in 1952 was made over to the museum in Leszno.

GM

100

COFFIN PORTRAIT OF
BOGUSŁAW KARCZEWSKI WITH
ARMORIAL PLATES, C. 1723

GREAT POLAND

OIL ON COPPER PLATE; PLATE REPOUSSÉ
AND SILVERED, WOOD

PORTRAIT 54 × 58.5 CM (21 1/4 × 23 IN.);
INSCRIBED TABLET 44.2 × 46.2 (17 3/8 × 18 1/8);
ARMORIAL SHIELDS 33 × 26.5 (13 × 10 3/8)

REGIONAL MUSEUM, LESZNO, INV. MLD 2

LITERATURE
Kubistalowa 1982, 271–308; Kubistalowa 1985, 183–87; *Stolz and Freiheit* 1991, 81, cat. 14; *Gdzie Wschód spotyka Zachód* 1993, 415–16, cat. 423; *Vanitas* 1996, 94–95, cat. 70.

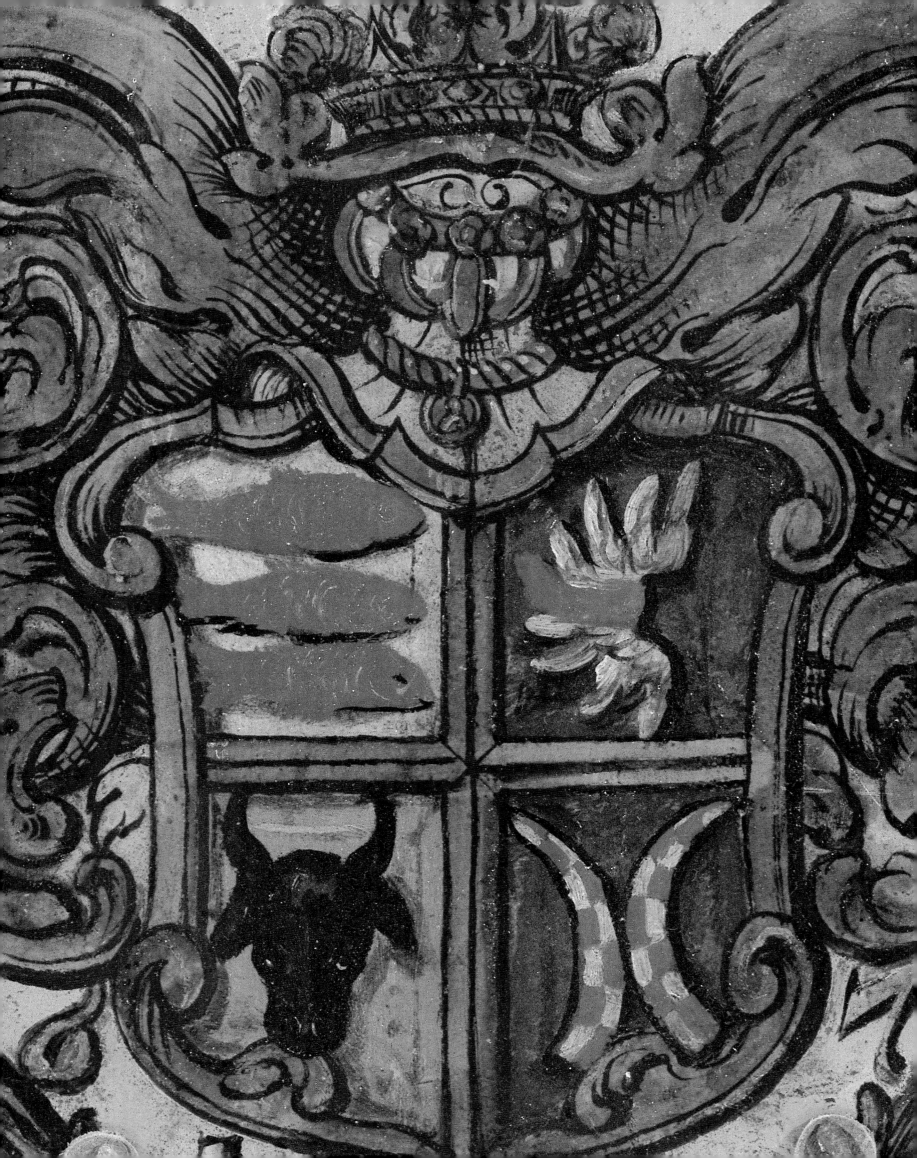

HERALDIC SHIELDS

A, B, SHIELDS OF SABINA HAZA RADLIC,
C. 1676

GREAT POLAND

OIL ON TIN PLATE

EACH, 30 × 28 CM (1 3/4 × 11 IN.)

MUSEUM OF THE WSCHOWA REGION,
INVS. MZW/6/AH, MZW/8/AH

During a funeral ceremony in Great Poland in the seventeenth and eighteenth centuries a portrait of the deceased as well as a pair of heraldic plates were fixed to the coffin, the plates being either repoussé or painted. As a rule one plate bore the arms of the paternal ancestors and the other those on the maternal side. In addition, the plates were inscribed with *sigla* (initials permitting the identification of the deceased) and with the date of his/her death. After the funeral the plates were sometimes detached from the coffin and nailed together with the coffin portrait on a wooden board to form a specific epitaph hung in a church. Groups of such epitaphs were found in churches that functioned as noblemen's necropolises, such as the church at Jędrzychowice.

Sabina Haza Radlic was the wife of Jan Fabian Haza Radlic, royal secretary, burgrave of the district of Wschowa. On her shields are the letters S-H/D-B and the date of the funeral 1.6–7.6. These shields are from the Lutheran church of Saint John at Szlichtyngowa.

The sisters Anna and Konstancja Mielęcka (overleaf) died in childhood in the same year. Anna's shields bear the letters A. E.-M. / Z. M. and the date of her funeral 1.6–7.9; her sister Konstancja's shields are marked with the letters C.- / Z. M. and the date 1.6–7.9. The sisters' shields came from the church of the Bohemian Bretheren at Jędrzychowice.

WC

C, D, SHIELDS OF ANNA ELEONORA
MIELĘCKA, C. 1679

GREAT POLAND

OIL ON TIN PLATE

EACH, 23.5 × 20.5 (9 1/4 × 8 1/8)

MUSEUM OF THE WSCHOWA REGION,
INVS. MZW/IZ/AH, MZW/14/AH

286

e, f SHIELDS OF KONSTANCJA JADWIGA
MIELĘCKA, C. 1679

GREAT POLAND

OIL ON TIN PLATE

EACH, 25.5 × 23 CM (10 × 9 IN.)

MUSEUM OF THE WSCHOWA REGION,
INVS. MZW/11/AH, MZW/16/AH

LITERATURE
Kubistalowa 1985, 184–87.

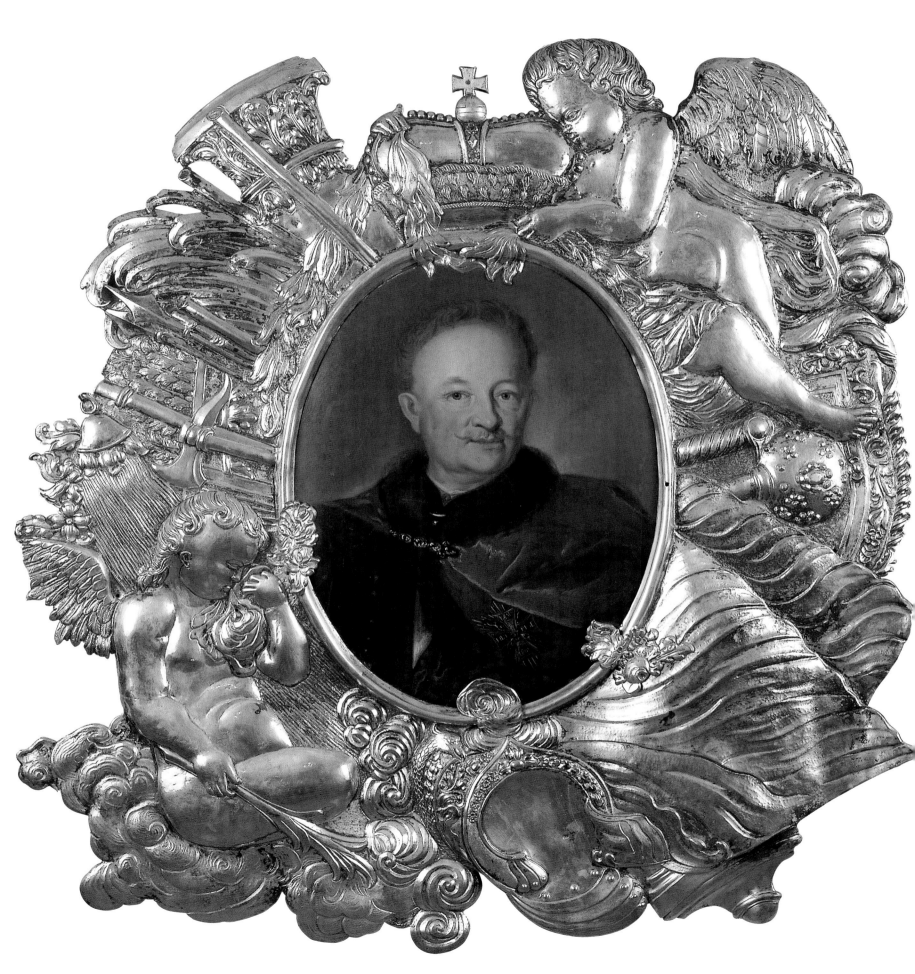

The portrait is a unique and mysterious object. After 1945 it was brought from the collegiate church at Stanisławów. It is traditionally thought to represent Józef Potocki (1673–1751), palatine of Kiev and grand hetman of the Crown, benefactor to the above-mentioned church and buried there with great pomp in 1751. However, the Potockis were not entitled to a ducal coronet, so if the identification is correct, its use in the decoration of the frame is a usurpation.

The original function of the object is not clear either. It could have been an element of an extremely sumptuous *castrum doloris* of the hetman, but it has no direct analogies. It cannot be excluded that it was conceived as an element of an epitaph composition to be placed in the church.

The portrait, a reduced, bust-length version of a ceremonial portrait, is a good example of local painting of the middle of the eighteenth century. Even more interesting is the extremely rich silver frame, which has no analogies among existing coffin portraits. Its anonymous author is known from a dozen or so silver objects stamped with identical marks (workshop mark *SHW* in a horizontal rectangle with rounded corners; standards of silver *12* in a square). These objects with similar marks include the funeral orb and crown of Augustus II the Strong. The silversmith should be sought among numerous artists working in Warsaw in the second quarter of the eighteenth century. The frame bears also the Austrian contribution mark for the years 1806/07 stamped in Lvov.

DN

COFFIN PORTRAIT OF
HETMAN JÓZEF POTOCKI(?), C. 1751

WARSAW OR LVOV(?)

PORTRAIT, OIL ON COPPER PLATE,
38.5 × 30.5 CM (15 1/8 × 12 IN.);
FRAME, SILVER-GILT, HAMMERED,
77 × 75 (30 1/4 × 29 1/2)

METROPOLITAN CURIA OF THE LATIN RITE,
LVOV, ON LOAN TO THE MUSEUM AT
LUBACZÓW (ORIGINALLY IN THE PARISH
CHURCH AT STANISŁAWÓW, TODAY
UKRAINE)

LITERATURE
Gdzie Wschód spotyka Zachód 1993, 261, 416–17, fig. 429; Chrościcki, Gajewski 1994, 123, cat. 1.

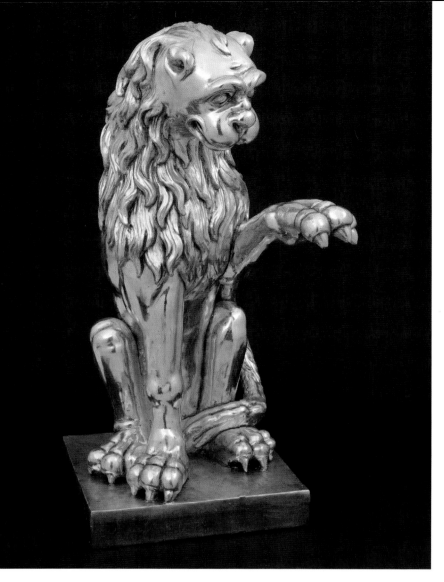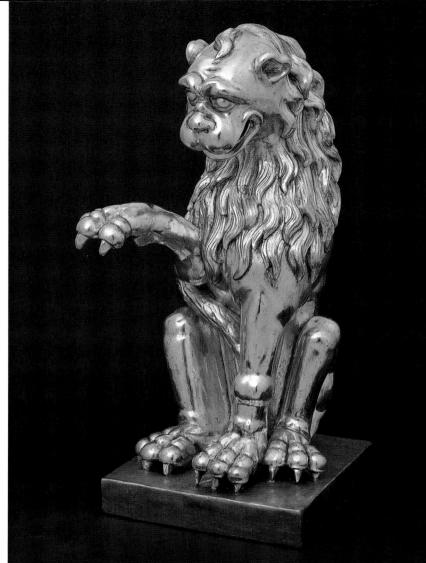

103

FOUR LIONS FROM THE CASTRUM DOLORIS
OF FRANCISZEK SALEZY AND ANNA
POTOCKI, 1758

GILDED WOOD

EACH, C. 95 CM (37 3/8 IN.)

MUSEUM OF THE PROVINCE OF THE
BERNARDINES, LEŻAJSK

LITERATURE
Czernecki 1939, 200, 214, 228–35; Chrościcki
1974, fig. 94; *Katalog Zabytków* 1989, 72, figs.
398, 399; *Vanitas* 1996, 286.

In 1772, within a short space of time, Anna Potocka née Łaszcz and her husband, Franciszek Salezy Potocki, palatine of Kiev, died. He was one of the most powerful and richest magnates in the Polish Commonwealth and at the same time one of the last exponents of the traditional Sarmatian attitude. Their funerals at Krystynopol (where the Potockis had their main residence) assumed the character of magnificent baroque spectacles and were attended by numerous clergy of the Roman Catholic, Greek Catholic, and Armenian rites as well as military detachments and crowds of the nobility. In the *castrum doloris* erected in the Bernardine church for Anna Potocka, and in a few months reconstructed for Franciszek Salezy's body to lie in state in the drawing room of his palace, temporarily converted into a chapel, the lions standing on a three-step platform carried a coffin on their heads and with their paws supported the shields with coats of arms and panegyrical inscriptions. In the first case, the construction was completed by an inscribed tablet extolling Anna's virtues, and in the second by a portrait of Franciszek Salezy and wooden candlesticks. In a second *castrum doloris* of Franciszek Salezy, set up in the Bernardine church, the lions were replaced by eagles. It remains unknown whether the eagles had been used earlier, during Anna Potocka's funeral, when more than one *castrum doloris* had also been erected.

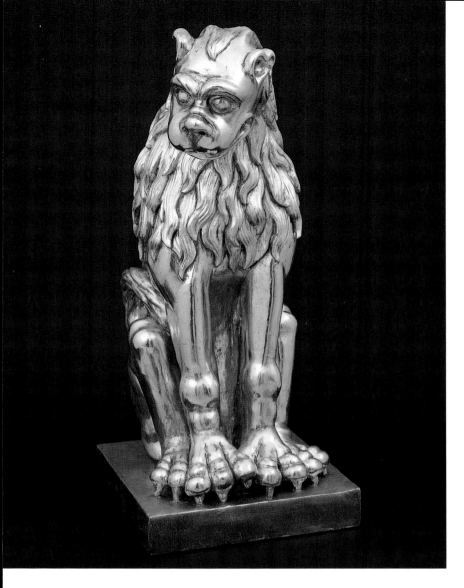

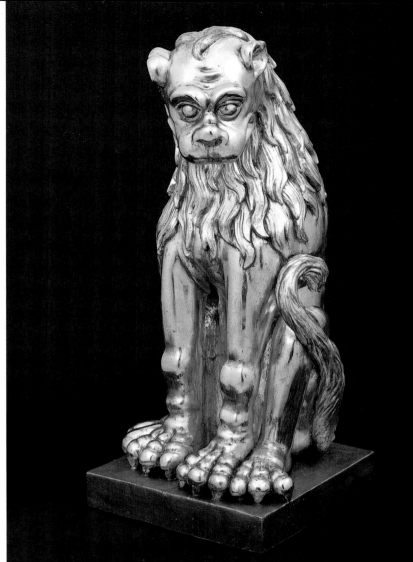

The main elements of the *castra dolori* used during the two funerals of the Potockis, the four gilded lions and the four silvered eagles (somewhat obscure references imply that originally there may have been six of each kind), have been preserved to this day. Until 1951 they survived in the Bernardine church at Krystynopol, and after the "correction of the frontier," on the strength of which this town was given up to the Soviet Union, the sculpted figures were transported to the Bernardine church at Leżajsk. In 1996 they were restored at the conservation studios of Wawel Royal Castle.

Splendid *castra dolori*, consisting of architectural, sculptured, and painted elements, were widespread in the baroque period throughout Europe (see the Ostrowski essay "Polish Art in Its Social and Religious Context," fig. 10, for a sketch of a typical *castrum doloris*). Made for the most part of nondurable material, after a single use they were generally no longer fit to be used again in daily religious cult, hence the irretrievable loss of most of them.

The choice of lions and eagles as the main motifs of the composition of a *castrum doloris* is not surprising in view of the heroic symbolism of these animals. From Roman times an eagle was associated with eschatological beliefs as a sign of the soul flying to the other world.

JKO

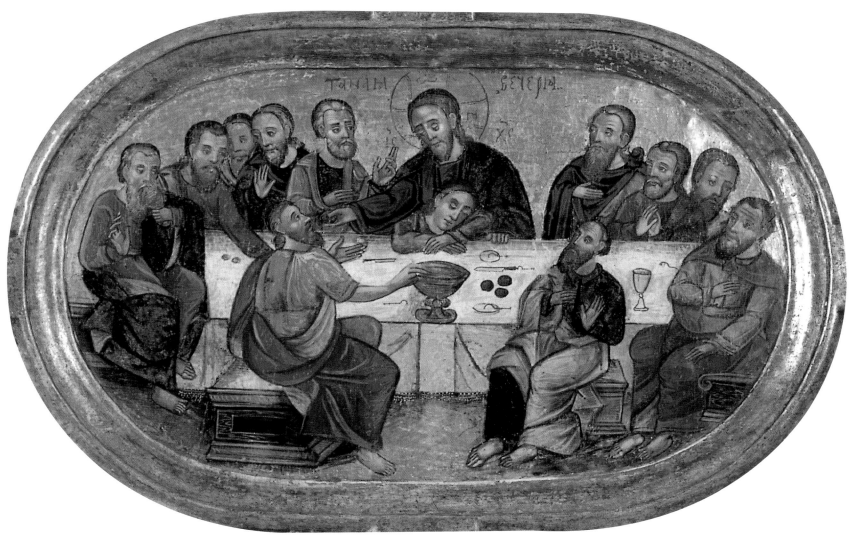

The icon, a panel picture used in the Orthodox Church, is usually painted with tempera on a specially prepared wooden support. It is characterized by the strictly prescribed iconographic types of images of Christ, the Virgin Mary, saints, and biblical or liturgical scenes and distinguished by its own means of expression and specific stylistic features. Icons were created for the purpose of religious contemplation. Their location in the *iconostasis*, the inner screen in an Orthodox church separating the sanctuary from the nave, determined their subject matter and imposed the fixed formal canons. This, a monumental structure segmented into several tiers, had a characteristic arrangement of icons set together into cycles in accordance with the prescriptions of liturgy. Its lower part was pierced by three openings for communication in the form of the "royal" door and two deacons' doors.

The present icon once crowned the royal door. This place in the *iconostasis* was reserved for the *Acheiropoeitos* (Mandylion, an image of Christ's face), the Holy Trinity, or the Last Supper, the subject of this icon.

The icons in the *iconostasis*, venerated as sacred images fraught with spiritual essence rendered in an artistic medium, were very slow to yield to formal transformations. The character of Carpathian Submontane icons was strongly influenced by the Union of Brest-Litovsk concluded in 1596 between the Roman Catholic Church and part of the Orthodox Church. In the Orthodox churches subordinated to Rome by this agreement there began a slow penetration of western artistic influences. The earliest signs of this tendency are observable in minor elements, such as the carved wooden frames, which were not subject to any definite ideological rigors. The exhibited icon is an illustration of this tendency. The painterly rendering of the Last Supper, following the canons of icon painting, was set in a frame of cartouche-rollwork and strapwork ornament, an indisputable borrowing from western European art originating in the Netherlands.

The icon is in the form of an ellipse in a molded frame set in a cartouche bearing cartouche-rollwork, strapwork, and vegetal (grapevine) motifs. At the bottom is a plain horizontal batten. This is a multifigural, symmetrical composition, a scene showing Christ and the Twelve Apostles gathered at a table covered with a white cloth (see detail, opposite, below). In the center is the figure of Christ wearing a red robe and a greenish blue cloak. With his right hand he gives a piece of bread to Judas, seated on the opposite side of the table, who is dipping his right hand into a cup of wine. Seated in front of Christ is Saint John, his hands resting on the table. The other apostles are arranged in two groups flanking Christ. The coloring of the icon is vivid, the background silvered and glazed to imitate gold. The cartouche is bright red, while the remaining background of the frame is black with a bluish shade. The frame and all relief elements are silvered and glazed. The bottom batten is not polychromed. On the reverse is a vertical brace.

JK

104

THE LAST SUPPER, 1ST HALF 17TH C.

CARPATHIAN SUBMONTANE REGION, POLAND

LIMEWOOD, TEMPERA, SILVER GLAZED TO IMITATE GOLD, CARVED FRAME

53 × 109 CM (20 7/8 × 43 IN.)

NATIONAL MUSEUM OF THE PRZEMYŚL REGION, INV. MPH–281

LITERATURE
Ikony 1981, fig. 16.

*E*pimanikia are ornamental cuffs worn over the ends of the sleeves of the *sticharion* for the purpose of gathering the sleeves lest they hinder the movements of the officiating priest. They symbolize divine power assisting that of the priest. According to some commentators on the liturgy, they derive from the manacles put on Christ after he was taken prisoner.

The Przemyśl *epimanikia* are of carmine satin on a linen foundation with a silk lining, edged with a silver border. They are decorated with an appliqué relief head of a seraph made of painted hardened wax and with ornamental embroidery. Around the seraph's head are a nimbus, in its form resembling a mandorla, and three pairs of wings. On either side are ribbon ornaments forming pincer-like patterns and additionally stylized vegetal motifs. The edge is hemmed with a silver border bearing geometrical motifs. Along each of the shorter sides five brass rings have been sewn for lacing the cuffs. The lining is of two pieces of pink silk, differing in hue. The pincer-like arrangement of the ribbon used as a decorative motif in the *epimanikia* dates them to the second quarter of the eighteenth century. At the same time this decorative motif is an unquestionable example of a borrowing from western European art in which this kind of ornament originated. The *epimanikia* come from the former Greek Catholic cathedral in Przemyśl and were made over by the Carmelites to the National Museum of the Przemyśl region.

JK

EPIMANIKIA, 2ND QUARTER 18TH C.

PRZEMYŚL(?), POLAND

SATIN, SILK LINING, LINEN, SATIN RIBBON; BORDER, FLAT EMBROIDERY WITH SILVER THREAD, POLYCHROMED HARDENED WAX, BRASS RINGS

19 × 31 CM (7 1/2 × 12 1/4 IN.)

NATIONAL MUSEUM OF THE PRZEMYŚL REGION, INVS. MPH 654 A, B

LITERATURE
Biskupski 1994, 367.

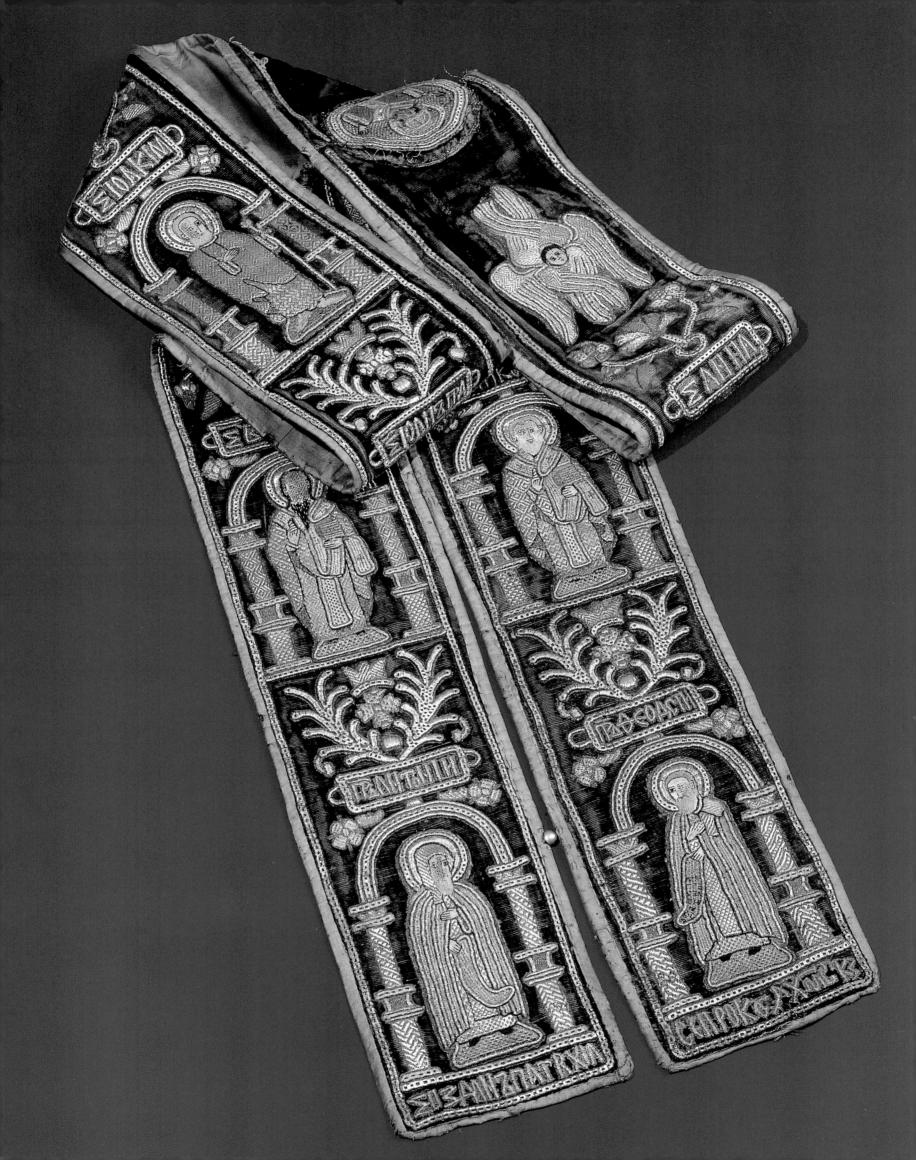

The *epitrachelion* was an element of the liturgical vestments for priests in the eastern church in the form of a long ornamental band worn around the neck, its edges being joined at some points. Specialists in Orthodox liturgy hold that it derives from the rope by which Christ was dragged before the archpriests. It symbolizes the sanctifying grace of priesthood.

The Przemyśl *epitrachelion* is made of olive green velvet decorated with figural embroidery in a symmetrical arrangement, with silver and gilded thread, and with blue and deep red silk. The lining of thin pink silk spreads over the outside edges.

In the center of the *epitrachelion* is a sewn-on round embroidered medallion with a half figure of Christ represented as a bishop-orant. It is flanked by the heads of seraphs with three pairs of wings. Both hanging parts of the *epitrachelion* are divided into four segments, each containing an arcade with the figure of a saint inside; above the arcade is an inscribed tablet and vegetal ornament in two varieties. The arcade is formed by a semicircular arch resting on imposts carried by short columns with bases on plinths. The saints in the arcades, identified by Cyrillic inscriptions, are as follows: on the left, from the bottom upward, Anthony, Basil, John the Baptist, and Joachim; on the right, from the bottom upward, Theodosius, Nicholas, Andrew the Apostle, and Anne. The standing shortened figures of the saints are rendered frontally or slightly turned to the center, wearing long robes and holding a scroll or an attribute. Their faces, hands, and feet, made from applied creamy-white satin, are outlined with black thread. Their robes are partly embroidered with silver, while for some elements, such as the lining of the attire, shoes, and architectural details, black, blue, or deep red thread was used. Each of the rectangular tablets above the arcades, flanked by arched elements, bears the name of a saint inscribed in Old Church Slavonic. At the bottom is the framed occasional inscription and the date 1640. The remaining spaces are filled with vegetal ornamentation in the form of stylized bouquets of flowers or of two palm branches with a cross and crown in the middle. A conical metal button is sewn to the left inside edge.

The *epitrachelion* is from the former Greek-Catholic cathedral in Przemyśl, made over by the Carmelites to the National Museum of the Przemyśl region.

JK

106

EPITRACHELION, 1640

PRZEMYŚL(?)

VELVET, SILK; APPLIQUÉS, EMBROIDERY
ON FOUNDATION AND FLAT, STEM STITCH,
SPLIT WITH SILVER AND SILK

279 × 15 CM (109 7/8 × 5 7/8 IN.)

NATIONAL MUSEUM OF THE
PRZEMYŚL REGION, INV. MPS 7606

LITERATURE
Biskupski 1994, 367, fig. 28.

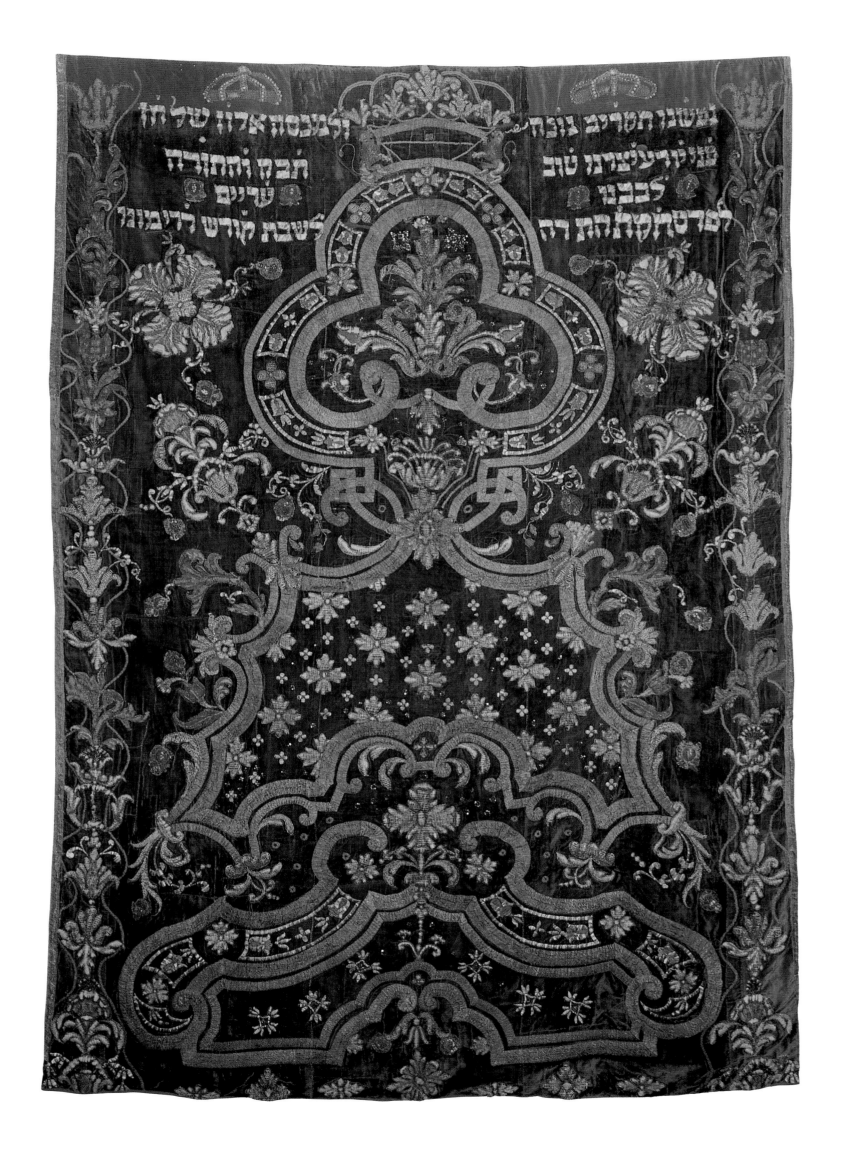

A *parokhet* is a curtain for the *aron ha-kodesh*, the recess in the synagogue for keeping the Torah scrolls. The exhibited *parokhet* was originally a secular textile. Its center is filled with a ribbon ornament in pincer-like arrangement forming a three-tiered throne, with a trefoil at the top. The background is covered with tendrils, flowers, and acanthus leaves. The borders decorating the right and the left edges of the *parokhet* are composed of similar motifs. In the eighteenth century crowns were added to the upper part of the textile as well as lions flanking the main crown, open pomegranates, and the inscription in Hebrew, translated here: *And for the purpose of veiling the beautiful chest of the Ark / and the Torah / theJewels of the Holy Shabbat / Let our soul be / surrendered to the Lord of our will / and of sincere hearts / According to the date—The Ordinance of the Law.* The last two words of the inscription are the name of the sixth Parashah in the Book of Numbers (19, 2), which, after summing the numerical value of their letters, gives the date 508 (or 1748).

IKB

107

PAROKHET, END 17TH C. AND 1748

POLAND

VELVET; EMBROIDERED WITH SILVERED AND GILDED METAL THREAD, APPLIQUÉS, GALLOON

260 × 187 CM (102 3/8 × 73 5/8 IN.)

JEWISH HISTORICAL INSTITUTE, WARSAW, INV. C-266, PURCHASED IN 1975

LITERATURE
Żydzi-polscy 1989, 116; *Muzeum ŻIH* 1995, 34; *Pod jedną koroną* 1997, cat. XV 43.

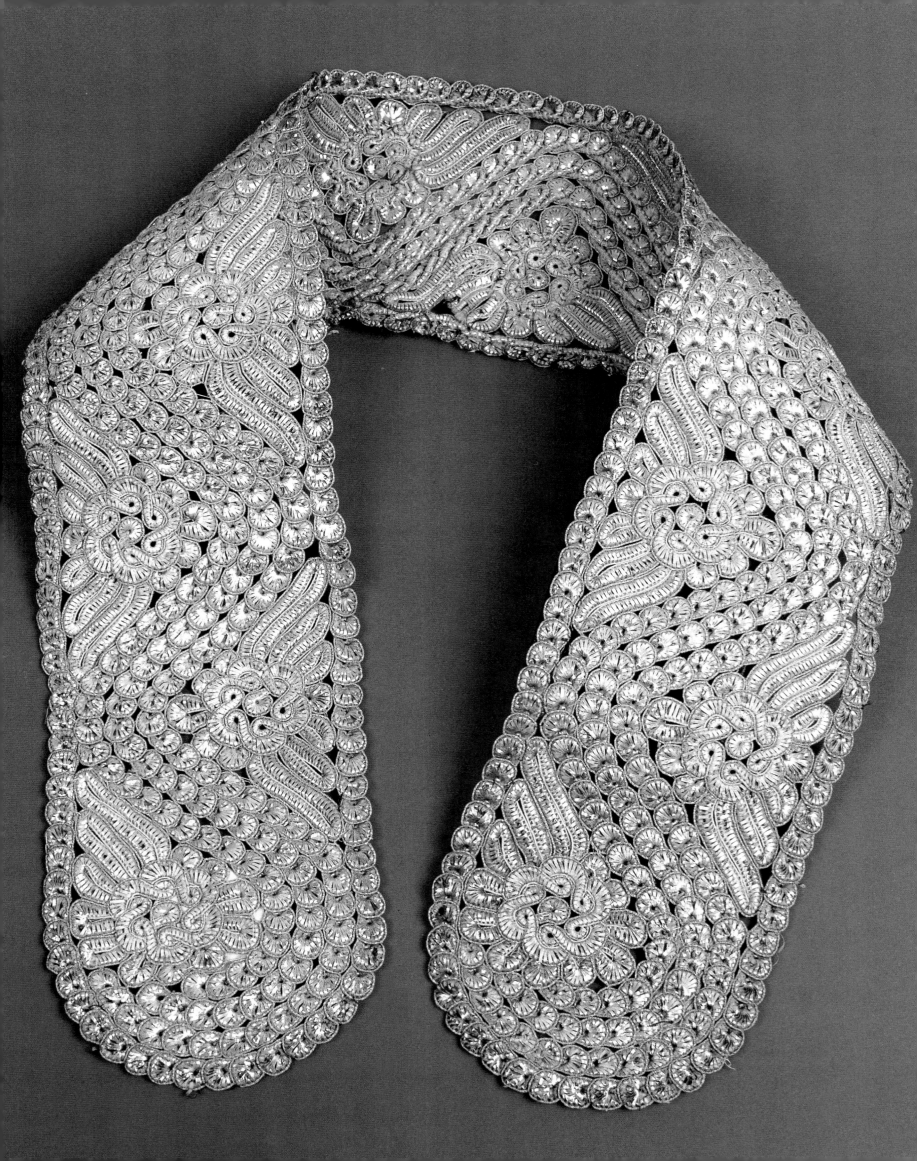

An *atarah* is the decoration of a *tallith*, sewn on in the middle of its top edge, in the part for the head and shoulders. The present specimen was made in an unknown Jewish passementier's workshop, probably at Sasów, the largest center of production of *atarahs* and other elements of Jewish attire (collars to men's *kitels* for the festival of Yom Kippur, and pectorals for women's dresses), or in another country town on the southeastern territory of Old Poland.

This is a strip of lace with rounded ends, filled with the motif of a broad wavy band in whose bends are placed small rosettes against foliage. Most *atarahs* that have survived in Poland are passementerie produced on special looms using silver thread and silver or tinsel gold foil. According to tradition, the technique of their production, called "Spanish work," had been brought here by the Sephardim expelled from Spain who settled in Poland in the sixteenth century. The ornamentation of *atarahs* was based on a modest stock of traditional motifs such as rosettes, stars, and hearts, perhaps transferred by the Sephardim from the Iberian Peninsula. The design in the present object is one of the few most frequently repeated decorative patterns on *atarahs*.

MT

108

ATARAH, 1ST HALF 19TH C.

SASÓW, POLAND (TODAY UKRAINE)

SILVER THREAD (STRIP OF METAL FOIL WOUND AROUND A LINEN CORE) AND SILVER FOIL, LACE PASSEMENTERIE

101 × 12 CM (39 3/4 × 4 3/4 IN.)

NATIONAL MUSEUM, CRACOW, INV. MNK-XIX-4767, GIFT OF HELENA DABCZAŃSKA TO THE NATIONAL MUSEUM IN CRACOW, 1916–22

109

CHANUKAH LAMP, END 18TH C.

EASTERN LITTLE POLAND

CAST BRASS, CHASED

25 × 30 × 6.5 CM (9 7/8 × 11 3/4 × 2 1/2 IN.)

NATIONAL MUSEUM, CRACOW,
INV. MNK-IV-M-2395, PURCHASED FROM
IZAAK OLDINGER, 1937

A chanukah lamp is used for home liturgy during the Jewish festival of Chanukah (renewal, cleansing), also known as the Feast of Lights. The festival commemorates the victory of the Maccabees over the Seleucids (168 B.C.) and the revival of the cult in the Jerusalem Temple, following its cleansing after desecration. The lamp is lit for the eight days of the festival, each day one more light being added. The lamps made in eastern Little Poland are additionally provided with two side candleholders for Shabbat candles. Only in Poland did less-affluent Jewish families use these lamps not exclusively during the festival of Chanukah, but also on the Shabbat. The Cracow chanukah lamp has a rectangular stand resting on four feet, with eight oil containers in the form of small conical beakers fixed to it. The back and side walls are openwork. Among the vegetal ornaments on the back are two snakes flanking a vase with flowers and above them two lions supporting a crown. On the sides are additionally two candlesticks.

SO

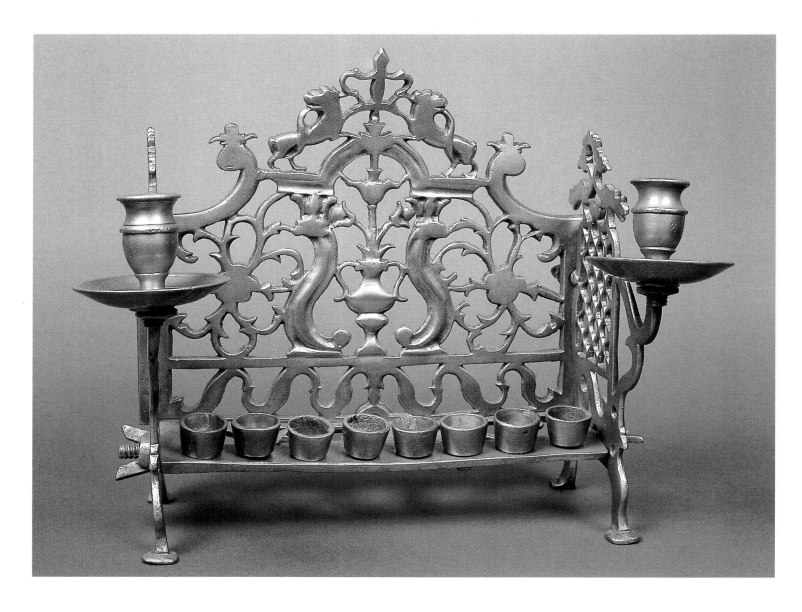

This rectangular stand rests on four feet, and fixed to it is a long container divided into eight smaller rectangular ones. The row of smaller containers is covered by a hinged oblong lid. The back and side walls are openwork. On the back is the representation of a menorah (a seven-branched candelabrum) flanked by two columns, and above are two hands in a gesture of blessing. On the sides are two additional candlesticks.

SO

110

CHANUKAH LAMP, 18TH C.

EASTERN LITTLE POLAND

CAST BRASS, CHASED

27.5 × 30 × 6 CM (10 5/8 × 11 3/4 × 2 3/8 IN.)

NATIONAL MUSEUM, CRACOW,
INV. MNK-IV-M-2412, PURCHASED
FROM H. RABINOWICZ, 1938

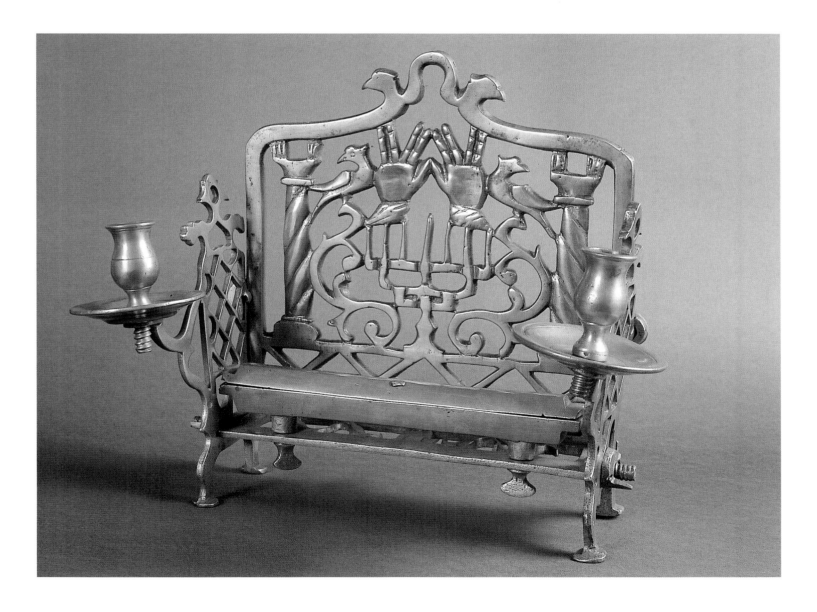

A *besamin* is a box for spices and fragrant herbs whose scent is inhaled during the Havdalah ceremony at the close of Shabbat or a festival. The essence of the ceremony is to separate the holy day from the days of the working week.

The present object has a square convex foot with a flat edge. The stem has an embossed knob. The container for spices is in the form of a quadrilateral turret surmounted by a high hipped roof crowned with a vane. The loose roof is the cover of the *besamin*. The sides of the turret bear the motif of a portal with a broken pediment, above which two birds hold hanging vines. The slopes of the roof are decorated with the motif of a fish (or Leviathan) whose tail turns into a vine.

On the edge of the foot is the Lvov contribution mark stamped in 1806/07, repeated twice.

SO

111

BESAMIN, TURN OF 19TH C.

LVOV(?)

SILVER; REPOUSSÉ, PARTLY CAST, OPENWORK, ENGRAVED

20 CM (7 7/8 × 1 7/8 IN.)

NATIONAL MUSEUM, CRACOW, INV. MNK-IV-2-1025, BEQUEST OF MACIEJ WENTZEL, IN THE MUSEUM COLLECTIONS SINCE 1935

DECORATIVE ARTS

I n the Commonwealth, the political predominance of the gentry, who preferred living at their country estates, stifled development of the towns that had been flourishing in the late Middle Ages, where modern forms of art schooling, public exhibitions, and art criticism might have evolved. The organization of creative activity and training in the arts remained bound in the medieval guild structures.

Art patronage moved to the provinces. An ambitious magnate ready to invest funds in works of art found few artists with proper skills and had no way to evaluate the merit of the works produced for him. But the field of decorative art was different. Even top-quality goldsmithery and various weaving techniques did not require a command of the rules of perspective or anatomy that could only be attained by academic studies; here mastery could be achieved through traditional forms of guild training. The importation of superb works from abroad as well as the wide popularization of engraved pattern books ensured contact with current stylistic trends. It is also worth emphasizing the international character of the craftsmen's milieu in Poland. In addition to Poles, it embraced a large number of Germans, Italians, Armenians, and Jews. Each group introduced into its products elements stemming from its own tradition, combining to form a rich and diversified picture.

Poles of the sixteenth through eighteenth centuries were characterized by their great fondness for the decorative value and richness of costume, military equipment, and other objects both of secular and religious character. They were determinants of prestige on a scale hardly comprehensible today. Local artists satisfied these tastes on a level that did not essentially differ from that afforded by great centers abroad. What is more, it was in the field of the decorative arts that the crossing of western and eastern influences became the most spectacular, giving rise to works of unique character and remarkable decorative merit.

Present-day collections of decorative art objects in Poland give only a faint idea of their number in the sixteenth through eighteenth centuries. Older pieces in gold and silver were treated as a source of precious metal and reworked after a new fashion or simply melted down. They, too, were the easiest to plunder and confiscate. One should bear in mind at least four great waves of expropriation and pillage that befell the Commonwealth: after the Uprisings of 1830–1831 and 1863–1864; during the Bolshevik revolution; during the Second World War; and in the postwar period. They caused the annihilation of practically all noble residences and along with them the collections amassed for centuries; only old inventories reveal some idea of their wealth. Hence the majority of the extant specimens are of a religious character, though church treasuries also suffered heavy losses in the eighteenth through twentieth centuries.

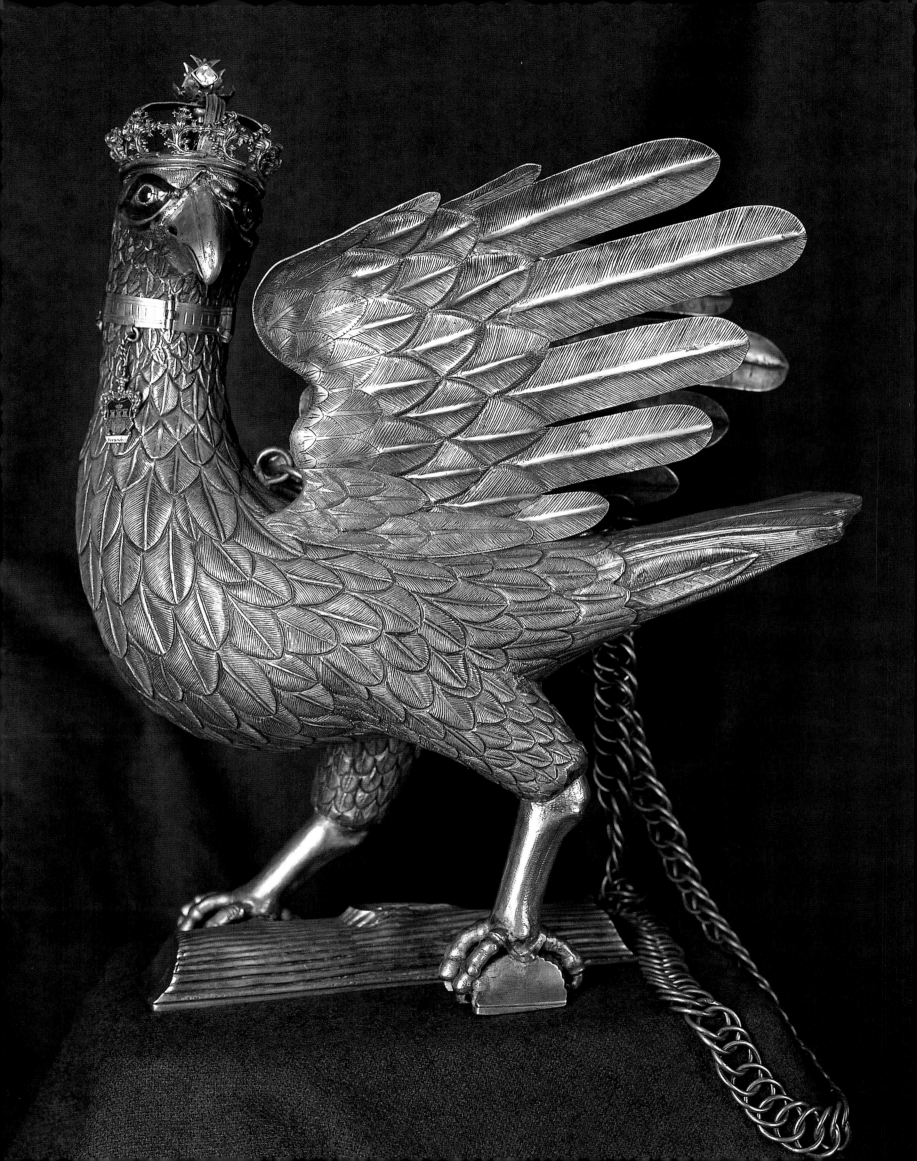

The exhibited object is the symbol of the dignity and authority of the king of marksmanship, that is, the best marksman among Cracow burghers. This person was the winner of the shooting competition organized once a year, around the feast of Corpus Christi, by the Marksmen's Brotherhood under the patronage of the Cracow City Council. This organization trained merchants and craftsmen to wield weapons for the defense of the city in case of an attack by an enemy. The king of marksmanship received highly valued privileges such as the right of duty-free importation of Hungarian wine. The competition for the title was a strong incentive for the members of the brotherhood to participate in shooting exercises.

The bird was made in 1564/65 for the brotherhood, which in 1564 also received from the councillors its first statute. On the reverse of the cross surmounting the crown are the letters *SSV*; the sculpted figure bears also the Austrian contribution mark stamped at the Cracow assay office in 1806/07.

The underside of the base of the silver cockerel is stamped with the inscription *DAS.SYNDT.DIE.ELTEST / EN.DIE.IN.DEM.YAR / 1.5.6.5 / CHRSTOF.ZURICH / ERASMUS.ZURUS / SIMON.STOLARSZ / IAN.KROTZECK / ENDRIS' FOGELWADER / STENZEL.GROSCH / JAN LANG / FRIDRICH .LEYTZNER*, which lists members of the first council of the Elders of the Brotherhood, consisting of eight men elected in accordance with the statute. The cock itself was defined in the statute as a "gem" and in compliance with the donors' will regarded as a challenge awarded to the best marksman called the king of marksmanship. His rule lasted for one year, until the next competition, and could only be repeated after he again won the contest. Over the centuries the bird's form changed slightly; for instance, small jewelry pieces or coins were suspended from its wings, and for some time it was even provided with an additional pair of wings. After World War II the communist state authorities dissolved the Marksmen's Brotherhood (which had existed since the late thirteenth century), confiscating its property. In 1952 the cock, together with other mementos of the brotherhood, found its way to the collections of the Museum of the History of Cracow. In 1964 Wiesław Łabędzki made the first copy of the bird (likewise stored in the above-mentioned museum). Another one, for the brotherhood revived in 1956, was wrought in 1984 by Stefan Luchter.

The figure of the bird, which stands on a base in the form of a relief bough, is to be viewed in its left profile; it is rendered with raised wings and its head facing the viewer. The tail is flat and slightly spread. In its body the bird resembles a cock, while its head is similar to that of an eagle. On the head is a crown, and around the neck a ring with a suspended enameled pendant bearing Cracow's coat of arms. The chain of round links attached to the bird's body serves to suspend the bird from the neck. The texture of the neck, body, and wings imitates plumage. The beak, claws, crown, ring on the neck, and edges of the base are gilded. The crown is openwork, its circlet consisting of twelve fleurs-de-lis closed with four arches, at the junction of which is a Maltese cross set on six small fleurs-de-lis with a precious stone mounted at the crossing of its arms.

GL-N

112

EMBLEM OF THE CRACOW MARKSMEN'S BROTHERHOOD, 1564–65

CRACOW

CAST SILVER; REPOUSSÉ, PARTLY GILDED; ENAMELED, SEMIPRECIOUS STONES

41.4 × 22 × 15.5 CM (16 1/4 × 8 5/8 × 6 IN.)

MUSEUM OF THE HISTORY OF CRACOW, INV. MHK 179/BR.K., SINCE 1952

LITERATURE
Lichończak 1987, 113–26; *Między Hanzą a Lewantem* 1995, cat. IV.16, 76–77.

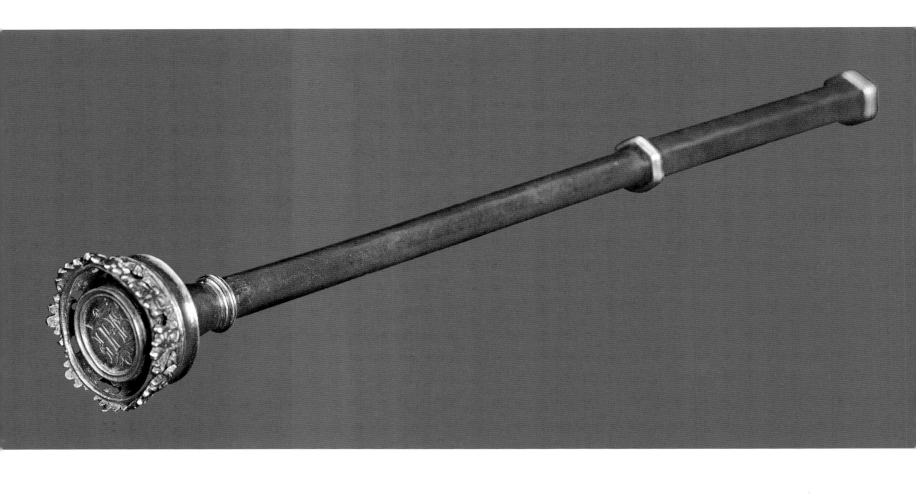

The scepter, together with a ring, was an attribute of authority of the head of the city council of Cracow. By the early fifteenth century the members of the council numbered twenty-four. Eight of them constituted the municipality proper, dealing with current affairs; they were called aldermen. One of them was appointed mayor of the city, at first every six weeks and later every four weeks. When passing his duties to his successor, the mayor turned the scepter over to him. It was always placed on the table, in front of the mayor, as a sign of authority; he also held it in his hand when pronouncing sentences or changing title deeds.

The scepter of the mayors of Cracow should be dated to the early sixteenth century. It was probably wrought in the workshop of a Cracow goldsmith. Its head resembles that of the rector's scepter presented to Cracow Academy by Cardinal Fryderyk Jagiellon, dating from 1493–95, and attributed to Marcin Marciniec. The shaft of the exhibited scepter is hexagonal from the bottom to one-third of its height, the lower part constituting a grip terminating at the bottom and top in gilded hexagonal molded bands. Above the upper band the shaft takes the form of a cylinder terminating in a gilded round band—the base of the head in the form of a cone with a slightly concave side surface—which in turn forms the base of the crown of gilded late-Gothic leaves surmounting the scepter. On the cone is the inscription in Renaissance majuscule *JVDICATE IVSTE F[ilii] H[ominum]*. The cone is closed at the top with a gilded disc engraved with the letters *IHS*. The underside of the handle bears a mark, probably of the person who commissioned the scepter.

DR

113

SCEPTER OF THE MAYORS OF CRACOW, EARLY 16TH CENTURY(?)

CRACOW

SILVER; PARTLY GILDED, EMBOSSED, CAST

22.8 CM (9 IN.)

MUSEUM OF THE HISTORY OF CRACOW, INV. 621/II, MADE OVER BY THE CRACOW AUTHORITIES TO THE MUSEUM IN 1952

LITERATURE
Bochnak, Pagaczewski 1959, 146;
Sztuka w Krakowie 1964, cat. 198.

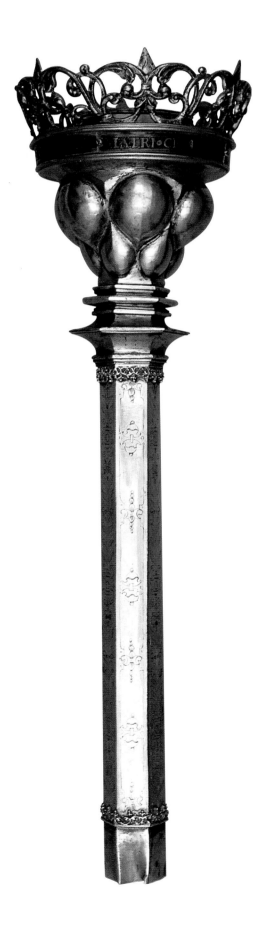

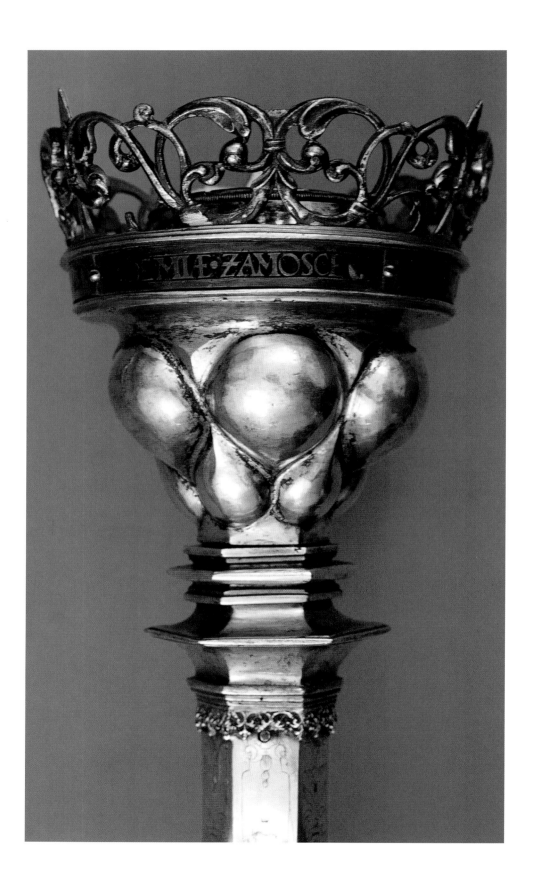

The Zamość Academy, founded in 1594 by Jan Zamoyski, grand chancellor of the Crown, was one of the three institutions of higher education in Poland in the seventeenth and eighteenth centuries. Among the insignia of its rectors, two scepters were particularly remarkable; commissioned after 1618 by Tomasz Zamoyski, they were in all likelihood wrought in a Cracow goldsmith's workshop, which seems to be indicated by their forms and the mode of decoration. Until the liquidation of the academy they were its property, to be next kept by the Zamoyski family, who at the beginning of the nineteenth century placed them in the library of the Zamoyski Entailed Estate in Warsaw. During the Second World War one of the scepters was lost, while of the other only the upper part, the head, has survived. In March 1945 the Zamoyskis deposited the extant part of the scepter in the Czartoryski Museum in Cracow. In 1980 Jan Zamoyski presented the object to the Zamość authorities, who in turn deposited it in the local regional museum.

The preserved fragment consists of one element of the shaft and the head, joined together with a metal tang. The hexagonal shaft bears an engraved strapwork ornament with floral motifs; foliate lacework encircles the lower part of the shaft; the head is also hexagonal in cross-section and has two rows of embossed guttae. It is surmounted by a ring inscribed *ACADEMIAE ZAMOSCENSI ALTRICI SUAE BONORUMQ[UE]ARTIUM TANQUAM MATRI CHARISSIMAE* and decorated with a crown with foliate motifs. At the top of the head, on a molded base, is a round plaque covered with multicolored enamels and emblazoned with Tomasz Zamoyski's quartered arms surrounded by various *sigla*. The scepter of the Zamość Academy is almost identical in form with the scepter presented to the Cracow Academy by Cardinal Fryderyk Jagiellon after 1493. The mode of embossing and the mannerist ornamentation recall the decoration of Nuremberg goldsmiths' works.

PK

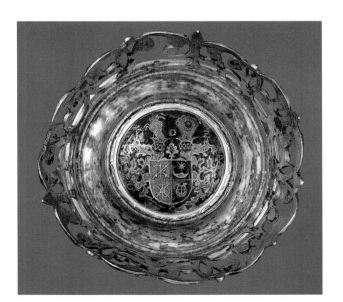

114

SCEPTER OF THE ZAMOŚĆ ACADEMY,
AFTER 1618

CRACOW(?)

SILVER-GILT; ENAMELED, ENGRAVED,
EMBOSSED, CHASED, PARTLY CAST

54 CM (21 1/4 IN.)

REGIONAL MUSEUM, ZAMOŚĆ,
INV. MZ/137/DEP, GIFT OF
JAN ZAMOYSKI

LITERATURE
Kowalczyk 1980, 177–82; Kondraciuk 1994,
131–42.

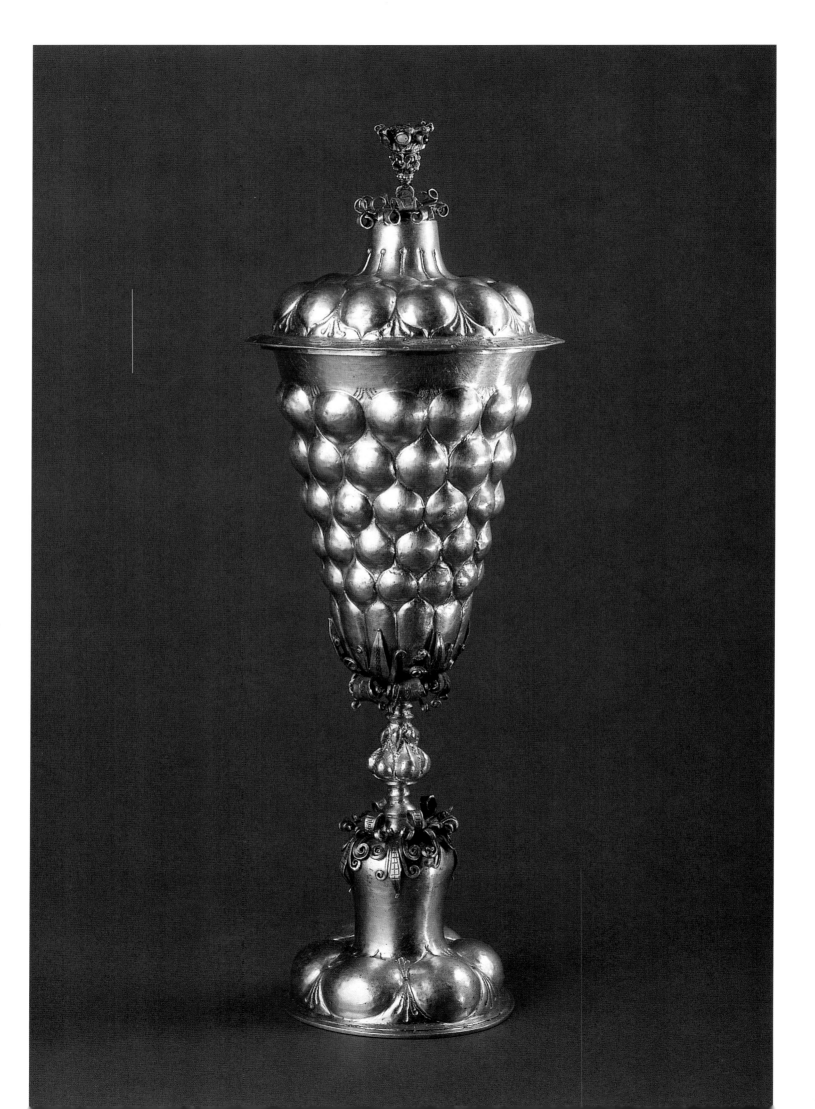

The goblet embossed in a bunch of grapes was used for drinking wine, as can be seen in the *Feast of Balthasar* by an unknown Gdańsk painter from the early seventeenth century. A goblet with a similar embossed pattern, but stylistically more advanced, decorates the sumptuous buffet behind the throne of Wealth in an allegorical triptych by Anton Möller, likewise from the early seventeenth century.

As may be concluded from the period of Kadau's artistic activity, the goblet was wrought between 1607 and 1625. Probably during later restoration the finial of the cover was altered: its present elements, a "plate" with cut-out leaves and a hinged "vase," are of later date.

The goblet has a circular foot, in the lower part decorated with six bosses separated from one another by simplified vegetal ornament; its upper part is cylindrical, slightly flaring upward. At the base of the stem is a row of silver cut-out and engraved leaves. The knob is embossed. The bowl is in the shape of an inverted truncate cone, at the base resting in a calyx analogous to the ornament at the top of the foot; it is embossed, in the lower part a zone of elongated bosses resembling a foliate calyx, above it five zones of oval bosses; the rim is plain. The cover has a protruding edge, ornamented similarly as the lower part of the foot; it is crowned by a rosette of cut-out silver sheet and a finial in the form of a vase ornamented in a strapwork design, hinged to the cover. On the edge of the bowl are the hallmarks of Gdańsk and of the goldsmith *LK*, somewhat defaced.

Despite the organic character of its embossed decoration, the goblet, considered to be an example of imitation of Nuremberg patterns, has retained a regular form typical of Renaissance vessels, thereby differing from later products of this kind, in which the bowl together with the cover indeed took the form of a bunch of grapes.

JJD

115

GOBLET AND COVER, 1ST QUARTER 17TH C.

LUCAS KADAU, GDAŃSK (1576–1625)

SILVER, BEATEN, EMBOSSED AND GILT; CUT OUT AND ENGRAVED; THE STEM AND KNOB CAST; THE FINIAL OF THE COVER SET WITH SMALL TURQUOISES AND GARNETS

25.2 CM (9 7/8 IN.)

PRINCES CZARTORYSKI MUSEUM, CRACOW, INV. XIII-1668

LITERATURE
Rembowska 1971, 122, 183, fig. XV; Bujańska 1972, 49/50, cat. 13, fig. 13; Samek 1984, 81, fig. 44 on p. 80; Samek 1988, 119, fig. 115.

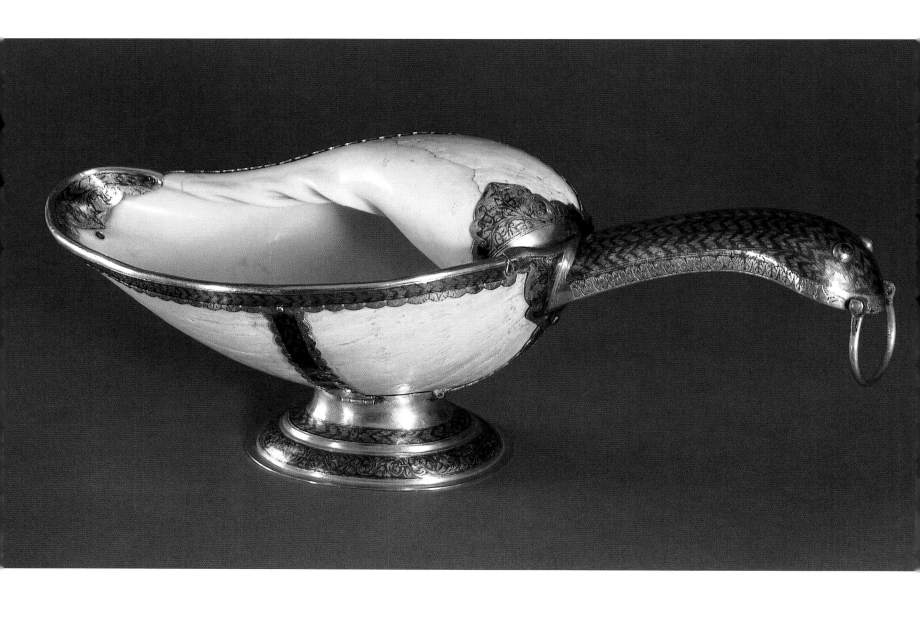

Until 1939 the vessel was in the collection of Count Pusłowski in Cracow, exhibited in 1938 and 1939; after 1945 in that of Bruno Konczakowski in Cieszyn; in 1961 given to Wawel by his heirs; and in 1970 it was displayed at the exhibition of Polish art in London.

This is a ceremonial vessel in the form of a dipper. The oval molded foot supports an oblong shell enfolded by bands whose edges are accentuated by a foliate motif; the spout is mounted; on the other side is a handle in the form of a reptile's head and neck, ending in an arched element. The ornamentation consists of intertwined acanthus and rows of leaves imitating snakeskin on the handle.

Nielloed decoration is characteristic of such objects as military appliances and cutlery produced at the turn of the eighteenth century, traditionally linked with Armenian workshops active above all in Lvov. Among them the present dipper is distinguished by its original, unique form.

DN

116

REPTILE-SHAPED VESSEL, END 17TH C.

POLAND

SILVER PARCEL GILT, SHELL; BEATEN, CHASED CAST, REPOUSSÉ, ENGRAVED, NIELLOED

13.4 × 36.3 CM (5 1/4 × 14 1/4 IN.)

WAWEL ROYAL CASTLE, CRACOW, INV. 4655

LITERATURE
Wystawa starych zegarów 1938, 10, cat. 104; *Wystawa miniatur* 1939, 9, cat. 104; *1000 Years* 1970, 85, cat. 156.

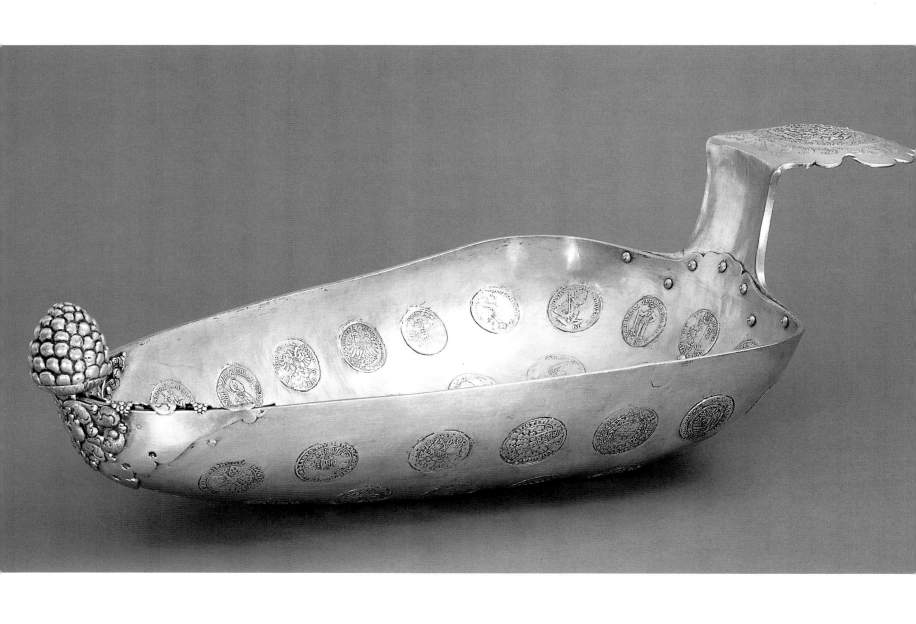

This vessel was probably wrought on the occasion of the marriage of Karol I Stanisław Radziwiłł (1669–1719), at that time chancellor of Lithuania, with Anna Katarzyna Sanguszko (1676–1746); the wedding ceremony took place in Vilnius on 6 March 1691. Until 1813 it was in the Radziwiłł treasury at Nieśwież; after confiscation by the czarist authorities, in the Kremlin Armory in Moscow (inv. 2068); and in 1928 recovered from the Soviet Union and made over to Wawel.

Objects of luxury presented on the occasion of important events in magnate families were often splendid vessels. Their sole function was to display the wealth and magnificence of the family, hence the frequent appearance on them of "ancient" coins or elaborate heraldic compositions. Many a time reference is made to traditional symbols of marriage; in the present object this takes the form of half an egg (sign of a new life) and an embossed heart form at the bottom. The narrower end of the vessel is decorated with an applied foliate ornament and a large cone in the form of a bunch of grapes (a symbol of fertility, among other things); at its wider end is a riveted handle bent at a right angle, in the upper part forming a rosette-like cartouche with sinuous edges. In the cartouche, against a drapery, within a wreath of acanthus branches surmounted by a ducal coronet, is a ten-field shield with coats of arms: Trąby, Janina, Pogoń, Sas(?), Lis(?), Bogoria, the Radziwiłł eagle, Korybut, Odrowąż, Rawa, and Lubicz, relating to Karol Stanisław Radziwiłł and his ancestors, beginning from the first half of the sixteenth century. The bottom and sides of the vessel are inlaid with a collection of thirty-eight coins (thalers, half-thalers, and guilders) ranging from the end of the fifteenth century to 1666, arranged in three rows.

This unusual object was a wedding gift for one of the wealthiest magnates in the Commonwealth at that time, from 1690 chancellor of Lithuania and heir of Nieśwież. This is one of about a dozen goldsmith's works that have survived from what was once the richest private treasury in the Polish kingdom, annihilated in 1812–13 in reprisal for the participation of the last lord of the Nieśwież Entailed Estate in the Napoleonic campaign against Russia.

Probably wrought in Vilnius, the piece has the form of a Ruthenian *kovsh*, a dipper used for taking up mead or wine out of a barrel or for the liturgical drinking of holy water, but was executed in the style of western goldsmithery.

DN

117

DIPPER-SHAPED VESSEL, C. 1691

UNIDENTIFIED GOLDSMITH, POLAND

SILVER; BEATEN, CHASED, CAST, ENGRAVED; COINS

20 × 68 × 32 CM (7 7/8 × 26 3/4 IN.)

WAWEL ROYAL CASTLE, CRACOW, INV. 159

LITERATURE
Opis 1885, 227–28, cat. 2068;
Wystawa rewindykacyjna 1929, 94,
cat. 409; Gibasiewicz 1966, 170–72.

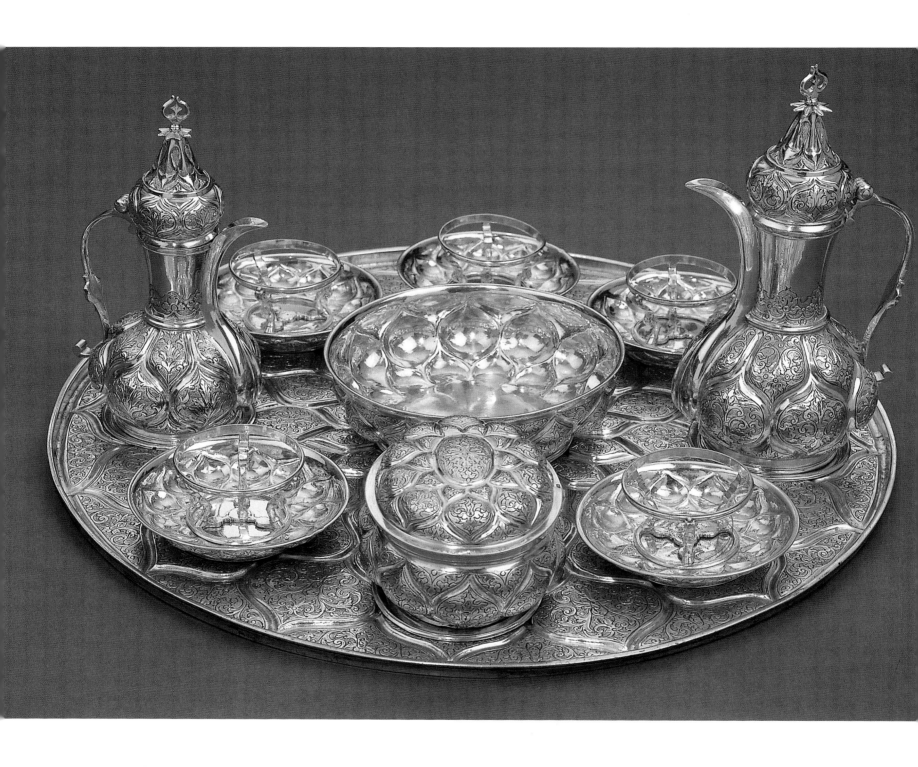

According to tradition, this silver-gilt service was a Turkish sultan's gift to one of the ancestors of the Dąbski family. At the beginning of the nineteenth century it was kept in the Austrian partition zone (western Galicia). Hallmarks include the Austrian contribution marks for the years 1806/07 stamped in Cracow and for the years 1809–10 stamped in the Austrian Empire. In 1933 it was exhibited at Wawel as the property of the Łukasiewiczs.

The flat tray with a molded edge bears the motif of ogival medallions filled with a geometrical-vegetal pattern, arranged in four radiating rows, which is repeated in all pieces of the service; the sockets for setting the vessels are decorated with engraved rosettes. The oval, bulbous sugar box has a prominent rim and a cover. The circular bowl has an everted rim. The bodies of the jugs are set on round bases; they are bulbous in their lower part and in the upper take the form of a flaring neck with a flange triangular in section; each jug has an S-shaped handle; the hinged lid, repeating the form of the body, is crowned by a finial. The saucers are small plates in the form of shallow bowls, each with a holder for a bowl—surely made of porcelain—that consists of three bent legs terminating in hooves, at the top closed by a rim.

This is one of the more interesting examples of the consistent orientalization in Central European goldsmithery, with no European trait except for the form of the sugar box, which was in general use throughout Europe from the second quarter of the eighteenth century. The persistence of traditional forms and techniques in the goldsmith's art determines the dating of the set to that time. The stylization of the ornament has its analogies in products linked with Armenian workshops active above all in Lvov at the turn of the eighteenth century. It was then that the revived fashion for luxurious "Turkish" articles of this kind reached its apogee.

DN

118

GILT-SILVER SERVICE, 1725–50

POLAND(?)

SILVER PARCEL GILT; BEATEN, CHASED, CAST, REPOUSSÉ, ENGRAVED

A, TRAY, DIAM. 49 CM (19 1/4 IN.)

B, SUGAR BOX, 7.8 × 13 (3 1/8 × 5 1/8)

C, JUG, 24 × 13.7 (9 1/2 × 5 3/8)

D, JUG, 20.5 × 12.3 (8 1/8 × 4 7/8)

E, BOWL, 5.8 (2 1/4), DIAM. 12.3 (4 7/8)

F–J, FIVE SAUCERS FOR BOWLS, 5 (2), DIAM. 12.3 (4 7/8)

WAWEL ROYAL CASTLE, CRACOW, INVS. 1310–19, GIFT OF WŁODZIMIERZ AND RÓŻA ŁUKASIEWICZ OF LVOV, 1935

LITERATURE
Świerz-Zaleski 1933, 19, cat. 83; Szablowski 1960, n.p.; *Zbiory Zamku* 1969, cat. 249; *Zbiory Zamku* 1975, cat. 271; *Orient* 1992, 89, cat. II/100, fig. 114; Gradowski 1994, 234, nos. 26, 28.

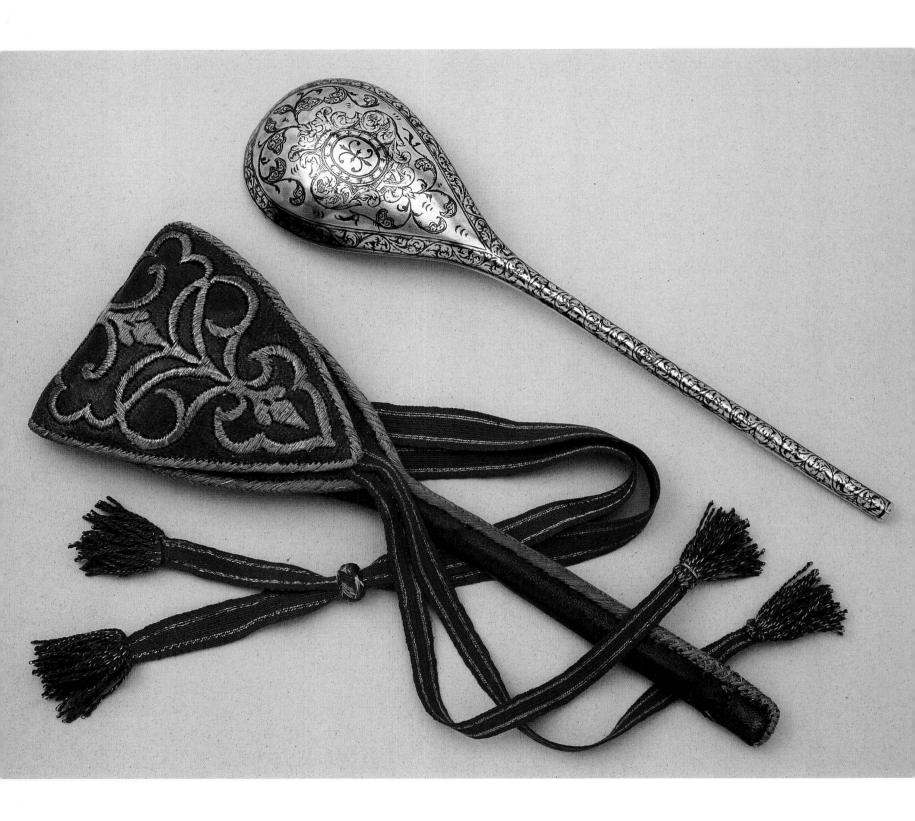

In 1933 the spoon and its case were on display in the Wawel exhibition in commemoration of King John III Sobieski. In 1939 they were taken abroad, to be returned from Canada in 1959.

The spoon has an oval bowl and a straight handle whose inner ridge is decorated with twisted silver wire. The inside of the bowl is gilded, while its outer surface is nielloed with a border of acanthus scroll spreading over the handle and with a cartouche bearing the Gozdawa arms in an oval shield surmounted by a nobleman's crown.

The case repeats the shape of the spoon. It is red with a silk lining, with a medallion of vine on the flap. Two long ribbons are sewn on the back for hanging, two shorter ones at the flap for tying up the case, all of them threaded with gold and terminating in tassels.

A silver spoon was one of the most important accessories of noblemen's culture in Poland as a sign of its owner's wealth and independence. Hence there was a predilection for its sumptuous, elaborate decoration, including an armorial bearing. Such a spoon would have been carried inside a boot or in an appropriate wooden or embroidered case; today barely a few such cases are known, the closest analogy being a specimen at the National Museum in Warsaw (30977 MN), emblazoned with the Korczak coat of arms and the monogram *SL*.

This spoon represents a type linked with Armenian production. The Gozdawa coat of arms was associated, apparently on no grounds, with the Pac family.

DN

119

A, SPOON, END 17TH CENTURY

POLAND

SILVER PARCEL GILT, NIELLO; CHASED, CAST, ENGRAVING, INLAY
23.5 × 5.6 CM (9 1/4 × 2 1/4 IN.)

B, CASE, END 17TH CENTURY

POLAND

LEATHER, MOROCCO, SILK, SILVER; EMBROIDERY
24 × 8 (9 1/2 × 3 1/8)

WAWEL ROYAL CASTLE, CRACOW, INV. 1331/1–2, GIFT OF ALFRED PIOTRUCH-KUBLICKI OF WARSAW, 1936

LITERATURE
Świerz-Zaleski 1933, 20, cat. 106; Szablowski 1960, n.p.; *Zbiory Zamku* 1975, cat. 185; *1000 Years* 1970, cat. 165.

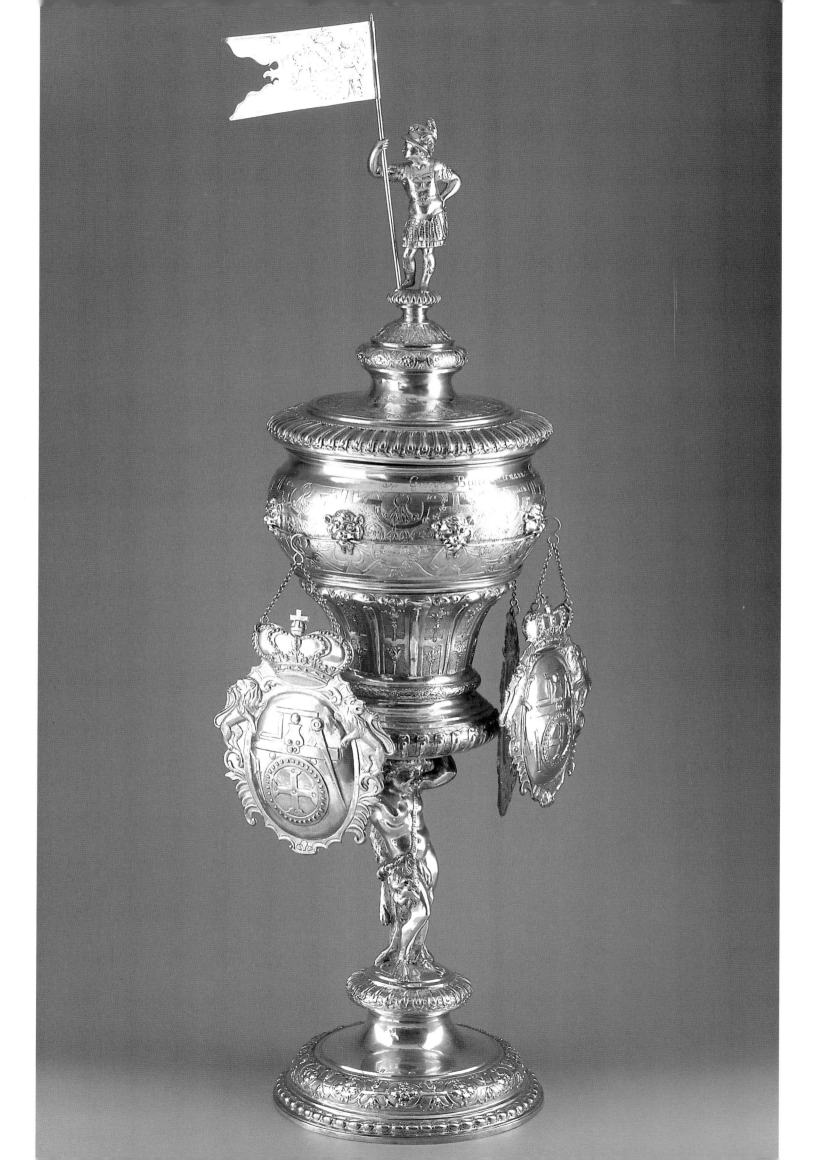

The cup bears the assay mark with the coat of arms of Gdańsk—two crosses surmounted by a crown—and the workshop mark of S. Örnster, *SÖ*, in a horizontal oval. A date is inscribed on the foot, referring to the date of production, *Ao 1715*. On 10 March 1716 the Gdańsk millers' guild paid the goldsmith Siegfried Örnster for the execution of a cup, the total sum amounting to 499.5 florins.

The iconography of the miller's craft is represented by the emblems engraved on the banner held by a warrior placed at the top and by a figure of Samson, the blind biblical miller of prodigious strength, which functions as a stem. The figure of Samson clad in skins is girded by a belt bearing an inscription on the banderole: *Judic 16: SIMSON DER MÜLLER* (Judges 16, 21), who with his raised arms holds up the bowl in the shape of a bell turned upside down, which rests on his head. Soldered to the upper part of the bowl are eight lion heads with apertures for suspending plaques. Inscribed around the edge of the bowl are the names of an elder and his assistant in the millers' guild: *Georg Beyer Eltermann: George Noach sein Compan*. The cover is surmounted by the figure of a warrior in antique-style armor, gripping a banner with the engraved emblems of the miller's craft (a pair of compasses, L-square, and circle), words *FINIS CORONAT*, and an inscription *Anno / Wer CIrCkeL MVhLen SteIn / NVn WoL f Vrt bethet feIn / NahrVng Von Gott kan haben / LetzLICh aVCh eWIg Gaben / Matth: 24*. The foot, bowl, and cover are decorated in the late Louis XIV style with ribbon, acanthus, rosettes, and bellflowers.

In the seventeenth and eighteenth centuries Gdańsk artists made welcome cups representing the type borrowed from southern German goldsmithery, whose bowl was broadly waisted in its middle part; the structure of the cup was characterized by the accentuation of horizontal elements counterbalanced by their massing upward. Örnster in turn, by swelling the upper part of the bowl, which thereby dominates over the tapering, funnel-like middle zone and the flattened lower part, took a marked step forward toward the baroque unification of the form of a cup, this finding its full solution twelve years later in the skippers' cup by Johann Jöde.

Such cups were used for drinking ceremonial toasts during the feast following the admission of a craftsman into the group of master craftsmen of a guild. The new master would have submitted his masterpiece in order to qualify for the rank. Hence the generally accepted name of guild cups, a welcome cup. Around the edge of the bowl were suspended commemorative plaques engraved with emblems of particular crafts and with inscriptions of the donor's first and last names as well as the date; the Örnster cup has retained ten such plaques dating from the period 1697–1838, which are also exhibited.

BT-W

120

A, GDAŃSK MILLERS' GUILD CUP, 1715

SIEGFRIED ÖRNSTER, GDAŃSK (1662–1735)

SILVER; HAMMERED, CAST, CHISELED WITH A BURIN AND PUNCHES, PARCEL GILT

65 CM (25 5/8 IN.)

INV. MNG/SD/125/MT

B, MILLER'S PLAQUE, 1697
12.7 × 16 CM (5 × 6 2/4 IN.)
INV. MNG/SD/197/MT

The plaque bears an assay mark with the arms of Gdańsk for the years 1689–99, workshop mark undecipherable, and an inscription *Daniel Pantel 1697*.

C, MILLER'S PLAQUE, 1738
WILHELM RATHS
17.6 × 14 (6 7/8 × 5 1/2)
INV. MNG/SD/192/MT

On this plaque are an assay mark with the arms of Gdańsk for the years 1705–34, mark of an elder of the guild in the years 1730, 1738, and 1744, L. Dietrich *LD*, workshop mark of W. Raths *R*, and the inscription *Michael. Gronau. Anno.1738. Dis Geschenk zu lieb und Ehren Wird mir aller Gunst gewehren*.

D, MILLER'S PLAQUE, 1739
17.9 × 13.7 (7 × 5 3/8)
INV. MNG/SD/193/MT

Visible here are an assay mark with the arms of Gdańsk, from the early 18th c., and the inscription *Christa:Heinnich:Richart:Eggert, Anno 1739*.

E, MILLER'S PLAQUE, 1746
BENJAMIN BEREND II
17.7 × 14 (7 × 5 1/2)
INV. MNG/SD/194/MT

This plaque contains the assay mark with the arms of Gdańsk for the years 1745–66, mark of an elder of the guild in the years 1748, 1756, 1762, and 1766, W. Raths *R*, workshop mark of B. Berendt II *BB*, and inscription *Peter Christoff Eggert, Anno 1746 / Dis Geschenck zu Lieb und Ehren / Mir wird aller Gunst gewehren*.

F, MILLER'S PLAQUE, 1751
SIMON GOTTLIEB UNGER
17.5 × 12.5 (6 7/8 × 4 7/8)
INV. MNG/SD/195/MT

Here can be seen the assay mark with the arms of Gdańsk for the years 1745–66, mark of an elder of the guild in 1751, J. G. Schlaubitz *S*, worskop mark of S. G. Unger *SGV*, and inscription *Anno 1751 / Peter Hoffman / Auff Dich Herr traue / Ich mein Gott Hilf mir / von allen meinen / Verfolgern und / errette mich*.

G, MILLER'S PLAQUE, 1754
15.8 × 11.7 (6 1/4 × 4 5/8)
INV. MNG/SD/196/MT

This plaque bears an inscription *Johann Gottlieb / Krüger / Ao:1754/d.11 Mertc*.

H, MILLER'S PLAQUE, 1785
CARL LUDWIG MEYER
16.8 × 11.5 (6 5/8 × 4 1/2)
INV. MNG/SD/199/MT

This plaque is rich with marks and an inscription including the assay mark with the arms of Gdańsk, mark of an elder of the guild in the years 1781, 1785, 1792, and 1795, E. Ellerholtz *E*, workshop mark of C. L. Meyer *MEYER* in a field with a wavy outline, and inscription *Wer Zirckel / Zolstock und Grund Wage/Beym Mhhlwerck zu gebrau / chen Weitz.u.sich dabey läst fleisig / finden, bekomt seyn Brodt an allen / Enden / Syrach. 29. u. 28 Sych.33.u.4 / Joh.Gottl.Walend / d.23 Mai 1785 / Freigesprochen*.

I, MILLER'S PLAQUE, 1803
14.5 × 10.7 (5 3/4 × 4 1/4)
INV. MNG/SD/203/MT

This piece is inscribed *Gottfried Hintz / d.26 September / Ano 1803*.

On this plaque are the assay mark with the arms of Gdańsk for the years 1820–36, workshop mark of J. J. Raths *I.RATHS*, and inscription *Johan Theodor Wagner d. 26 ten Maers 18.5, ausgelernet bei Johan Salomon Ziehm.*

This plaque bears the assay mark with the arms of Gdańsk, illegible, mark of an elder of the guild in the years 1829–33 and 1836, J. J. Raths *R*, workshop mark of J. G. Ulrich *Ulrich*, and inscription *Friedrich Wilhelm Donat Thil d 19 December 1838, Dies Geschenck zu Lieb und Ehren/Wird mir Aller Gunst Gewähren.*

BT-W

J, MILLER'S PLAQUE, C. 1825–1850
JOHANN JACOB RATHS
14.5 × 12.2 (5 3/4 × 4 3/4)
INV. MNG/SD/205/MT

K, MILLER'S PLAQUE, 1838
JOHANN GOTTLIEB ULRICH
17 × 13.4 (6 5/8 × 5 1/4)
INV. MNG/SD/204/MT

NATIONAL MUSEUM, GDAŃSK

LITERATURE
Czihak 1908, cat. 397/10; Rembowska 1971, cat. 99, fig. 39; *Polonia* 1989, cat. and fig. 135; Tuchołka-Włodarska 1991, 185, 186, figs. 16 and 17; *Danziger Silber* 1991, cat. and fig. 26; *Aurea Porta* 1997, cat. and fig. III.23.

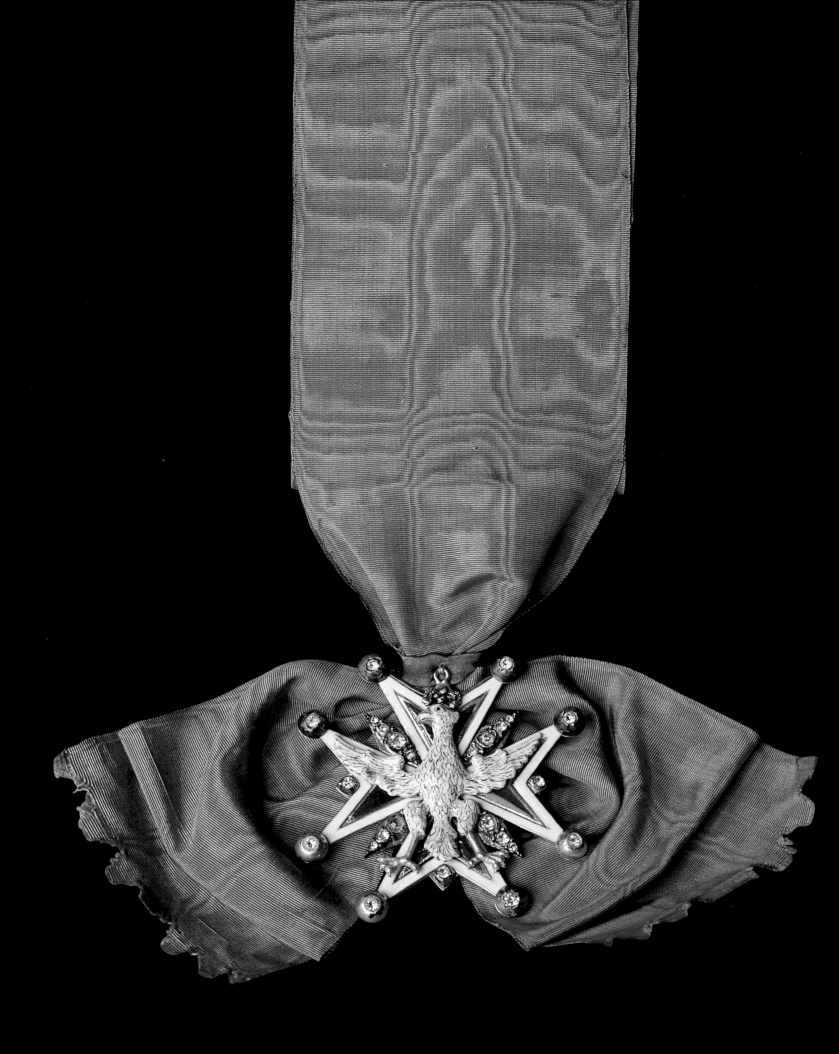

According to tradition, the cross and ribbon belonged to Ignacy Krasicki (1735–1801), bishop of Warmia and archbishop of Gniezno and an eminent poet who was decorated with the order by King Stanislas Augustus Poniatowski on 12 December 1774. It was next owned by Krasicki's family and purchased for the Wawel in Warsaw in 1990 from Xawery Krasicki from funds donated by Dr. Józef Grabski.

This is the oldest and highest Polish decoration, one of the most valued in eighteenth-century Europe; founded by Augustus II the Strong and distributed from about 1705 among the persons who had rendered particular services to the king. It still exists though in a slightly modified form. It is worn on a blue sash from the left shoulder to the right side, and in the case of clergymen is suspended on a ribbon. The here-presented version took form around 1713 as a Maltese cross whose arms are filled with red enamel except the edges, which are white; the points of the arms terminate in balls; between the arms are four shafts of silver rays. In the middle of the obverse is set a high-relief white eagle in a royal crown (with small diamonds). The balls at the points and the oblique rays contain twenty-five circular mounts with diamonds (today their imitations). In the center of the reverse is a round white plate with the crossed swords of the Wettins, a cross, and the monogram A[ugustus] R[ex]; the arms carry the device of the order PRO FIDE REGE ET LEGE (for faith, king, and law) inscribed in gold on red enamel. At the top is a plate with a ring.

The cross is on a blue ribbon to be put around the neck, sewn together at one place, toothed at the ends.

In spite of damaged parts and partial reconstruction, this is one of the more valuable specimens among a dozen or so extant eighteenth-century items.

DN

121

CROSS AND RIBBON OF THE
ORDER OF THE WHITE EAGLE, 1774(?)

POLAND

CROSS, GOLD, SILVER-GILT, COPPER,
PAINTED ENAMEL, DIAMONDS, ROCK
CRYSTALS; CAST CHASED AND INLAID,
7.5 × 7.7 CM (3 × 3 IN.)

RIBBON, SILK TABBY, 150 × 9.7 (59 × 3 3/4)

WAWEL ROYAL CASTLE, CRACOW,
INVS. 7642/1–2

LITERATURE
Zbiory wawelskie 1992, 7–8, 18, cat. 15, fig. 21;
Sprawozdanie 1992, 126, cat. 8.

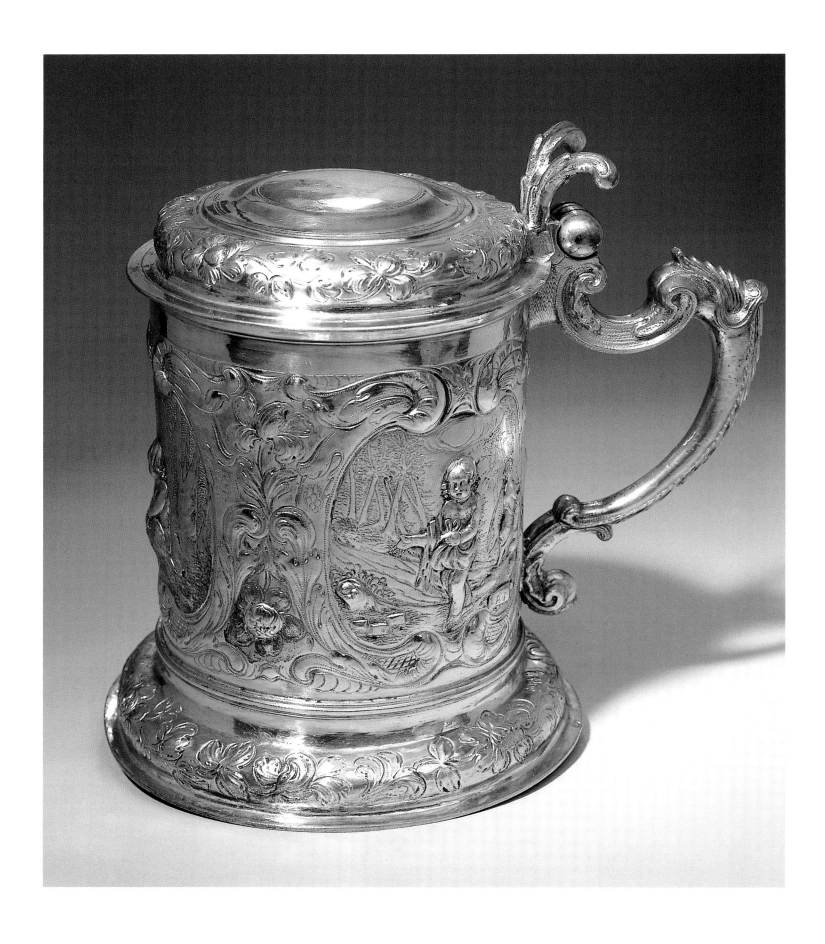

The tankard bears the hallmarks of Toruń for the years around 1676–1728: *T*, with a pair of dots in a circle; of Petersen's workshop: *S.P* in a bifoliate form; of the workshop of Sergei Ivanovich Shaposhnikov, working in Moscow in the period 1897–1908, who repaired the tankard: *CW* in a rectangle. On the underside of the foot appear the engraved Przyjaciel coat of arms (a variety) with the letters *IŻ* and *N 5* (seventeenth century), the painted number *8178*, and traces of other numeration (nineteenth–twentieth centuries). The piece was originally the property of the Żabiński family. In the nineteenth century it was kept in Russia and was purchased for the Wawel in 1935 in Moscow through Józef Stieglitz. In 1939 it was evacuated abroad and was returned from Canada in 1959.

The object is cylindrical with a lid and handle. The foot is round, slightly domed; the body is separated from it by a molded ring. The hinged lid is domed similarly as the foot. The handle consists of three volutes and a thumbpiece on the lid of two small volutes linked on the hinge.

The body bears three oval cartouches of auricular motifs that turn into acanthus stems with medallions featuring pairs of *putti* symbolizing April, marked *AP*, engaged in sowing; May, marked *MAI*, kissing; and June, marked *IV*, shearing a sheep. Between the cartouches is an acanthus ornament with flowers; an analogous decoration appears on the foot and lid.

This is one of the artistically most remarkable products of Toruń goldsmithery of secular character that have been preserved to this day. Its form—the proportions of particular elements, a cylindrical body, the lid domed similarly as the foot, and a three-volute handle—should be acknowledged as a model for vessels of this type, the production of which was the specialty of the Toruń and Gdańsk as well as Elbląg and Królewiec (Königsberg) workshops. Among a number of similar solutions in the Gdańsk goldsmithery of the 1670s, especially noteworthy are the tankards from Hans Polmann's workshop, with allegories of summer (MNG [SD/95/MT], *Danziger Silber* 1991, 61, no. 38) and winter months (Berlin, SMPK, K. 8863, ibid., 61).

DN

122

TANKARD WITH PERSONIFICATIONS OF SPRING MONTHS, C. 1676–80

STEPHAN (STEFFAN) PETERSEN (PETERES) (ACTIVE 1660–AFTER 1688), TORUŃ

SILVER, PARCEL GILT; BEATEN, REPOUSSÉ, CHASED, CAST, ENGRAVED

21.5 CM (8 1/2 IN.)

WAWEL ROYAL CASTLE, CRACOW, INV. 1293

LITERATURE
Zbiory Zamku 1969, cat. 166; *Zbiory Zamku* 1975, cat. 178; Samek 1980, 675–76; Fischinger 1983, 324, note 26; Chrzanowski, Kornecki 1986, 257; Chrzanowski, Kornecki 1988, 66, 116, fig. 141 and on the cover; *Danziger Silber* 1991, 61; Samek 1993, 34, 66, fig. 123; Tylicki 1993, 58.

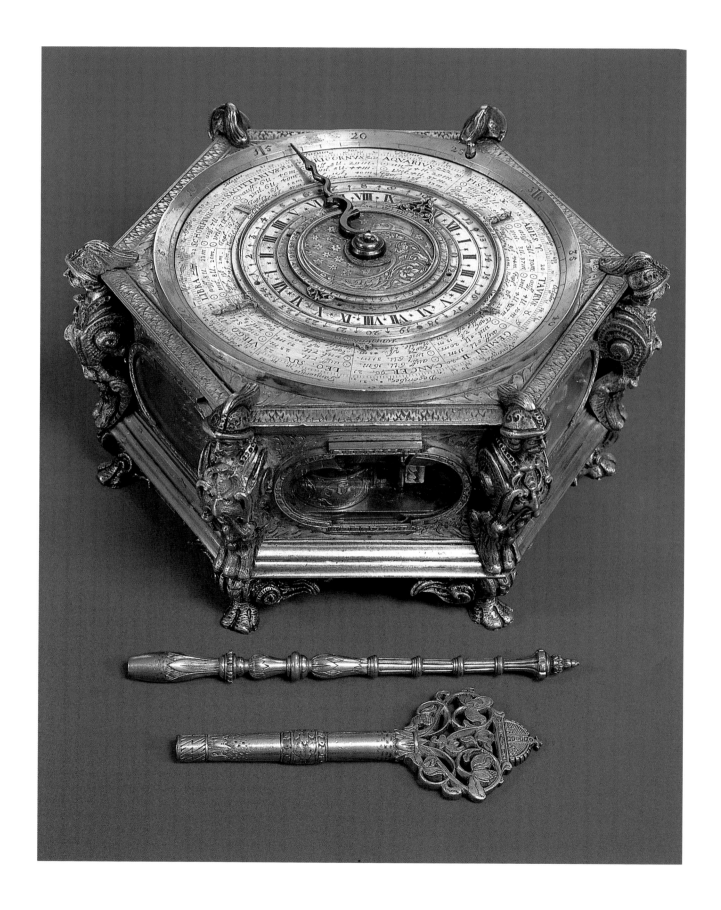

The clock has the form of a hexagonal casket resting on lion paws that in the upper part turn into scrolled wings. The sides have glazed oval medallions in engraved frames, showing the ornamental works. The corners are adorned with busts of helmeted knights with shields in the form of mascarons. Around the bells on the hatch of the base are engraved scenes from the history of Zeus and Io and of Pan and Syrinx. On the outer side of the lower plate are two scenes: Hermes, playing the pipe, puts Argus, guardian of Io turned into a cow, to sleep, and Zeus reclines at the foot of a tree, beside him Io the cow; on the right Hera rides in a chariot drawn by peacocks. On the inner surface, Hermes is depicted with the cut-off head of Argus, and nearby is Io the cow driving a gadfly away, while in the distance Hera is placing Argus' eyes in a peacock's tail; above, Pan is in pursuit of Syrinx who is changing into a reed. The representations are modeled upon engravings by Bernard Salomon of Lyons, painter, illustrator, and engraver (1506/10–61), based on Ovid's Metamorphoses, illustrating the book *Les métamorphoses d'Ovide figurées* (Lyons: Jean de la Tournes, 1557–58). The cock screen and the lower plate of the clock are decorated with an openwork plant design; the hammers are in the form of lion and dog heads. On the lower plate, beside the cock, is the signature *Simon Ginter A Gedanensis An 1607*.

The works has a hairspring escapement with transmission to a spindle escapement with two springs, one for movement and the other for striking. It strikes quarters of an hour and hours and functions as an alarm clock. There are dials with the so-called large clock (24 hours), half-clock (2 × 12 hours), and for setting the alarm for a definite hour. The clock also indicates minutes, months, days of the month, sunrises and sunsets, position of the sun in the zodiac, length of day and night, moonrise and moonset, and lunation. There are a decorative hour hand and tongue-like pointers at each dial. Keys for winding the clock are preserved, one in the form of a scepter and the other decorated with an openwork plant and floral ornament surmounted by a crown.

Table clocks in the shape of a drum and later as square or hexagonal caskets with dials in horizontal position were widespread mainly in the Germanic lands. They also won considerable popularity in Poland, from the early seventeenth century until well into the middle of the eighteenth being the favorite form of clockmakers and their customers. They owed their Polish name *kaflak* or *żaba* to their shape, *kaflak* meaning tile and *żaba*, frog. Gdańsk, the largest center of production of such clocks, attracted a large number of well-known clockmakers (among others Michael Schulz, Benjamin Zoll, Paulus Horn, and Ginter), whose works were distinguished by intricate mechanisms and individual decoration. *Kaflaks* were also produced in other centers of seventeenth-century clockmaking: Toruń, Vilnius, and to a lesser extent Cracow, Wrocław, and Poznań. The Gdańsk and Toruń *kaflaks* have characteristic decoration of the corners of their cases, including stylized figures of moustachioed Sarmatian knights, as in the present case, or mermaids. The supports in the form of figurines of recumbent lions with cleft bodies or lion paws ending in wings and scrolls spreading sideways are also distinctive features of the clocks made in Poland, permitting one to differentiate them from contemporaneous pieces produced in other European countries.

SB-L

123

TABLE CLOCK, 1ST HALF 17TH C.

SZYMON (SIMON) GINTER, GDAŃSK

CASE, BRONZE-GILT, SILVER; MECHANISM, BRASS, IRON; CHASED, ENGRAVED, OPENWORK, TURNED

10 × DIAM. 16 CM (3 7/8 × 6 1/4 IN.)

WAWEL ROYAL CASTLE, CRACOW, INV. 920, PURCHASED 1933

LITERATURE
Pendule 1974, 797, no. 1; Siedlecka 1974, 71, figs. 18–19; Maurice 1976, cat. 617; Bulanda 1982, fig. 1; Samek 1984, 123–24; *Zbiory Zamku* 1990, cat. 84; *Aurea Porta* 1997, 1:267–81, 2:411–12, cat. IX.73.

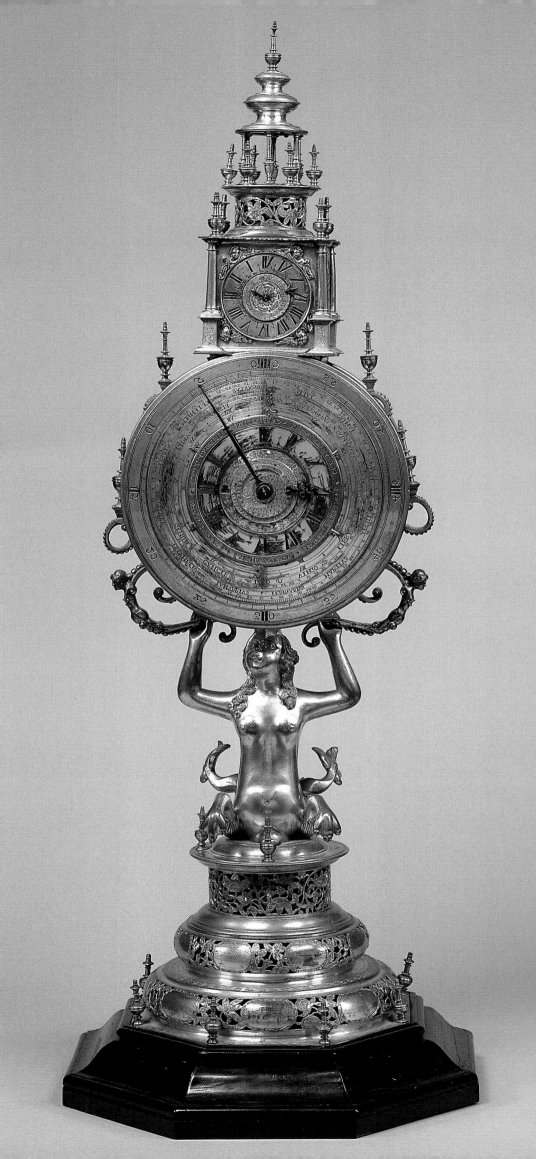

The main body of the clock, in its form resembling a monstrance, rests on an octagonal ebony base, on which stands the foot proper formed of two roll moldings tapering upward, with a broad openwork ring at the top; the ring encases a bell. The drum-shaped box with the works and dial is supported by the raised arms of a kneeling mermaid with two tails and two legs ending in fins. Above the large clock is a smaller, so-called tabernacle clock, situated on the axis, in the form of a prism with columns at its corners, crowned by a canopy with a spire. Lavish early baroque ornamentation with vegetal-flower motifs covers parts of the case. The mechanism of the larger clock is provided with a pendulum and spindle escapement. The dial has a large ornamental minute hand and a smaller, openwork hour hand fixed to the central movable disc. From the center outward are indication of the phases of the moon, lunar calendar, date, and hours. In addition there is a circle with tongue-like pointers indicating months and days of the month, the length of day and night, sunrises and sunsets, and the position of the sun in the zodiac. At the back of the mechanism are a short pendulum and three discs that regulate strikes; the clock strikes hours (the bell for chiming hours, in the foot of the clock, is activated by means of a vertical lever passing through the body of the mermaid) and quarters of an hour (by a bell in the upper turret). The tabernacle clock has a movable alarm dial and a hand for setting the alarm for a definite hour, and with hour divisions, the hour hand being fixed to the alarm disc. The spindle escapement is used for triggering the alarm. The bell is placed in the top of the clock.

This is a rare kind of clock to be encountered in Poland, called, for its shape, a monstrance clock. The exceptionally decorative foot with the figure of a mermaid recalls German goldsmith's products known as *Nautiluspokal* from about 1600, wrought in Nuremberg and Augsburg workshops, whose bowl, made from a shell, is supported by fully molded figures of kneeling mermaids or tritons. More modest examples of timepieces of this kind appear in seventeenth-century portraits, such as that of Casimir Jagiellon in the church of the Reformati in Cracow, painted by Daniel Schultz. According to the tradition of the Cieński family, from whom it was acquired, it was either war booty from Vienna or, which seems more likely, was in the possession of the standard keeper of Sieradz, Marcin Cieński, commander of a hussar regiment at Vienna in 1683. Taking these records as a basis, Jan Matejko, when painting *Sobieski at Vienna*, placed the clock in a page's hands as booty captured from the Turks. Exhibited during the bicentenary of the battle in 1883, in the Cloth Hall in Cracow, it aroused enormous interest. It is said that Baron von Rothschild made an offer to purchase the clock from Ludwik Cieński for an immense sum in those days, sixteen thousand guilders. Jan Matejko persuaded the owner to turn down the offer. In 1935, thanks to Stanisław Świerz-Zaleski's endeavors, Count Witold Antoni Cieński decided to sell the clock to the Wawel Royal Castle for fifteen thousand *zlotys*. Part of the sum was donated by Ludwik Holcer on behalf of the Omega firm. In this way "the clock became the finest adornment of the Planet Room at Wawel." Today it is exhibited in the Crown Treasury.

On the mechanism of the large clock is the signature *LORENTZ WOLBRECHT IHN THORN* (ornamental); on the inner side of the mechanism in the turret is the engraved inscription *Johann Fronschik (f) reperował 1840 z Drohobycz w Wybranuwce*.

SB-L

124

MONSTRANCE CLOCK,
THIRD QUARTER 17TH C.

WAWRZYNIEC (LORENTZ) WOLBRECHT,
TORUŃ

CASE, BRASS-GILT, SILVER, EBONY;
MECHANISM, BRASS, IRON; CHASED,
ENGRAVED, OPENWORK, TURNED

96 × DIAM. 22 CM (37 3/4 × 8 5/8 IN.)

WAWEL ROYAL CASTLE, CRACOW,
INV. 1282

LITERATURE
Katalog wystawy 1883, cat. 625; Świerz-Zaleski 1937, 27; *Wystawa starych zegarów* 1938, cat. 225; Siedlecka 1974, fig. 79; *Pendule* 1974, 798, cat. 2; Maurice 1976, cat. 555; Bulanda 1982, fig. 9; Samek 1984, 243–44; *Zbiory Zamku* 1990, cat. 85.

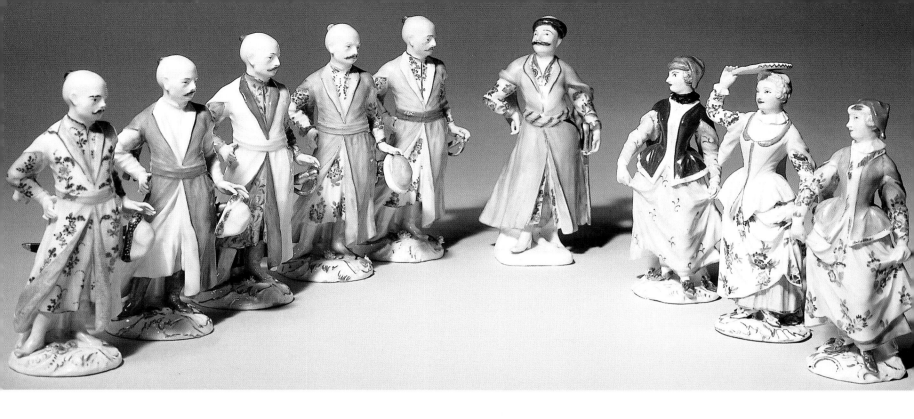

125

FIGURINES OF POLISH NOBLEMEN
AND NOBLEWOMEN

MEISSEN

FIRED PORCELAIN, GLAZED,
PAINTED OVERGLAZE, GILDED

WAWEL ROYAL CASTLE, CRACOW

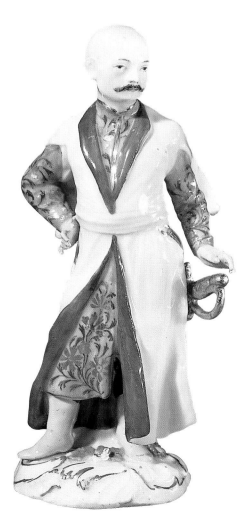

In addition to vessels of fine forms and multicolored painted decoration, the Meissen manufactory produced, among others, rococo figurines for the adornment of interiors and as a decorative supplement to table services during sumptuous court feasts. The figurines, set together to form thematic wholes, constituted a kind of theater in porcelain as centerpieces on the table; the themes of these compositions referred to the king's interests and provided a pretext for conversation during court receptions.

Elements of Sarmatian culture appeared at the Saxon court on account of the election of the Elector Friedrich August I Wettin as king of Poland and persisted also under his successor, who, in order to emphasize his relations with Poland, sometimes dressed after the Sarmatian fashion.

Polish customs, dances, and costumes, so unlike the French fashion that at that time prevailed in Europe, inspired numerous modelers of porcelain pieces. The earliest figurines of Poles, today very scarce, were made in Georg Fritzsche's workshop in the 1720s. In the 1730s and 1740s the subject was again taken up by Johann Joachim Kändler and Johann Friedrich Eberlein, from 1748 by Friedrich Elias Meyer, and later also by Peter Reinicke. The figurines' attire corresponded, with some simplification, to the contemporary costumes worn by the Polish nobility. The man's outdoor national costume consisted of a buttoned-up *żupan*, with a collar and long tight-fitting sleeves, over which a *kontusz* was worn with a broad soft silk sash tied around the waist. The characteristic feature of the *kontusz* was its sleeves slit from armpit to elbow, hanging loosely or thrown over the shoulders, revealing the sleeves of the *żupan*. From the belt fastened to the *kontusz* sash a parade saber was suspended. The costume was completed by soft high boots and a fur-trimmed round cap. Noblewomen wore short *kontuszes*, loose or tight-fitting, as outer garments over ample gowns.

Many a time the Meissen compositions were imitated by other German manufactories and by the French workshop of Samson. Exhibited here are several types of male and female figurines.

The figure stands on a round socle covered with plastic vegetal and rocaille decoration. He wears a *żupan* buttoned up to the neck and a *kontusz* with a soft sash tied around the waist; a saber is suspended from the belt fastened to the sash; the sleeves are thrown over the shoulders; the *żupan* reaches down to high boots; and the *kontusz* reaches down almost to the ground. The man is rendered in contrapposto, resting his right hand on his hip and with the left one reaching for the hilt of the saber, on which hangs a round fur-trimmed cap. The man's head is shaved, only a tuft of hair being left on the top. The colors of the costume are violet *żupan* with a pattern of violet-red flowers, white *kontusz* with a multicolored floral design, and yellow sash, cap, and boots. This figurine was the gift of Tadeusz Wierzejski, in 1966, formerly in the L. Golodetz collection, London. Another figurine from this mold is in the Princes Czartoryski Museum in Cracow (Ryszard 1964, fig. 31).

For the nobleman's pose and costume see the description at cat. 125a. This figurine was the gift of Tadeusz Wierzejski in 1966. The *żupan* is white, the *kontusz* violet with yellow lining, the sash green, cap yellow, and boots orange. Another figurine from this mold is kept in the Princes Czartoryski Museum in Cracow (Ryszard 1964, fig. 31).

The costume consists of a light violet *żupan* with a gold flower pattern, white *kontusz* with blue lining, and yellow sash and boots. The signature is cobalt-blue swords(?) on the base of the socle. This figurine was the gift of Tadeusz Wierzejski in 1966. Another figurine from this mold is in the Princes Czartoryski Museum in Cracow (Ryszard 1964, fig. 31).

A, FIGURINE OF A NOBLEMAN, C. 1743

FROM A MODEL BY J. F. EBERLEIN (MOLD NO. 2665), 15 CM (5 7/8 IN.) BLADE POINT RECONSTRUCTED

INV. 5496

LITERATURE
Piątkiewicz-Dereniowa 1983, 2: cat. 144.

B, FIGURINE OF A NOBLEMAN, 1750–60

PROBABLY FROM A MODEL BY J. J. KÄNDLER AND P. REINICKE (MOLD NO. 2665), 15.2 (6)

INV. 5091

LITERATURE
Piątkiewicz-Dereniowa 1983, 2: cat. 146.

C, FIGURINE OF A NOBLEMAN, 1750–60

PROBABLY FROM A MODEL BY J. J. KÄNDLER AND P. REINICKE (MOLD NO. 2665), 15.8 (6 1/4) SABER HILT RECONSTRUCTED

INV. 5092

LITERATURE
Piątkiewicz-Dereniowa 1983, 2:74, cat. 147.

D, FIGURINE OF A NOBLEMAN, 1750–60

PROBABLY FROM A MODEL BY J. J. KÄNDLER
AND P. REINICKE (MOLD NO. 2665), 15 (5 7/8)

INV. 5094

LITERATURE
Zbiory Zamku 1975, cat. 146;
Piątkiewicz-Dereniowa 1983, 2: cat. 145.

For the nobleman's pose and costume see the description at cat. 125a. The colors of the costume are yellow *żupan* with a multicolored floral pattern, violet *kontusz* with lining of a lighter hue, green sash and cap, and yellow boots. This figurine was the gift of Tadeusz Wierzejski, in 1966, formerly in the L. Golodetz collection, London. Another figurine from this mold is in the Princes Czartoryski Museum in Cracow (Ryszard 1964, fig. 31).

E, FIGURINE OF A NOBLEMAN, 1750–60

PROBABLY FROM A MODEL BY J. J. KÄNDLER
AND P. REINICKE (MOLD NO. 2665), 15 (5 7/8)

SABER HILT RECONSTRUCTED

INV. 5095

LITERATURE
Piątkiewicz-Dereniowa 1983, 2: cat. 149

For the nobleman's pose and costume see the description at cat. 125a. The colors of the costume are white *żupan* with a multicolored floral pattern, violet *kontusz* with yellow lining, blue sash, and yellow boots. This figurine was the gift of Tadeusz Wierzejski, in 1966. Another figurine from this mold is in the Princes Czartoryski Museum in Cracow (Ryszard 1964, fig. 31).

F, FIGURINE OF A NOBLEMAN, 1750–60

PROBABLY FROM A MODEL BY J. J. KÄNDLER
AND P. REINICKE (MOLD NO. 496), 15.2 (6)

INV. 5090

LITERATURE
Piątkiewicz-Dereniowa 1983, 2: cat. 151.

On a plain socle, a nobleman is standing in contrapposto, in a dancing pose. He leans from the hips, his head slightly turned to the right; the right hand rests on the hip and the left one at the hilt of a saber. He wears a *żupan* with a floral pattern, a *kontusz* with sleeves thrown over the shoulders, a sash tied around the waist, and loose wide puffed breeches. The *żupan* and *kontusz* are of almost the same length, reaching down to high boots. On his head he has a round fur-trimmed cap. He carries a saber suspended from the belt fastened to the sash. The *żupan* has a multicolored floral pattern on a yellow ground, the *kontusz*, breeches, and sash are violet, and the cap and boots yellow. This figurine was the gift of Tadeusz Wierzejski in 1966, formerly in the L. Golodetz collection, London. The signature is underglaze cobalt-blue swords on the back of the socle. Some figurines made from this mold are also in the Princes Czartoryski Museum in Cracow (Ryszard 1964, fig. 32), and another one, originating from Dolgorukov's collection, in the Hermitage (Butler 1977, cat. 60).

G, FIGURINE OF A NOBLEWOMAN, 1750–60

FROM A MODEL BY P. REINICKE(?)
(MOLD NO. 2669), 14.5 (5 3/4)

INV. 5100

LITERATURE
Piątkiewicz-Dereniowa 1983, 2: cat. 158.

This figurine is standing in a dancing pose on a round socle covered with plastic vegetal and rocaille decoration. Rendered in contrapposto, with her head facing right, she is lifting the folds of her long gown with both hands, revealing her shoes embellished with bows and the edge of her petticoat. She wears a short fur-trimmed *kontusz* with sleeves thrown over the shoulders and a tapering soft cap, likewise trimmed with fur, whose top hangs freely down the side of her head. The colors of the costume are yellow gown with a gold pattern, gold-edged petticoat, brown *kontusz*, violet cap, and yellow shoes with brown bows. This figurine was the gift of Tadeusz Wierzejski, in 1966. Other figurines from this mold are kept in the Princes Czartoryski Museum in Cracow (Ryszard 1964, fig. 31), and in the Hermitage collection (formerly F. F. Uteman's collection) (Butler 1977, no. 154).

On a round socle covered with plastic vegetal and rocaille decoration stands the figure. In her raised hand she holds a half-folded fan and with the left she is lifting the folds of her long gown, revealing the edge of the petticoat and shoes with plastic rosettes. As her outer garment she wears a short *kontusz* with sleeves thrown over the shoulders, under which can be seen a chemise with a ruffle around the neck. On her head she has fancy headgear held in place by a ribbon, revealing an elaborately plaited coiffure. The colors of the costume are white gown with a multicolored floral pattern, gold-edged violet petticoat, gold-trimmed yellow *kontusz* with a violet collar, and white chemise, headdress, and shoes. This figurine was the gift of Tadeusz Wierzejski in 1966. Another figurine from this mold is in the Princes Czartoryski Museum in Cracow.

The noblewoman's pose and costume are similar to cat. 125g. The colors of the costume are yellow gown with a multicolor floral pattern, gold-edged green petticoat, violet *kontusz*, blue cap with a gold tassel, and orange shoes with blue bows. This figurine was the gift of Tadeusz Wierzejski in 1966, formerly in the L. Golodetz collection, London. Other figurines from this mold are kept in the Princes Czartoryski Museum in Cracow (Ryszard 1964, fig. 31) and in the Hermitage collection (formerly F. F. Uteman's collection) (Butler 1977, no. 154).

JR

H, FIGURINE OF A NOBLEWOMAN, 1750–60

FROM A MODEL BY E. F. MEYER(?)
(MOLD NO. 2667), MEISSEN, 14.5 (5 3/4)
RIGHT HAND WITH A FAN RECONSTRUCTED

INV. 5101

LITERATURE
Piątkiewicz-Dereniowa 1983, 2: cat. 159.

I, FIGURINE OF A NOBLEWOMAN, 1750–60

FROM A MODEL BY P. REINICKE(?)
(MOLD NO. 2669), 14.5 (5 3/4)

INV. 5099

LITERATURE
Zbiory Zamku 1975, cat. 146;
Piątkiewicz-Dereniowa 1983, 2:88, cat. 157.

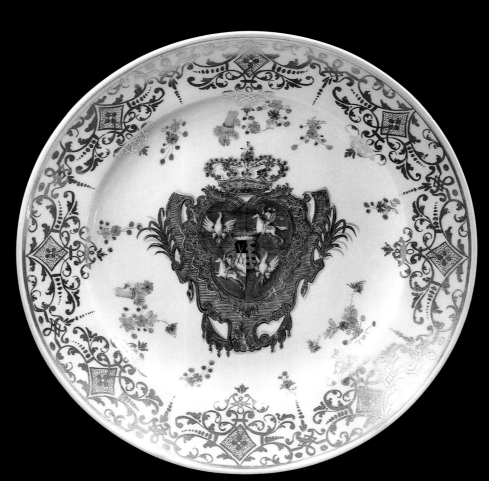

These plates belonged to the table service made in around 1733 to the order of the elector of Saxony, Friedrich August II. In the literature it is called the Coronation Service, as its execution coincided with the coronation of that member of the Wettin dynasty as king of Poland in 1733 (when he adopted the name of Augustus III), although data are lacking about its being used during those celebrations. However, there is a mention in archival sources that in 1734 a service "with the royal arms and gold ornamentation" was made over to the Japanese Palace in Dresden. It remained there until 1838, when it was transferred for use to the royal palace in Dresden. Auctions in the years 1919–20 scattered the service all over the world. This is one of the first services with armorial bearings to be produced in Meissen. With time missing vessels were replaced by new ones.

The larger of the two plates (above, left) was formerly owned by Szymon Szwarc, who was said to have bought it at the auction of the furnishings of the castle at Moritzburg. It was purchased by Tadeusz Wierzejski at F. Studziński's antiques shop in Cracow. It is slightly concave with a flaring rim. In the center is a large gold strapwork cartouche surmounted by a royal crown, with palm leaves on both sides and lambrequin-shaped festoons in the lower part. A trifoliate shield contains the five-field coat of arms of Poland and of the Wettin electors of Saxony under the elector's cap in the central field. The cartouche is surrounded by small oriental flowers and sheaves typical of the Kakiemon style. On the rim and partly at the bottom is a broad lace-patterned border in gold. It bears a signature of cobalt-blue swords painted underglaze, the molder's stamp (a circle with a cross inside), and the number of the Johanneum: *N 147* above and *W* below, incised and filled with black paint. Such a plate is in the collections of the National Museum in Cracow (M. Piątkiewicz-Dereniowa 1991, 38, cat. 113).

The form and decoration of the second plate (below, left) from the Coronation Service are similar to the first. It too bears a signature of swords painted underglaze in cobalt blue, the molder's stamp (a circle with a cross inside), and the number of the Johanneum: *N:147* above and *W* below, incised and filled with black paint.

JR

126

PLATES FROM THE CORONATION SERVICE, C. 1733

MEISSEN

OVERGLAZE PAINTED PORCELAIN, GILDED (BURNISHED GOLD, IN SOME PLACES ENGRAVED)

A, PLATE, DIAM. 24 CM (9 1/2 IN.)

INV. 5220, GIFT OF TADEUSZ WIERZEJSKI, 1966

LITERATURE
Zbiory Zamku 1990, 240, cat. 94, fig. on p. 159; Piątkiewicz-Dereniowa 1983, 1: cat. 75; Piątkiewicz-Dereniowa 1991, cat. 112; *Orzeł Biały* 1995, cat. IV 50, fig. 102.

B, PLATE, DIAM. 22.5 (8 7/8)

INV. 5530, PURCHASED ON THE ANTIQUARY MARKET, 1969

WAWEL ROYAL CASTLE, CRACOW

LITERATURE
Piątkiewicz-Dereniowa 1983, 1: cat. 76; *Orzeł Biały* 1995, cat. IV 50, fig. 102.

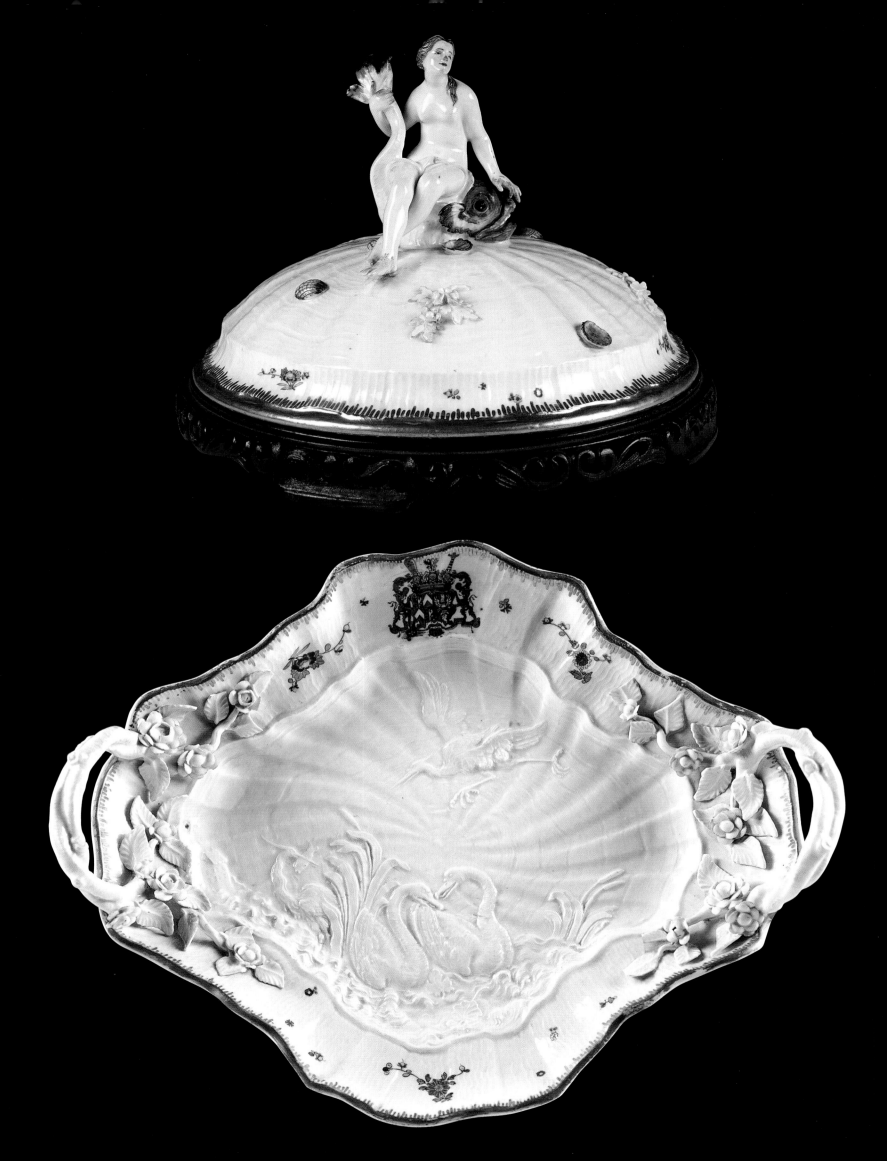

The designs for the Swan Service were made by the chief modeler of the manufactory and its most celebrated sculptor, Johann Joachim Kändler, in collaboration with another Meissen sculptor, Johann Friedrich Eberlein, and from around 1742 with Johann Gottlieb Ehder. The first work was submitted by Kändler as early as 1736, when he executed sample plates, and in 1737 two clay models of *surtouts de table* (sets for sweetmeats). One of these models referred to sea mythology, including Neptune in a shell chariot drawn by four sea horses. In December 1737 Kändler began to model the first molds of vessels; from January to June 1738 he prepared molds of a flat and a deep plate and of a dish, relying on his study of rare shell specimens in the Naturalienkammer in Dresden (report-note of January 1738) and on an engraving in the newly supplemented edition of an engraver's pattern book written by the engraver H. G. (Nuremberg, 1700). In 1739 a design was submitted for a coffee service, and in 1740, one for chocolate cups. By 1741 most of the vessels were ready. The researchers seeking the prototypes and inspirations for the forms of the celebrated service mention the collection of nautilus shell cups at the Grüne Gewölbe in Dresden, a bronze candlestick made around 1735 by the Paris goldsmith J. A. Meissonier, the artist's familiarity with the collection of the Royal Picture Gallery in Dresden (Galatea in a shell chariot by Francesco Albani used as a sculptural motif for a tureen), the fountain with nymphs at the Zwinger, and the Neptune well in Friedrichstadt, Dresden.

The service was made to the order of Heinrich Brühl, prime minister at the court of Augustus III, from 1733 supervisor of the Meissen manufactory and from August 1739 its director-in-chief, in 1740 granted the privilege of free use of its products. This is the most famous high baroque production in Meissen porcelain, which was directly decided by conferring on Brühl the dignity of count of the Reich (25 May 1737), his marriage to Countess Franciszka von Kolovrat-Krakowski (27 November 1737), and, finally, his triumph over his greatest rival at the Dresden court, Count Aleksander Sułkowski.

The tureen cover (above, left) is shallow, domed, with a fully molded finial-handle, a half-naked nymph sitting on a dolphin. The flat wooden stand whose edge is decorated with scroll and plant ornament was added to enhance the display. In the Porzellansammlung in Dresden there is a round tureen with an analogous cover. When it was purchased in 1948 the tureen cover was described as a piece from the Brühl castle at Pförten (now Brody in Lower Silesia).

The dish for roast meat (below, left) is rhomboid in shape, shallow, with handles of two molded intertwined branches. The signature is cobalt-blue crossed swords, stamped 26 (c. 1739–40).

127

VESSELS FROM THE SWAN SERVICE, 1737–41

JOHANN JOACHIM KÄNDLER, JOHANN FRIEDRICH EBERLEIN, JOHANN GOTTLIEB EHDER, MEISSEN

FIRED PORCELAIN, OVERGLAZE PAINTS, GILDING

A, TUREEN COVER, 19, DIAM. 26 CM (7 1/2, 10 1/4 IN.)

NATIONAL MUSEUM, WARSAW, INV. 129.475 MNW, PURCHASED ON THE ANTIQUARY MARKET, 1948

LITERATURE
Sztuka zdobnicza 1964, cat. 406.

B, DISH FOR ROAST MEAT, 10 × 42 × 33 (3 7/8 × 16 1/2 × 13)

NATIONAL MUSEUM, WARSAW, INV. SZC 3129 MNW, PURCHASED ON THE ANTIQUARY MARKET, 1948

LITERATURE
Piątkiewicz-Dereniowa 1991, cat. 115; *Sztuka niemiecka* 1996, cat. 716 and fig.

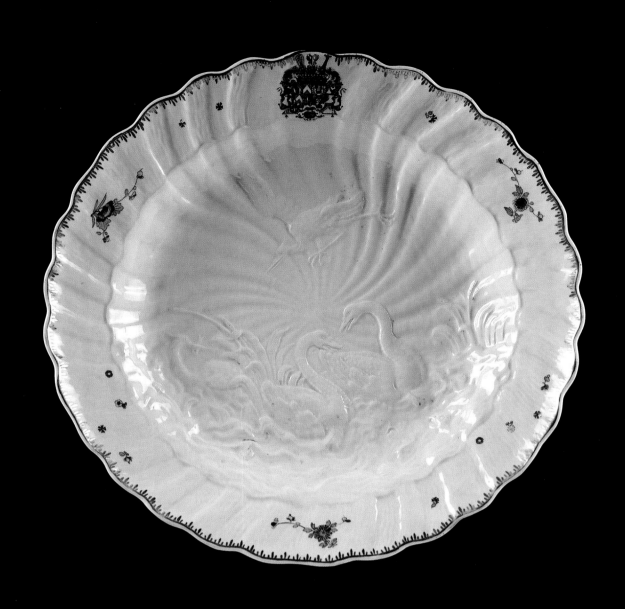

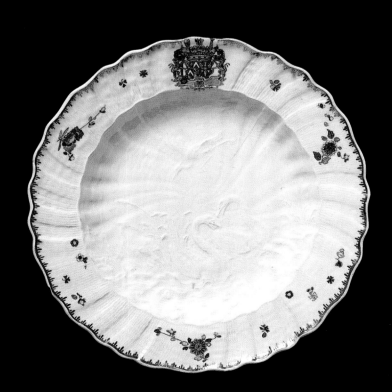

The relief surface of the swan vessels imitates that of a scallop shell; it is enriched with small plastic elements including handles of covers and dishes, decoration of tureens, Triton-shaped candlesticks, putti, nymphs, mermaids, and dolphins as well as those in the form of shells and crustaceans. Most of the vessels bear the arms of Brühl and his wife, von Kolovrat-Krakowski; the modest painted decoration (small "Indian flowers" and gilding of the edges) clearly gives precedence to sculptural ornamentation with the relief leitmotiv present on all flat surfaces, two swans and a crane among bulrushes. By its theme of water the service also refers to the etymology of the name Brühl (watery, damp place).

The service, comprising more than two thousand pieces, was stored by Brühl in the Pförten (Brody) castle in Silesia, which he bought in 1740. The larger part of the set (about 1,400 items) survived until the Second World War, but it has been scattered and partly destroyed since 1945.

At present the National Museum in Warsaw holds more than fifty vessels; most of them are dishes and plates, but there are also tureens (two of them being damaged), candlesticks, pots, a dish cover, and a table napkin holder.

The round dish (above, left) bears a signature of cobalt blue crossed swords, at the basal ring a scratched *4*, on the ring the incised ".." (Johann Martin Kittel).

The round, shallow plate (below, left) has a wavy edge accentuated with a gold border. It is covered with a bas-relief imitating a shell form, with swans among bulrushes and aquatic birds at the bottom. The rim bears an escutcheon supported by two lions and small "Indian flowers." Colors include blue, red, purple, green, yellow, black, brown, and gold. The signature is underglaze cobalt blue swords and the Brühl-Kolovrat arms.

The shallow, rectangular pot (below) with two flat rocaille handles has rounded corners and rests on four volute feet. The signature is cobalt blue crossed swords on the flat unglazed base. Another such pot is in the collections of the National Museum in Warsaw (inv.131.207).

WZ and JR

C, ROUND DISH, 5.7, DIAM. 38 (2 1/4, 15)

NATIONAL MUSEUM, WARSAW,
INV. 128.671?1 MNW,
GIFT OF E. MĘTLEWICZ, 1946

LITERATURE
Sztuka zdobnicza 1964, cat. 406, fig. 59; *Sztuka niemiecka* 1996, cat. 717 and fig.

D, PLATE, DIAM. 23.5 (9 1/4)

WAWEL ROYAL CASTLE, CRACOW,
INV. 6170, PURCHASED ON
THE ANTIQUARY MARKET, 1975

LITERATURE
Piątkiewicz-Dereniowa 1983, 1: cat. 79.

E, POT, 8 × 31 × 20.5 (3 1/8 × 12 1/4 × 8)

NATIONAL MUSEUM, WARSAW,
INV. SZC 3130 MNW, PURCHASED ON
THE ANTIQUARY MARKET, 1978

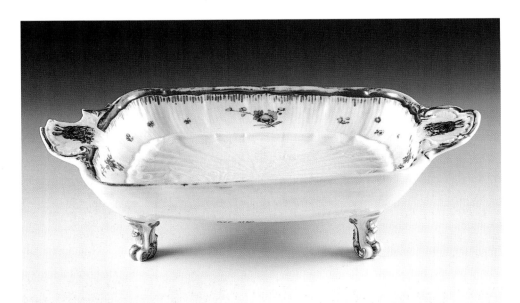

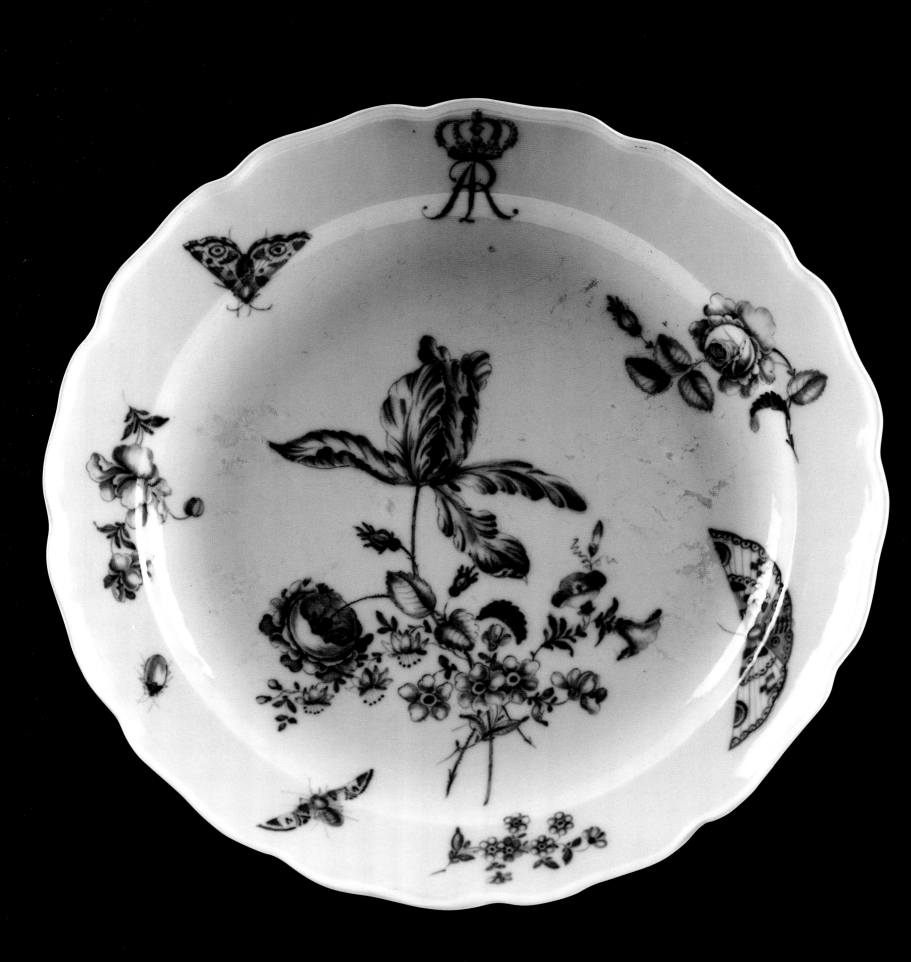

The service, decorated with blue "German" flowers and bearing the royal initials and the marks of ownership *K.H.C.W.* (the royal butler's pantry, or, more precisely, the court confectionery in Warsaw Castle), was sent from the Dresden storehouse of Meissen porcelain to Warsaw on 31 August 1756, shortly after the outbreak of the Seven Years' War. The number and kind of vessels dispatched are confirmed by an entry in the inventory of the grand marshal of the Court, preserved in Dresden (under no. 84 thirty dishes are listed).

The service was used by Augustus III at the time of his residence in Warsaw during the war, and after his death (1763) it was returned to Dresden, but reduced in number. Some vessels must have found their way to influential Polish magnates as royal gifts. They may have been presented to August Czartoryski, palatine of Ruthenia, or to Prince Stanisław Lubomirski, crown marshal. This is borne out by the extant cup and saucer and five bowls from the discussed service, now kept at the National Museum in Warsaw, which come from the collection of the Potockis of Krzeszowice, successors to the legacy of Prince Czartoryski and his daughter Izabella, wife of Prince Stanisław Lubomirski.

Half-deep, with a wavy edge slightly curved inward, the dish is decorated in cobalt blue with "German" flowers and insects; in the bottom is a bouquet with a large pinnate tulip and a branch of morning glory; on the rim is the monogram *AR* surmounted by a crown, three scattered floral sprigs (such as a rose and phloxes), two large and one small moth, and a beetle. There is a signature of crossed swords in addition to the letter *C* (probably for Peter Colmberger vel Kulmberger, painter in cobalt blue at Meissen from 1745–79), and *K. H. C. W.* (Königliche Hof Conditorey Warschau) in cobalt blue; impressed *67*; and incised on the basal ring.

WZ

128

DISH PRODUCED FOR KING AUGUSTUS III, C. 1750–55

MEISSEN

PORCELAIN, UNDERGLAZE COBALT BLUE

5.5; DIAM. 38 CM (2 1/8, 15 IN.)

NATIONAL MUSEUM, WARSAW, INV. SZC 1746 MNW, GIFT OF TADEUSZ WIERZEJSKI, 1955

LITERATURE
Sztuka zdobnicza 1964, cat. 409; Boltz, Chojnacka 1978, 74–84.

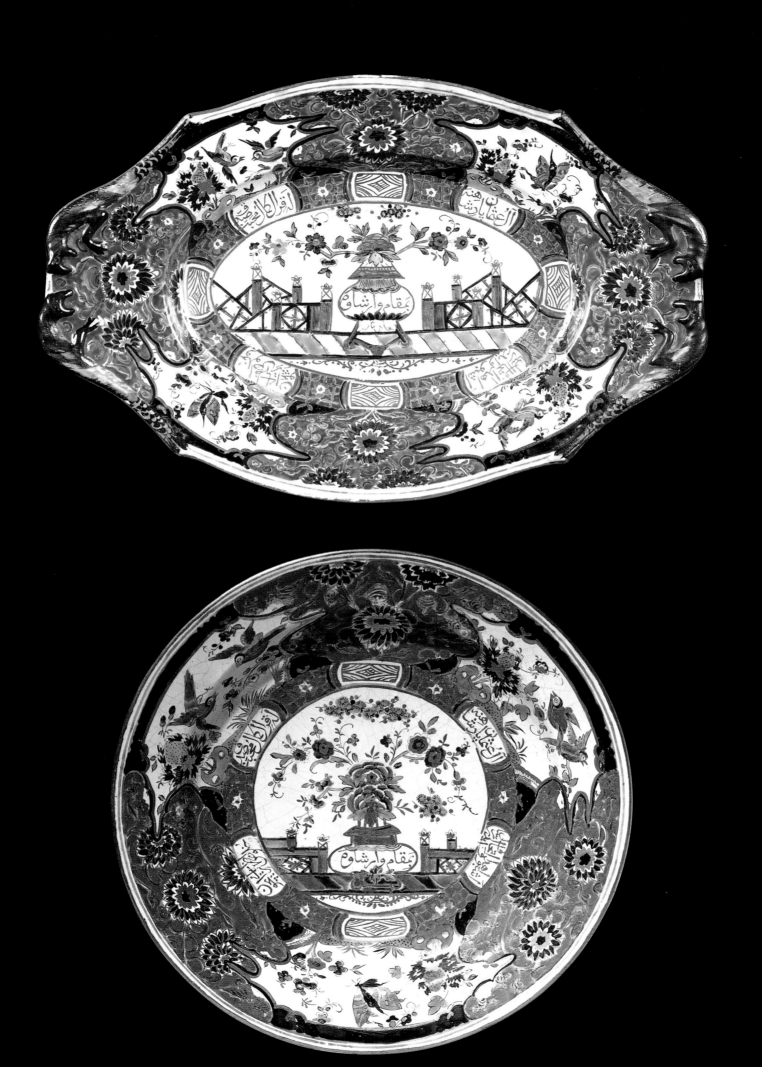

The service known as the Sultan Service was a gift from King Stanislas Augustus Poniatowski to the Turkish sultan Abdul Hamid, sent in 1777 through the envoy Numan Beyan. On this dish is a Turkish inscription (translated from Polish): "The king of the Poles sends these presents and gifts to the Padishah of the Ottoman dynasty in token of his unreserved love and sincere friendliness. In the city of Warsaw." Out of the set originally numbering 280 pieces (according to the 1777 inventory of the Old Seraglio, 160 pieces) only a small number have been preserved at the Old Seraglio Museum in Istanbul, and single objects in European collections. "La servis turc" was a gala table service, this being the reason of its elaborate decoration. Another set was made for King Stanislas Augustus at the Royal Castle in Warsaw. Furthermore, there survive in Poland some sample specimens, the present dish being probably one.

The royal manufactory at Belweder near Warsaw worked from 1770–80/83, producing exclusively faience wares. It carried out above all the king's orders, such as table services and vases modeled upon Chinese and Japanese porcelain.

This oval dish has a flat bottom, and the flared rim has a scalloped edge; on each of the shorter sides is a pair of highly stylized salamanders. Decoration is in the Imari style. On the rim are red-gold chrysanthemums on a cobalt blue ground, between them white fields with flowers and birds or butterflies. Around the bottom is a cobalt blue band with reserves, four of which are inscribed, and on the bottom are a bouquet of flowers in a vase and elements of architecture.

AS

This round concave plate has a gilded edge. On the bottom is a medallion surrounded by a circular border containing the motif of a bulbous vase with flowers standing on a terrace with an openwork wall. The gold inscription on the vase in Arabic letters is in Turkish (translated from Polish): "The sincerely and unreservedly amicable king of Poland sends this gift and souvenir to the monarch of the Ottoman dynasty in token of reverence and honor. In the city of Warsaw"; analogous inscriptions are in four of the six reserves around the medallion. The remaining surface is decorated with irregular panels: three with the motif of red-gold chrysanthemums on a blue ground and another three with multicolored peonies, birds, and insects among flowers on a white ground, represented in the *famille verte* style. On the underside is vegetal-geometrical decoration. Colors are grayish white, green in two shades (emerald and pea green), brick red, brown, blue in two hues (light and grayish blue), and gold.

The Sultan Service was modeled on Chinese porcelain wares, which in turn imitated Japanese vessels in the Imari style (so-called Chinese Imari). The Old Seraglio Museum in Istanbul holds more than twenty pieces. Moreover, there are pieces from the service at the National Museum in Cracow. The present specimen differs in its coloring from the remaining vessels, this being probably the result of technical conditions of its firing.

JR

129

VESSELS FROM THE SULTAN SERVICE, BEFORE 1777

ROYAL MANUFACTORY AT BELWEDER, WARSAW

FAIENCE, GLAZED, OVERGLAZE (MUFFLE) PAINTS, GILDED

A, DISH, 3.3 × 21.6 × 32.5 CM (1 1/4 × 8 1/2 × 12 3/4 IN.)

ROYAL CASTLE, WARSAW, INV. FC-ZKW/251, GIFT OF ANDRZEJ CIECHANOWIECKI

LITERATURE
Chrościcki 1974, fig. 2; Wróblewska 1976, cat. 510; Zatorska-Antonowicz 1993, fig. 9.

B, PLATE, DIAM. 24.8 (9 3/4)

WAWEL ROYAL CASTLE, CRACOW, INV. 6328, PURCHASED FROM ANDRZEJ CIECHANOWIECKI, 1977

LITERATURE
Zbiory Zamku 1990, 241, cat. 96, fig. on 161; *Japan und Europa* 1993, 354, cat. 9/9 b, fig. 305.

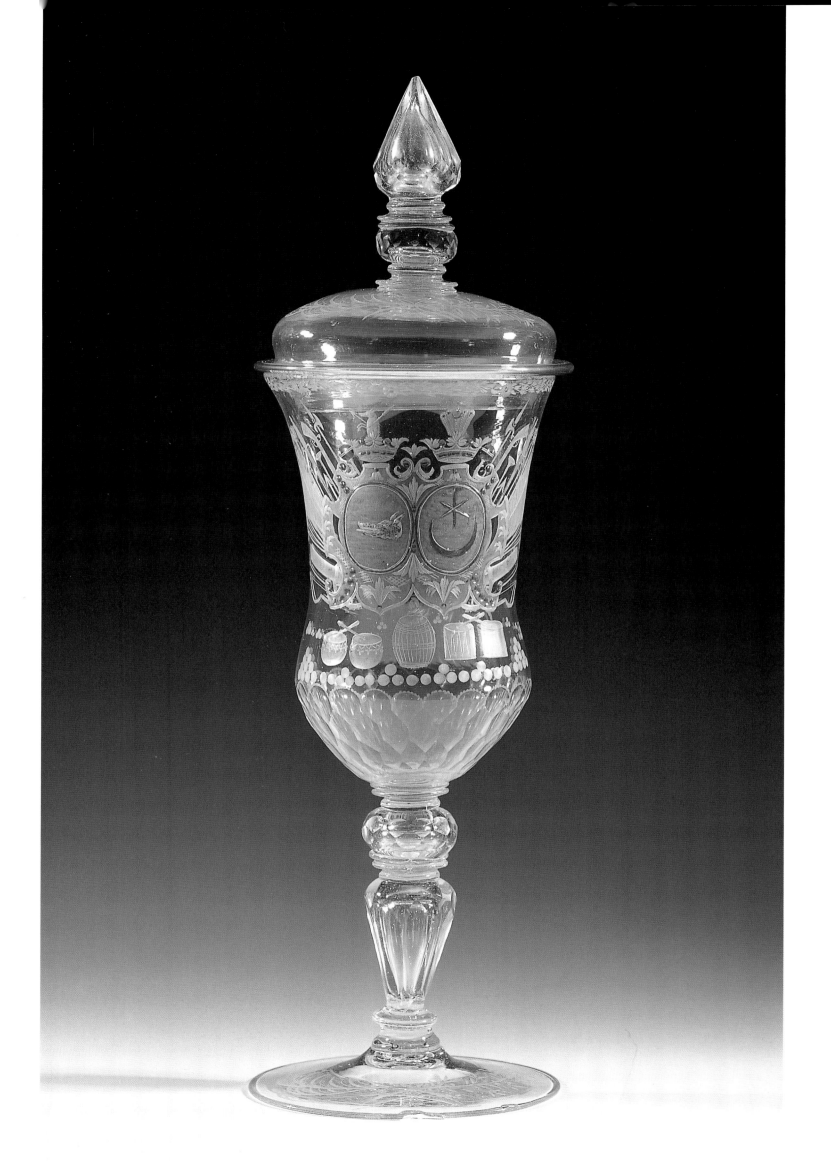

This capacious wine cup was called *kolejny* (successive); in accordance with its name it was used for drinking toasts: it was passed around from hand to hand, each person drinking from it.

The goblet was made on the occasion of the marriage of Zofia Sieniawska and Stanisław Denhoff, which took place in 1724 (Stanisław Denhoff died in 1728). Zofia's father, Adam Mikołaj Sieniawski, grand hetman of the Crown, was the founder of the crystal glass-works/crystal-glass factory at Lubaczów. The goblet was kept in the old collections of the Library of the Zamoyski Entailed Estate and was subsequently owned by Januariusz Gościmski. In 1984 it was acquired for the Royal Castle in Warsaw. The foot is round with engraved branches; the baluster stem is cut and octagonally faceted. The lower part of the bowl is bulged and cut in multilateral lenticular forms. The upper part of the bowl is conical, expanding upward, with engraved decoration. On the ground of panoply the there are two cartouches with coats of arms: Denhoff of Stanisław Denhoff, and Leliwa of his wife, Zofia née Sieniawska.

The domed cover is round, decorated with two engraved tied branches; the tall finial has the form of an octagonally faceted cone fixed on a flattened ball.

The form of the goblet and the lenticular cutting in the lower part of the bowl and on the stem, knob, and finial of the cover are very characteristic of Lubaczów glassware. The crystal factory at Lubaczów, founded in 1717, produced glass of high quality, the best period of its production being between 1717 and 1729.

AS

130

TOASTING GOBLET WITH THE DENHOFF AND LELIWA COATS OF ARMS, 1724–28

LUBACZÓW

GLASS, CUT AND ENGRAVED

34.5, DIAM. 14 CM (13 1/2, 5 1/2 IN.); COVER 16, 14 (6 1/4 , 5 1/2)

ROYAL CASTLE, WARSAW, INV. ZKW 1480/A, B

LITERATURE
Pamiętnik 1913, cat. 146; *Polskie szkło* 1987, figs. 53, 54; *Pod jedną koroną* 1997, cat. XIV 25; *Ceramika i szkło* 1998, *Szkło*: cat. 1.

131

GOBLET WITH THE ŚRENIAWA COAT OF
ARMS, 2ND HALF 18TH C.

URZECZE, POLAND

COLORLESS GLASS, CUT AND MAT
ENGRAVED

20 CM (7 7/8 IN.)

NATIONAL MUSEUM, CRACOW,
INV. MNK-IV-SZ-2128, PURCHASED 1957

Anna Radziwiłł née Sanguszko set up two famous glassworks in the palatinate of Nowogródek: at Naliboki in the years 1724–25 and at Urzecze in 1737. Initially the manufactory at Urzecze produced mirrors, but from the middle of the eighteenth century also luxury table vessels. The goblet bearing the Śreniawa arms has an original form characteristic of Polish baroque glassware, developed in the Urzecze manufactory.

The round, domed foot is decorated with continuous ornament in the form of a branch with pinnate leaves. The goblet has a baluster stem with a spherical knop and a ring. The lower part of the bowl, decorated with three moldings, flares upward and narrows, to widen again into a funnel-like form. The bowl bears a rococo cartouche with the crowned Śreniawa arms. Around the upper edge of the bowl runs an ornament of lattice and a hanging fringe.

SO

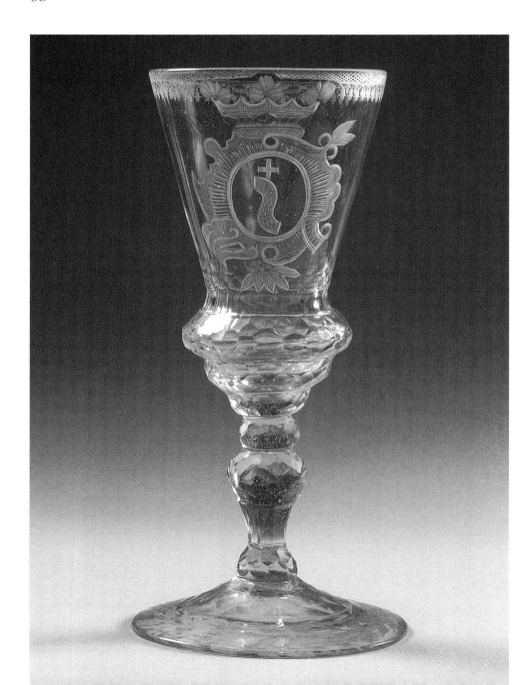

The Massalskis were of Lithuanian-Ruthenian aristocratic origin. The Lithuanian branch of the family received in Poland the confirmation of their title of prince in 1775.

The glass has a round foot with a folded edge. The stem is cylindrical, flaring upward, with an air bubble inside. The conical bowl is decorated with the Massalski arms (a variety) placed against a paludament (drapery), surmounted by a ducal coronet. A lattice band borders the edge of the bowl.

SO

132

DRINKING GLASS WITH THE COAT OF ARMS
OF THE PRINCES MASSALSKI,
LAST QUARTER 18TH C.

POLAND

GLASS WITH A SMOKED TINT,
MAT ENGRAVED

17.2 CM (6 3/4 IN.)

NATIONAL MUSEUM, CRACOW,
INV. MNK-IV-SZ-1160, PURCHASED 1919

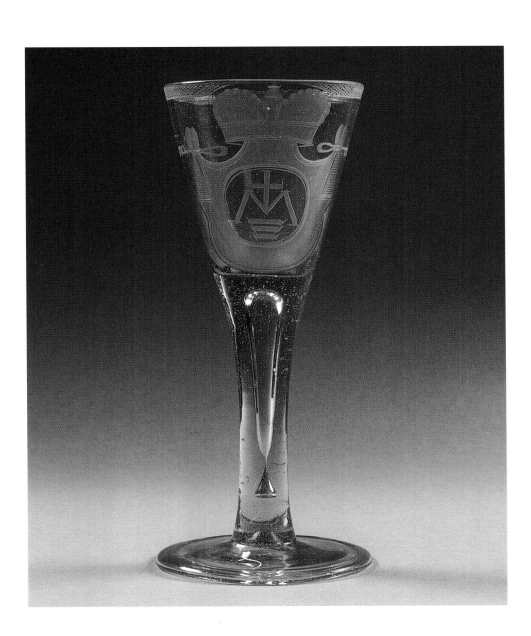

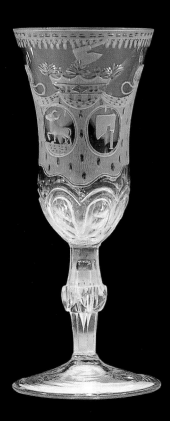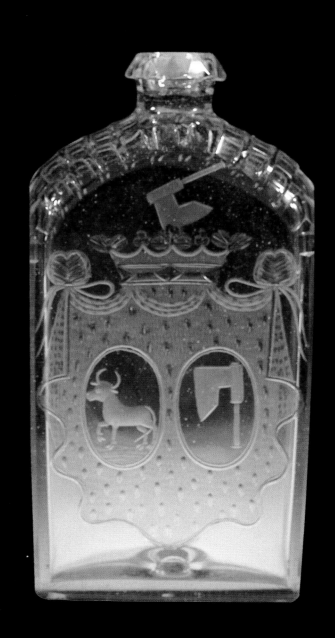

The bottle and goblet were part of a service composed of twelve goblets, twelve large bottles, twelve small ones, and twelve tumblers, placed in two cases called *puzdro*. The service was ordered in May 1757 by Teodora Grabowska, wife of the starosta of Wisztyn, on the occasion of the marriage of her son Michał Grzegorz (c. 1719–99) and Karolina Żelińska of Żelanka, which took place on 3 January 1757. (In that year Michał Grzegorz Grabowski was appointed chamberlain to His Royal Majesty.) The service was kept by the Grabowski family in Cracow, then by the Rajskis, to whom it had passed by marriage: Michał Grabowski's daughter Izabela married the general Rajski. In 1997 the bottle and goblet were acquired for the Royal Castle in Warsaw.

The bottle has the form of a strongly flattened perpendicular parallelepiped with rounded shoulders and a short neck. The shoulders are cut in rows of rectangles, and the collar of the neck in triangles. The goblet has a round foot, the stem cut in facets, and the knob deeply cut in squares. The slender bowl expands upward, its lower part being cut in an arcaded frieze. Both objects are decorated with engraved coats of arms: Oksza of the Grabowski family, and Ciołek of the Żeliński family, set in oval medallions against a paludament, under a crown with the crest of Oksza.

The glassworks at Naliboki was founded by Anna Radziwiłł née Sanguszko in 1722; it produced high-quality crystal. It was the most famous Polish glassworks in the eighteenth century.

AS

133

BOTTLE AND GOBLET WITH THE CIOŁEK AND OKSZA COATS OF ARMS, 1757–59

NALIBOKI

COLORLESS GLASS, CUT AND PARTLY MAT ENGRAVED

BOTTLE 15.2 CM (6 IN.); GOBLET 11.2 (4)

ROYAL CASTLE, WARSAW, INVS. ZKW 4110, ZKW 4111

LITERATURE
Szkła 1998.

134

WINE GLASS, LAST QUARTER 18TH C.

POLAND

GLASS WITH A SMOKED TINT,
MAT ENGRAVING

15.1 CM (6 IN.)

NATIONAL MUSEUM, CRACOW,
INV. MNK-IV-Sz-1637, GIFT OF
LEON KOSTKA, 1949

LITERATURE
Buczkowski 1958, 69, fig. 34.

The glass belongs to a group of the so-called "amusing" glassware intended for merrymaking at banquets. In this instance the joke was on the user of this glass who spilled wine on himself.

The foot is round with a folded edge. The cylindrical stem widens funnel-like upward; set inside it is an air bubble. The conical bowl is decorated with the motif of a vertical floral sprig of schematic form. Around the edge of the bowl runs an ornamental border of symmetrically arranged leaves and rosettes; apertures are bored through in three rosettes.

SO

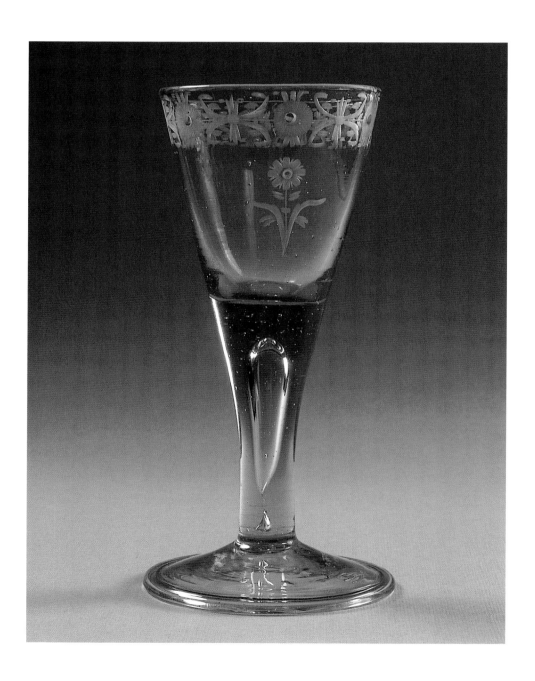

The body of the vessel is four-sided with a tall cylindrical neck and a glass ring around the mouth. One side bears an engraved cartouche with the Śreniawa and Nowina coats of arms under a common crown. On the opposite side is the monogram *JB* in a wreath of flowers and pearls. The remaining sides are decorated with the monograms *AS* and *JS* enfolded by branches.

SO

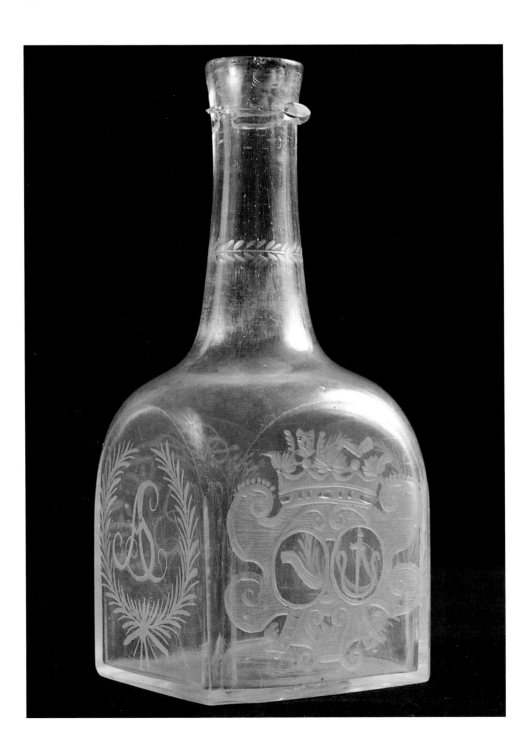

DECANTER, 2ND HALF 18TH C.

POLAND

COLORLESS GLASS, CUT, MAT AND
TRANSPARENT ENGRAVING

18 × 8 × 8 CM (7 1/8 × 3 1/8 × 3 1/8 IN.)

NATIONAL MUSEUM, CRACOW,
INV. MNK-IV-Sz-1334,
GIFT OF WIKTOR WITTYG, 1905

136

FLASK, MID-18TH C.

POLAND

GLASS OF GREENISH HUE, MAT AND
TRANSPARENT ENGRAVING

16.1 × 7.4 × 4.9 CM (6 3/8 × 2 7/8 × 1 7/8 IN.)

NATIONAL MUSEUM, CRACOW,
INV. MNK-IV-Sz-1324, GIFT OF
STANISŁAW URSYN-RUSIECKI, 1936

The body of the vessel is in the form of a standing cuboid with a short ringed neck. The wider sides bear the motif of a two-handled basket from which springs a vertical spray of flowers with a symmetrical arrangement of leaves and buds. The vertical floral spray on the narrower sides is similar in form.

SO

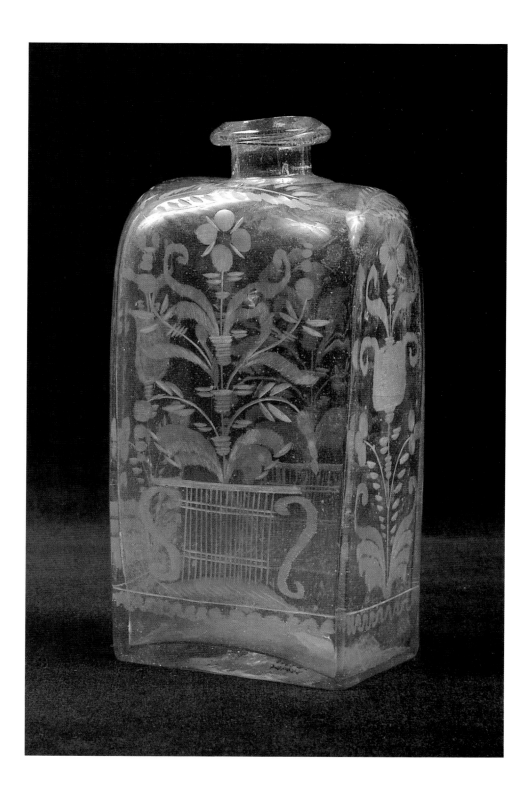

This bottle was probably originally owned by the Wielopolski family of Obory and then by the Potulicki family. In 1988 it was presented by Andrzej Ciechanowiecki to the Royal Castle in Warsaw.

Bottles of this kind served travelers to store liquors or medicine. They were carried in wooden lined cases. Their cuboid form was adapted to the shape of the case. The present item has rounded corners. Its short round neck is markedly separated from the shoulder. One of the sides bears the engraved decoration, the Starykoń coat of arms, in a rococo cartouche supported by a lion, surmounted by a coronet and an ax in the crest (ornamental cartouches with armorial bearings were characteristic motifs embellishing the glassware from Naliboki and Urzecze).

AS

137

BOTTLE FROM A TRAVELING GLASS SET WITH THE STARYKOŃ COAT OF ARMS, 3RD QUARTER 18TH C.

NALIBOKI-URZECZE(?)

COLORLESS GLASS, ENGRAVED AND CUT

16.7 × 12 × 7.2 CM (6 1/2 × 4 3/4 × 2 7/8 IN.)

ROYAL CASTLE, WARSAW, THE CIECHANOWIECKI FAMILY FOUNDATION, INV. FC-ZKW/257

LITERATURE
Zbiory Ciechanowieckich 1989, cat. 267.

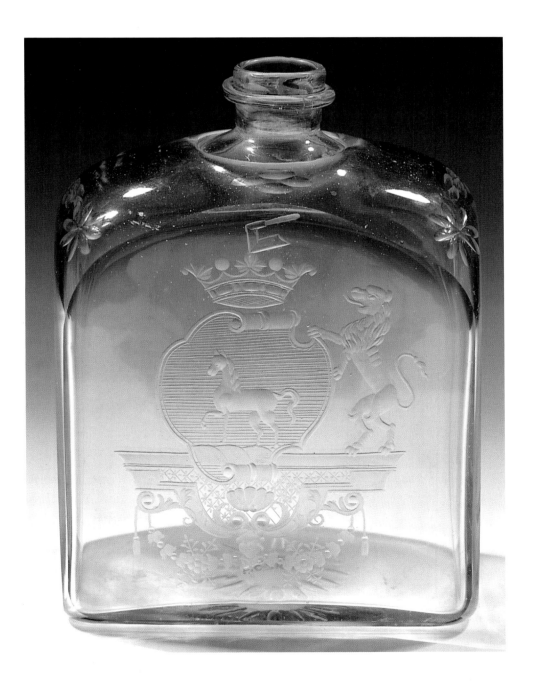

Biographies of Artists

CZECHOWICZ, SZYMON (Cracow, 1689–Warsaw, 1775), a painter, was born into a Cracow goldsmith's family. Thanks to Franciszek Maksymilian Ossoliński's patronage he was trained under his court painter and around 1711 continued his studies in Rome. There in 1716 he won the "Clementine" contest at the Accademia di San Luca. In 1725 he was admitted to the Congregazione dei Virtuosi at the Pantheon. In the course of his studies and then during many years of his work in Rome Czechowicz became familiar with the tradition of classicizing Italian painting, copying, among others, works by Raphael, Guido Reni, and Carlo Maratta. His manner is especially close to that of Benedetto Luti.

Czechowicz remained faithful to this style after his return to Poland in 1730 or 1731. Here he made two unsuccessful attempts to obtain the position of royal painter. Despite this failure, he set up a prosperous workshop in Warsaw and also developed prolific artistic production in other Polish centers. He painted religious pictures for churches as well as portraits. Among his patrons and clients were the Ossoliński, the Tarło family, Hetman Jan Klemens Branicki, and various religious congregations. Between 1762 and around 1767 Czechowicz stayed at Podhorce, at the court of Hetman Wacław Rzewuski, who in his gallery amassed more than a hundred canvases by this artist. It seems that in addition to the pictures painted by Czechowicz at Podhorce the collection included a group of preparatory sketches that the aged painter had probably sold wholesale to the hetman. This artist trained numerous pupils, among them Łukasz Smuglewicz and Jan Bogumił Plersch.

His oeuvre is characterized by technical proficiency, in which respect he surpasses his Polish contemporaries. The weaker side of his art is the lack of inventiveness and a slavish adherence to the models of Italian art that prevailed in the days of his youth.

DOLABELLA, TOMMASO (Belluno, c. 1570–Cracow, 1650), was a painter. He was a pupil of the Venetian painter Antonio Vassilacchi called Aliense, with whom he participated in decorating the ceilings at the Doges Palace in Venice. In 1598 he was brought by King Sigismund III to Cracow. Dolabella painted numerous pictures for the royal castles in Cracow and Warsaw, including portraits of the monarchs. These works have not survived. Today his oeuvre is mainly known from the extant paintings in monasteries and churches, especially in Cracow, which reveal affinity with the Venetian mannerism of the late sixteenth century. This is especially true of the paintings from the earlier period of his creative work. He stayed in Poland for more than fifty years, employing many Poles in his large atelier. He played an essential role in Polish art, initiating Italian influences in Polish painting and introducing large pictures into palace and church interiors.
KK

EBERLEIN, JOHANN FRIEDRICH (Dresden 1696–Meissen 1749), a sculptor and modeler, was trained under the court sculptor Vinage. He was employed from 1735 at the Meissen porcelain factory as assistant sculptor, a close collaborator of Kändler. Eberlein was probably the father of the Johann Friedrich Eberlein who worked in the manufactory as a molder.
JR

GASCAR, HENRI (1634/1635–1701), was a French portrait painter active in Italy, then in London; after 1679 he stayed in Holland. In 1680 he was given the title of academician in Paris.
KK

GINTER, SIMON, is mentioned among Gdańsk clockmakers working in the seventeenth century. In addition to the *kaflak* owned by the Wawel Royal Castle (*see* cat. 123), he is credited with the authorship of other table clocks in the form of a hexagonal casket.
SB-L

HOFFMANN, JOHANN ELIAS (JAN ELIASZ) (Vienna or its vicinity, c. 1691–Puławy, 1751), was a sculptor, probably trained in Vienna. In 1721 he was brought to Poland to the court of Elżbieta Sieniawska, the hetman's wife, and employed in the workshop at Łubnice. From 1732 to 1751 he ran a large sculptor's atelier connected with the Czartoryski residence at Puławy. This versatile artist was the author of numerous works following the classicizing current in Viennese sculpture of the first quarter of the eighteenth century. His art had an impact on the artistic aspect of sculpture between the Vistula and Bug Rivers (especially in the Lublin circle) until the early nineteenth century.
JG

KADAU, LUCAS (1576–1625), a goldsmith, was the son of the goldsmith Georg Kadau of Braniewo (Braunsberg). After four years' training under Simon Grunau at Braniewo he went to Gdańsk, where he was registered as master in 1607. In 1614 he was an elder of the guild. His son, Ernst, born in1618, was also a goldsmith.
JJD

KÄNDLER, JOHANN JOACHIM (1706–Meissen 1775), was a sculptor and modeler. From 1723 he was trained under the Dresden court sculptor Benjamin Thomae, a collaborator of Permoser, and in late 1723 and early 1724 worked at the Grüne Gewölbe in Dresden. From 1730 he held the position of court sculptor. On 22 June 1731 he was employed at the Meissen porcelain factory as a modeler, his first task there being the modeling of colossal animal figures that required masterly skill. In 1740 he was appointed head of the plastic department of the manufactory, and in the same year he undertook lectures at a training school for apprentice molders. In 1741 he became *Arkanist* and in 1749 *Hofkommissar*.
JR

KÖHLER, JOHANN HEINRICH (d. 1736), was a goldsmith active in Dresden, working for the royal courts of Augustus II and Augustus III.
RB

KUNTZE, TADEUSZ (Zielona Góra, 1727–Rome, 1793), a painter, was brought up in Cracow at the court of Bishop Andrzej Stanisław Załuski. From 1747, on Załuski's initiative, he went to Rome, where he studied painting at the Accademia di San Luca and at the Académie Française in addition to private training under Lodovico Mazzanti. His early works, painted between approximately 1754 and 1756 (including pictures for Cracow Cathedral, *The Raising of Piotrowin* for the Church of San Stanislao dei

Polacchi in Rome, *Fortune* at the National Museum, Warsaw), reveal that he was inspired by the paintings of the followers of Maratta and by the coloring of the oeuvre of Neapolitan artists. In 1757 Kuntze returned to Cracow, where he was employed as court artist to Bishop Załuski (it was then that he painted altar pictures for Cracow churches). In 1759 he moved to Rome for good. In that period he executed numerous altar paintings and frescoes for churches in Latium (these including wall paintings in S. Stefano a Cave and in the Santuario della Madonna del Buonconsiglio at Genazzano) as well as frescoes with biblical or mythological staffage against backgrounds of ideal landscapes of Campania (Palazzo Vescovile in Frascati, Casino Stazi at Aricci). Furthermore, Kuntze is the author of mythological scenes and decorative paintings in chiaroscuro at the Palazzo Borghese and Palazzo Rinuccini in Rome, which anticipate a neoclassical trend in his work. He also painted numerous small genre scenes in oils or gouache from street life in Rome. Kuntze's mature Roman works are characterized by whitened coloring, full of the luminous pinks and blues so typical of the Roman late rococo, and virtuosity in handling baroque schemes of composition and the rhetorical language of a gesture as well as by the elongation of the human figure.
MK

LEHNERT (LEHNER), JOHANN GEORG (b. Ratisbon?–Opava, Moravia, 1771), a late baroque sculptor, settled in Olomouc before 1729, where he executed a large number of sculptures for churches in Moravia. Between 1744 and 1747 he worked in Cracow, where he participated in decorating (with stuccowork, plaster sculptures) the Paulite church On Skałka.
KK

LONGHI, PIETRO (1702–85), a Venetian painter and engraver, was the author of multi-figural scenes from the life of the Venetians.
HM

MACKENSEN, ANDREAS I (Delmenhorst, c. 1596–Gdańsk, 1677), was a goldsmith. In 1628 he settled in Cracow and set up a workshop there; in 1643 he moved to Gdańsk, where he ran his own atelier until 1670. He was a court goldsmith to Kings Ladislas IV and John Casimir, at the same time being entrusted with numerous commissions for individual clients and the Church. His art was influenced above all by the goldsmith's products of Augsburg and the Netherlands, especially those wrought in the Van Vianen workshops. The objects made by him are distinguished by well-balanced ornamental decoration consisting of auricular and shell motifs and by the exceptionally conscientious execution of figural representations. Particularly noteworthy in Mackensen's rich artistic output are the monstrances from the former Cistercian church at Pelplin, the altar candlesticks from Gniezno Cathedral, and a set of *tazzas* bearing portraits of the kings, commissioned by the Gdańsk authorities for King John Casimir (cat. 22).
EM

MANNLICH, HEINRICH (b. Opava, Moravia, active 1658–98), an Augsburg goldsmith, was the son of Jacob Mannlich, a goldsmith active in that town but from Augsburg. In 1638 Heinrich enrolled as an apprentice in his father's workshop; in 1649 he was

granted the rights of a citizen of Opava. From 1651 he was employed in the workshop of the goldsmith Hans Jacob I Wildt in Augsburg, and in 1659 he married his master's widow, Sophie Drentwett (daughter of the goldsmith Elias I Drentwett).

Among the extant works made by Mannlich, numbering more than twenty (in some cases executed in collaboration with other goldmiths), there predominate richly embossed reliefs as well as fully molded figures of saints and heraldic animals. Despite certain technical shortcomings they rank among the significant achievements of European baroque goldsmithing.

DN

MATTHISEN, BRODERO (d. 1666), a German painter and engraver, was employed from 1646 at the court of the princes Holstein-Gottorp. He also executed numerous works for the Danish royal court and from 1659 was court portraitist to the elector of Brandenburg, Friedrich Wilhelm.

PM

MEYER, FRIEDRICH ELIAS (Erfurt 1724–Berlin 1785), was a sculptor and modeler. In 1746–48 he worked at the court of Weimar as a sculptor. Between 1748 and 1761 he was a full-time employee at the Meissen porcelain factory, and from 1763 he was master modeler at the porcelain manufactory in Berlin.

JR

MIRYS, AUGUSTYN (1700–90), was a portraitist and painter of religious and decorative scenes. Of Scottish descent, he was educated in France and Italy. Mirys was in Poland before 1731 in the service in turn of J. S. Jabłonowski, the Sapieha family at Nadwórna, the Branicki family in Białystok, Tyczyna, and Choroszcza, F. Bieliński in Otwock, and Bishop I. Krasicki in Lidzbark Warmiński.

MO

MOCK, JOHANN SAMUEL (Moritzburg?, c. 1687–Warsaw, 1737), was a painter at the court of the electors of Saxony in Dresden and from 1723 in Warsaw. In 1731 he was granted the title of court painter to Augustus II. Mock painted court ceremonies, military parades, and portraits as well as genre and allegorical scenes and also scenery for the theater. In 1732 he became a Warsaw citizen, converted to Catholicism, and was married. Mock retained his position after King Augustus II's death; in 1735 Augustus III conferred upon him the title of chief painter of Poland.

HM

ÖRNSTER, SIEGFRIED (Halle, 1662–Gdańsk, 1735), a goldsmith, trained in Gdańsk from 1688 for four years under Jakob Beckhausen, executing his masterpiece under the supervision of Benedict Clausen in the winter of 1691. He married Concordia Polmann (1649–1709). In 1691 Örnster was granted the freedom of the city. In 1709, 1716, and 1726 he fulfilled the function of an elder of the guild. In his workshop the craftsmen A. Clausen, D. Lubner, J. C. Stenzel, and Ch. Türck made their masterpieces. Örnster's two sons, Hieronim Siegfried and Emanuel Gotlieb, also trained in the goldsmith's craft. In his artistic career of more than forty years Örnster made vessels of great luxury

decorated with relief scenes whose subjects were drawn from ancient history and the Bible (tankards bearing scenes with the prophet Elijah are kept at the Historical Museum in Czernihov, Ukraine, and in the Wawel Royal Castle, Cracow). However he is mainly known as the author of numerous extant liturgical vessels and altar decorations, which are still used in the Roman Catholic liturgy in Gdańsk (the monstrance in the Church of the Blessed Virgin Mary), in Pomerania (monstrances at Płoweża, Puck, Chmielno, Mechowa, Starzyn, and Goręczyn) as well as farther south at Kowal near Włocławek and a chalice at Kurów near Puławy. He embellished radiate monstrances and chalices with relief figural scenes featuring biblical themes related to the Eucharist, around 1700 with the ornament of a withered acanthus, and in the first thirty years of the eighteenth century with French late baroque motifs. He was buried in the Goldsmiths' Chapel in the church of the Blessed Virgin Mary, Gdańsk.
BT-W

PESNE, ANTOINE (1683–1757), a French painter, was first a pupil of his father, Thomas, and of Charles de Lafosse and also was an alumnus of the Académie Française in Paris. He painted mainly portraits and historical scenes. From 1705 to 1710 he continued his studies in Italy (Rome, Naples, Venice); thereafter he worked in Berlin and Dresden as court painter to Friedrich I, later to Friedrich Wilhelm I, Augustus II the Strong, and Friedrich II. He traveled widely, won several awards, and from 1720 was a member of the Académie Française. In his work Pesne combined elements of French and Italian baroque art. He was a very fashionable artist; in order to meet a large number of commissions he was assisted by numerous collaborators.
AS

PETERSEN (PETERS), STEPHAN (STEFFAN) (active 1660–after 1688), was a Toruń goldsmith employed in 1657 in the workshop of Johann Christian Bierpfaff. In Petersen's atelier Efraim Hennings (1666–72) and Johann von Hausen I (1675) were trained. More than a dozen known works by Petersen—for the most part liturgical plate-monstrances, chalices, paxes—justify his recognition as the first Toruń goldsmith of the high baroque and as one of the most notable local masters in the seventeenth century.
DN

PINSEL, JOHANN GEORG (d. Buczacz, 1761 or 1762), is considered the outstanding exponent of the Lvov school of sculpture in the eighteenth century, although he stayed in this city only for a short time. He is a most puzzling person. His name appeared in the scholarly literature for the first time in 1923, his oeuvre being the subject of discussion since the 1930s; however, more detailed biographical data (names and information on his wife and sons, approximate date of his death) have been discovered only in recent years. He probably came from one of the Central European countries (Bohemia, Silesia?), but information about him prior to his marriage in Buczacz in 1751 is lacking. He lived in that town until his death as a court artist to Mikołaj Potocki and a close collaborator of the notable architect Bernard Meretyn. His works can or could be found in Buczacz, Horodenka, Lvov, Hodowica, and Monasterzyska. In the period of Soviet rule all of the church interior decorations of his authorship were destroyed or left in fragments. The surviving single figures are kept for the most part in the Picture Gallery collections in

Lvov, where there exists also a separate exhibition of his work in the former Church of the Poor Clares.

Pinsel is probably the last truly great artist of the European baroque. His art stems from the Central European tradition of wooden sculpture, which goes back as far as the late Middle Ages. In its artistic quality it is equal to the top achievements of Ignaz Günther and other contemporary Bavarian sculptors, while in its expressive power of conveying fervent religious feelings it surely surpasses them. In the Lvov circle, Pinsel's art had a strong impact on the sculptors working in the 1760s and 1770s, who repeatedly copied his compositional solutions.
JKO

LITERATURE: Bochnak 1931; Mańkowski 1937; Hornung 1976; Krasny, Ostrowski 1995; Ostrowski 1996.

REINICKE, PETER (Gdańsk 1715–Meissen 1768), was a modeler and a collaborator of Kändler at the Meissen porcelain factory from 1743 to 1768.
JR

RIGAUD, HYACINTHE FRANÇOIS HONORÉ RIGAUD Y ROS (1659–1743), was a French painter, from 1681 living in Paris. At first he was popular as a portraitist in the circle of the rich bourgeoisie, but from 1690 he worked almost exclusively for the royal court and top-ranking aristocracy. He was a master of state portraiture; his *Louis XIV in Coronation Robes*, dating from 1701, is regarded as one of the characteristic ceremonial portraits of the high baroque. Owing to a multitude of commissions he had numerous assistants.
PM

RUBENS, PETER PAUL (1577–1640), created a prototype in the portrait of the Polish Prince Royal Ladislas Sigismund Vasa, the future King Ladislas IV (see cat. 2). He influenced the development of Polish baroque painting, mainly through graphic copies of his works.
KK

SCHNEEWEISS, SAMUEL (d. 1697), a goldsmith, was born in Dresden and was active in Augsburg. He became master in 1670. He was married to Anna Maria, daughter of the goldsmith Johann Baptist I Weinhold, and after the death of Weinhold continued to run the workshop. The literature mentions a chalice made by Schneeweiss between 1675 and 1678, a pair of candlesticks from 1684–89, and a censer of 1690.
AP

SCHULTZ, DANIEL THE YOUNGER (c. 1615–83), a painter, was the son of a Gdańsk painter and probably the pupil of his father and of his uncle, Daniel the Elder (d. 1646). From 1649 in Warsaw as a court painter and official portraitist to Kings John Casimir, Michael Korybut, and John III (at the beginning of his reign), Daniel Schultz the Younger was an artist responsible for a new version of royal iconography. He was also a confidential courtier and participant in state missions and he spent the last years of his life in Gdańsk, where he died. This versatile painter and engraver earned renown and the recognition of his contemporaries and was one of the eminent portrait painters of his time in this part of Europe. He combined keen observation of the emotional

states of his models with careful analysis and profound, concentrated psychological characterization. The stylistic and formal aspects of his art, revealing inspiration by Dutch painting (of Rembrandt's circle in particular) and Flemish masters and to some extent also by French ceremonial portraiture, were influenced by his repeated visits to the Netherlands and Flanders. In 1643 he may have been in Leiden, if he is identical with the Daniel Schultz matriculated in that year at Leiden University; he was probably there around 1646–48 and perhaps in 1655. He is alleged to have departed for France around 1660 and stayed in Paris in 1670. His art exerted a considerable influence on Polish portraiture.
JG

SILVESTRE, LOUIS DE (Sceaux, 1675–Paris, 1760), was a French painter, the pupil of Charles Le Brun and Bon Boullogne. From 1693 he worked in Italy (Rome, Lombardy, and Venice) and from 1702 was a member of the Académie Royale in Paris, in 1752 being appointed its director. In 1715 Augustus II made him the painter of the Polish-Saxon court. In 1727 Silvestre became the director of the Academy of Painting in Dresden and was ennobled by Augustus III in 1742. He worked in Dresden and in Warsaw at the polychromies of the royal castle. He painted mythological and religious scenes as well as numerous portraits, including those of Polish notables. Silvestre was one of the major artists in the Saxon artistic milieu of the baroque period.
BC

SUBLEYRAS, PIERRE (1699–1749), a French painter and engraver active in Paris and Rome, anticipated neoclassicism in painting.
HM

VANEAU (VANNEAU), PIERRE (Le Puys, 1653–Le Puys, 1694), a sculpter, having first been trained in the carpentry workshop of his father, perhaps stayed for some time in Flanders. In his atelier at Le Puys he sculpted figures in the round and bas-reliefs and also elements of furnishings for the local cathedral and the Church of Saint George as well as for the church at Brionde (Haut-Loire) and for the chapel and castle at Monistrol.
AB

WOLBRECHT, LORENTZ (Wawrzyniec) (active 17th c.), was entered in the Toruń guild documents as a royal (John Casimir's) clockmaker who, after leaving Toruń, worked in Warsaw. Late in his life, in 1669, he returned to his native town with the intention of continuing his work. There exist some known *kaflaks* signed by him, one of which, hexagonal in shape, is in the Wawel collections and another, analogous, in a private collection in Germany.
SB-L

SIGNIFICANT POLITICAL EVENTS IN POLAND, C. 1550–1770

1569

The Union of Lublin sets the structure of the Polish-Lithuanian state for more than two hundred years.

1572

Death of King Sigismund Augustus, the last king of the Jagiellonan dynasty.

1573

The Confederation of Warsaw, accepted by the parliament, secures religious freedom.

1573

First free election of the king; henceforth every elected monarch was compelled to accept conditions limiting his power.

1573–74

Reign of King Henry of Valois, who soon left the country to become king of France.

1576–86

Reign of King Stephen Batory, formerly prince of Transylvania.

1579–81

King Stephen's successful wars against Russia.

1587–1632

Reign of King Sigismund III Vasa, from 1592 also king of Sweden; his claims to the hereditary Swedish throne are among the reasons for a long conflict with Sweden.

1596

Synod of Brześć (Brest Litovsk); the Orthodox Church in Poland accepts union with Rome.

1600–05

First stage of the war with Sweden; Poland keeps its possessions in the Baltic area.

1604–10

Political intrigue of a group of Polish magnates aiming to put the false Prince Dmitri on the Russian throne.

1606–07

Mikołaj Zebrzydowski's rebellion against the king.

1609

King Sigismund III leaves Cracow; Warsaw becomes his permanent residence.

1609–12

Wars against Russia; Polish troops occupy Moscow.

1618–19

Expedition to Moscow aiming to secure the Russian throne for Ladislas Sigismund Vasa (future King Ladislas IV), son of Sigismund III.

1620

Polish troops defeated by the Turks in Moldavia, beginning of a long-term conflict with Turkey.

1621

Successful defense against the Turks at Chocim.

1621–29

War with Sweden in the Baltic area; Poland loses a large part of its coastal territory.

1632–48

Reign of King Ladislas IV.

1648–54

Cossack rebellion in the Ukraine opens a crisis in the country; fighting ravages the southeastern provinces; despite efforts at reconciliation, the Cossacks recognize the sovereignty of the czar of Russia; Russia annexes the Ukrainian territory east of the Dnieper River.

1648–68

Reign of King John Casimir.

1654–56

War with Russia, whose troops occupy a large portion of Lithuanian territory.

1655–60

Swedish invasion; systematic pillage of the country; treason committed by a large part of the magnates and nobility; first national war against an invader.

1664–66

Jerzy Lubomirski's rebellion against the king.

1667

Treaty with Russia; Poland recognizes its territorial losses in the east.

1669–73

Reign of King Michael Wiśniowiecki, first magnate elected to the throne.

1672

War with Turkey; Poland signs the ignominious treaty of Buczacz and cedes to the enemy the province of Podolia with the famous fortress of Kamieniec.

1673

Victory of Hetman Jan Sobieski over the Turks at Chocim; Kamieniec remains in the hands of the enemy.

1674–96

Reign of King John III Sobieski.

1683

Polish army under John III plays a decisive role in the liberation of Vienna from the Turkish siege.

1686

The Holy League of Poland, Austria, Sweden, and the pope against Turkey.

1697–32

Reign of King Augustus II the Strong, prince elector of Saxony.

1699

Peace with Turkey signed in Karlovitz; Poland regains Podolia with Kamieniec.

1700–21

Northern War; Poland becomes the passive object of a conflict between Sweden and Russia; country is heavily ravaged.

1704

Election of Stanislas Leszczyński as king under Swedish pressure; after the defeat of the Swedes he leaves the country.

1717

The "Dumb Sejm"; Russia becomes a guarantor of the political system in Poland.

1724

Anti-Catholic mutiny in Toruń, ending in the execution of ten Protestants; Poland earns the reputation of an intolerant country and the neighboring states gain an excuse to interfere in its internal matters.

1733

Double election of Augustus III, prince elector of Saxony, and Stanislas Leszczyński as kings.

1733–35

War of Polish Succession; Russian troops secure the throne for Augustus III.

1733–63

Reign of King Augustus III.

1736

Stanislas Leszczyński withdraws and becomes duke of Lorraine, where he earns a reputation as an enlightened administrator and art patron.

1764–95

Reign of King Stanislas Augustus Poniatowski, grand duke of Lithuania and last king of Poland. Henceforth the country would be divided between Russia, Prussia, and Austria.

1767

The Radom Confederation, manipulated by Russia, discloses the weakness of the country and the absence of any coherent political program.

1768–72

The Bar Confederation against the king and Russian domination; civil war.

1768

Last rebellion in the Ukraine; massacre of the gentry and Jews.

1772

First partition of Poland; almost thirty percent of Poland's territory occupied by Russia, Austria, and Prussia.

1773

Establishment of the first permanent administration, including a ministry of Education, the first in Europe.

GLOSSARY

atarah a long narrow strip sewn to the top edge of a *tallith*, an element of Jewish attire

Bauamt building office of the Saxon court in Dresden, also active in Warsaw

bimah a raised platform in a synagogue on which the reading desk stands

buława (pron. "bulava") war mace of eastern origin, with a bulb-shaped head, used as a baton of command by Polish hetmans

buńczuk see *tugh*

buzdygan war mace, used as a baton of command by Polish officers

cadogan queue queue of hair tied with ribbon, after William, Earl of Cadogan

castellan (Pol. *kasztelan*) governor of a castle (fully honorary title), member of the Senate

castrum doloris Latin term for an elaborate arrangement set up inside a church on the occasion of a funeral ceremony, consisting of elements of architecture, sculpture, and painting

chancellor minister in charge of the royal seal with a function similar to that of the present prime minister

cheder elementary religious school for Jewish boys, attached to a synagogue or housed in the private home of a teacher

cope in the Roman Catholic Church, a liturgical vestment worn by a priest during particularly solemn celebrations, usually belonging to a set consisting of a chasuble, two dalmatics, and a cope

crosier staff curved at the top, a distinction of Roman Catholic bishops, abbots, and other clergymen entitled to wearing pontificals

dalmatic a liturgical vestment of a Roman Catholic deacon

delia man's outer garment, a fur-lined coat with a wide collar

entre cour et jardin French layout of a baroque residence, with a courtyard at the front and a garden at the rear

epimanikia in the Orthodox and Uniate Churches, ornamental cuffs worn over the ends of the sleeves of the *sticharion*

epitrachelion an element of Orthodox and Uniate liturgical vestments in the form of a long ornamental band worn around the neck

feretory a sculpture or double-sided picture mounted on a support, allowing it to be carried in a religious procession

ferezja man's outer garment with short sleeves and silk loops on the chest

fustian hard-wearing fabric of cotton mixed with flax or wool with a slight nap

galligaskins loose wide breeches or hose, worn by men in the seventeenth century

guttae cylindrical or cone-shaped elements in the Doric entablature

hajduk soldier or servant dressed after the Hungarian fashion

hetman supreme commander of the army, of which there were four at a time: one grand hetman and one field (deputy) hetman for the Crown and one grand hetman and one field hetman for the Grand Duchy of Lithuania

hussar a cavalryman serving in a *husaria* formation

husaria Polish heavy cavalry using special armor, long lances, and decorative feathered wings, the most prestigious formation in the Polish army from the sixteenth through the eighteenth centuries

janissaries members of an elite Turkish foot guard and a term used also for troops kept at the courts of Polish magnates

jasyr (from Turkish *esir*) captives taken during Tatar and Turkish incursions

jurydyka an area owned by a member of the gentry or by the Church within a town or in its precincts but exempt from its jurisdiction

kalkan circular shield of eastern origin

karacena scale armor made of iron scales riveted to a leather support

kenessah a Karaite temple

kontusz (pron. "kontush") man's outer garment of eastern origin, worn over a *żupan*

kolpak round, usually fur cap

lame iron or steel plate used in making up parts of a suit of armor, to provide flexibility

laufer servant running ahead of his master's carriage, showing or lighting the way

Magdeburg Law model of a city law used in most Polish towns from the thirteenth to the eighteenth centuries

magierka cap of Hungarian origin

menorah a seven-branched candelabrum used in Jewish religious observances

mensa (from Lat. for table) essential element of a Christian altar; offering table

Miles Christianus Christian hero, defender of the Christian faith

miter the liturgical headdress of a Roman Catholic bishop, abbot, or other clergyman entitled to wear pontificals

monstrance a liturgical object used in the Roman Catholic Church for exposing the Eucharistic Host during religious services and processions

pajuk servant dressed after the Turkish fashion

pancerni Polish light cavalry wearing mail armor

Pappenheimer helmet western European helmet, often used by ordinary hussars

parokhet curtain for the *aron ha-kodesh*, the place in the synagogue for keeping the Torah scrolls

pontificals insignia and special vestments worn by a bishop

pyx a Roman Catholic liturgical vessel used for reserving the Blessed Sacrament in the tabernacle; similar to a covered chalice

ratse archaic term for hussars

saltire in heraldry, a bearing in the form of a Saint Andrew's cross

sewer a servant of high rank in charge of the serving of meals and the seating of guests

shagreen rough grainy leather

spahis elite Turkish cavalry

starosta officer empowered by the king to administer the smallest territorial unit; also, tenant of the royal estate

sticharion a long tunic-like vestment worn by Orthodox and Uniate deacons, priests, and bishops

szarak colloquial designation of the poorest category of the gentry, called after their gray (Pol. *szary*) clothes

szlachta ruling class in the Polish-Lithuanian Commonwealth, encompassing the English notion of gentry and nobility

tallith a white shawl with black stripes and with fringes at its shorter sides, worn over the head and shoulders by men during Jewish religious services

torus a large convex molding of semicircular profile, typically at the base of a column or pilaster

tugh (Pol. *buńczuk*, pron. "buntchuk") Turkish ensign of military authority, used also in Poland a kind of standard consisting of a shaft with a tassel of horse or yak hair

uhlans Polish lancer formation; in the nineteenth century most European armies had lancer regiments dressed after the Polish fashion

voivode (Pol. *wojewoda*) governor of a province (in practice an honorary title), member of the Senate

zischägge (Germ.; Pol. *szyszak*) decorative helmet

żupan (pron. "zhupan") man's long garment worn with or without a *kontusz* over it

BIBLIOGRAPHY

GENERAL BIBLIOGRAPHY

BIAŁOSTOCKI 1962
Białostocki, J. "Le 'Baroque': style, époque, attitude" [1958]. *L'Information d'Histoire de l'Art* 7 (1962), 21–33.

BIAŁOSTOCKI 1976
Białostocki, Jan. *The Art of the Renaissance in Eastern Europe*. Oxford and Ithaca, New York, 1976.

BIAŁOSTOCKI 1979
Białostocki, Jan. "Rinascimento polacco e rinascimento europeo." In *Polonia-Italia. Relazioni artistiche dal medioevo al XVIII secolo. Atti del Convegno tenutosi a Roma 1975*. Wrocław, 1979, 21–58.

BIAŁOSTOCKI 1981
Białostocki, Jan. "'Barock': Stil, Epoche, Haltung." Reprinted in *Stil und Ikonographie: Studien zur Kunstwissenschaft*. Cologne, 1981[1958], 106ff.

CRACOW 1992
The Orient in Polish Art. Exh. cat. Cracow, 1992.

DAVIES 1982
Davies, N. *God's Playground. A History of Poland*, vols. 1–2. New York, 1982.

DMOCHOWSKI 1956
Dmochowski, Z. *Architecture in Poland, A Historical Survey*. London, 1956.

KARPOWICZ 1974
Karpowicz, Mariusz. "Il filone italiano dell'arte polacca del Seicento e i suoi rappresentanti maggiori." In *Barocco fra Italia e Polonia (Atti del IV Convegno di Studi promosso ed organizzato del Comitato degli Studi sull' Arte dell' Accademia Polacca delle Scienze e dalla Fondazione Giorgio Cini di Venezia 1974)*. Ed. Jan Śląski. Warsaw, 1977, 101.

KARPOWICZ 1983
Karpowicz, M. *Artisti ticinesi in Polonia nel '600*. Bellinzona, 1983.

KARPOWICZ 1987
Karpowicz, M. *Artisti ticinesi in Polonia nel '500*. Lugano, 1987.

KARPOWICZ 1988
Karpowicz, Mariusz. *Barock in Polen / Barok w Polsci*. Leipzig and Warsaw, 1988.

KARPOWICZ 1990
Karpowicz, M. *Baldasar Fontana 1661–1733. Un Berniniano ticinese in Moravia e Polonia*. Lugano, 1990.

KAUFMANN 1978
Kaufmann, Thomas DaCosta. Review of "Jan Białostocki, *The Art of the Renaissance in Eastern Europe*." *Art Bulletin* 58 (1978), 164–69.

KAUFMANN 1993
Kaufmann, Thomas DaCosta. "Schlüter's Fate. Comments on Sculpture, Science, and Patronage in Central and Eastern Europe c. 1700." In T. Gaehtgens, ed., *Künstlerischer Austausch/ Artistic Exchange. Akten des XXVIII. Internationalen Kongress für Kunstgeschichte, 1992*. Berlin, Akademie Verlag, 1993, 2:199–212.

KAUFMANN 1995a
Kaufmann, Thomas DaCosta. *Court, Cloister and City: The Art and Culture of Central Europe 1450–1800* (Chicago and London, 1995).

KAUFMANN 1995b
Kaufmann, Thomas DaCosta. "Italian Sculptors and Sculpture Outside of Italy (Chiefly in Central Europe): Problems of Approach, Possibilities of Reception." In Claire Farago, ed., *Reframing the Renaissance*. New Haven and London, 1995, 47–66.

KAUFMANN FORTHCOMING
Kaufmann, Thomas DaCosta. "Ethnic versus Dynastic Identity." In a chapter in a forthcoming book, *The Place of Art: Essays on the Geography of Art in Europe and the Americas*.

KNOX 1971
Knox, Brian. *The Architecture of Poland*. London, 1971.

KOZAKIEWICZ 1976
Kozakiewicz, Helena, and Stefan Kozakiewicz. *Die Renaissance in Polen*. Leipzig and Warsaw, 1976.

KUBLER 1962
Kubler, George. *The Shape of Time. Remarks on the History of Things*. New York, 1962.

PORTRAIT 1985
"Portrait of Sarmatian Type in the 17th Century Poland, Bohemia, Slovakia and Hungary." In *Seminaria Niedzickie* 2. Cracow, 1985.

RENAISSANCE 1976
The Art of the Renaissance in Eastern Europe. Oxford and Ithaca, New York, 1976.

SAID 1978
Said, Edward. *Orientalism*. New York, 1978.

WARSAW 1993
See GDZIE WSCHÓD SPOTYKA ZACHÓD 1993.

WOLFF 1994
Wolff, Larry. *Inventing Eastern Europe: The Map of Civilization on the Mind of the Enlightenment*. Stanford, 1994.

ZAMOYSKI 1990
Zamoyski, A. *The Polish Way. A Thousand-Year History of Poles and Their Culture*. London, 1990.

ŻYGULSKI 1973
Żygulski, Z., Jr. "Winged Hussars in Poland." *Arms and Armour Annual* 1 (1973), 90–103.

ŻYGULSKI 1987
Żygulski, Z., Jr. *An Outline of the History of Polish Applied Art*. Warsaw, 1987.

ŻYGULSKI 1990
Żygulski, Z., Jr. "Turkish Art in Poland." In *Seventh International Congress of Turkish Art*, ed. T. Majda. Warsaw, 1990, 285–92.

SELECT BIBLIOGRAPHY

ANTOINE PESNE 1983
Antoine Pesne 1683–1757. Ausstellung zum 300. Geburtstag, ed. G. Bartoschek. Exh. cat. Sanssouci, Potsdam, 1983.

ARNOLD 1996
Arnold, U. "König August III und Juwelengarnitur des Grünes Gewölbe." *Dresdner Hefte* 46 (1996): 2, 70.

AUREA PORTA 1997
Aurea Porta Rzeczypospolitej. Sztuka Gdańska od drugiej połowy XV do końca XVIII wieku. Exh. cat. Muzeum Narodowe. Gdańsk, 1997.

BADACH 1994
Badach, A. "Rzeźba XVI-XX w. ze zbiów Fundacji im. Ciechanowieckich." *Kronika Zamkowa* 29/30 (1994): 85–86.

BARĄCZ 1891
Barącz, S. *Cudowne obrazy Matki Najświętszej w Polsce*. Lvov, 1891.

BARELLI 1963
Barelli, E. S. *L'Arazzo in Europa*. Novara, 1963.

BÉNÉZIT 1976
Bénézit, E. *Dictionnaire critique et documentaire des peintres, sculpteurs, dessinateurs et graveurs*. Vol. 10. Paris, 1976.

BERCKENHAGEN, DU COLOMBIER, KULM-POENSGEN 1958
Berckenhagen, E., P. du Colombier, and G. Kulm-Poensgen. *Antoine Pesne*. Berlin, 1958.

BIEDROŃSKA-SŁOTOWA 1987
Biedrońska-Słotowa, B. "Kobierce perskie tzw. polskie. Studium nad budową i znaczeniem ornamentu w sztuce Islamu." *Folia Historiae Artium* 23 (1987): 85–122.

BIENIECKI 1960
Bieniecki, T. *Kurdybany gdańskie XVII i XVIII w.* Gdańsk, 1960.

BISKUPSKI 1994
Biskupski, R. "Sztuka Kościoła prawosławnego i unickiego na terenie diecezji przemyskiej w XVII i pierwszej połowie XVIII w." *Polska-Ukraina. 1000 lat sąsiedztwa.* Przemyśl, 1994, 2:351–70.

BLANK 1835
Blank, A. *Katalog galerii obrazów słynnych mistrzów z różnych szkół zebranych przez ks. Hieronima Radziwiłła.* Warsaw, 1835.

BOCHEŃSKI 1939
Bocheński, Z. "Dodatkowe uwagi o polskich karacenach 17–18 wieku." *Broń i Barwa* 6 (1939): 6–8.

BOCHEŃSKI 1988
Bocheński, Z. "Opis Rolki Sztokholmskiej // A Description of the Stockholm Roll." *Studia do Dziejów Dawnego Uzbrojenia i Ubioru Wojskowego* 9/10 (1988): 39–114.

BOCHNAK 1931
Bochnak, A. *Ze studiów nad rzeźbą lwowską w epoce rokoka.* Cracow, 1931.

BOCHNAK, PAGACZEWSKI 1959
Bochnak, A., and J. Pagaczewski. *Polskie rzemiosło artystyczne wieków średnich.* Cracow, 1959.

BOHDZIEWICZ 1964
Bohdziewicz, P. *Korespondencja artystyczna Elżbiety Sieniawskiej z lat 1700–1729 w zbiorach Czartoryskich w Krakowie.* Lublin, 1964.

BOLTZ, CHOJNACKI 1978
Boltz, C., and H. Chojnacki. "Fata des Meissner Porzellanserwices mit blauen Blumen und AR für die Königliche Hof Conditorey Warschau." *Bulletin du Musée National de Varsovie* 19 (1978): 74–78.

BUCZKOWSKI 1958
Buczkowski, K. *Dawne szkła artystyczne w Polsce.* Cracow, 1958.

BUJAŃSKA 1972
Bujańska, J. *Stare srebra.* Cracow, 1972.

BULANDA 1982
Bulanda, S. *Zegary renesansowe.* Warsaw, 1982.

BUTLER 1977
Butler, K. *Mejsenskaja farfornaja plastika XVIII veka v sobranii Ermitaža.* Leningrad, 1977.

CEINTURES ET COSTUMES POLONAIS 1972
Ceintures et costumes polonais. Exh. cat. Musée de l'impression sur etoffes. Mulhouse, 1972.

CERAMIKA I SZKŁO 1998
Ceramika i szkło Fundacji Zbiorów im. Ciechanowieckich i Zamku Królewskiego w Warszawie. Exh. cat. Muzeum Rolnictwa w Ciechanowcu. Ciechanowiec, 1998.

CHROŚCICKI 1974
Chrościcki, J. A. *Pompa funebris. Z dziejów kultury staropolskiej.* Warsaw, 1974.

CHROŚCICKI 1977
Chrościcki, J. A. "Rubensowskie portrety Wazów." In *Rubens, Niderlandy i Polska. Materiały sesji naukowej.* Lodz, 1977, 42–61.

CHROŚCICKI 1981
Chrościcki, J. A. "Rubens w Polsce." *Rocznik Historii Sztuki* 12 (1981): 134–219.

CHROŚCICKI 1988
Chrościcki, J. A. "Kolekcja sztuki królewicza Władysława Zygmunta z r. 1626." *Kronika Zamkowa* (1988): 3:3–7.

CHROŚCICKI, GAJEWSKI 1994
Chrościcki, J. A., and J. Gajewski. "Gdzie Rzym, gdzie Krym? Dyskusja na wystawie 'Gdzie Wschód spotyka Zachód. Portrety osobistości dawnej Rzeczypospolitej.'" *Barok* 1 (1994): 117–25.

CHROŚCICKI, L. 1974
Chrościcki, L. *Porcelana-znaki wytwórni europejskich.* Warsaw, 1974.

CHRZANOWSKI, KORNECKI 1982
Chrzanowski, T., and M. Kornecki. *Sztuka Ziemi Krakowskiej.* Cracow, 1982.

CHRZANOWSKI, KORNECKI 1986
Chrzanowski, T., and M. Kornecki. "Złotnictwo toruńskie manieryzmu i baroku-przemiany formy." In *Sztuka Torunia i Ziemi Chełmińskiej 1233–1815.* Toruń, 1986.

CHRZANOWSKI, KORNECKI 1988
Chrzanowski, T., and M. Kornecki. *Złotnictwo toruńskie. Studium o wyrobach cechu toruńskiego od wieku XIV do 1823 roku.* Warsaw, 1988.

CHWALEWIK 1927
Chwalewik, E. *Zbiory polskie.* Warsaw-Cracow, 1927.

CHYB 1978
Chyb, D. "Trony zamkowe w latach 1795–1939." *Kronika Zamkowa* 1978, 3:10–23.

CIECHANOWIECKI 1974
Ciechanowiecki, A. "Złotnicy czynni w Krakowie w latach 1600–1700." In *Materiały do biografii, genealogii i heraldyki polskiej* 6 (Buenos Aires-Paris 1974): 13–142.

CORPUS INSCRIPTIONUM 1987
Corpus Inscriptionum Poloniae 6: "Województwo krakowskie," vol. 2: "Bazylika Mariacka w Krakowie." Ed. Z. Piech. Cracow, 1987.

CRACOW 1976
Court Art of the Vasa Dynasty in Poland. Exh. cat. Wawel Royal Castle. Cracow, 1976.

CRACOW 1992
The Orient in Polish Art. Exh. cat. Cracow, 1992.

CZERNECKI 1939
Czernecki, J. *Mały król na Rusi i jego stolica.* Krystynopol-Cracow, 1939.

CZIHAK 1908
Von Czihak, E. *Die Edelschmiedekunst früher Zeiten in Preussen* 2. Leipzig, 1908.

CZYŻEWSKI, NOWACKI, PIWOCKA 1995
Czyżewski, K., D. Nowacki, and M. Piwocka. "Tyniec. Sztuka i kultura Benedyktynów od wieku XI do XVIII—na marginesie wystawy." *Studia Waweliana* 4 (1995): 168–79.

DANZIGER SILBER 1991
Danziger Silber. Die Schätze des Nationalmuseums Gdańsk. Ed. B. Tuchołka-Włodarska, A. Löshr. Exh. cat. Bremer Landesmuseum, Focke Muzeum. Bremen, 1991.

DECORUM 1980
Decorum życia Sarmatów w XVII i XVIII w. Katalog pokazu sztuki zdobniczej ze zbiorów Muzeum Narodowego w Warszawie. Exh. cat. Muzeum Narodowe. Warsaw, 1980.

DOBROWOLSKI 1948
Dobrowolski, T. *Polskie malarstwo portretowe. Ze studiów nad sztuką, epoki sarmatyzmu.* Cracow, 1948.

DRECKA 1953
Drecka, W. "Materiały do ikonografii Stefana Czarnieckiego." *Biuletyn Historii Sztuki* 15 (1953): 67–74.

DROST 1957
Drost, W. *Sankt Johann in Danzig. Kunstdenkmäler der Stadt Danzig* l. Stuttgart, 1957.

ESTREICHER 1973
Estreicher, K. *The Collegium Maius of the Jagiel-
lonian University in Cracow. History, Customs,
Collections*. Warsaw, 1973.

FIJAŁKOWSKI 1969
Fijałkowski, W. "Łazienka wilanowska marszałkowej
Izabeli Lubomirskiej." In *Muzeum i Twórca. Studia z
historii sztuki i kultury ku czci prof. dr. Stanisława
Lorentza*. Warsaw, 1969.

FISCHINGER 1982
Fischinger, A. *Skarbiec Koronny na Wawelu. Prze-
wodnik*. Cracow, 1982.

FISCHINGER 1983
Fischinger, A. "Christian Paulsen i Jan Polmann,
złotnicy gdańscy XVII wieku." *Biuletyn Historii
Sztuki* 45 (1983): 317–26.

FISCHINGER 1988
Fischinger, A. *Skarbiec Koronny na Wawelu. Prze-
wodnik*. Cracow, 1988.

FISCHINGER 1990
Fischinger, A. "Srebrny orzeł w zbiorach Skarbca
Koronnego na Wawelu." In *Curia Maior. Stu-
dia z dziejów kultury ofiarowane Andrzejowi
Ciechanowieckiemu*. Warsaw, 1990, 85–90.

FRIDRICH 1904
Fridrich, A. *Historye cudownych obrazów
Najświętszej Marii Panny w Polsce* 2. Cracow,
1904.

GAJEWSKI 1977
Gajewski, J. "O kilku portretach Jana Kazimierza.
Przyczynek do twórczości Daniela Schultza i
ikonografii króla." *Biuletyn Historii Sztuki* 39
(1977), 47–61.

GAJEWSKI 1992
Gajewski, J. "Z Wiednia i Pragi(?) przez Łubnice
do Puław. Działalność Jana Eliasza Hoffmanna
w Lubelskiem." In *Dzieje Lubelszczyzny*, VI.3:
Kultura artystyczna. Ed. T. Chrzanowski. Lublin,
1992.

GDZIE WSCHÓD SPOTYKA ZACHÓD 1993
*Gdzie Wschód spotyka Zachód. Portret osobistości
dawnej Rzeczypospolitej 1576–1763*. Ed. J. Mali-
nowski. Exh. cat. Muzeum Narodowe. Warsaw,
1993.

GEMBARZEWSKI 1926
Gembarzewski, B. *Muzeum Narodowe w Warsza-
wie*. Cracow, 1926.

GĘBAROWICZ, MAŃKOWSKI 1937
Gębarowicz, M., and T. Mańkowski. "Arrasy
Zygmunta Augusta." *Rocznik Krakowski* 29
(1937): 1–220.

GIBASIEWICZ 1966
Gibasiewicz, S. "Kowsz monetowy ze skarbca
wawelskiego." *Biuletyn Numizmatyczny* 10/11
(1966): 170–72.

GILLE 1860
Gille, F. *Notice sur le Musée de Tsarskoe-Selo renfer-
mant la collection d'armes de Sa Majesté l'Empereur*.
Saint Petersburg, 1860.

GILLE, ROCKSTUHL 1835–53
Gille, F., and T. Rockstuhl. *Musée de Tsarskoe-Selo
ou collection d'armes de Sa Majesté l'Empereur de
toutes les Russies*. Saint Petersburg-Carlsruhe,
1835–53.

GÖBEL 1934
Göbel, H. *Wandteppiche* 3, vol. 2. Leipzig, 1934.

GOBELINY 1971
*Gobeliny zachodnioeuropejskie w zbiorach polskich
XVI-XVIIIw*. Exh. cat. Muzeum Narodowe.
Poznań, 1971.

GOLDSTEIN, DRESDNER 1932
Goldstein, M., and K. Dresdner. *Kultura i sztuka
ludu żydowskiego na ziemiach polskich*. Lvov, 1932.

GOSTWICKA 1965
Gostwicka, J. *Dawne meble polskie*. Warsaw, 1965.

GRADOWSKI 1994
Gradowski, M. *Znaki na srebrze. Znaki miejskie i
państwowe używane na terenie Polski w jej obecnych
granicach*. Warsaw, 1994.

HENNEL-BERNASIKOWA 1998
Hennel-Bernasikowa, M. *Arrasy Zygmunta
Augusta*. Cracow, 1998.

HOŁUBIEC 1990
Hołubiec, J. W. *Polskie lampy i świeczniki*.
Wrocław, 1990.

HOOS 1981
Hoos, H. *Augsburger Silbermöbel*. Frankfurt, 1981.

HORNUNG 1937
Hornung, Z. *Antoni Osiński, najwybitniejszy
rzeźbiarz lwowski XVIII stulecia*. Lvov, 1937.

HORNUNG 1976
Hornung, Z. *Majster Pinsel snycerz*. Wrocław,
1976.

IKONY 1981
*Ikony ze zbiorów Muzeum Okręgowego w
Przemyślu*. Cracow, 1981.

IM LICHTE DES HALBMONDS 1995
*Im Lichte des Halbmonds. Das Abendland und der
türkische Orient*. Exh. cat. Staatliche Kunstsamm-
lungen Albertinum. Dresden, 1995.

ISKIERSKI 1931
Iskierski, S. *Katalog Galerii Obrazów w Pałacu w
úazienkach w Łazienkach w Warszawie*. Warsaw,
1931.

JABŁOŃSKI, PIWKOWSKI 1988
Jabłoński, K., and W. Piwkowski. *Nieborów-
Arkadia*. Warsaw, 1988.

JAPAN UND EUROPA 1993
*Japan und Europa. Eine Ausstellung des "43.
Berliner Festwochen*." Exh. cat. Martin-Gropius-Bau,
Berliner Festspiele. Berlin, 1993.

JENIKE 1862
Jenike, L. "Obraz przedstawiający króla Jana III
i jego rodzine." *Tygodnik Ilustrowany* 6 (1862): 33.

KALFAS 1988
Kalfas, B. "Zabytkowe tkaniny i hafty
żydowskie w zbiorach muzeów krakowskich."
*Krzysztofory. Zeszyty Naukowe Muzeum Histo-
rycznego Miasta Krakowa* 15 (1988): 142–58.

KATALOG WYSTAWY 1883
*Katalog wystawy zabytków z czasów Jana III i jego
wieku*. Exh. cat. Cracow, 1883.

KATALOG WYSTAWY 1934
*Katalog wystawy kobierców mahometańskich,
ceramiki azjatyckiej i europejskiej*. Exh. cat. Muzeum
Narodowe. Cracow, 1934.

KATALOG ZABYTKÓW 1953
Katalog Zabytków Sztuki w Polsce I: "Województwo
krakowskie." Ed. J. Szablowski. Warsaw, 1953.

KATALOG ZABYTKÓW 1965
Katalog Zabytków Sztuki w Polsce IV.1: "Miasto
Kraków. Wawel." Ed. J. Szablowski. Warsaw,
1965.

KATALOG ZABYTKÓW 1971
Katalog Zabytków Sztuki w Polsce IV.2: "Miasto
Kraków. Kościoły i klasztory Śródmieścia," vol.
1. Ed. A. Bochnak, J. Samek. Warsaw, 1971.

KATALOG ZABYTKÓW 1987
Katalog Zabytków Sztuki w Polsce IV.4: "Miasto
Kraków. Kazimierz i Stradom, Kościoły i klasz-
tory," vol. 1. Ed. I. Rejduch Samkowa, J. Samek.
Warsaw, 1987.

KATALOG ZABYTKÓW 1989
Katalog Zabytków Sztuki w Polsce. New series,
III.4: "Leżajsk, Sokołów Małopolski i okolice."
Ed. E. Śnieżyńska-Stolotowa, F. Stolot. Warsaw,
1989.

KLOSE 1993
Klose, C. "A Persian Tapestry Carpet in a Painting
of 1634." *Oriental Rug Review* 13 (1993), 4: 30–32.

KONDRACIUK 1994
Kondraciuk, P. "Pamiątki Akademii Zamojskiej w zbiorach Muzeum Okręgowego w Zamościu." *In Akademia Zamojska i jej tradycje.* Ed. B. Szyszka. Zamość, 1994.

KOPEĆ 1977
Kopeć, J. J. "Męka Pańska w religijności i kulturze polskiego średniowiecza. Studium nad pasyjnymi motywami i tekstami liturgicznymi." *Textus et Studia* 3 (1975).

KOPERA 1926
Kopera, F. *Dzieje malarstwa w Polsce* 2. Cracow, 1926.

KORNECKI, KRASNOWOLSKI 1972
Kornecki, M., and B. Krasnowolski. "Dwa insygnia pontyfikalne w dawnym skarbcu Bożogrobców w Miechowie." *Biuletyn Historii Sztuki* 34 (1972): 271–82.

KOWALCZYK 1980
Kowalczyk, J. *W kręgu kultury dworu Jana Zamoyskiego.* Lublin, 1980.

KRASNY 1994
Krasny, P. "Kościół parafialny w Hodowicy." In *Sztuka kresów wschodnich. Materiały sesji naukowej* 1. Ed. J. K. Ostrowski. Cracow, 1994, 39–61.

KRASNY, OSTROWSKI 1995
Krasny, P. , and J. K. Ostrowski. "Wiadomości biograficzne na temat Jana Jerzego Pinsla." *Biuletyn Historii Sztuki* 57 (1995): 339–42.

KUBISTALOWA 1982
Kubistalowa, I. "Portret trumienny w południowo-zachodniej Wielkopolsce." *Rocznik Leszczyński* 8 (1982): 271–308.

KUBISTALOWA 1985
Kubistalowa, I. "Zespół portretów trumiennych Braci Czeskich w Lesznie i Wschowie." *Seminaria Niedzickie* 2 (1985): 183–87.

KUCZMAN 1972
Kuczman, K. "Portret Stanisława Tęczyńskiego w zbiorach wawelskich. Zagadnienie proweniencji artystycznej i autorstwa." *Sprawozdania z Posiedzeń Komisji Naukowych PAN* 15 (1972), 1:149–50.

KUNST DES BAROCK 1974
Kunst des Barock in Polen. Exh. cat. Braunschweig, 1974.

KUNST IN POLEN 1974
Kunst in Polen von der Gotik bis heute. Exh. cat. Zurich, 1974.

KURFÜRST MAX EMANUEL 1976
Kürfürst Max Emanuel. Bayern und Europa um 1700. Exh. cat. Altes und Neues Schloss Schleissheim, I-II. Munich, 1976.

KWAŚNIK-GLIWIŃSKA 1984
Kwaśnik-Gliwińska, A. "Gobeliny w zbiorach Muzeum Narodowego w Kielcach." *Rocznik Muzeum Narodowego w Kielcach* 13 (1984): 165–70.

KWAŚNIK-GLIWIŃSKA 1991
Kwaśnik-Gliwińska, A. *Tkaniny. Katalog zbiorów Muzeum Narodowego w Kielcach.* Coll. cat. Muzeum Narodowe. Kielce, 1991.

KWIATKOWSKI 1991
Kwiatkowski, M. *Łazienki.* Warsaw, 1991.

LARSEN 1952
Larsen, E. *Rubens with a Complete Catalogue of His Works in America.* Antwerp, 1952.

LENZ 1908
Lenz, E. *Imperatorskij Ermitaž. Sobranie oružja.* Saint Petersburg, 1908.

LICHOŃCZAK 1987
Lichończak, G. "Prawda i legenda o srebrnym kurze Krakowskiego Towarzystwa Strzeleckiego." *Krzysztofory. Zeszyty Naukowe Muzeum Historycznego Miasta Krakowa* 14 (1987): 113–26.

LILEYKO 1983
Lileyko, J. *Dawne Zbiory Zamku Królewskiego w Warszawie.* Warsaw, 1971.

LILEYKO 1987
Lileyko, J. *Regalia polskie.* Warsaw, 1987.

LORENTZ 1971
Lorentz, S. *Pamiątki Zamku Królewskiego w Warszawie.* Warsaw, 1971.

ŁUNIŃSKI 1915
Łuniński, E. *Wilanów.* Warsaw, 1915.

MALARSTWO AUSTRIACKIE 1964
Malarstwo austriackie, czeskie, niemieckie, węgierskie 1500–1800. Coll. cat. Muzeum Narodowe. Warsaw, 1964.

MALARSTWO EUROPEJSKIE 1967
Malarstwo europejskie. Katalog zbiorów Muzeum Narodowego w Warszawie 2. Ed. J. Białostocki. Warsaw, 1967.

MALARSTWO POLSKIE 1971
Malarstwo polskie. Manieryzm-Barok. Ed. M. Walicki, W. Tomkiewicz, A. Ryszkiewicz. Warsaw, 1971.

MALARSTWO POLSKIE 1975
Malarstwo polskie. Katalog zbiorów Muzeum Narodowego w Warszawie. Warsaw, 1975.

MAŃKOWSKI 1932
Mańkowski, T. *Galeria Stanisława Augusta.* Lvov, 1932.

MAŃKOWSKI 1937
Mańkowski, T. *Lwowska rzeźba rokokowa.* Lvov, 1937.

MAŃKOWSKI 1949
Mańkowski, T. "Portrety królewskie Daniela Szultza." *Ochrona Zabytków* 2 (1949): 116–22.

MAŃKOWSKI 1950
Mańkowski, T. "Malarstwo na dworze Jana III." *Biuletyn Historii Sztuki* 12 (1250), 201–88.

MAŃKOWSKI 1954
Mańkowski, T. *Polskie tkaniny i hafty XVI-XVIII wieku.* Wrocław, 1954.

MAŃKOWSKI 1959
Mańkowski, T. *Orient w polskiej kulturze artystycznej.* Wrocław, 1959.

MASZKOWSKA 1956
Maszkowska, B. *Z dziejów polskiego meblarstwa okresu Oświecenia.* Wrocław, 1956.

MAURICE 1976
Maurice, K. *Die deutsche Räderuhr* 2. Munich, 1976.

MIĘDZY HANZĄ A LEWANTEM 1995
Między Hanzą a Lewantem. Kraków europejskim centrum kultury i kupiectwa. Exh. cat. Muzeum Historyczne Miasta Krakowa. Cracow, 1995.

MILLE ANS 1969
Mille ans des d'art en Pologne. Exh. cat. Paris, 1969.

MOSSAKOWSKI 1994
Mossakowski, S. *Tilman van Gameren. Leben und Werk.* Munich, Berlin, 1994.

MUZEUM ŻIH 1995
Muzeum Żydowskiego Instytutu Historycznego. Zbiory artystyczne. Ed. I. Brzewska, R. Piątkowska, K. Pałujan, M. Sieramska. Warsaw, 1995.

MYCIELSKI 1911
Mycielski, J. *Portrety polskie XVI-XVIII w,* 1–4. Cracow, 1911.

NABYTKI 1993
"Nabytki [Zamku Królewskiego na Wawelu w r. 1992]." *Studia Waweliana* 2 (1993): 115–19.

NABYTKI 1996
"Nabytki [Zamku Królewskiego na Wawelu w r. 1996]." *Studia Waweliana* 5 (1996): 215–19.

NARODZINY STOLICY 1996
Narodziny Stolicy. Warszawa w latach 1596–1668. Exh. cat. Zamek Królewski. Warsaw, 1996.

NOWACKI 1995
Nowacki, D. "The Munich Exhibition of Augsburg Goldsmiths' Art." *Folia Historia Artium.* New Series 1 (1995): 145–53.

ODSIECZ WIEDEŃSKA 1990
Odsiecz wiedeńska 1683. Wystawa jubileuszowa w zamku królewskim na Wawelu w trzechsetlecie bitwy. Exh. cat. Zamek Królewski na Wawelu. Cracow, 1990.

1000 YEARS 1970
1000 Years of Art in Poland. Exh. cat. London, 1970.

OPIS 1885
Opis' Moskovskoj Oruženoj Palaty 2, vol. 2. Moscow, 1885.

ORAŃSKA 1948
Orańska, J. *Szymon Czechowicz 1689–1775.* Poznań, 1948.

ORIENT 1992
Orient w sztuce polskiej. Exh. cat. Muzeum Narodowe. Cracow, 1992.

ORZEŁ BIAŁY 1995
Orzeł Biały. 700 lat herbu Państwa Polskiego. Exh. cat. Zamek Królewski. Warsaw, 1995.

OSTROWSKI 1993
Ostrowski, J. K. "Kościól parofialny p.w. Wszystkich Świętych w Hodowicy." In *Materiały do dziejów sztuki sakralnej na ziemioch wschodnich dawnej Rzeczypospolitej.* Ed. J. K. Ostrowski. Part 1, vol. 1 (Cracow, 1993), 29–37.

OSTROWSKI 1996
Ostrowski, J. K. "Jan Jerzy Pinsel, zamiast biografii." In *Sztuka kresów wschodnich. Materiały sesji naukowej* 2. Ed. J. K. Ostrowski. Cracow, 1996, 361–73.

OSTROWSKI 1998
Ostrowski, J. K. "Pokój Zielony w pałacu podhoreckim—XVIII-wieczne muzeum Szymona Czechowicza." In *Artes atque humaniora. Studia Stanislao Mossakowski sexagenario dicata.* Warsaw, 1998.

PAGACZEWSKI 1929
Pagaczewski, J. *Gobeliny polskie.* Cracow, 1929.

PAMIĘTNIK 1913
Pamiętnik wystawy ceramiki i szkła polskiego urządzonej w domu własnym w Warszawie przez Towarzystwo Opieki nad Zabytkami Przeszłości w czerwcu, lipcu, sierpniu i wrześniu 1913 roku. Warsaw, n. d.

PENDULE 1974
La Pendule française dans le Monde 3. Paris, 1974.

PETRUS 1978
Petrus, J. T. "Les portraits du roi de Pologne Jean-Casimir Vasa dans les collections française." *Gazette de Beaux-Arts* 91 (1978): 25–31.

PETRUS 1980
Petrus, J. T. *Polska broń drzewcowa.* Warsaw, 1980.

PETRUS 1981
Petrus, J. T. *Zbroje karacenowe.* Warsaw, 1981.

PETRUS 1989
Petrus, J. T. *Zbrojownia zamkowa na Wawelu. Przewodnik.* Cracow, 1989.

PETRUS 1996
Petrus, J. T. *Rolka Wazowska. Katalog wystawy w Zamku Królewskim na Wawelu.* Cracow, 1996.

PETRUS, PIĄTKIEWICZ-DERENIOWA, PIWOCKA 1988
Petrus, J. T., M. Piątkiewicz-Dereniowa, and M. Piwocka. *Wschód w zbiorach wawelskich. Przewodnik.* Cracow, 1988.

PIĄTKIEWICZ-DERENIOWA 1983
Piątkiewicz-Dereniowa, M. *Porcelana miśnieńska w zbiorach wawelskich* 1–2. Coll. cat. Państwowe Zbiory Sytuki na Wawelu. Cracow, 1983.

PIĄTKIEWICZ-DERENIOWA 1991
Piątkiewicz-Dereniowa, M. *Artystyczna ceramika w zbiorach polskich.* Warsaw, 1991.

PICTURES WITHIN PICTURES 1949
Pictures within Pictures. Ed. C. C. Cunningham. Exh. cat. Wardsworth Atheneum. Hartford, 1949.

PIERRE VANEAU 1980
Pierre Vaneau. Exh. cat. Puy-en-Velay, 1980.

PIWKOWSKI, ŻÓŁTOWSKA-HUSZCZA 1993
Piwkowski, W., and T. Żółtowska-Huszcza. *Nieborów-kolekcja Radziwiłłów.* Warsaw, 1993.

PIWOCKA 1972
Piwocka, M. "The Tapestries with Grotesques." In *The Flemish Tapestries at Wawel Castle in Cracow. Treasures of King Sigismunt Augustus Jagiello.* Ed. J. Szablowski. Antwerp, 1972, 287–374.

POD JEDNĄ KORONĄ 1997
Pod jedną koroną. Kultura i sztuka w czasach unii polsko-saskiej. Exh. cat. Zamek Królewski. Warsaw, 1997.

POLAKÓW PORTRET WŁASNY 1986
Polaków portret własny 20. Ed. M. Rostworowski. Warsaw, 1986.

POLONIA 1975
Polonia: arte e cultura dal medioevo all'illuminismo. Exh. cat. Palazzo Venezia. Rome, Florence, 1975.

POLONIA 1989
Polonia, gioelli, ornamenti e arredi Duemila anni di Arte Orafa. Exh. cat. Sottochiesa di S. Francesco. Arezzo, 1989.

POLSKIE SZKŁO 1975
Polskie szkło barokowe. Wystawa w 250-lecie założenia manufaktury szkła w Nalibokach. Exh. cat. Muzeum Narodowe. Warsaw, 1975.

POLSKIE SZKŁO 1987
Polskie szkło do połowy 19 wieku. Warsaw, 1987, figs. 53, 54.

PORTRET POLSKI 1977
Portret polski XVII i XVIII wieku. Exh. cat. Muzeum Narodowe. Warsaw, 1977.

PORTRETY 1967
Portrety osobistości polskich znajdujące się w pokojach i w galerii pałacu w Wilanowie. Katalog. Ed. S. Kozakiewicz and K. Sroczyńska. Warsaw, 1967.

PUYVELDE 1952
Van Puyvelde, L. *Rubens.* Paris-Brussels, 1952.

PRZEYDZIECKI 1937
Przeydziecki, R. "Trzy portrety Władysława IV przez Rubensa." *Arkady* 3 (1937): 206–11.

RAPORT 1993
Raport Roczny Muzeum Narodowego w Warszawie, 1 stycznia–31 grudnia 1992. Warsaw, 1993.

RASTAWIECKI 1857
Rastawiecki, E. *Słownik malarzów polskich i w Polsce działających* 3. Warsaw, 1857.

REHOROWSKI 1960
Rehorowski, M. *Meble gdańskie XVII i XVIII stulecia.* Gdańsk, 1960.

REMBOWSKA 1971
Rembowska, I. *Gdański cech złotników od XIV do końca XVIII w.* Gdańsk, 1971.

ROSENBERG 1923
Rosenberg, M. *Die Goldschmide Merkzeichen* 3. Frankfurt, 1923.

ROSENBERG, THUILLIER 1988
Rosenberg, P., and J. Thuillier. *Laurent de la Hyre 1606–1656. L'homme et l'oeuvre.* Exh. cat. Geneva, 1988.

ROTTERMUND 1970
Rottermund, A. *Pałac Błękitny.* Warsaw, 1970.

ROTTERMUND 1978
Rottermund, A. "Historia i sztuka." *Polska* (1978): 2:28–49.

ROŻEK 1973
Rożek, M. "Ostatnia koronacja w Krakowie i jej artystyczna oprawa." *Rocznik Krakowski* 44 (1973): 97–112.

ROŻEK 1976
Rożek, M. *Uroczystości w barokowym Krakowie.* Cracow, 1976.

ROŻEK 1977
Rożek, M. *Mecenat artystyczny mieszczaństwa krakowskiego w XVII wieku.* Cracow, 1977.

ROŻEK 1980
Rożek, M. *Katedra wawelska w XVII wieku.* Cracow, 1980.

RUSZCZYCÓWNA 1969
Ruszczycówna, J. "Portrety Zygmunta III i jego rodziny." *Rocznik Muzeum Narodowego w Warszawie* 13 (1969): 1:151–269.

RYSZARD 1964
Ryszard, R. S. *Porcelana od baroku do empiru.* Warsaw, 1964.

RYSZKIEWICZ 1957
Ryszkiewicz, A. "Dwa obrazy z warsztatu Antoine'a Pesne'a w zbiorach polskich." *Biuletyn Historii Sztuki* 19 (1957): 156–82.

RYSZKIEWICZ 1961
Ryszkiewicz, A. *Polski portret zbiorowy.* Wrocław, 1961.

RYSZKIEWICZ 1964
Ryszkiewicz, A. "Antoine Pesne. Uwagi w związku z monografią artysty." *Studia Muzealne* 4 (1964): 80–90.

RYSZKIEWICZ 1967
Ryszkiewicz, A. *Francusko-polskie związki artystyczne. W kręgu J. L. Davida.* Warsaw, 1967.

RYSZKIEWICZ 1981
Ryszkiewicz, A. *Kolekcjonerzy i miłośnicy.* Warsaw, 1981.

RYSZKIEWICZ 1992
Ryszkiewicz, A. "O zbiorach Fundacji im. Ciechanowieckich." *Biuletyn Historii Sztuki* 54 (1992): 86.

SAMEK 1980
Samek, J. "Peters (Petersen) Stefan." In *Polski Słownik Biograficzny* 25 (Wrocław, 1980): 675–76.

SAMEK 1984
Samek, J. *Polskie rzemiosło artystyczne. Czasy nowożytne.* Warsaw, 1984.

SAMEK 1988
Samek, J. *Polskie złotnictwo.* Wrocław, 1988.

SAMEK 1990
Samek, J. *Kościół Mariacki w Krakowie.* Warsaw, 1990.

SAMEK 1993
Samek, J. *Dzieje złotnictwa w Polsce.* Warsaw, 1993.

SEELING 1980
Seeling, H. *Die Kunst der Augsburger Goldschmiede 1529–1686* III. Munich, 1980.

SIDOROWICZ 1959
Sidorowicz, Z. "Z dokumentów kościoła i kolegiaty Św. Floriana w Krakowie." *Nasza Przeszłość* 10 (1959): 409–29.

SIEDLECKA 1974
Siedlecka, W. *Polskie zegary.* Wrocław, 1974.

SIGISMUND III 1990
Sigismund III—Sobieski—Stanislaus. Goldene Freiheit die Zeit der polnishen Wahlkönige. Exh. cat. Schloss im Marchweld, 1990.

SMULIKOWSKA 1989
Smulikowska, E. *Prospekty organowe w dawnej Polsce.* Warsaw, 1989.
Studia Waweliana 1 (1992): s 119–24.

SPUHLER 1968
Spuhler, F. *Seidene Repräsentationsteppiche der mittleren bis späten Safawidenzeit.* Berlin, 1968.

SREBRNE OPRAWY 1996
Srebrne oprawy książkowe ze zbiorów w Polsce. Ed. J. M. Krzemiński, B. Tuchołka-Włodarska. Exh. cat. Biblioteka Gdańska PAN. Gdańsk, 1996.

STENEBERG 1943
Steneberg, K. E. *Polonica. Zbiór obrazów.* Stockholm, 1943.

STOLZ UND FREIHEIT 1991
Stolz und Freiheit. Das Bild der polnischen Adels im Zeitalter des Barock. Exh. cat. Schleswig-Holsteinischen Landesmuseum Kloster Cismar, Rheinische Landesmuseum. Kiel-Bonn, 1991.

SUBLEYRAS 1987
Subleyras 1699–1749. Exh. cat. Musée de Luxembourg, Académie de France, Villa Medici. Rome, 1987.

SUDACKA 1994
Sudacka, A. "Zabytkowe organy w kościele Mariackim." *Rocznik Krakowski* 60 (1994): 51–74.

SWIEYKOWSKI 1906
Swieykowski, E. *Zarys artystystycznego rozwoju tkactwa i hafciarstwa objaśniony zabytkami Muzeum Narodowego.* Cracow, 1906.

SZABLOWSKI 1960
Szablowski, J. *Skarby wawelskie. Skarby kultury narodowej.* Cracow, 1960.

SZABLOWSKI 1963
Szablowski, J. "Nowe klejnoty wawelskie." *Pol-*

ska (1963): 8, 36.

SZTUKA NIEMIECKA 1996
Sztuka niemiecka 1450–1800 w zbiorach polskich. Exh. cat. Muzeum Narodowe. Kielce, 1996.

SZTUKA DWORU WAZÓW 1976
Sztuka dworu Wazów w Polsce // Court Art of the Vasa Dynasty in Poland. Ed. A. Fischinger. Exh. cat. Państwowe Zbiory Sztuki na Wawelu. Cracow, 1976.

SZTUKA W KRAKOWIE 1964
Sztuka w Krakowie w latach 1350–1550. Exh. cat. Muzeum Narodowe. Cracow, 1964.

SZTUKA ZDOBNICZA 1964
Sztuka zdobnicza—dary i nabytki 1945–1964. Exh. cat. Muzeum Narodowe. Warsaw, 1964.

ŚWIERZ-ZALESKI 1933
Świerz-Zaleski, S. *Przewodnik po jubileuszowej wystawie epoki króla Jana III w Zamku Królewskim na Wawelu od 16 lipca 1933 w dwustupięćdziesięciolecie odsieczy wiedeńskiej.* Exh. cat. Zamek Królewski na Wawelu. Cracow, 1933.

ŚWIERZ-ZALESKI 1937
Świerz-Zaleski, S. "Królewski zegar na Wawelu." *Światowid* 14 (1937): 13, 27.

SZKŁA 1998
Szkła z hut radziwiłłowskich. Naliboki (1722–1862), Urzecze (1737–1846). Exh. cat. Muzeum Narodowe w Warszawie. Warsaw, 1998.

TASZYCKA 1985
Taszycka, M. *Polskie pasy kontuszowe.* Coll. cat. Muzeum Narodowe. Cracow, 1985.

TEATR I MISTYKA 1993
Teatr i mistyka. Rzeźba barokowa pomiędzy Wschodem a Zachodem. Ed. K. Kalinowski. Exh. cat. Muzeum Narodowe. Poznań, 1993.

THIJSSEN 1992
Thijssen, L. *1000 Jaar Polen en Nederland.* The Hague, 1992.

TKANINA I UBIÓR 1976
Tkanina i ubiór w Polsce XVIII w. Exh. cat. Muzeum Okręgowe. Białystok, 1975.

TOMKIEWICZ 1958
Tomkiewicz, W. "Les rapports des peintres français du XVII siècle avec la Pologne." *Biuletyn Historii Sztuki* 20 (1958): 174–85.

TRON PAMIĄTEK 1996
Tron Pamiątek 1694–1996. Exh. cat. Pałac w Wilanowie. Warsaw, 1996.

TUCHOŁKA-WŁODARSKA 1991
Tuchołka-Włodarska, B. "Puchar Szyprów Wiślanych Johanna Jöde." *Rocznik Gdański* 51 (1991): 1, 181–97.

TÜRKEN VOR WIEN 1983
Die Türken vor Wien. Europa und Entscheidung an der Donau. Exh. cat. Historisches Muzeum der Stadt Wien. Vienna, 1983.

TÜRKISCHE KUNST 1985
Türkische Kunst und Kultur aus osmanischer Zeit I-II. Exh. cat. Museum für Kunsthandwerk. Frankfurt, 1985.

TYLICKI 1993
Tylicki, J. "Bröllmanowie. Złotnicy toruńscy przełomu XVII i XVIII w. (Część 2)." Acta *Universitatis Nicolai Copernici. Zabytkoznawstwo i Konserwatorstwo* 19 (1993): 55–100.

TYNIEC 1994
Tyniec. Sztuka i kultura Benedyktynów od wieku XI do XVIII wieku. Ed. K. Żurowska. Exh. cat. Zamek Królewski na Wawelu. Cracow, 1994.

URBAN 1984
Urban, W. *Szkice z dziejów archidiecezji lwowskiej.* Rzym, 1984.

VANITAS 1996
Vanitas. Portret trumienny na tle sarmackich obyczajów pogrzebowych. Ed. J. Dziubkowa. Exh. cat. Muzeum Narodowe. Poznań, 1996.

VITRY 1938
France à la gloire de Jean Sobieski." *La France et la Pologne dans leurs relationes artistiques* (1938): 1, 5–71.

VOISÉ, GŁOWACKA-POCHEĆ 1975
Voisé, J., and T. Głowacka-Pocheć. *Galeria malarstwa Stanisława Kostki Potockiego w Wilanowie.* Warsaw, 1975.

WACŁAW Z SULGUSTOWA 1902
Wacław z Sulgustowa (Nowakowski). *O cudownych obrazach w Polsce Przenajświętszej Matki Bożej.* Cracow, 1902.

WAŹBIŃSKI 1977
Waźbiński, Z. "Władysław IV jako 'artis pictoriae amator.' Przyczynek do polityki artystycznej Wazów." In *Rubens, Niderlandy i Polska. Materiały sesji naukowej.* Lodz, 1977, 62–79.

WIŚNIEWSKI 1916
Wiśniewski, J. *Monografia dekanatu miechowskiego.* Radom, 1916.

WIŚNIEWSKI 1917
Wiśniewski, J. *Dekanat miechowski.* Radom, 1917.

WOZNICKI 1990
Woznicki, B. *Mistrz Pinsel. Legenda i rzeczywistość.* Exh. cat. Pałac w Wilanowie. Warsaw, 1990.

WRÓBLEWSKA 1976
Wróblewska, G. *Dawne fajanse polskie.* Exh. cat. Muzeum Narodowe. Poznań, 1976.

WYBÓR DZIEŁ 1989
Wybór dzieł sztuki polskiej i z Polską związanych ze zbiorów Fundacji imienia Ciechanowieckich. Exh. cat. Pałac pod Blachą, Zamek Królewski. Warsaw, 1989.

WYSTAWA MINIATUR 1939
Wystawa miniatur na tle wnętrz pałacu hr. Pusłowskich. Exh. cat. Cracow, 1939.

WYSTAWA REWINDYKACYJNA 1929
Wystawa rewindykacyjna zbiorów państwowych. Ed. W. Suchodolski. Exh. cat. Warsaw, 1929.

WYSTAWA STARYCH ZEGARÓW 1938
Wystawa starych zegarów na tle wnętrz pałacu hr. Pusłowskich. Exh. cat. Cracow, 1939.

ZABITKY 1884
Zabitky XVII wieku. Wystawa jubileuszowa Jana III w Krakowie 1883. Cracow, 1884.

ZARYS DZIEJÓW 1966
Zarys dziejów włókiennictwa na ziemiach polskich. Ed. J. Kamińska, I. Turnau. Wrocław, 1966.

ZATORSKA-ANTONOWICZ 1993
Zatorska-Antonowicz, J. *Osiemnastowieczna fajanse warszawskie w zbiorach Zamku Królewskiego.* Warsaw, 1993.

ZBIORY CIECHANOWIECKICH 1989
Zbiory Fundacji im. Ciechanowieckich. Exh. cat. Pałac pod Blachą, Zamek Królewski. Warsaw, 1989.

ZBIORY ZAMKU 1969
Zbiory Zamku Królewskiego na Wawelu. Ed. J. Szablowski, A. Fischinger. Cracow, 1969.

ZBIORY ZAMKU 1975
Zbiory Zamku Królewskiego na Wawelu. Ed. J. Szablowski, A. Fischinger. Cracow, 1975.

ZBIORY ZAMKU 1990
Zbiory Zamku Królewskiego na Wawelu. Ed. J. Szablowski. Cracow, 1990.

ZBIORY WAWELSKIE 1992
Zbiory wawelskie: zakupy—depozyty—dary 1990–1991. Exh. cat. Państwowe Zbiory Sytuki na Wawelu. Cracow, 1992.

ŻYDZI-POLSCY 1989
Żydzi-polscy. Dzieje i kultura. Cracow, 1989.

ŻYGULSKI 1964
Żygulski, Z., Jr. "Geneza i typologia buław hetmańskich." *Muzealnictwo Wojskowe* 2 (1964): 239–88.

ŻYGULSKI 1975
Żygulski, Z., Jr. *Broń w dawnej Polsce.* Warsaw, 1975.

ŻYGULSKI 1982
Żygulski, Z., Jr. *Broń w dawnej Polsce na tle uzbrojenia Europy i Bliskiego Wschodu.* Warsaw, 1982.

ŻYGULSKI 1984
Żygulski, Z., Jr. *Stara broń w polskich zbiorach.* Warsaw, 1984.

ŻYGULSKI 1988
Żygulski, Z., Jr. "Uwagi o Rolce Sztokholmskiej / Remarks on the Stockholm Roll." *Studia do Dziejów Dawnego Uzbrojenia i Ubioru Wojskowego* 9/10 (1988): 23–38.

INDEX